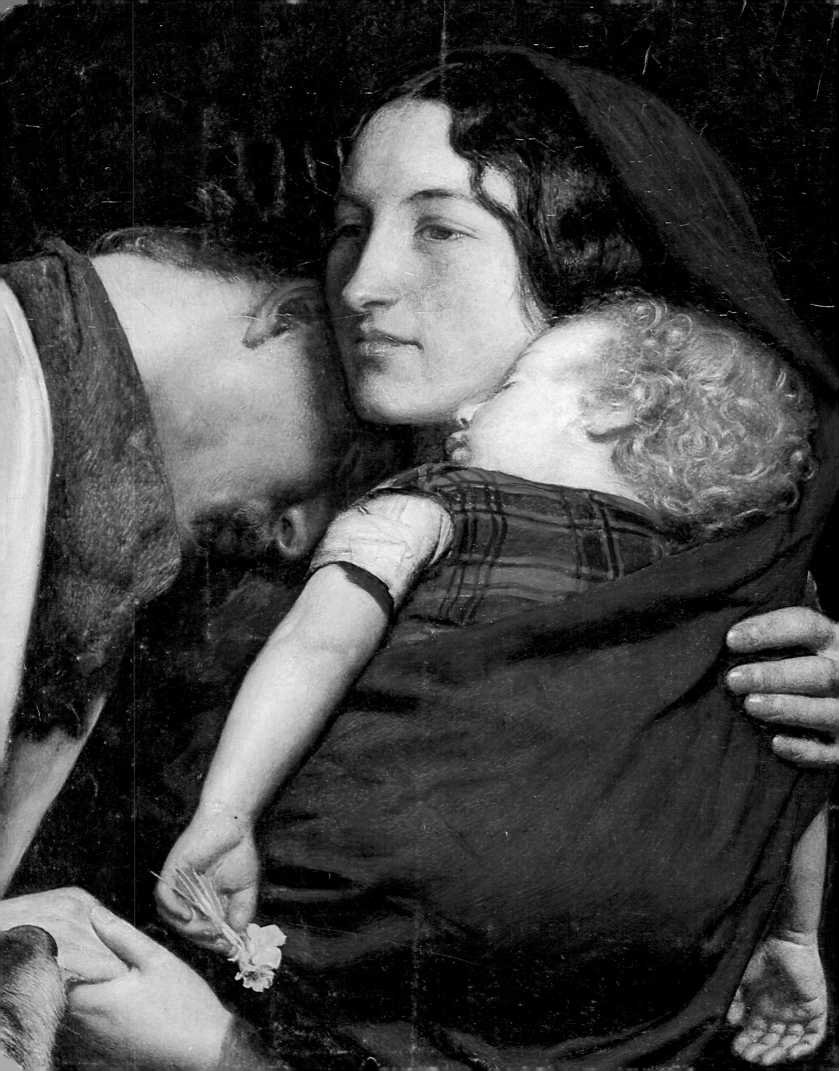

The Pre-Raphaelites

EDITED BY LESLIE PARRIS

TATE GALLERY PUBLICATIONS

frontispiece
John Everett Millais
The Order of Release 1852–3
(detail, No.49)

ISBN 1 85437 144 4

Published by Tate Gallery Publications, Millbank, London SW1P 4RG
First printing 1984
Reprinted with corrections 1994. Second reprint 1996
Copyright © 1984 The Tate Gallery All rights reserved
Designed by Caroline Johnston
Lettering by Michael Harvey
Printed in Italy by Amilcare Pizzi

CONTENTS

FOREWORD

This book was first published in 1984 as the catalogue of the Tate Gallery exhibition *The Pre-Raphaelites*. Visited by about 220,000 people, this was (and remains) one of the most popular exhibitions ever mounted by the Gallery. Its catalogue sold out around the time the exhibition closed and has been in great demand ever since. The Gallery is pleased to be able at long last to offer a reprint.

A few words are necessary to explain the scope and arrangement of the volume, which necessarily reflects the organisation of the original exhibition. The main focus is on the period from 1848, when the Pre-Raphaelite Brotherhood was founded, to 1860, by which time Pre-Raphaelitism was beginning to head in fresh directions. The years immediately preceding the formation of the Brotherhood are covered in a short introductory section, but no attempt is made to deal with the movement's many precursors (an even larger exhibition would have been required for this). Developments after 1860 are, however, treated more fully, taking the story up to Rossetti's death in 1882. A final section is devoted to Pre-Raphaelite drawings and watercolours. Throughout the arrangement is chronological, allowing direct comparisons to be made at any one time between the work of the various adherents of Pre-Raphaelitism.

The Introduction to this volume is by the then director of the Tate Gallery, Sir Alan Bowness. He and I selected the items in consultation with a team of specialists: Mary Bennett for Brown, Judith Bronkhurst for Hunt, John Christian for Burne-Jones, Alastair Grieve for Rossetti, Benedict Read for sculpture and Malcolm Warner for Millais. They wrote most of the catalogue entries; others were provided by Deborah Cherry, David Cordingly, Robin Hamlyn, Ronald Parkinson and myself. We were watched over by a formidable Committee of Honour comprising Quentin Bell, John Gere, Diana Holman-Hunt, Mary Lutyens, Lady Mander and Virginia Surtees.

A list of corrections and selected additions appears at the end of this reprint. I am grateful to Mary Bennett, Judith Bronkhurst, John Christian, Alastair Grieve, Robin Hamlyn and Malcolm Warner for assistance (at short notice) in compiling this. As will be seen, several privately owned items in the 1984 exhibition are happily now in the national collections on Millbank and Merseyside and in other public collections. The body of the volume remains unchanged.

The 1984 exhibition was sponsored by Pearson and this book was originally published in association with Allen Lane and Penguin Books.

Leslie Parris
Deputy Keeper of the British Collection

ACKNOWLEDGEMENTS

The authors of the catalogue are grateful to the following for their help: Patricia Adams, Kenneth Bendiner, J.P. Birch, Marilyn Bronkhurst, David Blayney Brown, Susan Casteras, the staff of the Courtauld Institute Library, Erica Davies, Lindsay Errington, John Fisher, Alasdair Forbes, John Gere, Stephanie Grilli, Diana Holman-Hunt, Lionel Lambourne, the staff of the London Library, Mollie Luther, Mary Lutyens, Jeremy Maas, Denise McColgan, Katharine Macdonald, Sir Ralph and Lady Millais, Christopher Newall, Jane O'Mahony, Richard Ormond, Fiona Pearson, Judith Pringle, Esmé Prowse, Arthur Searle, John Sunderland and the staff of the Witt Library, Virginia Surtees, the staff of the Tate Gallery Library, Julian Treuherz, Philip Ward-Jackson. Further acknowledgements appear in the catalogue entries.

Published and unpublished material is quoted by kind permission of the following: Special Collections Department of Arizona State University Library; Ashmolean Museum, Oxford; J.P. Birch, Esq.; Bodleian Library, Oxford; Special Collections Division, University of British Columbia Library; British Library; the heirs of Ford Madox Brown; University of Durham Library; Huntington Library, San Marino, California; Mary Lutyens (*Millais and the Ruskins*); Jeremy Maas, Esq.; City Art Gallery, Manchester; Merseyside County Council (Walker Art Gallery and Lady Lever Art Gallery); National Museum of Wales; Oxford University Press (*Letters of Dante Gabriel Rossetti* and *The P.R.B. Journal*); Pierpont Morgan Library; Princeton University Library; John Rylands University Library of Manchester; Kenneth Spencer Research Library, University of Kansas; Virginia Surtees (*Sublime and Instructive*); Tennyson Research Centre, Lincoln (by courtesy of Lord Tennyson and the Lincolnshire Library Service); Humanities Research Center, University of Texas at Austin; the Master and Fellows of Trinity College, Cambridge; Yale Center for British Art, Paul Mellon Collection; Yale University Press (*The Diary of Ford Madox Brown*); and several private owners.

LIST OF ARTISTS

by catalogue number

INTRODUCTION

The Pre-Raphaelite Brotherhood was founded in September 1848 in the Millais family house at 83 Gower Street, just round the corner from the British Museum. There were seven founder members, of whom only three really count. They were William Holman Hunt, aged twenty-one, Dante Gabriel Rossetti, aged twenty, and John Everett Millais, aged nineteen. Hunt introduced his friend F.G. Stephens, aged twenty, then an aspiring painter but soon to turn to writing on art. Rossetti (who was without much doubt the ringleader) brought in two slightly older friends, his next door neighbour, the sculptor Thomas Woolner, and the painter James Collinson, who was courting his eighteen-year-old sister, Christina. And then to provide a secretary for the Brotherhood (and perhaps to reach the magic number of seven), he added his younger brother, William Michael, aged twenty, a clerk in the Inland Revenue.

It is easy to overlook the extreme youth of the P.R.B. They were art students, at the beginning of their careers, impatient with their elders, ambitious for themselves. One should not take their declared aims too seriously. With a touching naivety, William Michael Rossetti tells us what they were:

1 To have genuine ideas to express;
2 to study Nature attentively, so as to know how to express them;
3 to sympathise with what is direct and serious and heartfelt in previous art, to the exclusion of what is conventional and self-parading and learned by rote; and
4 and most indispensable of all, to produce thoroughly good pictures and statues.[1]

Holman Hunt, writing in his book *Pre-Raphaelitism and the Pre-Raphaelite Brotherhood*,[2] wanted to put the record straight by giving his own account of the formation of the Brotherhood. He says that Rossetti planned to use the then fashionable term 'Early Christian', but that he objected (no doubt scenting hints of the Roman Catholic religion and of the German Nazarene style). Hunt tells us that it was he who proposed 'Pre-Raphaelite', and that Rossetti (a conspiratorial Italian at heart) added the word 'Brotherhood'. But, as Hunt explains, 'it is simply fuller Nature we want. Revivalism, whether it be of classicism or mediaevalism, is a seeking after dry bones'.[3]

Essentially, here were three enterprising and variously (but hugely) gifted young men, feeling that English art was at a low ebb and that they had a unique opportunity of doing something about it. Painting had been in the doldrums since the accession of the young Queen in 1837; people were always talking about a new movement but nothing much had happened. The annual Summer Exhibitions of the Royal Academy were regularly called dull and uninspiring by the press, though there were signs of a new liveliness in 1846. The

[1] W.M. Rossetti 1895, I, p.135. Abbreviations used in these notes are listed at the beginning of the catalogue section. If no source is given for a quotation, it is identified in the catalogue entry on the work under discussion.
[2] First published 1905 but based on articles Hunt wrote for the *Contemporary Review*, 1886–7.
[3] Hunt 1905, I, p.87.

three young painters of course learnt something from their elders, but they preferred to stress their own originality. Hunt in his book gives the impression that they created English art afresh, disregarding all the rules and turning to Nature for inspiration.[4]

When he used the word Nature, Hunt was certainly thinking of John Ruskin, the brilliant young critic, still in his twenties at the time the P.R.B. was formed. Hunt had been excited in 1847 when he read the second volume of Ruskin's *Modern Painters*. The first volume with its praise of Turner and its talk of landscape painting did not interest Hunt much (if indeed he read it), except perhaps for Ruskin's final exhortation to young artists to 'go to Nature . . . rejecting nothing, selecting nothing, and scorning nothing . . .'.[5]

The second volume of *Modern Painters* was another matter. Like Ruskin, Hunt came from an evangelical background; he was a great reader of the Bible, and a strong believer in a personal religion. Ruskin gave him a sense of mission. The passage that impressed him most was Ruskin's description of Tintoretto's 'Annunciation of the Virgin' in the Scuola di San Rocco, Venice – the ruined house, with its shattered brickwork and mildewed plaster, the carpenter's tools of Mary's husband, the narrow line of light, the cornerstone of the old edifice. Ruskin explains that every realistic detail has its symbolic meaning; every symbol is typological, or prefigurative, because it looks forward to events to come.[6] This is a way of thinking alien to us nowadays, but very natural to those brought up, as were Hunt and Ruskin, to read the Old Testament stories as anticipating the New Testament and in particular the actions and teachings of Christ. Ruskin was applying these ideas to elucidate the symbolism of Venetian Renaissance painting: Hunt realised that they can equally well be applied to modern art. Thus every detail in a painting becomes full of meaning, and there is that total identification of realism and symbolism which is to become the particular characteristic of Hunt's art.

Hunt's first attempt at a new kind of painting was 'Christ and the Two Maries' (No. 5). He also called the picture 'The Resurrection Meeting', because it depicts the reality of a direct personal confrontation with the Risen Christ. But he could not complete the picture: it was a failure – 'put aside | face to the wall' – as the label on the back records. Hunt was searching for a new way of combining symbolism and realism: perhaps he still lacked the spiritual conviction to overcome the practical difficulties.

Hunt, like his friend Millais, was very anxious to have a painting in the 1848 Royal Academy exhibition that would attract public and critical attention, and if possible sell. The two had become friends while studying together in the Royal Academy Schools, and in the winter of 1847–8 they had worked together in Millais' studio, each preparing a picture for the exhibition (Nos 9 and 10). Their friendship had developed slowly, for their backgrounds and characters were very different. Hunt was ambitious, arrogant, obstinate, unlikeable. His father was a warehouse manager in Cheapside, and William went out to work as a clerk at the age of twelve. He was determined to be an artist: in truth, he had little natural talent, and only great determination could keep him going. At the R.A. Schools, Hunt did not think much of the teaching and found little to admire in contemporary British painting. 'Altogether it was evident that I had to be my own master', he says.[7]

Millais, two years younger, had wonderful natural talents, and a charming, winning

[4] In a perceptive phrase, Geoffrey Grigson once said that the Pre-Raphaelites surrounded themselves for posterity 'with a set of gigantic magnifying-glasses' (*The Harp of Aeolus*, 1947, p.86).

[5] Ruskin, III, p.624.

[6] ibid., IV, pp.263–5; Hunt quotes the passage at length in *Pre-Raphaelitism* (1905, II, p.262).

[7] Hunt 1905, I, p.53.

manner. He entered the Royal Academy Schools at the age of eleven, the youngest student ever, and completed the course at sixteen. His middle-class parents were always supportive, rightly proud of their remarkable son. He remained unspoilt; a generous friend to the underprivileged Hunt, perhaps because he realised instinctively that this rather uncouth young man had the imagination and the vision that he lacked. One can appreciate this point if one compares the pictures that the two young men were painting for submission to the 1848 Academy exhibition. Millais' 'Cymon and Iphigenia' (No.10) is competent but conventional: an uninteresting subject painted in the style of William Etty. The elders of the Royal Academy on the exhibition selection committee, rightly thinking that their star pupil could do better, turned it down.

Hunt was deservedly fortunate, and his painting 'The Flight of Madeline and Porphyro during the Drunkenness Attending the Revelry' (No.9) was accepted, though it attracted little notice. In fact, it is also conventional in composition, and its novelty lay in the choice of subject matter – an illustration of the penultimate stanza of Keats' 'The Eve of St Agnes', in which the poet describes the lovers slipping past the drunken porter and his wakeful bloodhound. The confrontation between 'the sacredness of honest responsible love' and 'the weakness of proud intemperance' appealed to Hunt: he could 'practise [his] new principles . . . on that subject'.[8]

Hunt claimed that 'no one had ever before painted any subject from this still little-known poet'.[9] He was a little disingenuous, but broadly correct, for Keats had been almost forgotten since his death in 1821, and the revival of interest dates from 1848 when the poems were republished and the biography by Monckton Milnes appeared.[10] Keats' poems, with their intensely visual quality, appealed to the young painters, who learnt from Monckton Milnes that the poet had been very interested in Italian art before the time of Raphael.[11] There was an immediate common interest.

It was the Keats subject that led to the historic meeting with Rossetti. He was one of the few who noticed Hunt's picture at the 1848 Academy exhibition, and on 10 May he introduced himself to Holman Hunt. The two young men immediately became very friendly, and thus the Pre-Raphaelite triumvirate of Hunt, Millais and Rossetti was formed, and the Brotherhood established.

Rossetti had a classless, cosmopolitan background. Encouraged from childhood to draw and to write poems and stories, he grew up in a world where art was seen as inseparable from literature, too often perhaps as illustration to it. It was always understood in the family that 'Gabriel meant to be a painter' – this could prove a lucrative profession, whereas poetry was not. Rossetti had difficulty in choosing between poetry and painting; indeed he refused to make the choice, and always practised both, but this, while it characterises his art, spotlights his weakness. As a young man there was so much he wanted to read that he had no time to learn to paint properly. He preferred to spend his time in the Reading Room of the British Museum, and before he was twenty he had a wide knowledge of German, French and Italian as well as English literature; he had also made the first drafts of many of his finest poems, among them 'My Sister's Sleep', 'Jenny' and 'The Blessed Damozel'.

[8] ibid., 1, p.85.
[9] ibid., 1, p.106.
[10] Richard Monckton Milnes, *Life, Letters, and Literary Remains of John Keats*, 2 vols.
[11] Indeed, it was probably the mention that Benjamin Robert Haydon had lent Keats his copy of Lasinio's engravings of the frescoes in the Campo Santo at Pisa that led the curious Pre-Raphaelite brethren to look at this folio during their inaugural meeting.

The young Rossetti was making many drawings with subject matter taken from his favourite authors – Goethe, Poe, Shakespeare, Coleridge. He found it more difficult to paint in oils. Getting little encouragement from his teachers at the Royal Academy, in March 1848 he dropped out of the course, and decided to go for private lessons to Ford Madox Brown. He wrote the older painter such a flattering letter that Brown thought he was being made fun of – he went to Rossetti's house with a 'thick stick', but when he found that Rossetti was both sincere and serious, he agreed to take him as a pupil, with no payment.

Brown was an outsider who never quite fitted into English art and society. He had been born in Calais, of British parents, in 1821, which made him seven years older than Rossetti. He studied art in Antwerp and Paris, and was only attracted to London in 1844 by the possibility of big commissions for the decoration of the new Houses of Parliament. Though he exhibited in London in the 1840s, he was paid little attention – except perhaps by Rossetti. Brown's earliest works are eclectic in character. He completely changed his manner after a visit to Rome in 1845–6, adopting the Nazarene style, invented and practised by the German painters, Overbeck and Cornelius, and favoured by the Prince Consort as the new art of the day.

When Rossetti first met him in March 1848, Brown was finishing 'The First Translation of the Bible' (No.8), in order to show it at the Free Exhibition of 1848. The subject cel-

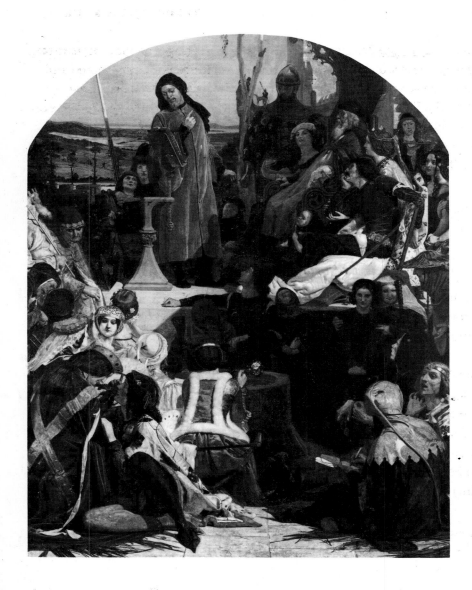

fig.i Ford Madox Brown, 'Geoffrey Chaucer Reading the "Legend of Custance" to Edward III and his Court . . .', R.A. 1851; oil on canvas, 146½ × 116½ (372 × 296)
Art Gallery of New South Wales, Sydney

ebrates, almost aggressively, the Reformation, but the style is Nazarene or early Christian in its simplicity and symmetry of composition, and this would have been immediately associated with the Roman Catholic faith. The neo-gothic architectural surround confirms this. In Brown's studio was an even larger painting showing Chaucer at the Court of Edward III (fig.i; cf. No.7), conceived in 1845 to illustrate 'The Origin of our Native Tongue' and then recast in Rome in triptych form, with other poets in the side panels, as 'The Seeds and Fruits of English Poetry' (No.6). Brown's ambition was admirable, and his plans were highly original, but his difficulties in completing work and his bad habits of retouching later help explain his relative lack of success. Though Rossetti became and remained a good friend, Hunt and Millais were always suspicious of Brown's foreignness. He was not invited to join the Brotherhood in September 1848, and was always kept a little apart from the Pre-Raphaelites proper.

Brown set his enthusiastic pupil to work painting bottles and pickle jars and phials of paint. It was this hard schooling, necessary but unimaginative, that caused Rossetti after a month or two to switch his allegiance to Hunt. In any case Rossetti found drawing more to his taste than painting, and with his new friends, Hunt and Millais, he began to forge a new and common style, the first true Pre-Raphaelite manner. This suddenly emerges in the summer of 1848, typified by awkward poses, hard outlines, absence of shadows, prickly, spiky forms – perhaps best exemplified in the drawings that Rossetti and Millais dedicated to each other (Nos 162 and 158). Exchange of work was an important practice for the P.R.B.[12]

There was indeed a plan for the Brothers to make together a series of etchings illustrating Keats' poem 'Isabella, or the Pot of Basil'. According to Hunt, Rossetti procrastinated and did not produce. Hunt, sensitive to the class distinction at the heart of the story, drew 'Lorenzo at his Desk in the Warehouse' (No.163), but the scheme was thwarted because of copyright difficulties. Millais chose to depict Isabella feasting with her brothers and their servant Lorenzo, with whom she has fallen in love. Excited by the subject, he decided in October 1848 to use it for the painting he was planning to show at the 1849 Summer Exhibition.

'Isabella' (No.18) marks a new beginning for Millais, and, with Hunt's 'Rienzi' and Rossetti's 'Girlhood of Mary Virgin', it signals the emergence of Pre-Raphaelite painting as a distinct and completely new style. All three pictures were made in the last months of 1848 and the first months of 1849; all three were publicly shown in the spring of 1849. Painted with small brushes on a white ground, a technique in part derived from fresco painting, they are lighter, brighter pictures than was normal in 1849. All use friends to pose, rather than professional models. We are aware too that the three young painters are closely studying nature, following the precepts of Ruskin, and that they love the detail for its own sake.

In the case of 'Isabella', we can say that Millais finds a symbolism in these details. We notice the spilled salt on the table, the hawk tearing at a white feather, the blood orange that the doomed lovers share. Where does Millais get this idea from? It is part of the texture of Keats' poem, but Millais seems to take it further, and I believe that it was Rossetti rather than Hunt who encouraged him to do so.

Both of them had begun their major paintings before Millais (they needed to: neither found it easy to paint). Hunt's 'Rienzi' (No.17) was planned in the summer of 1848, and

[12] Hunt dedicated his drawing 'One Step to the Death-bed' (No.159) to Rossetti. No Rossetti drawing dedicated to Hunt has survived, but one probably existed.

owes its conception to the Chartist demonstrations and general unrest of that year. As Hunt said, 'Like most young men, I was stirred by the spirit of freedom of the passing revolutionary time'.[13] Bulwer Lytton's novel, first published in 1835 (Wagner's early opera dates from 1837), had appeared in a new edition in 1848. Hunt sympathised with the young outsider who, spurned by the proud and ill-treated by the powerful, goes on to gain his objectives. He chooses to make the painting celebrate a moment of revelation: Rienzi, the plebeian, decides to act and revenge the death of his young brother.

'Rienzi' is an out-of-doors picture, letting fresh air into Victorian art. Hunt painted it all from nature, but piecemeal, not integrally. Rossetti posed for Rienzi, Millais for the dead brother. There is a loving attention to the natural details, which shows perhaps that Hunt is following Ruskin's precepts. There is a hint of symbolism in the flowers around the sword hilt, in the Pietà-like pose of the brothers, and in the new moon in the sky, announcing the dawn of a new era.

This new pictorial symbolism is strikingly evident in Rossetti's contribution to the emergent Pre-Raphaelite style, 'The Girlhood of Mary Virgin' (No. 15). It was actually painted in Hunt's studio, begun before 20 August 1848, and worked on simultaneously with 'Rienzi'. The use of symbols is so elaborate that Rossetti wrote two sonnets in explanation. Truth to nature, so important for Hunt, is used essentially for symbolic purposes. It is both a symbolism of objects (the dove, the lamp, the rose, the flower, the vine), and a symbolism of colour (gold for charity, blue for faith, green for hope, white for temperance).

The question remains, is it a religious picture? I think not. There is no evidence that Rossetti himself had any religious beliefs: he was a Victorian agnostic, holding everything in doubt. He was to be constantly asking questions about the meaning of existence, and getting no answers except those that he invented. His deepest belief was that woman enshrines the mystery of existence, both in an actual and a metaphysical sense. When he painted the 'Girlhood' he was certainly affected by the High Anglicanism of his mother and his sister Christina; he was also fascinated by the cult of mariolatry, but there is no true religious or mystical feeling in Rossetti. As he wrote in 1852 to F.G. Stephens, 'That picture of mine was a symbol of female excellence. The Virgin being taken as its highest type. It was not her *Childhood* but *Girlhood*'.[14]

Rossetti was also aware that much of the great painting of the past, and certainly of the period he most admired, was religious in inspiration. Why then should the Pre-Raphaelites not paint religious pictures? Rossetti's example was quickly followed by Millais and Hunt, and all three showed religious subjects to the public in 1850.

Millais' painting, 'Christ in the House of His Parents' (No.26), popularly known as 'The Carpenter's Shop', seems to follow directly upon Rossetti's 'Girlhood'. Holman Hunt tells us that Millais' 'new subject was suggested to him by a sermon he had heard in Oxford in the past summer' (i.e. 1849) on a text from Zacharias, which was quoted in the Royal Academy exhibition catalogue as the only title for the picture. The sermon Millais heard may well have been preached by the Oxford Movement theologian, E.B. Pusey, for the painting is, effectively, a tractarian sermon in paint. I find it hard to believe that Millais himself could have worked out unaided the complex programme of reference to events in the life of Christ and to Biblical texts which the picture certainly contains. This is prefigurative, or typological symbolism, at its most obvious in the way that the crucifixion is anticipated by the wounds on the child Christ's hands and the drops of blood that fall on to His feet, or by the pincers and nail that Anne pushes across the table. Every detail in the

[13] Hunt 1905, I, p.114. [14] Grieve 1973, p.8.

picture has a symbolic meaning of one kind or another – for example, the sheep in the fold are the faithful restrained by the Church, and the fact that the carpenter has a door on his bench may perhaps refer to the biblical text: 'I am the door: by me if any man shall enter in, he shall be saved'.

As we have seen, this kind of symbolism was more to the taste of Holman Hunt, who knew his Bible better than Millais or Rossetti did. He inscribed no fewer than four Biblical texts on the frame of his 1850 Academy submission, 'A Converted British Family Sheltering a Christian Missionary from the Persecution of the Druids' (No.25). This is not exactly a religious subject – though Hunt said it was done 'to honour the obedience to Christ's command that His doctrine should be preached to all the world at the expense, if needs be, of life itself'. Hunt was attracted by the idea of painting the missionary persecuted for his faith – it was another outcast subject, and he could readily identify with the dying priest whom he paints in the pose of the dying Christ. As with Millais, the naturalistic details in the picture all have symbolic meanings.

Rossetti's painting of the annunciation of the Virgin Mary, 'Ecce Ancilla Domini!' (No.22) is in many ways the most remarkable of the three, and the most audacious of all Pre-Raphaelite paintings. Rossetti had to hurry to get a picture ready for public exhibition, and once again he did not risk sending it to the Royal Academy but showed in the jury-free exhibition. He planned a diptych on the life and death of the Virgin, but completed only the first part. Again, it is less a devotional image than a painting about female purity and innocence and virginity.[15] And Rossetti expresses this, not so much by the symbolic details used in the 'Girlhood', as by form and colour. Most of the 'Ecce' is white, and the colours that do appear are restricted to the primaries – red and blue and golden yellow.

The Pre-Raphaelites' attempt to revive religious art in 1850 was not a success with the public. Poor Millais suffered an abusive press for the 'Carpenter's Shop', arising partly from disappointment that so talented an artist (he was only twenty when it was exhibited) had adopted a 'foreign' style and a subject matter that smacked of Roman Catholicism. Fortunately he had already sold the picture for a good price before the Academy exhibition, but Hunt, who needed to earn a living from art, could not at first sell the 'Missionary'. Millais however persuaded his new Oxford friend to buy it. This was Thomas Combe, the University printer, very High Church and in his early fifties. Combe and his wife were to become surrogate parents for Hunt (who was a little ashamed of his modest lower middle class background).

Discouraged by their attempts to revive religious art, Hunt, Millais and Rossetti now resorted again to literary subject matter. They could express their personal ideas in this way, and they were beginning to take a greater interest in landscape – preceded here by Ford Madox Brown, who operated on the periphery of the Brotherhood.

Rossetti knew that he needed to paint a larger, more ambitious composition, and he turned to Browning, then a 'difficult' modern poet aged thirty-eight whom he much admired. 'Hist! – Said Kate the Queen' (cf. No.31) was to have been over seven feet wide, with thirty figures grouped together. Unable to finish it, Rossetti switched to painting the meeting of Dante and Beatrice in Paradise: 'My canvas is a whopper again, more than 7 ft. long', he wrote in October 1850, hoping that Mr Combe might buy it.[16] But, alas, he had to abandon this as well, and had nothing ready for exhibition in 1851.

[15] Rossetti says of Chiaro in 'Hand and Soul': 'much of that reverence which he had mistaken for faith had been no more than the worship of beauty'.

[16] Rossetti to J.L. Tupper, 25 October 1850; Doughty & Wahl, I, p.94.

Millais also had a problem picture on his hands. Encouraged by his Oxford friends, he planned to paint 'The Eve of the Deluge' – a marriage feast taking place at the moment of the Flood, with everybody, apart from a terrified servant, oblivious of the rising waters (cf. No. 171). It was intended 'to affect those who may look on it with the awful uncertainty of life and the necessity of always being prepared for death'. Everything was planned in detail, but never carried out. Millais substituted a smaller composition, showing 'The Return of the Dove to the Ark' (No. 34). Even here, a background of birds and animals was never painted, and Millais concentrated on what he instinctively knew he could do best – the confrontation of two figures, sensitively painted and permeated by tenderness and warmth.

'The Return of the Dove' was one of three pictures that Millais showed at the 1851 Academy. The others both had Oxford settings and subjects drawn from modern poets. 'Mariana' (No. 35) was Millais' first subject from Tennyson – a timely choice because the forty-one year old author of *The Princess* (1847) and *In Memoriam* (1850) had just been made Poet Laureate. 'Mariana' was exhibited without a title, only the refrain from Tennyson's poem:

> She only said, 'My life is dreary,
> He cometh not', she said;
> She said, 'I am aweary, aweary,
> I would that I were dead!'

Millais' painting establishes the mood of lassitude and despair, exploiting the contrast of intense colour in Mariana's blue dress and the empty orange stool behind her. It is again a scene of confrontation, even though the second figure is absent.

The third painting, 'The Woodman's Daughter' (No. 32), is the most original of the three. Millais had read Coventry Patmore's poem 'The Tale of Poor Maud' in May 1849, and decided to make a painting from it. Patmore was a friend of the sculptor Woolner, one of the original P.R.B. He was born in 1823, and had no public reputation until the publication of *Angel in the House* in 1854. His poem is about the rich squire's son who falls in love with a woodman's daughter. In later life they meet and have an affair but cannot marry because of the social gulf between them. All ends in the tragedy that the woodman's felling of the tree seems to prefigure.

'The Woodman's Daughter' is the first Pre-Raphaelite picture to deal openly with a genuine contemporary social problem, though indirectly we can perhaps interpret Hunt's contribution to the 1851 Academy exhibition as moving in the same direction. Superficially 'Valentine Rescuing Sylvia from Proteus' (No. 36) illustrates, conventionally enough, a scene from Shakespeare's *Two Gentlemen of Verona*. Hunt however chooses the moment when Valentine rebukes his best friend Proteus, who has just tried to rape his girl friend, Sylvia; so the painting is in fact about the prevention of rape. We can, I think, sense a certain sexual tension invading the chaste world of Pre-Raphaelite painting: the subject itself has undertones of jealousy between friends and the opposition of parents to young love. It is surely not without significance that Elizabeth Siddal (who had once jokingly been introduced as Hunt's wife) modelled Sylvia, and perhaps it was Annie Miller who first appeared in Pre-Raphaelite painting as the model for Julia.

Girls had now entered the Pre-Raphaelite circle, and the close group of young men was breaking up. Throughout 1851 Rossetti was falling in love with Lizzie Siddal, with a growing passion that identified her as the Beatrice to his Dante. Love changes from the son's and brother's love to sexual attraction, and Rossetti's ideal now has a particular object.

When Hunt's and Millais' paintings were exhibited at the 1851 Royal Academy exhibition there was another outcry in the press. It was so manifestly unfair and damaging to the young artists that Millais asked Patmore if he would speak to Ruskin, by now the most influential art critic in England. Ruskin wrote a letter to *The Times* of 13 May 1851 praising the power, truth and finish of Hunt's picture. Ruskin's defence and subsequent friendship made an enormous difference, especially to Hunt, who had despaired of success and had contemplated emigration.[17]

Even Ruskin's help was no immediate answer, and it was in this depressed state of mind that Hunt experienced what amounts to a religious conversion. He was staying with Millais at Worcester Park Farm, near Kingston, and had begun work on 'The Hireling Shepherd' (No. 39), ostensibly a subject from *King Lear*, but as Hunt's change of title from 'Jolly Shepherd' to 'Hireling Shepherd' indicates – redolent of the New Testament, and in particular of Chapter 10 of St John's Gospel. In September 1851 Hunt conceived of the counterpart to the Hireling Shepherd – the painting of the good shepherd, the light of the world, which is another phrase from John's Gospel. In his autobiography Hunt does not discuss this experience, but he told William Bell Scott that 'The Light of the World' (No. 57) recorded his own conversion, and that it was the turning point in his artistic and spiritual history. 'I painted the picture with what I thought to be divine command, and not simply as a good subject'.

The paintings of the hireling and of the good shepherd are clearly linked – by the contrast of day and night, light and darkness, for example. Spiritual neglect in both works is depicted by over-luxuriant nature – the ivy-covered door, or the choked stream and marshy ground. In both pictures, Hunt makes use of symbolism, especially obvious in 'The Hireling Shepherd', where the neglected lamb on the girl's lap munches unripe apples. Apples recall the temptation and fall of Eve, and perhaps 'The Hireling Shepherd' records sexual temptation for Hunt personally; perhaps even his own seduction by (or of) the girl, and his loss of sexual virginity. A pretty Ewell farm girl, Emma Watkins, had posed for him. Hunt had also by this time got to know Annie Miller, a beautiful red-haired girl living in a Chelsea slum and working as a barmaid. She was only fifteen when Hunt met her in 1850, and whether or not she posed for Julia she certainly modelled the girl in 'The Awakening Conscience' which Hunt painted in 1853.

'The Awakening Conscience' (No. 58) is the secular or material counterpart to 'The Light of the World' – they are both images of sudden revelation, one eternal and the other time-bound, and the temptation inherent in 'The Hireling Shepherd' is here followed by the fall. Hunt inscribed a text from Proverbs on the frame below the picture, because 'These words, expressing the unintended stirring up of the deeps of pure affection by the idle sing-song of an empty mind, led me to see how the companion of the girl's fall might himself be the unconscious utterer of a divine message'.[18]

Christ's knock on the door, and His bringing of light, can come to anyone, and at any time, and in any circumstances. Illumination comes suddenly to the kept woman, and every detail in the furnishings of the love-nest symbolises her position and her fate – the music on the floor or on the piano, the cat tormenting a bird, the tangled wools of the embroidery, the engraving of 'Cross Purposes' on the wall. As Ruskin said, once again supporting Hunt, in a letter to *The Times* of 25 May 1854: 'There is not a single object in all that room, common, modern, vulgar . . . but it becomes tragical if rightly read. Painting taking its proper place beside literature'.

[17] Hunt 1905, I, p.261. [18] ibid., II, p.430.

Ruskin was defending Hunt's two paintings in the 1854 Academy, 'The Light of the World' and 'The Awakening Conscience'. 'The Hireling Shepherd' had been shown two years earlier, in the summer exhibition of 1852 alongside 'Ophelia' (No.40) with the beautiful green-eyed, copper-haired Elizabeth Siddal as the model, and 'A Huguenot' (No.41), which brought Millais his first real public success. When one considers that the 1852 exhibition also included Brown's 'The Pretty Baa-Lambs' (No.38) (which was badly hung and scarcely noted) one may say that this marks the move out-of-doors for the Pre-Raphaelites.

Brown had painted outside the studio before, but this was the first time that he had painted the figures in natural light as well – a practice that Hunt and Millais had yet to emulate. Using brilliant white grounds, all the young artists were now producing work much brighter in hue, and with naturalistic details of remarkable fidelity. Such pictures took an enormous time to complete, and of course could not represent a single moment in time, but they were as 'true to nature' as the artist could make them.

The mainspring of Hunt's 'Shepherd' was a complex and personal symbolism, the ramifications of which are discussed in the catalogue. By comparison, Millais now dispensed with this kind of programme. 'Ophelia' was a popular Academy subject, and the Huguenot theme was an injection by his friend Hunt: Millais wanted simply to paint two lovers whispering by a garden wall. 'A Huguenot' was a very popular picture; it was plainly anti-Catholic in sentiment, and the fears of heresy, both artistic and religious, that the 'Carpenter's Shop' had given rise to, were now forgotten. In the following summer, 'The Order of Release' (No.49) won even greater popularity. Millais, still only twenty-four years old had become the most successful painter in England. He was elected an associate of the Royal Academy in November 1853, at the earliest possible age, and he remained a faithful Academician, regularly showing his work and ending up as President in 1896, the year of his death. Hunt had applied for associate membership in 1852. Refused, he never tried again.

'The Order of Release' is suffused with a very personal feeling, for the girl's head was modelled by Effie Ruskin, with whom Millais was, as everyone knows, to fall in love and marry. Millais' work over the next few years is deeply felt, whether it be the 'Portrait of Ruskin' (No.56), or the pen and ink drawings of 1853–4 (Nos 185–94), or the two 'honeymoon' pictures that were shown at the 1856 Royal Academy, 'The Blind Girl' (No.69) and 'Autumn Leaves' (No.74). Like 'The Awakening Conscience', 'The Blind Girl' touches on a social problem, but this is not Millais' main interest in the subject: it is the pathos of blindness – the deprivation of one sense and perhaps the consequent heightening of smell and sound and touch – that interests him.

'Autumn Leaves', Millais' masterpiece, projects a mood. Tennysonian in feeling, it was, according to Ruskin, 'much the most poetical work the painter has yet conceived'.[19] Effie tells us that her husband 'wished to paint a picture full of beauty and without subject'. So Millais paints Effie's sisters, and the two local Perth girls who had sat for 'The Blind Girl', burning the leaves at the end of summer. The sun sets, the smoke curls away – everything is transient, even beauty passes, especially after the temptation represented by the apple held by the youngest girl. But it is not a trivial work: 'I intended the picture to awaken by its solemnity the deepest religious reflection', Millais told F.G. Stephens.

By 1856 Millais was the most influential painter at work in England, and the Academy exhibitions of the 1850s are full of Millaisian painting. When we speak of Pre-Raphaelite

[19] *Academy Notes*, 1856; Ruskin, XIV, p.66.

influence at this date we generally mean Millais – Bowler and Burton, Wallis and Windus, Arthur Hughes, Dyce for a time – a whole generation of young painters (and some older ones) fall under Millais' spell. Scarcely anyone was immune: 'Autumn Leaves' provided the starting point for Whistler. With a few exceptions however – 'Chill October' (No.140) for example – Millais' own later work is disappointing. Lovely passages of paint, but such vacuity behind the conception. Without the support and stimulus of his Pre-Raphaelite brethren, Millais seems sadly lost.

Hunt had a toughness and a personal sense of mission that enabled him to survive. He was never an influential artist, and had few followers. Divine inspiration does not come to everyone. He painted remarkably few paintings, considering his very long career. With his two pictures at the 1854 Academy he demonstrated that he had created a new kind of pictorial language – symbolic realism – which he was now going to use in the service of Christ. By the time the exhibition opened, he had already left for the Holy Land, and he was to be away for over two years, returning in time for the Academy exhibition of 1856.

It was on this occasion that Hunt showed 'The Scapegoat' (fig.ii; cf. No.84), which immediately became one of the most memorable images in the history of art. No wonder Hunt was surprised that the subject had never been painted before. The goat is both symbol of Christ, carrying the sins of the world, and symbol of the artist (i.e. Hunt himself) scorned and neglected by a philistine public, but the bearer of truth, 'guided by his own light'. The other Palestinian pictures are less remarkable, though some of them brought Hunt great public success (and a substantial income from reproduction rights). Biblical realism slowly takes over from the symbolic realism of the Pre-Raphaelite period. Literal-mindedness stunts an original imagination, and though Hunt can rise to the occasion when not too much is at stake, he too like Millais slips away into an unproductive later career.

For the third member of the original triumvirate, Rossetti, it was the early career that was unproductive, at least in the eyes of his contemporaries. After 1850 not a single work appeared in a public exhibition for more than a decade. Rossetti was far from idle – ideas came pouring from him in the form of poems, watercolours and drawings, but the

fig.ii William Holman Hunt, 'The Scapegoat', 1854–5, R.A. 1856; oil on canvas, 33¾ × 54½ (85.7 × 138.5) *Merseyside County Council, Lady Lever Art Gallery, Port Sunlight*

fig.iii Dante Gabriel Rossetti, 'Found',
begun 1854 or 1859, never completed;
oil on canvas, 36 × 31½ (91.4 × 80)
Delaware Art Museum (Samuel and
Mary R. Bancroft Memorial)

exhibition picture he found too difficult to achieve. He could claim the primacy in the Pre-Raphaelites' interest in modern moral subject matter – had he not first drafted his poem, 'Jenny', at eighteen? But when it came to his painting of the fallen woman, 'Found' (fig.iii; cf. No.63), he was too slow in getting it finished. He worked at 'Found' throughout the early months of 1854, but then had to watch Hunt get the public attention at the Academy exhibition with 'The Awakening Conscience'. 'You feel as if it were not worth while now to bring out your modern subjects, as Hunt has done his first', Ruskin wrote in encouragement, but modern life 'belongs to all three of you equally in *right of possession*'.[20]

Rossetti had still not completed 'Found' when Hunt returned from the East with the 'Scapegoat' in 1856, and now there was no longer any incentive to continue. He would certainly have been labelled a follower of Hunt had he exhibited 'Found' (the cartoonists of *Punch* would have had a great time with the Rossetti lamb and the Hunt goat), and this was not something that the proud Rossetti could bear to contemplate. So the modern-life subject was abandoned, and with one or two tentative exceptions Rossetti never returned to it.

It was Rossetti's friend, Ford Madox Brown, who had the greatest success in this area. He too had a problem in bringing work to completion (and a deplorable habit of repainting everything), but the three modern subjects that were all planned in a few months in 1852

[20] Ruskin to Rossetti, 5 June 1854; Ruskin, XXXVI, p.167.

are certainly his finest work. 'The Last of England' (No.62) is as much about the humiliations to the educated that emigration involved, as it is about the drama of emigration itself. The setting of both 'An English Autumn Afternoon' (No.51) and 'Work' is middle class Hampstead. For Brown the landscape is a literal transcription of the scenery around London, nothing more: this led to Ruskin's unkind dismissal ('such a very ugly subject'), and poor Brown suffered throughout his career from genteel poverty and critical indifference.

Even 'Work' (No.88) had little contemporary success; its fame is a twentieth-century phenomenon. Admittedly the programme that fascinates us seemed 'excessive elaboration' even to Rossetti, and it is true that Brown had to modify his original impetus from Carlyle (and probably Mayhew) to satisfy the demands of a prospective purchaser who wanted to step up the 'moral and religious element'. It took Brown thirteen years to complete 'Work', and by the time it was ready as the centrepiece of his 1865 exhibition, Brown seemed to have lost confidence in this kind of modern moral subject, and was all too damagingly seen as a follower of the now rather successful Rossetti. In any case Brown had already decided to put his energies into his collaborative work for Morris and Company, and many of his later paintings arise from stained glass designs or projects for illustrations. With so much time and energy spent on the Manchester Town Hall murals, Brown too falls into the background in the latter part of his career.

It was Rossetti who was to give Pre-Raphaelite painting a completely new lease of life in the 1860s. Putting 'Found' on one side, and with it any serious attempt at modern moral subject matter, he was happy to pursue his cult of feminine beauty. From 1853 onwards his private life was dominated by the presence of Elizabeth Siddal, whom he was to marry in 1860 and who died in tragic circumstances in 1862. She was a respectable middle class girl, exceptionally striking in appearance. She had worked in a West End milliner's – perhaps the equivalent of today's King's Road boutique – when the Pre-Raphaelites first noticed her, but she soon became Rossetti's exclusive possession. As Rossetti believed that everyone had the innate capacity to make art, and especially to draw and to write poetry (as he did), he encouraged Lizzie to write and paint. Both were greatly helped by Ruskin's patronage, for Ruskin not only bought work for himself, he also introduced to Rossetti a whole circle of collectors such as Ellen Heaton, Charles Eliot Norton and J.P. Seddon, the architect who commissioned Rossetti's only large painting of the 1850s, 'The Seed of David', for Llandaff Cathedral.

It was in this way that Rossetti's reputation slowly, almost clandestinely, grew. He was obsessed with Lizzie, and was at his happiest introducing her features into the small and richly detailed watercolours that he found so much more satisfying to paint than oil pictures. She was his Beatrice (No.176), she was the Virgin Mary (No.209), she was St Catherine (No.90), she was Guinevere (No.213).

The Arthurian subjects, encouraged by Ruskin, become all-important in the mid-1850s, and culminate in the 1857 decoration of the Oxford Union building. Rossetti could not do this on his own, so he brought together a new group of friends to help him. Once again there were seven, and though no title was ever attached to them, this is effectively a second Pre-Raphaelite Brotherhood and one that excluded Hunt and Millais. Again, exactly as in 1848, there were three dominating personalities (Rossetti, Morris and Burne-Jones), and four supporters (Hughes, Prinsep, Pollen and Spencer Stanhope). The major literary figure of the circle this time was Algernon Charles Swinburne.

William Morris, born in 1834, and Edward Burne-Jones, born in 1833, were undergraduates at Oxford University when they met Rossetti in 1856. Morris, a confident, rich

young man, and a valuable patron for Rossetti, had already taken up the shy and diffident Burne-Jones, who came from a modest Birmingham background. Both had been destined for the Church, but Rossetti changed all that and they henceforth dedicated their lives to art. Morris moved on, with Rossetti's backing, to the reform of design and then of society itself, but Burne-Jones, faithful to Rossetti's example, was to build a substantial career, and an international fame, as a Pre-Raphaelite painter that none of the others achieved.

Rossetti's own painting mirrors very exactly the state of his emotions: it hints at the secrets of his heart. There is a sudden change around 1856 when the mood of innocence and simplicity and virginity that surrounds the first rapture of his love for Elizabeth Siddal gives way to a very different manner – lush, rich, ornate, sensual and highly particularised. Lizzie now seems to stand for something threatening to Rossetti, morbid perhaps, even frigid. She was very ill before the marriage, and in 1860 Gabriel married a dying bride.

By this time Rossetti's emotional life was in turmoil: at Oxford in 1857 he had fallen in love with the seventeen-year-old Jane Burden, but she had married William Morris in 1859, and in any case he was still engaged to Lizzie. His love for her had faded, proving as impermanent as the head of Lizzie that appears in 'Writing on the Sand' (No.226). But quite apart from these relationships – and despite speculation there is in fact no evidence to show that his behaviour towards both Lizzie and Jane was ever anything but absolutely correct by the strict moral standards of the day – Rossetti had meanwhile discovered the pleasures of the company of a different kind of woman. Appropriately enough, they enter

fig.iv Dante Gabriel Rossetti,
'Bocca Baciata', 1859;
oil on panel, 13¼ × 12
(33.7 × 30.5) *Private Collection*

his art and life as models for Mary Magdalene. The most notable was Fanny Cornforth, whom Rossetti met in 1856 or '57: an outgoing, unshockable, cockney girl, she became his model, housekeeper and almost certainly his mistress.

Rossetti perhaps celebrated his personal loss of virginity in a small painting of 1859, 'Bocca Baciata' (fig.iv), which is the turning point of his whole career. Fanny Cornforth was the model, her head encircled by marigolds which in the language of flowers (very significant for Rossetti) symbolise grief and regret. On the back of the painting Rossetti wrote the Italian couplet from which the title comes: 'The mouth that has been kissed loses not its freshness; still it renews itself as does the moon'. Here is something quite new for Rossetti – a voluptuous, inscrutable image, coarse and sensual perhaps, but experienced in precisely the way that differs so essentially from the early work. And Venetian Cinquecento painting now provides Rossetti with a model that replaces his earlier preference for Florentine and Sienese Quattrocento.

Two years after his wife's death in 1862, Rossetti painted 'Beata Beatrix' (No.131) in her memory. There is a renewed interest in colour symbolism, referring back to the books in the 'Girlhood'. The dove however is now not white but red, as is the figure of love, because Rossetti now equates love with death; the burning heart, the loss of blood, not purity and virginity. The sundial is prominent, casting a shadow on nine, the hour of Beatrice's death and a perfect number, three times three. It is also an image of the passing of time, and of the loss that goes with it. The bird drops a poppy into the hands of Lizzie/Beatrice, bringing the sleep of death from the laudanum that caused it; whether administered deliberately or accidentally we shall never know.

Rossetti's largest picture was another memorial to Lizzie – the enormous version of the 1850 watercolour of 'Dante's Dream at the Time of the Death of Beatrice' (No.218) that seems to show Rossetti's anticipation of his wife's fate. In general, however, Rossetti in the 1860s tried to forget Lizzie, and to subsume his personal experience into a view of life, a deep sense that woman enshrines the mystery of existence, both in an actual and a meta-physical sense. We are presented with a long series of images of feminine beauty (for Rossetti paints nothing else) which slowly grow more disenchanted perhaps, less concerned with the present and more with the past. Rossetti eventually comes to see every-thing against the passage of time, a slow progress from life to death, through the changing sentiments of love.

His own feelings for Jane Morris had deepened in 1868 as she sat for him as 'La Pia' (No.153). The subject is from Dante's *Purgatorio*, about the wife who, confined by her husband in the fortress of the Maremma, pined away and died of malaria (or perhaps of poison). The mood is now one of extreme melancholy: Jane herself, combining the sensuous and the mystic, had ensnared Rossetti, who felt as personally hopeless as the prisoner he was painting.

Rossetti's health declines in these years, and in 1872 he took an overdose of laudanum, but, like Gauguin some twenty-five years later, he failed to kill himself, and was to live another ten years, asking the questions (cf. No.248) for which he knew there were no answers.

Rossetti's death in 1882 marks the effective end of Pre-Raphaelite painting, at least in its creative phase. Rossetti's great friend and disciple, Burne-Jones, had, like his master, made a successful transition from the small-scale drawings and watercolours of the 1860s to the much grander canvases of the 1870s, of which 'Laus Veneris' (No.150) is perhaps the finest. This is the story of Tannhäuser on the Hill of Venus, about the wandering knight who is irrevocably lost when he gives himself up to a life of sensual pleasure. In 'The Wheel

of Fortune' (No. 155), Burne-Jones borrows from Michelangelo to express his own fatalistic and pessimistic personal philosophy. But in other works, such as 'The Golden Stairs' (No. 154), the subject altogether loses any specific meaning and slips into deliberate ambiguity, offering the viewer a chance to meditate and dream. This is now fully-fledged symbolist art, demonstrably 'aspiring towards the condition of music' as Walter Pater demanded in 1873. Burne-Jones, like Rossetti in the 1872 'Bower Meadow' (No. 142), seems to look back to the mood-painting of Millais' 'Autumn Leaves', and of course in their broader circle of friends can be found artists such as Whistler or Leighton who extend Pre-Raphaelite ideas into the general rich texture of Victorian painting.

In Burne-Jones's hands Rossetti's message is softened and translated into a more assimilable language. His are the pictures which are shown on the Continent and which inspire what is loosely called Pre-Raphaelite painting in the later nineteenth century in France or Germany or especially Italy. But to use the adjective Pre-Raphaelite to discuss this phenomenon as well as Millais-influenced pictures that filled the Royal Academy exhibitions of the later 1850s is almost meaningless, and perhaps we should think in terms of Millaisian and Huntian and Rossettian rather than of Pre-Raphaelite painting.

The Brotherhood of seven, when it was formed in 1848, contained three great individualists who happened to be personal friends, but whose ideas and temperaments were vastly different. At the beginning they benefited from each other's company, and learnt much, and were stimulated by the competition, but very quickly their individual paths opened up before them. One of them, and perhaps he was always the organiser and the driving spirit of the Brotherhood, formed a new group of seven, and this second wave was to bring Pre-Raphaelite painting international fame, and a major role in the European symbolist movement.

But it was only one kind of Pre-Raphaelite painting that was so admired in the nineties, whereas ultimately it is the sheer variety of the work produced that impresses. Holman Hunt's symbolic realism, Millais' Tennysonian mood-painting, the colour symbolism and cult of feminine beauty in Rossetti, Burne-Jones's musical and romantic dreams, the modern-life allegories of Madox Brown, indeed the modern moral subjects of them all – what group of English painters can match them?

Alan Bowness

BIOGRAPHICAL NOTES

HENRY ALEXANDER BOWLER
1824–1903

Born Kensington, 30 November 1824. Studied at Leigh's School and the Government School of Design, Somerset House. Exhibited at the R.A. and the B.I. for the first time 1847. Appointed Headmaster, Stourbridge School of Art 1851 but soon after received a post at Somerset House. Married Ellen Archer 1853. Official Inspector, Science and Art Department 1855; involved with the organisation of the International Exhibitions of 1862 and later years. Teacher of Perspective, Royal Academy, 1861–99. Assistant Director of Art, South Kensington Museum 1876, finally retiring from the Science and Art Department 1891. Official duties appear to have left Bowler little time for painting and he exhibited only sixteen works (mainly landscapes) at the R.A. and B.I. between 1847 and 1871. He is not known to have been personally acquainted with the Pre-Raphaelites and 'The Doubt' (No.65) appears to be his only substantial work in the style. Died 6 August 1903.

GEORGE PRICE BOYCE
1826–1897

Born 24 September 1826 in London, son of a city wine merchant who later became a prosperous pawnbroker. Educated at Chipping Ongar and in Paris. Trained as an architect and from 1846 was with the firm of Wyatt and Brandon in London. About 1849 decided to devote himself to landscape painting instead, encouraged by a meeting with David Cox at Betws-y-Coed that year. Cox subsequently gave him lessons and his influence is apparent in Boyce's early watercolours. Around 1849–51 met Rossetti, who became a life-long friend, and in 1853 Hunt and Millais. Began to collect the work of his Pre-Raphaelite friends; his diaries (1851–75) are an important record of their activities. Painted with Seddon at Dinan 1853 and, on Ruskin's advice, visited Venice 1854. Exhibited at the R.A. from 1853 but more extensively at the O.W.C.S., of which he became an associate in 1864 and a member in 1877. Visited Switzerland 1856, probably also on Ruskin's advice, and Egypt 1861–2. Took Rossetti's old studio at Blackfriars 1862 and became friendly with Whistler, with whom he shared an interest in nocturnal river effects. Married a French girl, Caroline Soubeiran, 1875. Had a house built by Philip Webb in Chelsea, 1869, and died there 9 February 1897.

JOHN BRETT
1831–1902

Born near Reigate, 8 December 1831, son of an army vet attached to the 12th Lancers. As a boy his interests were equally divided between painting and astronomy but in 1851 he began taking lessons from the landscape painter J.D. Harding and also received instruction in drawing from Richard Redgrave. Entered R.A. Schools 1853 but learned more from the writings of Ruskin and the work of the Pre-Raphaelites. Became one of the circle of artists and writers who gathered at the home of the poet Coventry Patmore, where he was introduced to Holman Hunt in autumn 1853. In 1856 visited Switzerland where he met J.W. Inchbold, whose work greatly impressed him (see No.79). 'The Stonebreaker' (Walker Art Gallery, Liverpool), exhibited at the R.A. in 1858, made his reputation and inspired high praise from Ruskin. Spurred on by Ruskin, returned to the Alps in 1858 and painted 'Val d'Aosta' (No.99). Spent the winter of 1861–2 in Florence. A second stay there the following year resulted in a minutely detailed, panoramic view of the city, 'Florence from Bellosguardo' (Tate Gallery), which was rejected by the R.A. and caused a minor scandal in the art world. In August 1863 sailed to the Mediterranean in the steamship *Scotia*, and spent the winter in Capri. Around this time his work changed direction. While retaining the highly wrought finish and brilliant colouring of his earlier works, he moved away from landscape subjects and concentrated on coastal scenes and seascapes. The rocky coastlines of Devon, Cornwall and Pembrokeshire became his favourite haunts. After the purchase of the schooner *Viking* in 1883 he also visited the Channel Islands and the north-west coast of Scotland. Around 1869 met Mary Ann Howcraft and the first of their seven children was born in 1870. Elected a Fellow of the Royal Astronomical Society 1871. Died at Putney, 7 January 1902.

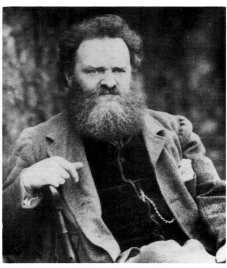

Photograph of Boyce:
National Portrait Gallery

Photograph of Brett:
National Portrait Gallery

FORD MADOX BROWN
1821–1893

Born Calais, 16 April 1821, son of a half-pay ship's purser. His family moved to Belgium, 1833–9, where he received a sound academic art training, first at Bruges under Albert Gregorius, then at Ghent under Pieter van Hansel (both pupils of David), and finally at the Antwerp Academy, 1837–9, under the historical painter Gustave, Baron Wappers. At Paris 1840–3 studied Rembrandt and the Spanish masters in the Louvre and academic and Romantic contemporaries, Delacroix, Delaroche, Flandrin, etc. His early style showed a mixture of sombre tonality and romantic lighting with increasing experiment in a more dashing, fluid technique, particularly in his drawings, and a developing concern for outdoor lighting effects. Settled in London 1844, having married his cousin Elizabeth Bromley in 1840. His style changed radically (see Nos 6–8), partly under the discipline of designing cartoons for the Westminster Hall Competitions, and more particularly following his visit via Basle to Rome in 1845–6 (for his wife's health; she died 5 July 1846). At Basle saw the work of Holbein, at Rome the German Nazarenes and the Italian masters. He was already attempting a clear-cut realistic style with daylight effects and delicate fresco-like colouring, in subjects from early British history, when Rossetti applied to him in March 1848 for painting lessons. They became life-long friends. Though older, he sympathised closely with the new Pre-Raphaelite Brotherhood, which paralleled his own ideas, though he was never a member. At first an adviser, at least to Rossetti, in turn he was influenced by them, trying out Millais' 'wet white' technique, employing their minute finish, turning to contemporary subjects, tackling landscape painting seriously (see Nos 51, 60, 61, 68) and, like Millais and Hunt, brightening his colour as he looked more closely at nature out-of-doors. While at first well received, his work gained little public recognition in the 1850s and the influential Ruskin was antagonistic. He ceased exhibiting at the R.A. after 1853 though he gained two prizes at the Liverpool Academy in 1856 and 1858. At this period led a retired and often despondent existence at Hampstead and Finchley. Married Emma Hill 1853, whom he had known since about 1848, and she was often his model. She appears in his two greatest paintings, both begun in 1852, 'The Last of England' (No.62) and 'Work' (No.88). In the late 1850s, with an increase in patronage, undertook much retouching of earlier works and some replicas. Founder member in 1861 of the decorating firm of Morris, Marshall, Faulkner and Company, with which he remained until its rearrangement as Morris and Co. in 1874. Designed both furniture and stained-glass cartoons. These last were influential on his later style, which saw a return to his earlier historical approach combined with a looser, more decorative style in which his tendency to overemphatic gesture and expression became increasingly characteristic. Held one-man show in Piccadilly 1865 and later exhibited occasionally at the Dudley Gallery. Moved to Fitzroy Square 1865. A period of prosperity and new patrons lasted into the mid-1870s but his style was not generally popular, though he gained some notice on the Continent. His children Lucy, Catherine and Oliver were his pupils. He usually carried out several versions of the same subject in different media, his children sometimes acting as his assistants. In 1878 commissioned, largely through the interest of Frederic Shields, for the murals in Manchester Town Hall, with subjects from the history of Manchester; lived in Manchester 1881–7 and these were his chief occupation until his death in London, 6 October 1893.

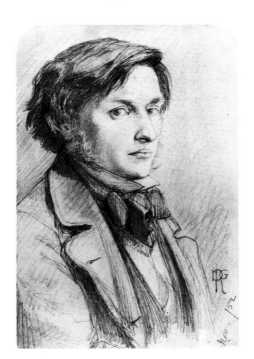

Drawing of Brown by Rossetti, 1852: National Portrait Gallery

EDWARD COLEY BURNE-JONES 1833–1898

Born Birmingham, 28 August 1833, son of a gilder and frame-maker; his mother died a few days after his birth. In 1844 entered King Edward's School, Birmingham, where he showed clear evidence of the scholarship that later distinguished his paintings. Went up to Exeter College, Oxford 1853, intending to enter the church. There met his lifelong friend and collaborator William Morris. Inspired by reading Ruskin and seeing Pre-Raphaelite pictures, they resolved to devote themselves to art, finally taking their decision on the way home from a tour of the cathedrals of north France in the summer of 1855. Introduced to Rossetti early in 1856 and settled in London. Rossetti gave him a few informal lessons, otherwise as an artist he was virtually self-taught. His early work, mainly small pen drawings and watercolours (see Nos 224–5), shows the strong influence of Rossetti and in 1857 he was one of the young artists recruited by him to paint murals in the Oxford Union. In 1859 paid his first visit to Italy and in 1861, together with Rossetti, Madox Brown and others, helped Morris found the firm of Morris, Marshall, Faulkner and Co. From then on provided Morris with an endless supply of cartoons for stained-glass, tiles, tapestry, etc. In the 1860s evolved his own characteristic style, assisted to some extent by G.F. Watts, who urged him to improve his drawing, and Ruskin, who took him to Italy in 1862 and made him copy Venetian paintings (see Nos 235–6). Elected Associate of O.W.C.S. 1864 but encountered hostility due to his unusual subject matter and unorthodox watercolour technique, which resembled oil. However, began to attract patrons, notably William Graham, M.P. for Glasgow, and F.R. Leyland, Liverpool shipowner. Through exhibiting also acquired the first of his many followers and came to be seen as the leader of a new school. In 1867, now married with two children, settled at The Grange, Fulham. Resigned from O.W.C.S. 1870 when objections were raised to the nudity of one of his figures. Next seven years a period of isolation, punctuated in 1871 and 1873 by his last two visits to Italy, where he studied the work of Mantegna, Botticelli and Michelangelo, the artists who had the greatest influence on his mature style. In 1877, however, contributed eight pictures to the opening exhibition of the Grosvenor Gallery, bringing him sudden fame and placing him in the forefront of the Aesthetic Movement (see Nos 149–50). In 1878 gave evidence for Ruskin in the Whistler-Ruskin libel trial. Continued to show important works at the Grosvenor Gallery until 1887 when he transferred to the New Gallery. In 1885 reluctantly accepted Associateship of the R.A.

but only exhibited there once (1886) and resigned 1893. Burne-Jones often worked on his pictures over many years and his career is remarkably consistent. Nearly all his paintings take their subject from mediaeval legend or classical myth, although he also treated Biblical themes and fanciful subjects of his own. Increasingly he yearned to work on a large scale and his later works are often easel versions of designs he had made for stained-glass or tapestry. From the mid-1860s employed a number of studio assistants. His reputation in England reached a climax when the 'Briar Rose' paintings (Buscot Park) were shown at Agnew's, 1890. Collected works shown at New Gallery 1892–3. Accepted a baronetcy 1894. By this time also enjoyed a considerable reputation in France. Much occupied in his later years with illustrations for books published by Morris at the Kelmscott Press, notably the famous *Chaucer* (1896). Died at Fulham, 16 June 1898.

WILLIAM SHAKESPEARE BURTON 1824–1916

Born 1 June 1826 in London, son of the actor and dramatist William Evans Burton. Studied at the Government School of Design, Somerset House and from 1846 at the R.A. Schools. Befriended by Tom Taylor, through whom he had designs for initial letters accepted by *Punch*. After his parents' separation, supported his mother and himself by similar work. Exhibited at R.A. from 1846 and was awarded gold medal, December 1851, for his 'Delilah Begging the Forgiveness of Samson in Captivity' (R.A. 1852). His 1856 R.A. exhibit, 'A Wounded Cavalier' (No.71; so far as is known, his most Pre-Raphaelite picture), was much acclaimed but the R.A. rejected his work the following year and his health broke down. His first wife, a cousin, died after seven years of marriage. He remarried in 1865 and appears to have moved to Guildford and later to Chingford. Settled in Italy 1868, remaining until his mother's death in 1876. Suffered a breakdown 1882 and gave up painting until about 1889. By this time he was almost forgotten as an artist. In the 1890s, however, he was rediscovered by critics who saw his 'Cavalier' picture and also praised his most recent work, including a small religious painting, 'The World's Gratitude', which has since been recognised for its Symbolist qualities. Died at Lewisham, 26 January 1916.

CHARLES ALLSTON COLLINS 1828–1873

Born Hampstead, 25 January 1828, son of the genre painter William Collins and younger brother of Wilkie Collins the novelist. Like his brother, named after an artist, Washington Allston. Studied at the R.A. Schools, developing a style indebted to William Etty. First exhibited at R.A. 1847 (two portraits). Met Millais and in 1850 painted his first picture to show Pre-Raphaelite influence, 'Berengaria's Alarm' (No.27). Millais proposed him for membership of the P.R.B., supported by Hunt, Stephens and D.G. Rossetti; but Woolner objected on the grounds that he had not established sufficient claim through his work to be considered a Pre-Raphaelite, and that his admission might cause dissension amongst the original members. W.M. Rossetti agreed and he was rejected. Fell in love with the Rossettis' pious sister Maria but was apparently rejected by her as well. His sensitive, introspective character, tendency towards asceticism and attraction to the ritualistic aspects of the High Church are reflected in his best-known work, 'Convent Thoughts' (No.33), begun in 1850 while he was staying in and near Oxford with Millais and exhibited at the R.A. in 1851. In the summer of 1851 was painting with Millais again, and Hunt, at Worcester Park Farm. Further pictures exhibited at the R.A. include 'May, in the Regent's

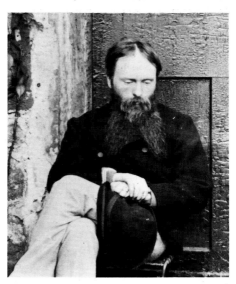

Photograph of Burne-Jones by Scott and Scott, 1874 (detail): National Portrait Gallery

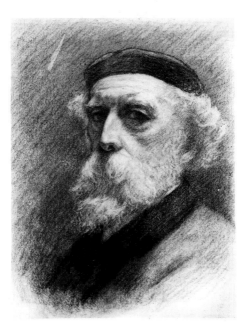

Self- Portrait by Burton, 1899: National Portrait Gallery

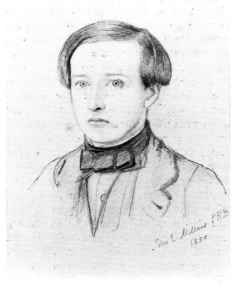

Drawing of Collins by Millais, 1850: Ashmolean Museum, Oxford

JAMES COLLINSON
1825–1881

WILLIAM DAVIS
1812–1873

Park' (No.43; his family home was 17 Hanover Terrace) and 'The Devout Childhood of St Elizabeth of Hungary' in 1852, 'A Thought of Bethlehem. Part of the Life of Madame de Chantal' in 1854 and 'The Good Harvest of '54' (Victoria and Albert Museum) in 1855. In the later 1850s abandoned painting in favour of writing. His most successful publications were *The Eye-Witness* (1860), a collection of humorous essays, and *A Cruise Upon Wheels. The chronicle of some Autumn wanderings among the deserted post-roads of France* (1862). Married Dickens' daughter Kate, 1860. In 1870 designed the cover to the monthly parts of Dickens' *The Mystery of Edwin Drood*. Died after a protracted illness, 9 April 1873.

Born 9 May 1825, presumably at Mansfield, Nottinghamshire, where his father was a bookseller, stationer and sub-postmaster. Came to London some time before 1847 when he first exhibited at the R.A. ('The Charity Boy's Début'); until about 1850 worked very much in the Wilkie tradition. Appears to have first met Hunt, Millais and Rossetti while a student in the R.A. Schools. Proposed by Rossetti for membership of the P.R.B. and elected 1848. Is said to have renounced Roman Catholicism (to which he had been recently converted) to become engaged to Christina Rossetti. Visited Isle of Wight with W. M. Rossetti, September 1849. Contributed long poem and etching to second issue of *The Germ*, 1850. Engagement to Christina Rossetti broken off, spring 1850. Resigned from P.R.B., May 1850, on the grounds that membership was incompatible with the Catholic faith which he had re-espoused. Exhibited his most Pre-Raphaelite work, 'An Incident in the Life of St Elizabeth of Hungary' at Portland Gallery 1851 (see No.169). Entered Stonyhurst, the Jesuit house in Lancashire, to train for priesthood; began his novitiate on 15 January 1853 but left without completing it some time before September 1854. Resumed painting, returning to the genre subjects he had painted at the beginning of his career: 'For Sale' (or 'The Empty Purse': version in Tate Gallery) and 'To Let' remain his best known works of this type. At an unknown date married a sister-in-law of the painter J.R. Herbert. Secretary of the Society of British Artists 1861–70. Last exhibited 1870 but continued painting until at least 1880. Died at Camberwell, 24 January 1881.

Born Dublin, son of an attorney. Studied in Dublin and first exhibited portraits at Royal Hibernian Academy 1833–5. Moved to England by 1837 and probably settled in Liverpool by 1842–3 when he first exhibited at L.A. Studied in L.A. schools from 1846 and became Associate of L.A. 1851, Member in 1853 and Professor of Drawing there 1856–9. Exhibited chiefly at L.A. 1851–73, but also showed a total of 16 works at R.A., 1851–72, and once at S.B.A. in 1870. He seems to have started painting small-scale landscapes c.1853, perhaps influenced by a fellow Liverpool artist, Robert Tonge (1823–56) and by the active encouragement of his first – and for many years, only – patron, John Miller (who also patronised Millais, F.M. Brown and Windus). He appears to have come to the attention of the Pre-Raphaelites in 1855 when the first landscape he exhibited at the R.A. was noticed by Rossetti and described by him as one of the four best landscapes in the exhibition, containing 'unity of perfect truth with invention'; Rossetti persuaded Ruskin to write favourably of this picture in *Academy Notes*, though Ruskin later, privately, expressed disapproval of Davis' work. In 1856 F.M. Brown also expressed his admiration for Davis' work, but considered him one of the most unlucky artists in England. This referred particularly to the meagre patronage which he received – a fact undoubtedly partly accounted for by his retiring nature and his slow and very fastidious painting technique. Through his contacts with Rossetti and Brown, he showed six pictures at Russell Place in 1857, three in the American Exhibition of British Art in New York, 1857, and exhibited with the Hogarth Club from 1858. His output was large but he had little success on the whole. About 1870 he moved to London where he died, 22 April 1873.

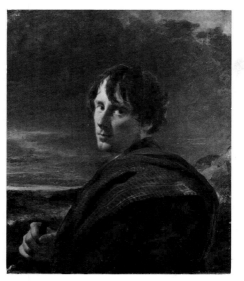

Self-Portrait by Davis, c.1852: Private Collection

WALTER HOWELL DEVERELL 1827–1854

Born 1 October 1827 of English parents at Charlottesville, Virginia, where his father held a teaching post; the family returned to England 1829, Deverell senior eventually becoming Secretary of the Government School of Design, Somerset House, where the Deverells had rooms until 1852. Placed in a Westminster solicitor's office 1843 but allowed to attend Sass's Academy the following year. At Sass's met Rossetti, who henceforth became his mentor. Entered R.A. Schools 1846 and first exhibited at the R.A. 1847. Joined Rossetti, Hunt, Millais and others in reviving the Cyclographic Society 1848. Appointed assistant master at the School of Design 1848. 'Discovered' Elizabeth Siddal 1849. One of the proprietors of, and a contributor to, *The Germ* 1850. Following the exhibition of his 'Twelfth Night' (No.23) at the National Institution in 1850, was proposed by Rossetti for membership of the P.R.B. in place of Collinson but was never actually elected. Shared rooms with Rossetti in Red Lion Square 1850–1. Moved to Kew with his family 1852. On the death of his father in 1853, became responsible for the support of his young brothers and sisters and moved to a smaller house in Chelsea. By October 1853 became too ill to continue teaching at the School of Design. Hunt and Millais gave financial help by buying his painting 'A Pet' (No.54) at the Liverpool Academy that month. Continued to paint at home. Died of Bright's Disease at the age of 26, 2 February 1854.

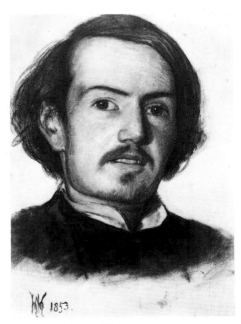

Drawing of Deverell by Hunt, 1853:
Birmingham City Art Gallery

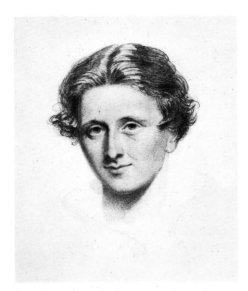

Drawing of Dyce by John Partridge, 1825:
National Portrait Gallery

WILLIAM DYCE 1806–1864

Born Aberdeen 19 September 1806, son of a lecturer in Medicine at Marischal College. Studied briefly at R.A. Schools, then made two visits to Rome and came under the influence of the German Nazarene artists there. By 1829 was back in Scotland, establishing a practice as a portraitist in Aberdeen, then Edinburgh. Always a polymath, kept up the intellectual and scientific interests acquired from his father and in 1830 wrote a prize-winning essay on electro-magnetism. Became involved with art education and the question of design in relation to art and industry, and in 1837 moved to London to become Superintendent of the new School of Design. Beset by controversy and bureaucratic obstacles, and unable to devote much time to painting, he resigned the post in 1843. Successful in 1844 in the fresco competition to select painters to decorate the New Palace of Westminster (Houses of Parliament). His frescoes there are mostly Arthurian subjects; the best-known is 'Religion: The Vision of Sir Galahad and his Company' in the Queen's Robing Room (completed 1851). These were his main employment until his death. A devout High-Churchman, theologian, authority on Church ritual and music, and founder of the Motett Society, he also produced easel paintings of religious subjects, notably 'Joash Shooting the Arrow of Deliverance' (1844, Hamburg) and 'Jacob and Rachel' (1850–3, Leicester), and a fresco of 'The Holy Trinity and Saints' at All Saints', Margaret Street (completed 1859). Enjoyed the patronage of Prince Albert, who commissioned Raphael-esque works for Osborne House, including a 'Madonna and Child' (1845) and a fresco of 'Neptune Resigning his Empire of the Seas to Britannia' (1847). Admired Pre-Raphaelite pictures at the R.A. and in 1850 persuaded Ruskin to look seriously at them for the first time. Responded to Pre-Raphaelitism in his own work with the meticulously painted 'Titian Preparing to Make his First Essay in Colouring' (1857, Aberdeen) and a number of stony landscapes, notably 'Pegwell Bay' (No.106, 1858–60). Died 15 February 1864 at his home since 1856 in Leigham Court Road, Streatham.

ARTHUR HUGHES
1832–1915

Born London, 27 January 1832. Educated at Archbishop Tenison's Grammar School and from 1846 at the School of Design, Somerset House, where he studied under Alfred Stevens. Entered R.A. Schools 1847 and first exhibited at the R.A. 1849. Became interested in Pre-Raphaelitism after reading *The Germ*, 1850; met Hunt, Rossetti and Brown the same year. Exhibited his first Pre-Raphaelite painting, 'Ophelia' (Manchester City Art Gallery), 1852 and met Millais that year. Inspired in the first place by Millais' paintings of lovers' meetings, Hughes produced a number of works during the 1850s that rank among the most memorable of all Pre-Raphaelite pictures, for example 'April Love' (No.72), 'The Long Engagement' (No.95) and 'Home from Sea' (No.120). From about 1852 to 1858 shared a studio with the sculptor Alexander Munro. Married Tryphena Foord 1855 and eventually had five children. In 1855 he also began a successful career as an illustrator, being particularly associated with the work of Thomas Hughes, George Macdonald and Christina Rossetti. After about 1860 his best work was produced in this field rather than in painting. Hughes was one of the contributors to the Oxford Union decorations, 1857. Moved from London 1858 and visited Italy 1862. Exhibited for the last time at the R.A. 1908 and died at Kew, 23 December 1915.

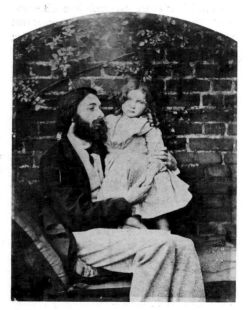

Photograph of Hughes with his daughter Agnes by Lewis Carroll: Tate Gallery Archives

WILLIAM HOLMAN HUNT
1827–1910

Born 2 April 1827 in London, son of a warehouse manager, William Hunt, and Sarah (née Hobman). Became an office clerk in 1839, continued his artistic activities whenever possible, and persuaded his father to let him apply for a place at the R.A. Schools, 1843. Accepted on third attempt, 1844; supported himself by making portraits and copies. Exhibited at the Royal Manchester Institution from 1845, and at the R.A. and B.I. in 1846. In 1847 showed a still life at Suffolk Street and a subject from Scott at the R.A.: all these were in the accepted conventions of the day. Interest in David Wilkie's technique in 'The Blind Fiddler'; discussions with Millais, whom he had met *c.*1844; the reading, in 1847, of *Modern Painters*, vols. I–II, and of Keats, profoundly influenced his search for an original style and iconography. His 1848 R.A. exhibit (No.9), from Keats, led to friendship with D.G. Rossetti, and, via the Cyclographic Society, to the formation of the Pre-Raphaelite Brotherhood in September 1848. 'Rienzi' (No.17), exhibited R.A. 1849, instituted a series of major figure paintings with landscape backgrounds painted from nature. 'A Converted British Family' (No.25), R.A. 1850, was sold that September to Thomas Combe, who became Hunt's major patron, friend and business adviser. In 1850–2 spent some months in the country, painting backgrounds: 'Valentine Rescuing Sylvia' (No.36) at Sevenoaks with D.G. Rossetti and Stephens; 'The Hireling Shepherd' (No.39) and 'The Light of the World' (No.57) at Ewell with Millais and Collins; 'Our English Coasts' (No.48) and 'Fairlight Downs' (No.52) near Hastings with Edward Lear. Hunt's financial position improved with the sale of 'The Hireling Shepherd' in 1852, the first work to display his fully developed style of symbolic realism. The 1853 R.A. exhibits attracted the attention of Thomas Fairbairn, whose commission enabled Hunt to complete 'The Awakening Conscience' (No.58) as the pendant to 'The Light of the World'. On the threshold of success, Hunt left England on 13 January 1854 to join Seddon in Egypt. His two-year absence was prolific in terms of output, but he was unable to complete a major religious figure painting while in the Holy Land. 'The Finding of the Saviour' (No.85) occupied him for six years, the inevitable outcome of his painstaking methods; the pattern was to be repeated in 'The Shadow of Death' (No.143), 1870–3, and 'The Triumph of the Innocents' (Walker Art Gallery, Liverpool), 1875–87. Contributed to the Moxon Tennyson, 1857. Relations with D.G. Rossetti cooled, owing to Hunt's infatuation with Annie Miller which ended acrimoniously in 1859. Soon after-

wards, Woolner introduced Hunt to Fanny Waugh; they married on 28 December 1865, and left England for a proposed trip to the East on 23 August 1866. Detained by quarantine regulations in Florence, their son was born 26 October 1866; Fanny contracted miliary fever and died on 20 December. Hunt returned to England with Cyril Benone ('child of sorrow'), September 1867; completed and exhibited 'Isabella and the Pot of Basil' (No.138), and painted portraits, including that of his sister-in-law Edith Waugh. Went back to Florence, June 1868, to work on memorial to Fanny. Elected to the O.W.C.S., February 1869, and finally reached Jerusalem on 31 August that year. Returned to England July 1872 and further worked on 'The Shadow of Death'. His relationship with Edith Waugh was opposed by her family; their wedding took place at Neuchâtel, November 1875, as marriage with a deceased wife's sister was then illegal in England. Arrived Jerusalem December 1875; began 'The Triumph of the Innocents' on a faulty canvas. Daughter Gladys Millais Mulock born 20 September 1876; the family returned to London April 1878, and moved to Draycott Lodge, Fulham, 1881. By this date Hunt no longer contributed to the R.A., preferring to show works at the Grosvenor and New Galleries (1877–99) or in one-picture exhibitions, e.g. 'The Triumph of the Innocents' at the Fine Art Society, 1885. First retrospective, London 1886, was accompanied by publication of Hunt's series of articles on the Pre-Raphaelite Brotherhood in the *Contemporary Review*. In this year Hunt began a portrait of his second son Hilary (b.1879) and 'The Lady of Shalott' (Wadsworth Athenaeum), which was completed in 1905. Other major late works are 'May Morning on Magdalen Tower' (Lady Lever Art Gallery, Port Sunlight), 1888–91, and 'The Miracle of the Sacred Fire' (Boston), 1893–99. Visited the Middle East for the last time, 1892. Replica of 'The Light of the World' was commenced 1899, by which date Hunt's eyesight had greatly deteriorated, necessitating the use of studio assistance. Moved to Melbury Road, Kensington, 1903; awarded the O.M. and an honorary D.C.L. by Oxford University, 1905. His memoirs, published later that year, stressed his role as the intellectual leader of the Pre-Raphaelites, and further antagonised Stephens, with whom he had quarrelled in 1880. A series of one-man shows was held 1906–7 in London, Manchester, Liverpool and Glasgow. In 1907 'The Ship', 1875, was bought by a group of Hunt's friends and presented to the Tate Gallery to commemorate his eightieth birthday. Died in London, 7 September 1910; his cremated

JOHN WILLIAM INCHBOLD
1830–1888

JOHN EVERETT MILLAIS
1829–1896

remains were interred in St Paul's Cathedral on 12 September, and W.M. Rossetti, the last surviving member of the Brotherhood, was one of the pall-bearers.

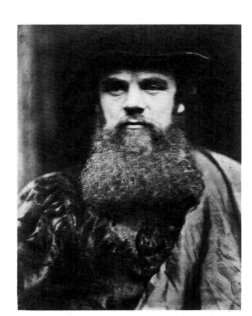

Photograph of Hunt by David Wilkie Wynfield, 1860s: National Portrait Gallery

Born Leeds 29 August 1830, son of a newspaper proprietor. His youthful drawings were distinguished by their precision and delicacy. Came to London to study as a lithographic draughtsman, becoming a pupil of the watercolourist Louis Haghe. According to an obituary in the *Athenaeum*, by about 1847 he was a student at the R.A., though his name does not appear in its registers. His earliest exhibited works, at S.B.A., were broadly handled watercolours but his first exhibited oil painting, R.A. 1852 – a landscape study now lost – apparently showed Pre-Raphaelite influence. Earliest contact with P.R.B. might have been through the Rossettis; by 1854 he was known to Ruskin and his exhibited landscapes for the period 1852–7, with their characteristic concentration on foreground detail (see No.66), led W.M. Rossetti to describe him as 'perhaps highest of the strictly Pre-Raphaelite landscape painters'. In 1856 and 1858 he was in Switzerland with Ruskin who bullied him over his drawings in the same way as he bullied John Brett. Brett's meeting with Inchbold in the Alps in 1856 was a decisive influence on the former artist's career. A rather mild-mannered man, it seems quite possible that some of Ruskin's adverse comments on Inchbold's work at this time directly affected the course of his art for after *c*.1858 it rarely possesses its earlier intensity. In later years he travelled abroad frequently, living in Switzerland *c*.1877–87; he published a volume of sonnets, *Annus Amoris*, in 1876. Last exhibited at R.A. 1885. Died in Leeds 23 January 1888.

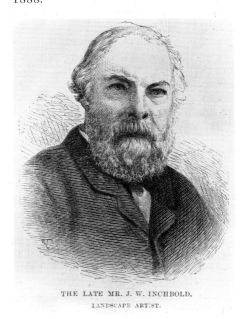

THE LATE MR. J. W. INCHBOLD, LANDSCAPE ARTIST.

Wood-engraving of Inchbold:
Illustrated London News, 11 February 1888

Born 8 June 1829, son of John William Millais, a man of independent means from an old Jersey family. Spent early boyhood in his native Southampton, where his mother's family were prosperous saddlers, then Jersey and Dinan, before coming to London in 1838 to cultivate his prodigious artistic talents at the R.A. Schools. Briefly attended Sass's art school, then entered the R.A. in 1840, its youngest ever student. Won silver medal there in 1843 for drawing from the antique and gold medal in 1847 for his painting 'The Tribe of Benjamin Seizing the Daughters of Shiloh', an exercise in the manner of William Etty. First work at R.A., 1846: 'Pizarro Seizing the Inca of Peru' (No.1). Became friendly with fellow student Holman Hunt and excited by his radical ideas about art. Contributed with Hunt and D.G. Rossetti to the Cyclographic Society, then in 1848 helped form the Pre-Raphaelite Brotherhood. The discussion leading to its foundation took place at his house, 83 Gower Street. His first Pre-Raphaelite painting, 'Isabella' (No.18), was generally well received at the R.A. in 1849 but his principal work of the next year, 'Christ in the Carpenter's Shop' (No.26), provoked extremely hostile reviews. Achieved popularity in 1852 with 'A Huguenot' (No.41), his first picture to be published as an engraving. Elected A.R.A. 1853. The same year spent holiday in Scotland with the critic John Ruskin and his wife Effie. He and Effie fell in love. She had her marriage to Ruskin annulled and they were married on 3 July 1855. Settled in Perth, Scotland, staying first at Annat Lodge, then with Effie's parents at their home, Bowerswell. There painted dreamy, non-narrative pictures on the theme of mortality, beginning with 'Autumn Leaves' (No.74). These proved less attractive to dealers and collectors than earlier works and in 1860 he reverted to the more saleable theme of ill-fated love with 'The Black Brunswicker' (No.108). In 1855–64 made illustrations for numerous publications, notably the Moxon Tennyson (1857), the magazine *Once a Week* (1859 onwards), Trollope's novels *Framley Parsonage* (*Cornhill Magazine*, 1860–1), *Orley Farm* (1861–2) and *The Small House at Allington* (*Cornhill Magazine*, 1862–4), and the *Parables* (published in *Good Words*, 1863, and as a separate volume, 1864). Moved back to London 1861, living at 7 Cromwell Place, then from 1878 till his death at 2 Palace Gate, an imposing mansion that reflects the great wealth he enjoyed in later life. In 1863 exhibited 'My First Sermon' (Guildhall Art Gallery), first of many sentimental studies of pretty children, often his own, which sold widely as engravings and won him immense popularity with

WILLIAM MORRIS
1834–1896

the public if not always with critics. Elected R.A. 1863. Presented a child subject, 'A Souvenir of Velasquez', as his Diploma Picture, 1868. His style became increasingly painterly in emulation of the Old Masters, especially Velasquez and Hals. The child subjects are occasionally historical, e.g. 'The Boyhood of Raleigh' (1870, Tate Gallery), but mostly just in fancy dress like 'Bubbles' (1886, A. & F. Pears Ltd.), which became famous as an advertisement for Pears soap. His studies of beautiful young women were also popular, and with 'Stella' (1868, Manchester City Art Gallery) he inaugurated a line in costume-pieces that recall eighteenth-century English portraiture. From the early 1870s built up an impressive practice as a portraitist. His sitters included many of the most prominent figures of the age: Thomas Carlyle (1877), Lillie Langtry (1878), Gladstone (1879 and 1885), Disraeli (1881), Tennyson (1881), Henry Irving (1883), the Earl of Rosebery (1886) and Arthur Sullivan (1888). With 'Chill October' (No.140, 1870) began to paint large-scale Scottish landscapes, mostly bleak scenes in the area around Dunkeld and Birnam, where he rented various houses during the autumn and early winter for family holidays, fishing and shooting. In 1885 became the first artist to be created a baronet. Elected P.R.A. early in 1896 but died the same year on 13 August. Buried in St Paul's.

Born Walthamstow, 24 March 1834, son of a wealthy bill-broker. Entered Marlborough College 1848 and went up to Exeter College, Oxford 1853, intending to be ordained. There met his lifelong friend and working associate, Edward Burne-Jones, who was also destined for the Church and shared his passion for everything mediaeval. Ruskin, Tennyson and the Pre-Raphaelites were their heroes. At Oxford Morris discovered his own gift for poetry. Made his first journey abroad 1854, visiting Belgium, where he saw the work of Van Eyck and Memling, and the cathedrals of northern France. Returning from another tour of French cathedrals with Burne-Jones in 1855, the friends finally decided to devote themselves to art. In January 1856 articled himself to the architect G.E. Street, then practising in Oxford. A few months later, through Burne-Jones, met Rossetti, who encouraged him to take up painting (see No.94); in 1857 he was one of the group of young artists recruited by Rossetti to paint murals in the Oxford Union. His first volume of poetry, *The Defence of Guenevere*, appeared March 1858. Married Jane Burden 1859, settling at Red House, Bexley Heath, built for them by Philip Webb. In 1861 took the lead in launching the firm of 'fine art workmen', Morris, Marshall, Faulkner & Co., in which Burne-Jones, Rossetti, Webb and Madox Brown were also partners. In 1865 moved with his wife and two young daughters to Queen Square, Bloomsbury and transferred the firm's workshops there from their first premises in Red Lion Square. Two years later published *The Life and Death of Jason* and in 1868–70 *The Earthly Paradise*, the great cycle of stories in verse on which his contemporary fame as a poet was chiefly to rest. Took joint tenancy with Rossetti of Kelmscott Manor, near Lechlade, 1871. The same year visited Iceland, returning there in 1873. This experience moved him deeply and is reflected in much of his later writing, notably the epic poem *Sigurd the Volsung* (1876). In the 1870s produced a series of remarkable illuminated manuscripts, while the firm began to specialise in printed and woven textiles, to which carpets and tapestry were soon added. In 1875 the firm was reformed as Morris and Co., giving Morris full control. Took Kelmscott House, Hammersmith, as his London home 1878 and in 1881 the firm moved to Merton Abbey, Surrey. In his later career emerged as a philosopher and political activist. Instrumental in launching the Society for the Protection of Ancient Buildings 1877. In 1882 joined the Democratic Federation and when this broke up in 1884 helped found the Socialist League. Financed and wrote extensively for the socialist week-

lies, *Justice* and *The Commonweal*, the latter publishing his utopian romances *A Dream of John Ball* (1886) and *News from Nowhere* (1890). In the late 1880s, disillusioned by feuding among the socialist leaders, began to play a less militant part in the movement. Took a leading part, however, in the Arts and Crafts movement, being involved with the Art Workers Guild and the Arts and Crafts Exhibition Society, founded in 1888. His main venture in this field was the launching of the Kelmscott Press in 1891; its crowning achievement was the folio *Chaucer* illustrated by Burne-Jones (1896). Died at Hammersmith, 3 October 1896.

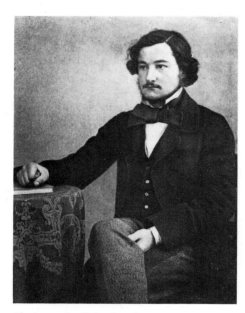

Photograph of Morris, 1857:
William Morris Gallery, Walthamstow

Photograph of Millais by Herbert Watkins:
National Portrait Gallery

ALEXANDER MUNRO
1825–1871

Born 26 October 1825 at Inverness. At school there modelled medallion portraits of his friends. Through the Duchess of Sutherland obtained work in London under Charles Barry as decorative carver at Houses of Parliament from 1844. Attempted entry to R.A. Schools 1846; unsuccessful, worked briefly in studio of Edward Hodges Baily. Accepted at R.A. Schools 1847. Though aspiring to poetic subjects, began producing portrait busts for a livelihood which, with portrait medallions, remained the mainstay of his working life. First exhibited at R.A. 1849. About this time became a particular friend of Rossetti. Shared a studio with Arthur Hughes in 1850s. Began series of figure groups 1851, occasionally, like 'Paolo and Francesca' (No.44), drawn from literature; others were more genre-like (e.g. 'Lovers' Walk', 1855). Also in 1850s, specialised in portrait groups of young children. Executed tympanum relief at Oxford Union from design by Rossetti 1857–8 and from 1857 six portrait statues of historical scientists at Oxford Museum. Married Mary Carruthers, 30 September 1861. Most familiar works today probably two fountains in London: 'Nymph', Berkeley Square, 'Boy with Dolphin', Regent's Park. Went to south of France for reasons of health 1865. Died at Cannes, 1 January 1871.

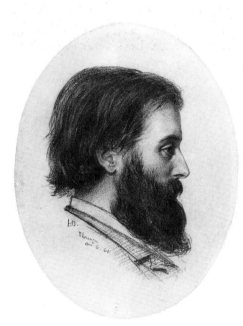

Drawing of Munro by John Brett, 1861: Private Collection

DANTE GABRIEL ROSSETTI
1828–1882

Born 12 May 1828 at 38 Charlotte (now Hallam) Street, London; his father was an Italian political refugee, a poet and Dante scholar and from 1831 Professor of Italian at King's College, London; his mother, half Italian and half English, was a private teacher. His brother William Michael was born 1829 and his sisters Maria 1827 and Christina 1830. Probably late summer 1841, entered Sass's Drawing Academy but spent most of his time reading and illustrating Shakespeare, Goethe, Byron, Scott and Maturin. Entered R.A. Schools as probationer, summer 1844, becoming a full student in December 1845. Made his first important illustrations to *Faust* and Poe 1846, also many drawings of Bohemian subjects influenced by Gavarni and Cruikshank. In April 1847 purchased a notebook of William Blake and the same year wrote to W.B. Scott and Leigh Hunt for advice on the respective careers of painter and poet. Pupil of Madox Brown for a few weeks, March 1848. Belonged to the Cyclographic sketching club, spring and summer 1848; also tried to launch a parallel literary club. In August 1848 moved with Holman Hunt to a studio in Cleveland Street and a little later, probably in September, was instrumental in forming the Pre-Raphaelite Brotherhood. Finished his translation of the *Vita Nuova*, October 1848. Showed his first major oil painting, 'The Girlhood of Mary Virgin' (No.15), at Free Exhibition, March 1849. In September and October of that year visited Paris and Flanders with Hunt: was greatly impressed by mediaeval and Renaissance art and by followers of Ingres such as Flandrin. Probably met Elizabeth Siddal late in 1849 through Walter Deverell. Largely responsible for the Pre-Raphaelite magazine *The Germ*, published January–April 1850. In April 1850 exhibited 'Ecce Ancilla Domini!' (No.22) at the National Institution; after its harsh reception, rarely showed in public again. Stayed at Sevenoaks with Hunt, October 1850, to paint a Dante subject out-of-doors (see No.142). After short periods in studios in Newman Street and Red Lion Square moved to 14 Chatham Place, Blackfriars, November 1852. Worked predominantly in watercolour until about 1860. In April 1854 became friendly with Ruskin, an influential though demanding patron, and in 1855–6 with Robert Browning. In Paris late October or early November 1855 to see Exposition Universelle. Met Burne-Jones early 1856 and by summer was on intimate terms with him and William Morris; contributed to Morris's *Oxford and Cambridge Magazine*. Commissioned for a large triptych for Llandaff Cathedral. Five of his illustrations included in Moxon Tennyson 1857. Showed

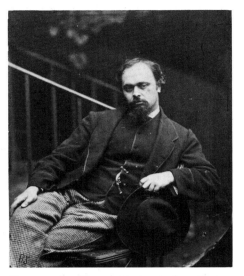

Photograph of Rossetti by Lewis Carroll, 1863: National Portrait Gallery

eight works in the private Pre-Raphaelite exhibition, Russell Place, July 1857. During the Long Vacation, to November, worked on mural in Oxford Union. In April 1858 joined Madox Brown and others in founding the Hogarth Club, an exhibiting and social club. In that year probably met Fanny Cornforth, who became his main model and mistress for the next decade. Married Elizabeth Siddal 23 May 1860; on their honeymoon in Paris admired especially Veronese's 'Marriage Feast at Cana'. Became increasingly friendly with Swinburne. A founder of Morris, Marshall, Faulkner and Co., April 1861. His translations of *The Early Italian Poets* published 1861. On 11 February 1862 his wife died from an overdose of laudanum. In October 1862 settled at 16 Cheyne Walk which he shared briefly with Swinburne and even more briefly with George Meredith. Was also friendly with Sandys and Whistler; through Whistler met Fantin-Latour and Legros. Took on W. Knewstub as assistant. Assisted in publication of Gilchrist's *Blake* 1863. Visited Belgium with his brother, September 1863. In November 1864 visited Paris and was shown around contemporary artists' studios by Fantin-Latour. In spring 1865 met Alexa Wilding who became an important model for him. Knewstub replaced by H.T. Dunn as assistant 1866–7. Eye-trouble started and insomnia grew worse; traces of paranoia appeared. By July 1869 had established an intimate relationship with Jane Morris who sat to him for many subsequent works. In

JOHN RUSKIN
1819–1900

FREDERICK SANDYS
1829–1904

October 1869 the poems he had placed in his wife's coffin were exhumed. *Poems* published April 1870. Spent long periods at Kelmscott Manor near Lechlade 1871–4. In June 1872 his health broke down following attack on himself and his circle by Robert Buchanan. Severed friendship with Swinburne and saw little of his other old friends except Madox Brown. Started new friendship with Theodore Watts (-Dunton) and grew closer to Frederic Shields, whom he had known since 1864. New edition of *Poems* published 1881 together with *Ballads and Sonnets*. Died 9 April 1882 at Birchington-on-Sea, Kent.

Born London, 8 February 1819, the only child of a prosperous wine shipper. Brought up in a cultivated but repressive atmosphere; his childhood was solitary and up to the age of ten he was educated exclusively at home. By the same age he had travelled through much of Britain with his parents and in 1833 made the first of the many trips to the Continent that were to become a feature of his later years. From an early age wrote prose and poetry. His interest in art was stimulated by drawing lessons and, particularly, his first sight of Turner's work in 1832. At Oxford 1837–40, finally graduating 1842. In 1836 his (unpublished) defence of one of Turner's pictures marked the commencement of an intense interest in the artist's work which found its fullest expression in *Modern Painters* (first volume published 1843). First met Turner 1840, becoming a friend, purchasing many of his pictures and finally becoming an executor of his will and organiser of the Turner Bequest. Wrote and lectured widely throughout his life, on artistic, architectural, political and social matters as well as engaging in practical philanthropy. In May 1851, although not acquainted with the Pre-Raphaelites, he greatly helped their cause by countering severe criticism of their paintings in two letters which he wrote to *The Times*; in August 1851 he published *Pre-Raphaelitism*, a pamphlet defending Millais and Hunt. He had met these two artists the same year but did not make Rossetti's acquaintance until 1854. Ruskin's thoughts on exhibited pictures by the P.R.BS and other artists were further expanded over the next few years in the annual *Academy Notes* (1855–9): his extraordinarily keen eye for detail and relentless, emphatic, if not always just, opinions gave him a status which no other art critic had enjoyed. Millais, Rossetti, Brett and Inchbold were amongst those whose art Ruskin tried to influence directly, not always with the happiest outcome. He was a prolific draughtsman himself (see No.195) with an output of well in excess of two thousand drawings, ranging from studies influenced by Turner to finely rendered architectural details. In 1878 suffered a mental breakdown (perhaps paranoid schizophrenia) just before the notorious Whistler v. Ruskin case came to court. Other attacks followed until by 1889 he had ceased writing completely. Died at Brantwood in the Lake District, 20 January 1900.

Born Anthony Frederick Augustus Sands, 1 May 1829 at Norwich, where his father was first a dyer, then a drawing master and ultimately a professional painter. Educated at Norwich Grammar School and later the Government School of Design at Norwich. Found an early patron in the Rev. James Bulwer, Rector of Stody and a former pupil of Cotman; made architectural and antiquarian drawings for Bulwer and etched his drawings. Exhibited drawings at the Norwich Art Union from 1839 and won Royal Society of Arts medals in 1846 and 1847. Moved to London by 1851, when he exhibited for the first time at the R.A. Married Georgina Creed, daughter of a Norwich artist, 1853; about 1855 began spelling his name Sandys instead of Sands. A precocious draughtsman, Sandys worked mainly in the fields of illustration (see No.241) and portrait drawing but in the late 1850s and during the 1860s he also painted in oils. After publishing 'The Nightmare', a print parodying Millais' 'Sir Isumbras at the Ford', in 1857, he became a friend of Rossetti, whose influence is seen in some of his oils (see No.101). His first independent illustration appeared in the *Cornhill Magazine* 1860. Visited Holland and Belgium 1862. Stayed with Rossetti at 16 Cheyne Walk for most of 1866 and went on a walking tour with him in October that year but they afterwards fell out. In the late 1860s began living with Mary Jones (the actress Mary Clive), who bore him nine children. Among his later works was a series of chalk portraits of writers commissioned by Alexander Macmillan in 1880. A founder member of the International Society of Sculptors, Painters and Gravers 1898. Died 25 June 1904 in London.

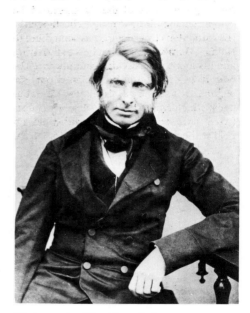

Photograph of Ruskin, 1856:
The National Trust (from *A Pre-Raphaelite Circle* by Raleigh Trevelyan)

Photograph of Sandys,
*c.*1900: Jeremy Maas

WILLIAM BELL SCOTT
1811–1890

Born 12 September 1811 at Edinburgh, son of the engraver Robert Scott and brother of the painter David Scott. Trained as an engraver, studied at the Trustees Academy and also began writing poetry, his first verses being published in 1831. Exhibited at the Royal Scottish Academy from 1834. Moved to London 1837 where he got to know Frith, Egg, Dadd and other painters and the writers Leigh Hunt and G.H. Lewes. Exhibited at the B.I. from 1841 and the R.A. from 1842. Published his first volume of poems 1838; married Letitia Norquay 1839. Unsuccessful in the competition for the decoration of Westminster Hall but offered the mastership of the Government School of Design, Newcastle, which he took up in 1843 and retained for twenty years. Following the publication in 1846 of his poem *The Year of the World*, Rossetti wrote to express his admiration and the two met in 1847; Scott contributed to *The Germ*, 1850. Published *Memoir of David Scott* 1850 and *Poems by a Painter* 1854. Met Sir Walter and Lady (Pauline) Trevelyan 1854 and was commissioned to paint murals for their house, Wallington Hall, Northumberland; executed in 1856–61, these scenes from Northumberland history were exhibited in Newcastle and London before being installed and are Scott's main achievement as a painter. In 1859 met Alice Boyd, owner of Penkill Castle, Ayrshire, who became his companion until his death. Moved from Newcastle to London 1864 and in 1870 became a neighbour of Rossetti in Cheyne Walk. Executed murals at Penkill Castle 1865–8. Published *Poems*, dedicated to his friends Rossetti, Morris and Swinburne (see No.112), 1875 and *A Poet's Harvest Home* 1882. Died at Penkill 22 November 1890. His *Autobiographical Notes* appeared posthumously in 1892.

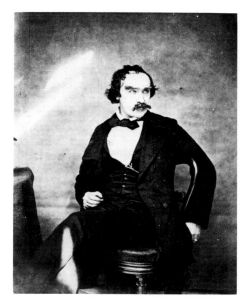

Photograph of Scott, 1861:
The National Trust (from *A Pre-Raphaelite Circle* by Raleigh Trevelyan)

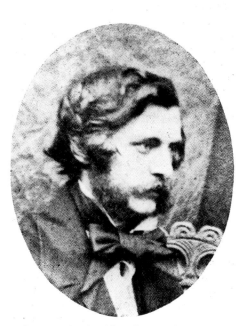

Photograph of Seddon: from William Holman Hunt, *Pre-Raphaelitism . . .*, 1913

THOMAS SEDDON
1821–1856

Born Aldersgate Street in the City of London, 8 August 1821, son of Thomas Seddon, a cabinet maker. At age sixteen entered father's business and in 1841 visited Paris to study ornamental art though by this time he wished to become a painter. In 1848 won a silver medal from the Society of Arts for the design of a sideboard but was simultaneously pursuing a conventional course of artistic studies at Charles Lucy's drawing school in Camden Town and drawing from the life at the Artists' Society in Clipstone Street. In 1849 visited North Wales where started studying landscape in earnest and continued this in 1850 at Barbizon in France. In the same year was instrumental in setting up a school of drawing and modelling in Camden Town for the instruction of workmen; this was an extension of his own 'school' run earlier from his father's premises in Gray's Inn Road. A near fatal attack of rheumatic fever in 1850–1 and subsequent recovery marked the commencement of his 'practical Christianity' which was very much responsible for his decision to travel to the East in winter 1853. Stayed abroad for more than a year, some of the time in company of Holman Hunt. Returned again to Egypt in Autumn 1856 in search of subject matter but died of dysentery in Cairo, 23 November 1856. Although not one of the Brotherhood he came into the circle through the Rossettis. His meticulous technique owes something to Holman Hunt's example but he was by nature and instinct a painstaking draughtsman. His output was small and he exhibited only six pictures at R.A., 1852–6; almost his entire oeuvre, including 'The Valley of Jehoshaphat' (No.83), was shown in a memorial exhibition held at the Society of Arts during May 1857.

ELIZABETH ELEANOR SIDDAL
1829–1862

Born 25 July 1829, the daughter of Elizabeth Eleanor Evans and Charles Siddall, a cutler of 8 Kent Place, Old Kent Road, London s.e. Probably worked in a milliner's shop near Leicester Square (two of her sisters were dress-makers), where she met Deverell, who introduced her to the Pre-Raphaelite circle. Although the family name was spelled Siddall her surname was changed to 'Siddal' when she entered the circle. According to W.M. Rossetti and other sources, she worked as a model, sitting to Deverell for 'Twelfth Night' 1850, to Hunt for 'A Converted British Family . . .' 1850 and 'Valentine Rescuing Sylvia from Proteus' 1851, to Millais for 'Ophelia', and to D.G. Rossetti. Encouraged by the cult of expressive genius unfettered by academic training, from 1852–61 she worked as an artist and wrote poetry. Tutored by D.G. Rossetti and Madox Brown. Was supported by Ruskin who in March 1855 bought 'every scrap of [her] designs' and the following month settled on her an annual sum of £150 in return for all that she produced. Contributed to the Russell Place exhibition 1857 and to the exhibition of Modern British Art in New York 1858. Over 100 works by her are recorded: oil paintings; watercolours such as 'Clerk Saunders' 1857 (Fitzwilliam Museum, Cambridge), 'Sir Patrick Spens' 1856 and 'Lady Affixing Pennon to a Knight's Spear' (Tate Gallery), 'The Haunted Wood' 1856 and 'St Agnes Eve' (Wightwick Manor, Wolverhampton), 'Madonna and Child with an Angel' (Delaware Art Museum); finished drawings such as 'Pippa Passes' (Ashmolean Museum, Oxford), and sketches. Worked on the decorations for Red House. Married D.G. Rossetti 1860. Died 11 February 1862.

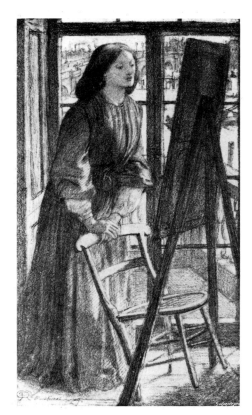

Drawing of Siddal at Chatham Place, Blackfriars by Rossetti: whereabouts unknown

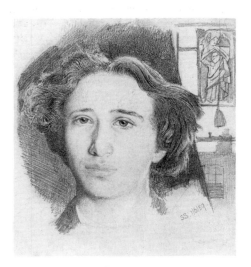

Self-Portrait by Solomon, 1859: Tate Gallery

SIMEON SOLOMON
1840–1905

Born Bishopsgate, London, 9 October 1840, son of an importer of Leghorn hats and a prominent member of the local Jewish community; his brother Abraham and sister Rebecca were also artists. Trained first in his brother's studio and in 1855 entered the R.A. Schools, where he met Henry Holiday, Marcus Stone and Albert Moore, with whom he formed a sketching club. Almost from the start his work showed Pre-Raphaelite influence (see Nos 228, 233) and he was soon in touch with Rossetti and Burne-Jones. His best work dates from this period, when he was producing watercolours and pen drawings usually illustrating Hebraic history or ritual. First exhibited at the R.A. 1858, returning in 1860 and from then on annually until 1872; also a regular contributor to the Dudley Gallery. Took part in the contemporary revival of book illustration and undertook decorative work for William Burges and William Morris. During the 1860s and early 1870s moved in circles which were formulating the ideals of the Aesthetic movement. Became an intimate of Swinburne, whose more pornographic productions, the novel *Lesbia Brandon* and the epic poem *The Flogging Block* he illustrated. Under Swinburne's influence turned to classical subject matter, his 'Bacchus' of 1867 winning the praise of Walter Pater. In 1866 and 1869 visited Italy where he wrote a prose poem, *A Vision of Love*, published 1871. His career collapsed in 1873 when he was sentenced to eighteen months imprisonment for homosexual offences; the sentence was later suspended but he was never to regain his position in respectable society, or apparently wish to. He continued to produce a large number of drawings, all showing the strong influence of Leonardo and his school, whose work he had studied in Italy in the 1860s. For the last twenty years of his life lived mainly at the St Giles Workhouse, Seven Dials, Holborn, sometimes working as a pavement artist or as a match and shoelace vendor. Died at St Giles 14 August 1905.

JOHN RODDAM SPENCER STANHOPE 1829–1908

Born 20 January 1829 at Cannon Hall, Yorkshire, son of John and Lady Elizabeth Spencer Stanhope. Educated at Rugby and Christ Church, Oxford. Studied with G.F. Watts during the summer vacation of 1850 and subsequently helped with his frescoes at the Prinseps' house in Chesterfield Street, London and at Little Holland House, where he met Rossetti and other Pre-Raphaelites. Visited Italy with Watts 1853 and joined him and Val Prinsep on Sir Charles Newton's expedition to recover the Mausoleum of Halicarnassus at Budrum in Asia Minor 1856–7. On Rossetti's invitation, painted 'Sir Gawaine and the Damsels at the Fountain' as part of the Oxford Union decorations 1857. Life-long friendship with Burne-Jones, whose influence is seen in some of Stanhope's works after about 1860, dates from this time. Occupied a studio below Rossetti's in Chatham Place, Blackfriars 1858. Married Elizabeth King 1859 and exhibited for the first time at the R.A. that year (see No.98). Had a house built by Philip Webb at Cobham 1860. Decorated Marlborough College Chapel 1872–9. Exhibited at the Grosvenor Gallery from its opening in 1877. Because of ill-health, which had dogged him all his life, decided in 1880 to settle near Florence at the Villa Nuti. Died there 2 August 1908.

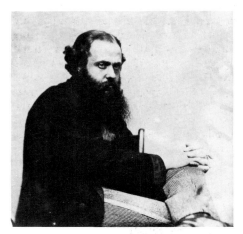

Photograph of Stanhope by Lewis Carroll, c.1856: National Portrait Gallery

FREDERIC GEORGE STEPHENS 1828–1907

Born London, 10 October 1828, only son of parents who were for a time master and mistress of the Strand Union Workhouse in Cleveland Street. Enrolled as Student in the R.A. Painting School, 13 January 1844 and finally admitted to the Life School in January 1853. In 1848 was successfully nominated for the P.R.B. by Holman Hunt. His first important picture seems to have been 'Mort d'Arthur' which he hoped to submit to L.A. 1849 but which remained unfinished (now Tate Gallery). A picture based on the story of Griselda and the Marquis was commenced in early 1850 with the intention of submitting it to R.A. of that year, but it was not sent until 1851 – and then under an assumed name, 'Brown' – when it was rejected. Part of the background to this picture (now Tate Gallery) was painted in company with Hunt at Knole Park in October 1850. At about the same time a design from *Measure for Measure* was started and left unfinished. His only exhibited works, portraits of his parents, appeared at the R.A. in 1852 and 1854. It is recorded that Stephens declared 'with satisfaction' that he had destroyed all his paintings though the claim is not accurate. It is quite clear that the difficulties he experienced in bringing works to completion and lack of encouragement led him to abandon painting for writing. Contributed two items to *The Germ* (February and May 1850) and the same year started writing weekly notices on art, for at least a year, for the *Critic*. From 1861 until 1901 he was art critic for the *Athenaeum* and also wrote for the *London Review*, *Macmillan's Magazine* and the *Crayon*. Secretary of the Hogarth Club and for many years teacher of art at University College School. Besides his journalism, he was a prolific writer of books, the subjects of which included Mulready and Landseer. Died at Hammersmith Terrace, London, 9 March 1907.

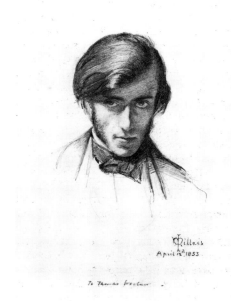

Drawing of Stephens by Millais, 1853: National Portrait Gallery

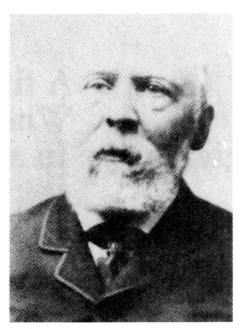

Photograph of Wallis: from *Lesser Lives*
by Diane Johnson

HENRY WALLIS
1830–1916

Born London, 21 February 1830. He was the son of Mary Ann Thomas but adopted his stepfather's surname when she was re-married, in 1845, to Andrew Wallis. Studied at F.S. Cary's Academy and admitted Probationer of R.A., 7 January 1848, and enrolled in the R.A. Painting School, 31 March 1848. According to nineteenth-century editions of *Who's Who*, Wallis also studied in the atelier of M.G. Gleyres and at the Academie des Beaux Arts in Paris; exactly when is not known but it was presumably sometime during the late 1840s or early 1850s. Whilst slightly unusual in this respect, Wallis was one of an increasing number of English artists who were studying on the Continent at this time. First exhibited in 1853 at the Royal Manchester Institution and in London at B.I. 1854. Exhibited a total of thirty-five pictures at R.A. 1854–77; also exhibited at S.B.A. 1854–5 and 1870 and showed a total of eighty-one works at O.W.C.S., of which he became an Associate in 1878 and Member in 1880. On his stepfather's death in June 1859 inherited a number of freehold properties in London, the income from which probably meant that he did not have to rely on art for a living. After the appearance of 'The Stone-breaker' (No.92, R.A. 1858) he seems to have made little impact as a painter. Was on the fringe of the P.R.B. – in May 1854 Rossetti knew of only one picture by him – and seems to have been closest to Arthur Hughes at this date; however, exhibited with the Hogarth Club as early as March 1860. His most important patron seems to have been the Leeds stockbroker T.E. Plint, at whose sale at Christie's in May 1868, five pictures by Wallis were sold. In later years travelled and painted in Italy, Sicily and Egypt, where he also assisted in archaeological excavations. Hon. Secretary of the Committee for the Preservation of St Mark's, Venice, 1879–82. A number of volumes on Italian, Egyptian and Persian ceramics, written and edited by Wallis – a noted collector of such objects – appeared between 1885–1905. Died at Croydon, 20 December 1916.

WILLIAM LINDSAY WINDUS
1822–1907

Born 8 July 1822 at Liverpool where there was a flourishing circle of artists of whom he and William Davis were probably the most talented and influential in the 1850s. Trained under local artists and at the Liverpool Academy schools. Exhibited at Liverpool Academy from 1845, becoming a Member 1848; his subjects chiefly romantic literary and historical themes with moral overtones. Visited the R.A. 1850 where he saw Millais' 'Carpenter's Shop' and as a result came under Pre-Raphaelite influence. He was instrumental in awarding the Liverpool Academy annual £50 prize to the work of Holman Hunt, Millais and Madox Brown six times during 1851–8, which led to the annihilation of the Academy itself. A slow worker and of abnormally sensitive temperament. 'Burd Helen' (No.73, R.A. 1856) was his first work to show P.R.B. influence and it gained Ruskin's approbation; afterwards met Madox Brown, Holman Hunt and Rossetti and became a member of the Hogarth Club. Ruskin's adverse criticism of 'Too Late' (No.97, 1859) contributed drastically to his natural despondency and, together with the untimely death of both his son and his wife (sister of the Liverpool artist Robert Tonge) in the early 1860s, was apparently the cause of his soon ceasing to paint any substantial work. Lived at Walton-le-Dale, Lancashire, as trustee of his daughter and of independent means; moved to London, probably at her majority, c.1882. Some of his sketches appeared at the New English Art Club in 1886 and 1892. Died London, 9 October 1907.

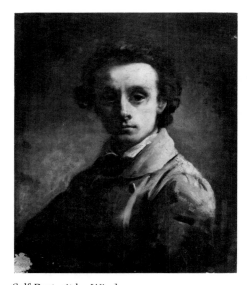

Self-Portrait by Windus:
Walker Art Gallery, Liverpool

THOMAS WOOLNER
1825–1892

Born 17 December 1825 at Hadleigh, Suffolk. Trained with William Behnes in London. Attended R.A. Schools from 1842 and first exhibited at R.A. 1843. Entered (unsuccessfully) the Westminster Hall competition 1844. During 1840s projected ideal works from literature (Shakespeare, Shelley) and associated with John Hancock and Bernhard Smith. Through Rossetti met Hunt and Millais. Agreed that their views on art were applicable to sculpture, so accepted membership of the P.R.B., 1848. Poet as well as sculptor, introduced Coventry Patmore to the circle and established substantial friendship with Tennyson, both of whom he portrayed. Contributed poetry to *The Germ*, 1850. Commissions unforthcoming, went to Australia to dig for gold, 1852, his departure inspiring Brown's 'The Last of England'. Finding gold scarcer than sculpture, reverted to portraiture in Sydney and Melbourne. Returned to London 1854, gradually establishing substantial practice in portrait sculpture (busts and statues) with occasional architectural and ideal work (e.g. at Manchester Assize Courts and 'The Lord's Prayer' at Wallington). Busts of the 1860s include F.D. Maurice, Cobden, Newman, Carlyle and Gladstone. Married Alice Waugh, 6 September 1864, later becoming Hunt's brother-in-law (twice over). A.R.A. 1871. R.A. 1875. Professor of Sculpture at R.A. 1877–9. After 1870 received major commissions for public monuments: Palmerston, London; Cook, Sydney; Queen Victoria, Birmingham; Lawrence, Westminster Abbey; Landseer, St Paul's. Final work 'The House-maid' (1892), a rare modern-life subject. Died in London, 7 October 1892.

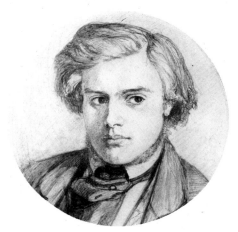

Drawing of Woolner by Rossetti, 1852: National Portrait Gallery

CATALOGUE

The catalogue, like the exhibition, is divided into six chronological sections devoted to oil paintings and sculpture, followed by one comprising watercolours and drawings. Within each of the seven sections the order is also approximately chronological rather than by artist. The order of works executed over long periods of time is necessarily more arbitrary.

The apparatus at the head of the catalogue entries has been kept to a minimum. Dimensions are given in inches followed by centimetres in brackets; height precedes width. 'First exh:' refers to the first exhibition of the work in question but only if this took place in the artist's lifetime. 'Ref:' gives a reference to a recent catalogue of the artist's work in which fuller details of provenance and exhibition history can be found. Locations are given in abbreviated form for manuscripts quoted in the entries.

Authorship of the entries is indicated in the following way:

A.G. Alastair Grieve

B.R. Benedict Read

D.C. Deborah Cherry

D.M.B.C. David Cordingly

J.B. Judith Bronkhurst

J.C. John Christian

L.P. Leslie Parris

M.B. Mary Bennett

M.W. Malcolm Warner

R.H. Robin Hamlyn

R.P. Ronald Parkinson

ABBREVIATIONS: GENERAL

B.I.	British Institution
Coll.	Collection
exh.	exhibited
L.A.	Liverpool Academy
MS	Manuscript
O.W.C.S.	Society of Painters in Water Colours ('Old Water-Colour Society')
R.A.	Royal Academy
repr.	reproduced
R.W.S.	Royal Society of Painters in Water-Colours

ABBREVIATIONS: EXHIBITIONS

Arts Council 1979	*The Drawings of John Everett Millais*, Arts Council tour (Bolton, Brighton, Sheffield, Cambridge, Cardiff), 1979. Catalogue by Malcolm Warner
Brighton 1974	*Frederick Sandys 1829–1904*, Brighton Museum and Art Gallery and Mappin Art Gallery, Sheffield, 1974. Catalogue by Betty O'Looney [Elzea]
Hayward Gallery 1975–6	*Burne-Jones*, Hayward Gallery, 1975–6, Southampton Art Gallery and City Museum and Art Gallery, Birmingham, 1976. Catalogue by John Christian
Liverpool 1964	*Ford Madox Brown 1821–1893*, Walker Art Gallery, Liverpool, 1964, City Art Gallery, Manchester, 1964–5, and City Museum and Art Gallery, Birmingham, 1965. Catalogue by Mary Bennett
Liverpool 1969	*William Holman Hunt*, Walker Art Gallery, Liverpool and Victoria and Albert Museum, 1969. Catalogue by Mary Bennett
Piccadilly 1865	*The Exhibition of WORK, and other Paintings, by Ford Madox Brown*, 191 Piccadilly, 1865. Catalogue by the artist
R.A. 1967	*Millais*, Royal Academy and Walker Art Gallery, Liverpool, 1967. Catalogue by Mary Bennett
R.A. 1973	*Dante Gabriel Rossetti. Painter and Poet*, Royal Academy and City Museum and Art Gallery, Birmingham, 1973. Catalogue by Virginia Surtees
Russell Place 1857	[Pre-Raphaelite Exhibition], 4 Russell Place, Fitzroy Square, 1857

ABBREVIATIONS: LITERATURE

Allingham 1907	Helen Allingham and D. Radford (eds.), *William Allingham, A Diary*, 1907
Allingham 1911	Helen Allingham and E.B. Williams (eds.), *Letters to William Allingham*, 1911
Bennett 1967	Mary Bennett, 'Footnotes to the Millais Exhibition', *Liverpool Bulletin*, XII, 1967, pp.32–59
Bennett 1970	Mary Bennett, 'Footnotes to the Holman Hunt Exhibition', *Liverpool Bulletin*, XIII, 1968–70, pp.26–64
Bronkhurst	Judith Bronkhurst, 'Fruits of a Connoisseur's Friendship: Sir Thomas Fairbairn and William Holman Hunt', *Burlington Magazine*, CXXV, 1983, pp.586–97
G. Burne-Jones	G[eorgiana] B[urne]-J[ones], *Memorials of Edward Burne-Jones*, 2 vols., 1904
Doughty & Wahl	Oswald Doughty and J.R. Wahl (eds.), *Letters of Dante Gabriel Rossetti*, 4 vols., Oxford, 1965–7
Fredeman	William E. Fredeman (ed.), *The P.R.B. Journal, William Michael Rossetti's Diary of the Pre-Raphaelite Brotherhood 1849–1853*, Oxford, 1975
Grieve 1973	A.I. Grieve, *The Art of Dante Gabriel Rossetti: The Pre-Raphaelite Period 1848–50*, Hingham, Norfolk, 1973
Grieve 1976	A.I. Grieve, *The Art of Dante Gabriel Rossetti: 1. Found 2. The Pre-Raphaelite Modern-Life Subject*, Norwich, 1976
Grieve 1978	A.I. Grieve, *The Art of Dante Gabriel Rossetti: The Watercolours and Drawings of 1850–1855*, Norwich, 1978
Hueffer	Ford Madox Hueffer, *Ford Madox Brown: A Record of His Life and Work*, 1896
Hunt 1863	[William Holman Hunt], 'Notes of the Life of Augustus L. Egg', *The Reader*, I, 1863, pp.462, 486–7, 557–8, II, 1863, pp.42–3, 91, 516–7, III, 1864, pp.56–7.
Hunt 1886	William Holman Hunt, 'The Pre-Raphaelite Brotherhood: A Fight for Art', *Contemporary Review*, XLIX, 1886, pp.471–88, 737–50, 820–33
Hunt 1905	William Holman Hunt, *Pre-Raphaelitism and the Pre-Raphaelite Brotherhood*, 2 vols., 1905
Hunt 1913	William Holman Hunt, *Pre-Raphaelitism and the Pre-Raphaelite Brotherhood*, 2nd edition, revised by M.E. Holman-Hunt, 2 vols., 1913
Ironside & Gere	Robin Ironside and John Gere, *Pre-Raphaelite Painters*, 1948
Lago	Mary Lago (ed.), *Burne-Jones Talking. His conversations 1895–1898 preserved by his studio assistant Thomas Rooke*, 1982

Lutyens 1967	Mary Lutyens, *Millais and the Ruskins*, 1967
Lutyens 1974	Mary Lutyens (ed.), 'Letters from Sir John Everett Millais . . . and William Holman Hunt . . . in the Henry E. Huntington Library . . .', *Walpole Society*, XLIV, 1974, pp.1–93
Maas	Jeremy Maas, *Gambart, Prince of the Victorian Art World*, 1975
Mackail	J.W. Mackail, *The Life of William Morris*, 2 vols., 1899
Marillier 1899	H.C. Marillier, *Dante Gabriel Rossetti: An Illustrated Memorial of His Art and Life*, 1899
Marillier 1904	H.C. Marillier, *The Liverpool School of Painters*, 1904
J.G. Millais	John Guille Millais, *The Life and Letters of Sir John Everett Millais*, 2 vols., 1899
W.M. Rossetti 1889	William Michael Rossetti, *Dante Gabriel Rossetti as Designer and Writer*, 1889
W.M. Rossetti 1895	William Michael Rossetti (ed.), *Dante Gabriel Rossetti: His Family Letters, with a Memoir*, 2 vols., 1895
W.M. Rossetti 1899	William Michael Rossetti (ed.), *Ruskin: Rossetti: Preraphaelitism. Papers 1854 to 1862*, 1899
W.M. Rossetti 1900	William Michael Rossetti (ed.), *Præraphaelite Diaries and Letters*, 1900
W.M. Rossetti 1903	William Michael Rossetti, (ed.), *Rossetti Papers, 1862–1870*, 1903
W.M. Rossetti 1911	William Michael Rossetti (ed.), *The Works of Dante Gabriel Rossetti*, 1911
Ruskin	E.T. Cook and A.D.O. Wedderburn (eds.), *The Works of John Ruskin: Library Edition*, 39 vols., 1902–12
Scott	William Bell Scott (ed. W. Minto), *Autobiographical Notes of the Life of William Bell Scott*, 2 vols., 1892
Seddon	[John P. Seddon], *Memoir and Letters of the Late Thomas Seddon, Artist. By His Brother*, 1858
Smith	Roger Smith, 'Bonnard's *Costume Historique* – a Pre-Raphaelite Source Book', *Journal of the Costume Society*, VII, 1973
Spielmann	Marion H. Spielmann, *Millais and His Works*, 1898
Staley	Allen Staley, *The Pre-Raphaelite Landscape*, Oxford, 1973
Stephens	[F.G. Stephens], *William Holman Hunt and His Works*, 1860
Surtees *or* Surtees 1971	Virginia Surtees, *The Paintings and Drawings of Dante Gabriel Rossetti (1828–1882). A Catalogue Raisonné*, 2 vols., Oxford, 1971. Usually abbreviated here to 'Surtees' followed by her catalogue number
Surtees 1972	Virginia Surtees (ed.), *Sublime & Instructive. Letters from John Ruskin to Louisa, Marchioness of Waterford, Anna Blunden and Ellen Heaton*, 1972
Surtees 1980	Virginia Surtees (ed.), *The Diaries of George Price Boyce*, Norwich, 1980.
Surtees 1981	Virginia Surtees (ed.), *The Diary of Ford Madox Brown*, New Haven and London, 1981
Troxell	Janet Camp Troxell, *Three Rossettis: Unpublished Letters to and from Dante Gabriel, Christina, William*, Cambridge, Mass., 1937
Vaughan	William Vaughan, *German Romanticism and English Art*, New Haven and London, 1979
Woolner	Amy Woolner, *Thomas Woolner, R.A., Sculptor and Poet: His Life in Letters*, 1917

ABBREVIATIONS: MANUSCRIPT SOURCES

AM	Ashmolean Museum, Oxford
ASU	Arizona State University Library, Tempe, Arizona
BL	Bodleian Library, Oxford
FMBP	Ford Madox Brown family papers, private collection, Eire
HL	Henry E. Huntington Library, San Marino, California
HL/ Deverell Memoir	Frances Deverell and W.M. Rossetti, 'The P.R.B. and Walter Howell Deverell', Huntington Library (HM 12981–2)
JRL	John Rylands University Library of Manchester
LAG	Lady Lever Art Gallery, Port Sunlight
LAG/RP	Rae Papers, Lady Lever Art Gallery
MAG	Manchester City Art Gallery
PC	Private Collection (collections not differentiated)
PML	Pierpont Morgan Library, New York
PUL	Princeton University Library
UBC	University of British Columbia Library, Vancouver
UBC/AP	Angeli Papers, Special Collections, University of British Columbia Library
UBC/LP	Leathart Papers, Special Collections, University of British Columbia Library
WAG	Walker Art Gallery, Liverpool

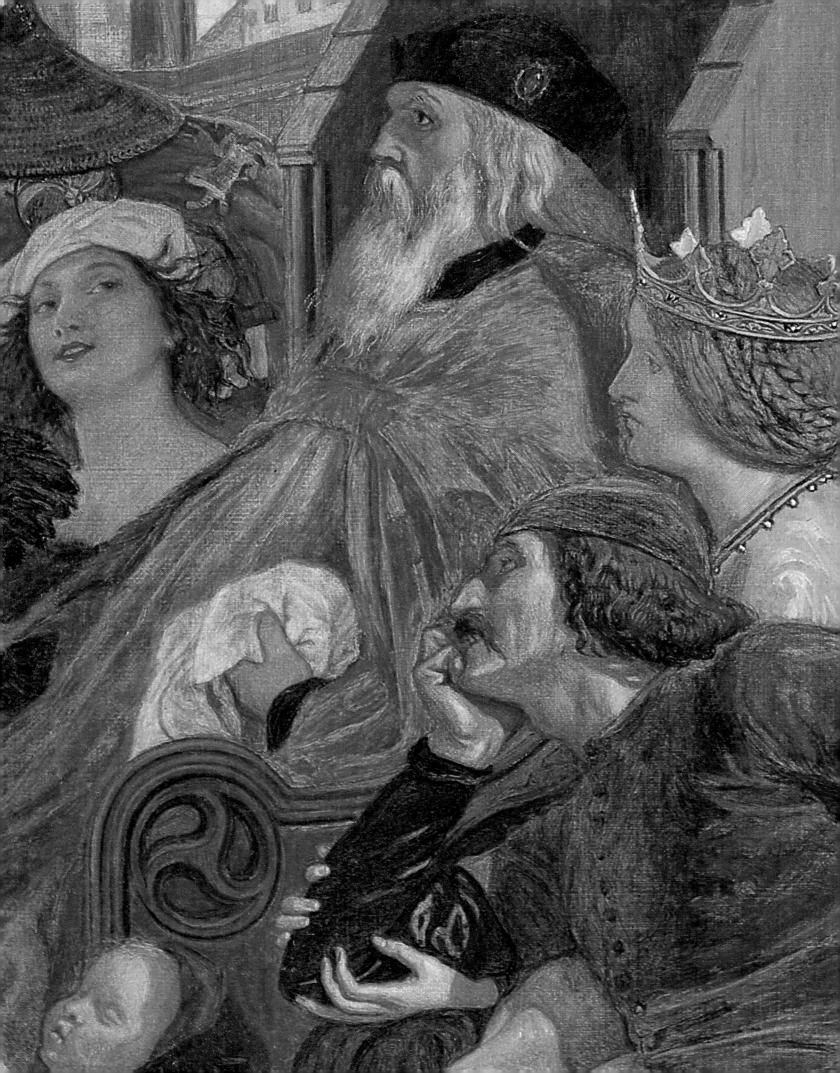

SECTION I

1845-1848

In the mid-1840s the future leaders of the Pre-Raphaelite Brotherhood were still students in the Royal Academy Schools, Millais having gone there at the age of eleven in 1840, followed by Hunt and Rossetti in 1844. Millais and Hunt became close friends while there and both exhibited at the R.A. for the first time in 1846 (see No. 1). Never a member of the P.R.B. but an important associate, Ford Madox Brown, who was older than the others, returned to London in 1846 after studying in Rome. Rossetti became his pupil for a short time in 1848 before transferring his allegiance to Hunt, whose R.A. exhibit that year (No.9) he much admired.

During 1848 all the future Pre-Raphaelite Brothers, with the exception of W.M. Rossetti, were members of the Cyclographic Society, a sketching club based on the principle of mutual criticism. This was a forerunner of the Brotherhood itself, which was formed later that year, apparently in September, with seven members: Rossetti, Millais, Hunt, James Collinson, F.G. Stephens, the sculptor Thomas Woolner and Rossetti's brother, William Michael, who was not an artist but acted as secretary to the group. In the autumn and winter of 1848 the members held their first meetings and worked on paintings in the new style for exhibition the following spring.

opposite Ford Madox Brown, 'Geoffrey Chaucer Reading the "Legend of Custance" to Edward I I I and his Court, at the Palace of Sheen, on the Anniversary of the Black Prince's Forty-fifth Birthday', 1851, 1867–8 (detail, No.7)

1

JOHN EVERETT MILLAIS

1 **Pizarro Seizing the Inca of Peru** 1846
 Inscribed 'JEM 1846' (initials in monogram)
 Oil on canvas, 50½ × 67¾ (128.3 × 172.1)
 First exh: R.A. 1846 (594)
 Ref: R.A. 1967 (4)
 Victoria and Albert Museum, London

The picture with which Millais made his debut at the R.A. exhibition, aged sixteen. It represents the capture of the Inca Atahualpa by Francisco Pizarro at Cajamarca on 16 November 1532, which was accompanied by the massacre of some 7000 Indians by Spanish troops. Millais exploits the fact that the event took place at sunset for its obvious symbolic connotation, suggesting the coming to an end of the Inca empire and religion. Already partly below the horizon, the sun is about to be eclipsed by the figure of the priest Vicente de Valverde brandishing a crucifix. The mother and child group to the right ironically recalls the Massacre of the Innocents.

Millais' choice of subject may have been influenced by H.P. Briggs' 'The First Interview between the Spaniards and the Peruvians', exhibited at the R.A. in 1826 and now in the Tate Gallery. He would have seen this work in the Vernon Collection, which was open to the public. Another, perhaps more immediate, source was Sheridan's play *Pizarro*, an adaptation of A.F. von Kotzebue's *Die Spanier in Peru*. Although it does not actually feature the seizing of the Inca, the play might well have brought home to Millais the dramatic and picturesque potential of the Inca conquest as a theme. He would have seen it at the Princess's Theatre on Oxford Street, where it was revived early in 1846. He was a frequent visitor to the Princess's, having become friendly with the leading actor James William Wallack, who appeared in the play as the Indian

hero Rolla. Indeed, he had Wallack sit as a model for his picture, re-casting him as Pizarro. The other models are unidentified except for the artist's father, who sat for Valverde (J.G. Millais, I, p.18). It seems likely that Millais would have used costumes and props from the Princess's. According to Holman Hunt (1905, I, p.58), he borrowed some of the native garments and ornaments the artist Edward Goodall had brought back from a trip to South America. He may also have seen original Inca material at the British Museum.

Exactly when No.1 was begun is unknown, although it was clearly well under way by 28 February 1846 when Millais made a sketch of himself at work on it on the back of a cheque (J.G. Millais, I, p.35). It would have been finished by early April for submission to the R.A. exhibition.

Later the same year it was shown at the Liverpool Academy and in 1847 at the Society of Arts, where it was awarded a gold medallion (see Malcolm Warner, 'John Everett Millais and the Society of Arts', *Journal of the Royal Society of Arts*, CXXIV, 1976, pp.754–7).

An oil sketch was sold at Christie's, 5 June 1981 (40).

M.W.

THOMAS WOOLNER

2 **Puck** 1845–7
 Plaster, painted black, 19½ × 13 × 11 (49.5 × 33 × 28)
 First exh: B.I. 1847 (550)
 Major-General C.G. Woolner C.B., M.C.

Woolner began modelling his figure of 'Puck' in 1845 and had completed it by 1847 when it was exhibited at the British

Institution. The subject derives from Shakespeare's *A Midsummer Night's Dream* although the incident portrayed comes, we are told in the 1847 catalogue, from an 'Imaginary Biography of Puck': 'As he was sailing through the air one day, searching for wherewith to please his humorous malice, right well was he satisfied to alight upon a mushroom and awaken a sleeping frog, of which a hungry snake was about to make a meal'. Amy Woolner gives the following short description with the comment that it cannot be improved on: 'The sprite stands on a toadstool. A snake is stealthily creeping towards an unconscious toad. Puck is about to touch the toad with his foot, that thus warned it may escape the jaws of the enemy. A smile of half mischievous satisfaction is on his face' (Woolner, p.4).

Ideal or poetic subjects, drawn from mythology, literature or history, were very much seen by sculptors as the highest level of their art, the area in which they could best express the finest qualities of sculpture. This ideal was consistently maintained in spite of the fact that effective practical patronage for this sort of work (which would result in its execution in a more permanent medium such as marble or bronze) was rare. There seems nonetheless to have been a particular surge of interest in this type of work during the 1840s – Foley, Thrupp and Thomas all exhibiting Shakespearean subjects at the British Institution in this period, which was exceptional. This surge was probably due to the terms of the competitive sculpture exhibitions held in 1844 and 1845 at Westminster Hall as part of the campaign to decorate the Houses of Parliament. Although the ultimate object of these was to choose sculptors to execute portrait statues of famous parliamentarians, the specifications left the choice of subject to the artist, specifying only work-types: ideal or portrait statues, or groups. Subjects from literature, particularly Shakespeare, featured strongly, the sculpture in this respect paralleling the more frequent paintings exhibitions, where the range of subject choice evolved from a well-defined History or Shakespeare, Spenser and Milton in 1843 to a general free-for-all in 1847. Woolner would certainly have been aware of all this, as he submitted to the 1844 exhibition a life-size group in plaster of 'The Death of Boadicea'.

'Puck' features in Holman Hunt's account of the early days of the formation of the Pre-Raphaelite Brotherhood. He recalls a visit in 1847 to the studio shared by Woolner and Bernhard Smith, and seeing 'Puck' there, which Woolner showed 'with much paternal fondness' (Hunt 1905, I, p.114). It is not hard to see why the work could have gone down well with the prospective Brothers: Shakespeare was to be a three-star Immortal, and it is possible to see a certain general similarity between 'Puck', certain early Rossetti grotesques (Surtees Nos 22, 36 of 1846–8), and the spirit figures in Millais' 'Ferdinand Lured by Ariel' of 1849–50 (No.24, which was later owned by Woolner).

That the original plaster model of 'Puck' (shown here) should have survived is due no doubt to the sculptor's particular regard for the work (see Hunt's account, above). The survival rate for plaster versions is generally not good – the material is recyclable in practical studio terms, and fragile in a wider context. A plaster cast was made for Coventry Patmore in 1849, but a bronze version not made until 1865 for Lady Ashburton. A posthumous bronze cast was made in 1908 for Sir John Bland-Sutton of the Middlesex Hospital. The particular feature of Puck's anatomy that was of medical interest involved his pointed ears. Woolner examined ears closely, both of men and monkeys, and found a vestigial relationship involving this point or 'tip' connecting the two. He subsequently had this confirmed in discussions with Charles Darwin, when model-

2

ing his bust in 1869, and Darwin incorporated the point in *The Descent of Man*, published in 1871. Lady Bland-Sutton bequeathed her husband's 'Puck' to the Royal College of Surgeons in 1943 but it has since been stolen.

B.R.

WILLIAM HOLMAN HUNT

3 **Frederic George Stephens** 1846–7
Inscribed 'Whhunt 1847' (initials in monogram) and 'FGS' in monogram
Oil on panel, $7\frac{15}{16} \times 6\frac{7}{8}$ (20 × 17)
Ref: Liverpool 1969 (6)
Tate Gallery

F.G. Stephens (1828–1907) met Hunt at the Royal Academy Schools, which Hunt entered at the third attempt in December 1844. Although Stephens had been a student there since January, it seems that Hunt soon became the younger man's artistic mentor as well as close friend. He encouraged Stephens to paint, secured his election to the Pre-Raphaelite Brotherhood in 1848, and used him as model and studio assistant. Until their relationship foundered in 1880, Stephens faithfully

served Hunt as go-between, propagandist, research assistant and errand boy.

According to a label of 18 February 1872 on the verso of the panel, signed by Stephens, No.3 was painted in 1846–7 and given to Stephens' mother by Hunt on her son's twenty-eighth birthday (10 October 1856). It was bequeathed to Stephens' son Holman in 1871, and bequeathed by him to the Tate Gallery in 1932.

No.3 is the first of Hunt's oil paintings to display his monogram. For a painting by Stephens, see No.64 and for a drawing of him by Ford Madox Brown, No.177.

J.B.

3

WILLIAM HOLMAN HUNT

4 **The Church at Ewell** 1847
Inscribed 'EWELL | OLD CHURCH | Painted in June | 1847 | FOR THE REVD | SIR G.L. GLYNN BART | LAY RECTOR AND | VICAR | BY W.H. HUNT'
Oil on canvas, 25 × 30 (63.5 × 76.1)
Private Collection

Although Hunt, in his memoirs, relates that Sir George Glyn 'engaged me to make a painting' of the old church of St Mary the Virgin, Ewell (Hunt 1905, I, p.72), the exact nature of the commission was only revealed in a letter from one 'J.P.' published in *The Times* of 12 September 1910: 'I remember the late Sir George Glyn (who for fifty years had been vicar of Ewell) showing me, when curate of Ewell, the picture of the old church and churchyard. He told me that he had seen a youth busy upon it, and had said, "If you do that well, I will buy it of you"'. The figures in the foreground were probably added once Sir George Glyn decided to buy No.4, and this would account for the contours of the graves showing through the figures.

Hunt's maternal uncle and aunt, the Hobmans, lived at Rectory Park Farm, which was adjacent to the old church, and some of Hunt's earliest attempts at painting from nature were undertaken in this locality. It may seem odd that Hunt should have begun a painting of this scale on canvas without the assured support of a patron, but No.4 may have been inspired by the young artist's reading of *Modern Painters*, in particular Ruskin's insistence on the need for truthful, detailed representations of nature. Although the trees on the right in No.4 are conventional in colour, recalling the advice given to the artist by his first teacher, Henry Rogers (Hunt 1905, I, pp.25–6), they represent an advance in handling on the more generalised treatment employed in 'Little Nell and her Grandfather' of 1845 (Sheffield City Art Galleries, exh. Liverpool 1969, No.5). This quality of careful observation is also present in the accurate rendering of the early morning shadows: according to the church clock it is 6.45 a.m.

The fifteenth-century tower, of cut flint and Reigate stone with nineteenth-century brick parapets, is all that is now left of the old church, which was demolished in 1848 to make way for Henry Clutton's new Church of St Mary. The knowledge that No.4 was a record of a condemned building made Hunt's accurate depiction of the architecture all the more important. A certain artistic licence has, however, been taken with the wording on the tombstones, for Hunt's own inscription, signature and date can be found on the third stone from the right in the foreground.

J.B.

4

WILLIAM HOLMAN HUNT

5 **Christ and the Two Marys** 1847, ?1897
Inscribed 'W. HOLMAN HUNT. 1847.'
Oil on canvas, $46\frac{1}{4}$ × 37 (117.5 × 94)
First exh: *The Collected Works of W. Holman Hunt*, Manchester City Art Gallery, 1906–7 (ex-cat.)
Ref: Liverpool 1969 (8)
Art Gallery of South Australia, Adelaide (D'Auvergne Boxall Bequest Fund 1964)

No.5 was financed by the £20 Hunt received for his 1847 Royal Academy exhibit, 'Dr. Rochecliffe performing Divine Service in the cottage of Joceline Joliffe' (private collection), and the number of extant preparatory studies attest to the importance Hunt accorded this subject, which he also referred to as 'The Resurrection Meeting' (Hunt 1905, I, p.81). At this period Hunt was a student in the Royal Academy life class, and there is a study from the life for the figure of the suppliant Mary Magdalene (Coll. Mrs Burt) as well as compositional thumbnail sketches in which different poses are explored. Early studies (Coll. Mrs Burt, exh. Liverpool 1969, No.90) reveal that Hunt originally concentrated on the relationship between a draped

5

Christ with bowed head and extended left arm and a kneeling figure with face upraised, dramatising the encounter between the risen Saviour and Mary Magdalene. He then developed the conception to include the prostrate form of Mary the mother of the apostles James and John, following Matthew 28. His main difficulty centred round the figure of Christ: the initial idea of depicting the Saviour leaning on a staff was rejected, but Hunt had little room on the canvas for manoeuvre, even after the colourman had extended it down the left-hand side (see Hunt 1905, I, p.78). On realising that he could not possibly finish No.5 in time for the 1848 Royal Academy exhibition, the canvas was abandoned.

According to Hunt's autobiography, No.5 was the first of his works to be executed to a large extent 'without any dead colouring' or dark underpainting, following the example of David Wilkie (ibid., I, pp.53, 78–9). It is possible that Hunt's unfamiliarity with this technique contributed to his decision to abandon the painting.

The main reason for giving up No.5 was the difficulty of attempting to forge a new style of religious painting, relevant to the 1840s. Such an ambition was fuelled by Hunt's reading at this period of Ruskin's *Modern Painters* (vol.2, 1846), a work of crucial importance to Hunt's development, as it pointed the

way forward to a style of symbolic realism. Although the figure of Mary Magdalene in No.5 is revivalist, probably influenced by William Dyce, Hunt felt that traditional religious iconography lacked emotional impact: 'If I were to put a flag with a cross on it in Christ's hand, the art-galvanising revivalists might be pleased, but unaffected people would regard the work as having no living interest for them. I have been trying for some treatment that might make them see this Christ with something of the surprise that the Maries themselves felt on meeting Him as One who has come out of the grave, but I must for every reason put it by for the present' (1905, I, p.85).

In fact, according to the label on the verso of No.5, 'Christ and the Two Marys' was put by until 'At the age of 70 W.H.H. painted the Christ (roughly sketched) and background of Mountains of Mo[ab?]'. The figure of the Saviour was at this stage greatly influenced by 'The Shadow of Death' (No.143).

Although No.5 was referred to as 'unfinished' when it was reproduced in Hunt's autobiography in 1905, the artist did agree to its being lent to his retrospective for the last few weeks at Manchester and for the exhibition at Liverpool in 1907 (Hunt to Mr Dibdin, 4 January 1907, WAG). This suggests that he regarded it as a key work in his artistic development.

J.B.

6

FORD MADOX BROWN

6 The Seeds and Fruits of English Poetry 1845–51, 1853
Inscribed 'FORD MADOX BROWN DESⁱ [I]N
ROMA.1845.|COLORAVIT IN HAMPSTEAD. 1853'
Oil on canvas, $13\frac{3}{8} \times 18\frac{1}{8}$ (34 × 46)
First exh: L.A. 1853 (662)
Ref: Liverpool 1964 (12)
Visitors of the Ashmolean Museum, Oxford

Study for 'Chaucer', the artist's first important painting on
settling in England (see No.7), and showing the assimilation of
many new influences which resulted in a major change of
direction in his style.

Planned in his short period in England in 1845 and designed
and begun soon afterwards at Rome, its theme grew naturally
out of those being considered for the Houses of Parliament
decorations in which the splendours of English literature as
well as history were included. The sight of the luxuriant
materials in Maclise's 'Chivalry' in the 1845 Competition for
frescoes inspired him to emulation.

Looking for a subject 'of a general and comprehensive
nature' in Mackintosh's *History of England* in the British
Museum Library, he came upon a reference to the ennobling of
the English language by Chaucer and, as he wrote in retrospect
in his new diary in 1847, 'immediately saw visions of Chaucer

reading his poems to knights & Ladyes fair, to the king & court
amid air & sun shine' (Surtees 1981, p.1). At Rome 1845–6,
he planned it as a triptych, intending to encompass the 'Seeds
and fruits of the English language', but finding such a theme
too extensive he decided to limit it to poetry.

The idea for the centre panel to include the court of Edward
III and the Black Prince was already in his mind before leaving
for Rome. It has been recently suggested (by Miss J. Elkan and
Dr L.H. Hornstein, to the compiler), that he may have been
influenced by the frontispiece to the important illuminated
manuscript of Troilus and Criseyde in Corpus Christi College,
Cambridge (MS 61), which also shows Chaucer reciting his
poems to people of rank, once thought to have been the court of
Richard II (R. Marks and N. Morgan, *The Golden Age of
Manuscript Painting*, 1981, p.113, pl.37). There are superficial
details in common but no present evidence that he could have
seen it, though no doubt he could have heard of it, and he
would certainly be aware of the format of various mediaeval
illuminations through material in the British Museum and the
engraved illustrations of current costume and historical source
books.

The high tiered format owes much to Maclise, but is
translated into an easy naturalness. The gothic architectural
framework and tracery is a blend of Gothic Revival of a kind
popularised by German illustrators and of Madox Brown's
direct recollection of Flemish painting from his student days.

The monumental figures in the wings set against gilt diaper backgrounds and looking directly out, together with their low viewpoint, the putti below and the classical medallions above, echo Italian altarpieces (the artist passed through Modena, Florence, and Bologna on his way to Rome). The clear linear drawing, which is carried through into the large oil, owes much to the sight of Holbein's work at Basle on the outward journey, while the whole ultimately bears the imprint of his awareness of Raphael's Stanze and the Nazarenes at Rome. This study bears out his 1865 statement: 'During my sojourn, Italian art had made a deep, and as it proved, lasting impression on me, for I never afterwards returned to the sombre Rembrandtesque style I had formerly worked in'. The bright colouring as we now see it was probably strengthened in finishing it in 1851 and in two months retouching in 1853 and reflects the brighter palette of those years, following his association with the Pre-Raphaelites.

No.6 shows one of several slight variations in composition for the centre panel (others are in compositional drawings in the Cecil Higgins Museum, Bedford, Birmingham City Art Gallery, and the Ashmolean Museum; a further study in watercolour is lost). In particular John of Gaunt, in armour, is given at first a more prominent role, no doubt to emphasise both his role as patron of Chaucer and as virtual ruler of England. Some figures are in different poses, with notably the jester seated alone in the right foreground. The fountain is first introduced in this study: it may represent the fountain of knowledge and be derived from Overbeck's 'Triumph of Religion', 1840 (a debt which is pointed out by Keith Andrews, *The Nazarenes*, 1964, p.167); Madox Brown would also have known Van Eyck's Ghent altarpiece. The ground plan, spatial depth and sunlight effect are clearly worked out.

In the side panels appear, at the left, Milton, Spenser and Shakespeare, with the head of Goldsmith above; in the right panel, Byron, Pope and Burns, with the head of Thomson above. Below, the putti hold four cartouches, each inscribed with two names; from the left: Campbell and Moore, with an anchor; Shelley and Keats, with a pierced heart; Chatterton and Kirke White, with a sickle; Coleridge and Wordsworth, with an owl. In the spandrels are seated sleeping figures representing the Saxon Bard and the Norman Troubadour. Corn grows around the poets' feet and the fruit of vines which entwine the columns hangs before diapered stonework which is reminiscent of Westminster Abbey arcading. Vines are repeated on the frame.

Madox Brown called his absorbing new subject 'a love offering to my favorite poets, to my never-faithless Burns, Byron, Spencer & Shakespear' (*Diary*, 4 September 1847), but Holman Hunt recalled his first visit with Rossetti to the studio in Clipstone Street a year later in August 1848 when the three big canvases were under way, and Rossetti's scorn: 'he declared that Shelley and Keats should have been whole-length full figures instead of Pope and Burns, and the introduction of Kirke White's name, he said, was ridiculous' (Hunt 1905, I, p. 126). Madox Brown's introduction to a wider field of poetry through Rossetti explains his subsequent abandonment of the side compartments. 'But this idea was conceived abroad', he stated in 1865, 'at a time when I had little opportunity of knowing the march of literary events at home. On my coming to England, I soon found that the illustrious in poetry were not all among the dead, and to avoid what must either have remained incomplete, or have appeared pretentious criticism, I gave up the idea indicated in the side compartments'.

M.B.

FORD MADOX BROWN

7 **Geoffrey Chaucer Reading the 'Legend of Custance' to Edward III and his Court, at the Palace of Sheen, on the Anniversary of the Black Prince's Forty-fifth Birthday** 1851, 1867–8
Inscribed 'F. MADOX BROWN – 68'
Oil on canvas, arched top, 48½ × 39 (123.2 × 99)
First exh: the original was shown at the R.A. 1851 (380)
Ref: Liverpool 1964 (under No.11)
Tate Gallery

Replica, dating from the 1860s, of the largest, most complex and ambitious painting by Madox Brown. The original, unavailable for this exhibition, is in the Art Gallery of New South Wales, Sydney (fig.i). Its scale (146½ × 116½), its subject, and its initial lighter tonality, reflect contemporary concern in England with mural painting for state patronage in the mid-1840s. While stylistically it drew on the many influences bearing on him at this significant period of his development (outlined under No.6), its importance lies in its distinctive easy naturalness and its novel effect of natural sunlight.

Madox Brown emphasised this prime feature in his 1865 one-man exhibition catalogue: 'This picture is the first in which I endeavoured to carry out the notion, long before conceived, of treating the light and shade absolutely, as it exists at any one moment, instead of approximately, or in generalised style. Sunlight not too bright, such as is pleasant to sit in out of doors, is here depicted'.

Chaucer dominates the composition. He reads an early poem written, probably, after his visit to Italy (later reworked as 'The Lawyers Tale'), which makes possible the inclusion of the Black Prince, in his last illness, 1375, as well as Chaucer's patron John of Gaunt. The poem was perhaps chosen to parallel the artist's own experience and the need after the death of his first wife for the fortitude which Custance symbolises.

At the right are seated Edward III with Alice Perrers, his mistress. John of Gaunt stands behind and at the King's side are the Fair Maid of Kent, the Black Prince and their child Richard; behind them are Princess Margaret and the Princess Royal. In the foreground at the left Thomas of Woodstock, patron of Gower, sits whispering to Lady de Bohun, later his duchess; at the right are Sir John Froissart with his tablets and the poet Gower. Behind Chaucer is Henry, son of John of Gaunt, holding his father's shield and spear, and to the left Robert de Vere, Grand Chamberlain, and the Earl of Pembroke, Marshal. Philippa Roet, wife of Chaucer, in a red headdress, speaks to her sister Catharine. In the centre is seated a Provençal troubadour with his minstrels and to the right a Cardinal, the Pope's Nuncio, directs the attention of the Countess of Warwick to the jester, wrapt in wonder at the tale (R.A. 1851 catalogue).

The importance of the picture in Madox Brown's development is underlined by the detailed day by day entries he gave it in his diary started for the purpose after settling finally in London, from September 1847. Many studies were made both at Rome and in London for figures, drapery and heads. Much work was tried out in the oil study (No.6) and a lost watercolour, and painting was begun on the side panels first. The centre canvas was, however, apparently only begun in oil (the outline of course already elaborately chalked in and many of the studies made much earlier) in June 1849, that is, the summer after he had met Rossetti and the Pre-Raphaelites and seen their first productions as a Brotherhood. Their influence came most immediately through Rossetti's greater knowledge of poetry, which must lie behind Madox Brown's decision,

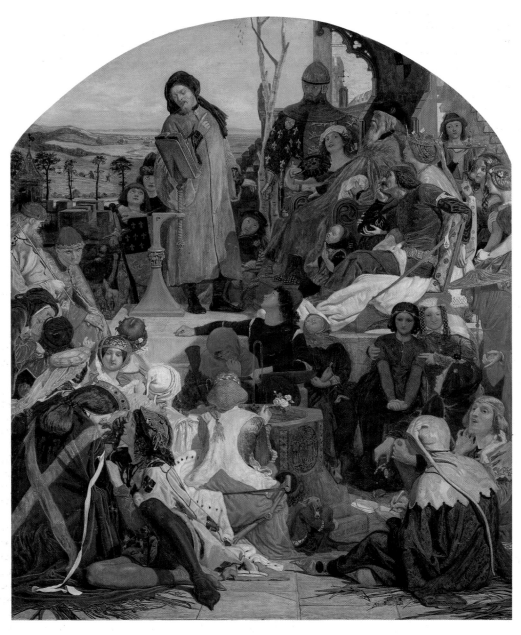

7

sometime between 1849–51, to abandon the wings. The
architectural setting was also abandoned, though on the large
canvas the figures of the Saxon Bard and Norman Troubadour
were as late as 1865 visible in the spandrels.

The diary details the artist's technique in which, while he
was still using bitumen, he was also using white grounds. He
records: 'find I can put the models in the sun' and 'always
laying in the flesh with pure white' (22, 23 June 1849). The
sun was admitted through an arrangement of blinds in his
studio and he had already been using white for a partial ground
in 'Wycliffe' (No.8). His own tentative ideas for sunlight effects,
which dated from his Paris days, must have been crystallized
through association with the Pre-Raphaelites.

To Pre-Raphaelite influence is probably due his introduction
of friends as well as professional models for some of the heads.
In June and July 1849 he had a series of sitters: his favourite
model, Maitland, with cadaverous face and hook nose, sat for
the Black Prince and for Gower; the handsome Walter Deverell

for Thomas of Woodstock; John Marshall, surgeon and friend
of the artist, for the Jester; Julia Wild, a professional model, for
the young Catharine Roet, in sunlight looking round at the left;
Emma, later his wife, sat for Philippa Roet and at some date for
the Fair Maid of Kent; his daughter Lucy was her small child;
while for Chaucer appropriately sat D.G. Rossetti, 'the very
image of Occleve's little portrait', from 11 at night till 4 in
the morning just before the sending-in day in April 1851.
Landscape studies were also made on the spot for the back-
ground (see No.20).

Historical accuracy was becoming important and though
Madox Brown does not mention his sources for costume and
authentic portraits there were many possibilities by the 1840s.
At Rome he traced costumes in Bonnard's *Costumes Historiques*,
1829 (drawing Birmingham; published in Smith, pp.29, 30).
He owned at some stage a copy of Fairholt's *History of Costume*,
1846, in which are several items including the rolled head-
dress (and see Roy Strong, *And when did you last see your father?*,

1978, p.59, for other sources). The peculiar lectern is engraved in Knight's *Pictorial History of England*, 1837, along with many costumes (Surtees 1981, p.12 n). The ploughing scene introduced into the landscape, probably with symbolic intent, may be after an engraving of the Seasons in Shaw's *Dresses and Decorations of the Middle Ages*, 1843. Madox Brown mentions searching for portrait prints and buying one of Byron. He also notes on 16 October 1847 a visit to Westminster, 'and to the abbey to see some of the old effigies'. He also records consulting Mark Anthony (1817–86) and others about Daguerreotypes for some of the figures 'to save time' (12 November 1847), but there is no evidence that he actually made use of such a means.

The picture required more than one season's work and long intervals were devoted to preparing 'Wycliffe' and 'King Lear' for exhibition. At the 1851 R.A. it was badly hung but well received. Holman Hunt had been dismissive of the whole concept in 1848 as an essay in the current germanic, balanced and conventional style – it 'failed to represent the unaffected art of past time'; but Madox Brown was afraid in 1851 that an association with the now vilified Brotherhood might be suspected. The *Illustrated London News* (17 May 1851) noted a connection but found 'no Pre-Raphaelite nonsense': 'Mr. Brown has known when to quit a peculiar school. He sees its beauties and its defects, and he knows what to copy and what to reject'. The *Athenaeum* (24 May) treated his work well while abusing the Pre-Raphaelites. The *Spectator* (10 May) in particular noted the broad sunlight and the colour 'alike brilliant and delicate' but the *Art Journal* (May) in an otherwise sympathetic notice thought 'a deficiency of shade deprives the composition of depth and the figures of substance'. The artist retouched it considerably in February 1855 for the Paris Universal Exhibition, 'to improve the solidity and truth of colour', so that its original effect was to some extent lost.

It proved difficult to sell, Dickinsons, the Bond Street printsellers ostensibly buying it for a large percentage of any subsequent sale, but Madox Brown only received £25 in 1854. It gained the £50 prize at Liverpool in 1858 after it had passed to his own usual dealer D.T. White. He got it back from him by an exchange arrangement in November 1863 (White had been planning to cut it up), ready for his one-man exhibition in 1865.

No.7, which had been begun back in 1851 by Thomas Seddon, perhaps as an exercise under Madox Brown's eye in reducing a picture to scale (Hueffer, p.75; and copy of the artist's Account Book, FMBP), was taken up at that time and was on offer to clients in 1865. Madox Brown mentioned it to George Rae in November as 'in the hands of my assistant which I shall begin on when I can clear off the Jacob' (LAG / RP); the assistant may have been Albert Goodwin (1845–1932). He wanted 600 gns, with 100 off to old clients, and commented, 'I think I may hope to make it, in some respects, colour for instance, better than the large one' (he also offered the original picture at 500 gns). It was finally commissioned by Frederick Leyland, the Liverpool shipowner, about August 1867 for 500 gns, and was finished by January 1868. It differs from the large picture in minor details and colours, in particular the tone is flatter. His more fluid handling of paint from the 1860s onwards is notably apparent in the robe of the lady with the sideless gown, which is distinctive from the polished finished style of the original picture. It remained with Leyland until his death in 1892 and the Tate Gallery acquired it in 1906.

The large picture was sold by the artist to the new art gallery at Sydney, New South Wales, in 1876, for £500, as his first painting to enter a public collection.

M.B.

FORD MADOX BROWN

8 **The First Translation of the Bible into English: Wycliffe Reading his Translation of the New Testament to his Protector, John of Gaunt, Duke of Lancaster, in the Presence of Chaucer and Gower, his Retainers** 1847–8, 1859–61
Inscribed 'F. MADOX BROWN'
Oil on canvas, 47 × 60½ (119.5 × 153.5)
First exh: Free Exhibition 1848
Ref: Liverpool 1964 (15)
Bradford Art Galleries and Museums

Painted during the winter of 1847–8 for the exhibition season, while 'Chaucer' (see No.7) was put by, and appearing publicly therefore in advance of that as an essay in Madox Brown's new style following his trip to Rome. Its subject follows on from 'Chaucer' and similarly celebrates the flowering of the English language at the dawn of the Reformation.

In composition it is more frontal, static and formalised, in fact nearer to the overall concept of 'Chaucer' in triptych form (see No.6), and its debt particularly to the Nazarenes is more apparent. Extensive retouching for a new client in 1859–61 obscured much of the original pale and delicate tonality under brighter colours and some heavy-handed workmanship. The Puginesque architectural framework which was an integral part of the original work was hidden at the same time under a plain gold flat which was badly aligned for the roundels, where are figures representing Catholic and Protestant Faiths. Along the bottom of the tromp l'oeil setting, also hidden by the later flat, are inscribed the names of the participants: 'CHAUCER: GOWER: WYCLIFF: JOHN of GAUNT'; the pages hold volumes inscribed 'CONFESSIO AMANTIS' and 'Troilus and Creseide' (similarly dating from the end of the fourteenth century and in which Gower and Chaucer compliment each other); the Holy Bible is placed upside down on the lectern. Wycliffe wears a simple cassock and is barefoot to express his contempt for worldly vanities.

No.8 is recorded in detail in the artist's diary and follows his standard plan of work. An oil sketch was prepared for composition and colour (recently re-discovered and now also at Bradford), and many detailed and beautifully worked out drapery and portrait drawings made. Models were almost entirely professional, which seems to confirm that his later use of friends for models in 'Chaucer' stems from Pre-Raphaelite ideas. 'Old Coulton' sat for five hours on 14 January 1848 presumably for Wycliffe (a sympathetic study of old age is in Birmingham Art Gallery, where are other drawings), and both he and 'Krone' sat for the painting itself; Yates sat for Chaucer, Miss (Julia) Wild for Protestant Faith, Maitland for Catholic Faith, for Gower and for John of Gaunt; a Mrs Ashley sat for the duchess and Madox Brown also used a drawing of his cousin Elizabeth Bromley; Lucy Madox Brown was the child.

He consulted Pugin's works for furniture, and borrowed Shaw's *Furniture* and a dictionary of architecture: the lectern, as Roy Strong points out (*And when did you last see your father?*, 1978, p.65), may be a combination of two published in Henry Shaw's *Specimens of Ancient Furniture*, 1836. The lettering beneath the figures is an exact copy of an example, 'time of Richard III', in Shaw's *Handbook of Mediaeval Alphabets and Devices*, 1845: Madox Brown records copying an alphabet in the British Museum Library on 2 December 1847. Chaucer follows Occleve's portrait (variously published, including Shaw's *Dresses and Decorations of the Middle Ages*, 1843). Gower is after his monument in St Saviour's, Southwark, or an engraving after it. Wycliffe follows standard portrait engravings.

8

The artist carefully recorded his technique and his problems. He was taken aback at an early stage over wrong proportions of some figures which had to be rectified, and W. Cave Thomas provided him with an outline of Vitruvius' proportions. He was dissatisfied with some colour effects, repainting Gaunt's dress more than once: 'painted in the ground afresh for the jupon (yellow for the blue & white for the red). Nothing like a good coating of White to get bright sunny colour'. This was written on 17 March 1848 and shows current practice in the use of white before the Pre-Raphaelites developed their technique. The figures in the spandrels were tried out in the oil sketch in a different form, taking up the whole space above each side of the narrow arch. The final architectural framework here provides an apposite religious setting in Pugin's Houses of Parliament manner. An outer frame was also designed by Madox Brown, but this first recorded essay by him was since discarded and is now lost.

The Free Exhibition, to which it was sent in the middle of April, was now in its successful second year and provided space to members for a fee. Hanging was therefore certain and the sending-in day allowed for an extra fortnight after that of the

R.A. for the usual rush of finishing. The picture was well and sympathetically reviewed. The *Athenaeum* was encouraging and, evidently with the Houses of Parliament Competitions in mind, considered it 'obviously designed with a view to its execution in fresco', and thought that 'his judgement has been shown in having arranged much that can be done in a material where effect is to be obtained rather by opposition of colour than strong contrasts of light and shade, or the delicate gradations of half tint'. A wood-engraving was published in the *People's Journal*, whose reviewer considered that the artist had 'secured himself imperishable fame in this selection of a subject'. This was the second time his work had thus been brought before a wider public: the outline published after his cartoon of 'The Spirit of Justice' had been admired and acquired by Rossetti.

No.8 did not find a buyer until around 1851 when it was acquired, probably after the 1850 Dublin exhibition, by Francis McCracken of Belfast, a shipper who kept up with the reviews and bought Pre-Raphaelite pictures by correspondence. By 1855 it belonged to B.G. Windus of Tottenham, collector of Turners and Pre-Raphaelites. Seeing it there on a

visit in March that year Madox Brown commented 'My Wycliff looks quite faded', and thought similarly of Millais' 'Isabella', adding 'but I suppose it is I who have brightened'.

T.E. Plint of Leeds bought it at the Windus sale, 1859, and characteristically wanted it touched up. 'I should not have bought the Wycliffe', he wrote, 'but for the kind hint as to retouching. I have no doubt it may be made as good as any of yours, the *subject* is a *noble* one' (FMBP). He was prepared to spend £100. It is not clear whether the suggestion to cover up the surround came from him or was hinted at by Madox Brown, either being too difficult to re-work or perhaps by then old-fashioned. Plint was very dissatisfied with the initial result, complaining in December 1860 that the agreement was that it be brought 'up to the mark' of his latest work, 'employing models' etc. He was evidently expecting a match to 'The Last of England' (No.62) which he had also bought at the Windus sale. The sky was brightened all over (the paler earlier work is visible in a strip across the top, covered by the new flat, and there must once have been clouds: *Diary*, 20 March 1848); the flags were reddened and the chair of John of Gaunt altered. Sompting Church, Sussex and its surrounding landscape, which is in heavier paint, is also probably of this period, overlaying what may have been a marshy or watery landscape (it does not appear in the oil sketch or the engraving, and see *Diary*, 27 March 1848). Its addition would bring the background into line with Madox Brown's new interest in landscape which post-dated the first finishing of 'Wycliffe.'

M.B.

WILLIAM HOLMAN HUNT

9 **The Flight of Madeline and Porphyro during the Drunkenness Attending the Revelry (The Eve of St Agnes)** 1848
Inscribed 'WILLIAM H. HUNT'
Oil on canvas, $30\frac{1}{2} \times 44\frac{1}{2}$ (77.5 × 113)
First exh: R.A. 1848 (804)
Ref: Liverpool 1969 (9)
Guildhall Art Gallery, Corporation of London

Exhibited at the 1848 Royal Academy, with the following quotation in the catalogue from Keats' 'The Eve of St Agnes':

They glide, like phantoms, into the wide hall;
Like phantoms, to the iron porch, they glide;
Where lay the porter, in uneasy sprawl,
With a huge empty flagon by his side.
The wakeful blood hound rose, and shook his hide,
But his sagacious eye an inmate owns;
By one, and one, the bolts full easy slide:–
The chains lie silent on the footworn stones;–
The key turns, and the door upon its hinges groans.

The original title of No.9, 'The flight of Madeline and Porphyro during the drunkenness attending the revelry', demonstrates a deliberate misreading of Keats' poem, in which the lovers escape after all 'the bloated wassailers' have drunk themselves into oblivion. Preparatory studies, depicting the lovers on the left of the composition (Coll. Mrs Burt, exh. Liverpool 1969,

9

No.90), reveal that the revellers in the background of No.9 were not part of the original conception. The moving of the lovers to the right, near to the slightly open door, may have been prompted by Hunt's use of the engraving 'Bester Mann!' from Retzsch's illustrations to Goethe's *Faust* (repr. Vaughan, p.129): Porphyro's cap and half cloak, and the positioning of his legs, though reversed, are derived from this work. The subject of *Faust* was, however, far removed from that of 'The Eve of St Agnes', which Hunt came to interpret as a demonstration of 'the sacredness of honest responsible love and the weakness of proud intemperance' (1905, I, p.85). The addition of the riotous party, the seated page, and the wine flowing from the flagon in the right foreground dramatised this reading of the poem.

Hunt set about painting No.9 in a thoroughly academic fashion, as befitted a work destined for the Royal Academy. Thumbnail compositional studies of 1847 (Coll. Mrs Burt, exh. 1969, Nos 90–2), an oil sketch for the left-hand side of the composition (ibid., exh. 1969, No.10), a study from the life for the foreshortened figure of the sprawling porter (ibid., exh. 1969, No.93), two pencil sketches of the entire composition (Ashmolean Museum, repr. Hunt 1913, I, p.208, and Coll. Mrs Burt, exh. 1969, No.94) and a careful study in oils, to be finished years later (Walker Art Gallery, exh. 1969, No.11), were considered necessary preliminaries to No.9, which was commenced on 6 February 1848 (Hunt 1886, p.478).

As his days were spent at the Royal Academy life class, No.9 was worked on in the evenings by candlelight, and this accounts for the discrepancies in the direction of the shadows. According to Hunt's memoirs: 'The architecture I had to paint with but little help of solid models, but the bough of mistletoe was hung up so that I might get the approximate night effect upon it; the bloodhounds I painted from a couple possessed by my friend, Mr. J.B. Price; my fellow-student, James Key, sat to me for the figure of the sleeping page and for the hands of Porphyro, so I was enabled to advance the picture with but little outlay' (1905, I, p.98). Apart from its associations with the wintry setting of Keats' poem, the mistletoe, according to the Victorian language of flowers, denoted 'obstacles' and was therefore most appropriate to the theme of No.9. The crouching bloodhound, not part of the original conception, was probably added to demonstrate Hunt's prowess in the field of animal painting. The association of dogs with fidelity, as a counterbalance to the intemperance symbolised by the immense figure of the sprawling porter, may also have been in the artist's mind.

Hunt gave himself only two months in which to complete No.9, and found that he had to work through the night in Millais' studio as the sending-in date for the exhibition approached. At this point Millais painted in the head of the bearded baron enthroned in the left background, and the left hand of the reveller whose head is thrown back towards the spectator (Hunt 1905, I, p.99), although the finished pencil preparatory sketch reveals that Millais was here following Hunt's conception.

Hunt's uncle paid for the original frame of No.9, which 'was hung somewhat high up in the Architectural Room, but in a good light' (ibid., I, p.105) at the Academy. It there attracted the attention of Dante Gabriel Rossetti, who was probably struck by Hunt's use of purple in Madeline's robe as well as by the Keatsian theme. Rossetti had just illustrated Keats' 'La Belle Dame sans Merci' (Surtees No.32) for the Cyclographic Society, and although Hunt was a member of this sketching club, it was only after Rossetti viewed No.9 at the Royal Academy that the two men became close friends.

Hunt contacted Charles Bridger, a friend of F.G. Stephens who had watched the artist paint No.9, as a potential purchaser of the work, when he learnt that Bridger had won £60 in the 1848 Art-Union lottery. In June Bridger was prevailed upon to select Hunt's painting as his prize, and No.9 was exhibited at the Art-Union premises at the close of the Royal Academy (*Catalogue of Pictures, &c., selected by the prizeholders in the Art-Union of London*, 1848, No.60).

<div align="right">J.B.</div>

JOHN EVERETT MILLAIS

10 **Cymon and Iphigenia** 1848
Inscribed 'JEMillais' (initials in monogram)
Oil on canvas, 45 × 58 (114.3 × 147.3)
Ref: R.A. 1967 (8)
The Right Hon. The Viscount Leverhulme

The subject is from a story in Boccaccio's *Decameron*. Cymon, a handsome swain but coarse and ignorant, falls for the beautiful maiden Iphigenia and eventually marries her. Through love he is transformed into an accomplished and polished gallant. No.10 shows a moment some time before this has happened. It is based on the following lines from Dryden's translation:

> Then Cymon first his rustick Voice essay'd,
> With proffer'd Service to the parting Maid
> To see her safe; his Hand she long deny'd,
> But took at length, asham'd of such a Guide;
> So Cymon led her home . . .

The story had been painted by Rubens, Lely, Reynolds and many other artists, although the episode normally represented is that of Cymon's first sight of Iphigenia lying asleep. Stylistically, Millais' picture is an imitation, one is tempted to say parody, of the work of the most respected British figure-painter of the day, William Etty.

According to Holman Hunt, the composition was drawn in and some of the heads finished by mid-February 1848. Hunt painted some of the draperies in return for Millais' contributions to 'The Eve of St. Agnes' (No.9) and the work was submitted for the R.A. exhibition at the beginning of April. It was rejected, Hunt says because it was unfinished (Hunt 1905, I, pp.81, 99, 105).

It was bought from the artist in 1849 by the Oxford collector and dealer James Wyatt (see No.28) for £60. J.G. Millais states that Millais suggested altering it in 1852 and Wyatt allowed him to repaint the sky and retouch some of the foliage and draperies (I, p.42). There are certainly areas, in particular the foreground foliage, that show a degree of detail more characteristic of that later date than 1848.

An oil sketch is in the collection of Mr and Mrs D.L.T. Oppé.

<div align="right">M.W.</div>

10

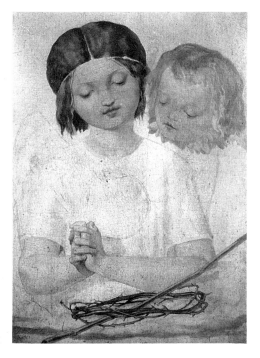

11

DANTE GABRIEL ROSSETTI

11 **Cherub Angels Watching the Crown of Thorns** 1848
Oil on canvas (mounted on panel?),
$19\frac{1}{2} \times 13\frac{1}{2}$ (49.5 × 34.3)
Ref: R.A. 1973 (35); Grieve 1973, p.2
Mrs Jane Elliott

During the spring and early summer of 1848 Rossetti studied oil painting under Madox Brown. No.11 is a copy made then of an untraced painting by Madox Brown titled 'Seraphs' Watch', perhaps the same as 'A Reminiscence of the Early Masters' (B.I. 1847, No.447) which Rossetti mentions in his letter of March 1848 to Brown requesting tuition. Although according to Hueffer (p.43), Brown's picture predated his visit to Rome of 1845, it would seem more likely that it reflected his studies of early Renaissance paintings and of Nazarene ideas made then. Of Brown's surviving works No.11 can best be compared with 'Oure Ladye of Good Children' (No.156). In its archaism, light tonality and religious subject matter, No.11 looks ahead to Rossetti's first major oils, 'The Girlhood of Mary Virgin' and 'Ecce Ancilla Domini!' (Nos 15, 22).

A.G.

[59]

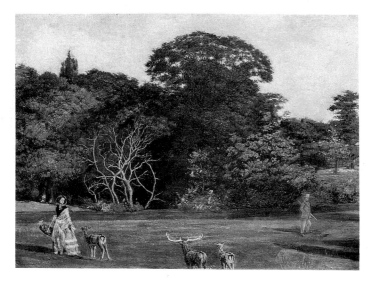

12

WILLIAM HOLMAN HUNT

12 Love at First Sight (Blackheath Park) 1848
Oil on canvas, 9 × 11¼ (23 × 28.5)
Ref: Liverpool 1969 (13)
Makins Collection

A label on the verso, probably written by Edith Holman-Hunt, reads '"Love at First Sight". Study made in Blackheath Park for a picture he intended to paint. W. Holman Hunt. Sept. 1848'. In his autobiography, Hunt dates the Blackheath sketching expedition, on which he was accompanied by D.G. Rossetti, to August 1848, just before Rossetti began sharing a studio with Hunt in Cleveland Street (Hunt 1905, I, p.114). Fired with Ruskinian principles, Hunt probably painted only the landscape on this occasion, using a brighter palette than that of 'The Church at Ewell' (No.4) of the previous year.

There are three pencil studies for the deer, two in the collection of the late Stanley Pollitt, and a third, inscribed with colour notes, in the collection of Mrs Burt (exh. Liverpool 1969, No.108). This depicts the deer in their final poses, but stylistically belongs to a later period than that of August 1848. The figures, too, are probably afterthoughts, adding narrative content to what is essentially a transcript from nature. According to the artist's daughter, these were not studied from live models (typescript, PC, p.81). The man, in particular, bears little relation to the rest of the painting, and was substituted for an unfinished figure after No.12 was photographed for inclusion in Hunt's memoirs (repr. 1905, I, p.117). The picture is there entitled 'Blackheath Park', and was probably called 'Love at First Sight' by the artist's widow.

The landscape of No.12 was used for the central portion of the background of 'A Converted British Family' (No.25), but it seems unlikely that No.12 was painted for this purpose, as it antedates the commencement of the larger picture by nine or ten months.

J.B.

FORD MADOX BROWN

13 Windermere 1848, 1854–5
Inscribed 'F.MADOX.BROWN.WINDERMERE.1855.'
Oil on canvas, oval, 6⅞ × 18⅞ (17.5 × 48)
First exh: Manchester Royal Institution 1855 (470)
Ref: Liverpool 1964 (18)
*Merseyside County Council, Lady Lever Art Gallery,
Port Sunlight*

The view is south from the head of the lake from a position above the Roman fort by Waterhead, with Brathay Neck running down below an outcrop on the right with Scalehead Claife beyond, Holme Crag islet off shore slightly to left of centre in the lake and Bowness on the far distant shore, centre, below Brant Fell (the position pin-pointed by the Director, Brathay Centre for Exploration and Field Studies, 1983).

No.13 is the artist's second known landscape from nature, following the now lost 'Southend' sketch of 1846. With his friend and fellow artist Charles Lucy (1814–73) he visited the Lake District for a short walking tour late in September 1848, taking in the Manchester Institution exhibition on the way and the Liverpool Academy on the return journey. Now acquainted with Rossetti and having just met Holman Hunt, his own enthusiasm for outdoor effects of light, tentatively tried out earlier in the Paris days, may have been rekindled by them during a period of despondency in attempting to compose a new design.

It was begun as a sketch on the spot: '6 days at about 4 hours a day. Last day in the rain under an umbrella', he recorded in his diary for 25 September. Charles Lucy must have been painting by his side as he exhibited a sketch of this view 'from below Lough' in 1851.

He touched at its sky in the studio after his return but dropped it to produce a 'finished' version to send to the R.A. (where it failed to get in). Both pictures were reworked in 1854, in Madox Brown's usual fashion in improving pictures he still had by him. He also made a lithograph, apparently from the original sketch. The finished picture was then sold to his dealer D.T. White and thence went to B.G. Windus of Tottenham (destroyed 1939–45 War). A later replica dates from 1859–61 (William Morris Gallery) and looks like the lithograph with an added rainbow and using the same oblong form with curved corners.

The alterations to the present sketch in 1854 and between March and July 1855 to make it 'into a picture' were radical. In August 1854 he worked at the 'sky & all over', while in March 1855 when arranging a frame for it he noted that he intended to cut it down 'like the other Windus has'. It must originally have been much bigger for the oblong canvas under the narrow oval mount is cut off along the top and right edges, eliminating part of the sky and much of the bank of trees at the right, visible in the other versions. His framemaker cut the oval flat wrong and he was 'at a loss whether to use it or not' and had the stretcher cut smaller. This error may have led to retouchings in the points of the oval (the frame itself uses a lozenge and circle repeat motif which appears on several of his pictures). He finished it in a long day's session on 21 July 1855 for the Manchester exhibition. He makes it clear in his 1865 catalogue that he considered it a study from nature 'Made into a picture and the cattle added in 1854'. He gave it to J.P. Seddon, brother of Thomas Seddon, in part exchange for 'King Lear' (No.16).

The simple lowering sky must date from 1854–5 and virtually eliminates the elaborate stormy effect with curving banks of clouds seen in the extant versions, which, as Staley

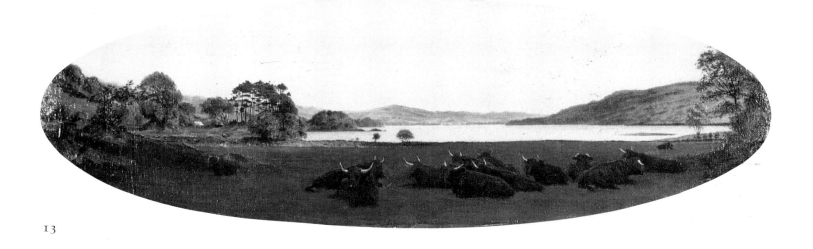

13

points out (pp.32–3), seems to indicate an initially romantic approach to stormy scenery within the English landscape tradition, which the conventional planning of the landscape itself certainly follows. However, with the lithograph as our only present evidence, and itself incorporating the cattle which were only composed in 1854, the date for the original conception of the sky must be uncertain: undoubtedly it anticipated the varied cloud and lighting effects which Holman Hunt was to tackle.

In the picture as it now is, the sky reflects much more subtly the wet weather which the artist encountered on his original trip. Most of the bank of trees at the right which balanced the over-busy sky is cut off here as no longer necessary. The eye is now drawn into the picture by the narrow oval of the mount which creates a balance between the overcast sky and dense green verge with the shadowy cows at rest as we now see the picture. Its tranquil mood is closer to the little 'natural' landscapes of 'The Brent' and 'Carrying Corn' (Nos 60–61) which, as Staley emphasises, immediately follow the repainting of 1854.

M.B.

14

JOHN EVERETT MILLAIS

14 **William Hugh Fenn** 1848
Inscribed 'JEMillais' (initials in monogram)
Oil on panel, 12 × 10 (30.5 × 25.4)
First exh: *The Collected Work of John Everett Millais*,
Fine Art Society, 1881 (1)
Owens Art Gallery, Sackville, New Brunswick, Canada

According to Holman Hunt, Millais painted No.14 just before beginning work on 'Isabella' (No.18) in late October 1848 (Hunt 1905, I, p.157). If this is correct, it is the first painting any of the Pre-Raphaelites produced after the foundation of the Brotherhood. Like the portrait of James Wyatt that Millais painted the following year (No.28), it is highly detailed and suggests a direct, particularising approach to the sitter's features. Hunt compares it with Van Eyck and Holbein.

The artist knew Fenn through his son, William Wilthew Fenn, a friend and fellow member of the 'H.B.'s' sketching club, which was a forerunner of the Cyclographic Society and the

P.R.B. itself. W.W. Fenn later became a writer and contributed a couple of articles on Millais to *Chambers's Journal*, 'Memories of Millais' (IV, 1901, pp.833–7) and 'Millais and Music: Some More Memories' (V, 1902, pp.822–5).

The father was Treasurer at Covent Garden and would often get Millais free tickets to the opera – from which he was later to derive the subjects of some of his pictures (see Nos 41, 46, 70). He used occasionally to rent a cottage at North End in Hampstead and it was probably while staying with him in 1848 that Millais painted the Hampstead view now in the Holt Bequest, Sudley, Liverpool (exh. R.A. 1967, No.9). No.14 may also have been executed in Hampstead at about the same time. According to Spielmann (p.71), Millais painted it on condition that an earlier portrait he had made of Fenn, presumably in an embarrassingly un-Pre-Raphaelite style, be destroyed. Fenn also sat to Millais as the model for the man peeling an apple, third from the back on the right side of the table, in 'Isabella'.

M.W.

SECTION II 1849-1850

The first paintings bearing the P.R.B. monogram were exhibited in 1849, by Rossetti at the Free Institution, Hyde Park Corner (No.15) and by Hunt and Millais at the R.A. (Nos 17–18); they were generally well received. By May of the following year, however – by which time four issues of a P.R.B. magazine, *The Germ*, had been published – the meaning of the secret initials became public, suggesting to some the existence of a subversive, possibly Romanist organisation. The exhibits of 1850 (Nos 22–7 particularly) were savaged by the press, Millais' 'Christ in the Carpenter's Shop' (No.26) being especially vilified for its supposed blasphemy. Collinson resigned from the P.R.B. in May but the movement had already attracted followers: Deverell and Collins both exhibited Pre-Raphaelite pictures in 1850 (Nos 23, 27) and Deverell was proposed for membership of the Brotherhood that year.

opposite John Everett Millais, 'Isabella', 1848–9 (detail, No.18)

15

DANTE GABRIEL ROSSETTI

15 The Girlhood of Mary Virgin 1848–9
Inscribed 'DANTE GABRIELE ROSSETTI|P.R.B. 1849'
Oil on canvas, $32\frac{3}{4} \times 25\frac{3}{4}$ (83.2×65.4)
First exh: Free Exhibition 1849 (368)
Ref: Surtees No.40; Grieve 1973, section I
Tate Gallery

Rossetti's first major oil and the first picture to be exhibited bearing the initials 'P.R.B.'. It must have been composed during the early summer of 1848 and in August nude studies and a colour sketch were made. Work proceeded slowly. By mid-November Rossetti had only painted the background and parts of the Virgin, for whom his sister Christina sat. St Anne's head was painted later that month from his mother. William Bell Scott saw Rossetti working on the picture and records: 'He was painting in oils with water-colour brushes, as thinly as in water-colour, on canvas which he had primed with white till the surface was as smooth as cardboard, and every tint remained transparent' (Scott, I, p.250). In this technique Rossetti was emulating the methods of the 'primitives' as described by authorities such as Eastlake. Madox Brown's 'Wycliffe reading his Translation of the Bible' (No.8), sent to the Free Exhibition in April 1848, must also have been influential.

Following Brown's example, Rossetti sent 'The Girlhood . . .' to the juryless Free Exhibition which opened on 24 March 1849. It was well received there and sold for 80 gns to a family acquaintance, the Dowager Marchioness of Bath. Before being sent off to her on 25 July 1849, the dress of the Virgin and the Angel's face were reworked. The picture was again in Rossetti's hands in the mid-1860s when he altered the Angel's wings from white to deep pink and the Virgin's sleeves from yellow to brown. He also reframed it then, changing what had been a frame with curved top corners to a rectangular design of the type he had evolved with Madox Brown earlier that decade. The picture was therefore originally more archaic in appearance. The gilt details in the Tri-point on the red cloth, the haloes, the Virgin's hair and the star above the Angel's head, must have been brighter.

On the original frame Rossetti had inscribed his sonnet explaining the symbolism, while a second sonnet, referring more generally to the picture's subject, was printed in the catalogue of the Free Exhibition. Both sonnets are inscribed at the bottom of the present frame:

I

This is that blessed Mary, pre-elect
God's Virgin. Gone is a great while, and she
Was young in Nazareth of Galilee.
Her kin she cherished with devout respect:
Her gifts were simpleness of intellect
And supreme patience. From her mother's knee
Faithful and hopeful; wise in charity
Strong in grave peace; in duty circumspect.
So held she through her girlhood; as it were
An angel-watered lily, that near God
Grows, and is quiet. Till one dawn, at home,
She woke in her white bed, and had no fear
At all, – yet wept till sunshine, and felt awed;
Because the fulness of the time was come.

II

These are the symbols. On that cloth of red
I' the centre, is the Tripoint, – perfect each
Except the second of its points, to teach
That Christ is not yet born. The books (whose head
Is golden Charity, as Paul hath said)
Those virtues are wherein the soul is rich:
Therefore on them the lily standeth, which
Is Innocence, being interpreted.
The seven-thorned briar and the palm seven-leaved
Are her great sorrows and her great reward.
Until the time be full, the Holy One
Abides without. She soon shall have achieved
Her perfect purity: yea, God the Lord
Shall soon vouchsafe His Son to be her Son.

Rossetti's use of symbols is much more elaborate and comprehensive than in contemporary pictures by his friends. The books representing the virtues are coloured symbolically. The lamp is an emblem of piety, the rose is the flower of the Madonna. The vine refers to the coming of Christ and the red cloth, embroidered with the Tri-point, beneath the cross-shaped trellis, symbolizes His robe at the Passion. The palm and thorn branches prefigure the seven joys and sorrows of the Virgin. The inscription on these branches is in Latin, as are the titles on the books, the names on the haloes and the exhortation on the portative organ.

Rossetti stressed that the picture 'was a symbol of female excellence. The Virgin being taken as its highest type' (BL). He also emphasised that its subject was historically realistic and that the Virgin probably was educated in tasks of the kind she is shown performing. But it also has strong contemporary relevance and must have been inspired by the High Anglican religious beliefs of his mother and his sisters. Its symbols resemble those being introduced in the furnishings of the ritualist churches in which they worshipped – stone altars decked with particular flowers, coloured frontals, lamps, a crucifix, latin mottoes, organ music, embroidered vestments. The picture smacks of Mariolatry. Rossetti had written a hymn to the Virgin before, in 1847, 'Mater Pulchrae Delectionis', and episodes from her life were to form the subjects of his next oil and of several drawings and watercolours made in the next few years.

A.G.

FORD MADOX BROWN

16 **King Lear** 1848–9, 1853–4
Inscribed 'F. Madox Brown'
Oil on canvas, arched top, 28 × 39 (71 × 99)
First exh: Free Exhibition 1849 (82)
Ref: Liverpool 1964 (20)
Tate Gallery

The tragedy of *King Lear* was an obsessive theme for Madox Brown. This is the first of three paintings (see also No.239) which stem from a series of robust and vivid pen and ink sketches illustrating the play, made in 1843–4 during his sojourn in Paris, and which reflected on the one hand the Shakespearian and early British historical themes set for the Houses of Parliament Competitions, and on the other, the artist's response to French and Continental illustration.

On 2 May 1848, free of 'Wycliffe' (No.8), his diary records that he visited the new R.A. exhibition and in the evening saw William Charles Macready in his production of *King Lear*. Its barbaric splendour may have recalled to mind those early sketches and influenced his next choice of this subject, which was taken up in November.

No.16 illustrates Act IV, Scene vii, Cordelia's tent in the French camp at Dover, the moment before the king's awakening as the physician cries, 'Louder the music there!' and she exclaims: 'Had you not been their father, these white flakes | Had challeng'd pity of them . . .'. Now, with the experience of 'Chaucer' and 'Wycliffe' in his new 'English' realistic style, this is a much more mature and subtle approach to dramatic expression than the Paris sketches. While effectively echoing the marked horizontality of the comparable pen and ink sketch of 'Lear's awakening' (Birmingham City Art Gallery, 757'06), in the recumbent pose of Lear and the kneeling Cordelia, here their poses perfectly suggest the exhausted sleep of age and the pitying onlooker just come to rest. The standard frontal stage setting, current in the artist's day and evident in the sketches (and perhaps confirmed by seeing the play itself), is organised into a many-angled tent, its shape reinforced by the shallow arch of the frame. The uneasy isolation and stillness of the foreground figures is underlined by the contrasting movement and music beyond the confining half-screen. The storm-lit brilliance of the seashore seen through the opening re-emphasises the claustrophobic interior with its diffused lighting. While a simpler use of stage setting with back opening appears in some of the Paris sketches, the idea may have been suggested or confirmed by sight of Holman Hunt's 'Eve of St Agnes' (No.9) at the 1848 R.A. Similarly also, this is on a more domestic scale than Madox Brown's earlier works.

Following the usual preliminary oil sketch, the painting was begun in December and finished in March 1849. The diary records his work on it section by section and his models: his favourite Maitland for the soldiers at the right; the head of Lear 'from a cast of Dante's and a drawing of Coulton' (this may be the highly finished 1847 study made for the head of 'Wycliffe', Birmingham City Art Gallery, 670'06); the jester was from Dante Gabriel Rossetti, who had become his pupil and friend in March 1848, and was painted in on 1 March 1849 with the hands from the model Mrs Ashley. The head of Cordelia as it finally appears after several retouchings, is close to a pencil study dated 'Xmas 48' of Emma (Birmingham, 789'06), later his wife, and who first entered his life at this time. For the costume he noted in his 1865 catalogue that he had 'chosen to be in harmony with the mental characteristics of Shakespear's work, and have therefore adopted the costume prevalent in Europe about the sixth century, when paganism was still rife,

and deeds were at their darkest'.

He again hung it at the Free Exhibition where it got an even better press than 'Wycliffe'. The *Athenaeum* (31 March 1849) in a long notice on the exhibition thought it one 'Of the many works which have pretension, in poetry or history, and of the few which can boast success', adding: 'On former occasions we have had to speak of this artist in terms of praise: this year he unites to technical merits a power of pathos without which the subject might have degenerated into either the maudlin or the commonplace. Mr. Brown has avoided both extremes; and has, notwithstanding a certain formality, realised an affecting picture'. The *Art Journal* distinguished it along with Rossetti's 'Girlhood of Mary Virgin' (No.15) as amongst a group of the most excellent on show. It remained unsold.

Madox Brown retouched it and altered Cordelia's head and figure, which had been criticised as wanting in dignity. It was again marked out for special attention at Antwerp in 1852 as part of a group from invited British artists. He afterwards put in between four and eight months work on it in 1853–4. The greater solidity of the figures and depth of colour may date from this period. It was included in his desperate attempt to sell some of his pictures in a disastrous auction in July 1854, when it was bought by John Seddon the architect for 15 gns. It went with the English exhibition to America in 1857–8 where it was reported to William Rossetti as the 'most popular picture of the Exhibition' (W. M. Rossetti 1899, p.185).

The artist got it back from Seddon and in 1858 sold it to T.E. Plint, who characteristically asked him to look it over; he did not like the queen's veil, nor the 'want of embroidery' about the doctor (FMBP). Plint sold it to James Leathart in 1860 and in 1863 it was re-framed by Joseph Green. 'The frame is a combination and rearrangement of one I designed with Rossetti's thumb-mark pattern', he wrote to Leathart in January and added in a later letter, 'I had told Green to employ all or any of my patterns, as it might spread a taste for a different kind of thing from the debased article now in use'. He had again retouched Cordelia: 'what I have done to the face is of course very infinitesimal in material alteration, but by adding a line to the chin taking somewhat from the smile of the mouth, and elevating a point of the eyebrow I think I have diminished the somewhat too girlish quality of the face' (UBC/LP).

At his 1865 exhibition the *Art Journal* commented: 'Mr. Brown considers it one of his best works. We agree with him, and go further than he does; it is his most complete picture . . . When it was first exhibited the impression it gave was that which he has since admitted, otherwise he would not have acted upon it. He felt that it wanted softness and combination, and he has very wisely retouched it'.

It remained with Leathart, who kept his collection almost intact until his death (1897), and later belonged to George Rae, whose executors sold it to the Tate Gallery, 1916.

M.B.

WILLIAM HOLMAN HUNT

17 **Rienzi Vowing to Obtain Justice for the Death of his Young Brother, Slain in a Skirmish between the Colonna and Orsini Factions** 1848–9, retouched 1886
Inscribed 'WILLIAM HOLMAN HUNT | P-RB 1849'
Oil on canvas, 34 × 48 (86.3 × 122)
First exh: R.A. 1849 (324)
Ref: Liverpool 1969 (12)
Private Collection

Hunt's first picture to be exhibited bearing the initials 'PRB' appeared at the 1849 Royal Academy accompanied by the following quotation from Bulwer Lytton's novel *Rienzi, the Last of the Tribunes*:

> But for that event, the future liberator of Rome might have been but a dreamer, a scholar, a poet – the peaceful rival of Petrarch – a man of thoughts, not deeds. But from that time, all his faculties, energies, fancies, genius, became concentrated to a single point; and patriotism, before a vision, leaped into the life and vigour of a passion.

A second edition of the novel had been published in 1848, with a preface stressing the influence the book had had on nationalist movements in Italy. Hunt began No.17 in summer 1848, after witnessing the great Chartist meeting on Kennington Common, and it was conceived not only as a reflection of the populist-inspired events of 1848 but as a revolutionary painting in terms of rejection of conventional artistic practice. Inspired by 'the address of Oceanus in Keats's *Hyperion*', on which Hunt based a progressive theory of the history of art (1905, I, p.87), as well as by his reading of *Modern Painters*, No.17 was planned as 'an out-of-door picture, with a foreground and background, abjuring altogether brown foliage, smoky clouds, and dark corners, painting the whole out of doors, direct on the canvas itself, with every detail I can see, and with the sunlight brightness of the day itself' (ibid., I, p.91).

Pre-Raphaelitism charts the progress of No.17, stressing the plein-air elements, and stating that while much of the landscape was painted on Hampstead Heath, the fig tree in the left middleground was painted in the summer of 1848 in the Lambeth garden of Septimus Stephens (1905, I, p.111). The foreground detail Hunt recalled in 1905 partly disappeared when No.17 was restored by the artist in 1886 (ibid., I, p.183 n.2). The sky and some of the costumes were also affected, but not the figures.

Hunt never envisaged painting these out-of-doors at the same time as the landscape, and made careful studies from the life for the seated soldiers (Ashmolean Museum, exh. Liverpool 1969, No.103; and untraced, repr. *Magazine of Art* 1891, p.84); the dead boy (Coll. Mrs Burt, exh. 1969, No.102); the

17
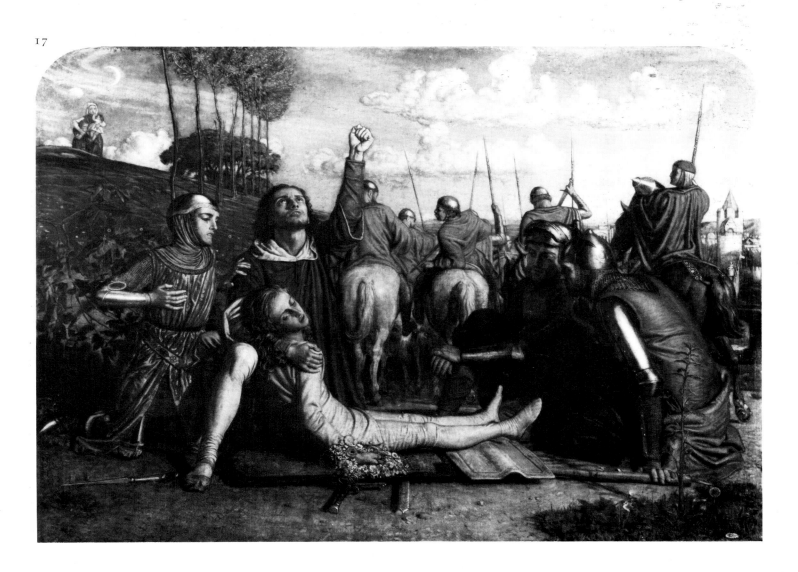

figure of Adrian di Castello at the far left (Coll. of the late Stanley Pollitt); two of the horsemen (Coll. Mrs Burt, exh. 1969, No.104; and untraced, repr. *Magazine of Art* 1891, p.81); and two of the horses (Coll. Mrs Burt, exh. 1969, No.106), the latter lent by his friend John Blount Price. Hunt followed current academic practice in making a study for the left hand of Adrian di Castello (Coll. Mrs Burt, ibid., No.105), as well as a careful cross-hatched drawing of Rienzi's foreshortened right leg (untraced, repr. *Magazine of Art* 1891, p.85), the pose of which may have been influenced by Millais' lunette 'Manhood' of 1847–8 (Leeds City Art Gallery, exh. R.A. 1967, No.12). The working out of these drawings affected Hunt's original conception, as a compositional study of the left-hand side of 'Rienzi', in which the heads of the principal figures are erased, demonstrates (Coll. Mrs Burt, exh. 1969, No.101). There are studies from Millais for the head of Adrian di Castello, monogrammed and dated 1848 (private collection, ibid., No.107), and from D.G. Rossetti for Rienzi, in the final pose, in the collection of Mrs Dennis. Rossetti had superseded an earlier model; his brother was to replace Millais as the model for Adrian (Hunt 1913, I, p.100). Fittingly, three members of the Pre-Raphaelite Brotherhood modelled for a painting conceived by a fourth as a revolutionary work.

The title Hunt gave No.17 sums up the gist of the first chapter of Lytton's novel, while the tragic nature of the death of Rienzi's brother is reinforced by the poignant juxtaposition of sword-hilt and lovingly observed garland of flowers. It is possible that these were selected for their emblematic qualities, which would have been apparent to contemporary viewers. In Greek legend Hyacinthus was killed accidentally by Apollo and out of his blood grew the flower called *hyacinthos*. The blue hyacinth thus became an emblem of grief or sorrow. Similarly, the anemone was said to have sprung from the blood of Adonis, slain by a wild boar. While the hyacinth and anenome comment on the boy's violent death, daisies and blue violets, according to a Victorian lexicon of the language of flowers, denote 'innocence' and 'faithfulness'. The former reflects the youth of the murdered boy, while Rienzi's vow is the means by which he will remain faithful to his brother's memory. The dandelion, glossed as 'oracle', is appropriate to the moment of revelation No.17 dramatises.

A feature such as the garland led the critic of the *Athenaeum* of 2 June 1849 to castigate Hunt and Millais (in No.18) for perpetrating the sort of archaism found 'in the mediaeval illumination of the chronicle or the romance' (p.575). Far from applauding Hunt for suiting his style – in, for example, the awkward pose of the dead boy – to the fourteenth-century subject matter, No.17 was accused of affectation. The work's indebtedness, in terms of colour, to the Venetians, in particular Titian, was overlooked. The critics paid tribute to Hunt's (misdirected) artistic abilities, but No.17 returned from the Academy in August unsold.

Bulwer Lytton, however, congratulated Hunt on producing a work 'full of genius – & high promise' (n.d., 1849, JRL), and Augustus Egg much admired it. On 7 August 1849 he wrote to Hunt, arranging to call on him the next day (HL), when he viewed No.17 in Hunt's studio. He suggested altering the colour of Rienzi's robe (which Hunt, following the description in Lytton's novel, had painted grey) so as to distinguish it from the colour of the horses (Hunt 1863, p.558), and ascertained that the price of No.17 was £100. He then arranged for its sale to John Gibbons, handing over 100 gns (£5 for the frame) to Hunt on 14 August (Fredeman, p.10 where, however, W.M. Rossetti gives the price as 160 gns). Before sending No.17 to the purchaser on 27 August, Hunt, according to the P.R.B.

Journal of 24 August, 'put into his picture the figures of a [mother and children coming over the top] of the hill, on which he has painted various buttercups and dandelion puffs. He has painted up the sky, put a plume onto the casque of one of the troopers, etc.' (Fredeman, p.12).

The disproportionate group in the upper left-hand corner may have been intended to balance the composition and to lead the viewer's eye down towards the central trio. Without it, the seated soldiers on the right are thrown into prominence. The presence of the distressed children reminds the spectator of the youth and innocence of the dead boy, while the emphasis on maternity and the placing of the moon above the woman's head evokes associations with the Virgin Mary. This ties in with the *pietà*-type pose of the brothers, which, together with the figures of the watching soldiers, suggests that Hunt viewed Rienzi as a type of the Saviour. The presence of the new moon symbolises the dawning of the new era which is ushered in by Rienzi's oath.

J.B.

JOHN EVERETT MILLAIS

18 **Isabella** 1848–9
Inscribed 'J E Millais 1849 PRB [in monogram]'
Oil on canvas, 40½ × 56¼ (102.9 × 142.9)
First exh: R.A. 1849 (311)
Ref: R.A. 1967 (18)
Merseyside County Council, Walker Art Gallery, Liverpool

The first exhibition picture Millais painted after the formation of the Pre-Raphaelite Brotherhood, his allegiance to which is proclaimed by the initials 'PRB', both after the signature and date, and on the carved bench-end in the lower right corner.

Like 'Cymon and Iphigenia' (No.10), 'Isabella' is based on a story by Boccaccio, as retold in Keats' 'Isabella; or, The Pot of Basil'. Isabella falls in love with Lorenzo, an employee in her brothers' business. Having hoped she would make a profitable marriage, the brothers are incensed. They murder Lorenzo, bury him in a forest and tell Isabella that he has been sent away on some urgent affairs. Lorenzo's ghost appears to Isabella to reveal his true fate, she exhumes the body and cuts off the head, which she keeps in a garden pot covered with basil. The brothers finally discover and steal it, then flee. Isabella dies brokenhearted. No.18 shows an early scene from the story. The catalogue of the 1849 R.A. exhibition gave the following extracts from the poem:

Fair Isabel, poor simple Isabel!
Lorenzo, a young palmer in Love's eye!
They could not in the self-same mansion dwell
Without some stir of heart, some malady;
They could not sit at meals but feel how well
It soothed each to be the other by . . .

These brethren having found by many signs
What love Lorenzo for their sister had,
And how she loved him too, each unconfines
His bitter thoughts to other, well nigh mad
That he, the servant of their trade designs,
Should in their sister's love be blithe and glad,
When 'twas their plan to coax her by degrees
To some high noble and his olive-trees.

Isabella and Lorenzo are sharing a blood-orange. The majolica plate in front of them on the table shows a beheading scene, David and Goliath or possibly Judith and Holofernes, a biblical

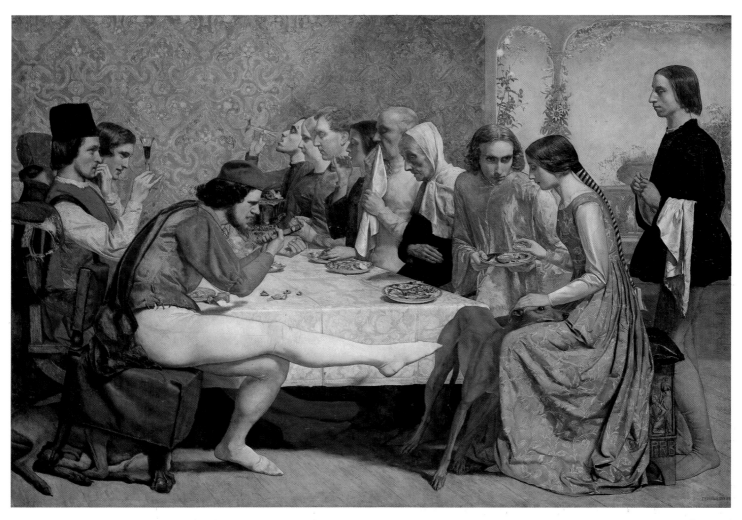

18

parallel to Isabella's removing the head of Lorenzo. Behind the lovers, on the balcony, are two passion flowers and some ominous garden pots. The hawk tearing at a white feather on the left is an image of the brothers' rapacity derived from Keats, who calls them 'the hawks of ship-mast forests'. The bench-end carving may show an 'Adoration of the Shepherds' or some pilgrims, which would connect with the image of Lorenzo as 'a young palmer in Love's eye'.

No.18 is closely based on a drawing of this subject Millais made in the summer of 1848 towards a projected series of illustrations to Keats undertaken jointly with Holman Hunt (see No.163). According to Hunt, the painting was begun towards the end of October that year (Hunt 1905, I, pp.157–8). It was sent in finished for the R.A. exhibition in early April 1849 but some retouching was done after the exhibition was over. The P.R.B. Journal for 8 November 1849 notes that Millais has sent it off and been paid, 'having done what little the background etc. required' (Fredeman, p.24).

The costume and hairstyle of Isabella are derived from an illustration by Paul Mercuri in Camille Bonnard's *Costumes Historiques*, 1829–30, a copy of the figure of Beatrice d'Este from the Pala Sforzesca in the Brera, Milan. Millais had a number of tracings from Bonnard's book, probably made by his father. The one relating to 'Isabella' is now at the Walker Art Gallery. Others are in the collections of R.A. Cecil, E.G. Millais and Sir Ralph Millais. For a discussion of the importance of

Bonnard for the Pre-Raphaelites, see Roger Smith, 'Bonnard's *Costume Historique*, a Pre-Raphaelite Source Book', *Journal of the Costume Society*, VII, 1973, pp.28–37.

Accounts as to the identities of the models in No.18 vary considerably (see J.G. Millais, I, pp.26, 69, Spielmann, pp.84–5 and F.G. Stephens in the catalogue to the Millais exhibition at the Grosvenor Gallery in 1886) but the following seem most likely: F.G. Stephens for the brother on the left holding a glass (compare No.24), Walter Deverell sitting to his left and Jack Harris to his right, kicking the dog; D.G. Rossetti for the man at the back drinking; William Hugh Fenn for the man peeling an apple (compare No.14); the artist's father for the man with a napkin; William Michael Rossetti and perhaps partly Charles Compton for Lorenzo; Mary Hodgkinson, wife of the artist's half-brother Henry Hodgkinson, for Isabella; and either an architect called Wright or an R.A. student called A.F. Plass for the serving-man.

When first exhibited, the work was generally well received. Not surprisingly, reviewers praised its technique and the strong characterisation in the figures. Some commented on its 'Early Italian' qualities and the *Literary Gazette* called it 'a very clever copy of that ancient style', remarking that 'The absence of perspective and aerial distance is of a piece with the original school which is imitated, and the very formality of the impasting and distribution of the forms, carries us back to the period of aspiring but imperfect art' (9 June 1849, p.433).

In a letter to a Miss Sass of 10 July 1863 (formerly with Ian Hodgkins & Co.) Millais named the buyer of No. 18 as the dealer Richard Colls. According to Holman Hunt, however, it was bought by 'three Bond Street tailors' for £150 and a new suit (Hunt 1905, I, p.177). This suggests the involvement of William Wethered, a dealer who was also a tailor. Colls and Wethered had combined with Charles W. Wass to buy William Etty's 'Joan of Arc' triptych in 1847 and these three may be the partnership to which Hunt is referring. By the end of 1849 the picture had been bought by B.G. Windus, who was to become a leading Pre-Raphaelite collector and own a number of major works by Millais (see Nos 35, 37, 40, 41, 55, 78, 100).

The earlier drawing of the subject is at the Fitzwilliam Museum, Cambridge (exh. R.A. 1967, No. 230) and a sketch for it is at the British Museum (ibid., No. 229). There are studies for heads in the painting in Birmingham City Art Gallery (ibid., Nos 231–4) and the collection of the late Sir Edmund Bacon, Bt; an oil study for the figure of Isabella in the collection of Basil Gray and a sketch for the whole composition in the Makins Collection (ibid., No. 19). A watercolour study for the wall decoration, traced from a fabric design and squared up for transfer, is in the collection of Sir Ralph Millais, Bt. (ibid., No. 235) – it may have been made by Millais himself or equally for him by someone else, possibly his father. The watercolour of 'Isabella' in the Guildhall Art Gallery corresponds closely to the engraving by H. Bourne published in the *Art Journal* in 1882 (facing p.188) and is not, in the opinion of the compiler, an autograph work.

M.W.

19

WILLIAM HOLMAN HUNT

19 The Haunted Manor 1849–?56
Inscribed 'Whh 1849' (initials in monogram)
Oil on millboard stuck on panel,
$9\frac{1}{8} \times 13\frac{1}{4}$ (23.25 × 33.75)
First exh: L.A. 1856 (307)
Ref: Liverpool 1969 (7)
Tate Gallery

On 15 June 1849 Millais wrote to Hunt: 'I purpose going out sketching at Wimbledon with my brother on monday *we will* start very early I have not seen any [*sic*] of you for a tremendous time . . . Try and get brother Stephens to come with us you had better come and breakfast with me mind and come – . . . I suppose you have nearly completed your

Wimbledon sketch' (HL). This suggests a joint sketching expedition to Wimbledon prior to 15 June. Millais knew the area well, for on 15 May he had told W.M. Rossetti of a suitable site there for an illustration to Coventry Patmore's poem 'The Woodman's Daughter' (Fredeman, p.3). Whether or not Hunt did join Millais at Wimbledon on 18 June, the similarity between No. 19 and Millais' 'The Kingfisher's Haunt' (destroyed, repr. Staley, pl.19a) suggests that the two artists worked on their pictures side by side. Millais' painting was identified at John Miller's sale of 21 May 1858 (153) as 'A Study in Wimbledon Park', and this, together with Millais' reference to Hunt's 'Wimbledon study' in a letter of 1853 (see below), rules out Ewell as the location of No. 19, despite descriptive passages in Hunt's memoirs (1905, I, pp.71–2) which have prompted this identification.

On 30 April 1853 Hunt wrote to Combe that he had 'been engaged steadily' on a sketch for McCracken, for which he was to ask 50 gns (BL). On 2 April 1853 the Belfast patron, the owner of No. 36, had asked Hunt to arrange with D.G. Rossetti for 'the transmission of your own little work' (JRL), and a letter from Rossetti to Hunt of 11 May states that 'Green's man . . . will come to-morrow for M'C's picture' (ASU). No. 19 was sent off to McCracken with 'Ecce Ancilla Domini!' (No. 22), which had been purchased despite Rossetti's refusal to have it first vetted by Ruskin (Doughty & Wahl, I, p.133). Hunt, however, must have sent No. 19 on approval, for in June 1853 he was to write to Edward Lear in bitter condemnation of Ruskin, here aptly nicknamed 'the art-Warwick' (after the fifteenth-century Warwick 'the king-maker'): 'You know the little landscape. old McCracken had the impudence to refuse it – because the art-Warwick had seen it on the way and did not approve of the thing – I refused to let it be exhibited at Dublin as the Irishman desired but begged him to return it to me immediately – on the way however it was seen at Liverpool by Miller, who wrote to buy. which favor I expressed myself willing to confer – I suppose he has since heard Warwick's opinion for he has not availed himself of my permission – upon my word this "puller up. and setter down" takes a responsible position – I have seen him twice with the intention of bullying him but as his wife and mother were present could not get an opportunity. Supposing him to be right I can't always paint equally well nor can I afford to keep my less successful works' (JRL). Millais' letter to Hunt of early September 1853 identifies 'the little landscape' as No. 19: 'I wonder that you give McCracken any advice as he is a sneak after his behaviour to you about the Wimbledon study business and Ruskin's opinion regarding it' (HL).

It is significant that in this letter Millais does not call No. 19 'The Haunted Manor'. Although the foreground landscape can be dated 1849–53, the sunlit background, as Allen Staley has suggested (p.59), may be a later addition. The hayrick at upper left could date from Hunt's visit to Fairlight in July 1856 (see No. 52), while the house with its blazing windows, which gave rise to the title 'The Haunted Manor', may have been introduced in the hope that a certain narrative element would help the picture to sell at the forthcoming Liverpool Academy.

Hunt went up to Liverpool in September 1856, when, as F.M. Brown's diary reveals, he saw John Miller (Surtees 1981, pp.188–9). Although Miller did not change his mind about wishing to purchase the painting, which was then on show at the Liverpool Academy, he may have had a hand in its being sold to Mrs Wilson, to whom he was to write in 1857 requesting its loan to the Russell Place Pre-Raphaelite Exhibition (Hueffer, p.144, where erroneously identified as Peter Miller).

J.B.

20

FORD MADOX BROWN

20 The Medway Seen from Shorn Ridgway, Kent 1849,
1873
Inscribed on the back 'F.M.B. 49–73'
Oil on panel, 8 × 12 (20.2 × 30.5)
First exh: L.A. 1852 (538)
Ref: Liverpool 1964 (14)
Miss Sylvia Crawshay

The artist's diary for 2 July 1849 records: 'Set off to Shorn ridgway, found some fine scenery overlooking the Thames & Essex. Began a study of it for my background to Chaucer (3 hours)'. He had earlier that year finished a version of 'Windermere' intended for the Royal Academy (see No.13) and this summer, perhaps in emulation of Millais and Hunt, was also planning a landscape background. In his case it could not be painted directly on to the enormous canvas. He looked for his background, moreover, not around Sheen where he set 'Chaucer' but in his home territory of north Kent.

In 'Chaucer' (see No.7) the landscape appears at the top left beyond the curtain walls, and is reversed to bring the hill to the left, and a ploughing scene is added which gives it the flavour of early Flemish paintings.

This sketch was given to Thomas Seddon in 1851, 'he having kindly lent me money about this time' (Surtees 1981, p.74). The artist got it back from another source in 1873, when he informed Charles Howell, to whom he may have afterwards sold it, that he planned to retouch it (letter, Sotheby's sale 30 May 1961). The heavier technique of the foreground, including the beggar and the boy at the stile, is probably this later work, added to make it into a saleable picture.

M.B.

FORD MADOX BROWN

21 Lucy Madox Brown 1849
Oil on cardboard, 6¼ diameter (15.9)
Ref: Liverpool 1964 (17)
Private Collection

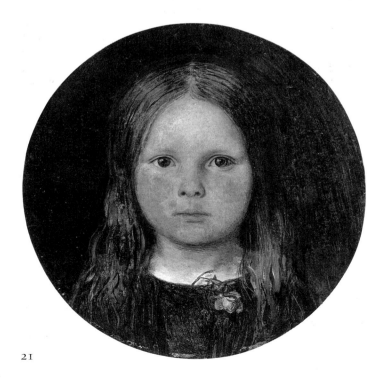

21

Daughter of the artist and his first wife Elizabeth, née Bromley, who was his first cousin. Lucy was born when they were living in Paris, 19 July 1843. When Madox Brown settled in England, after her mother's death, Lucy was put in the care of her aunt Helen Bromley who had a school at Gravesend. The artist records making several studies from her when he visited her there and he used two of them for the children in 'Wycliffe' (No.8) and in 'Chaucer' (No.7). This more finished portrait of her as a rosy cheeked, very natural child, with a rose in her dress, is probably that recorded in his diary for August–September 1849 when he 'went to Margate with my daughter & stayed there two weeks during [which time] had three sittings for her portrait (9 hours)'. She would then have been six.

Like her half-brother and sister, Lucy took up painting in her father's studio and exhibited from 1869 but virtually gave it up after her marriage to William Michael Rossetti in 1874. She died in 1894.

M.B.

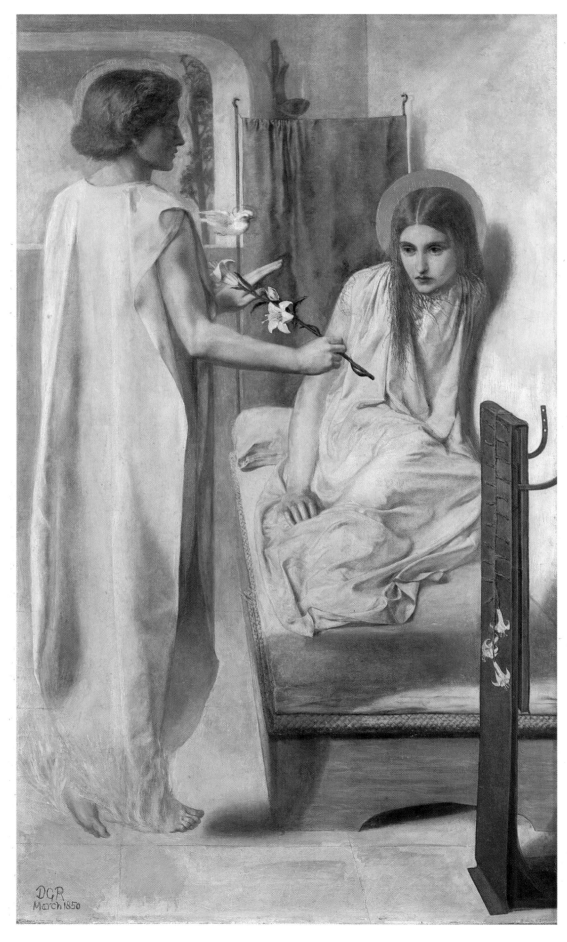

22

DANTE GABRIEL ROSSETTI

22 Ecce Ancilla Domini! 1849–50
Inscribed 'DGR|March 1850'
Oil on canvas mounted on panel,
$28\frac{7}{8} \times 16\frac{1}{2}$ (72.6 × 41.9)
First exh: National Institution 1850 (225)
Ref: Surtees No.44; Grieve 1973, section 2
Tate Gallery

The start of this picture was recorded by W.M. Rossetti on 25 November 1849: 'Gabriel began making a sketch for *The Annunciation*. The Virgin is to be in bed, but without any bedclothes on, an arrangement which may be justified in consideration of the hot climate, and the Angel Gabriel is to be presenting a lily to her. The picture, and its companion of the Virgin's Death, will be almost entirely white' (Fredeman, p.29). So the startling iconography, unusual because the Virgin is normally shown reading a missal at a *prie-dieu*, was established at the beginning. So was the idea of symbolising purity by using all white. And there was to be a companion picture, showing the Virgin's death, which was never begun but which partly helps to explain the tall narrow shape of No.22 for a diptych would have been almost square in format.

No doubt Rossetti was inspired by the 'primitive' pictures in several parts which he had seen on his visit to the Continent in the previous month. Triptychs of other subjects were planned at this time and he was attracted to compositions with more than one scene because they enabled him to depict more than one episode at a time. Sequential change was always one of his main concerns and is seen not only in the series of the Virgin's life planned now but also in his many Dante subjects and finally, in its most developed form, in his sonnet sequence *The House of Life*.

Work went ahead during the winter of 1849–50 with much hesitation. Several different models sat for the figures, including his brother for the Angel and his sister Christina for the Virgin. On 1 February 1850 the Virgin's drapery was finished and the Angel's on the twenty-second of this month when Rossetti also discussed with Madox Brown 'the background, the bed, and other accessories'. On 3 March Rossetti was looking for a red-haired woman for the Virgin. By using hair of this colour he was able to restrict his palette almost entirely to the primaries which he juxtaposes in the area of the picture around her head. By 29 March the embroidery stand, lamp and a vase, later removed, had been painted. Work continued, with Deverell's help, into the following month and the canvas must have gone wet to the National Institution which opened on 13 April. Interestingly, it hung in the same room as Deverell's 'Twelfth Night' (No.23) for which the red-haired Elizabeth Siddal had posed, as well as Rossetti himself, but he does not seem to have used her as a model for the Virgin. More reworking took place in the winter of 1850 when the picture was shown again at an exhibition organised by Thomas Seddon to raise money for the North London School of Design. It was sold two years later for the original asking price of £50 to Francis McCracken. Before it was sent to him, on 28 January 1853, the Angel's face was retouched again and a halo painted behind his head. In 1874 it was once more in Rossetti's hands when its frame was altered to the present one. The original frame evidently bore Latin mottoes, copies from a brass or brass-rubbing owned by F.G. Stephens, which were 'Popish' in sentiment. They must have increased the didactic quality of the picture.

The picture was harshly criticised partly because of its didacticism. For example, the *Athenaeum*'s critic wrote that it was: 'a work evidently thrust by the artist into the eye of the spectator more with the presumption of a teacher than in the modesty of a hopeful and true aspiration after excellence' (20 April 1850, p.424). Rossetti used white to suggest the purity of the Virgin. Blue is also associated with her and red with Christ. The vertical division of the space, made by the left side of the blue hanging and the edge of the bed, falls almost on the Golden Section. The dove, symbolising the Holy Spirit, and the lily, with one bud still to break, move across this division and are the instruments of conception. The division of space is also one of time, for Rossetti saw the Virgin, when she conceived Christ, as:

> Faith's Present, parting what had been
> From what began with her, and is for aye.
> (W.M. Rossetti 1911, p.166)

Possibly Rossetti added the unusually specific and at the same time inaccurate date of 'March' in the bottom left of the canvas because it is in that month that the Feast of the Immaculate Conception is held. William Rossetti justly remarked, in a review of 1 July 1850, that the picture was outstanding as a 'vehicle for representing ideas'. (S.N. Ghose, *D.G. Rossetti and Contemporary Criticism*, Dijon, 1929, pp.40–1).

A.G.

WALTER HOWELL DEVERELL

23 Twelfth Night 1849–50
Oil on canvas, $40\frac{1}{8} \times 52\frac{1}{4}$ (102 × 132.7)
First exh: National Institution 1850
FORBES Magazine Collection, New York

Deverell's first major work in the Pre-Raphaelite style, 'Twelfth Night' showed sufficient promise for him to be nominated (though never elected) as a member of the Brotherhood when Collinson resigned in May 1850. The subject is from Act II, Scene iv, of *Twelfth Night*. Duke Orsino, unrequited in his love for the lady Olivia, asks his clown Feste to sing the song 'Come away, come away, death'. Orsino is unaware that his page Cesario, seen here seated at the left, is Viola in disguise or that she is in love with him. Honeysuckle climbs the column behind Orsino while passion flowers entwine the stone tracery that runs between him and Viola.

Deverell painted Orsino from himself, Feste from Rossetti and Viola from Elizabeth Siddal, whose first appearance in a Pre-Raphaelite painting this was. The exact date of Deverell's famous discovery of Elizabeth Siddal in a milliner's shop is not recorded but it almost certainly took place late in 1849. Mary Lutyens (in *Pre-Raphaelite Papers*, Tate Gallery, 1984) has reasonably argued that a reference in the P.R.B. Journal to Rossetti having 'painted at the hair in Deverell's picture' on 14 December 1849 (Fredeman, p.31) is to his help with the head of Viola, i.e. Elizabeth Siddal, in 'Twelfth Night'. Hunt mentions the difficulty Deverell had with this figure: 'I got my mother', he reports Deverell as saying, 'to persuade the miraculous creature to sit for me for my Viola in "Twelfth Night," and today I have been trying to paint her; but I have made a mess of my beginning' (Hunt 1905, pp.198–9); according to Hunt, Rossetti went along the following day to Deverell's studio to see her.

The picture did not find a buyer when it was shown at the National Institution exhibition in May 1850. Francis McCracken, the Belfast shipping agent and Pre-Raphaelite enthusiast, tried to acquire it in March 1853 but offered

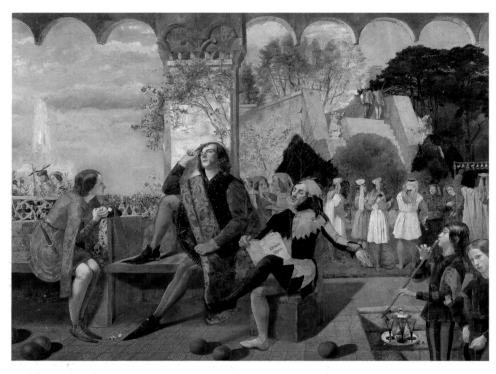

23

paintings by Danby, Herbert and Branwhite in part payment, an arrangement that did not appeal to Deverell (HL/Deverell Memoir, p.59). The painting was later in William Bell Scott's collection.

For a study for 'Twelfth Night', see No.166 below. Deverell also made an etching of 'Viola and Olivia' for the final issue of *The Germ*, published in May 1850.

L.P.

JOHN EVERETT MILLAIS

24 Ferdinand Lured by Ariel 1849–50
Inscribed 'JEMillais | 1849' (initials in monogram)
Oil on panel, 25½ × 20 (64.8 × 50.8)
First exh: R.A. 1850 (504)
Ref: R.A. 1967 (22)
Makins Collection

At the 1850 R.A. exhibition the work's title was accompanied in the catalogue by the following lines from Shakespeare's *The Tempest* (Act I, Scene ii):

Ferdinand Where should this music be? i' the air or the
 earth?
Ariel Full fathom five thy father lies;
 Of his bones are coral made;
 Those are pearls that were his eyes:
 Nothing of him that doth fade
 But doth suffer a sea-change
 Into something rich and strange.
 Sea nymphs hourly ring his knell.
 [*Burthen*, ding-dong.
 Hark! now I hear them, – Ding-dong, bell.

The sprite Ariel, servant to Prospero, leads Ferdinand to his master, teasing him with false news that his father, the King of Naples, has perished in the shipwreck that has landed them on Prospero's island. He is carried through the air by fantastic bats ('On the bat's back I do fly') and holds a sea-shell to illustrate his story.

No.24 was Millais' first major essay in outdoor Pre-Raphaelite painting. He executed most of the background during the summer of 1849 while staying with his old friend George Drury at Shotover Park, near Oxford. The panel is mentioned as having just been sent up to him 'the other day' in the P.R.B. Journal for 25 July (Fredeman, p.9). In an undated letter written from Shotover, presumably a few weeks later, he told Holman Hunt: 'The landscape I have painted in the Ferdinand for the name of an Artist is *ridiculously elaborate*. I think you will find it very minute, yet not near enough so for nature. To paint as it ought to be it would take me a month a weed – as it is, I have done every blade of grass and leaf distinct' (UBC).

Some time in September he left Shotover to stay for a while with James Wyatt in Oxford itself (see No.28). He came back to London with the background to No.24 virtually finished between 15 and 18 October.

Probably shortly after his return he painted Ferdinand's face, using F.G. Stephens as a model. According to the P.R.B. Journal he had been painting the beard from Stephens as early as 15 May (Fredeman, p.3) but Stephens' own account mentions only the later sittings: 'In the summer and autumn of 1849 he executed the whole of that wonderful background, the delightful figures of the elves and Ariel, and he sketched in the Prince himself. The whole was done upon a pure white ground, so as to obtain the greatest brilliancy of the pigments. Later on my turn came, and in one lengthy sitting Millais drew my most un-Ferdinand-like features with a pencil upon white paper, making, as it was, a most exquisite drawing of the highest finish and exact fidelity . . . My portrait was completely modelled in all respects of form and light and shade, so as to be a perfect study for the head thereafter to be painted. The day after it was executed Millais repeated the study in a less finished manner upon the panel, and on the day following that I went again to the studio in Gower Street, where "Isabella" and

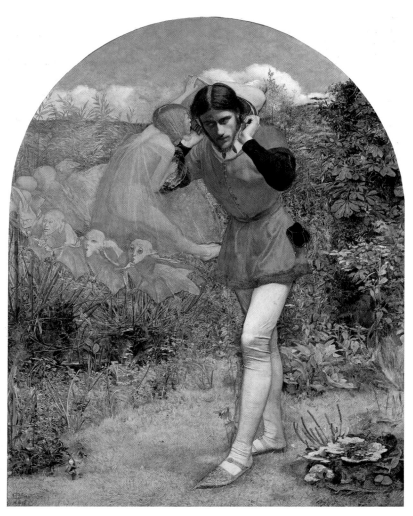

24

similar pictures were painted. From ten o'clock to nearly five the sitting continued without a stop, and with scarcely a word between the painter and his model. The clicking of his brushes when they were shifted in his palette, the sliding of his foot upon the easel, and an occasional sigh marked the hours, while, strained to the utmost, Millais worked this extraordinarily fine face. At last he said, "There, old fellow, it is done!" . . . Later the till then unpainted parts of the figure of Ferdinand were added from the model and a lay-figure' (J.G. Millais, I, pp.84–7).

The outfit and pose of the figure are taken from plate 6 of Camille Bonnard's *Costumes Historiques*, which is entitled 'Jeune Italien' and dated 1400. Millais had already used Bonnard as a source for 'Isabella' (No.18, q.v.). The P.R.B. Journal records his working on the fur trimming to Ferdinand's tunic on 8 and 9 November, the legs on 11 and 12 November and having finished the legs, feet, hat and a lizard in the lower right corner by 19 November. On 7 December the picture was 'not very far from finished', on 23 December Millais was at work on the bats and on 30 December he had finished 'all except some thing more he means to do to the background' (Fredeman, pp.24–6, 30, 36, 39). According to J.G. Millais he did further work on the background during his 1850 stay in Oxford (I, p.83).

While work on No.24 was still in progress, the dealer William Wethered made some kind of undertaking to buy it, but finally withdrew on account of the way Millais had painted

Ariel and the bats (see P.R.B. Journal, 12 January 1850). Wethered's feeling that they should have been more 'sylph-like' suggests that he had expected the coyly erotic creatures that were the stock-in-trade of the Victorian fairy-painter. In spite of this setback, Millais still managed to sell his picture before sending it in to the R.A. exhibition in early April 1850. It was bought by the well-known collector Richard Ellison for £150.

In a letter to Morland Agnew of 2 July 1909 (HL), Holman Hunt says that No.24 was 'ignorantly varnished' some time before entering the Makins collection and that he had been called in to restore it – this would presumably have been after Millais' death in 1896.

There is a sketch with Ferdinand in a different pose at the Walker Art Gallery, Liverpool, which is dated 1848 and was probably made before the formation of the P.R.B. The pencil sketch in a private collection (exh. Arts Council 1979, No.42) and the oil sketch in the Holt Bequest, Sudley, Liverpool (exh. R.A. 1967, No.23), both of which show an extensive background with the shipwreck, are undated but probably later. A pencil sketch close to the final composition and studies for Ferdinand and a bat are at the Victoria and Albert Museum and the Fitzwilliam Museum, Cambridge (ibid., Nos 250 and 253, verso). The preparatory drawing for the face that Stephens describes is now in the Yale Center for British Art (exh. Arts Council 1979, No.43).

M.W.

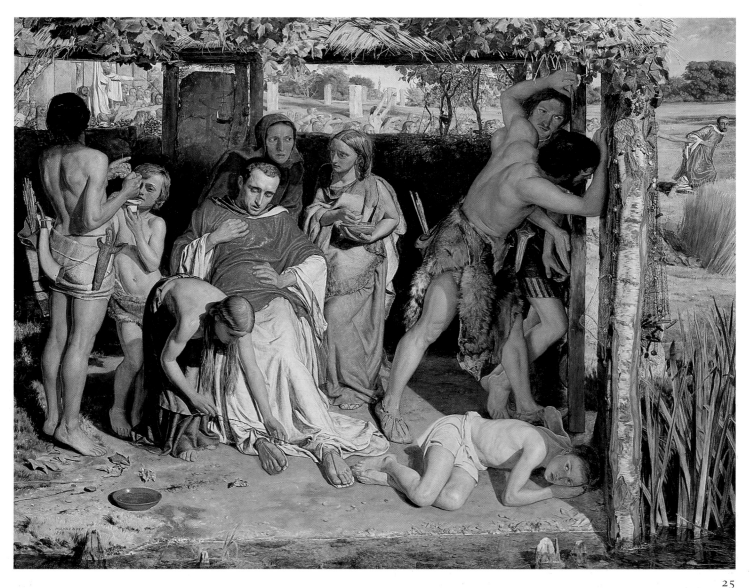

25

WILLIAM HOLMAN HUNT

**25 A Converted British Family Sheltering a Christian
 Missionary from the Persecution of the
 Druids** 1849–50
 Inscribed 'W. HOLMAN HUNT|1850'
 Oil on canvas, $43\frac{3}{4} \times 52\frac{1}{2}$ (111×141)
 First exh: R.A. 1850 (553)
 Ref: Liverpool 1969 (15)
 Visitors of the Ashmolean Museum, Oxford

No.25 was conceived in May 1849 (see No.164) as an entry for
a Royal Academy Gold Medal contest on the theme 'An Act of
Mercy' (Hunt 1905, I, p.173). Its depiction of the oppressed
continues the theme of Hunt's 1848 and 1849 exhibits (Nos
9 and 17), while the focus on religious persecution may
have been decided on in consultation with Millais, whose
'Disentombment of Queen Matilda' (No.165) also dates from
May 1849.

Hunt soon found the Academy brief too restricting, as the

prescribed canvas size precluded the working out of Pre-
Raphaelite principles in the landscape. After having been paid
for 'Rienzi', he went down to Homerton in late August 1849 to
paint the foreground, background and hut from the Lea
Marshes. Progress on the figures was well advanced by 10
December 1849, as W.M. Rossetti noted in the P.R.B. Journal
(Fredeman, p.30). Hunt stressed in his memoirs that he was
concerned to paint these in the studio only under sunlit
conditions (1905, I, p.173), and his desire to obtain the correct
sort of models for the Druids led him in March 1850 to
Battersea Fields in search of gipsies 'of a proper savage
brownness' (Fredeman, p.66).

One of the last parts to be worked on was the face of the
principal missionary, for which W.M. Rossetti posed on 7 April
1850 (ibid., pp.68–9). The pencil study of the head (private
collection, repr. Hunt 1905, I, p.195) reveals that Hunt had
intended to depict the missionary as a tonsured monk, with
a half-open grimacing mouth. He must have altered these
features after reading the attacks on 'Ecce Ancilla Domini!'

(No.22) at the Portland Gallery, for fear that No.25 would be accused of Romanism. The decision not to add the initials 'PRB' to 'A Converted British Family' may have been prompted by Hunt's realisation that their meaning was about to be revealed: the association of the word 'Brotherhood' with monasticism unleashed a storm exacerbated by the ramifications of the Gorham Judgement (which led many High Churchmen, including James Collinson, to convert to Roman Catholicism).

The full fury of the reviewers was indeed directed at 'Christ in the House of His Parents' (No.26), a much more overtly Tractarian picture. The Tractarian newspaper the *Guardian*, in its reviews of 8 May and 1 June, applauded both artists' contributions, and this would have encouraged Millais in his generous efforts to sell No.25 to Thomas Combe, the superintendent of the Oxford University Press and a prominent High Churchman. Hunt worked on No.25 after its return from the Royal Academy, and Millais sold it to William Bennett, Mrs Combe's uncle, almost immediately after its arrival in Oxford in late September 1850 (Mary Lutyens, 'Selling the Missionary', *Apollo*, LXXXVI, 1967, pp.385–6). The picture was presented to Combe, who soon became a major Pre-Raphaelite patron.

Combe's religious beliefs gave rise to his nickname 'The Early Christian', and he would have been attracted by the fact that No.25 is set in the first century A.D., as well as by its Tractarian undertones. The juxtaposition of a red cross daubed on the monolith at the back of the hut with the pendent cruse of burning oil may reflect Tractarian ritual, which revived the practice of placing a cross and candlesticks on the altar. The garments of the priests probably relate to the 1840s High Church revival of Eucharistic vestments, specifically to the riots of 1845 and 1848 generated by the wearing of surplices at Communion (see Alastair Grieve, 'The Pre-Raphaelite Brotherhood and the Anglican High Church', *Burlington Magazine*, CXI, 1969, p.295). Hunt's regard for archaeological accuracy led him to robe his priests in white dalmatics and red *paenulae* (see Herbert Norris, *Church Vestments: Their Origin and Development*, 1949, pp.43–4, 55–9), but these could easily have been mistaken for surplices and chasubles by nineteenth-century viewers. According to Pugin's *Glossary of Ecclesiastical Ornament and Costume*, 1844: 'Red, in its mystic sense, signifies the intensity of divine charity and love. It is also used as an emblem of Martyrdom' (p.179).

Christ's martyrdom is, of course, commemorated through communion, and the figure at the far left in No.25 squeezing grape juice into a cup suggests that the Eucharist is about to be celebrated. The child holding the cup wears a fur loincloth, the attribute of John the Baptist; his presence at the ceremony suggests support for the Tractarian belief that Baptismal Regeneration dates from childhood, a tenet challenged by the Gorham Judgement of March 1850 (see Alastair Grieve in *Pre-Raphaelite Papers*, Tate Gallery, 1984). The importance of the baptismal rite is emphasised by the bowl of water in the left foreground, and the loving care with which Hunt depicts the river at the lower edge of the picture.

Hunt sent Combe an explanation of the symbolism of No.25 in July 1851, but did not amplify the sectarian undertones which would anyway have been apparent to his patron, perhaps because at the time of writing he was reading Ruskin's *Notes on the Construction of Sheepfolds* (J.G. Millais, I, p.122), a pamphlet condemning the schism between Tractarians and Evangelicals. Hunt stressed that the incident depicted in No.25 could well have occurred historically, and was, on a symbolic level, 'a fulfilment of the texts quoted in connection with the picture' (AM). The inscriptions on the frame are, however, an amplication rather than explanation of the action of No.25,

and their function of underlining the parallels between the missionaries and Christ's disciples would have appealed to Tractarian and Evangelical alike. The texts inscribed above – 'The time cometh, that whosoever killeth you will think he doeth God service' (John 16. 2) and 'Their feet are swift to shed blood' (Romans 3. 15) – stress the theme of persecution, which the upper part of No.25, with its demagogic Druid leader inciting the mob, dramatises. The birds on the thatched roof of the hut just below the frame fuse the themes of persecution and mercy; they recall the parable of the fallen sparrow – 'one of them shall not fall on the ground without your Father' – in Matthew 10, a chapter in which Christ prophesies the forthcoming persecution of His disciples. The texts below stress the aspect of mercy: 'For whosoever shall give you a cup of water to drink in my name, because ye belong to Christ, verily I say unto you, he shall not lose his reward' (Mark 9. 41); 'I was a stranger and ye took me in' (Matthew 25. 35). They relate to Christ's identification with the disciples and, by extension, reveal the missionary to be an analogue or type of Christ. Any viewer of No.25 would, however, have realised this from the action within the picture space: the girls tending the missionary hold a thorn branch and a sponge with which to bathe his face, attributes of the Passion, while the older woman supports the priest in the pose of the Deposition.

In 1851 Hunt explained that even the most naturalistic elements of No.25, such as the vine and corn, were symbols of 'the civilizing effect' of Christianity. The cabbages are also images of cultivation, while the meticulously painted net hanging from the beech stump and partially obscuring the cabbage patch symbolises the Christian Church, in its role as fisher of men, and stresses that the inhabitants of the hut are converts, Druids believing fish to be sacred and forbidding their capture.

Hunt's high estimate of No.25 is revealed in a letter to Edward Lear of September 1872: 'Sometimes when I look at the Early Xtians I feel rather ashamed that I have not got further than later years have brought me but the truth is that at twenty – health enthusiasm and yet unpunished confidence in oneself carries a man very near his ultimate length of tether' (JRL).

<div style="text-align:right">J.B.</div>

JOHN EVERETT MILLAIS

26 **Christ in the Carpenter's Shop (Christ in the House of His Parents)** 1849–50
Inscribed 'JMillais 1850' (initials in monogram)
Oil on canvas, 34 × 55 (86.4 × 139.7)
First exh: R.A. 1850 (518)
Ref: R.A. 1967 (26)
Tate Gallery

Millais' first important religious subject, showing a scene from the boyhood of Christ, follows the lead taken by Rossetti in 'The Girlhood of Mary Virgin' (No.15). The subject of the Holy Family at Nazareth with Joseph practising his trade as a carpenter is not uncommon in art, although normally further characters are not introduced and the Virgin is shown spinning or sewing. Millais would have known Correggio's 'Madonna of the Basket' at the National Gallery, for example, and this may have been a source for his subject, although he would have disapproved heartily of Correggio's idealising style. He may also have known J.R. Herbert's 'Our Saviour, subject to His Parents at Nazareth' (Guildhall Art Gallery), which had

been shown at the R.A. in 1847.

No.26 shows Christ and the Virgin Mary in the centre, with Joseph and John the Baptist to the right, and the Virgin's mother St Anne and an assistant in Joseph's workshop to the left. Millais follows the prefigurative symbolism often associated with the subject, in which the wood and nails in the workshop remind us of Christ's death on the cross, elaborating on the idea by showing Christ as having cut himself on a nail and spilt a drop of blood down on to his foot. St John is shown bringing a bowl of water to bathe the wound, which acts as a kind of attribute identifying him as the Baptist. The baptismal association is extended by the white dove on the ladder, which anticipates the Holy Spirit's descent from heaven in the form of a dove at the baptism of Christ. The triangular set-square above Christ's head suggests the idea of the Trinity, or the 'Two Trinities' (Father, Son and Holy Spirit, and Christ, Mary and Joseph). The use of the triangular shape for this purpose probably derives from Rossetti's 'The Girlhood of Mary Virgin', but it is typical of the difference between the two works that, whereas Rossetti offers no plausible reason for his 'Tri-point' on a realistic level, Millais ingeniously exploits an object quite likely to be found in the given setting. The sheep in the background to the left represent the Christian flock, and the birds drinking at a bowl of water on the right represent human souls and the spiritual refreshment Christ offers. The unfinished wicker basket on the left may be intended to suggest the unfinished state of Christ's mission; or perhaps the protruding sticks anticipate the Flagellation. The exotic red flower near the door reads as a kind of natural metaphor for Christ's blood.

According to Holman Hunt, Millais was inspired to paint the subject of No.26 by a sermon he heard in Oxford during the summer of 1849 (1905, I, pp.194–5). When first exhibited at the R.A. in 1850, it was given no title, only the following biblical quotation:

> And one shall say unto him, What are these wounds in thine hands? Then he shall answer, Those with which I was wounded in the house of my friends (Zechariah 13.6)

The interpretation of this verse as relating to the Passion of Christ is curious since the wounded man referred to seems clearly intended, from the context, to be a false prophet. It was, however, read as such by the eminent 'Oxford Movement' theologian E.B. Pusey, and the sermon Millais heard may well have been given by Pusey or one of his followers. For further discussion of No.26 in connection with the Oxford Movement, see Alastair Grieve, 'The Pre-Raphaelite Brotherhood and the Anglican High Church', *Burlington Magazine*, CXI, 1969, pp.294–5; Edward Morris, 'The Subject of Millais' *Christ in the House of His Parents*', *Journal of the Warburg and Courtauld Institutes*, XXXIII, 1970, pp.343–5; and Lindsay Errington, 'Social and Religious Themes in English Art, 1840–60', Ph.D. thesis, University of London, 1973.

Details of Millais' progress on No.26 are given in the P.R.B. Journal. On 1 and 8 November 1849 he showed the Rossettis a sketch or sketches; by 7 December he had 'redesigned the subject'; on 16 December he had been 'again' to look at a carpenter's shop and was planning to begin the actual painting in four days' time; by 29 December he had begun and was about to have a bed installed in a carpenter's shop so as to be able to get to work early in the mornings on painting the background; on 12 January 1850 he was suffering from a cold caught at the carpenter's; by 11 February he had 'done several hands, feet, legs, etc'; on 16 February he was painting Mary's head; on 21 February he had 'just set a white drapery' and

'done (or begun) the heads of the Virgin and of Christ'; on 3 March he was painting the chest of the assistant and had finished the figures of Mary and John the Baptist, Christ's head, the legs of Joseph and the assistant, the ground 'and some other accessory portions'; and on 8 April he showed D.G. Rossetti the finished work (Fredeman, pp.21, 23–4, 30, 32, 38, 42, 53, 55, 56, 60, 69).

The model for the Virgin Mary was Mary Hodgkinson, who also appears in 'Isabella' (No.18). J.G. Millais gives the other models as follows: Nöel Humphreys, son of the mediaevalising book-illustrator Henry Nöel Humphreys, for Christ; Edwin Everett, whom he describes as 'an adopted child of the Mr Everett who married Millais' aunt', for John the Baptist; H.St Ledger for the assistant; an anonymous carpenter for Joseph's body and the artist's father for his head (I, p.78). However, the P.R.B. Journal for 3 March 1850 says that Millais' brother William was sitting for the assistant's chest and that the model for his face was to be Alexander Tupper; and a letter to the Tate Gallery from Sydney Vinter, 4 November 1958, claims that the model for Joseph was his grandfather, John Vinter, who was the father of John Alfred Vinter, a fellow R.A. student and member of the Cyclographic Society.

The carpenter's shop on which Millais based the setting is said by Holman Hunt to have been in Oxford Street (1905, I, pp.202–5). J.G. Millais states that the sheep in the background were all painted from two heads bought from a local butcher (I, p.78).

The ferocious reactions of reviewers to No.26 at the 1850 R.A. exhibition have become almost legendary. For a few examples, see J.G. Millais I, pp.75–6. The most famous is Charles Dickens', in which he describes the Christ child as 'a hideous, wry-necked, blubbering, red-haired boy in a nightgown, who appears to have received a poke playing in an adjacent gutter, and to be holding it up for the contemplation of a kneeling woman, so horrible in her ugliness that (supposing it were possible for any human creature to exist for a moment with that dislocated throat) she would stand out from the rest of the company as a monster in the vilest cabaret in France or in the lowest gin-shop in England' (*Household Words*, 15 June 1850). The treatment of the Holy Family in a detailed, relatively realistic and documentary manner (notice St Joseph's dirty fingernails) offended deeply entrenched 'Raphaelite' expectations about religious art, and, worse, smacked of deliberate blasphemy. The picture became such a talking point that Queen Victoria had it removed from the exhibition and brought to her for a special viewing (P.R.B. Journal, 21 July 1850, Fredeman, p.71). 'I hope it will not have any bad effects upon her mind', Millais wrote to Holman Hunt (HL). There are references in the P.R.B. Journal for 30 November 1850 and January 1851 to a parody of it by an engraver called Earl, to be published by Fores of Piccadilly, but no copy has been traced.

The unfavourable reception did not affect the sale of the work, since it had been bought the morning before being submitted for the exhibition by the dealer Henry Farrer (P.R.B. Journal, 21 July 1850, Fredeman, p.70). Accounts of the price paid vary from £150 (J.G. Millais, I, p.78) to £350 (P.R.B. Journal, ibid). Holman Hunt says it was originally £300 but was reduced after the bad reviews (1905, I, p.206). Farrer sold it to Thomas Plint, a Leeds stockbroker and prominent Pre-Raphaelite collector, who by the time of his death in 1861 also owned Millais' 'The Proscribed Royalist, 1651' (No.46), 'Spring' (No.96) and 'The Black Brunswicker' (No.108).

Walter Armstrong stated in 1885 that No.26 was retouched 'some few years ago' and the colour modified ('Sir John Millais,

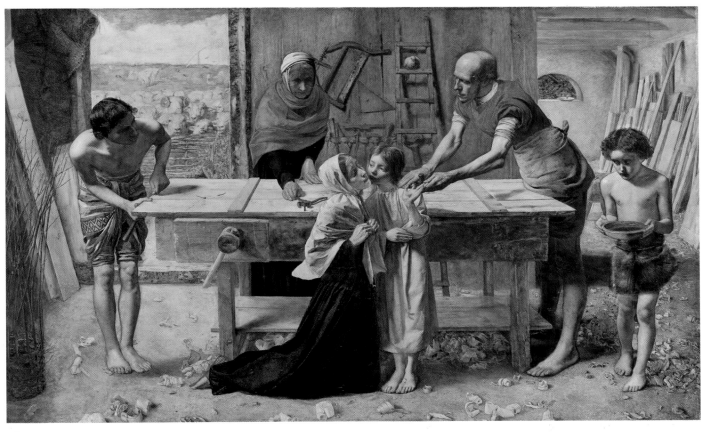

26

27

R.A.: His Life and Work', *Art Journal*, Christmas Number); and Spielmann that it was altered 'in some important, though minor particulars' around 1878 (p.101).

There are sketches at the Victoria and Albert Museum (exh. R.A. 1967, No.252), the Fitzwilliam Museum, Cambridge (ibid., No.253) and the Tate Gallery (ibid., Nos 254–5), and a copy made by Rebecca Solomon in 1863 and touched up by Millais himself was sold at Christie's, 11 July 1969 (121). Solomon's copy was made to assist Professor L.L. Grüner of Dresden in making his engraving of the work, which was published by Moore, McQueen & Co. in 1866. The only reproduction before that was an anonymous wood-engraving published in the *Illustrated London News* on 11 May 1850 (p.336).

M.W.

CHARLES ALLSTON COLLINS

27 **Berengaria's Alarm for the Safety of her Husband, Richard Coeur de Lion, Awakened by the Sight of his Girdle Offered for Sale at Rome** · 1850
Inscribed 'CHARLES COLLINS 1850'
Oil on canvas, 38 × 49½ (96·5 × 125.7)
First exh: R.A. 1850 (535)
City of Manchester Art Galleries

In 1192, returning to England after the conclusion of peace with Saladin in the Holy Land, Richard the Lionheart was forced by a shipwreck to cross the territory of his enemy Leopold of Austria. He was captured and imprisoned. Queen Berengaria, accompanied by Richard's sister Queen Joanna and the Princess of Cyprus, which the king had conquered on

28

his way to the Holy Land, sailed separately from Acre and spent the winter of 1192–3 in Rome. When No.27 was exhibited at the R.A. in 1850, the following explanation of the scene appeared in the catalogue: 'The Provençal traditions declare that here Berengaria first took the alarm that some disaster had happened to her lord, from seeing a belt of jewels offered for sale which she knew had been in his possession when she parted from him'. She was not reunited with Richard – who was released after the payment of a ransom, then for a period entirely neglected her – until the end of 1195.

The picture shows Berengaria engaged in embroidering a lion design – clearly a reference to her husband. The tapestries to the right of the composition bear scenes from 'Ye hystory of Joseph'. The figures just visible on the side wall are presumably Joseph's brothers plotting against him. The incident depicted on the back wall is easily recognisable as the brothers showing Joseph's coat smeared with kid's blood to their father Jacob to convince him that Joseph has been killed. The scroll on the floor in the foreground of the picture acts as a kind of caption to this scene, giving a mediaevalised version of the relevant verse from the Bible: 'And he knew it and sayde it is my sonne hys coate an evil beast hath devoured him. Joseph is wythout doubte rent in pieces' (Genesis 37.33). The parallel with the story of Berengaria and the girdle is obvious.

No.27 was the first of Collins' paintings to show the influence of the Pre-Raphaelite ideas he picked up from his close friend Millais. The source he acknowledged in the R.A. catalogue, Agnes Strickland's *Lives of the Queens of England*, was one that Millais himself had already tapped the previous year in his drawing of 'The Disentombment of Queen Matilda'

(No.165) and the mediaeval costumes and setting, high colour key, attention to detail and use of symbolism are reminiscent of 'Isabella' (No.18). On the other hand, there is a smooth prettiness about the female figures which is typical of more conventional British artists of the time.

The manuscript on the floor next to the scroll has recently been identified by Julian Treuherz (in *Pre-Raphaelite Papers*, Tate Gallery, 1984).

M.W.

JOHN EVERETT MILLAIS

28 James Wyatt and his Granddaughter 1849
Inscribed 'JEM|1849' (initials in monogram)
Oil on panel, 14 × 17¾ (35.6 × 45.1)
First exh: R.A. 1850 (429)
Ref: R.A. 1967 (20)
Private Collection

James Wyatt (1774–1853) was a collector and art dealer who lived and carried on his business at 115 High Street, Oxford. He was curator of the Duke of Marlborough's collection at Blenheim and had been Mayor of Oxford in 1842–3. No.28 shows him in the first-floor back room of his house, overlooking the garden. He was evidently a great admirer of Millais' work. He commissioned No.28 and its pendant No.29, bought 'Cymon and Iphigenia' (No.10) and by the time of his death owned several oil sketches, including 'Romeo and Juliet' (Manchester City Art Gallery, exh. R.A. 1967, No.17), and

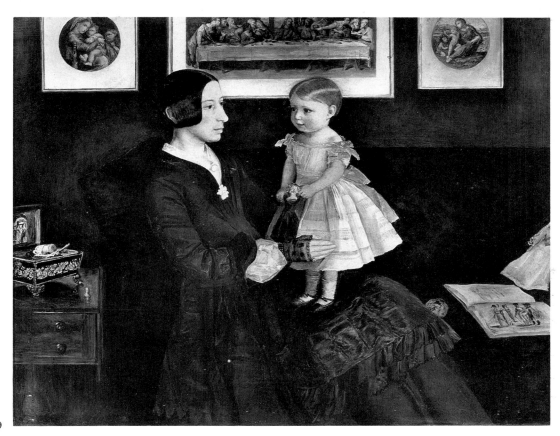

29

many drawings the artist made while staying at his house. The two men had known each other at least since 1846, when Millais made a watercolour portrait, now in a private collection, of the little girl here shown at Wyatt's knee – his granddaughter Mary Wyatt, later Mrs James Standen (1845–1903).

The work embraces not just two but four generations of Wyatt's family. The man in a top hat in the small portrait to the right of the window is Thomas Wyatt, his father, painted by William Waite of Abingdon; and the young lady in the upper right corner is his daughter-in-law, Eliza, Mary's mother, by William Boxall. Both are still in the same collection as No.28. The other pictures, ceramics and various *objets d'art* around the room suggest Wyatt's collecting and dealing activities. The open book at his side is hardly legible but seems to be a copy of the *Poems* of Anne Killigrew (1686).

Millais painted No.28 during a stay at Wyatt's that lasted from some time in September until between 15 and 18 October 1849. Early the next year he submitted it for the British Institution exhibition. By getting William Michael Rossetti to write an accompanying sonnet, which is unfortunately lost, he tried to pass it off as something other than a portrait, since portraits were not normally admissible. But this failed and the work's first showing was at the R.A. later in the year (see P.R.B. Journal, 12 January, 2 February 1850, Fredeman, pp.42, 50).

There is a copy in the possession of the sitters' descendants made by the artist's brother William in 1850, the faces and hands of which are said to have been finished by Millais himself.

M.W.

JOHN EVERETT MILLAIS

29 **Mrs James Wyatt Jnr and her Daughter** ?1850
Inscribed 'JEM' in monogram
Oil on panel, 14 × 17¾ (35.6 × 45.1)
Ref: R.A. 1967 (21)
Private Collection

This work was commissioned by James Wyatt as a pendant to No.28 and shows Eliza Wyatt, née Moorman (1813–95) with her daughter Sarah, later Mrs Thomas (1849–1916). In view of Sarah's birthdate, No.29 would seem to have been executed later than No.28, perhaps when Millais was in Oxford, where the Wyatts lived, in 1850 (see Nos.32, 35).

On the wall in the background are prints after Leonardo da Vinci's 'Last Supper', Raphael's 'Madonna della Sedia' and the 'Alba Madonna' by the same artist. Millais held Raphael in the deepest contempt at this time. While staying with his other Oxford patron Thomas Combe in 1850, he went to see the Ashmolean Museum's collection of Raphael drawings. On a page of the 'Combe Scrapbook', now also at the Ashmolean, Combe noted: 'The Raphael drawings in the University Galleries he greatly ridiculed; he thought as curiosities they might be worth a shilling apiece – "who would give more for such things as these?"'

The Raphael Madonnas in No.29, with their idealised figures and flowing, harmonious compositions, are used to set off the realism and awkwardness of the modern mother-and-child group in front of them. When hung next to No.28, the work also invites us to compare Millais' severe likeness of Eliza Wyatt

with William Boxall's dreamy, romantic portrait of her on the wall behind James Wyatt's chair. With its circular format and curvaceous lines, the Boxall is likened to the 'Madonna della Sedia'. As if painting a kind of Pre-Raphaelite manifesto, Millais spells out the 'Raphaelite' nature of recent British art and offers his own style as a corrective.

<div align="right">M.W.</div>

THOMAS WOOLNER

30 Alfred Tennyson 1849–50
Bronze medallion, 10⅞in. (27.7cm.) diameter
Lincolnshire Museums: Usher Gallery, Lincoln

30

Tennyson began sitting to Woolner for this medallion in London late in 1849; further sessions were held in the autumn of 1850 at Coniston, while Tennyson was staying there. The work had been cast in bronze by 8 December 1850, and examples sent out to Mrs Fletcher of Ambleside and Coventry Patmore early in January 1851.

In the P.R.B. Journal we read that Woolner prided himself not a little on Bernhard Smith's approval of the execution of this work (Fredeman, p.85). This is not surprising: Smith, with whom Woolner had shared a studio, had slightly more experience than Woolner in the field of portrait medallions, having exhibited them at the Royal Academy since 1842, four years before Woolner's first known example, that of Edwin Ashford (R.A. 1846). Moreover, Smith's subjects were, for that date, rather more significant as sitters – his Sir John Richardson (1842) and Sir James Ross (1843, both now National Portrait Gallery) were both established explorers. Woolner's earliest sitters were lesser known, being drawn from his friends and associates – Coventry Patmore (medallion 1849), for example, had not yet achieved much of a reputation. It was Patmore, though, who persuaded Tennyson to sit to Woolner; to have Tennyson as his subject represented a considerable advance for Woolner, to be followed up within two years by Carlyle and Wordsworth (posthumously).

While Smith may have had a certain advantage in experience with his medallions, Woolner's were certainly stylistically distinct. Smith's tend to retain a certain smooth generalisation in modelling, deriving from the conventions of both neoclassicism in sculpture and the particular requirements of medal production, towards which medallions would naturally tend to conform. In medals, although the modelling might be quite detailed, it would always demand a firmness and crispness (for ease in stamped execution) that could preclude a total truth to nature. On the other hand, Woolner, in this 'Tennyson', as in his marble relief of the head of Wordsworth (Grasmere, 1851), achieves an accuracy in modelling realistic detail that was without parallel in contemporary sculpture. The closest analogy for this is in fact in certain drawings by D.G. Rossetti and Millais, e.g. Rossetti's portrait of William Michael Rossetti of 1846 (Surtees No.452) and Millais' study drawing for the head of the youth in 'Isabella' of 1849 (Birmingham City Art Gallery, 653'06). In both of these certain conditions meet coincidentally with those of Woolner's medallions – they are portrait heads seen in precise profile. In all, though, there is a striking truthfulness in rendering strands of hair and particularising the modelling of the physiognomy.

For a later medallion and a bust of Tennyson by Woolner, see Nos 76 and 89.

<div align="right">B.R.</div>

DANTE GABRIEL ROSSETTI

31 **'Hist!' – Said Kate the Queen** ?1850
Inscribed 'DGR 1851' (initials in monogram)
Oil on canvas, $12\frac{3}{4} \times 23\frac{1}{2}$ (32.4×59.7)
Ref: Surtees No.49; Grieve 1978, pp.47–49
Provost and Fellows, Eton College

The subject of this colour sketch, the unrequited love of a page-boy for his queen, is taken from a song sung by Pippa in Robert Browning's poem 'Pippa Passes':

> Give her but a least excuse to love me!
> When – where –
> How – can this arm establish her above me,
> If fortune fixed her as my lady there,
> There already, to eternally reprove me?
> ('Hist' – said Kate the Queen;
> But 'Oh' – cried the maiden, binding her tresses,
> ''Tis only a page that carols unseen,
> Crumbling your hounds their messes!') (Act II, Noon)

Rossetti's selection of this minor incident is a good example of his habit of avoiding main-line poetic descriptions which allowed his imagination little scope. His enthusiasm for Browning dates from *c*.1847 and was very strong. As William Michael Rossetti remarked: 'Confronted with Browning, all else seemed pale and in neutral tint. Here were passion, observation, aspiration, mediaevalism, the dramatic perception of character, act and incident' (W.M. Rossetti 1895, I, p.102).

Evidently a finished design of the subject was already made in August 1848 which, according to F.G. Stephens, was in three compartments. This does not survive though we do have rough sketches of a year or so earlier in date (Surtees Nos 49 A, B). In May 1849 Rossetti redesigned it, possibly hoping to have it ready for exhibition as a picture in the following year but he decided instead to paint 'Ecce Ancilla Domini!' (No.22). It was the failure of this painting to sell that made him revert to scenes of romantic love and take up once more, in May or June 1850, '"Hist!" – said Kate the Queen'. He wrote to his Aunt Charlotte Polidori, who had encouraged him in his earlier religious subjects and who came to own No.31, to justify his change in direction: 'I am now beginning a large picture containing about thirty figures, and concerning the love of a page for a queen, as treated in one of Browning's songs – a subject which I have pitched into principally for its presumptive saleableness. I find unluckily that the class of picture which has my natural preference is not for the market! I have nearly finished the sketch in colour for my picture, have made many studies and am beginning to draw it on the canvas' (Doughty & Wahl, I, p.88). This canvas evidently measured $4 \times 7\frac{1}{2}$ feet and it is not surprising that it was abandoned by the start of September 1850.

Though No.31 is dated '1851' it is probably the colour sketch mentioned in the letter of the previous year quoted above. Its horizontal format is unusual in Rossetti's oeuvre and he may have intended it as a composition in three parts, following the design mentioned by F.G. Stephens. There is a square, central section which is divided from narrow, flanking sections by the vertical edges of the arcades. In the central area the queen has her hair dressed while being read to from Boccaccio's *Decameron*, the tale of the fourth day which is about the love of a princess for a commoner. The lovesick page in the right wing is contrasted with the light-hearted courtiers on the left. The repeated poses and red dresses of the line of sewing-maids unite the composition. In the very centre there are intense touches of primary colour given by the red and blue scent bottles and the queen's gold hair. It is an important sketch for in it we find for the first time in Rossetti's art a sense of intimate enclosure, mediaeval courtship and entertainment and a frank delight in women's hair. These were all to be important characteristics in his later work.

A.G.

31

SECTION III 1851-1854

After the attacks on the religious subjects they had shown in 1850, Millais and Hunt largely returned to literary themes for their 1851 R.A. exhibits (Nos 32, 34–6). Abused again by the press, they secured the support of Ruskin, who wrote two letters to *The Times* in their defence (and that of their fellow-exhibitor, Collins), followed by a pamphlet on Pre-Raphaelitism. The next year, 1852, their exhibits were well received, Millais' 'A Huguenot' (No.41) proving especially popular. Brown's contributions (Nos 38, 42) were still derided, however, and Rossetti had already given up exhibiting: for the rest of the decade he worked mainly in watercolour, selling directly to patrons (see Section VII).

The Brotherhood was now disintegrating. At one of its meetings in January 1851 Millais questioned 'the propriety of our continuing to call ourselves P.R.B.s'; a redefinition of aims was called for but never made. Woolner left for Australia in July 1852, effectively reducing the original membership to five. For the survivors the Brotherhood had served its purpose: 'We have emerged from reckless abuse', wrote W.M. Rossetti in January 1853, 'to a position of general and high recognition'. This was certainly true of Millais, whose R.A. exhibit that year (No.49) scored an even greater public success; later in 1853 he was elected an A.R.A. The sale in 1852 of 'The Hireling Shepherd' (No.39) confirmed Hunt in his chosen course, painting religious subjects (No.57) and modern-life moralities (No.58) in terms of symbolic realism. Early in 1854 he left for the Holy Land in pursuit of authentic settings for biblical subjects, only returning in 1856. It was Brown who was most concerned with contemporary subjects at this time (Nos 51, 62 and 'Work', No.88, begun in 1852). Landscape also assumed a new importance, especially in the work of Hunt (Nos 39, 48, 52) and Brown (Nos 51, 60–1).

opposite William Holman Hunt, 'The Hireling Shepherd', 1851–2 (detail, No.39)

JOHN EVERETT MILLAIS

32 The Woodman's Daughter 1850–1
Inscribed 'JMillais 1851' (initials in monogram)
Oil on canvas, 35 × 25½ (88.9 × 64.8)
First exh: R.A. 1851 (799)
Ref: R.A. 1967 (29)
Guildhall Art Gallery, Corporation of London

The beginning of an ill-fated friendship between Maud, daughter of a woodman called Gerald, and the son of the squire. Years later they have a love affair which cannot end in marriage because of the difference in social rank between them. Maud gives birth to an illegitimate child, drowns it in a pool and goes mad. The tale is from Coventry Patmore's poem, also called 'The Woodman's Daughter', the following lines from which were given in the catalogue when the work was first exhibited at the R.A. in 1851:

> She went merely to think she helped;
> And, whilst he hack'd and saw'd,
> The rich squire's son, a young boy then,
> For whole days, as if awed,
> Stood by, and gazed alternately
> At Gerald, and at Maud.
>
> He sometimes, in a sullen tone,
> Would offer fruits, and she,
> Always received his gifts with an air
> So unreserved and free,
> That half-feigned distance soon became
> Familiarity.

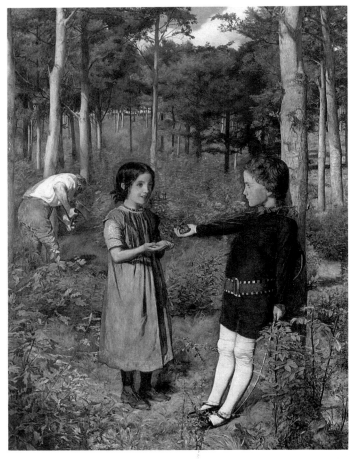

32

The bird's feathers at the boy's feet, near the end of his stick, and the action of Gerald felling a tree, seem to hint symbolically at the violence with which the story will end.

Millais knew Patmore, who greatly admired his work, pronounced 'Isabella' (No.18) 'far better than anything Keats ever did' and at one stage hoped Millais would illustrate the next edition of his poems (P.R.B. Journal, 22 November 1849, October 1850, Fredeman, pp.28, 72). The artist was reading 'The Woodman's Daughter' on 23 May 1849, although it was another of Patmore's poems, 'Sir Hubert', that he was then thinking of illustrating in a drawing or painting (ibid., p.5). On 7 December that year, however, he showed his friends a design, apparently the second, that he had made for the subject he was to paint in No.32 (ibid., p.29). This was probably the sketch dated 1849 now at the Yale Center for British Art.

He went to Oxford to execute the background to No.32 at the beginning of June 1850, staying initially with James Wyatt (see Nos.28–9). From Wyatt's he wrote to Holman Hunt: 'I am going to live in the country today at a most humble abode. JEM at Mr King's grocer at Botley nr. Oxford. There I shall be quite close to a wood where I shall commence painting tomorrow morning' (HL). On 5 June Wyatt told F.G. Stephens: 'Millais is hard at work painting the background of his picture from nature in Wytham Wood, not more than two miles from me. He has a comfortable lodging close to him and no-one disturbs him' (BL). He was back from Botley in Oxford itself, staying with Thomas Combe and his wife at the Clarendon Press, by 21 September, and returned to London on 12 November (J.G. Millais, I, p.88).

On 2 December he wrote to Mrs Combe describing the difficulties of painting in his cold studio, a day's work resulting in 'three hairs on the woodman's little girl's head or two freckles on her face' (ibid., I, p.90). On 28 January 1851 he

wrote to her again with a request for items of costume: 'You recollect the lodge at the entrance of Lord Abingdon's house, where I used to leave my picture of the Wood. Well, in the first cottage there is a little girl named Esther; would you ask the mother to let you have a pair of her old walking-boots? I require them sent on to me, as I wish to paint them in the wood. I do not care how old they are; they are, of course, no use without having been worn. Will you please supply the child with money to purchase a new pair? I shall settle with you when I see you in the spring. If you should see a country-child with a bright lilac pinafore on, lay strong hands on the same, and send it with the boots. It must be long, that is, covering the whole underdress from the neck. I do not wish it new, but clean, with some little pattern – pink spots, or anything of that kind' (ibid., I, p.97). Mrs Combe had supplied both boots and pinafore by 10 February and Millais wrote to thank her, describing No.32 as 'far advanced' (ibid., I, p.99).

The identities of the models are unknown. Arthur Hughes remembered that the strawberries in the boy's hand were bought at Covent Garden in March 1851 (ibid., I, p.111).

The picture proved very difficult to sell and, unusually for Millais, remained unsold at the close of the R.A. exhibition. It was eventually bought by the artist's half-brother Henry Hodgkinson. The problem was probably the face of the girl. Coventry Patmore later remembered No.32 as 'a charming picture in all save the principal point. The girl looked like a vulgar little slut' (letter to F.G. Stephens, 30 November 1885, BL). Her original appearance is now a matter for conjecture, since Millais repainted her face and other parts of the work at Henry Hodgkinson's request in 1886 (Spielmann, p.89 and

J.G. Millais, I, pp.98–9). This explains the pentimenti that are clearly visible in the picture, especially around the children's heads. The only apparent evidence as to how they may originally have looked is the drawing of No.32 at Princeton University Art Museum (repr. J.G. Millais, I, p.92), which seems to have been made before the repainting, though in an amateurish hand and definitely not by Millais himself.

M.W.

CHARLES ALLSTON COLLINS

33 Convent Thoughts 1850–1
Inscribed 'CAC 51' (initials in monogram)
Oil on canvas, arched top, $32\frac{1}{2} \times 22\frac{3}{4}$ (82.6 × 57.8)
First exh: R.A. 1851 (493)
Visitors of the Ashmolean Museum, Oxford

A nun, probably a novice, contemplating the crucifixion of Christ as symbolised in a passion flower – so called because of the cross shape formed by the stamens. The manuscript in her hand is open at illuminations showing the crucifixion and the Virgin Mary, to whom she is implicitly likened. The inscription at the top of the frame, 'Sicut Lilium', is from the Song of Solomon 2.2, 'Sicut lilium inter spinas' ('As the lily among thorns'), an image applied frequently to the Virgin Mary. Here it is taken up in the white lilies near the nun and (for the thorns) the roses towards the back of the flower beds. The garden also contains turk's-cap lilies, water-lilies and an African lily (agapanthus), and there are lilies on the frame, which was designed by the artist's friend Millais (see J.G. Millais, I, p.100). The image of the 'garden inclosed' or 'hortus conclusus' from the Song of Solomon 4.12 is also associated with the Virgin and virginity in general and Collins may have had that in mind as well when devising the iconography of his picture. The goldfish, some red, some white, seem to echo the major themes of Christ's sacrifice and the nun's purity.

When the work was shown at the 1851 R.A. exhibition, the title was accompanied in the catalogue by the following lines referring to nuns from Shakespeare's *A Midsummer Night's Dream* (Act I, Scene i):

> Thrice blessed they, that master so their blood
> To undergo such maiden pilgrimage

and the following from the Book of Psalms (143.5): 'I meditate on all Thy works; I muse on the works of Thy hands', which clearly refers to the nun's meditation on the passion flower.

The background was painted during the summer of 1850. It was begun at Botley, near Oxford, where Millais was painting the background to 'The Woodman's Daughter' (No.32). He and Collins were there from the beginning of June. Millais gives glimpses of Collins' progress on the picture, which was painted very much under his influence and guidance, in letters he wrote from Botley to Holman Hunt: 'All his faculties are running on the certainty of seeing the water lilies, he is painting, grown to a fairytale size' and 'Collins has brought home his picture to repair a hole, from a disastrous fall, the canvas coming in collision with the corner of a looking glass' (HL). According to a note by Thomas Combe on the back of No.33, the flowers were all painted from nature in the garden of his home in the quadrangle of the Clarendon Press in Oxford itself. 'He worked very slowly', Combe remembered, 'and I know that a flower of one of the lilies occupied a whole day'. Collins was certainly at Combe's, with Millais, by 21 September but must have been there for a considerable time before that

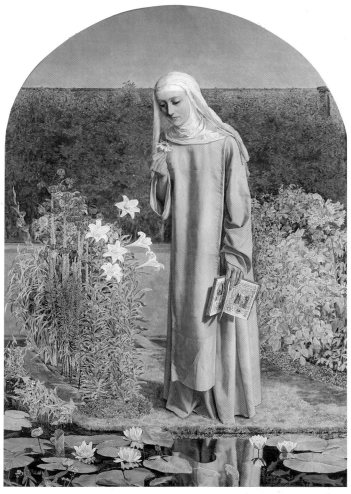

33

date. The two artists left together on 12 November (J.G. Millais, I, p.88).

Holman Hunt (1905, I, p.294) records a conversation of 1851 in which Millais said Collins had originally intended to paint an illustration to the lines

> And out of the cups of the heavy flowers
> She emptied the rain of the thunder showers

from Shelley's 'The Sensitive Plant', but changed to the nun subject after being disappointed in an affair of the heart. This is quite possible since the figure was not painted until some time after the background; and one of the sketches now in the British Museum shows a figure more like the Lady of Shelley's poem than the nun in the finished work.

On 15 January 1851, Millais wrote to Mrs Combe: 'I saw Carlo last night, who has been very lucky in persuading a very beautiful young lady to sit for the head of "The Nun". She was at his house when I called, and I also endeavoured to obtain a sitting, but was unfortunate, as she leaves London next Saturday' (J.G. Millais, I, p.94). About the same time Collins wrote to Holman Hunt mentioning that he had been painting the nun's face from 'a friend of a friend' at her own house (AM). According to a tradition in her family, the model was Frances Farah Ludlow (information from Hilarie Faberman, cited in *The Substance or the Shadow: Images of Victorian Womanhood*, exhibition catalogue, Yale Center for British Art, 1982, p.66). This is given some support by the fact that 'Fanny Ludlow' appears amongst other disconnected inscriptions on the same

sheet as the studies for 'The Eve of the Deluge' (No.171), which would probably have been made around the time Millais met Collins' model.

Collins had borrowed the nun's costume Hunt used in 'Claudio and Isabella' (No.45) and was writing to ask him whether the rope that came with it should be worn under or over the scapular – in the painting it is under, if anywhere. In another letter to Hunt, Collins wrote for advice on what to do about the sleeve of the costume, which was hanging down too far. 'Now though under ordinary circumstances this would be a pleasing trait of costume as it does away with the necessity of painting one of the hands, still in my case it is awkward, inasmuch as part of the story depends on the hand and the book held in it' (AM).

Millais wrote to Thomas Combe on 10 May 1851, during the R.A. exhibition, pointing out what a wise investment it would be to buy No.33, although it was a friend rather than Combe himself who was thinking of doing so (J.G. Millais, I, p.102). Eventually Combe and his wife did buy it, for £150, though more to help Collins than because they liked it (see J.G. Millais, I, p.103). They had already bought 'The Return of the Dove to the Ark' (No.34), which Millais may have intended as a pendant to his friend's picture.

There is a sketch for No.33 at the Ashmolean, two at the British Museum and a version in pen and ink, dated 1853, at the Tate Gallery. The original illumination on which Collins based the crucifixion scene in the nun's manuscript is identified by Julian Treuherz in *Pre-Raphaelite Papers*, Tate Gallery, 1984.

M.W.

JOHN EVERETT MILLAIS

34 The Return of the Dove to the Ark 1851
Inscribed 'JMillais 1851' (initials in monogram)
Oil on canvas, arched top, $34\frac{1}{2} \times 21\frac{1}{2}$ (87.6 × 54.6)
First exh: R.A. 1851 (651)
Ref: R.A. 1967 (32)
Visitors of the Ashmolean Museum, Oxford

Wives of the sons of Noah with the dove that was set free from the ark and returned with an olive leaf, showing that the flood waters were abating (Genesis 8. 8–11). The subject is related to that of 'The Eve of the Deluge', the many-figured composition Millais had had in mind for a painting since the previous year (see No.171). The choice of this particular incident may owe something to Charles Landseer's picture of the same title exhibited at the R.A. in 1844, now in the Forbes Magazine Collection, in which one of the wives of Noah's sons is also shown holding the dove to her breast.

Millais originally intended to include Noah himself in the composition. 'I shall have three figures', he told Thomas Combe on 28 January 1851, 'Noah praying, with the olive-branch in his hand, and the dove in the breast of a young girl who is looking at Noah. The other figure will be kissing the bird's breast. The background will be very novel, as I shall paint several birds and animals one of which now forms the prey to the other' (J.G. Millais, I, p.97).

On 10 February he wrote to Mrs Combe: 'I hope to commence the Noah the latter part of this week' (ibid., I, p.99). The figure of Noah and the animals must have been dropped from the design a short time later, since the work was submitted, presumably in a reasonably finished state, to the R.A. exhibition in early April.

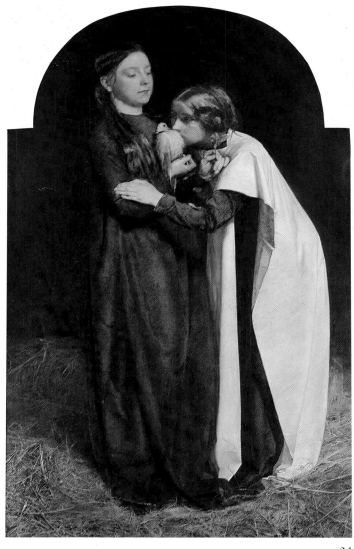

34

At the exhibition several offers were made for the picture, including one from Ruskin (ibid., I, p.101). The critic much admired it, except for the olive branch, which he quite rightly considered inaccurately painted (see Basil Champneys, *Memoirs and Correspondence of Coventry Patmore*, 1900, II, p.289). By the time it was on show, however, the work was no longer on sale, having been bought in late March by Thomas Combe (see J.G. Millais, I, p.100).

It seems likely that Millais had always had Combe in mind as a potential purchaser. On 25 September 1850, when Combe had decided to buy Holman Hunt's 'A Converted British Family . . .' (No.25), Millais had written to Hunt: 'Mr Combe is determined to have a choice collection and commences with your picture. I have to paint him a picture this year so we shall hang together. HARRAH FOR PRB' (HL).

Millais was at that time staying with Combe at his home in the Clarendon Press in Oxford. With him was Charles Collins and the two artists had just been painting matching portraits of Combe and his wife's uncle William Bennett (also Ashmolean Museum). Collins had begun 'Convent Thoughts' (No.33), which Combe also eventually bought, though not until the 1851 R.A. exhibition. 'The Return of the Dove to the Ark' and 'Convent Thoughts' are close in size and shape, and they have balancing themes – on the one hand hope and salvation, on the

other sacrifice and suffering, the olive branch forming the symbolic focus of the Millais, the passion flower that of the Collins – and Millais may well have conceived No.34 as a pendant to his friend's picture, hoping that Combe would buy them both as a pair. They certainly combine well with the Holman Hunt that Combe already had, making appropriate 'wings' to expand that work into a kind of triptych. The lighting is consistent through the three pictures; their subjects could be read together as representing the theological virtues of Faith (Collins), Hope (Millais) and Charity (Hunt); and the principal figures even wear the colours conventionally associated with those virtues, respectively white, green and red.

The artist held on to No.34 for some time after the R.A. exhibition. On 9 December 1851 he wrote to Combe: 'I have touched your picture, "The Return of the Dove", at last; and hope it will arrive safely ... You will perceive in some lights a little dulness on the surface of "The Dove's" background. It will all disappear when it is varnished, which must not be for some little time. It is almost impossible to paint a picture without some bloom coming on the face of it. You recollect it was arranged between Charley and myself that it should hang nearest the window, beside Hunt's. Please let it be a little leaned forward ... The reason for hanging the picture nearer the light is that it is much darker than Collins' "Nun"' (J.G. Millais, I, p.150).

In a letter of 30 January 1854 thanking Combe for giving his permission for the work to be shown at the Royal Scottish Academy that year, Millais advised him to have James Wyatt Jnr (see Nos.28–29) 'give it a very thin coat of *Mastic* varnish which cannot harm it as it is painted in copal. I should like also that it should have a glass before it, which could easily be put' (PC).

A sketch for the original composition with Noah is at Birmingham City Art Gallery (exh. R.A. 1967, No.260, verso). There is a sheet of sketches for the two girls at the Vanderbilt Art Gallery, Nashville, a finished sketch at the National Gallery of Canada, Ottawa (ibid., No.270) and a full-size nude study at the Royal Academy (exh. Arts Council 1979, No.48).

An anonymous wood-engraving was published in the *Illustrated London News* on 24 May 1851 (p.463).

M.W.

JOHN EVERETT MILLAIS

35 Mariana 1850–1
Inscribed 'JMillais 1851' (initials in monogram)
Oil on panel, $23\frac{1}{2} \times 19\frac{1}{2}$ (59.7 × 49.5)
First exh: R.A. 1851 (561)
Ref: R.A. 1967 (30)
Makins Collection

An illustration to Tennyson's poem of the same title, the following lines from which were given in the catalogue when the work was first exhibited at the R.A. in 1851:

She only said, 'My life is dreary,
 He cometh not,' she said;
She said, 'I am aweary, aweary,
 I would that I were dead!'

The idea for the poem comes from Shakespeare's *Measure for Measure*. Mariana is a character who has for five years been living a lonely life in a moated grange, after being rejected by her fiancé Angelo when her marriage dowry was lost in a

shipwreck. She still loves Angelo, who becomes the severely legalistic Deputy to the Duke of Vienna, and longs to be reunited with him. In the play this eventually comes about, but neither Tennyson nor Millais gives any clue that such a happy ending might be in store.

Mariana, working at some embroidery, stands and wearily stretches her back. The stained-glass windows in front of her show the Annunciation. The fulfilment the archangel brings the Virgin Mary emphasises by contrast Mariana's deep frustration. Millais copied them, changing their shapes, from windows in the Chapel of Merton College, Oxford, using the scaffolding on which John Hungerford Pollen was painting the Chapel ceiling (see Anne Pollen, *John Hungerford Pollen*, 1912, p.268). The heraldic stained-glass design seems to be the artist's own invention. The snowdrop represents 'consolation' in the language of flowers. It is also the birthday flower for 20 January, St Agnes' Eve, when maidens supposedly have visions of their lovers. It comes up in that connection in another Tennyson poem, 'St Agnes' Eve', which Millais also later illustrated (No.200). The motto above, 'In coelo quies', means 'In Heaven there is rest' and obviously refers to Mariana's wishing she were dead. The mouse in the lower right corner of the picture is presumably Tennyson's mouse that 'Behind the mouldering wainscot shriek'd, | Or from the crevice peer'd about'. The miniature altar in the background, decorated with a little triptych and the same silver caster that features in 'The Bridesmaid' (No.37) and 'St Agnes' Eve', suggests that Millais was also thinking of Tennyson's other poem on the same theme, 'Mariana in the South', in which Mariana desperately prays to the Virgin Mary.

As a subject ultimately from Shakespeare, No.35 was a kind of follow-up to Millais' 'Ferdinand Lured by Ariel' (No.24). It may also have been conceived as complementary to Holman Hunt's *Measure for Measure* subject, 'Claudio and Isabella' (No.45). Being from Tennyson as well gave it a certain topicality, since he was in November 1850 made Poet Laureate. Tennyson was himself keen that Millais should illustrate his work. Coventry Patmore told William Michael Rossetti that Tennyson had heard that Millais was painting 'The Woodman's Daughter' (No.32) from Patmore's poem and said 'I wish he'd do something from me' (P.R.B. Journal, October 1850, Fredeman, p.72).

According to the P.R.B. Journal (ibid.), the work was started before Millais left London in early June 1850 to begin 'The Woodman's Daughter' at Oxford. On page 2 of the 'Combe Scrapbook', however, Thomas Combe notes that he had only 'just begun' it on 23 September: 'He intended [two days previously] to have gone to Merton to paint the upper part of the east window in the chapel (the annunciation) in his picture which he has just begun of the dejected Mariana' (AM). He was by that date staying at Combe's house in the quadrangle of the Clarendon Press in Oxford, and J.G. Millais says that the view through the window in No.35 shows part of Combe's garden (I, p.109). This is hardly faithful to the poem, in which the view from Mariana's casement is over 'glooming flats' relieved only by a solitary poplar tree.

Millais returned from Oxford to London on 12 November. By 30 December he was buying silk and velvets to use as props, the latter presumably for Mariana's dress (J.G. Millais, I, pp.93–4). By 10 February 1851 the work was 'nearly completed' and already purchased from him for £150 by Henry Farrer, the dealer who had bought 'Christ in the Carpenter's Shop' (No.26) (ibid., I, p.99). Farrer sold it to B.G. Windus.

Some time after the artist's death, it was restored by Holman Hunt at the request of the then owner, Henry Makins, because

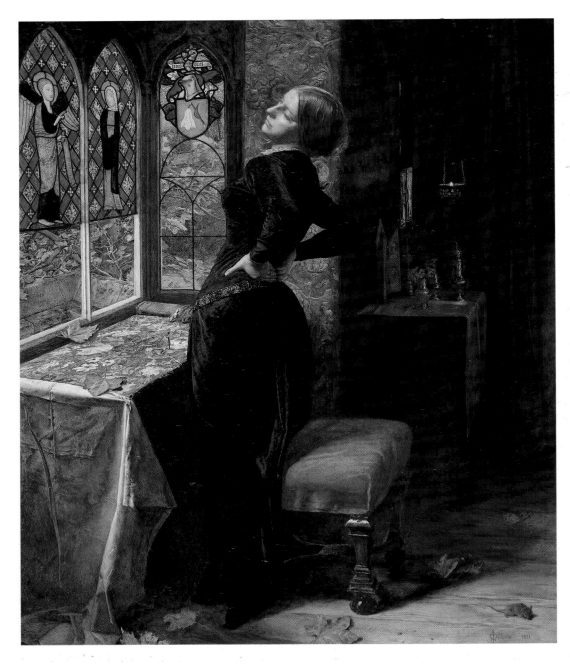

35

it had 'gone dull' (letter from Hunt to Morland Agnew, 2 July 1909, HL, quoted Lutyens 1974, pp.89–91).

The pose of Mariana is adapted from a stretching figure in a sketch for an unidentified subject at Birmingham City Art Gallery (exh. Arts Council 1979, No.45). The same figure occurs in two other drawings at Birmingham (exh. R.A. 1967, Nos 258–9) and the untraced drawing repr. J.G. Millais, I, p.105. What seems to be the earliest sketch specifically for No.35 is also at Birmingham (exh. R.A. 1967, No.260). There is another sketch in pen and ink at the Victoria and Albert Museum (ibid., No.263), a tracing probably used to transfer the stained-glass window design of the Annunciation onto the panel in the collection of Sir Ralph Millais, Bt, and an oil sketch for the whole composition in the Makins Collection (exh. R.A. 1967, No.31).

M.W.

WILLIAM HOLMAN HUNT

36 Valentine Rescuing Sylvia from Proteus 1850–1
Inscribed 'W. HOLMAN HUNT 1851. Kent'
Oil on canvas, arched top $38\frac{3}{4} \times 52\frac{1}{2}$ (98.5 × 133.3)
First exh: R.A. 1851 (594)
Ref: Liverpool 1969 (19)
Birmingham Museum and Art Gallery

No.36, Hunt's first exhibited work on a Shakespearian theme, was not accompanied by a quotation from *The Two Gentlemen of Verona* (Act V, Scene iv) in the 1851 Royal Academy catalogue. Hunt chose instead to integrate text and image, by having the following passages from this scene of the play inscribed on the spandrels of the frame: on the left: 'Valentine. Now I dare not say | I have one friend alive; thou would'st disprove me | Who

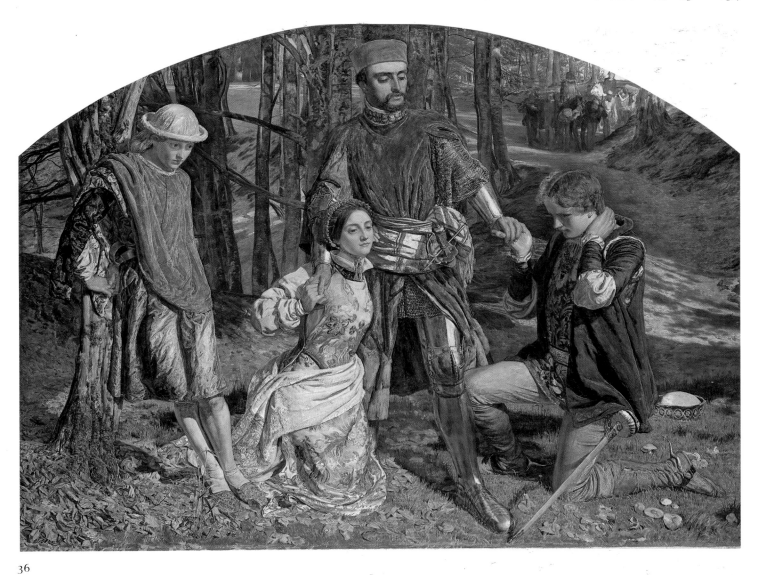

36

should be trusted now, when one's right hand | I've [*sic*, a mistake for 'Is'] perjured to the bosom? Proteus. | I am sorry I must never trust thee more | But count the world a stranger for thy sake'. Valentine's disillusionment with Proteus, whom he had considered 'complete in feature and in mind, | With all good grace to grace a gentleman' (Act II, Scene iv), stems from his having just foiled his best friend's attempted rape of Silvia (as Shakespeare spells her name in the play), Valentine's beloved. The clasped hands of the two men, however, reveal the scene to be one of reconciliation, and the right spandrel is inscribed: 'Proteus. My shame and guilt confound me | Forgive me Valentine if hearty sorrow | Be a sufficient ransom for offence, | I tender it here; I do as truly suffer | As e'er I did commit'.

The theme of struggle and conflict continues that of Hunt's last two exhibited works (Nos 17, 25), but the focus of No. 36 is on the psychological conflicts arising from betrayal of trust, blind lust masquerading as love at first sight and assailing innocence, and, in the tormented and disguised figure of Julia, nervously playing with the ring Proteus gave her as a pledge of his devotion (Act II, Scene ii), unrequited love and sexual jealousy. The underlying theme, and one that Hunt had often treated (e.g. Nos 9 and 163), is that of parental opposition to young love: this has driven Silvia to the forest in the first place in search of the banished Valentine. Her father, the Duke of Milan, forms part of the group in the right background, and this is an essential element in the composition: it points towards the forthcoming reconciliation between father and child which brings the play to a happy conclusion.

Hunt's decision to paint a scene from *The Two Gentlemen of Verona* may have been influenced by Augustus Egg's 1849 Royal Academy exhibit 'Launce's Substitute for Proteus's Dog' (Leicester Museum and Art Gallery), which Hunt, in his essay on Egg in the *Reader* of 6 June 1863, praised as 'sparkling and brilliant, like the wit of "The Two Gentlemen of Verona" itself' (p.557). The pencil study of the four protagonists (Coll. Mrs Burt, exh. Liverpool 1969, No.115, repr.) must date from before 27 September 1850, when Millais, in a letter to Hunt, mentioned a projected trip to 'the forest' (HL). The pen and ink compositional design (British Museum, exh. 1969, No.116, repr.) was also completed before Hunt went down to Knole Park, near Sevenoaks, as the P.R.B. Journal of October 1850 makes clear (Fredeman, p.73). The way in which Julia leans against a large tree trunk in the pen drawing may have been influenced by Millais' drawing of December 1849 for 'The Woodman's Daughter' (Yale Center for British Art, New Haven, repr. in Christie's sale catalogue of 19 June 1979, lot 192).

The cheque for 'A Converted British Family' (No.25),

enclosed in Millais' letter of 27 September, enabled Hunt to go to Knole in mid-October with a far larger canvas than any he had yet attempted, and a letter of 27 October to J.L. Tupper includes a self-portrait sketch of Hunt at work on No.36, surrounded by deer and sheltered by an umbrella from the driving rain (HL). By this date Hunt had been joined by Stephens and D.G. Rossetti (see No.142 and Doughty & Wahl, I, pp.94–5) and had, despite the weather, begun painting the foreground and tree trunks. The landscape, however, took much longer than anticipated, and Hunt was unable to return to London before mid-November (Fredeman, p.82). Parts of the foreground, such as the fungi and dead leaves, were further worked on in the studio, as the P.R.B. Journal of 2 December 1850 reveals (ibid., p.84).

The winter of 1850–1 was largely devoted to painting in the figures, and on 10 December W.M. Rossetti noted that a change in the position of Silvia was imminent (ibid., p.86); Hunt may have originally intended to depict Valentine pulling Silvia back from Proteus' advances, as in the two preparatory drawings. The change of pose altered the focus of the painting from violent recrimination to reconciliation: the struggle is just past, leaving a trail of evidence in Proteus' hat, which has tumbled off on to the grass, as well as in the trodden ground and uprooted fungi in the foreground. The position of Julia's head, in profile in both drawings and in the small oil sketch in the Makins Collection (exh. 1969, No.20), was altered to three-quarters face in No.36, enabling Hunt to dramatise more successfully her conflicting emotions. The change may partly have been made to obviate comparisons between this figure and that of the boy in 'The Woodman's Daughter' (No.32), a painting also destined for the 1851 Academy.

According to W.M. Rossetti, James Lennox Hannay sat in early March 1851 for the head of Valentine (Fredeman, p.89 and see the preparatory study of the head in the Makins Collection, exh. 1969, No.117). The model for Proteus was, in the early stages, James Aspinal, and the wet white technique was used for the heads of both Valentine and Proteus, their hands, and the brighter costumes (Hunt 1905, I, pp.237, 246, 276). Valentine's hat and leg armour were based on two plates from Bonnard's *Costumes Historiques*, volume two: 'Victor Pisani' (Plate 89), as Roger Smith has demonstrated (p.35), and, in the foot armour and position of the leg in No.36, 'Gaston de Foix' (Plate 64). Hunt presumably consulted the coloured copy of Bonnard in the British Museum Print Room, for Pisani's crimson hat and scarlet coat are transposed in Valentine's orange/red hat and crimson tunic. According to Hunt's letter of 17 June 1887 to the *Pall Mall Gazette*, which defended the swords from charges of archaeological anachronism, the costumes of Julia and Proteus were made to his own design (Hunt 1913, II, 390–1), as was that of Silvia (Diana Holman-Hunt, *My Grandfather, His Wives and Loves*, 1969, p.76).

Lizzie Siddal, who had already modelled for 'A Converted British Family' (No.25), could not be prevailed upon to sit for the figure of Silvia until the spring of 1851 (Hunt 1905, I, pp.238–9). She had been deeply offended the previous September when Hunt and Stephens had introduced her to Tupper as Hunt's wife (Doughty & Wahl, I, p.92), and she could hardly have been mollified when Ruskin, in his letters to *The Times* of 13 May and 30 May 1851 in defence of the much-abused Pre-Raphaelite exhibits at the Royal Academy, criticised the commonness of feature of Silvia as the only weakness in the picture (Ruskin, XII, pp.323, 325).

In late August Hunt repainted the head of Silvia and some other parts (Hunt 1905, I, p.280 and Doughty & Wahl, I,

p.103) before sending No.36 to the Liverpool Academy, where, on 3 November amid great controversy, it was awarded the £50 prize (letter of this date from the Secretary of the L.A. to Hunt, JRL).

As early as 10 May 1851 Ruskin had asked Coventry Patmore to ascertain the price of No.36, as he had a purchaser in mind (Basil Champneys, *Memoirs and Correspondence of Coventry Patmore*, 1900, II, p.288). His advocacy, together with the publicity surrounding the Liverpool award, did finally secure an offer of '100 guineas and a picture of *young Danby's*' (Ruskin to John James Ruskin, 19 January 1852; Ruskin, XII, p.xlvii) from Francis McCracken, which Hunt accepted on 24 November 1851 (J.G. Millais, I, p.142). McCracken had not at that time seen No.36; it was eventually sent to him in August 1852, for he was paying Hunt in small instalments, the last of which was cashed as late as November of that year (Hunt to F.G. Stephens, Fairlight, n.d., mid-August 1852, BL).

J.B.

JOHN EVERETT MILLAIS

37　**The Bridesmaid**　1851
Inscribed 'JEM|1851' (initials in monogram)
Oil on panel, 11 × 8 (27.9 × 20.3)
First exh: *Inaugural Loan Collection*, Leeds Art Gallery, 1888 (264)
Ref: R.A. 1967 (33)
Fitzwilliam Museum, Cambridge

The artist himself referred to No.37 as 'The Bridesmaid' (see letter from T.R. Harding to the Fitzwilliam at the time he

37

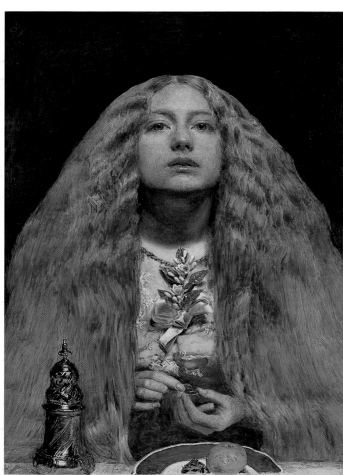

presented the work, 1889) but it has also been known, incorrectly, as 'The Bride' and 'All Hallow's E'en'. Superstition has it that a bridesmaid who passes a piece of the wedding cake through the ring nine times will have a vision of her future lover. The subject may have come out of Millais' concern with the marriage scene in 'The Eve of the Deluge' (see No.171) but as an image of maiden love-yearning, it is more closely akin to 'Mariana' (No.35). The orange blossom at the girl's breast is a symbol of chastity, and the 'orange' theme is ingeniously taken up in the fruit on the dish and the colour of the hair. The silver caster is the same one as in 'Mariana' and the drawing 'St Agnes' Eve' (No.200).

The work was finished by 15 January 1851 (see J.G. Millais, I, p.94). The model is identified in the P.R.B. Journal as a Miss McDowall (9 February 1851). Both Spielmann (p.146) and J.G. Millais (I, p.150) give her as Mrs Nassau Senior but almost certainly wrongly.

Its first owner was probably B.G. Windus. He definitely had it by 6 March 1855, when Ford Madox Brown saw it at his house (Surtees 1981, p.125).

M.W.

FORD MADOX BROWN

38 'The Pretty Baa-Lambs' 1851, 1852–3, 1859
Inscribed 'F. MADOX BROWN 1851–59'
Oil on panel, 24 × 30 (61 × 76.2)
First exh: R.A. 1852 (1291)
Ref: Liverpool 1964 (21)
Birmingham Museum and Art Gallery

The artist's first painting of figures in sunlight out-of-doors. Begun in 1851 at his home at Stockwell, when he was full of enthusiasm for the P.R.B. pure white ground, and completed in five months 'of Hard Labour' between April and September. He wrote of it in his diary of 1854, filling in a gap in his entries: 'The baa lamb picture was painted almost entirely in sunlight which twice gave me a fever while painting. I used to take the lay figure out every morning & bring it in at night or if it rained. My painting room being on a level with the garden, Emma sat for the lady & Kate for the child. The Lambs & sheep used to be brought every morning from Clappam common in a truck. One of them eat up all the flowers one morning in the garden where they used to behave very ill. The back ground was painted on the common. The medium I used was Robersons undrying copal (Flake White)' (Surtees 1981, p.76). He retouched the head early in 1852, 'being dissatisfied with it'. A pencil study for Emma holding the baby Catherine (Katty, who had been born in November 1850) is in family ownership.

Whilst emulating Millais' and Hunt's successful outdoor landscape backgrounds and their brilliant white grounds, this picture is significantly different in that, unlike their practice, the figures themselves are set in the open air and painted in the same atmospheric envelope as their surroundings with the most exciting exploration of colours and shadows (discussed at length by Staley, pp.26–30). It should be compared with Holman Hunt's 'Hireling Shepherd' (No.39) for its cooler bluish shadows and pinker flesh tints. This was not Madox Brown's first attempt at landscape and carefully observed summer sky (see 'Windermere', No.13), nor at motherhood in simple domesticity (for example 'The Infant's Repast' of 1848, also an eighteenth-century costume piece, and the concurrent

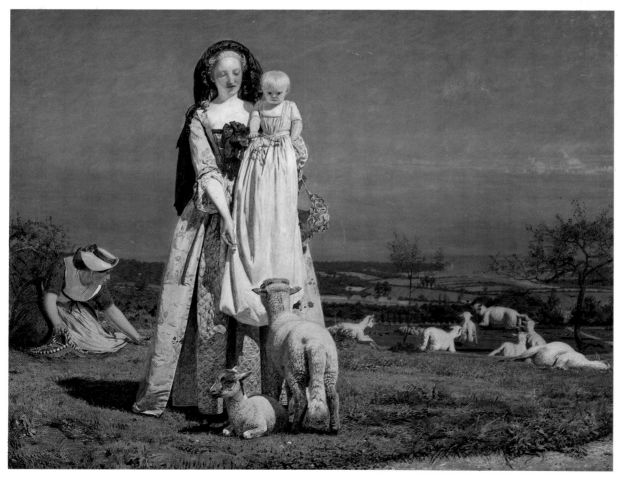

38

'Waiting', both however in interior settings). Initially, however, the landscape was less prominent, giving the woman and child more vertical dominance against the sky, and the vivid grassy foreground is scumbled and without the meticulous finish of the Pre-Raphaelites. Holman Hunt describes it as having had a low horizon with a few cottages in the distance (Hunt 1905, II, p.96: borne out by the small replica painted at Hampstead in 1852, now in the Ashmolean Museum). The view of fields and estuary beyond the sheep was added later in a much more delicate technique after a longer experience with painting landscape and may, as Allen Staley has suggested, represent a view of Southend, taken from a small landscape begun there in 1848 and retouched on the spot some time in 1858 (now lost): in that case this part would presumably have been done in the studio in 1858–9.

At the 1852 R.A. it was barely visible and carpingly criticised. In spite of the childlikeness of its title it was supposed to contain a hidden meaning, and according to Hueffer (p.84) blasphemy and catholicism were suspected. Seen at a distance in the notorious octagon room this might have been suggested by the Madonna-like pose of the mother, in radiant light, with her child on her arm and a lamb in immediate attendance, whilst the servant girl gathered the flowers of the field. The *Art Journal* commented: 'All that can be seen and understood of this picture is the minute finish of the figures . . . but such is the general animus of the work that it is impossible to apprehend its bent. When it is remembered that it is painted by the author of the admirable Chaucer picture of last year, it cannot be otherwise accredited than a facetious experiment upon public intelligence'.

It was again unsold, but towards the end of the year Francis McCracken of Belfast asked to see this picture along with Rossetti's 'Annunciation' (No.22, which he bought). Madox Brown eventually agreed and in early February 1853, McCracken commented: 'I am unwilling to say anything about the *lambs* until I have them before me a couple of days – the *detail* is beautiful, but I cannot understand the *summer heat* [the new title given it by Madox Brown], and the bluish [?] green of the ground, or the purplish tone of the sky – I would say that strong sunlight would make the ground more of a *yellow tone* – one of the distant jumping lambs is surely somewhat too active in spring . . . never did lambs in *this* country make such a bound . . . pray explain to me how you account for the colour of the grass and the sky, and also if it is the moon which appears or the *sun*. Altogether it is a beautiful painting and so is the *Annunciation*' (FMBP). He did not buy it. The artist had continued to work at it, giving it about ten days in 1852, probably for the Newcastle Exhibition, and about five weeks in 1853, and it was exhibited at Glasgow in 1854 but still without success in achieving a sale.

It remained with the artist until 1859 when it was the first purchase by a new patron, James Leathart, an industrialist of Newcastle, probably introduced by William Bell Scott, who paid 120 guineas. Madox Brown planned to send it off 'as soon as I have finished putting some touches to it as my rule is when a picture goes – In the course of time seeing a work constantly one becomes aware of certain imperfections which it is natural to wish to put right before parting with definitely'. He also had the flat altered as it had covered up one end of the picture, spoiling the composition. 'The lady's mouth among others was a part I intended touching', he wrote later, 'and I hope I have improved it'. It was to be lent that year to the Liverpool Academy Exhibition and at this time Madox Brown was still calling it 'Summer Heat', 'which is', he wrote, 'seriously the subject. However, the old quaint title of the Pretty Baa Lambs still pleases me best and as we have neither of us now much to lose by the wrath of the public, if you like it can retain it' (UBC/LP).

He reaffirmed his intention in his 1865 catalogue, while acknowledging the furore of discussion on Pre-Raphaelitism at the time of its exhibition: 'Hung in a false light, and viewed through the medium of extraneous ideas, the painting was, I think, much misunderstood . . . At the present moment, few people I trust will seek for any meaning beyond the obvious one, that is – a lady, a baby, two lambs, a servant maid, and some grass. In all cases pictures must be judged first as pictures – a deep philosophical intention will not make a fine picture'.

M.B.

WILLIAM HOLMAN HUNT

39 The Hireling Shepherd 1851–2
Inscribed 'Holman Hunt. 1851 – Ewell'
Oil on canvas, $30\frac{1}{16} \times 43\frac{1}{8}$ (76.4 × 109.5)
First exh: R.A. 1852 (592)
Ref: Liverpool 1969 (22)
City of Manchester Art Galleries

No.39 was exhibited at the 1852 Royal Academy accompanied by the following quotation in the catalogue from Edgar's song in *King Lear*, Act III, Scene vi:

Sleepest or wakest thou, jolly shepherd?
 Thy sheep be in the corn:
And, for one blast of thy minikin mouth,
 Thy sheep shall take no harm.

It was Hunt's first work to be shown in a frame whose design amplified the subject – in this case incorporating ears and sheaves of corn.

Despite the title and the motto from *King Lear*, the 1852 critics tended to concentrate on the representation of nature in No.39, and many years later Hunt endorsed their approach: 'my first object was to pourtray a real Shepherd and Shepherdess . . . sheep and absolute fields and trees and sky and clouds instead of the painted dolls with pattern backgrounds called by such names in the pictures of the period' (Hunt to unidentified correspondent, ?F.W. Farrar, draft fragment, n.d., c.1890s, JRL).

Hunt went down with Millais to Surrey in late June 1851 in search of a suitable landscape, and settled on a site in the Ewell meadows, looking north towards the fields of Ewell Court Farm (Cloudesley S. Willis, *A Short History of Ewell and Nonsuch*, 1931, p.83). Although the direction of the shadows in No.39 suggests an early morning scene, we know from Millais' letter of 2 July to Mrs Combe that Hunt generally worked on his canvas from 8 a.m. until the early evening (J.G. Millais, I, p.119). The landscape itself was Hunt's first priority, and he used the wet white technique for the blossoms of the foreground marsh-mallows and elecampane plants (Hunt 1905, I, p.276). Attention to detail on such a scale was time-consuming, and it was not until 31 October that Millais was able to report to W.M. Rossetti: 'Hunt has finished to day all the landscape part of his picture' (Lutyens 1974, p.5). The sheep took up many daylight hours in November and early December; unsurprisingly, these proved to be intractable models who sometimes had to be held down by servants (J.G. Millais, I, pp.130–2, 142). Hunt finally returned to London on 6 December (ibid., I, p.143), a white patch on his canvas having been left for the addition of the figures (Hunt 1905, I, p.284).

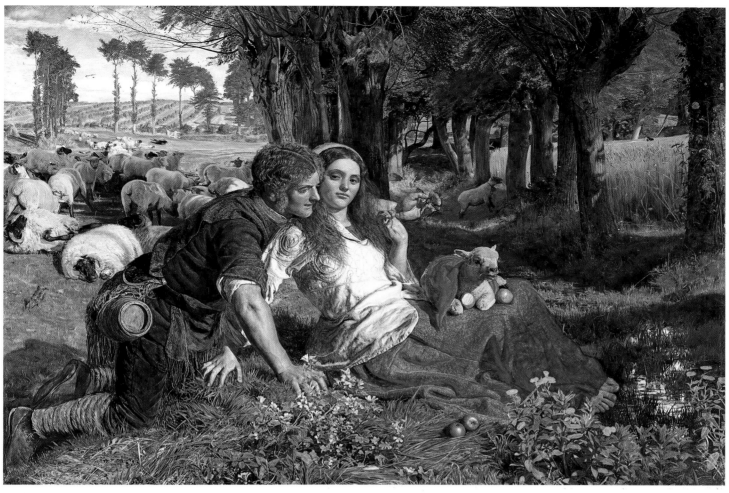

39

The drawings for these (Coll. Mrs Burt, exh. Liverpool 1969, No.122; The Makins Collection, ibid., No.123; The National Gallery of Victoria, ibid., No.124) are fairly conventional, and give little indication of the nature of the rustics in No.39, whose sunburnt complexions provided fuel for the 1852 reviewers. The *Athenaeum* of 22 May suggested that the ruddiness was in part attributable to 'over-attention to the beer or cyder keg' (p.581), and, indeed, No.39 can be taken as a sermon on the dangers of intemperance (cf. No.9). There is, moreover, a specific social allusion to the abuse of truck: the barrel slung from the shepherd's waist refers to the very common practice of supplying beer to field workers in lieu of pay. One of the models for the shepherd was Child, a professional who sat to Hunt in January 1852 (Millais to Hunt, 9 January 1852, HL), while Emma Watkins, a local Ewell girl nicknamed 'the Coptic', posed for the shepherdess.

'The Hireling Shepherd' and 'Ophelia' (No.40) were 'hung pendant, not together' at the 1852 exhibition, and were generally praised by the Academicians themselves (Hunt to Combe, 10 May 1852, BL). Maclise drew Hunt's work to the attention of the eminent naturalist W.J. Broderip (Hunt to Woolner, 10 September 1852, British Library), and in late July Broderip not only offered Hunt the full asking price of 300 guineas, to be paid in instalments (Hunt 1905, I, p.321), but agreed to the artist's request to retouch the work (Broderip to Hunt, 27 July 1852, JRL). Hunt immediately set about repainting the head of the shepherdess from Emma Watkins,

before receiving any remuneration, but was unhappy with the result (Hunt to W.M. Rossetti, 3 August 1852, UBC/AP, to F.G. Stephens, 19 August 1852, BL, and to Woolner, 10 September 1852, British Library). He again secured the services of the Coptic the following December, when No.39 was returned to enable the artist, with the assistance of F.G. Stephens, to work on the small oil sketch (Hunt to Stephens, 15 January 1853, BL; The Makins Collection, exh. 1969, No.23); and only then was he satisfied with the repainting (Hunt to Lear, 31 December 1852, JRL).

The title of No.39 adds a specifically Christian dimension to Shakespeare's 'jolly shepherd', as it has connotations of the good, as opposed to the hireling, shepherd (John 10. 11–14); in this sense the sheep can be taken as a symbol of Christ's flock, in need of spiritual guidance. In a letter of 21 January 1897 to J.E. Phythian (MAG), Hunt explained his reluctance 'to force the moral' of the painting, as he must have realised that too intellectual an interpretation would deflect attention from the work's sensual, physical qualities. Nevertheless, as the critic in the *British Quarterly Review* of August 1852 remarked: 'the very reflectiveness of Hunt inclines him a little more than might be wished to conceptions of his own having a doctrinal purport' (XVI, p.210), and No.39 can indeed be related to mid-nineteenth century religious controversies.

Before going down to Surrey to paint the background, Hunt had written to Coventry Patmore in mid-May 1851 with a request to borrow his copy of Richard Hooker, stating: 'I am

obliged to read for my next year's subjects much just now' (BL). The Tractarians considered their system of theology to be based on Hooker (Rev. James H. Rigg, *Oxford High Anglicanism and its Chief Leaders*, 1895, p.344), and Dr John Spenser's 1604 Prefix to *Of the Laws of Ecclesiastical Polity* would have seemed particularly apposite in terms of the contemporary divisions within the High and Low parties of the Protestant Church. As Lindsay Errington has demonstrated ('Social and Religious Themes in English Art 1840–60', University of London PhD thesis, 1973, p.302), this could have provided Hunt with his theme, in its attack on sectarianism for alienating 'the pastors from the love of their flocks' (ed. John Keble, *The Works of that Learned and Judicious Divine Mr. Richard Hooker*, 1845, I, p.121).

Soon after his arrival at Kingston, Hunt read Ruskin's 1851 pamphlet *Notes on the Construction of Sheepfolds* (J.G. Millais, I, p.122). This castigated the divisions between Tractarians and Evangelicals for deflecting the clergy from their real task of combating Romanism, a burning issue following Pius IX's decision to restore the Roman Catholic Hierarchy to England, immediately followed by the appointment of Wiseman as Cardinal. Hunt's 1897 explanation of the symbolism of No.39 does seem to echo Ruskin's viewpoint: 'Shakespeares song represents a Shepherd who is neglecting his real duty of guarding the sheep: instead of using his voice in truthfully performing his duty, he is using his "minnikin mouth" in some idle way, he was a type thus of other muddle headed pastors who instead of performing his services to their flock – which is in constant peril – discuss vain questions of no value to any human soul' (MAG). The shepherd is showing his girlfriend a death's head moth, which Hunt interpreted as an emblem of superstition, adding: 'She scorns his anxiety . . . but only the more distracts his faithfulness' (ibid.). The letter did not spell out what the shepherdess represented but Hunt's underlying criticism of the Tractarian tendency to discuss doctrine rather than save souls by practical means suggests Ruskin's Evangelical standpoint as the picture's intellectual source. If this is the case, the shepherdess, attired in scarlet like the recently appointed Cardinal Wiseman, becomes a symbol for the whore of Babylon (Revelations 17) or Roman Catholic Church, with whom the shepherd is flirting at his peril. The lamb, representative of the vulnerable youth of the country, will die from eating the green, unripe apple, an emblem of dangerous knowledge or seemingly attractive yet ultimately poisonous doctrine. The neglected sheep, representative of the bulk of the Protestant Church, are, in this reading, symbols of potential converts to Rome, at risk from being allowed to feed on the corn – indeed three animals in the left middleground have already died in this way. It is hardly surprising that, in 1897, Hunt expressed his reluctance 'to force the moral' of No.39; by that date such allusions would have given the painting an unfashionably didactic dimension. Nevertheless this virtually private religious symbolism does co-exist with an intensely naturalistic rendering of an apparently idyllic midsummer English landscape.

J.B.

JOHN EVERETT MILLAIS

40 Ophelia 1851–2
Inscribed 'JMillais 1852' (initials in monogram)
Oil on canvas, top corners rounded,
30 × 44 (76.2 × 111.8)
First exh: R.A. 1852 (556)
Ref: R.A. 1967 (34)
Tate Gallery

Driven out of her mind by the murder of her father by her lover Hamlet, Ophelia drowns in a stream. The episode is described in Act IV, Scene vii of *Hamlet* by the hero's mother, the Queen:

> There is a willow grows aslant a brook,
> That shows his hoar leaves in the glassy stream;
> There with fantastic garlands did she come,
> Of crow-flowers, nettles, daisies and long purples,
> That liberal shepherds give a grosser name,
> But our cold maids do dead men's fingers call them;
> There, on the pendent boughs her coronet weeds
> Clambering to hang, an envious sliver broke;
> When down her weedy trophies and herself
> Fell in the weeping brook. Her clothes spread wide,
> And, mermaid-like, awhile they bore her up;
> Which time she chanted snatches of old tunes,
> As one incapable of her own distress,
> Or like a creature native and indued
> Unto that element; but long it could not be
> Till that her garments, heavy with their drink,
> Pull'd the poor wretch from her melodious lay
> To muddy death.

Shakespeare was an immensely popular source of subjects for Victorian painters and Millais had already based a major picture on *The Tempest*, 'Ferdinand Lured by Ariel' (No.24). Pictures of Ophelia were practically a regular feature of the R.A. exhibitions and it was in the same year as No.40 that Arthur Hughes showed his version of her death scene, which is now in Manchester City Art Gallery.

No.40 contains dozens of different plants and flowers painted with the most painstaking botanical fidelity and in some cases charged with symbolic significance. The willow, the nettle growing amongst its branches and the daisies near Ophelia's right hand, associated respectively with forsaken love, pain and innocence, are taken from Shakespeare's text. The purple loosestrife in the upper right corner is probably intended for the 'long purples' in the text, although Shakespeare actually meant a different flower, the early purple orchid. The pansies Millais shows floating on the dress in the centre may come from the scene shortly before Ophelia's death, Act IV, Scene v, where she mentions pansies among the flowers she has gathered in the fields. The pansy can signify both 'thought' and 'love in vain'. In the same scene she speaks of violets that 'withered all when my father died', an image that draws on the association of violets with faithfulness – although they can also symbolise chastity and the death of the young. Millais undoubtedly had one or more of these meanings in mind when he gave Ophelia a chain of violets around her neck. The roses near her cheek and at the edge of her dress, and the field rose on the bank, may allude to her brother Laertes' calling her 'rose of May', also in Act IV, Scene v. The rest of the plants and flowers are Millais' rather than Shakespeare's. The poppy next to the daisies is a symbol of death and the faded meadowsweet on the bank to the left of the purple loosestrife can signify 'uselessness'; the pheasant's eye near the pansies and the fritillary floating between the dress and the water's

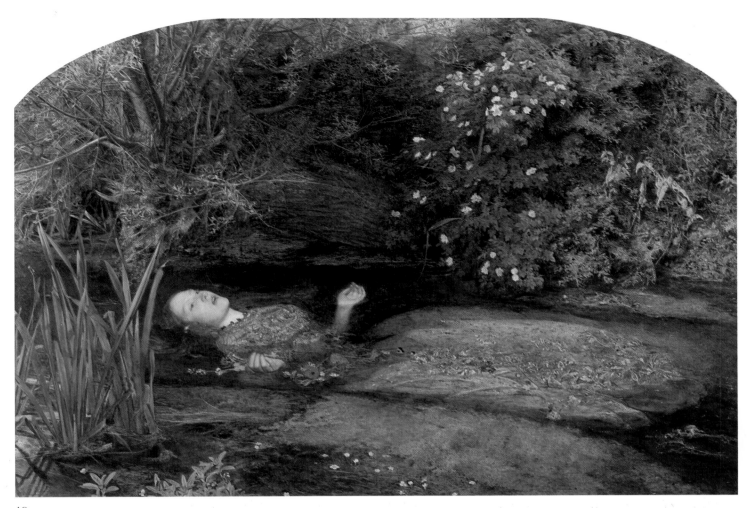

40

edge are both associated with sorrow; and the forget-me-nots at the mid-right and lower left edges of the composition carry their meaning in their name. According to Tennyson, Millais added some daffodils at the last minute but the poet pointed out that they were inconsistent with the summer flowers else-where in the work and he removed them (Allingham 1907, p.379). Tennyson said Millais just 'wanted a bit of yellow' but daffodils can mean 'delusive hope', which would certainly have made them appropriate for this subject. Even without the daffodils, the flowers in 'Ophelia' are unlikely to have been in bloom simultaneously, which is not surprising in view of the length of time Millais spent painting them.

The robin in the upper left corner may refer to one of the snatches of songs Ophelia sings in Act IV, Scene v: 'For bonny sweet Robin is all my joy'.

Immediately to the left of the forget-me-nots at the right edge, there is a configuration of light and shade vaguely resembling a skull. This common *memento mori* could here refer both to Ophelia's death and the famous graveyard scene that follows (Act V, Scene i). The idea of hinting at a skull through apparently random shapes may have something to do with Holman Hunt's 'The Hireling Shepherd' (No.39), painted at the same time, where the shepherd is showing the skull-like markings on a 'death's-head' moth.

When looking for a suitable location for his picture, Millais asked the painter John Linnell if he knew of any 'small deep river with willows overhanging the banks' at Under River, near Sevenoaks (A.T. Story, *The Life of John Linnell*, 1892, II,

p.26). But the spot he finally chose was near Ewell in Surrey, where his friends the Lemprière family lived, on the Hogsmill River. He had begun work on the background by 2 July 1851, when he wrote to Mrs Thomas Combe from lodgings he had taken with Holman Hunt a couple of miles away on Surbiton Hill: 'I sit tailor-fashion under an umbrella throwing a shadow scarcely larger than a halfpenny for eleven hours, with a child's mug within reach to satisfy my thirst from the running stream beside me. I am threatened with a notice to appear before a magistrate for trespassing in a field and destroying the hay; likewise by the admission of a bull in the same field after the said hay be cut; am also in danger of being blown by the wind into the water, and becoming intimate with the feelings of Ophelia when that Lady sank to muddy death, together with the (less likely) total disappearance, through the voracity of the flies. There are two swans who not a little add to my misery by persisting in watching me from the exact spot I wish to paint, occasionally destroying every water-weed within their reach. My sudden perilous evolutions on the extreme bank, to persuade them to evacuate their position, have the effect of entirely deranging my temper, my picture, brushes, and palette; but, on the other hand, they cause those birds to look most benignly upon me with an expression that seems to advocate greater patience. Certainly the painting of a picture under such circumstances would be a greater punishment to a murderer than hanging' (J.G. Millais, I, pp.119–20).

Hunt recalls that the first section to be executed was what he calls the 'willow-herb' on the bank, presumably the purple

loosestrife. Millais used a porcelain palette that could be wiped completely clean, avoiding accidental adulterations of his colours, and, especially with the flowers, painted on to a wet white ground (Hunt 1905, I, pp.262–4, 276–7). For Hunt's sketch of his friend at work on No.40, see Hunt 1913, I, p.190.

By September Millais had moved to new lodgings at Worcester Park Farm, closer to the place where he was working. Hunt, who was painting the background to 'The Hireling Shepherd', came with him and they were joined by Charles Collins. 'We all three live together as happily as ancient monastic brethren', Millais told Mrs Combe (J.G. Millais, I, p.123). The background to 'Ophelia' was finished in mid-October (Hunt 1905, I, pp.290–2). A late addition to it was a swimming rat, which Millais painted in on 28 October, rubbed out the following day, repainted on 6–7 November and eventually rubbed out for good on the advice of C.R. Leslie (J.G. Millais, I, pp.129–31 and Hunt 1905, I, pp.304–5).

The model for the figure, painted between his return to London from Worcester Park Farm on 6 December and sending-in day for the R.A. exhibition in early April 1852, was Elizabeth Siddal. She posed in a bath full of water kept warm by lamps underneath. According to J.G. Millais (I, p.144), the lamps once went out, she caught a severe cold and her father threatened Millais with legal action until he agreed to pay the doctor's bills. Millais had begun work on the figure, or was hoping to begin shortly, by 9 January 1852, when he wrote to Hunt: 'I recd. a letter from Miss Siddall by which (owing to the death of her brother) it appears she cannot sit to anyone for a fortnight' (HL). The head was finished by 6 March (J.G. Millais, I, p.160). Some time that month Millais wrote to Thomas Combe: 'Today I have purchased a really splendid lady's ancient dress – all flowered over in silver embroidery – and I am going to paint it for "Ophelia". You may imagine it is something rather good when I tell you it cost me, old and dirty as it is, four pounds', and on 31 March he wrote again to Combe that he had 'only to paint the skirt of Ophelia's dress, which will not I think take me more than till Saturday [3 April]' (ibid., I, pp.162–3).

The picture was bought from Millais on 10 December 1851, well before it was finished, by Henry Farrer for 300 guineas (ibid., I, p.151). Farrer was a dealer and already owned Millais' 'Christ in the Carpenter's Shop' (No.26) and 'Mariana' (No.35). He eventually sold 'Ophelia' to the leading Pre-Raphaelite collector B.G. Windus. An engraving, a mezzotint by James Stephenson, was published by Henry Graves in 1866.

Millais seems to have retouched No.40 on at least two occasions. On 25 December 1865 his wife wrote to her father that 'Ophelia is here being retouched' (Bowerswell Papers, PML). According to J.G. Millais (I, p.145), Millais noticed that some of the colour had deteriorated when he saw the work at the 1872 International Exhibition, 'notably the vivid green in the water-weed and the colouring of the face of the figure', and had it back to his studio to restore. And Hunt records his saying some time in the 1880s: 'It is true that lately, when I saw the "Ophelia", some of the foliage had gone quite blue, as I have seen leaves in Dutch fruit paintings changed; but I could put it right in half an hour if the owner would let me take it in hand. Lately, you know, there has been a prejudice against allowing a painter to touch an early work of his, and I have not yet heard from the possessor of the "Ophelia"'. Hunt attributes this colour change to Millais' having used 'chrome green', a mixture of chrome yellow and Prussian blue that tends to lose its yellow (Hunt 1905, I, p.374).

There is a study for the figure of Ophelia in the Pierpont Morgan Library (1973.15, verso), a finished sketch or version

at Plymouth City Museum and Art Gallery (exh. R.A. 1967, No.273) and a study for the head at Birmingham City Art Gallery (ibid., No.272). An oil study for the head was in the B.G. Windus sale, Christie's, 19 July 1862 (77), present whereabouts unknown, and a watercolour version of 1865 is in a private collection.

M.W.

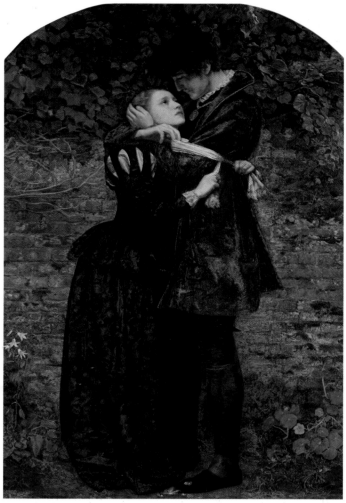

41

JOHN EVERETT MILLAIS

41 **A Huguenot, on St Bartholomew's Day, Refusing to Shield Himself from Danger by Wearing the Roman Catholic Badge** 1851–2
Inscribed 'JMillais 1852' (initials in monogram)
Oil on canvas, arched top, 36½ × 24¼ (92.7 × 62.2)
First exh: R.A. 1852 (478)
Ref: R.A. 1967 (35)
Makins Collection

A scene from the Massacre of St Bartholomew's Day. For several days from 24 August 1572, French Catholics led by the Duke of Guise slaughtered thousands of Huguenots (Protestants) in Paris. No.41 shows a Catholic girl trying to persuade her Huguenot lover to escape the massacre by binding a white cloth around his arm identifying him as a Catholic. He would rather die than deny his faith. The title given above was accompanied in the catalogue of the 1852 R.A. exhibition by the following order issued by the Duke of Guise, quoted from Anne Marsh's *The Protestant Reformation in*

France, or History of the Huguenots, II, p.352:

> When the clock of the Palais de Justice shall sound upon the great bell, at day break, then each good Catholic must bind a strip of white linen round his arm, and place a fair white cross in his cap.

The source of the subject was Meyerbeer's opera *Les Huguenots*, which had been performed at Covent Garden every year since 1848. Exactly this incident takes place in Act V, Scene ii. The Catholic heroine Valentine tries to tie the white cloth on the arm of her lover Raoul de Nangis, he refuses it, she embraces Protestantism, they marry and both die in the massacre. According to W.W. Fenn (see No.14), Millais was inspired to paint the scene after seeing a particularly moving performance with Pauline Viardot as Valentine ('Millais and Music: Some More Memories', *Chambers's Journal*, v, 1902, pp.822–5).

The painting was begun in 1851 during the time Millais spent with Holman Hunt at Worcester Park Farm (see Nos 39–40). Hunt (1905, I, pp.283–5, 289–91) and J.G. Millais (I, pp.136–8) both describe its genesis. Millais originally intended to paint simply an illustration to the line 'Two lovers whispering by a garden wall' from Tennyson's poem 'Circumstance'. Hunt felt this was too lightweight, lacking both drama and moral significance; Millais eventually agreed, remembered the white cloth incident from *Les Huguenots* and adopted it for his picture. The date of their discussion may have been 16 October, when Millais writes in his diary of having 'Sat up till past twelve and discovered first-rate story for my present picture' (J.G. Millais, I, p.125), although the earliest known reference specifically to the Huguenot subject is in a letter to Mrs Thomas Combe of 22 November (ibid., I, pp.134–6). The painting of the background seems to have been under way before the subject was fixed and the same diary entry refers to his working on the nasturtiums in the lower right corner. The diary (I, pp.127 ff.) contains many notes on Millais' progress with the background – 20 October: 'Finished flowers after breakfast, after which went out to bottom of garden and commenced brick wall'; 21 October: 'Painted from the wall'; 23 October: 'Painted on the wall'; 27 October: 'Painted on the wall'; 29 October: 'After breakfast, began ivy on the wall'; 30 October: 'dug up a weed in the garden path and painted it in the corner'; 31 October: 'Painted ivy on the wall'; 4 November: 'superintended in person the construction of my hut – made of four hurdles, like a sentry-box, covered outside with straw'; 5 November: 'Painted in my shed from ivy'; 8 November: 'Painted in my hut, from the ivy, all day'; 11 November: 'Painted ivy'; 17 November: 'Painted at the ivy'; 18 November: 'Painted ivy'; 19 November: 'painted ivy'; 20 November: 'Worked at the wall'; 24 November: 'Painted on brick wall'; 29 November: 'having nearly finished the wall, went on to complete stalk and lower leaves of Canterbury-bell in the corner'; 3 December: 'still at dandelions and groundsel'; 4 December: 'Painted the ground'; 5 December: 'This day hope to entirely finish my ivy background. Went down to the wall to give a last look'. The following day he returned to London.

Some of the plants and flowers in the work were probably chosen for their meanings in the 'language of flowers'. Ivy can stand for 'friendship in adversity' and Canterbury Bell for 'constancy' or 'faith'. Though apparently included before the subject was chosen, the nasturtiums could at least fit the theme, signifying 'patriotism' and here perhaps the Huguenot's loyalty to his religion.

The model for the head of the Huguenot was Arthur Lemprière, the 15- or 16-year old son of William Charles Lemprière, a close friend of the artist's family who lived at Ewell, near Worcester Park Farm, although the body may have been partly painted from a professional model called Child. The female model was the famous beauty Anne Ryan but with her dark hair made blond. Millais had begun the figures by 9 January 1852, when he wrote to Thomas Combe: 'The whole of this day I have been drawing from two living creatures embracing each other' (J.G. Millais, I, p.155). On the same day he told Holman Hunt: 'I was very anxious to see you tonight as I have entirely recomposed the lover design and wished to hear your opinion upon it . . . Child is going to sit for me – he said that he was engaged to you but I have had the audacity to make him come here tomorrow night' (HL); and on 26 January: 'I have rubbed twice out the head I have been commencing from young Lemprière' (HL); then in a letter of 20 February: 'I have today rubbed out two days work the legs of the Huguenot. I very nearly completed them but am not in the least clear as to their quality . . . The young lady I hoped could have sat to me for the girl is going to have an operation performed on her throat . . . Would you kindly get me (if you shd. go in the country Sunday) some similar ivy creepers to those against the door from which you took those you have. I want them for Chiswick the framemaker to cast for a frame he is going to make for the lovers. Choose some with a slight curve such as this [sketch]' (HL). The female figure was finished last. On 6 March Millais wrote to Mrs Combe that 'the Huguenot is very nearly complete, the Roman Catholic girl is but just sketched in. I am waiting for a young lady who has promised me to sit for her face. She is going to undergo an operation on her throat (something to be cut away) which will prevent her doing so for a fortnight or more' (PC, quoted J.G. Millais, I, p.160). He told Mr Combe that the work was complete in a letter of 31 March (ibid., I, p.162). Mrs Combe had borrowed some lace for him, presumably for the girl's cuff (ibid., I, p.164).

No.41 was immensely popular at the 1852 R.A. exhibition and very favourably reviewed. Its success may have been due in part to its anti-Catholic implications – this was a time of religious paranoia in England over the 'papal aggression' – although most reviewers emphasised how good-looking the characters were rather than any significance in the subject (see, for instance, *The Times*, 14 May 1852). It was sent to the Liverpool Academy later the same year and awarded a £50 prize. Both the picture and, implicitly, its copyright were bought by the dealer D.T. White just before 31 March 1852 (J.G. Millais, I, p.162). He paid Millais £250 and a further £50 after publishing the engraving, a mezzotint by T.O. Barlow, in 1856. He sold the picture to B.G. Windus some time before 18 April 1852. 'I am glad that it is in so good a collection', Millais reflected, 'but cannot understand a man paying perhaps double the money I should have asked him' (ibid., I, p.164).

Four sketches in the collection of Raoul Millais (repr. ibid., I, pp.130–1, 136–7) show that Millais at one stage considered including the figures of some priests or monks. Sketches closer to the final composition are in Liverpool City Libraries (Hornby Library, exh. Arts Council 1979, No.49), Birmingham City Art Gallery (exh. R.A. 1967, Nos 275–6 and 278), and the collections of R.A. Cecil, Esq. and Oliver Barclay, Esq. A study for the girl's head was formerly in the collection of H.M. Langton (ibid., No.277). An oil version was sold at Sotheby's, 19 March 1979, lot 24 (ibid., No.36) and there are water-colour versions made by Millais in the 1860s at the Cecil Higgins Art Gallery, Bedford, and the Fogg Art Museum.

An anonymous wood-engraving was published in the *Illustrated London News*, 8 May 1852, p.369. An early copy by Charles Compton is in a private collection.

M.W.

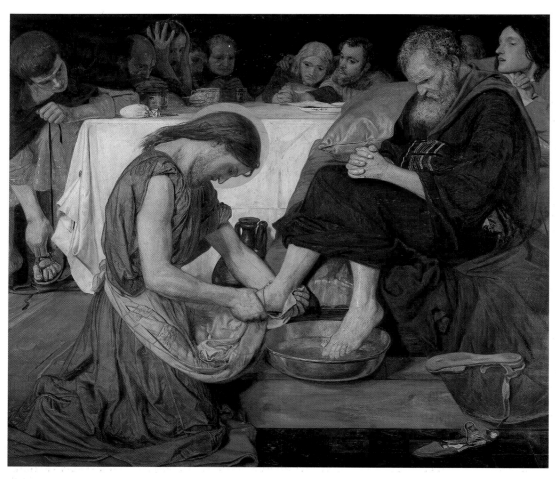

42

FORD MADOX BROWN

42 Jesus Washing Peter's Feet 1851–6
Inscribed 'F. Madox Brown 1851–56'
Oil on canvas, 46 × 52¼ (117 × 133.5)
First exh: R.A. 1852 (463)
Ref: Liverpool 1964 (23)
Tate Gallery

Exhibited with a quotation from St John 13. 4–5, 15:

> He riseth from supper and laid aside his garments; and
> took a towel and girded himself. After that he poureth
> water into a basin, and began to wash the disciples' feet,
> and to wipe them with the towel wherewith he was
> girded. For I have given you an example, that ye should
> do as I have done to you.

In a compressed space and seen from a low viewpoint, as if the
spectator were also kneeling, Jesus kneels drying Peter's feet,
his head bent in humility, while Peter too bows his head, his
pose relaxed into troubled resignation after saying 'thou shalt
never wash my feet'; Judas looks on as he re-ties his sandal, his
purse of silver lies on the table with the few dishes (the blue and
white china perhaps deliberately anachronistic to suggest
timelessness). The close-up view and rugged earthy detail of
the washing of the feet intensifies the immediacy of the
dominant figures; the frieze of watchful heads receding into the
shadows behind the table forces back concentration upon
them.

This departure from the accepted idea of a Last Supper was
further noteworthy by the semi-nudity of Jesus in the original
format, which Madox Brown had read into the text (although
he had consciously retained tradition with the nimbus, the
relative ages of SS Peter and John and the (?)red hair of Judas).
He explained his purpose long afterwards to a new patron:
'originally . . . the figure of Jesus was girt about the waist with a
towel for all clothing in illustration of John XIII 4, 5 . . . I send
you a little sketch I made at the time to give you an idea of how
it looked – of course with all the flesh painting the picture was
fuller of artistic material: but for which I should never have
chosen a subject without a woman in it – of course the
intention is that Jesus took upon himself the appearance of a
slave as a lesson of the deepest humility & with the gold nimbus
round his head the impression was very striking. People
however could not see the poetry of my conception, & were
shocked at it, & would not buy the work – & I getting sick of it
painted clothes on the figure' (letter to Charles Rowley, 3 May
1876, UBC/AP; partly quoted in E. Mills, *The Life and Letters of
Frederic Shields*, 1912, pp.183–4).

A religious theme may have suggested itself to Madox Brown
as a result of seeing Millais' controversial 'Carpenter's Shop'
(No.26) and Holman Hunt's 'Druids' (No.25) at the 1850 R.A.
He had, however, much earlier in his career designed an oil
sketch of the 'Ascension of Our Saviour', and a cartoon of
'Adam and Eve' for a Houses of Parliament Competition.

The picture was begun sometime after Michaelmas (29
September) 1851. On 9 November Madox Brown accom-

panied W.M. Rossetti on a visit to Millais and Holman Hunt at Worcester Park Farm while they were painting their backgrounds for 'Ophelia' and 'The Hireling Shepherd' (J.G. Millais, I, p.131, and Hunt 1905, I, pp.277–8). He had already been impressed earlier that year by their use of a white ground (Hueffer, p.77) and on this occasion was introduced to their special secret of the wet white ground, which he employed for this picture with the idea of intensifying the luminosity. There is no diary for this period but retrospectively, in 1854, he summed up his work on it: 'Twelve days before sending in the Christ picture [to the R.A.] I had given it up in despair, none of the heads being yet done . . . I afterwards took up the Christ again at the instigation of Millais & painted the heads of Peter, Christ & John (this one the only one laid in) also *all the other figures of* apostles, in ten days, & sent it in. This picture was painted in four months the flesh painted on *wet white* at Millais' lying instigation, Roberson's Medium, which I think dangerous like Millais' advice' (Surtees 1981, p.76). The hasty finishing at this time is still evident particularly in many of the heads, and Holman Hunt (1905, I, p.319) is firm in pointing out the not yet full assimilation of their technique and the streaky application of the transparent flesh tints without blending while still wet.

A combination of professional models and friends was used for the heads. Not all identities given by Hueffer (pp.81–2) are certain: F.G. Stephens sat for the head of Christ (see the study, No.177) though Hunt says also Elizabeth Siddal; and the heads of the Apostles from left to right are given as, 1, Judas, from a model, who according to Stephens' recollection in 1898 (see Surtees 1981, p.83n) was a bricklayer's labourer; 2, William Michael Rossetti, already going bald; 3, supposedly William Holman Hunt, who stated (1905, I, p.306) that both he and his father sat for first drafts of two apostles 'in tone' which were later altogether repainted, and who deprecated the lack of exact likenesses in the P.R.B. manner, but Stephens thought D.G. Rossetti and definitely not Hunt; 4, not given by Hueffer and by Stephens identified as Holman Hunt's father (looking not unlike him in a watercolour copy to which Stephens may have been referring, but not in this oil); the hook nose and general features recall three possibles to mind: W. Bell Scott as a young man, Thomas Seddon (as suggested by Virginia Surtees), and the artist's favourite model, Maitland; 5, Hueffer gives Holman Hunt's father, but, though middle-aged, not particularly like Hunt's own drawing of his father a year or two later, while with some resemblance to W. Bell Scott in later life, the sitter identified by Stephens; 6, the blond youth: according to Hueffer, C.B. Cayley, friend of the Rossettis; 7, D.G. Rossetti; 8, no face visible; 9, St John: both Hueffer and Stephens thought was from Christina Rossetti, but she told the latter that she did not sit; W.M. Rossetti thought Walter Deverell, with which Stephens did not agree, but certainly resembling him; 10, St Peter: unknown and may well therefore be a professional model.

Its bad hanging at the R.A., 'so as to shine all over', did not increase the artist's regard for Academicians, and it was given a bad press. The *Athenaeum* review, quoted by Hueffer (who attributed it to Frank Stone A.R.A., enemy of Pre-Raphaelitism), ridiculed the pervading purple tones and the action of Peter's feet: 'Certainly', it added, 'the copper utensil . . . seems filled with either blood or raspberries undergoing the jam process. The Apostles . . . appear to take no interest . . . appearing rather bored – so much has the artist rejected the conventional attitudes usual on this occasion'. The *Art Journal* found it altogether too insistent on a coarse realism: 'We care not whether the exhibitor affect pre- or post-Raffaellism, but we

contend that coarseness and indignity in painting are always objectionable. It is possible that the feet of Peter were not like those of the Apollo, but it is also probable, if severe truth be insisted upon, that they were proportionable to the figure. It is not the office of Art to present us with truths of an offensive kind'.

It was not sold and was retouched during the 1850s for various other exhibitions. In 1854 the artist was considering clothing the Christ, adding aureoles, and more religious feeling: 'William & Gabriel Rossetti in particular require veneration to be added to them', he noted, perhaps with a certain humour (*Diary*, 17 August). He scraped at it but not until June 1856 were the legs of Jesus cut out (to save them), new canvas inserted and the figure clothed; Peter's mantle was retouched and also his dress 'which had faded owing to Brown's Rose Madder' (27 July). He had bother with Jesus' legs below the knees, which he had made too long, and this part seems out of proportion and without adequate depth in front of the platform. At Liverpool in 1856 it gained the £50 prize for which he was desperate to alleviate his finances, and at the Manchester Art Treasures exhibition of 1857 (again retouched) it was bought by T.E. Plint, who had just previously commissioned 'Work', for 200 guineas. It was again retouched in 1858 when a small watercolour variant was made (Tate Gallery). In 1876 he painted a further watercolour following the original form, for Charles Rowley of Manchester. The oil was, according to Hueffer (p.437, copying the lost Account Books), retouched in 1876 and 1892. In 1893 it was presented by subscribing artists and friends to the proposed National Gallery of British Art.

The frame, which is a combination of motifs designed and used by both Madox Brown and Rossetti in the 1860s, was ordered from Joseph Green in 1865 for a later owner (FMBP).

M.B.

43

CHARLES ALLSTON COLLINS

43 **May, in the Regent's Park** 1851
Inscribed 'CACollins | 1851' (initials in monogram)
Oil on panel, 17½ × 27⁵⁄₁₆ (44.5 × 69.4)
First exh: R.A. 1852 (55)
Tate Gallery

The title can be taken to refer both to the month and the pink hawthorn, or May, shown in blossom in the left foreground. No.43 is a view eastwards across Regent's Park, probably taken from a window in Collins' family home at 17 Hanover

Terrace. As a distinctively modern, urban landscape it is a kind of setting much used in the novels of the artist's brother, Wilkie Collins. When first exhibited, it was adversely criticised for its emphasis on minutiae and seeming lack of composition. The *Athenaeum* declared that 'The botanical predominates altogether over the artistical, – and to a vicious and mistaken extreme. In nature there is air as well as earth, – she masses and generalizes where these fac-simile makers split hairs and particularize' (22 May 1852, p.582). Nevertheless, Collins did sell it, apparently to a Mr Crooke of Cumberland Terrace on the other side of the park, for £100 (see *The Tate Gallery 1978–80*, pp.11–12).

M.W.

ALEXANDER MUNRO

44 Paolo and Francesca 1851–2
Inscribed 'Alex. Munro | Sc.1852'
Marble, 26 × 26 9/16 × 20 7/8 (66 × 67.5 × 53)
First exh: in plaster, Great Exhibition, 1851 (Sculpture Court, No.41); in marble, R.A. 1852 (1340)
Birmingham Museum and Art Gallery

Precise documentation of the origin and development of this work before its appearance (in plaster) at the Great Exhibition of 1851 is not available. A slight pencil sketch of a couple sitting together exists in a notebook formerly belonging to Munro; this is datable to 1850–51. In a contemporary studio photograph showing the completed 'Paolo and Francesca' as we know it, there is a small model visible at the base of the work showing the couple in a much more energetic pose – Paolo has (quite literally) got his leg up behind Francesca who looks agitated. This at least shows that the existing form of the composition was not the only one Munro had in mind. Seeing the plaster model at the Great Exhibition, W.E. Gladstone commissioned a version in marble, which is No.44. The original plaster model was acquired by Sir Walter and Lady Trevelyan and installed in the Main Courtyard at Wallington in Northumberland. A plaster cast of the work was given by Munro to D.G. Rossetti, who had it in his studio by early January 1853.

The question of the relationship between Munro's work and the Rossetti versions of the same subject is a vexed one. We know from the P.R.B. Journal that Rossetti conceived a tripartite design involving Paolo and Francesca by mid-November 1849, and that he was working on the Paolo and Francesca kissing section as a single unit on 23 December 1849 (Fredeman, pp.27, 35). He executed his first completed watercolour of the tripartite design, apparently in a hurry, in 1855 – by which time, of course, he had been in possession of his cast of Munro's work for over two years.

Among the surviving Rossetti drawings that deal with Paolo and Francesca, it is possible to date Surtees No.75E to *c*.1846–8 on stylistic grounds, while Surtees No.75C could well be a December 1849 drawing on the same grounds. The vexed drawing is Surtees No.75D, bearing four different studies of the couple, one of which is particularly close to Munro's finished design. Stylistic comparisons do not help date this drawing precisely, as analogues for the four sketches can be found dating from 1849 (Surtees No.116B), ?1857 (Surtees No.100B) and 1865–6 (Surtees No.186F) – this latter is particularly comparable to the sketch closest to Munro's design. These two last datings could fit in with Rossetti's versions in watercolour of 1855 (No.215 here), 1862 (Surtees No.75 R.I) and 1867 (Surtees No.75 R.2). There certainly

seems little doubt that the drawing of Paolo and Francesca (Surtees No.75A) inscribed by Rossetti 'to his friend Alex. Munro' dates from Rossetti's 1855 work on the subject. It is not even impossible that the location of four of Rossetti's Paolo and Francesca drawings (particularly Surtees No.75A) in Munro's collection could have been an acknowledgement of a debt of Rossetti's to Munro.

The question must remain at least open. In the light of the uncertainties of the evidence it is clearly debatable to claim that Rossetti must be the origin of Munro's design through the inspiration of his personality and because he was *tout court* the animating genius of the whole Pre-Raphaelite movement. What is quite obvious is that both the majority of Rossetti's Paolo and Francesca designs and Munro's sculpture hark back to the fundamental source for the treatment of the subject over the previous sixty or more years, that is, Flaxman's line engraving of 'The Lovers Surprised' from his illustrations to Dante of 1793. This was a source for artists as various as Ingres, Delacroix, Koch, Dyce and (in sculpture) Félicie de Fauveau. Flaxman's reputation was still high in England around 1850: he was one of the Pre-Raphaelite Immortals and a personal hero of Munro's.

Munro's style as seen here is distinctive. While the sentiment of the subject is emphasised, particularly by the intensity of expression in Paolo's face, the modelling generally is scarcely naturalistic, let alone realistic. The smoothness of surface, the generalisation of planes, if not artificial, could possibly be called 'decorative' in the best sense of the word – this is certainly how William Bell Scott characterised Munro's work after his death. This suggests a possible origin for this aspect of Munro's style, in the decorative sculpture he worked on at the Houses of Parliament from 1844. It is difficult to find a similar style to Munro's in the fine art sculpture of his time, whereas there is a close similarity between his decorative, 'early' looking work (the latter adjective is used by W.M. Rossetti in the P.R.B. Journal) and the figure sculpture executed in association with A.W. Pugin, both at the Houses of Parliament and elsewhere. This 'Gothic' style in sculpture is equivalent to 'Pre-Raphaelitism' in painting.

B.R.

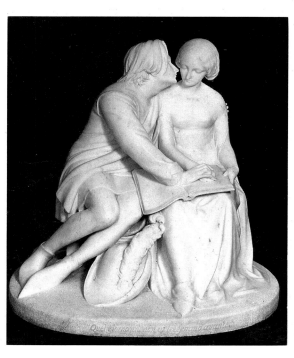

44

WILLIAM HOLMAN HUNT

45 Claudio and Isabella 1850–3, retouched 1879
Inscribed 'W. HOLMAN HUNT 1850|LONDON–' and
'Claudio|Julliete'
Oil on panel, 30½ × 18 (77.5 × 45.7)
First exh: R.A. 1853 (44)
Ref: Liverpool 1969 (17)
Tate Gallery

Exhibited at the 1853 Royal Academy, with a quotation in the catalogue from *Measure for Measure*, Act III, Scene i:

> *Claud.* Ay, but to die, and go we know not where;
> * * * 'Tis too horrible!
> The weariest, and most loathed worldly life,
> That age, ache, penury, and imprisonment
> Can lay on nature, is a paradise
> To what we fear of death.

This passage in the play immediately follows on from the quotation inscribed on the frame, which sums up the moment No.45 portrays: 'Claudio. Death is a fearful thing. Isabella. And shamed life a hateful'. The subject, conceived by May 1850 (see No.167), relates to Hunt's 1848–50 Royal Academy exhibits (Nos 9, 17 and 25) in its focus on the confrontation of good and evil at a moment of crisis.

The long gestation of No.45 is explained by the fact that Augustus Egg, who commissioned the painting, 'had always approved of my putting it aside wherever there was an opportunity of doing more pressing work' (Hunt 1905, I, p.338). In May 1850 Egg felt that the amount he could pay for No.45 was derisory, and he gave Hunt the option of selling the work to another buyer once it was completed. Egg's advance of £10 (Hunt 1863, p.517), possibly supplemented by a further £10 which was sent to the artist at Sevenoaks that autumn (Egg to Hunt, n.d., MS, Coll. J.S. Maas, Esq.), enabled Hunt to commence No.45 on a panel 'from a superannuated coach' (Hunt 1905, I, p.215), and by December he was working at the Lollard Prison at Lambeth Palace. Although he did not paint the models *in situ*, he 'made a man stand to adjust the true pitch of tone for the figure' (ibid.). No.45 could only be advanced in the mornings (P.R.B. Journal, 2 December 1850, Fredeman, p.84), as Hunt was also working on 'Valentine rescuing Sylvia' (No.36), which from mid-December onwards took precedence.

Once the 1851 exhibition opened, Hunt was free to return to No.45, writing to Coventry Patmore in mid-May: 'in a fortnight I anticipate finishing it when, I shall be most happy to show it' (BL). Ruskin, following his first letter to *The Times* in defence of the Brotherhood, had expressed an interest in seeing the painting (Basil Champneys, *Memoirs and Correspondence of Coventry Patmore*, 1900, II, p.289). No.45 was not, however, finished as anticipated, and was once again sacrificed in order to complete work for the next year's exhibition.

In May 1852 Hunt worked on 'Claudio and Isabella' in Egg's studio (see Hunt to Combe, 10 May 1852, BL), but the painting was not completed until the winter of 1852–3 (Hunt 1905, I, p.338). Even before the official opening of the 1853 Royal Academy Exhibition, where No.45 was most favourably hung, Egg came to tell Hunt that Lord Grosvenor wished to buy it for 300 guineas. Hunt, however, insisted on Egg securing it for the amount originally offered, a mere sixth of that sum (ibid., I, p.342).

In August 1848 Hunt and Rossetti had compiled a List of Immortals, in which Shakespeare and Jesus Christ were given

45

top ratings (Doughty & Wahl, I, p.42). Hunt's admiration was based on the way in which the plays could be interpreted at a variety of levels (Hunt 1905, I, p.148), and this significantly affected his development of a style of symbolic realism in his pictures, which can also be viewed on more than one plane.

No.45 is on the surface a straightforward illustration of the lines inscribed on the frame, but the viewer's responses are conditioned by Hunt's manipulation of his pictorial resources. Isabella, an upright figure symbolising her rectitude, is bathed in sunlight, and thus linked to the bright outdoors, with its apple blossom in full bloom and view of a church, a reminder of duty and Christian ethics. Her simple white habit is not only true to the play – Isabella belongs to the order of St Clare (I, iv) – but to her nature and purity. On the other hand, Claudio's contorted pose symbolises his troubled mind. He is richly attired in dark colours, and glowers into the corner of his cell which, in its gloominess, images his thoughts. The apple blossom strewn on his cloak and the cell floor was only added in 1879, but according to Hunt's letter of 18 July 1879 to the

then owner, Thomas Ashton, 'it was part of the original idea (JRL). Through the association of the blossom with Isabella, it can be taken as a symbol of Claudio's willingness to sacrifice her virginity to save his own life. Isabella's large hands are placed in a gesture of restraint on Claudio's heart, pointing to the fact that this led to his getting Juliet with child and to his subsequent imprisonment.

Although not present in the original compositional sketch (No.167), the lute in the window of the cell is an important symbolic element. Any viewer might have interpreted the scarlet of its ribbons as an emblem of passion, and linked it to Claudio's crimson jerkin, but the lute itself is endowed with a more specific meaning. It was painted in during Hunt's visits to the Lollard Prison in December 1850 (Hunt 1905, I, p.215), when D.G. Rossetti was working on his drawing from *Richard III*, 'To caper nimbly in a lady's chamber | To the lascivious pleasing of a lute' (Birmingham City Art Gallery, Surtees No.47). The association of the lute with lust represents the harshest view of Claudio's 'sin', but ties in well with Angelo's proposal to Isabella. The fact that the lute is in sunlight, however, suggests that it is not purely a negative symbol. It looks forward to the song 'Take, o take those lips away' in Act IV of *Measure for Measure*, which treats of Mariana's unrequited love for Angelo, and suggests that, through her agency, there will be a solution to the problem confronting Claudio and Isabella.

This reference is, however, too subtle to detract from the essentially dramatic nature of the confrontation, which is heightened by being confined to an enclosed space. The choice of setting was probably influenced by the Pre-Raphaelites' interest in the *Faust* theme. Deverell, who modelled for Claudio (W.M. Rossetti to F.G. Stephens, 10 December 1895, BL), had exhibited 'Margaret in Prison' (untraced) at the 1848 Royal Academy, and Hunt's anchoring of Claudio's manacle to the wall of the cell may be indebted to Plate 29 of Retzsch's illustrations to *Faust* (repr. Vaughan, p.151). *Measure for Measure*, like *Faust*, contains a devil figure – Angelo – and is concerned with similar moral issues.

In the pamphlet issued in 1864 to attract subscriptions for the engraving, the 'deep and noble moral' of No.45 was glossed as 'Thou shalt not do evil that good may come' (Tate Gallery files). Hunt directs the viewer's sympathies to Isabella, in her refusal to become a pawn of Angelo's lust or Claudio's selfishness, and in this respect No.45 looks forward to 'The Awakening Conscience' (No.58).

J.B.

JOHN EVERETT MILLAIS

46 The Proscribed Royalist, 1651 1852–3
Inscribed 'JMillais 1853' (initials in monogram)
Oil on canvas, arched top, 40½ × 28½ (102.9 × 72.4)
First exh: R.A. 1853 (520)
Private Collection

No.46 was commissioned from Millais by Lewis Pocock in May 1852. Pocock was Honorary Secretary of the Art Union of London, an organisation for the collective patronage of art, but seems in this case to have been acting in his own right as a collector. Clearly looking for a subject involving star-crossed lovers like 'A Huguenot' (No.41), Millais and Pocock initially discussed the possibility of his treating a scene from *Romeo and Juliet* (see J.G. Millais, I, pp.163–4). About this time Pocock was buying oil sketches from Holman Hunt of his 'Valentine Rescuing Sylvia from Proteus' (No.36) and 'Claudio and Isabella' (No.45), and he may have had it in mind to assemble a collection of Shakespearean scenes. The subject they finally agreed upon, however, features a pair of lovers from opposite sides in the Civil War. Millais had considered such a subject during the discussion with Holman Hunt that led to 'A Huguenot' the previous year. Like that earlier work, No.46 was inspired by an opera, Bellini's *I Puritani*. The characters correspond to Bellini's unhappy lovers Elvira, a Roundhead, and Arturo, a Cavalier. No scene exactly like the one in the picture occurs in the opera but Arturo is proscribed and the couple do meet secretly in a grove in Act III. *I Puritani* had been performed at Covent Garden, which Millais regularly attended, in 1848, 1851 and 1852. The idea of the Cavalier hiding in an oak tree may have come from the familiar legend of Charles II's having evaded the Roundheads by similar means. Oaks are traditionally emblematic of steadfastness and bravery.

On 9 June 1852 Millais wrote to Mrs Thomas Combe: 'I have a subject I am mad to commence and yesterday took lodgings at a delightful little country inn near a spot exactly suited for the background. I hope to begin painting on Tuesday morning [11 June] and intend working without coming to town at all, till it is done' (PC, quoted J.G. Millais, I, pp.164–5). The inn was The George at Hayes, near Bromley, and the site for the background was by one of the ancient oak trees on West Wickham Common, called 'The Millais Oak' in the late nineteenth century (see photograph, repr. ibid., I, p.166) but no longer identifiable. The artist wrote from Hayes to Mr

46

Combe on a 'Tuesday night', probably 12 October: 'I am but just returned to this place, after having spent a bedridden week at Gower Street where I went to be nursed in a tremendous rheumatic cold I caught painting out of doors. I am well again now, and worked away today as usual at my background which I hope to finish in two or three days at most, when I shall return to town for good' and two days later in the same letter: 'I am waiting here for one more sunny day to give a finishing touch to the trunk of a tree which is in broad sunlight' (PC, quoted J.G. Millais, I, pp.171–2). On 21 October he told Holman Hunt: 'I have just returned [to London] having finished my background yesterday. Upon my word it is quite ridiculous. I have been 4 months about a wretched little strip of uninteresting green stuff' (HL).

The model for the girl was originally to have been Effie Ruskin, according to a letter from her to her mother of 27 March 1853 (Lutyens 1967, p.38), but she was replaced by Anne Ryan, who had sat for 'A Huguenot'. Millais wrote to Holman Hunt on 11 November: 'Today I have been drawing the girl's figure in the landscape. Yesterday it was too small, and today too large. Tomorrow she comes again when I hope to get it between the two sizes* / *I don't mean her legs' (HL). Her costume was painted from a dressed lay figure, at least partly on location at the oak according to J.G. Millais (I, p.172). A letter to Mr Combe of 14 March 1853 mentions that Millais' mother was 'sewing away at costume for a gay cavalier I am painting' (PC). The head of the cavalier was painted last of all, from Arthur Hughes, who wrote an account of the sittings: 'I went, and sat five or six times. He painted me in a small back-room on the second floor of the Gower Street house, using it instead of the regular studio on the ground floor because he could get sunshine there to fall on his lay figure attired as the Puritan Girl. In the studio below he had taken the picture out of a wooden case with the lid sliding in grooves – to keep all dust from it, he said – and after my sitting he used to slip it in again. When I saw the picture I ventured to remark that I thought the dress was quite strong enough in colour; but he said it was the fault of the sun; that the dress itself was rather Quakery, but the sunshine on it made it like gold' (J.G. Millais, I, p.175).

There are studies for the girl at the Ashmolean Museum, Oxford (Combe Scrapbook, p.1), Birmingham City Art Gallery (584'06 and 585'06) and the Victoria and Albert Museum (D1445–1903), a study for the Cavalier's head at the Royal Academy (exh. R.A. 1967, No.287) and a watercolour version of 1864 at the Fogg Art Museum. A finished sketch or version in oil was sold at Christie's, 28 January 1972 (155).

A mixed method engraving by W.H. Simmons was published jointly by Gambart and Henry Graves in 1858.

M.W.

WILLIAM HOLMAN HUNT

47 New College Cloisters, 1852 1852
Inscribed 'Whh Oxford | 1852' (initials in monogram)
Oil on panel, 14 × 9 5/16 (35.5 × 23.6)
First exh: R.A. 1853 (554)
Ref: Liverpool 1969 (21)
Principal and Fellows, Jesus College, Oxford

Hunt first stayed in Oxford as the guest of Thomas and Martha Combe at Christmas 1851, and was invited to return in June for Commem. (Hunt 1905, I, pp.311–6). Thomas Combe commissioned him to paint No.47, a portrait of John David

47

Jenkins, M.A. (1828–76), before his second visit, as the following letter reveals: 'The result of some consideration of the best manner of doing Mr Jenkins is that he be painted as if walking in the cloisters in his gown, with his cap off his head. this requires some consideration, however, as to obtain the proper effect it would be necessary not only that I should be able to make use of some cloister while doing the background, but also while painting the head, as in a place of the kind there would be a light delicate shadow on it, which could not be obtained elsewhere I have another question to submit also. i.e. whether it would be well to have it life size, and this I should like to learn your opinion of before the 3rd of June as it would regulate the dimension of the canvass to be procured' (Hunt to Mrs Combe, fragment, c. late May 1852, BL). Mr Combe presumably wrote back to inform Hunt that he wanted a small oil panel, of similar size to his own portrait by Millais (Ashmolean Museum; exh. R.A. 1967, No.28) and that of William Bennett by Charles Allston Collins (Ashmolean Museum, both repr. in Jon Whiteley, 'The Combe Bequest', *Apollo*, CXVII, 1983, p.303, figs 2 and 3), which he had commissioned in 1850.

John David Jenkins, a native of Glamorgan, went up to Jesus College, Oxford in 1846 and was appointed to a Fellowship three years later. In 1852 he became curate of St Paul's, Oxford, a Tractarian church which Combe had endowed (Alastair Grieve, 'The Pre-Raphaelite Brotherhood and the Anglican High Church', *Burlington Magazine*, CXI, 1969, p.295). The incumbent of the benefice was another Oxford

don, Reverend Alfred Hackman, and the inscriptions on the verso of No.47 indicate that it was painted at his suggestion, possibly as a memento of the sitter who, in 1853, was to leave Oxford to become a missionary in Natal.

During June 1852, when No.47 was painted, Hunt and Jenkins were constant social companions (see Hunt to Stephens, n.d., BL, and to Brown, n.d., HL, which contains a sketch of Jenkins in 'the interior of a college hall' holding the arms of two young ladies while engaging a third in conversation). The presence of the meticulously rendered ivy in the portrait, an emblem of friendship in Victorian flower language, symbolises the relationship between Hunt and Jenkins, who was the only person the artist encountered in Oxford to endorse his 'enthusiastic defence of Tennyson' (Hunt 1905, I, p.316).

It seems likely that Hackman and Combe persuaded Hunt to relinquish the idea of portraying Jenkins walking in the cloisters in his M.A. gown in favour of a portrait stressing his role as clergyman. The only sign in No.47 of Jenkins' status as a member of the University is the crimson neckband of his M.A. hood. His hieratic pose and garments point up the sitter's adherence to Tractarianism: the robes are specifically those of a High Church priest on his way to or from celebrating Communion. Rev. Dr John Rouse Bloxam, Fellow of Magdalen, whom Hunt first met in 1851 (Hunt to the President of Magdalen, *Oxford Magazine*, XXIV, 30 May 1906, p.409) was the first member of the Oxford Movement to revive the practice, depicted in No.47, of wearing a stole of black silk over the surplice (S.L. Ollard, *A Short History of the Oxford Movement*, 1915, pp.162–3), but these vestments were the source of much controversy, and on 5 November 1848 an effigy of a Guy wearing a surplice, cassock and stole had been burnt in Exeter in a 'No Popery' riot (Alastair Grieve, op. cit., p.295).

Hunt's inclusion of the date in the title of No.47 was a further reminder of these issues, and on this level the ivy may, as Andrea Rose pointed out in *Pre-Raphaelite Portraits*, suggest 'the tenacity with which High Church Anglicanism was still gripping Oxford' (1981, p.51). From his first visit to the Combes, Hunt was at the centre of this movement (Hunt 1905, I, p.323), and his decision to paint Jenkins against the background of a cloister may be seen as a reflection of High Church interest in Gothic architecture (cf. ibid., I, p.325) and the revival of ritualistic practices, cloisters being traditionally used for processions on feast days as well as burials.

In addition to his Fellowship at Jesus, Jenkins was Chaplain of New College (information courtesy of Rear-Admiral I.W. Jamieson), and the specific setting of No.47 may, therefore, have been dictated by purely practical considerations. Hunt, however, must have been aware that New College Cloisters were the first to be built in Oxford, through the granting of a papal bull of 1389. Their monastic associations may have appealed to the Pre-Raphaelite in Hunt, recalling the Brotherhood's house-sharing scheme of November 1849 (Fredeman, pp.22–23) as well as the more recent visit to Worcester Park Farm, where the artist lived with Millais and Collins 'as happily as ancient monastic brethren' (J.G. Millais, I, p.123). The cloisters remind the spectator of Oxford's ancient traditions, while the precious gilt-edged Bible Jenkins is holding relates to the High Church revival of ritualistic forms of worship.

'New College Cloisters, 1852' was of course much more than a tribute to the Oxford Movement. Hunt informed Combe, in a letter of 30 April 1853, that it was well placed at the Royal Academy and that he had that morning received an enquiry from 'Mr Lygon. of Magdalen' as to its price. He immediately wrote back to say that it belonged to Combe (BL). Although somewhat overshadowed by the artist's other exhibits (Nos 45

and 48), the work received favourable mentions in the *Illustrated London News* of 14 May (p.388) and, understandably, from W.M. Rossetti in the *Spectator* two weeks later (p.517). Ruskin's verdict was far more gratifying: No.47's brilliant colouring, careful depiction of light, and strong characterisation won over this rabid opponent of Tractarianism, who, according to Hunt's ebullient letter of August 1852 to Combe, 'pronounced the portrait of the Curate to be the best he had ever seen as a specimen of painting, and as, he almost ventured to say, a likeness' (PC).

Jenkins returned from South Africa, where he had been appointed Canon of Maritzburg, in 1858, and in 1865 became Dean of Jesus College. He died at Aberdare, Glamorgan, on 9 November 1876, and on 19 December Hunt wrote to Mrs Combe: 'I never knew a man more pure in mind than Canon Jenkyns – It was a boon to have known him – not less a gain to those who like myself had in so many points different views than to those who could feel a pride in the thought that he added a lustre to their own school of mind' (JRL). By this date Hunt, as the result of his contact with the Anglican Mission in Jerusalem, had become totally disillusioned with any form of missionary activity, and the letter refers to this as well as to his lack of sympathy with the Oxford Movement, of which Martha Combe was an ardent adherent. It is dangerous to attempt to chart an artist's religious beliefs through his pictures, and although No.47, like 'A Converted British Family' (No.25), does contain many allusions to Tractarianism, a good deal of this imagery was probably suggested by Combe and Hackman, if not by Jenkins himself. Hunt was still evolving his own personal brand of Christianity at this period, and Combe's two pictures must be set against 'The Hireling Shepherd' (No.39), which seems to reflect an Evangelical type of concern for deeds rather than doctrine.

No.47 was bequeathed to Jesus College in 1893 by Mrs Combe. There is also a small pencil sketch of the head of the sitter, in the same pose as the painting, which was presented to the College by Edith Holman-Hunt in 1912 (exh. Liverpool 1969, No.121).

J.B.

WILLIAM HOLMAN HUNT

48 **Our English Coasts, 1852 (Strayed Sheep)** 1852
Inscribed 'Whhunt 1852 Fairlt' (initials in monogram)
Oil on canvas, 17 × 23 (43.2 × 58.4)
First exh: R.A. 1853 (534)
Tate Gallery

In June 1852 Hunt wrote to D.G. Rossetti from Oxford of a commission he had been offered before leaving London: 'it was to paint a picture with *sheep* only and I have. of course. been compelled to accept it, 16 inches by 20 inches for £70' (UBC/AP). By 20 July, however, the financial situation had eased, owing to Broderip's offer to purchase 'The Hireling Shepherd' (see No.39 and Doughty & Wahl, I, p.107), and the idea of repeating the group of sheep in that picture for Broderip's cousin Charles T. Maud seemed unbearable. On 27 July Broderip wrote to Hunt asking him to call and meet Maud, and Hunt presumably then persuaded the latter to agree to his painting an original picture rather than a copy (JRL and Hunt 1905, I, p.327).

The parents of Hunt's pupil Robert Braithwaite Martineau

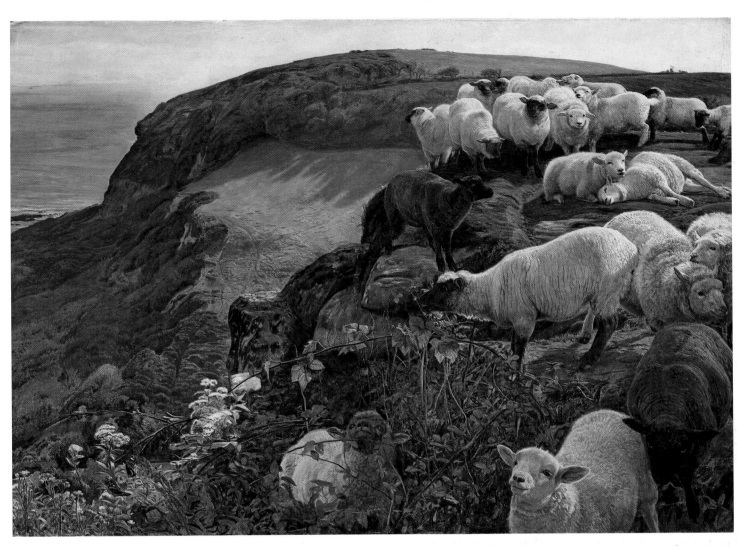

48

lived at Fairlight Lodge, near Hastings, and Hunt had a specific site in this locality in mind for No.48, that of the Lover's Seat, a well-known beauty spot frequented by painters and perched on the cliffs overlooking Covehurst Bay. Hunt joined Lear at Clive Vale Farm, between Hastings and Fairlight, in mid-August 1852, and took his canvas down to the Lover's Seat, from where, facing west, he began to sketch in the outlines of his composition in pencil on the white priming (see Christine Leback Sitwell, 'William Holman Hunt: "Our English Coasts, 1852 (Strayed Sheep)"', *Completing the Picture*, Tate Gallery, 1982, p.58). Hunt's letters to Lear of 5 November 1852 and to Maud of 6 November 1853 make clear that the cliffs, sheep and parts of the foreground vegetation were all painted from different viewpoints (JRL). The butterflies in the left foreground were painted indoors on 1 October 1852 from a live specimen sent to the artist by Miss Orme (Flora Masson, 'Holman Hunt and the Story of a Butterfly', *Cornhill Magazine*, n.s., XXIX, 1910, pp.645–6).

Hunt's letter to Stephens of 19 August 1852 reveals that Maud insisted on the sunlit quality of No.48 (BL), and this created great difficulties as the weather that summer and autumn was stormy. In consequence, Hunt was not able to report finishing 'Strayed Sheep' until 24 November (letter to Lear, JRL). On his return to London Hunt scraped 'out little specks . . . stippling up the same' (letter to Lear, 8 December 1852, JRL), but no major changes were made.

Hunt had obtained Maud's agreement to his changing the nature of the commission without negotiating a higher price for No.48, for which Combe now offered 100 gns. Broderip was also interested in purchasing it, and in March 1853 Maud finally agreed to pay Hunt 150 gns to cover the extra work an original composition had entailed (see Hunt's letters to Lear, 8 December 1852, 24 January 1853 and n.d., between 6 & 13 March 1853, JRL).

Hunt chose to exhibit No.48 at the 1853 Royal Academy with the title 'Our English Coasts, 1852'. In 1860 F.G. Stephens explained that the painting 'might be taken as a satire on the reported defenceless state of the country against foreign invasion' (Stephens, p.23). Fears of an invasion had been generated by press reaction to Napoleon III's autocratic régime, and were in the forefront of Hunt's mind in letters written to Miss Orme on 22 September 1852 and F.G. Stephens on 31 October 1852 (Masson, op. cit., p.643 and BL). The Militia Bill took up a great deal of parliamentary debate in the early summer of 1852, and was published in late May, at the time the commission of No.48 was first mooted. It proposed voluntary enlistment, 'in case of need, to be embodied for the defence of our coasts in aid of the regular army . . . It is denied

by military men that these militia regiments will ever be properly qualified to cope with such troops as we may expect an invading force to be composed of' (*The Times*, 26 May 1852). On this specifically topical level, the strayed sheep can be taken as symbols of the volunteers. Such an allusion must have lost its resonance by 1855, when Hunt sent the painting to the Exposition Universelle and decided to change the title from 'Our English Coasts, 1852' to 'Strayed Sheep'. He may at this point have wished to stress the religious symbolism of No.48, suggesting its relationship to 'The Light of the World' (No.57), his major contribution to the show.

According to the review in the *Illustrated London News* of 14 May 1853 (p.385), the frame of No.48 bore the inscription 'The Lost Sheep'. In addition to the specific political nature of the symbolism the straying flock could be taken in a generalised sense as that of erring mankind, and in a narrower sense as that of Protestants riven by squabbling on points of doctrine. Ruskin had attacked such divisiveness in *Notes on the Construction of Sheepfolds* of 1851, employing the metaphor of Christians as strayed sheep and lamenting the fact that 'Christ's truth' was restrained 'to the white cliffs of England and white crests of the Alps' (Ruskin, XII, p.557). No.48 symbolises fear of invasion rather than papal agression, no longer a burning issue in 1852, but together with Landseer's 'Peace' (repr. Staley, pl.28b), in which sheep are safely disposed on the cliff tops at Dover, Ruskin's pamphlet may have encouraged Hunt to visualise his sheep straying over the cliff.

From its first exhibition the symbolism of No.48 was virtually ignored, however, as critics concentrated on Hunt's treatment of light. It was this that singled out 'Strayed Sheep' at the Exposition Universelle, and which led Ruskin to claim in 1883 that 'It showed to us, for the first time in the history of art, the absolutely faithful balances of colour and shade by which actual sunshine might be transposed into a key in which the harmonies possible with material pigments should yet produce the same impressions upon the mind which were caused by the light itself' (Ruskin, XXXIII, pp.272–3).

J.B.

JOHN EVERETT MILLAIS

49 The Order of Release, 1746 1852–3
Inscribed 'JMillais 1853' (initials in monogram)
Oil on canvas, arched top, 40½ × 29 (102.9 × 73.7)
First exh: R.A. 1853 (265)
Ref: R.A. 1967 (38)
Tate Gallery

A Jacobite rebel has been imprisoned by the English, presumably after the defeat of Bonnie Prince Charlie's army at Culloden on 16 April 1746, and his wife has secured his release. Her expression is ambiguous enough to allow us to wonder whether she may not have paid the price of her virtue, the sacrifice Isabella is refusing to make for her brother's release in Holman Hunt's 'Claudio and Isabella' (No.45). The subject seems to have been Millais' own invention, although as a scene from Scottish history it must owe something to Walter Scott and the countless paintings and illustrations of incidents from his novels that the artist would have seen.

On 23 October 1852 Millais wrote to Thomas Combe: 'Today I am going to the Tower of London to look after a gateway or prison door. I am undecided between two subjects one of which requires the above locality, and the other the interior of a church [?No.70]' (PC, quoted J.G. Millais, I, p.178). By 5 or 6 November he seems to have decided on the present subject but was having difficulty finding an appropriate setting. 'I have been to the Tower of London today, hoping to find some gateway, or prison entrance', he wrote to Holman Hunt, 'but have been disappointed, all the stone work is so begrimed with soot that it is not paintable. I want you to let me know what there is at Lambeth, where you did that prison window to the Claudio and Isabella for Egg. Are there any courtyards or anything fit for a background? Something in the style of Martineau's prison background painted at Battle, which I have seen to day, and which I think *first-rate*' (HL). The Martineau he refers to is 'Picciola', dated 1853, exh. R.A. 1856, now in the Tate Gallery. Apart from the door, No.49 has no indications of a specific setting and was probably painted entirely in the studio.

On 11 November Millais wrote to Hunt about his progress with the figures: 'I am [painting (deleted)] drawing at night from nature a design of a man, woman, child, and dog, (the latter I do without at present). They are all mixed up together in the design, and of course in nature nothing is to be seen of anybody. The child who is in the arms of the woman perfectly obliterates the man (whose head is on the woman's shoulder) as well as her head also. The first child Westall and his wife brought was too large. She seemed so obstinate that she would not do anything I wanted, and when forced, by Westall's superior strength, squalled and foamed at the mouth . . . After an hour's dodging of the neck like a vulture, to catch (or endeavour to catch) something that might suggest, and be useful, the baby fell off to sleep from exhaustion. Then it was that I placed its arms and legs as nearly as I could to appear alive, but to very little purpose, as the little beast would look under the influence of Chloroform. I recklessly made an engagement for all of them to come again next Monday, Tuesday + Wednesday [15–17 November], fancy my courage' (HL). He described further troublesome sittings in a letter to Combe of 16 December: 'I have a headache and feel as tired as if I had walked twenty miles from the anxiety I have undergone this last fortnight. All the morning I have been drawing a dog, which in unquietness is only to be surpassed by a child, both of these animals I am trying to paint daily, and certainly nothing can exceed the trial of patience they incur . . . etc' (PC, quoted J.G. Millais, I, pp.186–9).

A study in the Whitworth Art Gallery (exh. Arts Council 1979, No.56) shows that Millais originally used a different model for the female figure, possibly Anne Ryan who posed for 'A Huguenot' (No.41) and 'The Proscribed Royalist, 1651' (No.46). The head in the final painting is that of the artist's future wife, then Effie Ruskin – though with her auburn hair darkened. Effie had agreed to sit by 6 January 1853 (Surtees 1980, p.9) but does not seem to have done so until March. She was herself Scottish and declared the picture 'quite Jacobite and after my own heart' (see Lutyens 1967, pp.37–9). Westall, a professional model, sat for the male figure, with William Michael Rossetti giving additional sittings for the hands (see Millais' letter to him, 22 February 1853, UBC).

For the tartans, Arthur Hughes remembered Millais' having consulted Robert McIan's *Highland Clans* in the R.A. Library. The man wears Gordon tartan, his child Drummond, presumably the wife's clan. The primroses relate symbolically to the child's youth and establish that the scene is taking place in the spring-time.

Sketches for No.49 at the Victoria and Albert Museum (exh. Arts Council 1979, No.52) and Birmingham City Art Gallery (exh. R.A. 1967, No.285) are inscribed 'The Ransomed' and

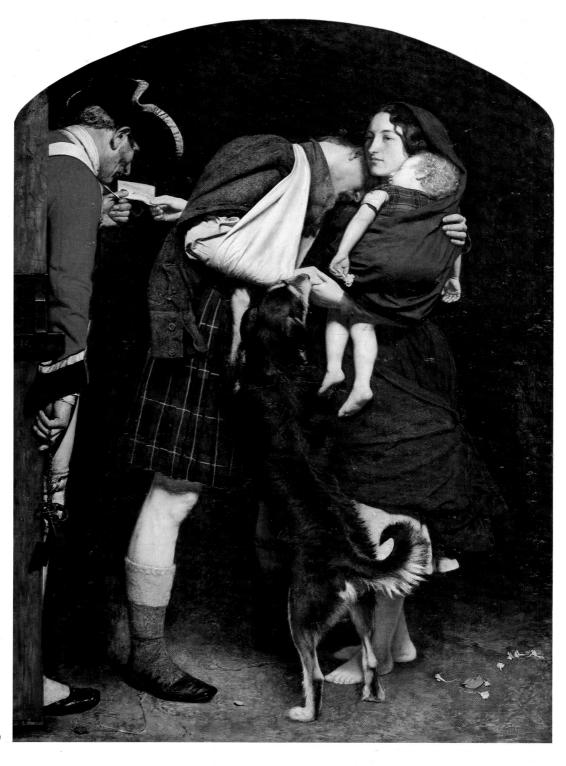

49

'The Ransom'. The latter and another sketch at the Victoria and Albert Museum (exh. Arts Council 1979, No.55) clearly show a purse of money being handed over. The fact that Effie is still referring to the picture as 'The Ransom' as late as 27 March 1853 (Lutyens 1967, pp.38–9) suggests that the change from money to an order of release was a last-minute one. On the document that gives the work its title, the signature is legible as that of Sir Hilgrove Turner, who recognised and encouraged Millais' talent when he was a boy in Jersey.

The picture was bought from Millais for £400 by the lawyer Joseph Arden, apparently through the agency of Thackeray, who knew both men. Arden was also to buy its pendant, 'The Rescue' (No.67). When it was shown at the R.A. exhibition in 1853 the *Illustrated London News* reported that Millais had attracted 'a larger crowd of admirers in his little corner in the Middle Room than all the Academicians put together' (7 May 1853). According to J.G. Millais (I, p.184), a policeman had to be installed in front of it to move spectators on. Two years later it was shown at the Exposition Universelle in Paris and admired by both Gautier and Baudelaire.

On 21 June 1853 Millais sold the copyright of No.49 to the

print publisher Henry Graves for 300 guineas (a copy of the agreement is now in the British Museum). The print, a mezzotint by Samuel Cousins, appeared in May 1856. On 25 October that same year an anonymous wood-engraving was published in the *Illustrated London News* (p.423).

In addition to the preparatory drawings mentioned above, there are sketches at the Ashmolean Museum (exh. Arts Council 1979, No.53), the Victoria and Albert Museum (ibid., No.54), the Royal Academy and the Yale Center for British Art (verso of No.185). There is a finished oil sketch or version in the Makins Collection (exh. R.A. 1967, No.39), a finished sketch or version in pen-and-ink at Plymouth City Art Gallery (exh. Arts Council 1979, No.57) and a watercolour version of 1863, the present whereabouts of which is unknown. An early copy by Charles Compton is in a private collection.

M.W.

50

FORD MADOX BROWN

50 Heath Street, Hampstead 1852, 1855
Oil on canvas, arched top, 9 × 12⅛ (22.8 × 30.8)
First exh: Piccadilly 1865 (50)
Ref: Liverpool 1964 (26)
City of Manchester Art Galleries

Study for the background of 'Work' (No.88), the first subject to be designed while living at Hampstead: set on The Mount, Heath Street, Hampstead, and painted on the spot during the summer of 1852. The viewpoint from the road by the brick wall and railings at the start of The Mount also embraces the winding hill of Heath Street. The arch frames more of the trees and sky and less foreground than in 'Work', where the latter was extended at the expense of the skyline to provide a stage for the figures. The sky is of a softer blue than the intense pitch given to it in the large picture, and the technique is more fluid. Otherwise the details match exactly and were painted afresh on the spot into the large canvas.

Much of this quiet offshoot of Heath Street remains the same. The gate in the brick wall at the left gives on to the present No.6. Beyond this are gate piers to what is now a later building, Heath Mansions. The block beyond this again, with white-walled gates and stable entrance is now Nos 8 and 9 with a flat-roofed garage entrance; there is a similar bollard to that appearing in the railings opposite this. At the far end the facing cottage is now 17 The Mount Square. On the right, on Heath Street itself, the brick pier and wall are between Nos 96 and 98, though higher up the street is now largely shops.

A butcher boy appears in the road where the artist grouped his figures: the study was retouched in December 1855 and January 1856 for Thomas Woolner, when the Madox Browns were living at Fortess Terrace, Kentish Town, and the artist 'had the butcher boy, painted him in Woolner's sketch 8 hours' (Surtees 1981, p.227).

M.B.

FORD MADOX BROWN

**51 An English Autumn Afternoon, Hampstead
– Scenery in 1853** 1852–3, 1855
Inscribed 'F. Madox Brown'
Oil on canvas, 28¼ × 53 (71.7 × 134.6)
First exh: B.I. 1855 (79)
Ref: Liverpool 1964 (28)
Birmingham Museum and Art Gallery

The view is north east over Hampstead Heath towards Highgate, with Kenwood house visible in the far distance at the left, the spire of St Anne's Church, Highgate (built 1852–3) a little further to the right, and a tall chimney in the Gospel Oak area (possibly Linton Buildings, Kentish Town) in the far right distance (identified with the aid of Swiss Cottage local history librarians); the house just visible on the right edge of the picture might be the roof of Carlisle House, which appears on the 1866 survey. In the fields below the houses workers harvest the fruit trees; at the bottom of the garden a woman with a toddler is feeding the chickens; two young people recline on the steep bank in the foreground. The view is now obscured by urban growth.

In June 1852 Madox Brown had moved from his studio in Newman Street to lodgings at Mrs Coates, 33 High Street, Hampstead (a china shop) while Emma finally settled, in 1853, over at North Hill, Highgate. This landscape was the second subject undertaken there and reflects the more tranquil moments of those troubled months, which gave rise also to 'The Last of England' and 'Work' (Nos 62, 88). Topographically the viewpoint must lie in a position at the bottom of the present High Street which lines up correctly with Kenwood and the lie of the land. The house was six doors from The Bird in Hand inn and may reasonably be identified in a position a little lower down from the present Gayton Street and next door but one to an alleyway (the present No.16): in the 1866 survey (published 1870), the gardens correspond closely to the picture.

Undoubtedly No.51 was begun from Mrs Coates' bedroom window, in October 1852, and she being ill and requiring her room, it was put by until the following September, 1853. The artist recorded in 1854 that it 'took me about 6 months was sold at Phillips Auction for 9 guineas to Dickinson [printseller of Bond Street], the frame having cost 4' (Surtees 1981, p.82).

No.51 reveals the fascination with which Madox Brown

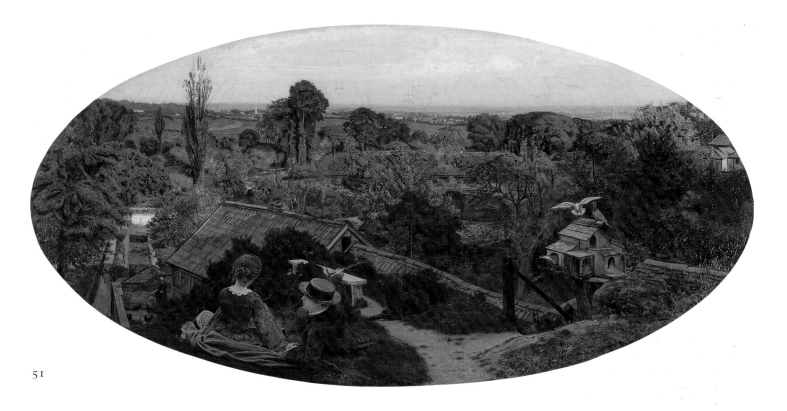

51

examined in detail the unspectacular semi-rural surroundings of his new location. In it he attempted to give to landscape the same importance as his subject pictures and like both 'Work' and 'The Last of England' it celebrates the ordinary and everyday from a middle class viewpoint. Again, the shape is carefully chosen, in this instance the wide oval suggests the full range of the eye from a high viewpoint. The absence of any studies, surviving or recorded, affirms that it was painted direct from the motif.

Except for the two figures acting as a foil there is no apparent concession to artistry. It owes most perhaps to parallel expression in the developing art of photography (and it must be remembered that Roger Fenton, then turning to photography, was his friend), while at the same time it draws on traditional conventions, with a partially shaded foreground and light-reflecting leafy trees and buildings, almost Dutch in feeling: as Staley points out (p.36), it uses a 'plateau' landscape with figures on a high foreground; but here with the importance lying in the landscape itself as the artist has fully evaluated the potential of the actual view. In distinction to the almost impressionistic detail of the autumnal background in Holman Hunt's 'Valentine Rescuing Sylvia' of 1850–1 (No.36), which Madox Brown had so much admired, here the concentration is on the sharp and detailed head-on reflection of low-lying autumnal light on massed banks of foliage in recession.

In his 1865 catalogue Brown wrote of the picture: 'It is a literal transcript of the scenery round London, as looked at from Hampstead. The smoke of London is seen rising half way above the fantastic shaped, small distant cumuli, which accompany particularly fine weather. The upper portion of the sky would be blue as seen reflected in the youth's hat: the grey mist of autumn only rising a certain height. The time is 3PM., when late in October the shadows already lie long, and the sun's rays (coming from behind us in this work) are preternaturally glowing, as in rivalry of the foliage. The figures are

peculiarly English – they are hardly lovers – more boy and girl, neighbours and friends . . .'. This emphatic statement of purpose emphasised his opposition to Ruskin's contemptuous dismissal of 1855, when having seen it at the British Institution, on first meeting Madox Brown at Rossetti's he asked: 'What made you take such a very ugly subject, it was a pity for there was some *nice* painting in it', to which the rejoinder was, simply, 'Because it lay out of a back window' (*Diary*, 13 July). He was also making it clear that he too knew about clouds and their proper subjection to the landscape, and finally, that he did not intend any suggestion of a narrative subject whatsoever.

It had been generally ignored at the 1855 exhibition, and Madox Brown got it back in 1856 for £50 on the advice of Hunt and Rossetti, they 'saying I was sure to sell it again before long' (*Diary*, 8 September). But White, the dealer, would not take it at £150, and the artist continued in his usual fashion to touch at it until selling it, for the same amount, in 1861 to a new patron, George Rae, bank manager of Birkenhead, as his first purchase. At that time he 'improved some rather raw & too vivid patches of colour' (LAG/RP). Rae encouraged him to send it to the International Exhibition in 1862, where after much bickering it was well placed. Only at his 1865 exhibition was its significance as part of his plan of work at that time summarised, in the *Athenaeum* (11 March: ? by F.G. Stephens): 'Mr. Brown does not paint, as many do of necessity, in a commonplace way. Student of nature, he chooses to paint what he sees: this is not always what men, from custom, believe that they see. Be it the blazing July noon of *Work*; the time "twixt night and day" of *The Hayfield*; the fading glories of October in an *English Autumn Afternoon*; the broad ineffable daylight at sea of *The Last of England*; or any of those phases which Mr. Brown has chosen, we recognize at once and in all the keen observation of an independent thinker guiding the skill of an admirable executant'.

M.B.

WILLIAM HOLMAN HUNT

52 **Fairlight Downs – Sunlight on the Sea** 1852–8
Inscribed 'Whh | FAIRLIGHT' (initials in monogram)
Oil on panel, 9 × 12¼ (22.7 × 31)
First exh: *Winter Exhibition*, Gambart, French Gallery
1858 (71)
Private Collection

Hunt wrote to D.G. Rossetti from Fairlight on 22 November 1852: 'I hope to return on Thursday morning, there is only one more mornings work to be done to the sheep picture [No.48]. the other I must spend on a small sketch I began some time ago for the torturer above mentioned: if the weather does not permit this I shall return at once – tomorrow perhaps' (Troxell, p.36). The 'torturer' was Hunt's dentist, and on 30 April 1853 the artist wrote to Combe from Chelsea: 'I have been engaged steadily at the sketches, one for McCracken [No.19] – and the other for the dentist; the last however I have worked out so much, as to make me reluctant to give it up as an acknowledgement of his savage services' (BL). It seems that Hunt had difficulty in finishing 'Fairlight Downs', and it is just possible that he worked on the sheep in July 1853 when he was in Ewell painting the oil sketch of 'The Hireling Shepherd' (The Makins Collection, exh. Liverpool 1969, No.23).

The picture was set aside, and is next referred to in a letter of 19 February 1856 to Millais, written shortly after Hunt's return from the East: Hunt mentions paying Robinson, his dentist, in kind, but 'without being *quite* prepared with the finished sketch he bargained for' (JRL). Hunt may have taken the picture with him to Fairlight in July 1856, but as he was there to recuperate from an attack of fever (see Hunt to W.M. Rossetti, 18 July 1856, UBC/AP) it seems that he was unable to bring the work to completion. It is likely that Hunt cancelled the agreement with his dentist at this point, feeling that the amount of time he was expending on 'Fairlight Downs' rendered the painting too valuable to be given in payment for the treatment he had undergone.

There is no evidence to suggest a further visit to Fairlight between 1856 and 23 February 1858, when W.M. Rossetti asked Hunt to lend something to the American Exhibition of British Art at the Boston Athenaeum, and suggested 'that oil landscape with the glittering sea at Hastings (I believe it is in a finished state)' (MS, Iowa University Library). Hunt wrote back the next day: 'The little picture of the sea at Hastings is not finished – and Burnett who has bought might object to letting it go' (UBC/AP). The mention of a new patron accounts for Hunt having taken up No.52 again, but the sale to the Tynemouth collector Jacob Burnett seems to have fallen through. This enabled Hunt to wait until autumn, the season in which No.52 was commenced, before returning to Fairlight. He wrote to Edward Lear from there on 23 September 1858: 'I had been longer at the first task than I had intended by two days or so' (JRL). The 'first task' was to complete No.52; the second, to commence 'The School-girl's Hymn' (No.102).

No.52 was shown in October 1858 in Gambart's *Sixth Annual Winter Exhibition of Cabinet Pictures, Sketches, and Water-Colour Drawings* at 120 Pall Mall. The painting was extensively reviewed but the critics were deeply divided in their assessments of its merits. The reviewers in the *Illustrated London News* of 27 November (p.508) and the *Art Journal* of 1 December (p.355) criticised the work for a lack of verisimilitude. The latter could not accept the harsh contrast between the shaded land and the sunlit sea, but in fact this was a recognised light effect, to which an engraving of 1833 published in John Parry's *An Historical and Descriptive Account of the Coast of Sussex* bears witness.

W.M. Rossetti, in his review in the *Spectator* of 6 November, stressed that No.52 should be viewed as 'a small fragment of English nature' (p.1171, republished in *Fine Art, Chiefly Contemporary*, 1867, p.244). Hunt had suggested this by including a walking-stick hurtling through the air in the left foreground, which has been thrown for the Newfoundland dog on the right of the picture to catch. The dog, Caesar, was owned by the Martineaus of Fairlight Lodge, who delighted in throwing it sticks, much to Lear's discomfiture (Hunt 1905, I, p.330). The incident introduces a narrative element, suggesting a human presence just beyond the picture space. The disproportionate scale of the walking-stick not only emphasises the fleeting nature of the moment depicted, but also draws attention to this unseen presence. A slight feeling of tension is engendered, and the spectator is reminded that such an apparently tranquil pastoral scene cannot exclude humanity for long.

The sale of the painting took place privately, and on 10 November 1858 Hunt wrote to Gambart: 'Will you please to mark my little picture of "Sunlight on the Sea" as sold' (PUL). Although we have no conclusive evidence as to the identity of the purchaser at this time, everything points towards its being the wealthy commission agent A.H. Novelli who, in 1886, was to lend No.52 to Hunt's one-man show. Novelli was a great friend of Hunt's patron Thomas Fairbairn and had entertained Thomas Woolner at his Aberystwyth home in the autumn of 1858 (see Woolner, pp.148, 152–3). It is extremely likely that Woolner, whom Hunt had introduced to Fairbairn, thereby securing the commissions 'Constance and Arthur' (No.117) and 'Bust of Sir James Brooke' (see Bronkhurst, fig. 4), would have taken the opportunity of praising Hunt's works to his host, who would have already known the two pictures by Hunt in Fairbairn's collection (Nos 36 and 58). Reviews such as that in the *Athenaeum* of 30 October 1858, which described No.52 as 'perhaps as exquisite a gem of landscape as ever was painted' (p.558), no doubt further encouraged Novelli to pay particular attention to Hunt's work when he visited the French Gallery exhibition. The patron would not have needed to approach Gambart in order to purchase the painting, and a transaction which cut out the middle man would have pleased both buyer and seller.

J.B.

WALTER HOWELL DEVERELL

53 · **The Irish Vagrants** 1853–4
Oil on canvas, 24¹⁵⁄₁₆ × 30⅜ (63.4 × 77.2)
Johannesburg Art Gallery

In this unfinished canvas Deverell depicts Irish labourers sitting or lying by a country roadside. Harvesting is in progress in the field beyond but Deverell's labourers are unemployed and their children are forced to beg from a lady and gentleman riding by on horseback; they, however, ignore them. Just as Brown's 'The Last of England' (No.62) is a picture about the emigration movement, Deverell's is about the immigrant problem. We do not know whether Deverell had witnessed such a scene himself. Hunt, writing years after the event, suggested a literary inspiration for his concern: 'He was an eager reader, and had contracted the prevailing taste among the young of that day, which Carlyle had inaugurated and Charles Kingsley had accentuated, of dwelling on the miseries of the poor, the friendless, and the fallen, and with this special

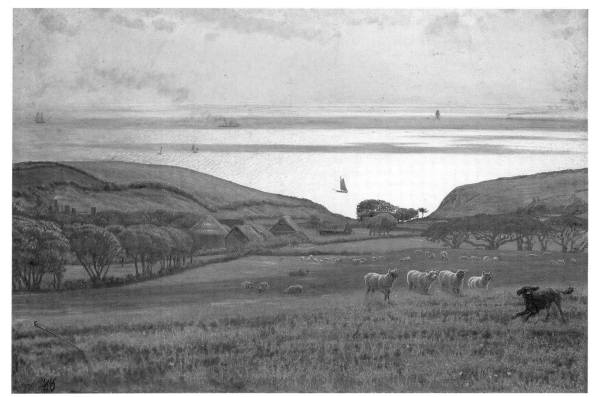

52

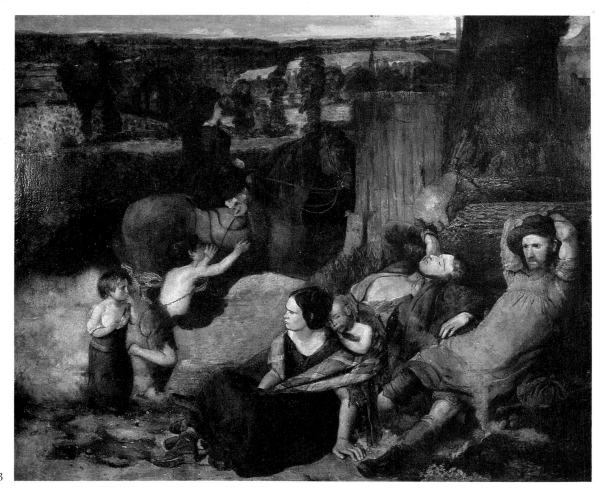

53

interest he had, perhaps all the more, a general sympathy for all social and human concerns' (Hunt 1905, I, p.197).

Deverell gave the following account of the picture in his journal in March 1853: 'To the picture of *Irish Vagrants* did very little this month. If any of the pictures are rejected [by the Royal Academy] I should prefer it to be this – Rossetti seemed of opinion that I should not exhibit it this year. As the subject was so good & important I had better paint it on a larger scale – I must confess however that I myself do not regard it so unfavourably, tho' I hardly know what to think of it till some little time has elapsed – when I shall be able to regard it with less partiality – The stern head of the Irish woman seems to offend greatly the few casual visitors I have had tho' it is certainly one of the most just & natural expressions I have ever done' (HL/Deverell Memoir, p.97). Although Deverell said he had submitted five works to the Academy in 1853, only two of which were accepted (ibid., p.102), the unfinished state of 'The Irish Vagrants' might suggest that it was not one of the works he sent in. There is, however, a possibility that Deverell did submit the picture, that it was rejected and that he subsequently started to repaint parts of it but never finished the repainting. X-rays taken by the Johannesburg Art Gallery suggest that the figures on horseback are later additions, painted over different images which are now too indistinct to

54

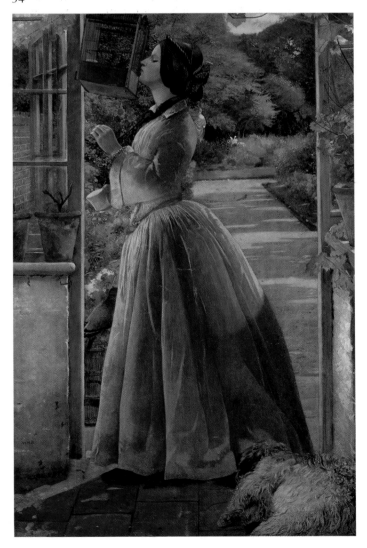

identify. The x-rays also reveal changes to the fence, the hat worn by the man at the right and the woman's dress, which was originally off the shoulder. Deverell was certainly working on the picture later in 1853. It was one of the paintings he was 'occupied with' when his father died in June that year and which he took with him when the family subsequently moved from Kew to Chelsea (HL/Deverell Memoir, p.114).

L.P.

WALTER·HOWELL DEVERELL

54 A Pet 1853
Inscribed 'WH△'
Oil on canvas, $35\frac{1}{8} \times 22\frac{1}{2}$ (89.2 × 57.2)
First exh: L.A. 1853 (248)
Tate Gallery

'A Pet' was exhibited at the Liverpool Academy with a short quotation from W.J. Broderip's *Leaves from the Note-Book of a Naturalist*, published in 1852 (the year its author bought Hunt's 'The Hireling Shepherd'): 'But after all, it is very questionable kindness to make a pet of a creature so essentially volatile'. Some modern commentators have suggested that the woman as well as the caged bird is intended as 'a pet' but, if so, Deverell's caption does little to make this clear. The picture itself is remarkable for the absence of symbolic detail of the kind used, for example, by Hunt in his portrayal of a kept woman, 'The Awakening Conscience' (No.58). What 'A Pet' certainly shows is Deverell's development of a more personal and more naturalistic style after the angularities and oddities of perspective of his essay in the early Pre-Raphaelite manner, 'Twelfth Night' (No.23).

'A Pet' was painted at the Deverell family home in Richmond Road, Kew, possibly with Eustatia Davy as a model (see Mary Lutyens in *Pre-Raphaelite Papers*, Tate Gallery, 1984). 'The Garden of the house at Kew', Deverell recalled in his journal, 'was a great delight to me – with its vista of shrubs flowers & trees from which I painted carefully a background to the picture of 2 Miss Bird and also the conservatory in *The Pet*' (HL/Deverell Memoir, p.96a). The other work referred to here, 'Miss Margaretta and Miss Jessie Bird', was exhibited at the R.A. in 1853 but was later cut up; it is said to have been 'a full-length portrait of two ladies, standing in the garden at Kew' and not unlike 'A Pet' (Ironside & Gere, p.28, probably from information received from the artist's nephew John Deverell). A head from it survives and is reproduced by Mary Lutyens, op. cit. The garden at Kew probably also inspired Deverell's sonnet 'The Garden', which begins 'Except the voice of birds, there is no sound' (HL/Deverell Memoir, p.96b, published for the first time in full by Lutyens, op. cit.).

Another painting exhibited by Deverell in 1853, 'The Pet Parrot', now in the National Gallery of Victoria, Melbourne, depicts the same model as No.54, this time playing with a grey parrot who, wrote W.M. Rossetti in the *Spectator*, is 'crimping his eyes up in brooding enjoyment under his mistress's caressing hand'. W.M. Rossetti evidently felt the same sort of mood in 'A Pet', which he associated (HL/Deverell Memoir, p.128) with his brother's sonnet 'Beauty and the Bird', originally called 'The Bullfinch'. The poem begins:

> She fluted with her mouth as when one sips,
> And gently waved her golden head, inclin'd
> Outside his cage . . .
> Taking some seed, she
> . . . fed him from her tongue, which rosily
> Peeped as a piercing bud between her lips

'A Pet' was bought from the Liverpool Academy exhibition by Millais and Hunt for £80 (eighty guineas according to some sources) when they heard of Deverell's serious illness in October 1853. Millais later sold his share in the picture to the dealer D.T. White of Maddox Street, who eventually secured Hunt's share as well. In January 1857 Hunt sent Deverell's sister the difference (£10) between what he had originally paid and what he had just received from White (Lutyens 1974, p.62). The painting was later in Burne-Jones's collection for a few years.

No.54 is frequently called 'The Pet'. The title used here is the one given in the 1853 Liverpool Academy catalogue, which is clearly meant to echo Broderip's reference to 'a pet' in the accompanying quotation.

L.P.

JOHN EVERETT MILLAIS

55 A Waterfall in Glenfinlas 1853
Inscribed 'JM' in monogram
Oil on panel, $10\frac{1}{2} \times 12\frac{1}{2}$ (26.7 × 31.8)
First exh: ? L.A. 1862 (105, as 'Outdoor study')
Delaware Art Museum (Samuel and Mary R. Bancroft Memorial)

A try-out for the background of Millais' portrait of Ruskin (No.56). Ruskin wrote to his father on 8 July 1853: 'We have been out all day again sitting on the rocks – painting and singing and fishing . . . Millais . . . is doing a bit for practice . . . beautiful thing it will be when done – and mine [No.56] will be begun I hope early next week' (Lutyens 1967, p.64). And on 10 July Millais wrote to Mrs Collins, mother of his friend Charles Collins: 'Every day that is fine we go to paint at a rocky waterfall and take our dinner with us. Mrs Ruskin brings her work and her husband draws with us, nothing could be more delightful . . . I am painting at present a fall about a mile from this house [in Brig o' Turk] until a canvas shall come whereon I intend to paint a portrait of Ruskin looking into the depths of a waterfall, standing upon a crag' (ibid., p.68).

He began the Ruskin portrait on 28 July, by which time No.55 was presumably finished. The rocks are typical of Glenfinlas though not precisely identifiable. The female figure sewing on the right is recognisable as Effie Ruskin.

No.55 was by 30 March 1854 in the collection of B.G. Windus (ibid., p.162) and later in that of Thomas Plint.

M.W.

55

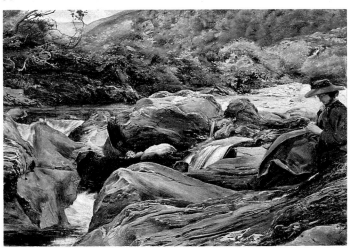

JOHN EVERETT MILLAIS

56 John Ruskin 1853–4
Inscribed 'JM 1854' (initials in monogram)
Oil on canvas, $31 \times 26\frac{3}{4}$ (78.7 × 68)
First exh: Fine Art Society 1884 (ex-cat.)
Ref: R.A. 1967 (42)
Private Collection

John Ruskin (1819–1900) was the most influential Victorian art critic and an enthusiastic champion of the Pre-Raphaelites. He and Millais became friendly in 1853, when his wife Effie was the model for 'The Order of Release, 1746' (No.49). In the summer of that year the two men and Effie went on a holiday together in Scotland. They arrived at Brig o' Turk in the Trossachs on 2 July and stayed there for nearly four months. The artist's brother William accompanied them but left after about six weeks. For a detailed account of the holiday, during which Millais and Effie formed an attachment that led to their marriage two years later, after her marriage to Ruskin had been annulled on the grounds of non-consummation, see Mary Lutyens, *Millais and the Ruskins*, 1967.

Most of the background of No.56 was painted during the Brig o' Turk holiday. On 3 July 1853 Millais wrote to Holman Hunt: 'We are likely to stay here some little time as I am going to paint Ruskin's portrait by one of these rocky streams' (Lutyens 1967, p.59). And the following day Ruskin wrote to his father: 'Another pouring wet day but we went out for an hour nevertheless to look for a subject and found plenty quite to Millais' mind beside the stream that runs through Glenfinlas – we are going out tomorrow, if possible, to get a glance of it in sunshine – and then he will fix – but he has nearly resolved to paint me beside the stream, and Effie at Doune castle – two companion pictures – and he is in high spirits about them because he says they will give him no trouble and be a rest to him, and yet be full of interest – only he says everybody will be plagueing him to do their portraits in the same way. The pictures will be simply called "Glen Finlas" and "Doune Castle"' (ibid., p.60).

The site, which is no longer identifiable, seems to have been chosen on 6 July, when Millais wrote to Charles Collins: 'Ruskin and I myself have just returned from a glorious walk along a rocky river near here and we have found a splendid simple background for a small portrait I am going to paint of him . . . I am going to paint him looking over the edge of a steep waterfall – he looks so sweet and benign standing calmly looking into the turbulent sluice beneath' (ibid., p.61). By 17 July Millais had ordered a canvas from Edinburgh (letter to Holman Hunt, HL) but the one sent was not white enough so he ordered another from London (Lutyens 1967, p.70). Ruskin refers again to the proposed portrait of Effie in a letter to his father of 19 July: 'Millais will be a good long time painting these two pictures, so you must not be in a great hurry for us back. The rocks in the torrent will take a long time. The pictures are to be companions this shape [sketch] 24 inches broad by 28 high' (ibid., p.70). But the idea was eventually abandoned, probably in view of the slowness of Millais' progress on No.56.

On 28 July Ruskin could at last tell his father: 'my portrait is verily *begun* to day and a most exquisite piece of leafage done already, close to the head' (ibid., p.75). On 18 August he wrote: 'It is getting on beautifully – but terribly slowly: indeed I saw as soon as it were begun that it would take two months at least' (ibid., p.84). On 22 September he sent a sketch to show what had been done, noting that 'Millais has put all his strength into the ash bough at the top of the picture – and the dark rocks and creepers below this. Nothing can be finer – and these are quite

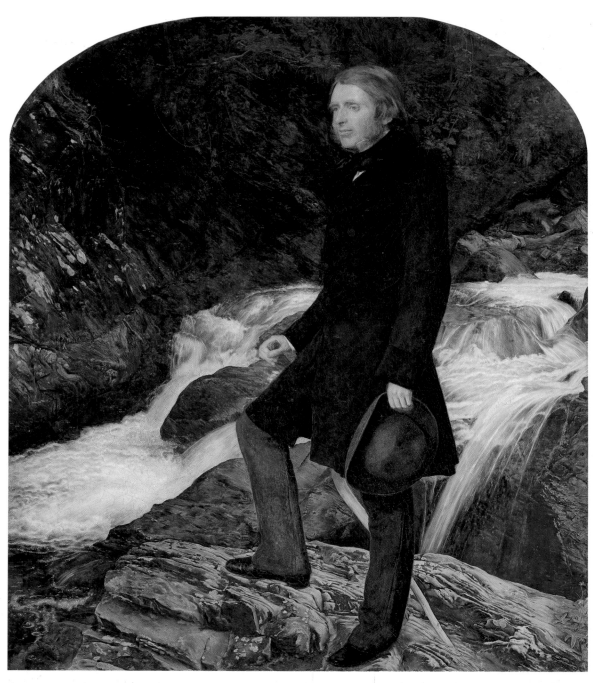

56

done. He is now at work on the stream' (ibid., p.92). And on 7 October he reported that 'Millais has done some glorious bits of rock in the picture these last two or three days with all their lichens gleaming like frosted silver – most heavenly. He is delighted with it himself' (ibid., p.93).

In a letter to Holman Hunt headed 'Saturday evg.', probably 8 or 15 October, Millais wrote: 'I so long to finish this background but I fear it will take me 3 weeks more at least. You know how dreadfully these out of door affairs hang fire . . . There is some falling water in it which is very perplexing' (ibid., p.94). On 20 October Ruskin estimated in a letter to Hunt that a quarter of the background remained to be finished (ibid., pp.100–1). The Ruskins left Brig o' Turk on 26 October. Though in a state of depression and suffering from headaches,

Millais stayed on to continue work, but the incessant rain soon changed his mind. On 27 October he too left Brig o' Turk, writing two days later to Hunt from Edinburgh: 'I have sent home the picture of Ruskin for the weather was terrible and would have killed me outright, so I intend coming for a week or so in March when it is dry although colder than now' (ibid., p.103). He returned to London on 10 November.

Infatuated with Effie and maddened by Ruskin's neglectful attitude towards her, Millais went on with the portrait with ever-deepening resentment. On 20 December he told Effie's mother that he would altogether give it up, 'had not Ruskin spoken about it . . . to the effect, that he should consider it an insult to his Father, besides himself, if I did not finish it' (ibid., p.123). Ruskin came to Millais' Gower Street studio to sit on

12, 17 and 19 January 1854, 2 March and probably 13 April (ibid., pp.130, 132, 150, 172). On 18 April Millais wrote to Effie's mother that 'the face is painted and I have a very little more to do from him, two days more will suffice. He comes Wednesday [19 April] and I will try to get him to come again on Friday as it will be as well to get all the sittings over at once' (ibid., p.178). Sittings were arranged for 27 April and 1 May but Ruskin failed to come (ibid., pp.196, 202). He was abroad from 9 May to 2 October and sittings for the only remaining part of the figure, the hands, presumably took place between his return and 4 December, when Ruskin's father paid Millais £350 for the work (ibid., p.249).

For a time Millais considered finishing the background in Wales. The idea came from G.P. Boyce, whose watercolour views in Wales Millais saw and admired on 8 April. He particularly recommended the Capel Curig area (Surtees 1980, p.12). Millais wrote to Hunt on 4 May: 'I have finished Ruskin's portrait all but the bit of waterfall which was left, which I am going to do in Wales in a week or so as soon as I have done the trousers and boots' (HL). Ruskin, however, 'did not seem satisfied with this notion as the rocks are of quite a different Strata there' (Lutyens 1967, p.215) and on 16 May the artist told Effie's mother: 'I have made up my mind that far the *shortest way* of finishing Ruskin's portrait will be to return to the old place for a week or so' (ibid., p.210). He arrived at Brig o' Turk on 24 May (ibid., p.216); by 18 June he had 'only a few more bubbles to paint in the smooth of the waterfall' (ibid., p.226) and he had presumably finished the whole background by 28 June, when he left on a walking tour with Charles Collins.

Ruskin exercised a considerable amount of influence and control over Millais' work during the Scottish trip, and, not surprisingly, the portrait reflects some of his ideas. It shows him as the patient observer of natural phenomena he believed every artist or critic should be, and is executed in a painstakingly meticulous style itself redolent of patient observation. More specifically, the kind of rock that dominates the setting, gneiss, had particular associations for Ruskin that may have helped determine the choice of Glenfinlas as a site. In Volume IV of *Modern Painters* he describes the distinctive undulations of its strata as 'the symbol of a perpetual Fear': 'The tremor which fades from the soft lake and gliding river is sealed, to all eternity, upon the rock; and while things that pass visibly from birth to death may sometimes forget their feebleness, the mountains are made to possess a perpetual memorial of their infancy' (Ruskin, VI, p.152). This was not published until 1856, but Ruskin had begun writing the volume in November 1853 and may well have had the ideas in mind as early as the time the portrait was begun. His interpretation of the strata as petrified motion and the contrast he makes with the movements of water certainly give point to the conjunction in the portrait of gneiss and waterfall. The churning of the water is turbulence of a transitory kind, the rocks a more permanent and profound reminder of natural violence.

Ruskin himself painted a watercolour of Glenfinlas (No.195). Millais' only extant sketch for the portrait (dated 28 July 1853 by Dr Henry Acland, who visited Brig o' Turk that summer) is at the Ashmolean. Millais' 'A Waterfall in Glenfinlas' (No.55) shows a view near the site of No.56 and was painted shortly beforehand as what Ruskin called 'a bit for practice'.

For other drawings Millais made during the holiday, some recording the activities of the party, others made in response to Ruskin's ideas about art and design, see *Rainy Days at Brig o' Turk*, ed. Mary Lutyens and Malcolm Warner, 1983.

M.W.

WILLIAM HOLMAN HUNT

57 The Light of the World 1851–3, retouched 1858, 1886
Inscribed 'Whh 1853.' (initials in monogram) and (behind frame) 'Non me praetermisso Domine'
Oil on canvas over panel, arched top,
$49\frac{3}{8} \times 23\frac{1}{2}$ (125.5 × 59.8)
First exh: R.A. 1854 (508)
Ref: Liverpool 1969 (24)
Warden and Fellows of Keble College, Oxford

No.57 was shown at the 1854 Royal Academy with the following text from Revelations 3. 20, both inscribed on the frame and printed in the catalogue: 'Behold, I stand at the door, and knock: if any man hear my voice, and open the door, I will come into him, and will sup with him, and he with me'. According to Hunt's first published account of No.57, 'An Apology for the symbolism introduced into the picture called The Light of the World', written in 1865 to accompany the exhibition of the work at 16 Hanover Street, the inspiration for his first religious painting was provided purely by his reading of the Bible. The text from Revelations led Hunt initially to envisage a daylight scene, but his desire to emphasise God's mercy as well as grace, attributes symbolised by the stigmata on Christ's hands in No.57 (A. Welby Pugin, *Glossary of Ecclesiastical Costume and Ornament*, 1844, pl.63), attracted him to the verse in Romans 13. 12: 'The night is far spent, the day is at hand'. This, in turn, suggested the concept of the lantern, inspired by such texts as 'Thy word is a lamp unto my feet, and a light unto my path' (Psalm 119. 105), for 'He who when in body was the LIGHT OF THE WORLD [e.g. John 8. 12], could not be unprovided when in the Spirit, with the means of guiding His followers when it was night' (Hunt 1865, p.1).

Hunt, in a letter of 19 August 1883 to William Bell Scott, stressed that he 'painted the picture with what I thought, unworthy though I was, to be divine command, and not simply as a good subject' (Scott, I, p.312). Despite the mystical nature of the work Hunt was keen to render the moonlit background accurately, and it is probable that his choice of a night scene was dictated by practical and aesthetic considerations as well as religious inspiration: the artist, always fearful of repeating himself, had not yet attempted a moonlit landscape and was in a position to do so in the autumn of 1851 at Ewell. The first design, on the back of an envelope bearing the postmark 'BELFAST | SE 25 | 1851' (Ashmolean Museum, repr. Hunt 1913, I, p.208), was followed by a more developed compositional sketch (Ashmolean Museum, repr. Hunt 1905, I, p.291) which elicited Millais' approval (ibid., I, p.289). On the evening of 19 October Hunt set out 'with a large horn-lantern' (J.G. Millais, I, p.126) to meet C.A. Collins from the railway station, and, according to his memoirs, he then came across the abandoned hut, the door of which was to be depicted in No.57 (1905, I, pp.295–6). Millais noted in his diary of 4 November: 'This evening walked out in the orchard (beautiful moonlight night, but fearfully cold) with a lantern for Hunt to see effect... which he intends doing by moonlight' (J.G. Millais, I, p.130).

The new canvas arrived on 7 November, and that day Hunt had a straw hut constructed in the orchard of Worcester Park Farm, similar to the one built three days earlier for Millais (ibid., I, pp.129, 131). By midnight Hunt was installed in his hut, working on No.57 'by a lantern from some contorted apple tree trunks, washed with the phosphor light of a perfect moon – the shadows of the branches stained upon the sward' (ibid., I, p.131).

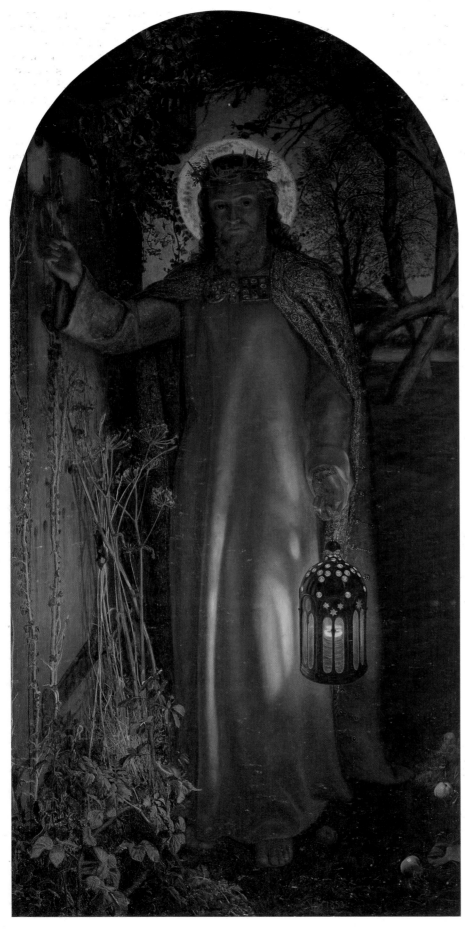

57

By dint of working steadily on 'The Light of the World' from 9 p.m. to 5 a.m. when the moon was full (Hunt 1886, p.749 and J.G. Millais, I, pp.131–2), the landscape was well advanced by the time Hunt returned to London on 6 December 1851. The artist then addressed himself to the position of the figure, and to painting those parts of the landscape that could not be worked on until this was established (Hunt 1905, I, p.309). On 20 February 1852 Millais asked Hunt to get him some ivy creepers (HL), which suggests that at this time Hunt was painting the ivy at the top of the door, but work was interrupted by the need to complete 'The Hireling Shepherd' (No.39) for the 1852 Royal Academy exhibition. Painting from nature was resumed at Fairlight, from where Hunt asked Stephens to send down 'The Light of the World', the weather being more suited to a night subject than a sunlit one (Thursday, August [?26, 1852]; MS, Sotheby's, 23 July 1979, part lot 137). The foreground brambles probably date from this visit: in both No.57 and 'Our English Coasts, 1852' (No.48) these can be interpreted as symbols of spiritual neglect.

W.M. Rossetti noted in his journal that Hunt resumed painting 'The Light of the World' in January 1853 (Fredeman, pp.98–9). According to William Bell Scott, the artist rigged up 'an elaborate arrangement of screens and curtains' so that he could work on the lay-figure, draped in a white robe made up from a table-cloth, by day as well as night (Scott, I, p.309). Scott continued, with a complete lack of sympathy with Hunt's Pre-Raphaelite principles: 'He was determined to carry out his accurate method of representation even when the subject was so removed from the realities of life that an abstract treatment … would have emancipated him from the slavery of painting lamplight in daytime, and of rendering moonlight by artificial means'. In one important respect, the face of the Saviour, Hunt deliberately chose an ideal rendering, as 'I felt very determined to make the figure mystic in aspect' (Hunt to J.L. Tupper, 20 June 1878, HL). The character of the head was a composite taken from several male sitters and 'many departed heroes in effigy' (Edward Clodd, *Memories*, 1916, pp.197–8), while Lizzie Siddal and Christina Rossetti sat for its colouring (ibid., and Hunt 1905, I, p.307). No.57 was still unfinished on 22 September 1853 (Hunt to F.G. Stephens, BL), a month after Thomas Combe had agreed to pay Hunt's full asking price of 400 guineas (Hunt to Combe, 22 August 1853, JRL). It was finally sent to the purchaser in early January 1854 (Hunt to Combe, 15–16 January, BL).

No.57 was hung on the line in the West Room at the 1854 Royal Academy exhibition, where it received generally poor notices. The June *Art Journal* criticised Hunt for realising the ideal: 'The knocking at the door of the soul is a spiritual figure of such exaltation that it must lose by any reduction to common forms' (p.169). However, Ruskin, in his letter to *The Times* of 5 May, explained the symbolism at length and brilliantly defended No.57 as 'one of the very noblest works of sacred art ever produced in this or any other age' (Ruskin, XII, p.330).

On 10 July 1854 Hunt sent Combe a description of No.57, stressing that it was not for general circulation: '*I* rather like a picture to be left without any explanation' (BL, description referred to by Hunt untraced). He justified this reluctance in his 1865 pamphlet, stating that 'The Light of the World' must first be judged as a work of art, and glossing the symbolism rather summarily as follows: 'physical light represented spiritual light – a lantern, the conservator of truth; rust, indicated the corrosion of the living faculties; weeds, the idle affection; a neglected orchard, the uncared for riches of God's garden; a bat [at the top of the door], which loveth darkness, ignorance; a blossoming thorn, the glorification from suffering – a crown, kingly power; the sacerdotal vestment, the priestly office, &c.' (Hunt 1865, p.2). He did not explain why 'the Israelitish and Gentile breast-plates' were 'conjoined', though he had written to Abraham (?) Solomon to ascertain whether rabbis still wore such things, and, if so, whether he could 'gain such a favor as the loan of it to paint from –' (n.d., *c.* summer 1853; MS, Victoria and Albert Museum). Stephens' 1860 pamphlet had noted that the rectangular clasp contained 'the mystic Urim and Thummim' and was set with 'the precious stones that bear the names of the chosen tribes' of the children of Israel (p.26). He also explained that the circular clasp to the left was 'significant of the heathen priesthoods, some of whom bore a symbol of this kind'. The five stones in the cross linking the rectangular and circular clasps symbolised Christ's wounds, according to the letter 'from a Clergyman' printed to accompany the showing of No.57 at Hanover Street in 1865 (proof copy in University of Kansas). The tripartite nature of the breast-plate may suggest not only that earlier creeds have prefigured the coming of Christ, but also that the light of the world is accessible to all; and this interpretation is strengthened by Hunt's rather cryptic comment on 'the diversity of designs of the openings of the lantern' being 'essential to the spiritual interpretation of the subject' (1865 pamphlet, p.1). Although only three sides of the heptagonal lantern (Coll. Sir Jack Sutherland-Harris, repr. Bennett 1970, cover), which Hunt had constructed to his own specifications, appear in No.57, the preliminary drawing (Ashmolean Museum, repr. Hunt 1905, I, p.308) reveals that the domed top of each of the seven sides contained differently-shaped apertures. According to the 1865 letter 'from a Clergyman', these seven sides represented the seven churches mentioned in Revelations, and a typescript of 1908 asserts that Keble College objected to the symbolism of the lantern as suggesting that there is more than one true church (typescript, University of Kansas).

The popularity of the picture was enhanced by the sales of the phenomenally successful engravings by W.H. Simmons and W. Ridgway and the numerous photographic piracies. No.57 had been retouched before being given to Simmons, as Millais' letter to Hunt of 28 August 1858 reveals: 'I went to see your "Light of the World" … & was much struck with the head, I think far the most beautiful head I have ever seen of Christ, it is *most lovely*, & much improved altho' I always liked it, the eyes look deeper, & still more tender in expression & the picture altogether looks better from the equallity of the surface' (HL). No.57 was again retouched in 1886, thirteen years after Mrs Combe had presented it to Keble College (Hunt 1905, II, p.343). Hunt's dissatisfaction with Keble's treatment of the picture led in 1899 to his beginning a larger replica (repr. ibid., I, facing p.368). This toured the colonies in 1905–7 and, as befitted a work that by now had the status of a Protestant icon, was presented to St Paul's Cathedral by Charles Booth in June 1908.

The small version of 'The Light of the World' (Manchester City Art Gallery, exh. 1969, No.25) was worked on concurrently with the Keble picture and completed in 1857.

J.B.

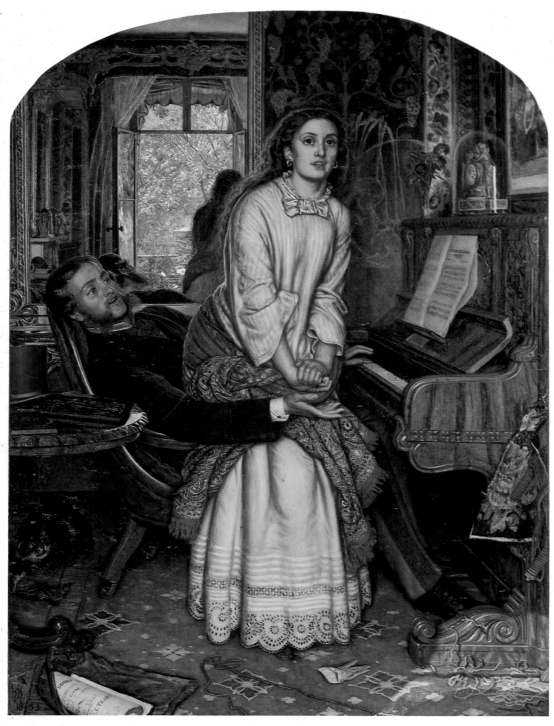

58

WILLIAM HOLMAN HUNT

58 The Awakening Conscience 1853–4, retouched 1856,
1857, 1864, 1879–80, 1886
Inscribed 'Whh LON|1853' (initials in monogram)
Oil on canvas, arched top, 30 × 22 (76.2 × 55.9)
First exh: R.A. 1854 (377)
Ref: Liverpool 1969 (27)
Tate Gallery

'As he that taketh away a garment in cold weather, so is he that
singeth songs to an heavy heart', the verse from Proverbs

which Hunt, in a letter of February 1854 to Combe, directed
should be inscribed 'as large as possible' on the frame (BL), was
the inspiration for No. 58, which was conceived as the material
counterpart of 'The Light of the World' (No. 57) 'to show how
the still small voice speaks to a human soul in the turmoil of life'
(Hunt 1905, I, p. 347).

 The modern-life setting was crucial to the conception, as the
small preparatory sketch of *c.* January 1853, in the collection
of the late Stanley Pollitt, reveals (repr. Bennett 1970, p. 26).
Edward Lear, to whom Hunt showed the design, tried to
dissuade the younger man from developing a subject which

might be misconstrued (letter of 29 January 1853, HL), and in fact the 1854 reviewers did greet the representation of a kept woman and her lover with a strong degree of bewilderment and disapproval. Lear's strictures seem to have discouraged Hunt from developing his design at this point. Apart from the need to complete 'The Light of the World', No.58 was held up not only through fear that the contentious theme might render the picture unsaleable but also through lack of funds. In late July 1853 Augustus Egg encouraged Hunt to proceed, and persuaded Thomas Fairbairn to sponsor the painting's completion, although there was no question of an advance (see Bronkhurst, p.588). Hunt worked steadily on No.58 from August until 13 January 1854, when he left England for Paris and, ultimately, the Holy Land.

Hunt researched No.58 with typical thoroughness, hiring a room at Woodbine Villa, 7 Alpha Place, St John's Wood – a 'maison de convenance' according to the painter's daughter (typescript, PC, p.286) – to use for the meretricious setting. Prostitution was a pressing metropolitan problem, and 'the fallen woman' was the inspiration for contemporary novels such as Wilkie Collins' *Basil* and Mrs Gaskell's *Ruth*, both of which probably influenced No.58. Hunt emphasised the irregular nature of the relationship between the protagonists by the girl's lack of a wedding ring, 'her provocative state of undress' (Ronald Parkinson, 'The Awakening Conscience and the Still Small Voice', *The Tate Gallery 1976–8*, p.25), and the lover's discarded and soiled glove, a warning that the likely fate of a cast-off mistress was that of prostitution. As Edward Lear wrote to Hunt on 12 October 1853: 'I think with you that it *is* an artificial lie that a woman should so suffer and lose all, while he who led her [to] do so encounters no share of evil from his acts' (HL).

The message of No.58, however, is that redemption is possible: the cat is a straightforward type of the seducer, but the bird it has been tormenting has escaped. The web in which the girl is entrapped is symbolised by the convolvulus in the vase on the piano and the tangled embroidery threads on the carpet. The title of the engraving above the piano (identified by Hunt in an 1865 pamphlet on 'The Light of the World'), 'Cross Purposes', is appropriate in the light of the lover being 'the unconscious utterer of a divine message' (Hunt 1905, II, p.430). Its artist, Frank Stone, strongly disapproved of Pre-Raphaelitism, and Hunt's use of this popular engraving, published in 1845, was a joke at his expense; even the disposition of the protagonists in No.58 echoes and satirises that of the female figures in the engraving. On the other hand, the sheet music unfurling on the floor is a tribute to Hunt's friend Edward Lear, whose setting of Tennyson's 'Tears, Idle Tears' from *The Princess* was published in October 1853 and deliberately incorporated in No.58 at this late stage. The emphasis on contemporaneity was reinforced by what Ruskin termed 'the fatal newness of the furniture', and by the papier mâché black binding of the volume on the table, which Ruari McLean identifies as *The Origin and Progress of the Art of Writing*, published in 1853. Such a work relates to Hunt's plans to educate his beautiful but barely literate girlfriend Annie Miller, the model for the woman in No.58.

The message of 'Tears, Idle Tears', like that of Thomas Moore's 'Oft in the Stilly Night', which the man has been singing, contrasts past innocence with present wretchedness. The effect of this on the woman is emphasised by the frame design: marigolds are emblems of sorrow, bells of warning, while the star at the top represents 'the still small voice' of spiritual revelation.

Other accessories prefigure the moment of revelation No.58

dramatises. The wall decoration behind the woman relates back to 'The Hireling Shepherd' (No.39) in its warning of the need for vigilance: 'The corn and vine are left unguarded by the slumbering cupid watchers and the fruit is left to be preyed upon by thievish birds' (Hunt, 1865 pamphlet). Chastity is the only weapon by which the human predators can be foiled, and the French clock, owned by Augustus Egg, depicts this virtue binding Cupid.

The seemingly endless proliferation of detail was best defended in Ruskin's letter to *The Times* of 25 May 1854: 'Nothing is more notable than the way in which even the most trivial objects force themselves upon the attention of a mind which has been fevered by violent and distressful excitement' (Ruskin, XII, p.334). Most critics attacked the sensational appearance of No.58 and ignored its underlying spiritual message, in spite of the title 'The Awakening Conscience' (chosen by Thomas Combe to assist the telling of the story in preference to Hunt's suggestion 'A still small voice'), the inscription on the frame, and the verses from the Apocryphal Ecclesiasticus and Isaiah in the 1854 Royal Academy catalogue. The mirror on the wall behind the couple was much misunderstood, and no one commented on its crucial role in the composition: nature, seen through the French windows, is presented as a mirror image; it represents the woman's lost innocence, from which she has divorced herself by her present way of life. The ray of light in the right foreground suggests, however, that redemption is possible.

The moral implications of No.58 were not lost on its first owner, but in 1856 Thomas Fairbairn instructed the artist to repaint the girl's face, as he found it too painful to live with (see Bronkhurst, p.588).

J.B.

JOHN EVERETT MILLAIS

59 **Waiting** 1854
Inscribed 'JM 1854' (initials in monogram)
Oil on panel, 12¾ × 9¾ (32.4 × 24.8)
Ref: R.A. 1967 (43)
Birmingham Museum and Art Gallery

One of several small 'cabinet pictures' Millais painted in 1854 showing single female figures. The girl, the nature of whose assignation we can only guess, if indeed she has one, is wearing a similar pink bonnet to the one that features in a study of a head also in this 1854 group (Coll. Mrs A. Alabaster) and the same model may well have sat for both works. She has been said to be Holman Hunt's girlfriend Annie Miller but this is probably incorrect (compare G.P. Boyce's portrait of Annie drawn the same year, Sotheby's 23 June 1981, lot 18). Her actual identity remains to be discovered.

The state of the grass and foliage suggests that the work was painted in the spring, probably just before Millais returned to Scotland to finish the Ruskin portrait (No.56) on 24 May 1854.

It was bought by Joseph Arden, who already had Millais' 'The Order of Release, 1746' (No.49) and the following year bought 'The Rescue' (No.67). In an article on his collection in the *Art Journal* of 1857 (p.310), it is referred to as 'The Stile', and in Arden's sale in 1879 as 'Girl at the Stile'. The present title seems to have been used for the first time, at least in print, by Spielmann in 1898.

M.W.

59

FORD MADOX BROWN

60 A Study on the Brent at Hendon 1854–5
Inscribed 'F. MADOX BROWN. Hendon / 54'
Oil on millboard, oval, $8\frac{1}{4} \times 10\frac{1}{2}$ (21 × 26.7)
First exh: *Winter Exhibition*, Gambart, 121 Pall Mall,
1854–5
Ref: Liverpool 1964 (31)
Tate Gallery

The first of three small landscapes painted around Finchley and
Hendon during 1854–5 with the idea of producing pot-boilers
for ready sale but to which the artist gave much time and
attention. He took advantage of his semi-rural surroundings to
which, after painting the 'English Autumn Afternoon' (No.51)
at Hampstead, he seems to have become particularly alive,
perhaps through the added fillip of Emma's more naïve
enjoyment.

The Brent was in easy walking distance of his new house in
Grove Villas, Church End, Finchley, 'a mere brooklet running
in most dainty sinuosity under overshadowing oaks and all
manner of leafgrass', he commented in his diary when
searching along it for a subject on 1 September 1854. A little
earlier (28 August) he had seen at his dealer, D.T. White's, a
small picture of a waterfall by Millais, 'The Kingfisher's Haunt',
which had surprised him: 'the figurs very pretty – the foliage &
foreground icy cold & raw in color, the greens unripe enough to
cause indigestion' (repr. Staley, pl.19a; destroyed 1939–45
war; see also under No.19). He must have determined to
emulate this but characteristically he tackled a much more
complex problem of painting reflections in running water

60

almost head on, intermingled with tangled undergrowth; this in spite of his fear when choosing his subject that there was 'no painting intertangled foliage without loosing half its beauties. If imitated exactly it can only be done as seen from one eye & quite flat & confused therefore'. He again chose an oval format, which emphasises the delightful enclosed secrecy of the spot he had chosen, but which also underlines the essential decorative and textured quality of this renewed attempt in an unaccustomed line of work.

Begun 2 September and continued in broiling sunshine, he gave most of his mornings to it, having on the 4th found another subject of a cornfield (No.61) where he worked in the afternoons. On the 20th it rained and in trying to continue he found the branches all altered by the weight of the water; at home in the evening he noted: 'worked at altering the little lady reading a letter . . . which had rubbed in from Emma the other day, I have made it more sentimental'. On the 21st he commented that it 'begins to look bravely & beautiful color but still requires all my energy & attention to master the difficulties attending a style of work I have not been bred to'. The weather was now turning cold and he finished it on the site on the 26th, 'as much as I can do to it from nature'. He touched at it at home during October and December, sent it to the Winter Exhibition of sketches, where it did not sell, and touched the water again during April 1855. He was delighted when his dealer White finally bought it on 27 June, for £10 along with 'Carrying Corn' and some drawings. It later belonged to B.G. Windus, who had several of his pictures, and was presented to the Tate Gallery in 1920.

M.B.

FORD MADOX BROWN

61 Carrying Corn 1854–5
Inscribed 'F. Madox Brown Finchley /54'
Oil on panel, $7\frac{3}{4} \times 10\frac{7}{8}$ (19.7 × 27.6)
First exh: Russell Place 1857 (11)
Ref: Liverpool 1964 (32)
Tate Gallery

Painted in the afternoons while also working on 'The Brent' (No.60) and later 'The Last of England' (No.62) in the mornings. The idea for it probably dated from a little before 'The Brent' when, on a joyride to St Albans with Emma on 22 August 1854, depression at their financial state was forgotton and he recorded 'Emma in a state of buoyant enjoyment. We should have thought more of the fields no doubt were we not so much used to them of late. However one field of turnips against the afternoon sky did surprise us into exclamation with its wonderful emerald tints'.

On 4 September he found such a field at Finchley, 'of surpassing lovelyness, corn shocks in long perspective, farm, hayricks, & steeple seen between them, foreground of turnips, blue sky & afternoon sun. By the time I had drawn in the outline they had carted half my wheat'. Most of it was already gone by the next day and he found it impossible to paint in a 'hurry & fluster'. His diary records twenty-one visits to the field with seventy-odd hours painting, the weather not always what he needed, sometimes rain or sun at the wrong time; on 3 October he noted trouble with the trees in the distance: 'or else I am not suited to this sort of work for I can make nothing of the small screen of trees though I have pottered over sufficient time

61

to have painted a large landscape, the men of english schools would say'; and on the 11th found the turnips 'too difficult to do anything with of a serious kind. I don't know if it would be possible to paint them well, they change from day to day'. On 13 October he was thankful to record his last visit, 'I have now only to work at home at it to put it a little in harmony'.

He settled the pattern of its frame on 18 February 1855, along with that for 'The Last of England' which he planned to send to the Royal Academy, but realised in despair at the beginning of April that this would not be finished: 'had I not painted the two little landscapes in the autumn I would have had time. I have foolishly trifled away my time, & am punished'. He painted and finished the sky with ultramarine on 8 April and sent it in to the R.A. on the 10th with 'The Parting of Cordelia and her Sisters', but neither were accepted. White bought it in June, along with 'The Brent', paying £12 for it. It also passed to Windus and the Tate Gallery acquired it in 1934.

This exercise in the painting of sunlit landscape at a particular time of day, which was to the artist such a labour and at the same time of such minor importance to him in comparison with his subject pictures, is perhaps the most delicately observed of all his works. His way of putting on the paint varies for each part of it: the swath of cornstooks in long brush-strokes almost merges into yellow light; the emeralds and greens of the turnip field sparkle with touches of reflected light even in the deep shadows; while the copse and line of trees with the dappled light on the red roofs are painted with delicate small touches that draw the eye into the distance; and the sky itself with the misty rising moon pales in long streaks from bright blue to palest lavender where clouds are getting up.

M.B.

FORD MADOX BROWN

62 The Last of England 1852–5
Inscribed 'F. Madox Brown 1855'
Oil on panel, oval, $32\frac{1}{2} \times 29\frac{1}{2}$ (82.5 × 75)
First exh: L.A. 1856 (110)
Ref: Liverpool 1964 (29)
Birmingham Museum and Art Gallery

The third picture designed in 1852 while living in rooms at Hampstead, 'most of the time intensely miserable, very hard up & a little mad' as he later recalled (Surtees 1981, p.78). The pressures on him while as yet unsuccessful are very apparent in the intense poignancy with which he imbued this picture, which is certainly his masterpiece. Its deliberately chosen oval format, almost a tondo, enfolds and concentrates the image of the middle class couple dignified but despairing as they take their last view of their country.

The subject is seen very much from the artist's own middle class viewpoint, which distinguishes it from other pictures of that great period of emigration, which appear chiefly to have celebrated the working class (for example, James Collinson's 'Answering the Emigrant's Letter', R.A. 1850, Manchester; and Richard Redgrave, 'The Emigrant's Last Sight of Home', R.A. 1859, Tate Gallery). Madox Brown's subject was sparked off by the departure of Thomas Woolner as an emigrant to Australia in July 1852 (though there is no concrete evidence that he actually saw him off as did Rossetti and Hunt), and his own first thoughts of emigrating to India, which were only finally resolved by the sale of this picture immediately upon its completion in 1855.

His lucid description of it in his 1865 catalogue is without sentiment or self-pity:

This picture is in the strictest sense historical. It treats of the great emigration movement which attained its culminating point in 1852. The educated are bound to their country by quite other ties than the illiterate man, whose chief consideration is food and physical comfort. I have, therefore, in order to present the parting scene in its fullest tragic development, singled out a couple from the middle classes, high enough, through education and refinement, to appreciate all they are now giving up, and yet depressed enough in means, to have to put up with the discomforts and humiliations incident to a vessel 'all one class.' The husband broods bitterly over blighted hopes and severance from all he has been striving for. The young wife's grief is of a less cankerous sort, probably confined to the sorrow of parting with a few friends of early years. The circle of her love moves with her.

The husband is shielding his wife from the sea spray with an umbrella. Next them in the background, an honest family of the green-grocer kind, father (mother lost), eldest daughter, and younger children, makes the best of things with tobacco-pipe and apples, etc., etc. Still further back a reprobate shakes his fist with curses at the land of his birth, as though that were answerable for *his* want of success; his old mother reproves him for his foul-mouthed profanity, while a boon companion, with flushed countenance, and got up in nautical togs for the voyage, signifies drunken approbation. The cabbages slung round the stern of the vessel indicate to the practised eye a lengthy voyage; but for this their introduction would be objectless. A cabin-boy, too used to 'leaving his native land,' to see occasion for much sentiment in it, is selecting vegetables for the dinner out of a boatful.

This picture, begun in 1852, was finished more than nine years ago [1855]. To insure the peculiar look of *light all round*, which objects have on a dull day at sea, it was painted for the most part in the open air on dull days, and when the flesh was being painted, on cold days. Absolutely without regard to the art of any period or country, I have tried to render this scene as it would appear. The minuteness of detail which would be visible under such conditions of broad day-light, I have thought necessary to imitate, as bringing the pathos of the subject more home to the beholder.

Begun in the winter of 1852–3 'when the snow was lieing on the ground' (Surtees 1981, p.80), it follows the cartoon (No.178) closely. The artist found it too detailed to get it done for the R.A. of 1853 and after a month on it in the following winter it was put by until September 1854 at Finchley, where the models, lay figure and details were painted chiefly out in the back yard of his home. Emma, his wife, sat for the woman and he painted himself as the man; their children Katty and Oliver were respectively the child with a green apple and the baby. The picture was painted on a zinc white ground prepared by the artist and it cracked, so both the heads and the man's coat were scraped out and repainted. To such details as the shawl (which his wife had to do without half the winter) he gave infinite pains. He determined to use 'Emma's shepherd plaid shawl instead of the large blue & green plaid as in the sketch' (*Diary*, 20 September 1854; visible in the cartoon, the sketch is lost). He spent days drawing it in in pencil and finally on 30 November commented: 'Now that the pattern is all drawn & covered with a tint I put in the out door effect. To have painted

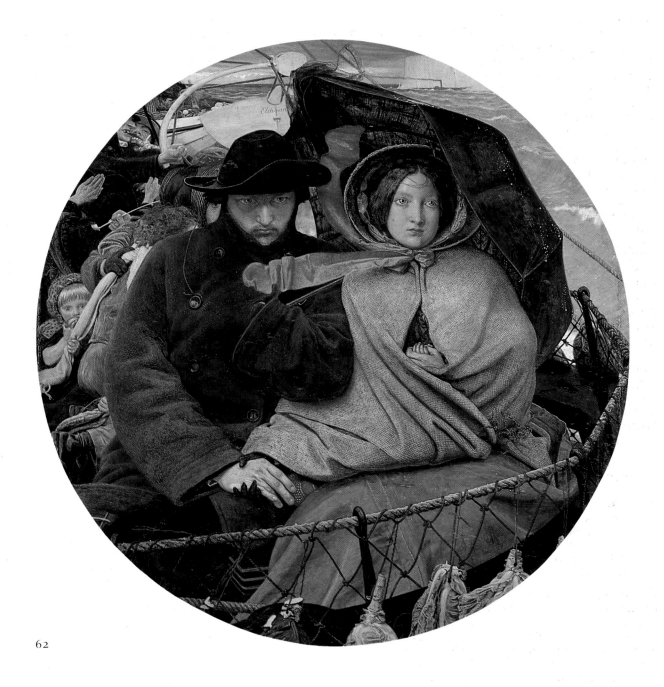

62

it all out of doors would have taken six weeks of intense cold & suffering & perhaps have failed'.

Only rain and wind, never snow, kept him indoors. He used local people for the background figures: 'All the red headed boys in Finchley came here to day' (14 March 1855); an old washerwoman sat for the mother of the reprobate (28 March) and later he found 'a poor wretch with a nose I thought would do for my scoundrel' (24 May); he bought spoiled cabbages from his greengrocer and built his own bulwarks for the foreground. Again it was not ready for the R.A. of 1855, and he continued it right through the summer in spite of the change of light. It was very nearly done when in August his friends Cave Thomas and Lowes Dickinson saw it, 'liked the heads very much. Thought the frame cut it off to close & injured it' (5 August). He therefore added strips to the top and sides of the panel and had the frame altered: 'The picture looks worth half

as much money again now that the sight of the frame is made larger', he noted. He frequently recorded in his diary his despondency with it but at the last, on Sunday 2 September he wrote: 'to day fortune seemed to favour me. It has been intensely cold, no sun, no rain – high wind, but this seemed the sweetest weather possible, for it was the weather for my picture & made my hand look blue with the cold as I require it in the work, so I painted all day out in the garden'. It was finished on the 4th.

He showed it for a few days with 'Pretty Baa Lambs' and some sketches in a room in Percy Street and his dealer D.T. White bought it on the spot for £150 to include copyright. For him Madox Brown altered the green of the seat, added a rope and some rust, and a string to the man's hat and delivered it up on 12 September. White sold it to B.G. Windus of Tottenham who had several of Madox Brown's pictures. They determined

not to send it to the 1856 R.A. but Vernon Lushington published an eulogium on it in the *Oxford and Cambridge Magazine* in August that year, and at Liverpool in the autumn it gained the second vote after 'Jesus washing Peter's Feet' for the £50 prize. It first appeared in London at the semi-private P.R.B. exhibition in Russell Place in June 1857, where it rated a descriptive paragraph in the *Saturday Review*, as in subject 'one of those which the Pre-Raphaelites sometimes venture to take not as comedy, but as a tragedy, from modern everyday life'; and in the *Athenaeum* was considered second after Rossetti's contributions for its 'Hogarth fertility of thought', but was mistaken for a Holman Hunt. Madox Brown was planning to get a calotype produced of it in 1855 and thought hopefully of engraving (*Diary*, 7 December).

After its appearance at the International Exhibition, 1862, he was again anxious to have it engraved 'for the advantage which would result from the publicity & the honour of Engraving' (draft of letter to the third owner, J. Crossley of Halifax, 22 November 1862, FMBP). He planned to use for this purpose the replica painted in 1860 for Major Gillum (Fitzwilliam Museum) and a copy of a photograph he had coloured for T.E. Plint, the second owner, at that time. It was finally engraved in the *Art Journal* of 1870, with an accompanying text intimating that the artist was still little known outside his own circle.

M.B.

DANTE GABRIEL ROSSETTI

63 Found 1854–c.1859
Oil on panel, $16\frac{1}{2} \times 18\frac{1}{2}$ (41.9 × 47)
Ref: Surtees Nos 64M and 64O; Grieve 1976, pp.4–5
Carlisle Museum and Art Gallery

The subject of 'Found' is best seen in the finished drawing of 1853, No.196, and is discussed under that entry. This unfinished oil is probably the first version of the painting, commissioned by Francis McCracken in 1853, begun in 1854 and abandoned *c*.1859 for the larger and more complete version now at Wilmington (fig.iii). The brick wall was painted at Chiswick in October 1854, the calf and part of the cart in November and early December at Finchley, where Rossetti stayed with Madox Brown. The panel was then probably put aside until *c*.1858–9 when the woman's head, modelled by Fanny Cornforth, was painted in. Rossetti possibly abandoned it then because he realised he had not left sufficient space for the drover. He must also have wanted to paint it on a more ambitious scale to do justice to the importance of the subject. He laboured to complete the second version for the rest of his life. No.63 belonged to the poet and playwright Gordon Bottomley who shared with his close friend Paul Nash a strong admiration for Rossetti.

A.G.

63

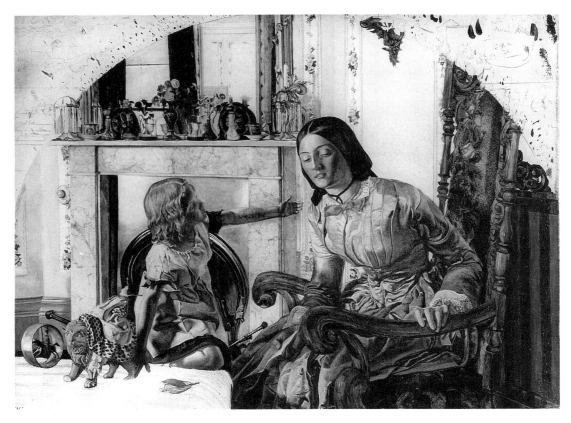

64

FREDERIC GEORGE STEPHENS

64 Mother and Child 1854–6
Inscribed 'F.G.S.' in monogram
Oil on canvas, $18\frac{1}{2} \times 25\frac{1}{4}$ (47 × 64.1)
Tate Gallery

This picture is usually dated to *c*.1854 on stylistic grounds, though an inscription 'N.Y.' in pencil on a part of the canvas now concealed by the frame suggests that Stephens might well have been working on it as late as 1856–7 when the exhibition of British Art in New York was being organised. It is the best and most complete of Stephens' surviving works and the most substantial in that it appears to show the artist deliberately turning, like others in the Brotherhood, to contemporary events for his subject matter.

The painting had been titled 'Mother and Child' before the Tate acquired it in 1932, but the blandness of this title has tended to obscure its rather weightier content. The mother holding the letter and the sense of disbelief, then grief, expressed in her face and in the way she is grasping the arm of the chair, combined with the particular childrens' toys which Stephens has chosen to place on the table – the (British) lion and the hussar – all suggest that the real subject is a commentary on the war between Russia and Britain in the Crimea

which Britain had entered in March 1854. A partly illegible inscription on the top left hand spandrel of the canvas, now concealed, draws a parallel between dead rose leaves and 'a perished heart' – words which presumably have a bearing on the theme. The domestic tragedy of the loss of a soldier husband and a father depicted here by Stephens finds its happier sequel in Millais' 'Peace Concluded' (R.A. 1856; now Minneapolis Institute of Arts) which deals with the end of the war in early 1856. The most famous incident in the war was celebrated by Tennyson in his poem 'The Charge of the Light Brigade', which was published in 1854.

Aspects of Stephens' technique in this picture have been fully discussed by Anna Southall in *Completing the Picture* (ed. S. Hackney; Tate Gallery 1982, pp.44–6), but the most noticeable feature of 'Mother and Child' is the difficulty the artist clearly experienced in the handling of perspective. Ruled pencil guidelines to establish, for example, the correct perspective for the mantelpiece and the right lines for the tops of the cup and saucer, appear on the outer, hidden edges of the composition; similarly the artist has drawn sections of the mirror frame as preliminaries to ensuring that its foreshortening is correct. The labour evident in this and in the actual working of the paint is a significant pointer as to why Stephens ceased painting.

R.H.

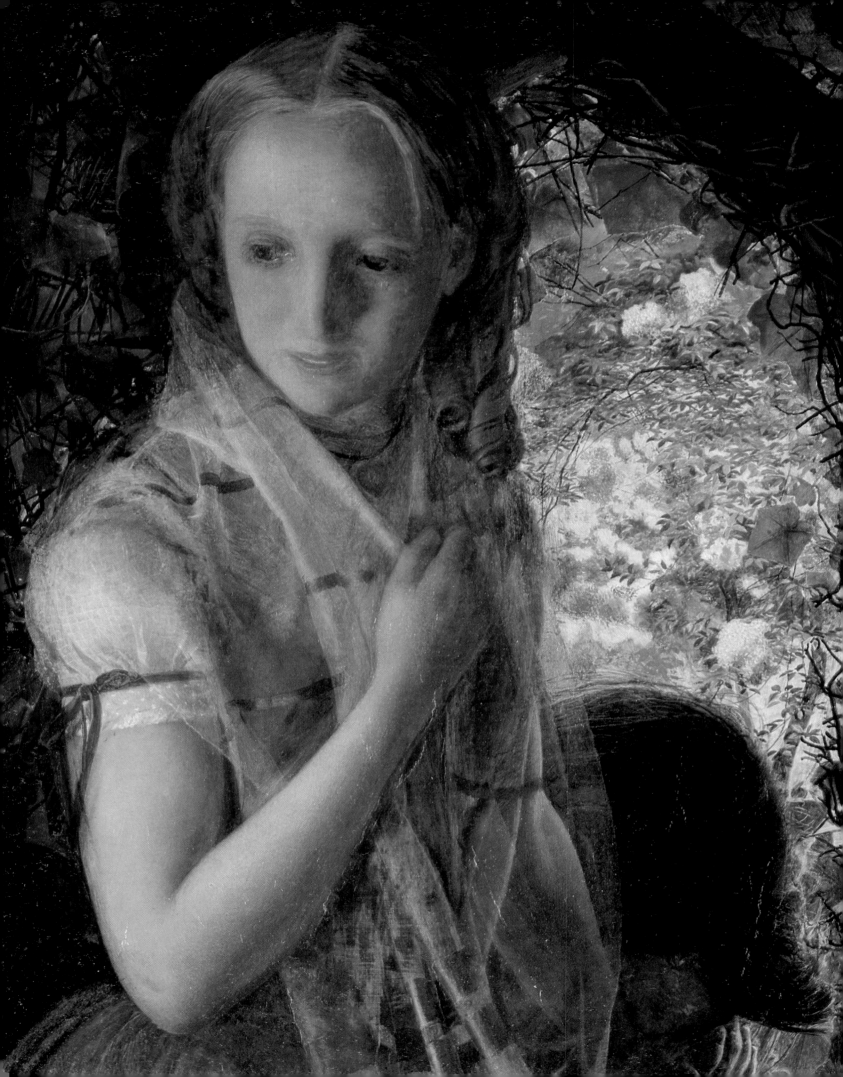

SECTION IV 1855-1856

With Hunt away in the Holy Land, Rossetti working privately on water-
colours and Brown now exhibiting in the provinces rather than London, Pre-
Raphaelitism in these years appeared to be largely in the hands of Millais and
the growing band of Pre-Raphaelite followers. Some of these (notably Arthur
Hughes) modelled their art on Millais', others were protégés of Ruskin
(Inchbold and Brett); for several Pre-Raphaelitism was an experiment that
hardly outlived one picture (Bowler and Burton). Of more far-reaching con-
sequence, Rossetti acquired two followers, Burne-Jones and Morris, who
decided to devote themselves to art in 1855 while undergraduates at Oxford
and attached themselves to Rossetti the following year.

Millais himself produced some of his finest work in this period but his move
away from obvious narrative in 'Autumn Leaves' (No.74) lost him some of his
earlier popular support. Hunt returned from Palestine in February 1856,
bringing with him two versions of 'The Scapegoat' (see No.84) and several
unfinished canvases that were to occupy him until the early 1860s.

opposite Arthur Hughes, 'April Love', 1855 (detail, No.72)

HENRY ALEXANDER BOWLER

65 The Doubt: 'Can These Dry Bones Live?' 1854–5
Inscribed '25 Aug. 1854' on the stretcher, the last
figure painted over a '2' or '3'
Oil on canvas, $23\frac{1}{2} \times 19\frac{9}{16}$ (59.7 × 49.7)
First exh: R.A. 1855 (644)
Tate Gallery

Bowler takes his quotation from the opening of Ezekiel 37, in
which God shows Ezekiel the valley of dry bones and asks, 'Son
of man, can these bones live?'. In Bowler's painting the
question is posed in a country churchyard by a young lady ('it
should have been asked by a man', complained the *Art Journal*),
who leans on a tombstone inscribed 'Sacred|to the|MEMORY|
of|John Faithful|Born 1711 Died 1791|"I am the Resurrection|
and the Life."'. Faithful's bones lie exposed to her gaze. At the
foot of the horse chestnut tree which spreads over her, and
which is almost the main subject of the picture, another stone
is inscribed 'RESURGAM'. A butterfly, traditional symbol of
Resurrection, perches on Faithful's skull. Whether the young
lady's doubts are answered, we are not told, though her
expression suggests that they may not be. On the stone at the
foot of the tree Bowler depicts a germinating chestnut: his own
symbol, perhaps, of natural regeneration and an alternative to
the supernatural resurrection proclaimed on the standing
stone.

'The Doubt' is Bowler's only well-known painting and the
only substantial work in which he is known to have adopted
the Pre-Raphaelite style. Its subject, however, is not found in
other Pre-Raphaelite painting but can be related to an older
pictorial tradition, inspired by Gray's *Elegy*, in which a figure is
depicted meditating in a churchyard, often leaning on a
gravestone. Bowler replaces the twilight melancholy of such
scenes with sunlight and rational doubts.

Bowler re-exhibited the painting at the International Exhibi-
tion of 1862, this time without the accompanying quotation,
but he never found a buyer for it; the work was presented to
the Tate Gallery by his family in 1921. He exhibited another
painting of a chestnut tree at the R.A. in 1871 ('Chestnut
blossoms').

L.P.

JOHN WILLIAM INCHBOLD

66 A Study, in March 1855
Inscribed 'J W I'
Oil on canvas, 21 × 14 (53 × 35)
First exh: R.A. 1855 (1162)
Visitors of the Ashmolean Museum, Oxford

Exhibited accompanied by lines 815–6, slightly altered, from
Book I, 'The Wanderer', of William Wordsworth's nine-part
poem *The Excursion* (first published 1814):

> When the primrose flower
> Peeped forth to give an earnest of the Spring.

There has been some doubt as to whether 'A Study, in March' –
which has also been called 'In Early Spring' – was indeed the
picture exhibited by Inchbold in 1855. However, the de-
scription of the painting given by the critic in the *Spectator*
would seem to confirm the correctness of the present dating: 'a
most delicious little piece – pure and perfect in its soft colour
and unsurpassedly tender as a description of the season of early
promise, with its blue sky, and scarce budding boughs, and
nibbling sheep, and clustered primroses' (23 June 1855,
p.658).

Most obviously, it is the artist's elaboration of foreground
detail which places him amongst the leading Pre-Raphaelite
landscapists – though such handling of subject matter could
not be described as exclusively Pre-Raphaelite. As Staley
has pointed out (p.114), 'A Study, in March' shared with
Inchbold's two other 1855 exhibits the use of accompanying
quotations from Wordsworth – a poet whose work Ruskin had
once referred to, in the first volume of *Modern Painters*, as an
example of careful finish when it came to transcribing nature.
Inchbold's own sensitive and retiring nature clearly found in
Wordsworth a pensiveness (especially in Book I of *The
Excursion*) which complemented his own cast of mind and – as
far as his eye and his technique were concerned – something
which one writer described as 'a feminine delicacy and an
almost painful elaboration of the motive of every spot and speck
in nature's handiworks' (*Athenaeum*, 26 May 1855, p.624). 'A
Study, in March' demonstrates particularly well those quali-
ties, with the delicacy of touch exemplified where the paint is
thinnest, almost like watercolour in parts, through which the
white ground shows.

According to the *Athenaeum* (loc. cit.), the picture was hung
'out of all reach' in the Academy but it was noticed by Ruskin
who described it as 'exceedingly beautiful' ('Academy Notes'
1855; Ruskin, XIV, p.22). The work was exhibited again at the
Liverpool Academy in 1855 (311) where it was unpriced; it
had probably by this time entered the collection of Henry
Thompson (1820–1904; later Sir Henry), an eminent surgeon
and an amateur artist.

R.H.

65

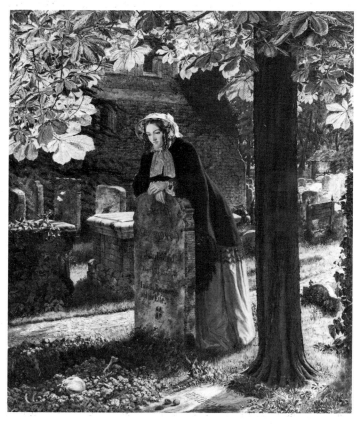

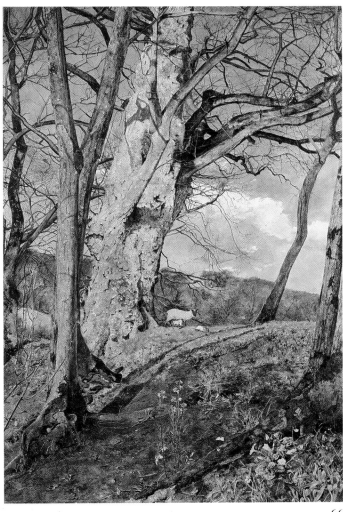

66

JOHN EVERETT MILLAIS

67 The Rescue 1855
Oil on canvas, arched top, 47 × 33 (119.4 × 83.8)
First exh: R.A. 1855 (282)
National Gallery of Victoria, Melbourne

The first picture Millais began on a subject from contemporary
life was 'The Blind Girl' (No.69) but the first he completed and
exhibited was No.67.

According to the artist's brother William, it was inspired by
the sight of firemen bravely fighting a blaze close to Meux's
brewery at the southern end of Tottenham Court Road.
'Soldiers and sailors have been praised on canvas a thousand
times', Millais declared. 'My next picture shall be of the
fireman' (J.G. Millais, I, pp.247–8). Before commencing work,
he visited several other fires and was rushed off to at least one
by the captain of the fire brigade himself, who J.G. Millais says
was a friend of his (I, pp.254–7). He seems to have discussed
his subject with Charles Dickens, whom he met through Wilkie
Collins. Dickens wrote to him on 13 January 1855 enclosing
'the account of the fire brigade, which we spoke of last night'
(J.G. Millais, I, p.249). The account he mentions was un-
doubtedly his own description of the work of the fire brigade,
including a dramatic evocation of a fire, from *Household Words*
(I, 11 May 1850, pp.145–51). Dickens wrote to Wilkie Collins
on 24 March 1855: 'When you see Millais, tell him that if he

would like a quotation for his fireman picture there is a very
suitable and appropriate one to be got from Gay's "Trivia"'
(G. Hogarth and L. Hutton (eds.), *Letters of Charles Dickens to
Wilkie Collins*, 1892, p.30). The passage in question here was
probably Book III, lines 362–8 of Gay's poem (1716), from his
description of a London fire:

> The fire-man sweats beneath his crook'd arms,
> A leathern casque his vent'rous head defends,
> Boldly he climbs where thickest smoak ascends;
> Mov'd by the mother's streaming eyes and pray'rs,
> The helpless infant through the flame he bears,
> With no less virtue, than through hostile fire
> The Dardan hero [Aeneas] bore his aged sire.

Dickens sent a copy to Millais on 10 April (J.G. Millais I, p.249)
but it was not used for the R.A. exhibition catalogue, in which
the title 'The Rescue' appears without any accompanying text.

Millais had presumably just begun work on No.67 or was
about to begin when Dickens wrote to him on 13 January
1855. The picture was finished in a last-minute rush for
submission to the R.A. exhibition in early April. Ford Madox
Brown noted in his diary for 11 April that it had been finished
in time 'although 3 weeks ago he had more than half
uncovered they say' (Surtees 1981, p.132). J.G. Millais quotes
a detailed description of Millais' work on No.67 by his friend
and fellow artist F.B. Barwell: 'This picture was produced in my
studio, and presents many interesting facts within my own
knowledge. After several rough pencil sketches had been
made, and the composition determined upon, a full-sized
cartoon was drawn from nature. Baker, a stalwart model, was
the fireman, and he had to hold three children in the proper
attitudes and bear their weight as long as he could, whilst the
children were encouraged and constrained to do their part to
the utmost. The strain could never be kept up for long, and the
acrobatic feat had to be repeated over and over again for more
than one sitting, till Millais had secured the action and
proportion of the various figures. When sufficiently satisfied
with the cartoon, it was traced onto a perfectly white canvas,
and the painting commenced. It was now no longer necessary
to have the whole group posed at one time; but Baker had to
repeat his task more or less all through. The effect of the glare
was managed by the interposition of a sheet of coloured glass of
proper hue between the group (or part of it at a time) and the
window. The processes employed in painting were most
careful, and indeed slow, so that what Millais would have done
in his later years in a week, took months in those earlier days. It
was his practice then to paint piecemeal, and finish parts of his
pictures as he went on. White, mixed with copal, was generally
laid on where he intended to work for the day, and was painted
into and finished whilst wet, the whole drying together. The
night-dresses of the children were executed in this manner.
Strontian yellow was mixed with the white, and then rose-
madder mingled with copal, floated, as it were, over the solid
but wet paint – a difficult process, and so ticklish that as soon as
a part was finished the canvas had to be laid on its back till the
colour had dried sufficiently to render the usual position on the
easel a safe one. By degrees the work was finished, but not till
near midnight of the last day for sending into the Royal
Academy. In those days Millais was generally behindhand
with his principal picture, and so much so with this one, that he
greatly curtailed his sleep during the last week; and on the last
day but one began to work as soon as it was daylight, and
worked on all through the night and following day till the van
arrived for the picture. (Mr Ruskin defended the appearance of
haste, which to him seemed to betray itself in the execution of

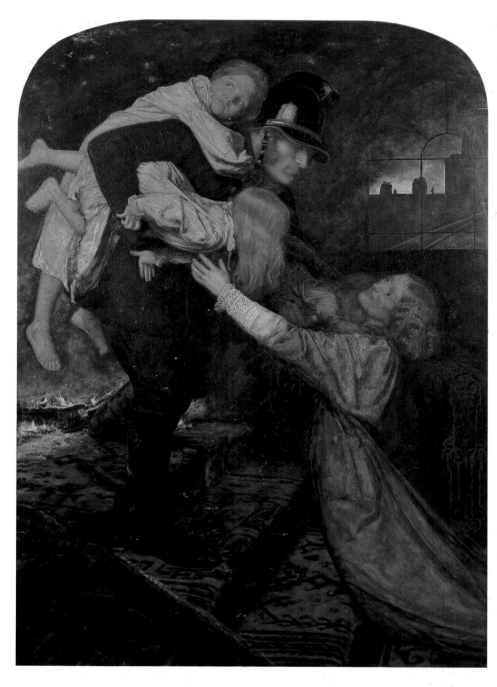

67

this picture, contending that it was well suited to the excitement and action of the subject.) His friend Charles Collins sat up with him and painted the fire-hose, whilst Millais worked at other parts; and in the end a large piece of sheet-iron was placed on the floor, upon which a flaming brand was put and worked from, amidst suffocating smoke. For the head of the mother, Mrs Nassau Senior, sister of Judge Hughes of *Tom Brown* fame, was good enough to sit' (I, pp.250–1).

Barwell gives the model for the fireman as Baker but J.G. Millais (II, p.469) gives him as Westall, who sat for 'The Order of Release, 1746' (No.49). The model for the mother was certainly Mrs Nassau Senior, whom Millais seems to have approached through Tom Taylor. While working on No.67 he wrote to him: 'I am very anxious to get a beautiful face for what I am painting this year. I hope you will use your influence in my

behalf to get her to sit for me' (PC).

The picture was at first badly hung at the 1855 R.A. exhibition but Millais insisted that it should be moved, becoming irate when the hangers proposed to put it back again. On 22 May he wrote to Holman Hunt: 'I almost dropped down in a fit of rage in a row I had with the three hangers in which I forgot all restraint and shook my fist in their faces, calling them every conceivable name of abuse. It is too long a story to relate now but they wanted to lift my picture up, after I had got permission to have it lowered three inches, and tilted forward so that it might be seen, which was hardly the case as it was first hung. Oh! they are felons' (Bowerswell Papers, PML). The dispute is also described in J.G. Millais, I, pp.253–4 and Hunt 1905, II, p.14.

The work was bought from Millais by Joseph Arden for

68

£580. Arden already owned 'The Order of Release, 1746' and it is possible that No.67 was from the outset conceived as a pendant to the earlier work in the hope that Arden would buy it. The sizes are close, the compositions fit together and both pictures touch on the themes of deliverance and family reunion. Millais seems to have been on close terms with Arden, who was his proposer when he became a member of the Garrick Club on 17 February 1855.

Later in the same year as its initial exhibition at the R.A. the picture was sent to the Liverpool Academy, where, according to J.G. Millais (I, p.258), it missed winning the prize by just one vote.

Millais retouched it on at least two occasions. He wrote to his wife that he had it with him for that purpose on 7 May 1856 (HL). By the time of the Arden sale in which it appeared on 26 April 1879, the canvas was covered in spots, owing, J.G. Millais says, to its having been kept in an uncongenial temperature. Arden's executors refused to allow Millais to retouch it, but when it was shown at the 1888 International Exhibition in Glasgow, J.G. Millais reminded his father of the spots and he succeeded in getting the permission of the new owner, Holbrook Gaskell, to remove them (J.G. Millais, I, pp.258–9). After the Gaskell sale on 24 June 1909, Holman Hunt wrote to Morland Agnew, who had bought No.67 for Charles Fairfax Murray: 'When I last saw the painting the surface was sprinkled over with little spots & from my experience with a picture of my own I was able to determine that these came from the ground on which the picture was painted having been prepared with some amount of sugar of lead (probably by the artist colourman to hasten its drying)' (HL, quoted in Lutyens 1974, pp.89–91). It is not clear whether Hunt had last seen the work before or after Millais' own repairs of 1888. In

any case, Fairfax Murray declined his offer to supervise its restoration.

The cartoon to which F.B. Barwell refers is now at Birmingham City Art Gallery (41'01) and there are two sketches at the Courtauld Institute Galleries.

M.W.

FORD MADOX BROWN

68 The Hayfield 1855–6
Inscribed 'F.MADOX BROWN, HENDON 1855'
Oil on panel, $9\frac{7}{16} \times 13\frac{1}{16}$ (24 × 33.2)
First exh: *Art Treasures*, Manchester 1857 (Modern Pictures, 319)
Ref: Liverpool 1964 (33)
Tate Gallery

Looking east at twilight on the Tenterden estate at Hendon, Middlesex, over rolling land towards a south or south-east facing house which the setting sun strikes on its west side. The dip between might be that of the Brent and the house itself be towards Finchley, where the artist was living. In the foreground he himself appears with his equipment scattered around and resting after his day's work; a farmer on horseback directs the last work in the hayfield and children get a ride in the haycart (Hendon, as other parts of Middlesex, specialised in hay-farming and the harvest was taken daily to Cumberland Market: *Victoria County History*, V, pp.23–4).

After selling his two small landscapes of 1854–5 (Nos 60–61), and having just completed his original study of 'Windermere' (No.13) on 20 July 1855, the artist was on the

look-out in his evening walks for small landscapes 'that will paint off at once', while he got on with his main task of painting 'The Last of England' (No.62). The next day he noted: 'What wonderful effects I have seen this eveng in the hay fields, the warmth of the uncut grass, the greeny greyness of the unmade hay in furrows or tufts, with lovely violet shadows & long shades of the trees thrown athwart all & melting away one tint into another imperceptibly, & one moment more & cloud passes & all the magic is gone' (Surtees 1981, p.145).

In spite of his despair over the lack of 'a life study such as Turner', he found a lovely spot in twilight on the 27th, 'with the full moon behind it just risen', and though finding it prosaic by daylight nevertheless began it the following day at 5 p.m. He worked at it on the spot about twice a week until early September and again in October, after moving house from Finchley to Kentish Town. He then sometimes walked 14 miles there and back but at the end of the month stayed two nights at the Queen's Head at Finchley and went once in a cab. He finished it from the view on 24 October. He recorded 9 days or 36 hours on it that month.

Returning to it in December at home, long past its season, he worked at the foreground. He sketched a haycart at Cumberland Market (a general purpose cart with ladders to take the load and two horses in tandem to take the weight: identified by R.D. Bridgen, Museum of Rural Life, Reading University). He set the lay figure for the artist in his conservatory at 13 Fortess Terrace, working in the cold in his overcoat. He set and painted the paintbox, canvas, easel and umbrella and a little later put in the farmer, workmen and children, apparently without any models. He touched it 'from feeling' in the evenings but was far from satisfied with it. On 10 December he found a way to 'break the dark line of trees which painfully cut the picture in two'; he darkened the hayfield 'which Lowes Dickinson thought spoild the background', later cuttlefished it and painted in the moon, having already painted the sky over again after it cracked as a result of being painted over zinc white. He was still 'disgusted' with it in January 1856 and after examining it from a distance retouched it yet again. On 27 January he recorded 100 hours work on it.

He commented in his 1865 catalogue that 'the stacking of the second crop of hay had been much delayed by rain, which heightened the green of the remaining grass, together with the brown of the hay. The consequence was an effect of unusual beauty of colour, making the hay by contrast with the green grass, positively red or pink, under the glow of twilight here represented'. His sustained work on it long after the season of its subject and in the studio, is perhaps apparent in the still uncertain working out of the foreground, where the colouring is a little muddy and the farmhands, children and most particularly the artist romantically looking on, are not fully worked out in the half-light. This portion lacks the quality of shimmering life and lyrical perceptiveness which is the special keynote of the middle and distance painted on the spot.

His dealer White would not buy it, he 'said the hay was pink & he had never seen such'. Madox Brown retouched it yet again from a field near Kentish Town in June 1856 and, on 23 August, 'Rossetti brought his ardent admirer Morris of Oxford who bought my little hay field for 40 gnas, this was kind of Gaggy'. However, he recorded in his Account Book under 1860 (MS copy, FMBP) getting it back, initially for work done for Morris at the Red House, Upton (ready for occupation in 1860), but finally, in 1864, for cash; and he sold it to Major Gillum, who had his 'Walton-on-the-Naze' (No.103) also in 1860. Hueffer gives the price of £63 under 1864.

M.B.

JOHN EVERETT MILLAIS

69 The Blind Girl 1854–6
Inscribed 'JMillais|1856' (initials in monogram)
Oil on canvas, 32½ × 24½ (82.6 × 62.2)
First exh: R.A. 1856 (586)
Ref: R.A. 1967 (51)
Birmingham Museum and Art Gallery

As a subject from modern life concerned with a social problem of the day, vagrancy amongst children and the disabled, No.69 was Millais' response to Holman Hunt's 'The Awakening Conscience' (No.58). It is considerably milder in tone than Hunt's picture, however, emphasising the pathos rather than the iniquity of the situation. Millais had treated a similar subject in his drawing of 1853 showing a blind beggar being shown across a busy street (No.191). Here the setting is a landscape, the beauty of which makes the girl's state all the more pitiable. The rainbows are a manifestation of the light she is denied. On the other hand, her concertina, the wet grass, harebells and forget-me-nots, and the way she is fingering the grass at her side convey the idea that, despite her blindness, her senses of hearing, smell and touch are still alive.

The background is a faithful view of Winchelsea in Sussex, including the church in which Millais painted the setting for his other child subject of this time, 'L'Enfant du Régiment' (No.70). Winchelsea had made a strong impression on him when he visited the place with Holman Hunt and Edward Lear in the summer of 1852 (Hunt 1905, I, pp.333–4). He arrived there to paint No.69 about 24 August 1854, when he wrote to Tennyson that he was 'intending to stay until it is too unseasonable to sit out of doors' (MS, Tennyson Research Centre, Lincoln). By 18 October he could write to John Leech: 'I have nearly finished my background now and I shd. like you to see it . . . I am painting rainbow. Saw another here a beauty so can easily manage it' (PC).

J.G. Millais states that neither the landscape nor the figures were completed at Winchelsea, but at Perth in Scotland, where the artist settled in early August 1855 after his marriage, 'the middle distance being, I think, painted in a hayfield near the railway bridge at Barnhill, just outside of Perth' (I, p.242). Whether or not at that spot, Millais certainly did work on No.69 in Perth that year. In a letter datable to the week of 11 August he wrote to Charles Collins: 'I set a palette this afternoon and absolutely commence work. The "Rainbow" thanks to you has arrived safely, and all the other things' (Bowerswell Papers, PML).

The models were the same two Perth girls who feature on the right side of 'Autumn Leaves' (No.74), Matilda Proudfoot as the blind girl and Isabella Nicol as her companion. They were found for Millais by his wife Effie, who wrote in her journal: 'She [Matilda] is in the picture of the "Blind Girl", a subject full of pathos and very touching in its story. She is represented as a wandering player on the Concertina accompanied by the other little girl [Isabella] . . . The background of this picture was painted in the Autumn of 1854 at Winchelsea, some of the wild flowers and grasses here at Perth and the figures entirely. First of all I sat for the blind girl. It was dreadful suffering, the sun poured in through the window of the study. I had a cloth over my forhead and this was a little relief but several times I was as sick as possible, and nearly agued [.Another] two days I sat in the open air, and when the face was done Everett was not pleased with it and later in the year scratched it out entirely. Then he put in Matilda. The plaid over the head was Papa's, the Concertina was lent us by Mr Pringle who had an only

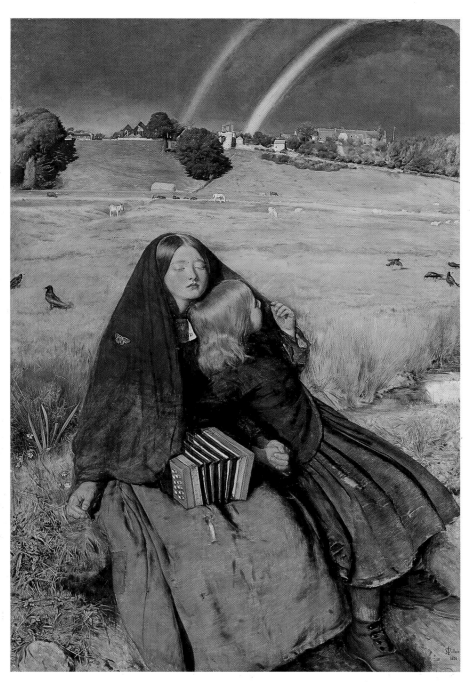

69

Daughter who played it. She died about six months ago and he said sadly we might keep it as long as we liked for it would never be played on any more. The petticoat of the girl was first an old red one of a girl in Bridgend but when it was done the Colour looked bad and violent and Everett had a whole evening's work scraping it out and part of a striped Linsey Wolsey brown and yellow one I made which likewise was ugly. Lastly when all the picture was done but little Isabella's feet, which he first began bare but afterwards put on boots, he said an amber colour petticoat was what he wanted. It was not a week before his going to town and I did not know what I should do. I went down to Bridgend to buy some meat and the first thing I saw was an old woman with the very thing I wanted on. I was in Jean Campbell's my Poultry woman and I said, ''You know that woman, Jean. Run and ask her if she would lend me her petticoat.'' At night Jean went and she swore an oath and said what could Mrs Millais want with her old Coat, it was so dirty, but I was welcome. I kept it two days and sent her it back with a shilling and she was quite pleased. The next day was Sunday and Everett being much pressed for time devoted it to painting that petticoat' (PC).

No.69 was the first picture Millais sold to the leading art dealer Ernest Gambart, who paid him 400 gns for it on or shortly before 10 April 1856 (letter from the artist to Effie, Millais Papers, PML).

The double rainbow was originally painted incorrectly, with the colours arranged in the same order in each arc. In the *Art Journal* of August 1856 (p.236) a writer signing himself 'Chromas' pointed out that the weaker one should be in reverse. Millais altered it, presumably after the R.A. exhibition,

and, according to J.G. Millais (I, p.240), 'was duly feed for so doing'. The same critic, writing as 'Chroma', had the previous year attacked 'The Rescue' (No.67) for its too-ruddy lighting (*Art Journal*, July 1855, pp.211–2).

Later in 1856 the work was shown at the Birmingham Society of Artists and in 1857 at the Liverpool Academy, where it was awarded a £50 prize.

There is a study for the figure of the younger girl at the Tate Gallery (exh. R.A. 1967, No.359).

M.W.

JOHN EVERETT MILLAIS

70 **L'Enfant du Régiment** 1854–5
Inscribed 'JEM 1855' (initials in monogram)
Oil on canvas, $17\frac{3}{4} \times 23\frac{3}{4}$ (45.1 × 60.3)
First exh: R.A. 1856 (553)
Ref: R.A. 1967 (52)
Yale Center for British Art (Paul Mellon Fund)

A girl has been accidentally wounded in fighting that involves soldiers recognisable from their uniforms as French. Like 'A Huguenot' (No.41) and 'The Proscribed Royalist, 1651' (No.46), 'L'Enfant du Régiment' is based on an opera. Both title and subject are derived from Donizetti's *La Fille du Régiment*, which Millais could have seen performed at Her Majesty's in 1847–8 or 1850–1. The heroine of the opera is Marie, offspring of a secret marriage between the Marchioness of Birkenfield and a French officer. He was killed in action while she was still a baby and his regiment adopted her. The action of the opera takes place in 1815 when Marie is a young woman. No.70 shows an imagined incident from her childhood, during a battle in the wars France fought under the First Republic or Napoleon. The jacket covering her is identifiable from the insignia as that of a grenadier.

The origins of Millais' picture may date back to October 1852, when he was about to begin work on 'The Order of Release, 1746' (No.49) and told Thomas Combe that he was also contemplating a subject set in a church. It was perhaps at this early stage, if at all, that the historical setting was going to be the Civil War. J.G. Millais (I, p.239) suggests that was the artist's original idea, citing 'Dante Rossetti' (a mistake for William Michael Rossetti perhaps) and the evidence of some sketches that are no longer extant.

70

The background was painted during the time Millais spent at Winchelsea in 1854, probably between 18 October, by which date he had nearly finished the landscape in 'The Blind Girl' (No.69), and 22 November, when he left to visit Tennyson on the Isle of Wight. It shows the interior of Winchelsea Church with the fourteenth-century tomb of Gervaise Alard, first Warden of the Cinque Ports. The figure of the child was added the following year in Perth. The model appears to have been Isabella Nicol, who is also in 'The Blind Girl' and 'Autumn Leaves' (No.74).

The title 'L'Enfant du Régiment' is the one given in the 1856 R.A. exhibition catalogue but the work was also known during the artist's lifetime as 'The Random Shot'. The alternative title was probably borrowed from Landseer's popular painting of a mortally wounded deer called 'A Random Shot' (exh. R.A. 1848, now Bury Art Gallery). Landseer adapted the phrase from the lines

Full many a shot at random sent,
Finds mark the archer little meant,

in Sir Walter Scott's *The Lord of the Isles*.

No.70 was bought by B.G. Windus and rapidly sold again, before 30 April 1856, to Thomas Miller, the Preston textile manufacturer.

M.W.

WILLIAM SHAKESPEARE BURTON

71 **A Wounded Cavalier** 1855–6
Oil on canvas, 36 × 41 (91.5 × 104.2)
First exh: R.A. 1856 (413)
Guildhall Art Gallery, Corporation of London

A cavalier has been attacked while travelling through a wood and his despatches stolen. A spider has spun a web between his sword, the tree in which it has lodged and the brambles below, suggesting that some time has elapsed before his discovery by the Puritan and his lady. The latter tends his wounds while the Puritan looks sourly on, his massive bible contrasting with the cavalier's playing cards left strewn on the ground. The butterfly perched on his broken sword was interpreted by F.G. Stephens as a symbol of the cavalier's departing soul (*Athenaeum*, 11 September 1886, p.343).

According to an article on Burton by E. Rimbault Dibdin, which appears to have been based on conversations with the artist, the picture was begun in the late summer of 1855, the landscape being studied in the grounds of 'an old cavalier mansion' near Guildford, formerly occupied by Sir Thomas More. Presumably Loseley Park, built by More's kinsman Sir William More, is the house intended. Dibdin reports that Burton had a hole dug for himself and his easel so that he could more closely study the brambles and ferns in the foreground ('William Shakespeare Burton', *Magazine of Art*, 1899, pp.289–95).

When exhibited in 1856, hanging next to Hunt's 'The Scapegoat' (see No.84), Burton's picture was listed in the first edition of the R.A. catalogue merely by number. 'Subject and painter not yet named in the Catalogue', Ruskin remarked in his *Academy Notes*: 'The former, not very intelligible; the latter is reported to be a younger member of the new school – Mr Burton. His work is masterly, at all events, and he seems capable of the greatest things' (Ruskin, XIV, p.66). Name and title appeared in later editions. Burton's picture had, it seems, lost its identifying label and would not have been hung at all

had not C.W. Cope come across it at the last moment and withdrawn one of his own works to make room for it (ibid., p.66 n.1).

Burton may have been inspired to paint a Civil War subject by Millais' 'The Proscribed Royalist, 1651' (No.46), which was shown at the R.A. in 1853. The pose of the cavalier and the Puritan girl clearly derives, however, from an Italian *pietà*. Burton painted a watercolour replica of the two principal heads in 1871; this is now in the Tate Gallery.

Despite Ruskin's prediction, Burton's career soon failed. His picture for the 1857 R.A. exhibition, 'A London Magdalene', was rejected by the Academy and his health broke down. Stephens, in the *Athenaeum* article cited above, thought that he died soon afterwards. Before his actual death in 1916, Burton in fact produced much more, though 'A Wounded Cavalier' remains his best-known work.

L.P.

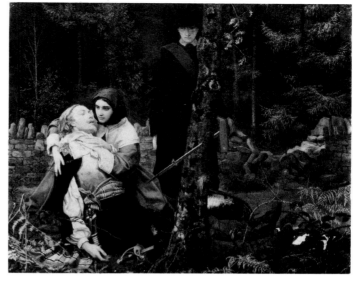

71

72

ARTHUR HUGHES

72 April Love 1855
Inscribed 'ARTHUR HUGHES·1856'
Oil on canvas, $35 \times 19\frac{1}{2}$ (88.9 × 49.5)
First exh: R.A. 1856 (578)
Tate Gallery

'April Love' was exhibited at the Royal Academy in 1856 with a quotation from one of the songs in Tennyson's 'The Miller's Daughter', in which the young lovers fear the passing of their love ('Love that hath us in the net, | Can he pass, and we forget?'):

> Love is hurt with jar and fret.
> Love is made a vague regret.
> Eyes with idle tears are wet.
> Idle habit links us yet.
> What is love? for we forget:
> Ah, no! no!

Although Hughes uses this passage to underline his own depiction of fragile young love, his painting is not conceived as an illustration to Tennyson's poem. In place of the poet's mill-stream, chestnut trees and forget-me-nots, Hughes sets the lovers in an ivy-clad arbor or summerhouse with lilac seen through the window and rose petals strewn on the stone floor. As with many of his works, ivy is also used to decorate the frame.

Hughes was married at Maidstone on 26 November 1855 to 'his early and only love' Tryphena Foord, whose father was the manager of a local plumbing and decorating business owned by Robert Cutbush (information communicated by Jerry Green from the Graham Hughes Papers). On his death in 1854 Robert left his business and property to his brother Thomas Robert Cutbush, presumably the same Mr Cutbush in whose garden at Maidstone Robert Ross said 'April Love' was painted (*Burlington Magazine*, XXVIII, 1916, p.171). Much of the painting, however, appears to have been done at 6 Upper Belgrave Place, Pimlico, where Hughes shared a studio with the sculptor Alexander Munro. The latter is said to have been the model for the man in the picture (letter from Margaret Munro, 20 August 1959, in Tate Gallery files). According to

Hughes' pupil Albert Goodwin, writing in 1916, the face of the girl was originally modelled from a country girl who disliked the way Hughes was painting her and promptly left. Tryphena appears to have been the final model for the girl.

'Last night I had the mulligrubs', Ford Madox Brown wrote in his diary on 9 September 1855, '& went for the first time to Munros & saw Hughes picture of the Lovers quarrel – it is very beautiful indeed. The girl is lovely, draperies & all, but the greens of his foliage were so acid that made my mulligrubs worse I do think' (Surtees 1981, p.153). The painting was finished by November, when Hughes wrote to the poet William Allingham: 'You remember the picture of a girl you saw unfinished – and suggested my calling "Hide and Seek" – now completed and rejoicing in the more graceful title of "April Love." Ruskin saw, went into enthusiastic admiration, and brought his Father to try and induce him to purchase it, but alas fate willed otherwise, altho' the old gentleman's enthusiasm equalled if not surpassed Ruskin Junior's, I believe' (Allingham 1911, p.62). On Ruskin's advice, Ellen Heaton of Leeds also saw the painting at about this time but evidently did not like it. 'I am so sorry', Ruskin wrote to her in late November, '– but I did like the face in Hughes' picture – What would you have? the girl is just between joy & pain – of course her face is unintelligible, all a-quiver – like an April sky when you do not know whether the dark part of it is blue – or raincloud' (Surtees 1972, p.177). Miss Heaton subsequently commissioned 'Aurora Leigh's Dismissal of Romney' (No.113) from Hughes.

Although Ruskin could not buy 'April Love', he continued to voice his enthusiasm for it, calling it in his *Academy Notes* for 1856 'Exquisite in every way; lovely in colour, most subtle in the quivering expression of the lips, and sweetness of the tender face, shaken, like a leaf by winds upon its dew, and hesitating back into peace' (Ruskin, XIV, p.68). The picture was in fact bought at the R.A. exhibition by William Morris, who wrote to Burne-Jones on 17 May asking him to 'nobble' it before anyone else could (G. Burne-Jones, I, p.132). At the end of his life Hughes still remembered Burne-Jones arriving at Upper Belgrave Place with Morris's cheque: 'My chief feeling then was surprise at an Oxford student buying pictures', he recalled in 1912 (*Pall Mall Gazette*, 13 July 1912).

A pencil and wash study for 'April Love', indicating the main features of the design as executed, is in the Tate Gallery (No.T.276). A quarter-size replica in oil belongs to John Gere.

<div style="text-align:right">L.P.</div>

WILLIAM LINDSAY WINDUS

73 Burd Helen 1855–6
Inscribed 'WLW 1856' (initials in monogram)
Oil on canvas, 33¼ × 26¼ (84.4 × 66.6)
First exh: R.A. 1856 (122)
Merseyside County Council, Walker Art Gallery, Liverpool

The first picture by this artist showing Pre-Raphaelite influence in the, still tentative, use of their minute technique and in his first use of a landscape background. The P.R.B. aim towards seriousness of subject matter would have been particularly appealing to Windus, whose earlier pictures, illustrating Shakespeare, Scott and history had all had religious and moralistic overtones.

No.73 illustrates the Scottish Ballad of 'Burd Helen' who desperately followed her cruel lover, bore his child, and was finally received by him with honour and wedded. It appeared at the 1856 R.A. with the following lines in the catalogue (inscribed with variations on the frame):

> Helen, fearing her lover's desertion, runs by the side of his horse as his foot page

> Lord John he rode, Burd Helen ran,
> A live-lang simmer's day;
> Until they cam' to Clyde water,
> Was filled frae bank to brae.

> 'Seest thou yon water, Helen,' said he,
> 'That flows from bank to brim?'
> 'I trust to God, Lord John,' she said,
> 'You ne'er will see me swim.'

A Mrs Burns sat for the woman and a Mr Steele, a connection of John Miller, the collector, for the lover (Marillier 1904, p.247). The background was apparently painted in North Sannox Glen, Isle of Arran (according to James Smith, *In Memoriam W.L. Windus...*, n.d., who may have had the information from the artist). While the idea of introducing an appropriate open-air background probably stemmed from Pre-Raphaelite influence, the work of his friends the landscape artists William Davis and Robert Tonge of Liverpool (of whom the latter painted in this glen in the late 1840s) must also be remembered. Windus was in Scotland around September 1855 (when he missed a Liverpool Academy Council to decide the year's prize: letter to Ford Madox Brown quoted in Hueffer, p.111, and Liverpool Academy Minutes).

At the R.A. No.73 was skied and passed over by the critics, but Rossetti saw it (he may have remembered the name through his contact with John Miller). He enthused about it to various correspondents including Francis McCracken and William Allingham over in Ireland; to the latter he commented: 'The R.A. Ex. is full of P.R. work this year. Hughes' "Eve of St. Agnes" is a real success. The finest thing of all in the place, to my feeling, is a picture by one Windus (of Liverpool), from the old ballad of *Burd Helen*, another version of *Childe Waters*. It belongs, I hear, to your friend Miller' (Doughty & Wahl, I, p.301). More important, he made Ruskin go back to look at it and add a long postscript to his *Academy Notes*. While pointing out several faults, Ruskin classed it as 'the second picture of the year; its aim being higher, and its reserved strength greater than those of any other work except the "Autumn Leaves." Its whiteness of colour results from the endeavour to give the cold grey of the northern fall of day when the wind is bleak, and the clouds gathering for storm; their distant cumuli, heavy with rain, hanging on the rises of the moorland. I cannot see, at the distance of the picture from the eye, how far the painting of the pebbles and heath has been carried; but I see just enough of the figures to make me sure that the work is thoughtful and intense in the highest degree. The pressure of the girl's hand on her side; her wild, firm, desolate look at the stream – she not raising her eyes as she makes her appeal, for fear of the greater mercilessness in the human look than in the glaze of the gliding water – the just choice of the type of the rider's cruel face, and of the scene itself – so terrible in haggardness of rattling stones and ragged heath – are all marks of the action of the very grandest imaginative power, shortened only of hold upon our feelings because dealing with a subject too fearful to be for a moment believed true' (Ruskin, XIV, pp.85–7).

To Windus, working in provincial isolation and from whom had emanated the Liverpool artists' enthusiasm and support for the Pre-Raphaelites, this came as a vital seal of approval, allied to Rossetti's praise. 'I assure you', he wrote to Rossetti, 'that you and Mr. Ruskin were the two persons in the world

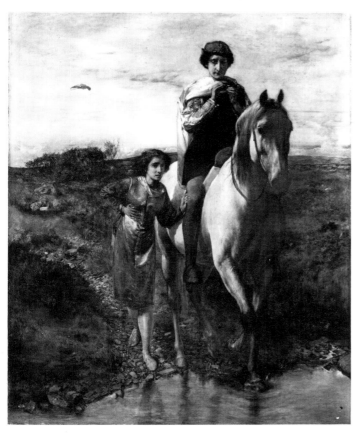

73

whose approbation I most ardently wished and scarcely dared to hope for, and that I felt the most inexpressible delight when the extract from your letter [to McCracken] was read to me, being at the time in a wretched state of despondency' (W.M. Rossetti 1899, p.138).

At the Manchester Art Treasures Exhibition, 1857, it gained the notoriety of a caricature in *Poems inspired by certain Pictures . . . dedicated to . . . The Immortal Buskin.*

Miller, as an essentially speculative buyer, sold it at Christie's in 1858 with other Pre-Raphaelite pictures. It later belonged to T.E. Plint and to Frederick Leyland the Liverpool shipowner and was bought by the Walker Art Gallery in 1956.

M.B.

JOHN EVERETT MILLAIS

74 Autumn Leaves 1855–6
Inscribed 'JM 1856' (initials in monogram)
Oil on canvas, 41 × 29 (104.1 × 73.6)
First exh: R.A. 1856 (448)
Ref: R.A. 1967 (53)
City of Manchester Art Galleries

With 'Autumn Leaves' Millais set out to paint 'a picture full of beauty and without subject', a work in which the very specific story-telling that plays such an important part in his paintings of the early 1850s is replaced by a concern for creating a mood and suggesting more universal ideas. The season, the dead leaves, the smoke and the sunset are all images of transience, reminders that all things must pass. It is a setting redolent of decay and death that makes us conscious that the girls in the

foreground, for all their youth and beauty, must inevitably go through the same processes. The apple held by the little girl on the right is an emblem of autumn but may also be intended to recall the Original Sin that made mankind subject to mortality.

When it was sympathetically reviewed by F.G. Stephens in the American journal *The Crayon* (III, November 1856, p.324), Millais was moved, uncharacteristically, to speak of his intentions in the work: 'I have read your review of my works in *The Crayon* with great pleasure, not because you praise them so much but because you entirely understand what I have intended. In the case of "Autumn Leaves" I was nearly putting in the catalogue an extract from the Psalms, of the very same character as you have quoted in your Criticism, but was prevented so doing from a fear that it would be considered an affectation and obscure. I have always felt insulted when people have regarded the picture as a simple little domestic episode, chosen for effect, and colour, as I intended the picture to awaken by its solemnity the deepest religious reflection. I chose the subject of burning leaves as most calculated to produce this feeling, and the picture was thought of, and begun with that object *solely* in view . . . I cannot say that I was disappointed that the public did not interpret my meaning in the "Autumn Leaves" as I scarcely expected so much, and I was not sanguine of my friends either, as I know I am not the sort of man who is accused of very deep Religious Sentiment, or reflection. However as you certainly have read my thoughts in the matter I do not hesitate to acknowledge so much' (BL). Which extract from the Psalms Millais was thinking of is a matter for speculation, although 'My days are consumed like smoke' (102.3) is a distinct possibility. Stephens had quoted St John 9. 4: 'For the night cometh in which no man can work', and Isaiah 9. 18–19: 'For wickedness burneth as the fire: it shall devour the briers and thorns, and shall kindle in the thickets of the forest; and they shall mount up like the lifting up of smoke. Through the wrath of the Lord of hosts is the land darkened, and the people shall be as the fuel of the fire: no man shall spare his brother'.

'Autumn Leaves' has a solemn, almost sacramental feeling that one might well call religious – though perhaps not quite the apocalyptic quality Stephens' quotations suggest. But the idea of autumn as inducing what Millais calls 'the deepest religious reflection' comes not from the Psalms or any other part of the Bible but contemporary English poetry. As early as the autumn of 1851, Holman Hunt remembered Millais as having said: 'Is there any sensation more delicious than that awakened by the odour of burning leaves? To me nothing brings back sweeter memories of the days that are gone; it is the incense offered by departing summer to the sky, and it brings one a happy conviction that Time puts a peaceful seal on all that has gone' (1905, I, p.286). He was reading Tennyson's *The Princess* at the time (J.G. Millais, I, p.127) and his thoughts echo the poet's as expressed in the well-known song in Part IV:

> Tears, idle tears, I know not what they mean,
> Tears from the depth of some divine despair
> Rise in the heart, and gather to the eyes,
> In looking on the happy Autumn-fields,
> And thinking of the days that are no more.

Millais visited Tennyson in November 1854 and, according to Hallam Tennyson's *Alfred Lord Tennyson: A Memoir* (1897, I, p.380), conceived the idea of painting a scene such as No.74 as a result of helping sweep up and burn dead leaves at Farringford. He would certainly have had Tennyson and his poetry in mind when he began 'Autumn Leaves' the following year, since he was simultaneously at work on his illustrations

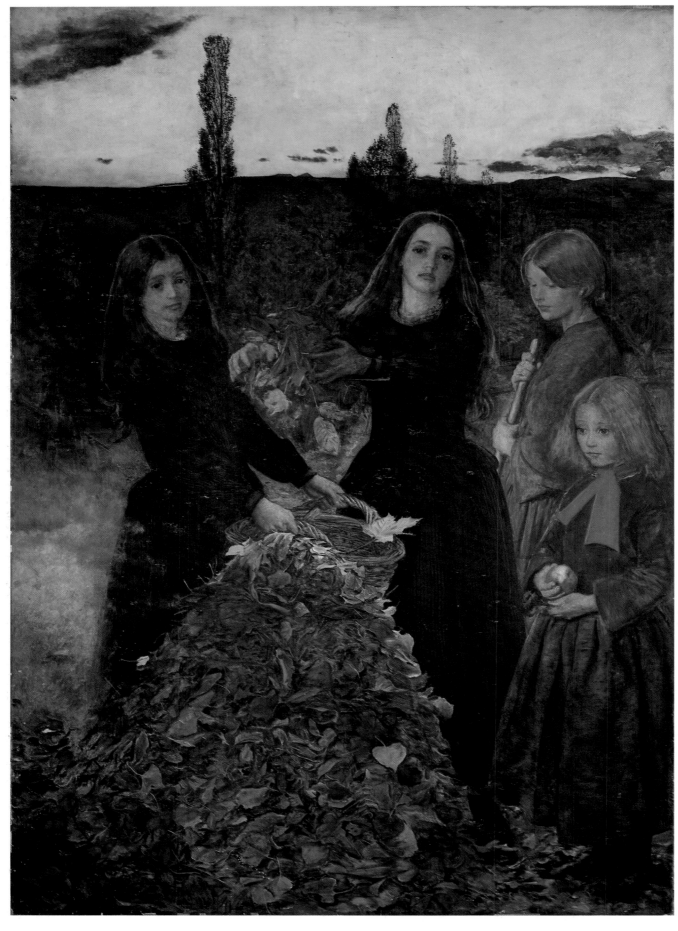

74

to the Moxon Tennyson (published 1857). Autumn and dead leaves come up frequently in Tennyson's work. They are also a favourite image of William Allingham's. Early in 1855 Millais read Allingham's *Day and Night Songs*, for which he also made an illustration, and may particularly have remembered the 'Autumnal Sonnet' with the lines:

Now Autumn's fire burns slowly along the woods,
And day by day the dead leaves fall and melt,

and:

now the power is felt
Of melancholy, tenderer in its moods
Than any joy indulgent summer dealt.

No. 74 is set in the garden of Annat Lodge in Perth, where the artist and his wife Effie settled after their marriage on 3 July 1855, and in the distance, just below the horizon on the left, shows the spire of St John's Kirk. It was begun in the autumn of 1855 and finished by early April 1856 for submission to the R.A. exhibition.

Effie wrote an account of her husband's work on it in her journal: 'Everett did not get settled to his work for long. He drew some of his Tennyson sketches but he did not begin painting till the 20th of October and was very irresolute what to do. He first thought he would paint me under the cedar tree and then in my brown velvet dress in the middle of the Apple tree. He wished to paint a picture full of beauty and without subject but could not decide so he went on drawing on blocks for Tennyson and finished the Sisters – "Marianna" and Dora. Then we went for a few days to Keir. Just the day before we left he began [Effie's sister] Sophie's head in the Drawing-room but when he returned he was so ill pleased with it that he took it all out . . . Everett got very impatient to return and we did so the 20th of October. He immediately began to paint on the Canvass he had commenced Sophie on. In two or three days he was in High spirits and much delighted with the rapidity of his execution. In the background he had put to her head, seizing the moment immediately after sundown, he painted [the] horizon behind Perth, the distant Peak of the Ben Vorlich, the Golden sky, the town lost in mist and the tall Poplar trees just losing their leaves. Later he softened it and brought the background into better colour, still magnificently bright. In the lower part of the back ground he put our lawn and the Apple trees at the foot of the garden, in the front four figures aurified with a Bonfire of Autumn leaves from which smoke issued. The figures were Sophie, Alice [Effie's other sister], Matilda Proudfoot, a girl from the School of Industry, and Isabella Nicol, a little girl from Low Bridgend. All the girls were under 13 years of age and grouped beautiful[ly]. Sophie in the middle is holding a bunch of leaves which are dropping into the basket; Alice is holding it with both hands. It is a large common garden whicker basket. Both the girls are in their winter dresses of green linsey Wolsey, their hair unbound hanging over their shoulders, little frills round their necks and stout walking boots. Matilda is standing with her face half round leaning on a rake or broom for gathering the leaves in a browning [word illegible] cotton dress and cape, the common dress of the School of Industry at that season, her brilliantly red hair glowing against the background of Hills of dark blue. Little Isabella on her side was in purple with her hair,

plaited at night, combed straight out in the morning and dressed in Linsey Wolsey purple with a scarlet neck tie, a couple of gentianellas in one hand, an Apple in the other. She has fine brown eyes, a pretty like nose and fair hair. She was a great amusement to us she was so old fashioned and thoughtful. I found her in rather a curious way. I was very anxious to find a pretty little girl for Everett. I found nothing to suit in Mr Murdock's school and the girls in the School of Industry were all so ugly that Matilda was the only one that was drawable. One day I went to see Kitty Cox a woman who has been now 29 years in her bed. I have visited her for 12 years and going one day as usual to see her I found her ill as ever and half sitting up but very cheerful . . . She had beside her a little girl to whom she had been giving a lesson in the new Testament. As both Kitty and her mother were bedridden a neighbour, Mrs Nicol, came in to tidy the little dark room and in return Kitty was teaching the child to read. She was sitting over the fire when I entered and was watching with great Interest two pears toasting on a little Tin bar before the fire; she was to have one . . . I thought she looked pretty as far as I could see. She came near the window to let me look. She was pretty and Everett thought she would do when he saw her. She sat to him remarkably well. Both she and Matilda served for both the Picture of the Autumn Leaves and Blind Girl. He often said he had never had such quiet good models. When they were not wanted they sat in the kitchen, helped to peel the Potatoes or watched the door or sat still looking into the fire for hours in perfect Idleness quite happy. Matilda the ladies tell me who teach her is a clever intelligent girl but it was not possible to get a word out of her either to us or the Servants. She was perfectly silent and had come from a miserable home' (PC).

Before the R.A. exhibition at which No. 74 was first shown, perhaps even before Millais began painting, James Eden, a collector who lived at Lytham and owned a bleaching works in Bolton, made some undertaking to buy it. Judging from works he is known to have had in his collection, including Thomas Webster's 'Spring' (repr. *Art Journal*, February 1866, facing p. 40; present whereabouts unknown), Eden seems to have liked *genre* painting, the kind of 'simple little domestic episode' that Millais rightly insisted 'Autumn Leaves' was not. This may explain why he tried to get out of his agreement when he first saw the finished work at the exhibition. But Millais held him to it and he had to pay the agreed price of £700 (see his letter to Eden, 12 May 1856, Millais Papers, PML). Eden soon afterwards exchanged it for three unknown paintings with the Liverpool collector John Miller (see *Magazine of Art*, November 1896, p. 53).

A wood-engraving of No. 74 by Henry Linton was published in the *Illustrated London News*, XXIX, 30 August 1856, p. 230. It was made after a drawing by J. Beech but Millais himself provided a sketch of the heads (J.G. Millais, I, p. 298).

A rough pencil study for one of the poplars and some clouds is at Birmingham City Art Gallery (593'06, verso). A copy, not by Millais, was sold at Christie's 7 July 1967 (131).

Spielmann (1898) claimed to see 'some failure of medium or pigment (? violet-madder) in the shadows . . . unfortunately most noticeable in the face of the right-hand child' (p. 92).

For further discussion of the picture see the compiler's article in *Pre-Raphaelite Papers*, Tate Gallery, 1984.

M.W.

HENRY WALLIS

75 Chatterton 1855–6
Inscribed 'HWallis | 1856'
Oil on canvas, $23\frac{11}{16} \times 36$ (60.2 × 91.2)
First exh: R.A. 1856 (352)
Tate Gallery

Exhibited at the Royal Academy with the following lines from Christopher Marlowe's play *Doctor Faustus* (written *c*.1590) inscribed upon the frame and also printed in the catalogue:

Cut is the branch that might have grown full straight
And burned is Apollo's laurel bough.

The words on the frame are now concealed by the glass 'window' put in at a later date to protect the picture.

Wallis's choice of subject matter in this picture has first to be seen in the context of a small group of paintings exhibited by him in which he depicted scenes and incidents with strong literary associations: his subjects included Dr Johnson, Shakespeare (both exh. 1854), Andrew Marvell (1856), Montaigne (1857) and Sir Walter Raleigh (1858 and 1862). Of all these it was 'Chatterton' which established the artist's reputation in his lifetime and which has remained since then as certainly his best known work and one of the most familiar of all nineteenth-century British pictures.

Thomas Chatterton, born in Bristol in 1752, was a poet whose genius was chiefly manifested in his authorship, at an early age, of spurious mediaeval histories and poems which he copied out in a fake hand on old parchment. His elaborate fabrications were detected – and ignored – by Horace Walpole whose patronage Chatterton had sought in 1769 and the embittered author decided to seek success in London, where he arrived in April 1770. Here he became a contributor of squibs, tales and songs to many of the leading publications (including the *Middlesex Journal*, seen in Wallis's painting), though without earning much money. In June 1770 he moved to a garret at 39 Brooke Street, Holborn, but soon penniless and with little hope of immediate success, on the night of 24 August, not yet eighteen years old, he took his own life by swallowing arsenic.

In 'Chatterton', Wallis adheres fairly closely to the few details that are known of the poet's death though one description of his body when it was found referred to the half empty phial of poison as still being grasped in his hand (and not on the floor as Wallis shows it) and the corpse violently convulsed – as it most certainly would have been – from the effects of the arsenic; the floor of his room was found to be covered with torn up scraps of all his manuscripts, as Wallis has shown it.

That Wallis chose, at this particular moment, to paint a picture inspired by Chatterton's life can be seen to a certain extent as a natural outcome of an obvious interest in literary anecdote – an interest which was shared by many contemporary painters of *genre* subjects. Seen simply in these terms, Wallis's 'Chatterton' shares much of that feeling of an elaborate *tableau vivant* characteristic of many paintings being exhibited at the Academy and elsewhere at this time. Like such works it eschews the very harshest realities and the place of 'Chatterton' within this tradition should not be overlooked, even if the intensity of the artist's vision and its execution allies it to truly Pre-Raphaelite works.

It has been suggested that Wallis's choice of subject might have been inspired by a two-part essay by David Masson, 'Chatterton: A Story of the Year 1770' which appeared in the *Dublin University Magazine* in July and October 1851. In fact,

Masson's essay deals neither with the poet's final months nor his dramatic death; it was only when it was republished in late 1856 – when the author incorporated into his narrative the graphic details of the poet's last hours as described in a spurious inquest report published in *Notes and Queries* (5 February 1853) – that the story was completed. As far as historical sources were concerned, therefore, it seems probable that Wallis either turned to material published in the eighteenth century, or had been inspired by the concocted, but vivid, inquest report, or, just conceivably, had met and spoken to Masson himself, who was intimate with the Rossettis, Holman Hunt and Woolner from about 1850 onwards.

In a much wider sense, both Masson's essay and the inquest 'report' were further manifestations of the recurrent fascination which Chatterton's writings, together with the melancholy story of his life and early death, had exerted on the romantic imagination. Keats and Wordsworth had been influenced by him with the latter describing him as '. . . the Marvellous Boy, | The sleepless Soul that perished in his pride'. Apart from his influence as a poet, as a symbol of blighted artistic genius and the misery of blasted hopes Chatterton had no equal: in 1854 the painter James Smetham called him a 'Titanic young mortal' and years later D.G. Rossetti thought him 'noble'. Undoubtedly Wallis was well aware of all this and it is rather curious that he seems to have been the first nineteenth-century British painter to explore the subject.

In all likelihood, 'Chatterton' was commenced in 1855. Two preliminary sketches (now Tate Gallery Nos T.1721 and T.1722) for the figure of Chatterton are clearly drawn from a model and they show the body stretched out on a couch in a similar attitude to that adopted in the finished picture. Since no portraits of Chatterton as a young man existed Wallis chose to portray – appropriately, because he was also a struggling writer – a living author, George Meredith (1828–1909) and it is his head, with its flowing chestnut-coloured hair, but lacking the beard which he had at this time, which appears in 'Chatterton'. Wallis's introduction to Meredith and his circle probably came through a mutual friend, P.A. Daniel, who had studied alongside Wallis at the Royal Academy (see Diane Johnson, *The True History of the First Mrs Meredith and other Lesser Lives*, 1973, p.187). The story of the artist's subsequent elopement with Meredith's wife has since become inextricably entwined with the history of the painting.

Whilst there has never been any doubt that Wallis used Meredith as the model for Chatterton, it has been stated many times that the painter actually used the room in which Chatterton died for the background of his painting. This has often been cited as one of the most notable instances of the Pre-Raphaelite concern for truth; however, the evidence is such that this assumption must be questioned.

According to Wallis's obituary in the *Burlington Magazine* (XXX, 1917, pp.123–4) 'Chatterton' 'was painted in his friend Mr A.P. Daniel's rooms in Gray's Inn'. In fact, both Wallis and Peter Augustin (not A.P.) Daniel – who practised briefly as a painter and was in later years a minor Shakespeare scholar – shared the same address at number 8 Gray's Inn Square between about mid-1855 and mid-1858 and it is a room in this set of chambers to which the obituary presumably refers. As it happens, number 8 Gray's Inn Square did not have an attic storey of the kind depicted in 'Chatterton' and, anyway, neither the west end of St Paul's Cathedral nor the tower of Holy Sepulchre, Holborn, visible on the skyline in 'Chatterton', could be seen as they are shown in the picture from the side of the square on which No.8 is situated: clearly the reference in the obituary can only refer to a room which Wallis used (for

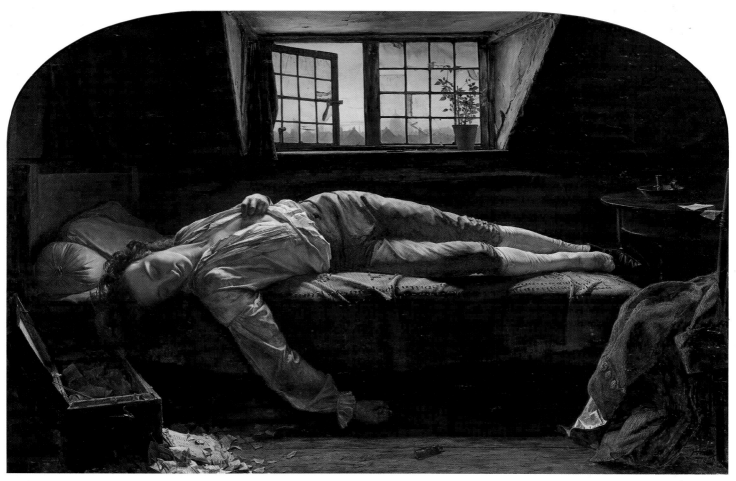

75

about three years at least) as his studio. Over the years, the assumption that Daniel's room and Chatterton's garret were one and the same and that therefore Daniel was the owner of the latter and hence gave Wallis access to it has assumed the weight of fact; its credibility has no doubt been reinforced because the geographical term 'Gray's Inn' might quite reasonably be applied to the area which embraces Brooke Street – a few minutes walk away from Gray's Inn Square just on the other side of Gray's Inn Road. But the exact location of the house in which Chatterton died only seems to have been positively established as No. 39 Brooke Street in 1857 (by W.M. Thomas in the *Athenaeum*, No. 1571, 5 December, p. 1519), that is, after Wallis had painted his picture. The occupant of the house at this date (though not, of course, necessarily the owner) was one William Jefford, a plumber and glazier, who seems to have resided there between c. 1832 and c. 1858 and it is his name alone, not Daniel's, which is mentioned in nineteenth-century researches into the whereabouts of Chatterton's last lodging.

Number 39 was on the west side of Brooke Street (its position is now marked by a plaque) which meant that a view from the top front attic would have been much as that shown through the window in 'Chatterton'; no views of the inside of the house appear to exist but a woodcut showing the street frontage was published in Walter Thornbury's *Old and New London* (II, 1873, p. 547) and this engraving does indeed show dormer windows of the kind which appear in 'Chatterton'. Nevertheless some

reminiscences by the antiquarian J.C. Hotten (1832–1873) also published by Thornbury suggest that by the time Wallis came to paint his picture the original room was considerably altered and this does seem to rule out the possibility that he used it for 'Chatterton'. Hotten also commented that 'it is a curious fact that, in the well-known picture (by Wallis) . . . St. Paul's is visible through the window; I say a singular fact, because, although this is strictly in accordance with the truth, as now known, the story previously believed was that the house was opposite, where no room looking into the street could have commanded a view of St. Paul's. This could only have been a lucky accident of the painter's'. A more probable explanation of this coincidence may well be that in order to render the scene of Chatterton's death as effectively as possible, and certainly in accordance with at least one of the known facts, Wallis needed to show and clearly suggest dawn breaking and that meant a view looking eastwards over the rooftops of the City.

Wallis's success in so dramatically realising the scene of Chatterton's death lies as much in the technical perfection of his work – with every detail inviting the closest scrutiny – as in the way the spectator is drawn into a simple and effective narrative through the artist's use of appropriate accessories. The onlooker can be left in no doubt about their significance. Thus, Chatterton's sense of pride, and his taste for fashion, is conveyed in the exquisite clothes which he wears and which are draped over the chair in the foreground; the rich lustrous-

ness of his purple-blue silk breeches infuses the principal light with a sickly funereal tone. A sense of time passing and a sense of the passing away of a spirit is conveyed in the burnt-out candle whose smoke curls up towards the window and in the single fading rose whose petals drop on to the window ledge.

'Chatterton' was universally praised on its appearance at the Academy and, in the words of the *Saturday Review* (17 May 1856, p.58), after the exhibition had been open a few days 'young Wallis "found himself famous"'. The *Art Journal* thought that it showed 'marvellous power and may be accepted as a safe augury of the artist's fame' (n.s., II, p.169, 1 June 1856). The *Spectator* thought it a 'high-minded work, thoroughly felt, thought and executed' (24 May 1856, p.570) but the highest praise came from Ruskin: 'Faultless and wonderful: a most noble example of the great school. Examine it well inch by inch: it is one of the pictures which intend and accomplish the entire placing before your eyes of an actual fact – and that a solemn one. Give it much time' (Ruskin, XIV, p.60).

That there was indeed a moral in this picture was, then, discerned by some critics. But other reactions were clearly at odds with the idea of homage to neglected artistic genius which must have been in Wallis's mind when he painted 'Chatterton'. Rather, the painting and its subject were seen – much as writers interpreted one of the functions of biography at this time – as an example of what others should avoid. The *Literary Gazette* (17 May 1856, p.284) had nothing to say against Wallis and his picture 'except the moral point of view' and this was clearly an indictment of the artist's seeming glorification of the suicide. The *Saturday Review* (17 May 1856, p.58) referred to the 'sad history of Chatterton's misdirected genius and boyish vanity' which culminated in his 'mad deed'. One year later, when exhibited at the Manchester Art Treasures Exhibition, Tom Taylor thought of 'Chatterton' that 'never was the moral of a wasted life better pointed in painting' (*A Handbook to the Gallery of British Paintings*, 1857, p.112).

Despite the favourable reviews in London, 'Chatterton' made a far greater impact when it appeared in Manchester in 1857: it was variously reported, later, as 'a sensation' (*Morning Star*, 5 May 1858, p.3) and 'one of the marvels' of the show (*Daily Telegraph*, 3 May 1858, p.6). However, eleven years later when it was again exhibited in Leeds, the *Art Journal* singled out 'Chatterton' as an instance of how the Pre-Raphaelite School and its protagonists were now of the past: 'It is, indeed, a striking sign of the instability of fashion and of fame, that Wallis's "Death of Chatterton" which needed two policemen for its protection in Manchester against the crushing crowd, is now . . . overlooked and neglected (n.s., VII, p.156, 1 Aug. 1868).

'Chatterton' was sold by Wallis to Augustus Egg in 1856 for either 100 gns (as reported in the *Art Journal*, n.s., V, p.227, 1 July 1856) or £200 (report of the sale of Egg's pictures, *Art Journal*, n.s., II, p.139; 1 July 1863) and Egg sold the copyright for £150, together with the right to have the picture engraved, to Robert Turner, a publisher in Newcastle-upon-Tyne. Egg printed a pamphlet advertising artist's proofs of the engraving priced at 8 gns and plain prints at 2 gns (Diane Johnson, *The True History of the First Mrs Meredith . . .*, 1973, p.92). The engraving by T.O. Barlow ($15\frac{7}{8} \times 23\frac{13}{16}$; 40.3 × 60.7; B.M. Dept of Prints and Drawings, 1889-4-9-357) seems to have been completed by 1860 though not, as far as can be ascertained, published. Barlow's engraving had been preceded by a crude woodcut, made with Wallis's permission, which appeared in the *National Magazine* in 1856 (I, p.33; $5\frac{1}{8} \times 7\frac{1}{2}$; 13 × 19).

R.H.

76

THOMAS WOOLNER

76 **Alfred Tennyson** 1855–6
Inscribed 'T. Woolner. Sc.|1856.'
Plaster medallion, 10in. (25.4cm.) diameter
First exh: in bronze, R.A. 1857 (1368)
National Trust, Wallington, Northumberland

While in Australia between 1852 and 1854, Woolner had met a certain demand for his medallion of Tennyson (see No.30) which he was unable to satisfy. On his return to England in October 1854, he still had half an eye on the potential market for his sculpture in Australia; he began to think in terms of making further casts of the 1850 medallion, but soon concluded it would be better to make another, of smaller size. Having reassured Tennyson that it would not require a great deal of his time as he considered he was so well acquainted with his features by now, Woolner went down to Farringford to work on the new version in February 1855. A first cast was completed by November 1855, but this was damaged; a potentially completed version was received by the Tennysons at Farringford in April 1856. Mrs Tennyson, however, suggested some minor amendments: scraping away a little of the nose underneath the nostril all along to the point so as to shorten the nose 'a wee bit'. Woolner added a slight touch of sweetness and brought it to completion by the end of July 1856 – 'now I consider it the *very best* med: I have done' (Woolner, p.115). Additional copies (such as the one exhibited here), which would be executed and finished by Woolner himself, were being sent out in September 1856; a bronze cast was shown at the Royal Academy in 1857.

Late in 1856 Moxon the publisher arranged to have an engraving made from the medallion to form the frontispiece of the illustrated edition of Tennyson's poems he was to publish the following year, and so it appeared in 1857. This edition with its illustrations by (among others) D.G. Rossetti, Holman Hunt and Millais, can be seen to symbolise the close relationship between Tennyson and the Pre-Raphaelite Brotherhood. Woolner's frontispiece (usually overlooked) has perhaps

77

Browning's 'the most unprepossessing poet's head it is well possible to imagine' (Woolner, p.124). It is nevertheless as effective in its verisimilitude as Woolner's 'Tennyson' (No.76). Browning was highly regarded by the Pre-Raphaelites, ranking as a two-star Immortal. In response to their admiration he became quite friendly, particularly for a time with D.G. Rossetti, but also to some extent with Woolner.

The presence of this medallion with that of Tennyson (No.76) at Wallington helps demonstrate a Pre-Raphaelite bias in the decoration of the hall there, confirmed by Bell Scott's paintings along the arcades and by the placing at either end of Woolner's group 'The Lord's Prayer' and Munro's 'Paolo and Francesca' (see No.44).

B.R.

JOHN EVERETT MILLAIS

78 Pot Pourri 1856
Inscribed 'JM' in monogram
Oil on canvas, $17\frac{1}{2} \times 14$ (44.5 × 35.6)
First exh: *The Works of Sir John Everett Millais,*
Grosvenor Gallery 1886 (80)
Mr & Mrs L.S. Melunsky

A dreamy mood-picture in a similar vein to 'Autumn Leaves' (No.74). Like the dead leaves in the larger work, the cut flowers can be seen as a metaphor of transience.

It is probably identifiable as the small painting Millais had begun by 1 May 1856 and the dealer Gambart was encouraging him to finish (letter to his wife, Pigott Collection, HL). J.G.

78

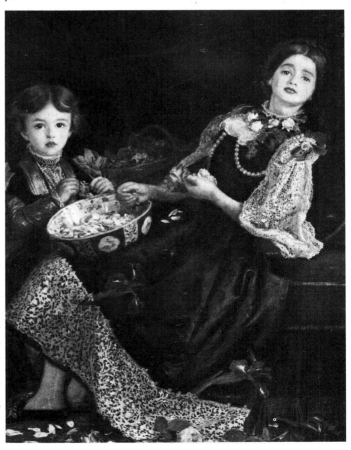

an additional symbolism of its own in that Woolner's relationship with the poet, dating probably from as early as 1848, may have preceded that of any of the other Pre-Raphaelites. It was certainly the most substantial; they remained in contact until they died within a day of each other in 1892. Within this period Woolner produced no less than six distinct portrait sculptures of the poet in medallion and bust form (see Nos 30, 89), as well as a series of statuettes of Tennyson heroines, e.g. 'Elaine' (1868), 'Guinevere' (1872). While it is certainly true that a major factor in this relationship was Woolner's close association with Mrs Tennyson – an extensive correspondence took place between them – Woolner was close enough to the poet to provide the source stories for Tennyson's 'Enoch Arden' and 'Aylmer's Field'. Woolner was poet as well as sculptor, and it is quite reasonable to suppose the two men were able to regard each other as fellow artists in this respect without any question of comparable stature.

While the main differences between the 1850 and 1856 Tennyson medallions are obvious – size, direction of head – the overall impression remains of truth to nature in both the appearance and the character of the sitter.

B.R.

THOMAS WOOLNER

77 Robert Browning 1856
Inscribed 'T. Woolner. Sc. | 1856.'
Plaster medallion, 10in. (25.4cm.) diameter
First exh: R.A. 1857 (1367)
National Trust, Wallington, Northumberland

Woolner was at work on his medallion of Browning in the summer of 1856; it was sufficiently advanced by August of that year for people to have seen it and (by Woolner's own account) complimented him on how like the sitter it was. Casts had been made and sent out by December 1856.

William Bell Scott admired the workmanship, but called

Millais (I, p.305) states that he painted it in August that year on returning to his home, Annat Lodge in Perth, after a holiday, and this may well be when most of the work was done.

Effie Millais wrote an account of No.78 in her journal: 'This little picture was painted for a Mr Burnett, but when completed he was unable to purchase it. It was painted from my sister Alice and little Smythe of Methven Castle, Alice's dress of green satin and point flounces forming a happy contrast to the rich velvet and gold trimmings in little Smythe's dress. The background is principally crimson, and the whole effect very rich and brilliant. Mr Millais sold this picture to Mr White, the dealer in Madox Street, for £150, and he in turn sold it, a week or two afterwards, for £200 to Mr [B.]G. Windus, junior. When Mr Burnett saw it he was most anxious to get it, and White promised it to him if he came on a certain day not later than four p.m. Mr Windus, however, was equally determined to have it; and arriving early on the appointed day, he waited till the clock struck four, and then carried off the picture in a cab, to the great disgust of Mr Burnett, who arrived a quarter of an hour late' (J.G. Millais, I, p.306). 'Mr Burnett' may be the Newcastle collector Jacob Burnett who was to buy 'Spring' (No.96) in 1861. Effie's sister Alice Gray also appears in that work, as well as 'Autumn Leaves'. 'Little Smythe of Methven Castle', then aged six, later became Colonel David Smythe of Methven. A letter of 18 June 1934 from his sister Beatrice to Manchester City Art Gallery quotes a letter from Millais to their father, William Smythe of Methven, asking if he could paint the boy, 'who I have seen with you in church and who struck me as one of the most beautiful little fellows I have ever seen'.

M.W.

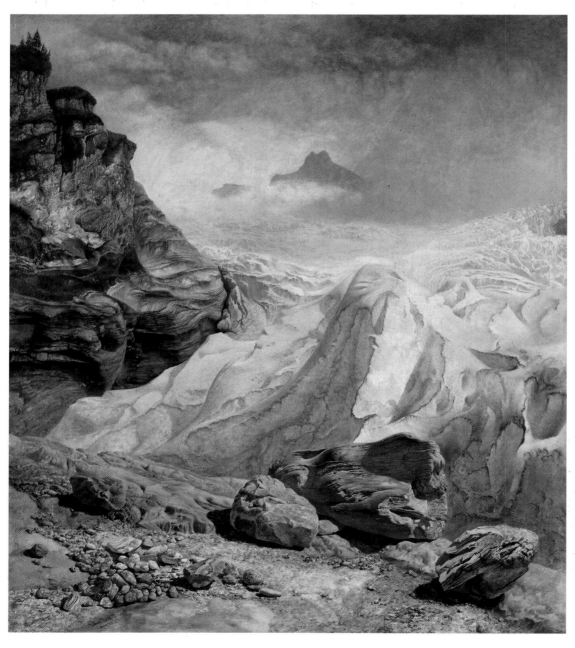

79

JOHN BRETT

79 The Glacier of Rosenlaui 1856
Inscribed 'John Brett|Aug. 23|56'
Oil on canvas, $17\frac{1}{2} \times 16\frac{1}{2}$ (44.5 × 41.9)
First exh: R.A. 1857 (1124)
Tate Gallery

This remarkable picture of a glacier in the northern Alps appears to have been directly inspired by the fourth volume of Ruskin's *Modern Painters*, subtitled 'Of Mountain Beauty'. It shows a thorough understanding of mountain structure, and reflects Brett's life-long interest in geology as well as his reverence for Ruskin's theories on the laws of beauty.

Brett had not yet met John Ruskin when he painted 'The Glacier of Rosenlaui' but for several years he had been a fervent admirer of his writings. He had read his pamphlet on Pre-Raphaelitism in May 1852 and considered it 'gloriously written and containing much earnest sound healthy truth' (Brett Diary, 20 May 1852, PC). By the time he had finished reading the first volume of *Modern Painters* he had decided that Ruskin was 'one of the greatest lights of the age' (ibid., July 1852).

Modern Painters, volume 4, was published on 14 April 1856 and Brett's diary indicates that two months later he had left his lodgings in Albert Street near Regent's Park and 'rushed off to Switzerland in obedience to a passion that possessed me and wd listen to no hindering remonstrance' (ibid., 9 December 1856). There can be little doubt that this passion was inspired by Ruskin's words. 'The Glacier of Rosenlaui' is, as Allen Staley (p.126) has pointed out, 'a picture of what Ruskin wrote about' with the added advantage that it shows in colour what Ruskin could only illustrate in black-and-white. In the centre foreground is a boulder of granite, with beyond it a block of gneiss with the characteristic curving lines which Ruskin so admired. Both granite and gneiss were considered by Ruskin to be superior to slate and other rock forms. Brett has treated the surface of every stone and pebble in the near foreground with the appreciation which Ruskin demanded when he pointed out that a small stone could be likened to a pearl, or to 'a mountain in miniature' (Ruskin, VI, pp.367–8).

Apart from its interest as a geological illustration 'The Glacier of Rosenlaui' is also an extremely skilful painting in a technical sense. For this Brett owed much to another Pre-Raphaelite follower who was in Switzerland in the summer of 1856. J.W. Inchbold was at work on 'The Jungfrau from the Wengern Alp' some ten miles from Rosenlaui so that it was hardly surprising that the two men should meet up. Brett was greatly impressed by Inchbold and a later entry in his diary suggests that their meeting had as decisive an effect on his own painting as his reading of *Modern Painters*. 'I first met him there on the Wengern Alp', he wrote of Inchbold in December 1856, 'there saw him do a few touches to his jung-frau and there and then saw that I had never painted in my life, but only fooled and slopped and thenceforth attempted in a reasonable way to paint all I could see' (Brett Diary, 9 December 1856, PC).

In the same diary entry Brett confided that painting had become incomparably easier for him after his Swiss expedition. When one considers that a few months later he was at work on 'The Stonebreaker' (Walker Art Gallery, Liverpool), his un-disputed masterpiece and one of the most memorable of all Pre-Raphaelite landscapes, he evidently learnt a great deal from the time he spent in Inchbold's company.

The whole episode ended in the most satisfactory manner possible for Brett. Soon after Brett had returned from Switzerland D.G. Rossetti saw 'The Glacier of Rosenlaui' in Brett's studio. He admired it and took it away with him to show Ruskin. 'Now he writes me that he can't tell me all his expressions of pleasure and praise – and that Hunt also was much interested in it' (Brett Diary, 9 December 1856, PC).

D.M.B.C.

FORD MADOX BROWN

80 Stages of Cruelty 1856–7, 1890
Inscribed 'FMB 56|–90' (initials in monogram)
Oil on canvas, $27\frac{7}{8} \times 23\frac{9}{16}$ (73.3 × 59.9)
First exh: *Special Loan Exhibition*, Birmingham, 1891 (146)
Ref: Liverpool 1964 (34)
City of Manchester Art Galleries

Initially called 'Stolen pleasures are Sweet' and thought up as a subject in June 1856 when the artist's dealer White rejected his design for 'Cromwell on his Farm' (No.180). It was one of three modern domestic subjects then in his mind (the others, a Christmas family interior and a soldier back from the Crimea, were never taken up as pictures). The delights of his new garden at 13 (now 56) Fortess Terrace, Kentish Town, may have sparked off the idea when he was searching for a subject more likely to be popular. In the event its moralistic overtones contradict the sentimental Victorianism of its early title.

A young woman is seated on the garden wall beneath a bank of lilac, sewing at a Berlin-work slipper pattern, seemingly unconcerned and amused by the attentions of her young lover over the wall; a child chastises a dog with a spray of Love-lies-Bleeding and convolvulus entwines the rail of the steps up to an unseen house.

A watercolour sketch incorporating all three figures (Warrington Museum) may date initially from this time but the artist's diary seems to indicate that he began straight on the canvas, which was prepared from one of the rejected side panels of the 'Chaucer' and tended to absorb the paint (*Diary*, 23 July 1856). He worked in a tent in the garden, 'for I find', he noted late in June, 'one thing very necessary when painting out of doors & that is to shade off the too great light that falls on ones work, otherwise when brought indoors it looks flat & colorless, the colors showing more bright in the open air'. Like Millais with 'A Huguenot' (No.41), he began with the brick wall and was in a great hurry in spite of other commitments to get the lilac leaves painted before they withered in the hot June sun.

Thomas Seddon and his wife first sat for the lovers but were unreliable at keeping appointments and Madox Brown set a lay figure on the wall (made of cushions in case of rain damage) to paint the leaves which touched the figure. On Sunday 20 July he designed the lovers from himself and daughter Lucy in a mirror and finished the leaves on the 27th. He spent a short time on it in September, painting a head from a little girl he had found; in mid-October he had Thomas Woolner's brother to model the young man's head, used the maids for the hair, painted in the white jacket and collar, and finished the geraniums (the girl's posy) before they faded.

It was then left until late in 1857 when he had hopes of a commission, through Holman Hunt, from Thomas Fairbairn of Manchester. He then gave it three weeks' work, painting the convolvulus, the Love-lies-Bleeding, touching at the heads and 'composed and drew in the child' (a full-scale study of Katty, dated 1857, is at Birmingham). No commission came.

By 1860, when it was listed as 'in hand', it was called 'Stages

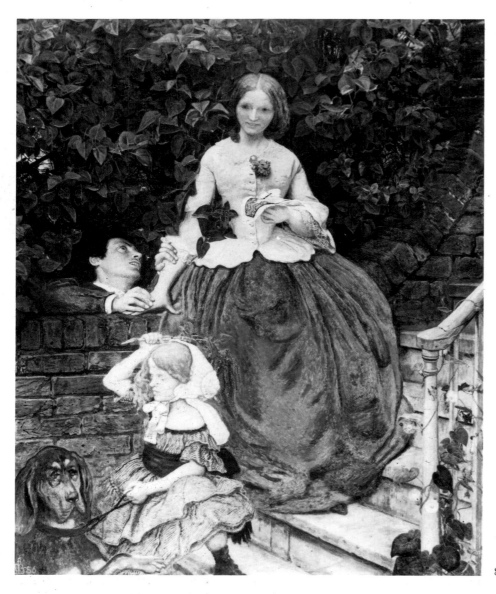

80

of Cruelty', this Hogarthian title more specifically underlining its purport. It was on offer to patrons in 1861 and 1864 at 300 gns though the artist considered it too unfinished to show; evidently the price was considered too high (FMBP). A 'first sketch', presumably the attractive watercolour at Warrington, was in his 1865 exhibition with hopes for a patron, and the subject was again on offer in 1867 to a dealer. The watercolour sketch was given to George Rae in 1867 in payment of interest on an advance but he did not rise to a commission. Rossetti's comment on 'Work' in 1866 was perhaps equally applicable: 'the epoch of preraphaelitism was a short one which is quite over and will never be renewed, and its products will be exceptionally valuable one day but not yet' (Doughty & Wahl, II, p.595).

Without a patron it was left unfinished until Henry Boddington of Manchester commissioned the completion and touching up of several early works in 1887, of which this appears to have been one; it was finished for him in 1890, and a watercolour replica was also completed. The artist recorded in a note on the back that the child was finished from Katty's own daughter (Juliet).

M.B.

FORD MADOX BROWN

81 William Michael Rossetti, Painted by Lamplight 1856
Inscribed 'To FMLR 1856 FMB' (initials in monogram)
Oil on panel, 6¾ × 6½ (17.2 × 16.5)
First exh: Russell Place 1857 (17)
Ref: Liverpool 1964 (35)
National Trust, Wightwick Manor

William Michael Rossetti (1829–1919), art critic and man of letters, younger brother of Dante Gabriel and a founder member of the Pre-Raphaelite Brotherhood. Here painted at 27 and already going bald. He is painted with the same close-up intimacy and sympathetic friendliness as Madox Brown's portraits of his own family. Compare also his head in 'Jesus Washing Peter's Feet' (No.42).

William Michael had an appointment in the Inland Revenue, which meant that he could only visit Madox Brown in the evening after work. Madox Brown records in his diary for February 1856 coming to an arrangement with Mrs Gabriel Rossetti, mother of William and Dante Gabriel, for the education of his daughter Lucy, and later the same month he was

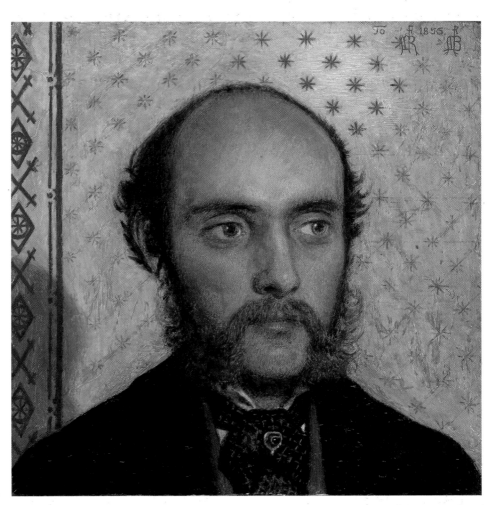

81

at their house again when he drew a portrait of William, which he appears to have continued in July (this drawing is untraced). Then in October he mentions working at a portrait at his own house and on the 8th William came to him and he 'Painted . . . till 12 [at night] from 8', and Gabriel coming in they stayed talking while William slept on the sofa, until half past two in the morning. The portrait was finished sometime before March 1857. The inscription implies that it was a gift to the sitter's mother (Frances Mary Lavinia Rossetti), perhaps in acknowledgment of her agreeing to teach Lucy. The artist had painted by lamplight before, in particular in the hurry of finishing 'Chaucer' (when Dante Gabriel sat to him half the night). Here the lamplight casts a silvery sheen on the wallpaper with its starry pattern and red border. Like the slightly different paper in 'Take your Son, Sir' (No.82), it was probably in one of the rooms in the artist's house at 13 Fortess Terrace, Kentish Town.

William Michael married Lucy Madox Brown in 1874 and this portrait belonged to their daughter Helen Rossetti Angeli.

M.B.

FORD MADOX BROWN

82 Take your Son, Sir 1851, 1856–7
Inscribed 'F.M. Brown | Take your Son Sir'
Oil on paper (7 strips), mounted on canvas,
$27\frac{3}{4} \times 15$ (70.4×38.1)
Tate Gallery

A picture of enigmatic meaning which may have evolved as the artist doubled the initial canvas and added strips to the sides and bottom. Finally left unfinished.

A young woman with a gentle smile and an attitude of composed triumph, stands at full length holding out a baby to an unseen man, but who is visible in the convex mirror behind her head holding out his arms and smiling or grinning; also visible in the mirror is the parlour in which they stand with a cottage piano and pictures on the walls, which are papered in green sprinkled with gold stars. Red ribbons are tied in her cap, which seems to proclaim her a matron, and a white rose hangs at one side, perhaps suggesting her to be the bride of a year; the outline of her dress is drawn in, with possibly the lines of an apron and with cream underpainting(?) round her shoulders; at her side is a cot with a nurse arranging the pillows behind the hangings. Emma, second wife of the artist, is the woman and their second son Arthur, born 16 September 1856, the baby. The man in the mirror has side-whiskers and his hair is parted in the middle and looks very like Madox Brown.

In the artist's diary referring to the winter of 1851–2, he mentions painting a study of Emma 'with her head back laughing'. This seems to be the canvas he refers to in March 1857 when listing the previous winter's work: 'Then I began upon the naked baby from Arthur, made a drawing of it, then painted it on the enlarged canvas on which I had painted a study of Emma's head one evening in Newman St. I have now sent it to be enlarged a second time, having made an error' (Surtees 1981, p.194). The initial small canvas cuts through the middle of the baby; Emma's head, painted with great

delicacy, would be contemporary with that in 'Pretty Baa Lambs' (No.38, where she appears holding their first child Katty). A drawing of Arthur, now in the British Museum, inscribed at 'ten weeks', puts the re-commencement in mid-November to December 1856. At that period Madox Brown was working both on religious and modern subjects (the 'Transfiguration' cartoon for Powell's, 'Work', 'Stages of Cruelty' and 'Jesus Washing Peter's Feet'). On 1 September, a fortnight before Arthur's birth, when he was just free of the last named, he had gone with Woolner to see the new pictures at the National Gallery. He commented on two 'delicious' virgins and children and the Perugino (N.G. No.288), which he found 'fine in tone & truthful as out of doors effect but absurdly drawn as usual'. Perhaps these (according to the *Art Journal*, 1 October, Nos 284 Vivarini, 285 Morone and 286 Taccani), may have reminded him of the unused study of Emma's head and put him in mind of a new subject. The same journal in

82

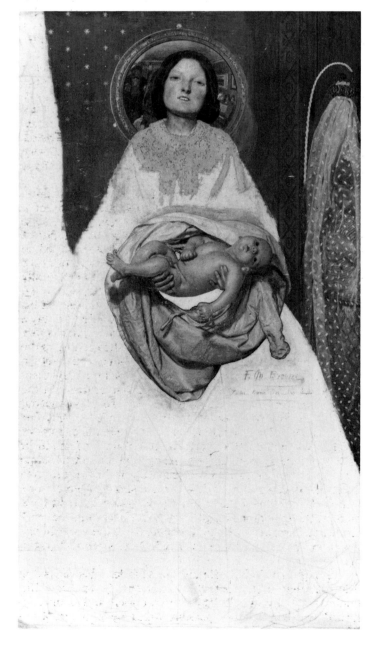

discussing these and other acquisitions by the National Gallery commented: 'If these works are Pre-Raffaelite, we commend them to the observation of the young gentlemen of the spasmodic school whose modellings in granite may become more plastic by due regard to the quality of these works'.

The initial and most satisfactory interpretation of this picture must be that of the celebration of marriage and parenthood with the young mother in madonna-like pose against a simulated starry background, the mirror, which has been deliberately moved higher up behind her head, acting as a halo and at the same time reflecting and enfolding both her home and her husband, to whom she offers their son. The Arnolfini marriage portrait, in the National Gallery since 1842, is called to mind as well as Holman Hunt's drawing for 'The Lady of Shalott' of 1850 (No.168), which uses the same motif of reflected scenes in a convex mirror. The theme is brought sharply into the artist's own time with the presentation of an unpretentious contemporary middle class family viewed with the same intense realistic concentration and with the same lack of idealisation which Madox Brown was applying to his picture of 'Work' (No.88), and with the same expressiveness in the features, almost amounting to grimacing, which is characteristic of him and was least liked by his contemporaries.

He gives no explanation for it in his diary, but No.82 definitely had the present title by 1860 when he noted that it was 'in hand' (Account Book, partly published in Hueffer's appendix list); the Tate Gallery suggests that on stylistic grounds the nurse and cot might date from this period (ms. catalogue; see also Anna Southall in *Completing the Picture*, Tate Gallery, 1982, p.48). It is also evidently the subject listed with several others on offer for a proposed commission in a letter to George Rae in December 1863, as 'Lady and naked baby (the *first born*) 2′11″ × 1′6″' (LAG/RP: the Account Book lists a proposed replica, with the original title, under 1864). While the new title still bears out the prime interpretation, the use of 'Lady' rather than 'mother' may point to an alternative interpretation: that of the friend or helper, the eternal mother, bringing down the new born baby to present to its proud father; but the child portrayed is in fact ten weeks old not new-born and it would be odd to find a cot in the living room in such a case.

On its first exhibition in 1897, H. Wilson in the *Artist* commented: 'It is but a simple study of Mrs. Madox Brown and the infant Oliver [sic], yet the sculpturesque perfection of presentment, the imaginative realism of it carries us beyond the real into the essential heart of things, to another sphere, another spiritual plane. It conveys the feeling that one is looking not at a picture, it is hardly complete enough for that, but through a lens of crystalline emotion into the creator's chamber of imagery, where the enthroned mother, her head haloed by the great mother-symbol of the mirror, becomes the type image of life – the ostended child, the token of that miraculous fusion of spirit which is the fount of life. And in the mirror, the mystic type of unity, the mother and the father meet again in worship of the child. All the devotion of the painter and the man went to the fashioning of this unfinished gem'.

However, the various inconsistencies which seem to be present in the picture as it is have given rise in the last two decades (for example J.H. Plumb, 'The Victorians Unbuttoned', *Horizon*, Autumn 1969) to a much more deliberate interpretation, that of a kept woman, here seen as a haloed magdalen, presenting their bastard to the reluctant father, thus putting this picture into the same bracket of social comment as Holman Hunt's 'Awakening Conscience', and

Rossetti's 'Found'. The interior, so far as it is visible, has none of the garish vulgarity of Hunt's painting, nor is it likely that Madox Brown would portray his young wife, their son, or himself in such roles. A further interpretation developing the idea of the sanctifying by marriage after the birth of a child is put forward by A.S. Marks (*Arts Magazine*, January 1980, pp.135–41; which see for other references).

Though it was apparently taken up again in 1860, perhaps with a view to selling it to Plint with his social and religious interests, and again in 1892, the artist may have found it ultimately too difficult either to resolve satisfactorily or, as suggested by the proposed 'replica' of 1864, to combine in style and technique with his subsequent method of work, and it remained with him until his death. The signature and inscription added just below the baby must date from a period when he had virtually given it up.

M.B.

THOMAS SEDDON

**83 The Valley of Jehoshaphat: Painted on the Spot,
 during the Summer and Autumn Months** 1854–5
Oil on canvas, 26½ × 32¾ (67.3 × 87.2)
First exh: the artist's room, 14 Berners Street, London,
17 March–3 June 1855; L.A. 1856 (138)
Tate Gallery

For its first appearance in a public exhibition at the Liverpool Academy, Seddon supplied a detailed description of the view which he had depicted:

> The valley is closed to the North by Mount Scopus. On the right the Mount of Olives with the church of the Ascension on the top, the nearer hill is the Mount of Offence, at the foot of which stands the Village of Silwan, the Old Siloam, on the left, the Mosk of El Aksa, and the walls on the site of the Temple. The nearer hill is Ophel, at the foot of which, opposite the Village, is the Pool of Siloam, an intermittent stream watering the King's Gardens below. The terraces at the foot of Mount Zion shew the old Jewish mode of cultivation. At the end of the Valley is the white wall enclosing Gethsemane and below Absolom's tomb and the tombs of St. James and Zacharias. The foreground on the Hill of Evil Counsel just south of the junction of the Valley of Hinnom and the King's Gardens, shows the exact state of the country around after the Spring, overgrown with thistles, among which the large tailed sheep of the country pick up the stubble of the early corn.

Seddon travelled to the Holy Land via Egypt – where he joined Holman Hunt – finally arriving in the Holy City on 3 June 1854. After exploring the city and its environs, he finally set up camp at Aceldama, on a hill just south of Jerusalem, from which point, significantly, the Garden of Gethsemane and the Mount of Olives occupied the central portion of the vista.

In choosing to ignore the better known and frequently described view of the actual city of Jerusalem from the north – generally regarded by travellers as the most impressive and moving sight – in favour of a view which incorporated the scene of Christ's last agony, Seddon was both opting for the kind of less obviously 'composed' view which the Pre-Raphaelites favoured as well as underlining the religious impulse and didactic purpose which had brought him to Jerusalem. Also significantly, perhaps, 'The Valley of Jehoshaphat' was

traditionally thought to be the scene where the Last Judgement would take place; Seddon's finished work, compared with John Martin's apocalyptic handling of the Last Judgement in the picture of the same title painted in 1853 and now also in the Tate, is a pointed reminder of what Pre-Raphaelite aims in landscape were.

In one respect, Seddon's trip to the Holy Land reflected a general interest in the area by artists, archaeologists and some sections of the public which had been growing apace since the late 1830s. A British Consulate had opened in Jerusalem in 1838 and two of the earliest artist visitors followed soon after – David Roberts in 1839–40 (Seddon was subsequently a subscriber to *The Holy Land*, a series of engraved views published by Roberts 1842–49) and David Wilkie in 1841. A more specifically Protestant involvement can be seen in the founding of an Anglican Bishopric in Jerusalem in 1844 as well as in the setting up of various missions to promote Christianity amongst the Jews at about the same time.

Whilst Seddon was undoubtedly aware of a market for views of the land of the Bible, the time he spent there was imbued far more with a sense of personal mission rather than any particular idea of pecuniary gain. Always a religious man he felt that here he was indeed treading holy ground and he was deeply moved by being amongst those places where Christ 'endured so much suffering and agony for me'.

Many years later the artist's brother singled out 'The Valley of Jehoshaphat' as very much the exception in Seddon's relatively small output: 'It was undertaken as a labour of love, in consequence of the subject, and not in accordance with his canons of art. He felt its undertaking to be a duty, but a sacrifice as well . . . He wished to present to those who could not visit it themselves an accurate record, not a fancy view, of the very ground our Saviour so often trod' (*Athenaeum*, 22 March 1879, p.386).

Seddon worked on 'The Valley of Jehoshaphat' and three other smaller pictures (one oil and two watercolours) for a period of about 120 days, sometimes working for up to eleven hours a day. It clearly took longer to complete than Seddon at first anticipated for though by 3 August he wrote that he had done 'about half' of it, he twice extended his stay by three weeks (the period between boat departures from Jaffa), finally leaving for Europe, against Holman Hunt's advice, on 19 October. Hunt's opinion of Seddon's work on the eve of his departure, combined with the recommendation that he stay a further three weeks to bring his canvas to a satisfactory conclusion must have been considerably disheartening to the artist, for his chief anxiety by now seems to have been to return home as soon as possible in order to formalise his engagement to Emmeline Bulford. Hunt thought 'It was scarcely in the pictorial sense a landscape. Sitting before the spot I pointed out to him how completely the tones and tints failed in their due relations, and how essential it was that he should supply the deficiency, explaining that in conventional art the demand for variety of tones was satisfied by exaggeration and tricks, and that these had increased the due expectation for effect to such an extent that when a work was done strictly from Nature, unless all the variety that Nature gave was rendered by the painter, the spectator had good cause for declaring the work crude and false; in short, that the more truth there was in one direction, the greater there must be in others' (Hunt 1905, I, p.447).

Although 'The Valley of Jehoshaphat' is described as having been painted on the spot, this is not strictly accurate. Undoubtedly partly impelled by Hunt's criticism, Seddon continued working on it – possibly aided by photographs –

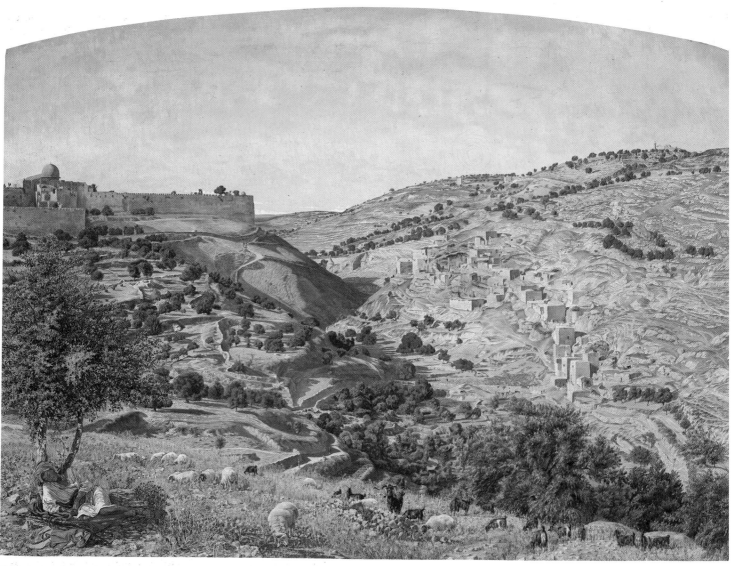

83

during a brief sojourn in France en route to London, where he arrived in January 1855. However, once back home even Madox Brown's opinion of all Seddon's paintings seemed to echo Hunt's earlier judgement for he thought them 'cruelly P.R.B[rotherhoo]d . . . The places are not well suited nor addapted [sic] & the high finish is too obtrusive. However, they present quantities [?qualities] of drawing & truthfulness seldom surpassed but no beauty, nothing to make the bosom tingle' (Surtees 1981, p.117, entry for 16 Jan. 1855). With some help from Brown Seddon continued to improve 'The Valley of Jehoshaphat' until by 5 March 1855 he could write that it was 'quite finished and much improved by a deeper blue sky'.

The fact that Seddon had received some assistance in completing his picture might explain why he chose to exhibit it for the first time in his own studio rather than submit it to the Royal Academy. Visitors and potential purchasers to Berners Street included John Ruskin, Joseph Arden (who had already bought works by Millais), Earl Grosvenor and Edward Lear and, in addition, Seddon appears to have taken his works to Buckingham Palace. Ruskin was encouraging: he praised 'The Valley of Jehoshaphat' 'wonderfully' and said of the eastern

subjects generally that before seeing them he had 'never thought it possible to attain such an effect of sun and light without sacrificing truth of colour'. Another visitor, a Mr Young, former Consul at Jerusalem, also spoke very highly of the accuracy and effect – particularly the way in which he had captured the clarity of the atmosphere – which Seddon had achieved in 'The Valley of Jehoshaphat' though he also felt sure that 'it could only be properly appreciated by those who have long resided there'.

A further, similar comment by a visitor about the 'lack' of atmosphere would seem to confirm that the unfamiliarity of the almost photographic accuracy of Seddon's delineation combined with the lack of aerial perspective in 'The Valley of Jehoshaphat', though truthful, were powerful deterrents to possible purchasers of the picture. Even the critic of the *Spectator* – apparently the only journal which reviewed Seddon's exhibition – though he was highly complimentary nevertheless described the painting as 'almost perplexing at first sight from the multiplicity of its detail and singular in its tawny violet shadowed tone'.

This combined sense that Seddon had here produced a most

unusual and in some ways disturbing image undoubtedly explains why the picture was to remain unsold, despite being exhibited twice again the following year, once more in Seddon's studio and once at the Liverpool Academy (where it was priced at £189). Certainly the picture is of a highly personal nature: the intensity of the artist's vision of the landscape, stimulated as it was almost by the sense of the actual presence of Christ in it, imparts a feeling of religious fervour, the nearest parallel to which in Pre-Raphaelite painting is found in Holman Hunt's 'The Light of the World' (No.57).

This was clearly neither immediately acceptable nor appreciated at the time. But in one sense at least, even though Seddon was not to reap the much needed financial rewards from a sale which he needed at this stage in his career, he did have the satisfaction of knowing that there was almost unanimous agreement that his picture would always have a lasting value because the subject itself was of undying interest. This led Ruskin to pronounce, not entirely accurately, that Seddon's works – and he must have had 'The Valley of Jehoshaphat' very much in mind – were the first representatives of a 'truly historic landscape art; that is to say, they are the first landscapes uniting perfect artistical skill with topographic accuracy being directed with stern self-restraint to no other purpose than that of giving to persons who cannot travel trustworthy knowledge of the scenes which ought to be most interesting to them' (Seddon, p.171).

After Seddon's premature death in 1856 it was 'The Valley of Jehoshaphat' – without doubt Seddon's chef-d'oeuvre – which was chosen by his friends to be presented by subscription to the National Gallery. It was thus the first Pre-Raphaelite painting to enter a public collection.

A small watercolour and gouache replica of the picture, now in the collection of John Gere, was exhibited at Russell Place in 1857 (63).

R.H.

WILLIAM HOLMAN HUNT

84 The Scapegoat 1854–5, 1858
Inscribed 'Whh' in monogram
Oil on canvas, $13\frac{1}{4} \times 18\frac{1}{16}$ (33.7 × 45.9)
First exh: ? L.A. 1858 (574)
Ref: Liverpool 1969 (34)
City of Manchester Art Galleries

No.84 is a much reduced version of the 1856 Royal Academy exhibit (fig.ii, Lady Lever Art Gallery, oil on canvas, $33\frac{3}{4} \times 54\frac{1}{2}$, 85.7 × 138.5; exh. Liverpool 1969, No.33). The latter was begun at Oosdoom on 17 November 1854 (Hunt journal, BL) and completed in early June of the following year (Hunt to Combe, June 1855, JRL).

Hunt realised the possibilities inherent in the theme shortly after his arrival in Jerusalem, while he was scouring the Bible for subjects. His letter of 10 July 1854 to Combe not only mentions 'The Finding of the Saviour in the Temple' (No.85), but 'another subject which I am sanguine about . . . I wonder it has never before been done. it is so full of meaning (one reason however against it) and it is so simple – The scapegoat in the Wilderness by the Dead Sea somewhere, with the mark of the bloody hands on the head' (BL). Hunt's source, Leviticus 16, describes the Day of Atonement ritual: two goats were selected as symbols of the Jews' annual expiation of their sins, but whereas one was sacrificed in the Temple the other 'shall be presented alive before the Lord, to make an atonement with him, and to let him go for a scapegoat into the wilderness . . . And the goat shall bear upon him all their iniquities unto a land not inhabited' (16.10,22).

Hunt's intimation that the subject was 'so full of meaning' suggests that he had already connected the passage in Leviticus with that of Isaiah 53: 'He is despised and rejected of men . . . Surely he hath borne our griefs, and carried our sorrows: yet we did esteem him stricken, smitten of God, and afflicted. But he was wounded for our transgressions, he was bruised for our iniquities: the chastisement of our peace was upon him; and with his stripes we are healed' (53.3–5). These verses, however, do not refer to the scapegoat but to the Passion and Crucifixion, and a further passage in Isaiah – 'though your sins be as scarlet, they shall be as white as snow; though they be red like crimson, they shall be as wool' (1.18) – can be related both to Christ's role as expiator of sin and to the scapegoat with the scarlet fillet on his brow. The latter is not mentioned in Leviticus, but was discussed at length in John Lightfoot's *The Temple Service as it Stood in the Dayes of our Saviour* (1649, pp.172–5: this was based on the Talmud). Although the scarlet fillet was not painted into the large version of 'The Scapegoat' until 14 February 1855, it was an essential part of the conception, as Hunt's diary of that date reveals: 'in the vagueness of the description in the Talmud of the form in which the scarlet was placed on the head I feel it to be very much left to myself. so I merely place it round about the horns to suggest the crown of thorns' (JRL). 'A scarlet ribbon' was mentioned in Hunt's letter to Millais of 10–12 November 1854 (British Library), suggesting that he had read Lightfoot before making the trip to the Dead Sea.

He would therefore have known that 'the wilderness' of Leviticus 16.21–2, was, according to the Talmud, 'a very steep and high promont' about twelve (rather than sixty) miles from Jerusalem, from which the scapegoat was pushed to his death (Lightfoot, op.cit., p.174). If Hunt had paid attention to this, he would have had to abandon his subject, for a goat being pushed off a cliff could not be interpreted as a type of Christ in his death agony. Hunt's decision to place the animal, personifying the sins of the people, in an area thought to be the site of Sodom and therefore 'accursed of God' (Hunt journal, 19 November 1854, JRL), emphasises the enormity of the sins the Messiah had to expiate, and it seems to have been taken largely because the artist realised the pictorial possibilities of the Dead Sea locale. He was not purely concerned to paint a didactic picture – which he hoped might convert the Jews to a belief that Christ was the true Messiah (Hunt to Millais, 10–12 November 1854, British Library) – but, as he wrote to D.G. Rossetti on 21 March 1855: 'I don't know I should have thought the subject demanding immediate illustration had I not had the opportunity of painting this extraordinary spot as background from Nature' (Troxell, pp.40–1).

Before his first trip to the Dead Sea, Hunt had read Félicien de Saulcy's *Narrative of a journey round the Dead Sea and in the Bible Lands in 1850 and 1851*, probably in the English translation of 1853 (Hunt to Millais, 10–12 November 1854, British Library). De Saulcy identified the site of Sodom as Kharbet-Esdoum, on the southern end of the Dead Sea (I, pp.456–78), and his description of the dramatic light effects of the area (ibid., I, pp.526–7) would have further stimulated Hunt's interest in its pictorial possibilities. He had written to Combe on 29 July 1854: 'Shortly I think of going to the Jordan,

[153]

and Dead Sea to find a background. next week perhaps' (BL), and on 13 September stated his intention of taking the picture 'in hand immediately the weather becomes cool enough to allow me to go to the Dead Sea' (Hunt to Combe, BL). Both letters contradict the published account, which states that Hunt postponed his visit so that it could coincide with the Day of Atonement (2 October in 1854; Hunt 1905, I, p.447).

Hunt finally set out on 20 October 1854, reaching his goal four days later. One of his travelling companions, Rev. William Beamont, kept a diary of the trip, in which he described the view of the southern end of the Dead Sea from the wady Zuara: 'The mountains beyond the sea . . . under the light of the evening sun, shone in a livery of crimson and gold, except where a floating cloud cast its shadow on their sides. On our right were the rocks of Usdam [Oosdoom, according to Hunt], and then as if to complete the magnificence of the scene, a lofty and most perfect rainbow, with one foot upon Usdam and the other upon Kerak, spanned the wide but desolate space of intervening sea and land – the symbol of God's covenant of mercy [with Noah, Genesis 9.13–15] above the most memorable scene of his wrath [the destruction of Sodom and Gomorrah, Genesis 19.24–5]' (William Beamont, *A Diary of a Journey to the East, in the Autumn of 1854*, 1856, II, p.43: entry of 24 October 1854; and cf. the account in Hunt 1905, I, p.456).

The camel's skeleton, at the foot of the rainbow in No.84, was also witnessed on this visit (Beamont, diary entry of 25 October; II, p.46). Beamont expressed disappointment at not seeing 'the medjin, or wild goat *Ibex*, remarkable for the size of its horns, fifteen or sixteen inches long and curved backwards, and which is met with near the Dead Sea' (24 October; ibid., II, p.40), but Dr Sim lent Hunt the skull of a Sinaitic ibex (Hunt 1905, II, p.11) and this was duly incorporated in both versions of 'The Scapegoat'. In No.84, its head and horns are visible, and the head is irradiated by a halo, formed by the reflection of the full moon. This probably alludes to the first goat, sacrificed 'for the Lord' during the Day of Atonement ceremonies (Leviticus 16.8); it suggests that both the expiring and dead goats can be seen as types of Christ.

Hunt's published accounts (1886, pp.829–30 and 1905, I, pp.456–60) imply that the first trip to the Dead Sea was purely for the purpose of reconnaissance, but he does mention sketching 'the scene' from above Engedi (1905, I, p.460). Beamont's diary of 26 October 1854 described this view as that of 'the Dead Sea in its whole extent, with the river Arnon entering it on the opposite side', and states that the party left Hunt at the site engaged in transferring 'to canvas the glowing hues of the evening landscape. If these should in due time be reflected on the Academy walls, it will be only one of a thousand testimonies to the magic of his pencil' (II, p.78). The canvas to which Beamont refers is probably that of No.84, the background of which differs somewhat from the larger picture.

According to the pencilled draft written by Edith Holman-Hunt to her husband's dictation and appended to a letter of 31 January 1906 from C. Morland Agnew to the artist: 'Before my return to Oosdoom [i.e. between 30 October and 13 November

1854] I made the rainbow experiment on the small picture' (JRL). It is possible that No.84 was taken to Oosdoom on the second visit, together with the large canvas; Hunt's journal of 17 November 1854, written at the Dead Sea, states: 'I sat down with my design at hand to adapt it to the place itself and this gave me very much trouble until I determined to make a complete reformation' (BL).

The draft letter of 1906 to Agnew continues: '. . . passing considerations determined me to represent a *black* goat as "Azazeel" [the scapegoat] But eventually for the large picture I felt it best to adopt a white goat & to omit the rainbow. It was ["long" erased] not till after ["the completion" erased] – my second return from Oosdoom that I completed the small picture' (JRL). The rainbow was probably omitted because, in conjunction with the olive branch in the left foreground, it puts a good deal of emphasis on God's covenant with Noah, thereby introducing too optimistic a note into a scene of desolation. The colour of the goat was important, for white symbolised the sinless nature of both scapegoat and Saviour. The 'passing considerations' refer to the difficulties Hunt encountered in obtaining this animal rather than the more common brown variety. By 11 February 1855 these difficulties had been resolved (Hunt to Combe, BL), and Hunt's diary (JRL), which begins on the following day and gives a detailed account of work on the large version, does not mention his painting on the small canvas.

No.84 was probably used to test out ideas for the large picture, and it returned to London unfinished. On 26 May 1858 Hunt wrote to W.M. Rossetti: 'I am obliged to turn all my thoughts now to getting some pence – by potboilers – and I am making another meal off the Scapegoat' (UBC/AP). Presumably Windus lent Hunt the large version to enable him to complete No.84, which, it seems, he had hoped to have ready in time for the 1858 Royal Academy. The letters between Ruskin and Hunt of 29 April and 4 May 1858 suggest that Ruskin's criticisms of the large canvas held up Hunt's progress on the small one (Ruskin to Hunt, 29 April 1858, Hunt to Ruskin, 4 May 1858, published in George P. Landow, '"Your Good Influence on Me": The Correspondence of John Ruskin and William Holman Hunt', *Rylands Bulletin*, LIX, 1976, pp.123, 124–5). It may have been as the result of Ruskin's strictures that the foreground of No.84 is much lower in tone than that of the large picture.

It is probable that the Manchester version of 'The Scapegoat', rather than the large canvas, was sent to the exhibition of the Liverpool Academy in 1858. No.84 was sold by 26 February 1859, when Hunt complained to Combe that 'White is bothering me in delaying payment for the Little Scapegoat' (BL). According to F.M. Brown's diary of 6 July 1856, the dealer David Thomas White was the first owner of the large 'Scapegoat' (Surtees 1981, p.181), which was sold to Windus by 14 June 1857 (Hunt to Lear, JRL). He also bought No.84 from White, and both versions were offered by Windus at Christie's on 19 July 1862 (lots 35, 56).

J.B.

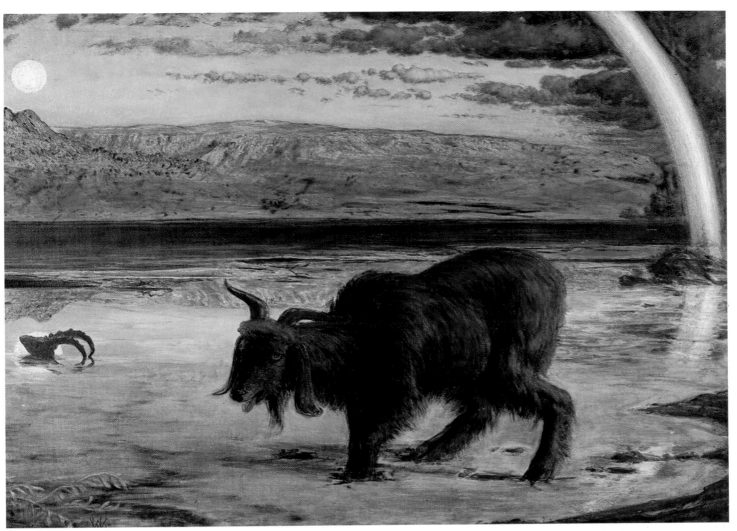

84

SECTION V 1857-1860

In the late 1850s Hunt continued work on the canvases he had begun in Palestine, especially the large 'Finding of the Saviour in the Temple' (No.85), which took six years to paint. Brown was similarly preoccupied with his long-term project, 'Work' (No.88), completed in 1863 after thirteen years. Millais exhibited further 'mood' pictures (Nos 96, 100), which proved no more popular than 'Autumn Leaves'. In 1860, however, he returned to general favour with 'The Black Brunswicker' (No.108), a deliberate attempt to repeat the success of his earlier narrative paintings.

Although the P.R.B. had long since dissolved, group activities of one sort and another revived in this period. Brown organised a semi-public exhibition of Pre-Raphaelite paintings and watercolours at 4 Russell Place, Fitzroy Square in July 1857. Later that year an *American Exhibition of British Art*, with a substantial group of Pre-Raphaelite works, was sent to New York. Hunt, Millais, Rossetti and Woolner were among the contributors to an illustrated edition of Tennyson's *Poems* published by Moxon the same year. In 1858 Brown, Rossetti and others formed the Hogarth Club, a social and exhibiting body which survived until 1862 and numbered among its members all the original Pre-Raphaelites except Millais and Collinson.

The most celebrated collaboration of these years, however, was the decoration of the Oxford Union building in 1857 by Rossetti and a team he put together for the purpose: Burne-Jones, Morris, Hughes, Prinsep, Stanhope and Pollen, with Munro supplying a sculpted tympanum. This is usually taken as the starting point of the second, Rossetti-inspired phase of Pre-Raphaelitism. After occasional works in the medium (e.g. No.90), Rossetti himself returned properly to oil painting in 1859 (see No.114).

opposite Ford Madox Brown, 'Work', 1852, 1856–63 (detail, No.88)

WILLIAM HOLMAN HUNT

85 The Finding of the Saviour in the Temple 1854–5,
1856–60
Inscribed '[E]T STATIM VENIET AD TEMPLUM SUUM
DOMINATOR QUEM VOS QUAERITIS' and the same in
Hebrew
Oil on canvas, $33\frac{3}{4} \times 55\frac{1}{2}$ (85.7 × 141)
First exh: German Gallery 1860
Ref: Liverpool 1969 (31)
Birmingham Museum and Art Gallery

The ivory flat of the frame of No.85 is inscribed in gold with the title at the top and texts from the picture's source in St Luke, chapter two, on the other three sides. On the left: 'And when they found him not, they turned back again to Jerusalem, seeking him. And, after three days, they found him | in the Temple' (2.45–6); below: 'And when they saw him, they were amazed: and his mother said unto him, Son, why has thou thus dealt with us? behold, thy father and I have sought thee sorrowing. | And he said unto them, how is it that ye sought me? wist ye not that I must be about my Father's business?' (2.48–9); on the right: 'And he went down with them, and came to Nazareth, and was subject unto them: but his mother kept all these sayings | in her heart' (2. 51). The theme is amplified within the picture space by the Latin and Hebrew inscription on the golden gate of the Temple, from Malachi 3. 1: 'and the Lord, whom ye seek, shall suddenly come to his temple', an Old Testament prophecy which alerts the spectator to look for other examples of prefigurative symbolism in No.85.

The first sketch for 'The Finding', a pencil study of Mary embracing the boy Christ (Coll. Mrs. Burt, exh. Liverpool 1969, No.144 verso) almost certainly dates from 11–17 May 1854, during Hunt's trip down the Nile to Damietta, and shows that he was at first more concerned with the human scene of parental reunion than that of the boy's exchanges with the doctors. However, it was only a first thought: Hunt's letter to Millais of June 1854 from Jerusalem mentions that he had not yet decided 'upon my next subject' (ASU). By 10 July Hunt was to inform Combe that he had 'at last' chosen '"the finding of our Lord in the Temple by his Mother and Joseph": (a secret of course.) for three or more weeks work I have made but little progress but then I have read and learned a great deal about the design of the Temple and also about the ceremony with which the event is connected [Passover] and now I feel nearly prepared' (BL). Hunt was at this time living in the house of a missionary in Jerusalem and had access to his library, which included works by John Lightfoot (Hunt 1905, I, p.408), no doubt *The Temple Service as it Stood in the Dayes of our Saviour* (1649) and *The Temple: especially as it Stood in the Dayes of our Saviour* (1650). Hunt relates that he also studied the Talmud (this would have had to be translated for him from the Hebrew) and Josephus, in addition to the Bible (1905, I, p.406); and on 31 March 1855 he attended a Passover service to ascertain to what extent the customs were still in force (Hunt diary, JRL).

According to Hunt's autobiography, he had completed the design for No.85 in July 1854, drawn the outline on the canvas, and commenced the perspective (1905, I, p.408). It is unlikely that any highly finished design was ever executed, but there are preparatory studies in the collection of Mrs Burt for the Holy Family (exh. 1969, No.154), a compositional study with Jesus, Mary and Joseph, some of the rabbis and the architectural background (ibid., No.155), and a pencil sketch indicating most of the seventeen foreground figures (ibid., No.156).

Hunt was at first fairly sanguine about obtaining male sitters from among the many destitute Jews in the city; he had carefully chosen the subject partly because it required only one female figure (Hunt to Combe, 29 July 1854, BL). However, in early July Albert Cohn had arrived in Jerusalem with funds from European Jewry to alleviate the appalling state of Jewish pauperism (James Finn, *Stirring Times, or Records from Jerusalem Consular Chronicles of 1853 to 1856*, 1878, II, pp.59–62, 79), and, according to Hunt and Seddon, he not only forbade the Jews to work for Christians (Hunt to J.L. Tupper, 24 July 1854, HL) but 'put . . . a special curse' on 'Hunt, who had spoken to some [Jews] about sitting to him' (Seddon, p.108). Hunt's plea that he had no connexion with the Anglican mission fell on deaf ears (ibid.), for, as James Finn explained in 1878: 'The Jews . . . got the idea that the picture was destined to be put up in a church and worshipped' (*Stirring Times*, II, p.100), and they were loath to assist such a flagrant breach of the Second Commandment.

Hunt was determined to use only semitic models for the figures, in an attempt to visualise the scene as accurately as possible. In the light of this opposition, it is hardly surprising that in 1854 he was only able to make separate sketches for the heads of the Virgin and Christ (Fitzwilliam Museum, exh. 1969, No.152; repr. Hunt 1905, II, p.27) and of Joseph (National Gallery of Victoria, exh. 1969, No.153; repr. Hunt 1905, II, p.25). He relates in his memoirs the difficulties he encountered in securing models for the rabbis, but by 13 September 1854 he was able to report to Combe: 'I have three heads painted in my picture and some parts of their figures' (BL). It was by now apparent that No.85 could not be finished in time for the 1855 Royal Academy, and the following month it was set aside in favour of 'The Scapegoat'. By 4 January 1855 Hunt had managed to paint in three more heads (Hunt to Combe, BL), and, according to his memoirs, Sir Moses Montefiore and Frederic Mocatta successfully negotiated with the Rabbis later in the year to lift the ban on Jews sitting to him (1905, II, p.4). In September 1855 Hunt felt that No.85 was sufficiently advanced to enable him to leave Jerusalem (Hunt to Mrs Combe, JRL). He had 'painted the heads of all the doctors save the one close to the arm of the Saviour . . . finished the head of St Joseph, that of the wine-carrier, and the figure of the youth holding a sistrum [musician in profile third from left]' (Hunt, 'Painting "The Scapegoat"', *Contemporary Review*, LII, 1887, p.218). Just before leaving the city, he managed, on 15 (?) October 1855, to make a sketch of the landscape view of the Mount of Olives from the roof of the Mosque As Sakrah (untraced, repr. Hunt 1905, II, p.37) for the right background of No.85, and he also painted the floor of the Temple in the foreground 'from slabs of the local limestone rock' (Hunt 1905, II, p.36). Its marble veined appearance was probably based on the description in Lightfoot's *The Temple: especially as it Stood in the Dayes of our Saviour* (1650, p.46).

By mid-March 1856 Hunt was installed in Claverton Terrace, Pimlico, where his half-finished picture was much admired by Brown, Rossetti and Gambart (Surtees 1981, p.167; Doughty & Wahl, I, p.300; Hunt to Lear, 13 April 1856, JRL). Hunt informed Lear on 13 April that he was unable to accept Gambart's offer for No.85 as it was already promised to Thomas Combe (JRL). He was now able to make a chalk study of the Holy Family from the life (Tate Gallery), and by 10 December 1856 was working on the interior of the Temple from the Alhambra Court of the Crystal Palace at Sydenham. Hunt did not consider that this transgressed his own self-imposed rules of archaeological exactitude, as Islamic architecture was thought to have derived from ancient sources

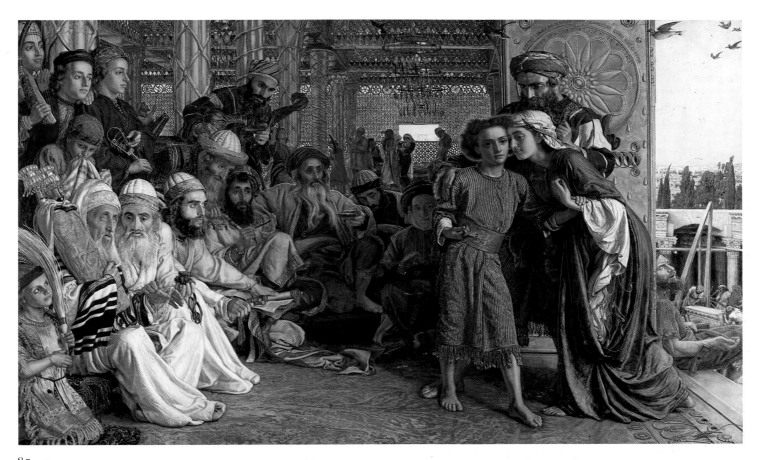

85

(Kenneth Bendiner, 'The Portrayal of the Middle East in British Painting 1835–1860', Univ. of Columbia PhD thesis, 1979, p.263). No doubt Hunt was aware also of the popularity of J.F. Lewis' scenes of Moorish architecture. Other features of the Temple, such as the copious use of gold and the pomegranates on the capital of the pillar sixth from the left were based on biblical descriptions of Solomon's Temple (2 Chronicles 3. 7; 4. 12–13).

Jewish sitters were easier to obtain in London than Jerusalem, though it seems that none could be persuaded to model for Christ. According to Munby's diary entry of 1 July 1860, the Virgin was painted from Mrs Frederic Mocatta, while 'the figure of the Saviour was finished in London from a Christian boy . . . though studied in Judaea' (Derek Hudson, *Munby: Man of Two Worlds, The Life and Diaries of Arthur J. Munby 1828–1901*, 1972, p.66). Munby thought that the model was a son of Thoby Prinsep's; but in 1908 he was identified by William Callow as Cyril Flower (*An Autobiography*, p.118). A highly worked study of the heads of Mary and Jesus, in the same pose as the painting, dates from 1858 (Walker Art Gallery, exh. 1969, No.157). Sitters for the figures at the far left included John Bergheim (Hunt to Bergheim, 1 March 1859, ASU), 'a young Hungarian Israelite found by the Revd Ridley Hirschill' (Hunt to the Editor of the *Birmingham Daily Post*, 15 June 1896; MS draft, Birmingham City Art Gallery), and pupils from Jewish schools (Hunt 1905, II, p.95).

According to Hunt's autobiography, Combe lent the artist £300 to enable him to finish No.85 (ibid., II, p.184), but it seems likely that this was in fact the price of 'The School-girl's Hymn' (No.102), which Combe purchased in November 1859. Hunt worked on No.85 steadily from November 1859 until

17 April 1860, the day of the private view of 'The Finding' at the German Gallery (Hunt to Lear, 24 April 1860, JRL). He estimated that it had cost him £2000 to paint (Millais to Effie Millais, 9 May 1860, PML), and it was sold to Gambart on 9 May 1860 for a down payment of £3000, and a further £2500 to be paid 'in bills at eighteen months' (Scott, II, p.58). This extremely high price included the copyright, but as No.85 was an immediate and sensational popular success the money was soon recouped from extensive exhibiting (at a shilling per head) both in London and the provinces, while a handsome profit accrued from the sales of the engraving, which was issued in November 1867 in a huge edition.

A key plate, written by Hunt, was published by Gambart at the same time as the engraving, reflecting not only the interest No.85 had aroused but also the fact that many of its details could only be fully appreciated with the aid of a literary gloss. This did not, however, present an explanation of its symbolism, which ranges from the fairly accessible to the esoteric, and in all cases relates to the past, present and future life of the Saviour.

According to Luke 2. 47, the doctors 'were astonished' at Christ's 'understanding and answers', but by choosing to make No.85 a scene of confrontation between the Old and New Dispensations Hunt has departed from his source. He portrays the rabbis as exhibiting hostility to Christ's teaching in a number of ways, ranging from senility, pride and self-conceit, through indolence and envy to sensuality (Stephens, pp.63–8; Stephens' pamphlet was vetted by the artist). Excessive Pharisaical reverence for the word of the Law, rather than its spirit, is emphasised by the prominently displayed phylacteries and the presence of the two little boys, one with a fly whisk to

keep insects from defiling the Torah (ibid., p.68), the other kissing its covering. This symbolic gesture had been noted with incomprehension and distaste in Hunt's letter of 10 November 1854 to Millais (British Library), and his unsympathetic depiction of the rabbis was no doubt influenced by the conduct of their mid-nineteenth-century counterparts in Jerusalem, who denounced the starving Jews for accepting help from the Gentiles (James Finn, *Stirring Times*, 1878, II, p.73). On this level, the blind and crippled beggar on the right of No.85 not only presents a contrast to the physical and spiritual blindness of the rabbi at farthest left but can be seen as representing the ranks of destitute Jewry still being neglected in Hunt's own day. Beggars were a feature of the life of the Temple at the time of Christ (Acts 3. 2), and the presence of the blind cripple is also a type of Christ's healing miracles (e.g. Matthew 21. 14).

The clash between the Old and New Dispensations is symbolised further by the frame of No.85, designed by the artist in February 1859 (Hunt to Combe, 26 February 1859, BL). The snake entwined round the cross on the left alludes to the brazen serpent of Mosaic law (Numbers 21. 8–9), while the eclipsed moon and blazing sun at the top of the frame suggest that the influence of the rabbis will be eclipsed by Christianity. The frame on the right incorporates 'a cross of thorns, with a garland of flowers about it' (Stephens, p.78), reminding the spectator of Christ's sacrifice, while the flowers at the lower edge – heartseases for peace and daisies for humility, devotion and universality (ibid., pp.78–9) – comment on the nature of his mission.

There are numerous incidents within No.85 which foretell the Crucifixion. These range from the doves, symbols of the Holy Ghost connected with Christ's baptism (Matthew 3. 16), which are being driven from the Temple by a youth waving a scarf; the ear of wheat in the right foreground, which has fallen from Mary's dress (Stephens, p.59), an allusion to the sacrifice of the first fruits (Leviticus 2. 12–14); and the scene in the background of the Temple, which includes a paschal lamb being taken away from the ewe and offered for sacrifice. A money-changer is involved in this operation, reminding the spectator of Christ's role as a reformer (Matthew 21. 12–13). By depicting the boy Christ 'as one who girds up his loins and makes ready to depart for labour' (Stephens, p.71), in the act of tightening his belt, Hunt suggests that Christ was already reforming abuses at the time at which he first became aware of his mission. Hunt's memoirs explain this esoteric piece of symbolism as follows: 'in the Passover institution it is ordained that the feast should be eaten with loins girded standing and prepared as for a journey [cf. Exodus 12. 11], whereas in Christ's time it is apparent that the same feast was taken lying at meat as if resting from a journey' (1905, I, p.407: this is probably based on John Lightfoot, *The Temple Service as it Stood in the Dayes of Our Saviour*, 1649, p.144). Only the most learned biblical commentator would have picked up this reference, whereas most spectators would have realised the importance of the landscape in the right background with its view of the Mount of Olives, from where, just before the Crucifixion, the Saviour prophesied the destruction of the Temple (Matthew 24). It is therefore a reminder of both the New Dispensation and of Christ's martyrdom, as is the scene in the outer courtyard of the Temple, in which a group of workmen are quizzically regarding a piece of masonry which they are about to reject as 'the head stone of the corner' (Psalm 118. 22). Although the Greek architecture of this courtyard had historical justification, Hunt must have known that Herod's Temple was completed some nine years before the Nativity (John Lightfoot, *The Temple: especially as it Stood in the Dayes of our Saviour*, 1650,

p.45), and he may have included a literal rendering of the headstone as a covert reference to Tintoretto's 'The Annunciation' (Scuola di San Rocco, Venice), which, as Ruskin had demonstrated in volume two of *Modern Painters* (Ruskin, IV, p.265), used this biblical type. Ruskin's interpretation was a crucial element in Hunt's search for a style of symbolic realism, which reached its apogee in No.85. He certainly regarded the picture as comparable to the works of the Old Masters, informing Ruskin on 28 December 1857: 'to me my "Finding" is as important [as] Da Vinci's Last Supper was to him' (George P. Landow, '"Your Good Influence on Me": The Correspondence of John Ruskin and William Holman Hunt', *Rylands Bulletin*, LIX, 1976, p.121).

W.M. Rossetti noted in his diary of 8 August 1861 that (the late) T.E. Plint had bought No.85 'for either £3000 or £4000' (W.M. Rossetti 1899, p.281). It reverted to Gambart and was sold to C.P. Matthews in April 1870 for 2500 gns (Maas, p.219). A half-size version, begun in Jerusalem but only completed in 1865, is at Sudley House, Liverpool (exh. 1969, No.32; repr. Bennett 1970, p.58, fig.21).

J.B.

86

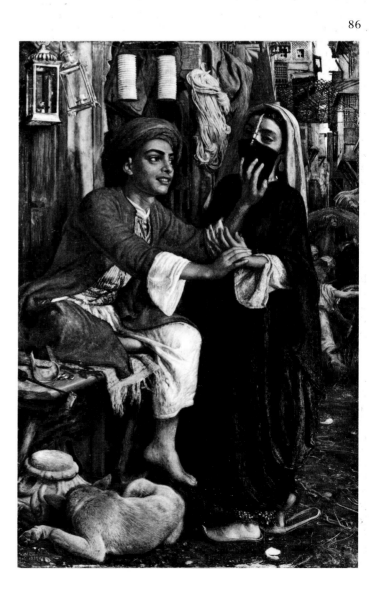

WILLIAM HOLMAN HUNT

86 A Street Scene in Cairo: the Lantern-maker's Courtship 1854–6, 1860–1
Inscribed 'Whh Cairo | 1854–61' (initials in monogram)
Oil on canvas, 21½ × 13¾ (54.6 × 35)
First exh: R.A. 1861 (231)
Ref: Liverpool 1969 (28)
Birmingham Museum and Art Gallery

No.86 was exhibited at the 1861 Royal Academy with the following explanatory note in the catalogue: 'The wearing of the burks, or face veil, is common to all respectable classes in Cairo. "The bridegroom can scarcely ever obtain even a surreptitious glance at the features of his bride, until he finds her in his absolute possession." – *Lane's Modern Egyptians*, book i., p.211'. The quotation suggests that No.86 was undertaken as a record of an alien culture, and this was indeed in Hunt's mind. He witnessed an incident similar to that depicted in 'The lantern-maker's courtship' shortly after his arrival in Cairo in February 1854, and decided to paint it 'as an illustration of modern egyptian life', partly as a 'trial of the question of getting models', and, more importantly, 'to en-sample a principle . . . that Painters may cease the uselessness of their employment hitherto and devote themselves to the task of spreading knowledge' (Hunt to Millais, 16 March 1854, ASU; to Combe 21 February, and 23 March 1854, BL; and to W.M. Rossetti, 12 August 1855, HL).

Hunt first made a careful pencil study for the architecture on the left-hand side of No.86, inscribed with colour notes and dated 'March 2nd 1854' (untraced, repr. *Gazette des Beaux-Arts*, XXXVI, 1887, p.403). This included the text from the Koran hung up inside the shop, the rope hanging from a beam, the rug suspended from the balcony, the two folding lanterns 'composed of waxed cloth strained over rings of wire, and a top and bottom of tinned copper' (E.W. Lane, *An Account of the Manners and Customs of the Modern Egyptians*, 1846, I, p.201), and part of the table in the left foreground. A further pre-paratory drawing, dated 30 March 1854 (Birmingham City Art Gallery, exh. Liverpool 1969, No.132, repr.), for the architecture on the right-hand side of No.86, reveals that the camel with its load of grass blocking the narrow street was an essential element of the composition. This detailed pencil sketch does not include the trellis hung up between the buildings on either side of the thoroughfare, a feature that was mentioned in Hunt's letter of 12–13 March 1854 to D.G. Rossetti and linked to the celebrations marking the betrothal of the Pasha of Egypt's son with the Sultan of Turkey's daughter (Lutyens 1974, pp.55–6). It was therefore apposite to the courtship theme of No.86.

The bare foregrounds of the preparatory drawings testify to the fact that Hunt's object was to paint a figure picture and not just a topographical record. He here encountered great difficulties as his over-optimistic initial assessment – 'I believe that nearly any of the Arab men or the Egyptian could be induced to sit' (Hunt to Combe, February 1854, BL) – came up against the Islamic prohibition concerning the representation of living objects. Hunt did finally persuade one youth of sixteen to sit to him on the Muslim sabbath (Hunt to Combe, 23 March 1854, BL), but, as he noted in his memoirs, this did not last once the boy was informed of his transgression (1905, I, pp.387–8). It was virtually impossible to secure a female model, and Hunt's letter to Millais of 16 March 1854 amusingly relates a reconnoitring visit to a brothel which enabled the artist to make some studies for use in the picture (Diana Holman-Hunt,

My Grandfather, His Wives and Loves, 1969, p.129).

Despite these trials, 'The lantern-maker's courtship' was advanced enough for Hunt to write to Combe on 26 April 1854 about his 'little picture of a street subject not a highly finished work but rather a complete sketch. I hope soon to be enable to send you this for it requires only four or five days more work . . . it is but a trifling affair nevertheless I hope it may have some value as an illustration of an unwise state of society which as it appears is fast falling to pieces' (ASU). At this point Hunt was thinking of offering No.86 to C.T. Maud for 150 gns (ibid.), but he then decided to work on it further in Jerusalem. The picture was there neglected in favour of No.85 and 'The Scapegoat' (Lady Lever Art Gallery, Port Sunlight, exh. 1969, No.33, repr.), and although there is a reference to its being 'on hand' in a letter of 12 August 1855 to W.M. Rossetti (HL, and see also Hunt 1905, II, p.16), No.86 was brought back to England in 1856 in an unfinished state.

Hunt very much wanted to exhibit the painting at that year's Royal Academy, but on 8 April he 'had to give in with . . . the little Cairene sketch for want of two hours more daylight and somewhat more of animal life' (Hunt to Lear, 13 April 1856, JRL). At this period Millais posed for the top-hatted Englishman intimidating the natives in the right background of No.86 (Hunt 1905, II, p.105). The incident echoes Hunt's own attitude towards the Egyptians, as relayed in his letter of 16 March 1854 to Millais: 'my nationality . . . is worth every other pretension one travels with, it finds one in cringing obedience and fear from every native, even a dog, with this indeed and a stick and in fact with only a fist I would undertake to knock down any two Arabs in the Esbekier and walk away unmolested' (ASU).

Despite having missed the sending-in date for the Academy exhibition, Hunt seems to have continued working on No.86, informing Lear on 13 April 1856: 'the sketch in Cairo has grown into a finished little picture' (JRL). Madox Brown viewed it in Hunt's studio on 28 July, and noted in his diary that the 'Lantern Maker . . . is lovely color & one of the best he has painted . . . very quaint in drawing & compo[sitio]n, but admirably painted' (Surtees 1981, p.184).

Hunt presumably felt that the picture could be improved, and set it aside until he had completed No.85. A letter to Lear of 24 April 1860 mentions his intention of taking up 'the little Cairene picture' for finishing (JRL), but it was not finally completed until the following year. Hunt offered it to Plint on 11 February 1861 for 500 gns, without the copyright (MS, Yale Center for British Art); No.86 was, however, unsold when it was exhibited at the 1861 Royal Academy. Hunt may have hoped that the contemporaneous show of his eastern works at the German Gallery would have paved the way for 'The Lantern-maker's Courtship', but in fact the Academy exhibit received generally poor reviews. It was subsequently bought from the artist by C.P. Matthews, and changed hands in 1891, when Hunt retouched and restretched the canvas (Hunt to William Kenrick, 7 July 1891; MS, Birmingham City Art Gallery).

The small version of No.86, oil on panel (Manchester City Art Gallery), was painted on a white ground, bears Hunt's monogram, and is virtually identical to the Birmingham painting in all but scale. In a letter of 5 December 1906 to William Kenrick Hunt denied ever having painted a signed and dated watercolour replica of No.86 (MS, Birmingham City Art Gallery), and as no watercolour version has come to light the name 'W. Bower' on the edge of the Manchester version has been thought to be that of the copyist. However, No.86 passed directly from Hunt to Matthews, and there was no opportunity

for the picture to have been copied without the artist's knowledge, as Hunt himself admitted (ibid.). Hunt's letter to Combe of 21 February 1854 mentions that James Clarke Hook had been in touch with the artist's father, possibly, Hunt surmises, about a picture 'which his friend Mr Bower has commissioned me to paint . . . nothing can be said further than that I will take the earliest opportunity to commence the work' (BL). The coincidence of names may perhaps suggest that Bower was the potential purchaser of the Manchester version rather than the painter. Certainly the length of time expended on 'The Lantern-maker's Courtship' does not rule out the possibility of Hunt working on two versions simultaneously.

<div align="right">J.B.</div>

WILLIAM HOLMAN HUNT

87 **The Afterglow in Egypt** 1854, 1860–3
Inscribed 'Whh | MEMPHIS 54–63' (initials in monogram)
Oil on canvas, arched top, 73 × 34 (185.4 × 86.3)
First exh: New Gallery, 16 Hanover Street 1864
Ref: Liverpool 1969 (29)
Southampton Art Gallery

Hunt went to Gizeh on 20 April 1854 without the canvases or etching tools that were on their way from England (Hunt to Combe, between 20 and 26 April 1854, BL; and to James Clarke Hook, 1 May 1854, JRL). While waiting for the box of materials from Roberson's to arrive, he worked on drawings and watercolours (see No.202), and almost certainly began a pencil study (with Agnew's, 1983) for the etching 'The Abundance of Egypt' (proof exh. Liverpool 1969, No.63) from a model in the same pose, though reversed, as that of No.87. The canvas for 'The Afterglow in Egypt', which arrived by 26 April, was approximately half its present size, as the line across the work at the girl's hip level demonstrates, and at this time Hunt concentrated on painting the face (Hunt 1886, p.828). On 27 April 1854 he wrote to Combe: 'since . . . my arrival here I have . . . begun a study of an egyptian girl. the size of life which however what with the difficulty of getting the model day by day and the horrible trials of wind and dust even in the best places I can find for painting in – is in danger of being abandoned – at least for the present' (ASU: letter headed by sketch of 26 April showing the artist laying in 'The Afterglow').

According to Hunt's memoirs, the sitter was unreliable rather than hostile (1905, I, pp.382–3); one might have expected him to express some degree of surprise at securing a model at all, after his experiences in Cairo (see No.86). However, his reading of a work such as *Eōthen*, which mentioned the lack of religion among the Bedouin women, who 'are not treasured up like the wives and daughters of other Orientals' (1844, p.248), would have prepared Hunt for greater co-operation from the felláheen. E.W. Lane's *An Account of the Manners and Customs of the Modern Egyptians* revealed, moreover, that the peasant women of Upper Egypt rarely concealed their faces with a veil or burko (1846, I, p.78). According to Hunt's letter of 2 May 1854 to his sister Elizabeth, the sight of an English artist painting in a cave hewn from a rock was a great tourist attraction, and 'several Egyptians have asked me to become a Mahommedan and accept their daughter or sister in marriage' (JRL).

Lane's *Modern Egyptians* could have provided Hunt with the

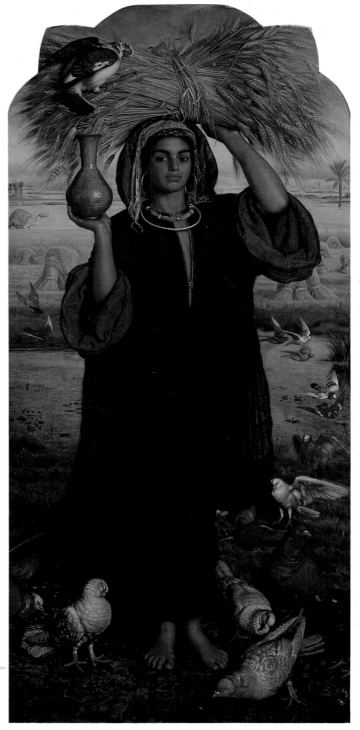

87

idea of depicting the sitter balancing a sheaf of corn on her head (cf. illustration, ibid., I, p.79), while the positioning of the arms and the way in which the water-pot is balanced on the palm of her right hand may, as Kenneth Bendiner has noted ('The Portrayal of the Middle East in British Painting 1835–1860', Univ. of Columbia PhD thesis, 1979, p.109), be indebted to the female figure in the lithograph 'Entrance of the Temple of Amun, Thebes', published in David Roberts' *Egypt and Nubia*, 1849. Lane was extremely informative on such aspects as the girl's dress, jewellery and tattooed chin (I, p.67), and this may

have led Hunt to abandon No.87 with less compunction on leaving Gizeh on 6 May 1854.

Nearly six years later, on 11 February 1860, Hunt wrote to Bell Scott of his intention to take up Nos 86 and 87 for finishing once he had completed 'The Finding of the Saviour in the Temple', No.85 (PUL). On 11 February 1861 he wrote to T.E. Plint that he was engaged on two versions of 'The Afterglow', and he offered him the 'sketch' (oil on canvas, $32\frac{1}{4} \times 14\frac{1}{2}$, Ashmolean Museum, exh. Liverpool 1969, No.30; repr. Hunt 1913, I, p.281), which differs in several respects from No.87, for 300 gns (MS, Yale Center for British Art). The Ashmolean version was almost certainly planned round a full-length figure, and by this date Hunt had added to the canvas of No.87 so that it could accommodate a full length the size of life (MS, ibid.). The chalk drawing for the figure (Coll. Mrs Burt, exh. 1969, No.137, repr.) must therefore date from 1860–1.

Hunt was still working on No.87 on 17 March 1862 (letter to Combe, BL), and one of the reasons for the slowness of his progress is suggested in a letter to Combe of 11 May 1862. This expressed his 'fear that the paint will dry ere it is finished and that I shall thus lose all my day's work' (BL), which may imply that Hunt was using the technique of wet white for parts, at least, of the picture. It would account not only for the brilliance of colour in No.87, but also for the presence of a smaller version painted concurrently, mistakes incurred while using this technique being very difficult to rectify.

Hunt was working on the drapery from a live model on 14 August 1862 (Hunt to Lear, JRL), in a period of respite from the pigeons, for which there are studies in the collections of Mrs Burt (exh. 1969, No.204, repr.) and the late Stanley Pollitt. By 10 September 1862 Hunt wrote to Lear in desperation: 'I will try and get free somehow from these eternal pigeons which threaten to occupy me for the remainder of my life –' (JRL).

Freedom took the form of work on the 'Portrait of Dr. Lushington' (National Portrait Gallery, London) and No.121, and 'The Afterglow' was resumed once these paintings were sent to the 1863 Royal Academy. Although Hunt informed Bell Scott on 24 April 1863 that he was close to finishing 'the big Egyptian Girl' (PUL), it was 29 November 1863 before he was able to report to Combe: 'Yes! at last the Egyptian is done – and I am glad to find other people thinking as I do that it is the best thing I have yet finished' (BL). Hunt drew up an agreement dated 15 February 1864 relating to the sale of No.87 for 1300 gns, exclusive of copyright or exhibition rights (British Library); according to his daughter it was sold to Gambart in 1862 for 700 gns (typescript, PC, p.506). It was certainly in the collection of C.P. Matthews by July 1867 (Doughty & Wahl, II, p.625).

F.G. Stephens wrote a detailed factual description of No.87, vetted by the artist, for distribution at the 1864 exhibition in Hanover Street (reprinted, with variations in Hunt 1913, II, pp.405–6). The *Daily Telegraph* of 18 May 1864 (p.5) noted that stylistically 'The Afterglow' represented a new departure for Hunt, and this was reiterated by F.T. Palgrave in his long review of the work in the *Saturday Review* of 18 June (XVII, p.751, republished in *Essays on Art*, 1866, pp.164–5). Ernest Chesneau, in *La Peinture Anglaise*, 1882, interpreted the figure in No.87 as an Egyptian Ceres, natural abundance being the only remaining attribute of a once glorious civilisation (pp.194, 196). The pomegranates within the hexagonal motifs on the frame at the girl's hip level, together with the poppy in the corn sheaf on her head, lend credence to Chesneau's interpretation, as they evoke associations with the myth of Demeter, the Greek corn goddess. Hunt's description of Egyptian society as 'fast falling to pieces' in his letter of 26–7

April 1854 to Combe (ASU) would seem to support the second part of Chesneau's theory also. By 1882, however, Hunt obviously felt that such an interpretation might deflect attention from aesthetic considerations, such as the treatment of light in No.87, and on 3 December he wrote to Chesneau that 'the title . . . comes from my choice of the hour which seemed to me most picturesque for the figure of a girl. one of very many now seen in Egypt with a singular resemblance to the old sculpturesque type. there is no kind or degree of mysticism in it' (Lutyens 1974, p.87).

J.B.

FORD MADOX BROWN

88　**Work** 1852, 1856–63
Inscribed 'F. MADOX BROWN 1852–65'
Oil on canvas, arched top, $53\frac{15}{16} \times 77\frac{11}{16}$ (137 × 197.3)
First exh: Piccadilly 1865
Ref: Liverpool 1964 (25)
City of Manchester Art Galleries

Presenting work in all its forms. The first and most complex of the three paintings begun at Hampstead in 1852, though the last to be finished and the culminating work of the artist's P.R.B. period. While stemming from the influence on the artist of Carlyle's writings, particularly *Past and Present* (1843), it also reflects advanced contemporary sociological concepts such as F.D. Maurice preached and practised at the Working Men's College and which Henry Mayhew published in his *London Labour and the London Poor* (1851; 2nd edition of 4 vols., 1861–2). The moral and religious overtones are partially due to T.E. Plint of Leeds, speculator, evangelical and picture collector, who commissioned the picture's completion late in 1856 and asked for modifications. Finished only in 1863, it formed the centrepiece and reason for the artist's one-man exhibition in 1865, where it was described at length in the catalogue.

The view is on the west side half way up Heath Street, Hampstead, by The Mount (see No.50). The idea came from seeing navvies at work on extensive excavations in the neighbourhood (not, as the artist stated, relating to the water supply, but more probably for the new sewage system: see F.M.L. Thompson, *Hampstead: Building a Borough, 1650–1964*, 1974, pp.440 ff, and information from Evan Richard). Holman Hunt seems to suggest (1905, I, p.225), in his usual fashion of dismissing Madox Brown's originality, his own priority in sketching something of the sort in 1850, which he saw as symbolic of 'the labourer in the market place at the eleventh hour', and which he mentioned to Madox Brown.

The picture is composed round 'the British excavator for a central group, as the outward and visible type of *Work*' (1865 catalogue). At the left the 'ragged wretch who has never been *taught* to *work*'; behind him 'the *rich*, who have no need to work . . . The pastry-cook's tray the symbol of superfluity, accompanies these'. The first lady is a portrait of the artist's wife Emma (see No.182); the older one behind her offers a tract, 'The Hodman's Haven, or drink for thirsty souls', to one of the navvies. In the background, at the top of the social pinnacle, are the leisured on horseback, 'But the road is blocked, and the daughter says, we must go back, papa, round the other way'. The gentleman is a portrait of the artist Robert Martineau. In the foreground, at the bottom of the social scale, a group of 'exceedingly ragged, dirty children' with their mongrel dog, their mother being dead, are cared for and cuffed by their eldest

sister, a child of ten; the baby is a portrait of Arthur Gabriel Madox Brown (1856–7). A stunted pot-boy from a nearby inn, 'The Princess of Wales', carries a copy of *The Times* and cries his wares; while in contrast in the shade of the trees lie distressed haymakers, seeking work, and Irish and other vagrants. In the background at the right an orange woman is moved on by the police (see Mayhew: one of the lowliest of the street sellers). Prominent at the right stand the brainworkers, philosophers representing literature and religion, 'who, seeming to be idle, work, and are the cause of well-ordained work and happiness in others'; these are portraits of Thomas Carlyle and F.D. Maurice. The artist used real workmen and poor Irish for his labourers.

On the walls are posters and bills for the 'Boys Home, 41 Euston Road', for 'The Working Men's College', a police bill offering £50 reward, and one of 'Money, Money, Money', an auctioneer's sale notice, a lecture poster, 'The Habits of Cats', for Professor Snoox (a favourite imaginary character of Rossetti's), a polling and electioneering notice for Bobus (from *Past and Present*), who also advertises himself on the boards carried up the street. A building in the background is the [Fl]ampstead (*sic*) Institute of Arts. This piling up of detail reflects the artist's interests in the later 1850s; Major Gillum, a patron of the Boys' Home in 1860, met the artist in 1858–9; the artist taught at the Working Men's College from about 1857. On the concealed spandrels of the arch are colour notes dated August 1857 and July 1862.

The effect was of 'hot July sunlight . . . because it seems peculiarly fitted to display *work* in all its severity, and not from any predilection for this kind of light over any other' (1865 catalogue). This gave full scope for the brilliant sparkling colour enhanced by contrast with the shady depths of the tree-lined setting.

The design was begun at Hampstead about June 1852 and the background painted on the spot during July and August, using a specially rigged costermonger's truck to carry a large canvas (Hueffer, p.91; Hunt 1905, II, pp.96–7). It was then put on one side but the design was continued, altered and improved during 1855. A slight pencil sketch (Manchester) indicates the basic composition but has a different figure at the left and a single figure, apparently representing an artist, at the right. Madox Brown mentions re-designing 'the artist' on 1 January 1855, working at the navvies and the couple on horseback that month, the pot-boy and children in April, and on 29 April records: 'all day at the designe of "Work." This is now to me a species of intoxication. When I drew in the poor little vixen girl pulling her brother's hair, I quite growled with delight'. The early design is incorporated in the watercolour (No.181).

On 12 November 1856 'Mr. Plint called, inveigled here by Gabriel Rossetti'. He commissioned the picture for 400 gns, but first wanted a radical new evangelical approach. He asked for two more figures to be added, one 'a young lady as a tract or bible distributor, and the other to give more fully the idea of the

88

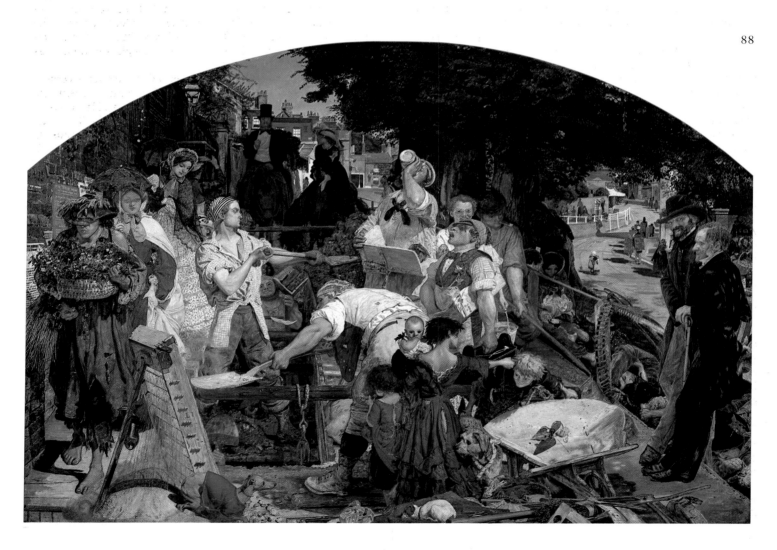

head and *heart* of the work of the *mind*' as he thought the design lacked sufficient of the moral and religious element of work (letter, 17 November 1855, FMBP). Madox Brown evidently chose to meet his wishes and seems to have offered alternative candidates for on 24 November Plint wrote again: 'I have your most interesting letter: cannot you introduce *both*, *Carlyle* & *Kingsley*, and change one of the *fashionable* young ladies, into a *quiet*, *earnest*, *holy* looking one, with a book or two & *tracts*, I want *this* put in, for I am interested in *this* work *myself*, & know others who are' (ibid., and Hueffer, p.112, without the first comma). He thought if necessary photographs would do (2 December).

The design was then gone on with and the painting begun. The pen drawing, begun 1852 and completed for Plint 1860, may possibly have incorporated the new features, but is now lost. F.D. Maurice (not Kingsley, whom Plint was most keen on), Christian Socialist and founder and principal of the Working Men's College, and whom the artist met in 1857, sat in January 1858, and on the 31st the artist commented in his diary: 'At night drew Maurice into the picture but drawn exactly from himself it looks rediculously stumpy & the head enormous. I must either falsify it or make the navvy's head bigger . . . Today out to see about a photographer for Maurice'. Carlyle, to whom he had also been introduced sometime in 1857, sat for a photograph between May and June 1859 (copy Birmingham). A full-scale cartoon made for these figures had apparently been designed before either of them sat (now at Manchester; *Diary*, 27 January 1858) and shows the grimacing grin of Carlyle lightly drawn in, which is repeated in the picture. This feature was generally disliked but Rossetti wrote on 22 June 1859: 'Your new Carlyle is a vast improvement I think. The whole picture seems growing together into thorough satisfactoriness'; but earlier, in 1858, he had written to Lowes Dickinson his doubt 'whether that excessive elaboration is rightly bestowed on the materials of a modern subject – things so familiar to the eye that they can really be rendered thoroughly (I fancy) with much less labour; and things moreover which are often far from beautiful in themselves' (Doughty & Wahl, 1, pp. 335, 352).

The picture was not completed at Plint's unexpected death in July 1861, and the money, paid by instalments, had already run out. A smaller duplicate painted concurrently for James Leathart (now at Birmingham) helped financially, and No.88 was finally finished in August 1863 for the Plint executors. After much trouble the artist came to an agreement with their representative, the dealer Gambart, over copyright and exhibition rights which brought him from first to last £1320. Nevertheless Gambart prevaricated over its promised exhibition and the artist mounted his own show in 1865. The painting was never engraved.

At this exhibition he got on the whole a good press, chiefly from his friends. The *Saturday Review* (25 March 1865) summed up: 'Now what, we are convinced, will most strike visitors to this Gallery is that the painter not only . . . grasps contemporary life, but that he grasps it with an intensity which is very rare in any of the fine arts. He strikes home, where we all can measure the blow. And to do this with success implies, not only the man of technical ability, but the man of mind. . . . His "Work" is simply the most truthfully pathetic, and yet the least sentimental, rendering of the dominant aspect of English life that any of our painters have given us' (and see the notice under No.51).

Otherwise the picture passed by with little general notice. It was badly hung at the Leeds exhibition of 1868 and afterwards disappeared into the Plint estate until 1883-4 when it

unexpectedly reappeared in Manchester, when the artist was himself living there, and was soon afterwards bought for the Art Gallery.

See also the compiler's essay, 'The Price of "Work": the background to its first exhibition, 1865', in *Pre-Raphaelite Papers*, Tate Gallery, 1984.

M.B.

THOMAS WOOLNER

89 **Alfred Tennyson** 1856-7
Inscribed 'T. WOOLNER SC. 1857'
Marble, 28 × 17 × 10 (71.1 × 43.2 × 25.4)
First exh: *Art Treasures*, Manchester, 1857 (Sculpture, No.145)
Master and Fellows of Trinity College, Cambridge

When it transpired in November 1855 that the Scottish sculptor William Brodie was to do a bust of Tennyson, Mrs Tennyson wrote apologetically to Woolner: 'I cannot help wishing it were you who had to do it . . . if you still wished it you should have an opportunity of fulfilling your wish' (Woolner, p.107). Woolner took her up on this almost at once, and had completed his clay model by March 1856, when he arranged to send down to Farringford his studio assistant, Luchesi, to take a mould not only of the bust, but also of the forehead and the tip of the nose of the sitter from the original; these were for use in the eventuality of a version in marble. In order to prevent the original clay model from drying and cracking up, Tennyson himself watered it 'sedulously'. The original plaster model was completed by mid-April 1856.

Rather unusually, Woolner proceeded to execute a version in marble without a specific guaranteed commission (this occupied him from autumn 1856 to March 1857). He probably foresaw little difficulty in finding a suitable buyer for it – at the start of the project there was a possibility Moxon the publisher might commission it in marble if his business went well. As it happened, other possibilities turned up. One was for the bust to go to Trinity College, Cambridge, to join an assembly there of busts and statues of famous former students. But there were problems with this, which caused considerable delays in finalising a deal. To start with, there was a certain reluctance on the part of the College to commemorate someone who was still alive. Even greater problems then arose because, according to Woolner, the organiser of the Trinity party, Vernon Lushington, was placing all sorts of restrictions in the way of those who wanted to subscribe, to the detriment of his, Woolner's, reputation; Tennyson considered the delay was disgracing him. Meanwhile other offers were coming in. One was from Boston, Mass., but Tennyson asked Woolner not to part with it to America, he was sure to find a buyer in England. Thomas Fairbairn had originally wanted to buy it himself, but had deferred to Trinity's apparent interest. But when over a year had passed and the Trinity scheme had still not come off he decided to try and persuade Lord Ashburton to buy it.

It was not in fact until November 1859, two and a half years since the Trinity idea first arose, that Woolner heard from Lushington that the college would finally accept the bust. And it would even then be placed only in the Vestibule of the Library, since the principal Valhalla in the Library was reserved for the dead. Although Woolner must have been frustrated by this delay, it turned out well for him in the end, as Trinity College was later to receive other works by him,

including statues of Macaulay and Whewell, as well as further busts.

The Tennyson bust won admiration as soon as the plaster model was visible in the sculptor's studio. Woolner wrote to Mrs Tennyson on 15 April 1856: 'No one has admired it so much as Millais who went quite into raptures at the sight of it, and told me to tell you he thought it "splendid", he said no other word would express his feeling with regard to it: as a proof of his sincerity he gave me a commission to do a bust of himself, which I am to do when he comes to live in London and he means to have in either marble or bronze; he said he would likewise have one of his wife if he could afford it, but at present this is uncertain'. Amy Woolner footnotes the 'proof of his sincerity . . .' passage: 'This Bust was not made' (Woolner, p.112). The Tennyson bust was impressive enough to warrant Woolner's making two further original marble replicas. That made for Charles Jenner was offered to Hallam, Lord Tennyson by Jenner after the poet's death and placed in Westminster Abbey as the national memorial to Tennyson. Hallam clearly regarded this bust as the best of his father; he was instrumental also in having an additional copy made by Mary Grant to be placed in the National Portrait Gallery, and he recommended it to Hamo Thornycroft for use as model in Thornycroft's full-size statue of Tennyson which was placed in the Trinity College, Cambridge, Valhalla in 1909, adjacent to Woolner's Macaulay and Whewell. Such testimony by the poet's son can be seen to demonstrate a quality of strong truth to nature in Woolner's work. Certainly it would confirm Woolner's stated intention 'to do such a likeness of a remarkable man that admirers of his centuries hence may feel it to be *true* and thankful to have a record which they can believe in'.

For earlier medallions of Tennyson by Woolner, see Nos 30 and 76.

B.R.

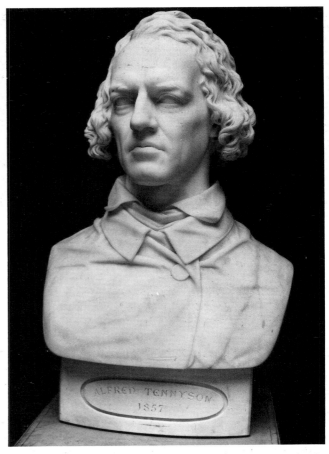

89

90

DANTE GABRIEL ROSSETTI

90 St Catherine 1857
Inscribed 'DGR/57' (initials in monogram)
Oil on canvas, 13½ × 9½ (34.3 × 49.5)
Ref: Surtees No. 89
Tate Gallery

This is the only oil completed by Rossetti between 1850 and 1859. It was originally intended for Ruskin but he disliked it and it was bought by John Miller of Liverpool. Produced at a time when Rossetti's energies were directed, apart from the Oxford Union fresco, at watercolours, it is, in the compiler's view, an unsatisfactory work, revealing the artist's uncertain handling of the medium. It depicts a mediaeval artist's workshop with a model posing as St Catherine with her symbols of martyrdom. In the background, assistants prepare a cartoon of St Sebastian. Rossetti thought artists were supremely important people and portrayals of mediaeval artists at work occur frequently in his pictures and writings. He shared this interest with Browning. A study for No.90, drawn from Elizabeth Siddal, has recently been identified (Surtees No.514). The frame is original.

A.G.

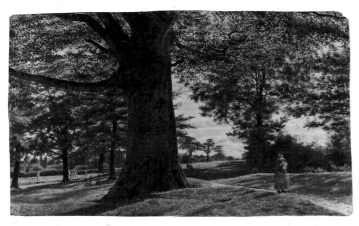

91

GEORGE PRICE BOYCE

91 Girl by a Beech Tree in a Landscape 1857
Inscribed 'G·P·Boyce·'57'
Oil on board, 11¾ × 18⅞ (29.8 × 48)
Tate Gallery

This is one of Boyce's rare landscapes in oil, his ouput being mainly in watercolour. It may have been painted in Surrey or Sussex. His diaries record him at Haywards Heath in May and Petworth in June 1857 (Surtees 1980, p.17) while in 1858 he exhibited two paintings of Surrey subjects at the R.A.: 'Heath side, in Surrey – an autumn study', described by the *Art Journal* (1858, p.170) as 'a most conscientious study of a strip of hillside verdure', and 'At a farmhouse in Surrey'. Ruskin's comments on the latter in his *Academy Notes* could equally well be applied to No.91: 'Full of truth and sweet feeling. How pleasant it is, after looking long at Mr. Frith's picture ['The Derby Day'], to see how happy a little girl may be who hasn't gone to the Derby!' (Ruskin, XIV, p.162). In 1854 Ruskin had privately advised Boyce to avoid the sunset and twilight effects for which he had expressed a liking and to aim instead at clear delineation (see Staley, pp.107–8), something he certainly achieved in this painting.

L.P.

HENRY WALLIS

92 The Stonebreaker 1857
Inscribed 'HW 1857–8' (initials in monogram)
Oil on canvas, 25¾ × 31 (65.4 × 78.7)
First exh: R.A. 1858 (562)
Birmingham Museum and Art Gallery

First exhibited at the Academy without a title but, according to the *Saturday Review* of 15 May 1858, with the first line from Alfred Tennyson's poem 'A Dirge' (published 1830) inscribed upon the frame: 'Now is done thy long day's work'. It was also accompanied by a quotation in the catalogue from Book III, chapter IV, of Thomas Carlyle's *Sartor Resartus* (first published 1833–4) and when the picture was exhibited again at the Liverpool Academy in 1860 (54) this quotation, but in a slightly extended form, again accompanied the work:

Venerable to me is the hard Hand; crooked, coarse; . . . indefeasibly royal, as of the Sceptre of this Planet. Venerable too is the rugged face, all weather-tanned,

besoiled, with its rude intelligence; for it is the face of a Man living manlike. Oh, but the more venerable for thy rudeness, and even because we must pity as well as love thee! Hardly-entreated Brother! For us was thy back so bent, for us were thy straight limbs and fingers so deformed: thou wert our Conscript, on whom the lot fell, and fighting our battles wert so marred. For in thee too lay a god-created Form, but it was not to be unfolded; encrusted must it stand with the thick adhesions and defacements of labour; and thy body, like thy soul, was not to know freedom.

In this chapter of *Sartor* Carlyle identifies two types of men whom he honours most, the first being the 'toilworn Craftsman', labouring to conquer the earth for man, who is described in the above quotation, and the second 'not earthly craftsman only, but inspired Thinker', who can be named 'Artist'. It seems reasonable to speculate that with Carlyle's classification before him Wallis perhaps conceived 'The Stonebreaker' as in some sense a pendant to that earlier work in which he had dealt with the subject of the creative artist – 'Chatterton' (No.75). The two pictures do certainly complement each other on this level and, interestingly, together they form a contrast which invites comparison with a similar emphasis on brainworkers and manual workers made by Ford Madox Brown in 'Work' (No.88) which was in progress at the time Wallis was painting 'The Stonebreaker'.

The genesis of the work is unknown but it was undoubtedly inspired by a familiar sight in rural areas where, under the much criticised Poor Law system, workhouse guardians frequently employed paupers in breaking stones for the repair of parish roads in return for food and lodging. The iniquities of this Poor Law – which amongst other things accounted for some of the upsurge in emigration (see, for example, No.62, Brown's 'Last of England') and a by-product of which, in the case of gangs of road menders, was often an increase in petty thieving, pilfering and poaching in the areas in which they worked – were the subject of intense debate during the middle decades of the nineteenth century.

Here we have, in the words of a writer in the *Daily News* for 10 May 1858, '. . . the model peasant, victim of social mistakes. In a kind of "Autumn Leaves" twilight [a reference to Millais' picture of that title, No.74], though less translucent and in a colder key, we dimly distinguished the dead stonebreaker, with his pauper smock-frock, corduroys and highlows [a kind of boot] partly lying on the heap of hard granite he has been toiling at through the cloudless, sultry, day with insufficient nourishment; and partly toppling forward among the brambles which line the road-side. Poor wretch, all his path in life has been beset with thorns! But he is at rest at last; no one waits for or will seek him; no one will miss him. His pale, parchment-drawn face and low brow, tell of stolid ignorance and abject misery. He has never been poacher or housebreaker; or come to London to be refined into a swindler and pickpocket, and he is still more harmless and uncomplaining now. He is very dead. A long, writhing stoat has mounted his foot, and lifts its nose, scenting death . . .'. 'The Stonebreaker' can be seen in particular as demonstrating the concern expressed by Carlyle in *Sartor Resartus* for the stultifying affects on the individual of a serfdom – as he saw it – still prevalent in industrial England. But in a much broader sense 'The Stonebreaker' expresses that compulsion felt by some of the more acute observers of the age to look beneath the surface of things in order to expose causes and realities. This manifested itself not only in the writings of essayists but also, for example, as much in contemporaneous

fiction as it did in scientific research and its consequences were too often and necessarily disillusioning. The specific parallel between the labour of the stonebreaker and that of the geologist – likewise a breaker of stones but one through whose work the idea of the transience of man within his landscape was constantly reinforced – would have been apparent to many viewers of Wallis's picture; and the presence of death within this landscape is as revealing and as shocking to the traveller through it as were the findings of his own research for the geologist who, as 'the man who has gone, hammer in hand, over the surface of a romantic country, feels no longer, in the mountain ranges he has so laboriously explored, the sublimity or mystery with which they were veiled when he first beheld them . . .' (Ruskin, *Pre-Raphaelitism*, 1851; Ruskin, XII, pp.391–2).

The social realism contained in novels like Benjamin Disraeli's *Sybil or the Two Nations* (1845) or Mrs Gaskell's *North and South* (1854–5) were, in a similar respect, powerful antidotes to conceived notions – especially those regarding poverty – so often subjected in the past to what George Eliot singled out as 'that softening influence of the fine arts which makes other people's hardships picturesque' (*Middlemarch*, 1872, chap.xxxix). It is very much against this background that 'The Stonebreaker' has to be seen in order to be properly understood today and a comparison between Wallis's picture and two other treatments of the same subject by Edwin Landseer (B.I. 1830, now V.&A.) and John Brett (Walker Art Gallery, Liverpool) shows, in differing degrees, the validity of Eliot's observation. By contrast, No.92, with its brooding pessimism, is much closer to the preoccupations of those who were discussing the 'condition of England', as it was termed, and it stands out as one of the most powerful statements of its kind from this period. As far as the Royal Academy exhibition itself and its public was concerned, it is indeed difficult to think of any earlier exhibit, outside the realm of historical and literary genre, in which a man's dead body (and that of a common labourer, too) had been so forthrightly and movingly presented to the spectator.

Evidence that 'The Stonebreaker' did strike a sympathetic chord can be seen in what the critics wrote, though there were exceptions. Thus, the *Athenaeum* thought that the work 'may be a protest against the Poor Law, but still it is somewhat repulsive and unaccounted for' whilst the *Illustrated London News* felt that the picture 'shocks the sight and offends the sense'. However, the writer in the *Spectator* singled out 'The Stonebreaker' as the best work in the exhibition and firm evidence of the new spirit animating English art – 'that of seeking strong interest and pathos in the rich by [the] latent resources of the life of the present age'; it was 'a picture of the sacredness and solemnity which dwell in a human creature, however seared, and in death, however obscure'. The *Art Journal* noted that the painting 'seems to give sadness to all who see it' but, most tellingly, the *Morning Star* thought it the only picture in the exhibition to have 'a pre-Raphaelitish character and tendency' and felt that it 'should be presented to one of our metropolitan workhouses to be hung up in the board-room'.

'The Stonebreaker' was not purchased from the walls of the Academy and when it was shown again two years later at the Liverpool Academy it was still for sale, priced at £262.10s.; the identity of the first purchaser has not yet been established. A print of the picture, $13\frac{15}{16} \times 16\frac{11}{16}$ (35.3 × 43.0) was published in 1877 (B.M. Dept. of Prints and Drawings, 1906-9-25-16).

R.H.

92

93

94

JAMES COLLINSON

93 The Parting ?1858
Inscribed 'J.Collinson. | 185[?8]'
Oil on canvas, $13\frac{1}{2} \times 16$ (34.3 × 40.6)
First exh: ?B.I. 1858 (566) as 'Leaving Home'
Private Collection

This painting is one of many Victorian treatments of a farewell scene, and may well be the picture exhibited by Collinson at the British Institution in 1858 under the title 'Leaving Home' (the critics seem to have ignored this exhibit in their reviews, giving only scant mention of Collinson's other B.I. picture that year, 'Short Change'). Graham Reynolds writes that the painting 'deals delicately with the distress of parent and suitor at the country girl's departure for town, doubtless under economic duress' ('The Pre-Raphaelites and their Circle', *Apollo*, XCIII, 1971, p.498).

<div align="right">R.P.</div>

WILLIAM MORRIS

94 Queen Guenevere 1858
Oil on canvas, $28\frac{1}{8} \times 20$ (71 × 50)
Tate Gallery

This is Morris's only completed oil painting, and by far the most important product of the brief period in the late 1850s when he was struggling to become a painter in response to Rossetti's insistence on this course. Figure drawing was never his forte, and the attempt caused him nothing but frustration and disappointment. His true talents lay in the handicrafts that he was also experimenting with at this time – illumination, carving, embroidery; and they would only find fulfilment with the launching of the firm, Morris, Marshall, Faulkner & Co., in 1861.

The records speak of three oil paintings that Morris worked on, and they have often been confused. In addition to No.94, there were two compositions inspired by the story of Tristram and Iseult – 'Tristram Recognised by Iseult's Dog' and 'Tristram and Iseult on the Ship'. It is doubtful if the 'dog' subject was ever started as an easel picture, although the design is known from a stained glass panel adapted from it in 1862 (*Studio*, LXXII, 1917, p.71, fig.8). The 'Tristram and Iseult' was certainly begun for the Leeds stockbroker T.E. Plint, but it does not seem to have been finished and is now known only from preparatory drawings. The story of Tristram and Iseult clearly had some special appeal for Morris at this date, perhaps, as his biographer J.W. Mackail suggests, because its theme of frustrated love was particularly relevant to himself. He chose another incident from it for his contribution to the famous murals illustrating Malory's *Morte d'Arthur* that Rossetti and his followers painted in the Oxford Union in 1857; and in fact No.94 has sometimes been called 'La Belle Iseult', thereby adding to the confusion between Morris's easel paintings. All the earlier records, however, refer to the subject as Guinevere, King Arthur's Queen whose adulterous love for Sir Lancelot is one of the central themes of the *Morte d'Arthur*. The story inspired Rossetti's mural in the Oxford Union, and Morris treated it again in *The Defence of Guenevere*, the poem in

the form of a dramatic monologue which gave its name to his first volume of poetry, published in March 1858.

In a sense the title of the picture is unimportant since it is essentially a portrait in mediaeval dress of Jane Burden, whom Morris married in April 1859. She was the daughter of an ostler or stableman living in Holywell, Oxford, and was 'discovered' by Morris and Rossetti – it is said during a visit to the theatre – when they were painting the Union murals. With her statuesque beauty and thick dark hair, she was immediately hailed as one of their chief 'stunners', a rival even to Lizzie Siddal herself. Indeed she sat to Rossetti for the later studies for Guinevere in his mural, superseding Lizzie who had posed for the preliminary drawings. Morris too made studies of her as well as the present picture, on which in a moment of despair he is said to have scrawled, 'I cannot paint you, but I love you'. He also described her in his poem 'Praise of My Lady', published in *The Defence of Guenevere*:

> My lady seems of ivory
> Forehead, straight nose, and cheeks that be
> Hollow'd a little mournfully.
> *Beata mea Domina!*
>
> Her forehead, overshadow'd much
> By bows of hair, has a wave such
> As God was good to make for me.
> *Beata mea Domina!*

and so on for twenty-two stanzas. The relationship between Jane, Morris and Rossetti at this time has been the subject of much speculation. Morris's feelings for Jane are not in doubt, though he seems to have been a shy and awkward suitor, but Jane later told Wilfred Scawen Blunt that she never returned her husband's love. It has been suggested that she preferred the more worldly Rossetti but was urged by her impoverished family to accept Morris because he could offer her wealth and position. It has also been argued that Rossetti fell in love with Jane but, considering himself committed to the ailing Lizzie, encouraged Morris's suit in order to keep her in the circle. Whatever the case, the drama was not played out. Frustration and misunderstanding continued to dog the marriage, and in ten years' time Rossetti and Jane would form an attachment which proved the main inspiration for his later work.

No.94 captures something of the aloof, withdrawn personality that so many who met Jane noted. It is also a splendid expression of the intense mediaeval style prevailing in Rossetti's circle in the late 1850s. The rich colours, the emphasis on pattern, and details such as the illuminated missal, are all characteristic. The room portrayed could well have been the Morrises' own bedroom at Red House, which Philip Webb built for them in 1859. The brass jug in the lower right corner probably belonged to Morris; it occurs again in one of the 'Sir Degrevaunt' murals that Burne-Jones was to paint at Red House in 1860.

In fact No.94 was painted before Red House was built, at least partly in the rooms at 17 Red Lion Square, formerly occupied by Rossetti and Walter Deverell, that Morris shared with Burne-Jones from the autumn of 1856 to the spring of 1859. These too were full of 'mediaeval' objects, whether massive pieces of furniture painted by Rossetti, Morris and Burne-Jones, or the Dürer prints, armour, manuscripts, ironwork and enamel that Morris was collecting at the time. Philip Webb later recalled how Morris set up the bed which 'was not disturbed for months, but one day we found Morris lying on it smoking. He said it was to make it look as if it had been slept in'. Eventually, 'after struggling over his picture for

months, "hating the brute", [he] threw it up. Rossetti took it to finish, and then Madox Brown. Yet Morris learnt all about painting in doing it' (W.R. Lethaby, *Philip Webb*, 1935, p.34).

Whether Rossetti or Brown in fact worked on the picture is impossible to say. It is next heard of in 1874 when it had apparently been given by Morris to Brown's precocious son Oliver (or 'Nolly'), and Rossetti wrote to the boy offering to buy it for £20. He wanted it 'as an early portrait of its original, of whom I have made so many studies myself'. After some correspondence it seems to have been given to Rossetti, who retained it until his death in 1882. It then passed to his brother William Michael, who some years later returned it to Jane Morris, receiving in exchange three Kelmscott Press books. It was in her possession by 1897, when it was shown at the New Gallery, together with a large group of works by Rossetti. After hanging at Kelmscott Manor for many years, it was bequeathed by May Morris to the Tate in 1938.

J.C.

ARTHUR HUGHES

95 The Long Engagement *c.*1854–9
Inscribed 'A·HUGHES|1859'
Oil on canvas, 41½ × 20½ (105.4 × 52.1)
First exh: R.A. 1859 (524)
Birmingham Museum and Art Gallery

Hughes exhibited this painting in 1859 with a quotation from Chaucer's *Troilus and Criseyde* in place of a title:

> For how myght ever sweetnesse hav be known
> To hym that never tastyd bitternesse?

The girl appears to be trying to console her clerical fiancé with this thought. The length of their engagement is suggested by the name 'Amy' cut into the tree by the man some time before and now covered with ivy.

Hughes began the painting with a different subject in mind: 'Orlando in the Forest of Arden'. He was working on this when G.P. Boyce visited Rossetti's studio on 13 March 1854: 'A young man of the name of Hughes was painting a picture of Orlando inscribing his mistress' name on a tree. Parts nicely painted' (Surtees 1980, p.12). Hughes is usually said to have begun the picture in 1853 but it is not clear what the evidence for this date is. The landscape was painted in the summer of 1854 and proved a trying experience: 'painting wild roses into "Orlando" has been a kind of match against time with me . . .', Hughes told William Allingham on 1 August, 'The least hint of rain, just a dark cloud passing over, closes them up for the rest of the day perhaps. – One day a great bee exasperated me to a pitch of madness by persisting in attacking me, the perspiration drizzling down my face in three streams the while' (Allingham 1911, p.51).

'Orlando' is said to have been rejected by the R.A. in 1855 (Ironside & Gere, p.43) but Hughes' own later recollection does not seem to tally with this. 'I painted with much care a background *for* an "Orlando and Rosalind"', he wrote in 1911, 'but wiped out the figures before they were completed and substituted modern lovers, and called the picture "The Long Engagement"' (Allingham 1911, p.299). Hughes would obviously not have submitted an unfinished painting to the

95

Academy. But there is also a discrepancy between this 1911 reference to 'Orlando and Rosalind', with its two figures, and the painting of Orlando alone which Boyce described in 1854. Possibly Hughes painted two 'Orlando' pictures.

Also puzzling is an oil study at Birmingham of 'Amy' (No.222'25), showing a girl looking at a similar tree to the one depicted in No.95, upon which her name is inscribed but not yet covered in ivy. There are also two drawings at Birmingham (Nos P 10'59, P 11'59) connected in some way with the development of 'The Long Engagement'. The precise relationship of these to No.95 is likewise unclear.

L.P.

JOHN EVERETT MILLAIS

96 Spring (Apple Blossoms) 1856–9
Inscribed 'JM 1859' (initials in monogram)
Oil on canvas, 43½ × 68 (110.5 × 172.7)
First exh: R.A. 1859 (298)
Ref: R.A. 1967 (58)
The Right Hon. The Viscount Leverhulme

Millais was considering painting a picture featuring apple blossoms in the spring of 1856. On 29 April he wrote to his wife Effie in Perth: 'I long to be back for good, and begin the trees in blossom' (J.G. Millais, I, p.296), and on 5 May: 'I hope the apple blossoms have not yet appeared – here they are far advanced, and the country beautiful' (HL). According to Effie's journal, however, he did not begin work on No.96 until considerably later that year: 'This picture, whatever its future may be, I consider the most unfortunate of Millais' pictures. It was begun at Annat Lodge, Perth [the house where Millais and Effie settled after their marriage], in the autumn of 1856, and took nearly four years to complete. The first idea was to be a study of an apple tree in full blossom, and the picture was begun with a lady sitting under the tree, whilst a knight in the background looked from the shade at her. This was to have been named "Faint Heart Never Won Fair Ladye". The idea was, however, abandoned, and Millais, in the following spring [1857], had to leave the tree from which he had made such a careful painting, because the [new] tenant at Annat Lodge would not let him return to paint, for she said if he came to paint in the garden it would disturb her friends walking there. This was ridiculous, but Millais, looking about for some other suitable trees, soon found them in the orchard of our kind neighbour Mrs Seton (Potterhill), who paid him the greatest attention. Every day she sent her maid with luncheon, and had tablecloths pinned up on the trees so as to form a tent to shade him from the sun, and he painted there in great comfort for three weeks while the blossoms lasted. During that year (1857) he began to draw in the figures, and the next year he changed to some other trees in Mr Gentle's orchard, next door to our home [Effie's family home, Bowerswell]. Here he painted in quiet comfort, and during the two springs [1857 and 1858] finished all the background and some of the figures. The centre figure was painted from Sir Thomas Moncrieff's daughter Georgiana (afterwards Lady Dudley); Sophie Gray, my sister, is at the left side of the picture. Alice [Gray] is there too, in two positions, one resting on her elbow, singularly like, and the other lying on her back with a grass stem in her mouth. He afterwards made an etching of this figure for the Etching Club, and called it "A Day in the Country" ['Summer Indolence', plate 10 of *Passages from Modern English Poets illustrated by the Junior Etching Club*, 1861]. When the picture of "Spring Flowers" was on the easel out of doors, and in broad sunlight, the bees used often to settle on the bunches of blossom, thinking them real flowers from which they might make their honey' (J.G. Millais, I, pp.323–4).

The picnic scene that replaced the mediaeval subject Millais originally had in mind may have come from an earlier drawing, No.172. In the frieze-like arrangement of figures against an orchard background, the work also recalls Botticelli's treatment of the same theme in the famous 'Primavera'. The theme of spring was a natural sequel to 'Autumn Leaves' (No.74), which was exhibited the same year as No.96 was begun. Like that work, 'Spring' is about the transience of human life and the inevitable passing of youth and beauty. The *memento mori* here is the scythe at the right, which reminds us both of the coming summer and harvest, and the harvest

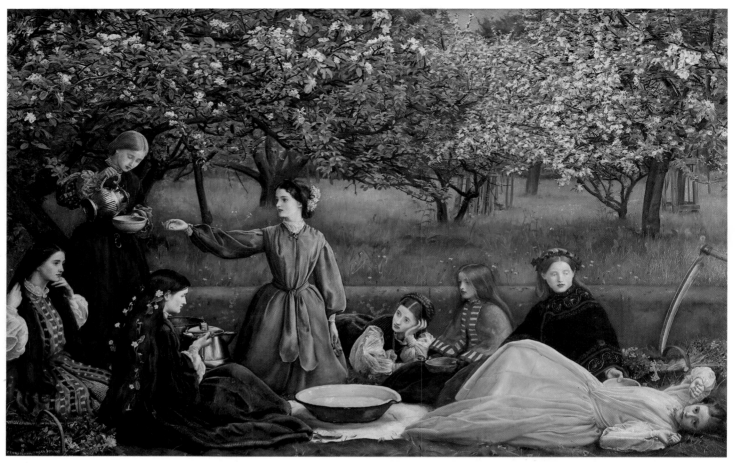

96

reaped by time and death, even among pretty young girls.

The models for the girls, who seem to be eating porridge, are partly identified in Effie's journal. Her sister Sophie appears on the far left, and her other sister Alice in the centre, resting her head on her hand, and lying on the grass on the far right. Both girls are also in 'Autumn Leaves'. Millais' reference in a letter to 'Sophie's and Alice's heads to the left of the picture' (J.G. Millais, I, p.342) implies that Alice may also have sat for the seated figure in blue, third from the left. The girl kneeling in the centre is Georgina Moncreiffe, later Lady Dudley and a famous beauty (Effie mis-spells her name). Her sister Helen, later Lady Forbes, also appears in the picture; according to family tradition, she sat for the figure second from the right. Another model, perhaps for the girl in the red cloak, was one Agnes Stewart (see below) and another, perhaps for the girl second from the left, is said to have been Henrietta Riley (see Bennett 1967, p.47).

On 16 May 1858 Millais wrote to Holman Hunt of his suspicion that the idea of painting apple blossoms had been stolen by Arthur Hughes: 'The last I heard of Hughes was that he is painting an orchard in bloom. It is too bad as it cannot be entirely accidental' (HL). Hughes may merely, however, have been responding, as many artists seem to have done, to Ruskin's comment in his *Academy Notes* of that year: 'How strange that among all this painting of delicate detail, there is not a true one of English spring!'. The work by Hughes in question was 'The King's Orchard' (present whereabouts unknown; a version in the Fitzwilliam Museum, Cambridge).

Millais was at work on No.96 in July 1858, when he wrote to Effie: 'I have been working hard all day; have finished Alice's top-knot, and had that little humbug Agnes Stewart again, but I am not sure with what success' (J.G. Millais, I, p.324). On 26 July he told Hunt: 'I have just left off working out of doors at a picture I am doing altogether figures & all in the open air, where I think one gets a much broader, & better grasp of both drawing, & effect' (HL). On 9 August Effie wrote on her husband's behalf to the Dalziel brothers apologising for his tardiness in working on his *Parables* illustrations and explaining that 'he has felt a disinclination to turn to that kind of drawing at present, when he is painting out of doors ... Next week the young ladies he is painting from leave, and he will be free to turn to something else' (*The Brothers Dalziel. A Record of Fifty Years' Work*, 1901, pp.105–6). But he was working on at least one of the figures in the early part of the following month, writing to Hunt on 10 September: 'The other day I painted a little girl who nearly made me *cry* with pain, and I desired a lady to do me a photograph of her, wh. gave me the first feeling of comfort I had felt for a very long while – it was so *hideous* that I was certain my head of her was prettyish' (HL).

He also had at least two photographs taken of the painting itself before it was finished, one showing the dresses of three of the figures yet to be painted in (repr. Bennett 1967, p.46, fig.27) and the other showing the work almost finished, with only the bowl and cloth to be added and finishing touches to be made, especially to some of the faces (repr. J.G. Millais, I, p.325).

The work was exhibited at the R.A. in 1859 under the title 'Spring' but has since often been known as 'Apple Blossoms'.

Millais had extraordinary difficulty (by his standards) in selling No.96. It remained unsold at the R.A., then at the Liverpool Academy later in 1859, and was finally bought by Gambart around 6 May 1860 (see the artist's letter to his wife of that date, Millais Papers, PML). Gambart failed to sell it in his usual manner and auctioned it off at Christie's on 3 May 1861 (298). The first collector to own it, from 1861 to about 1876, was Jacob Burnett of Newcastle.

Two sketches were sold at Christie's, 23 April 1974 (92) and another two are in the collection of John C. Constable. A study for the reclining figure on the far right of the composition (Alice Gray) is repr. Spielmann, p.153 (present whereabouts unknown).

<div align="right">M.W.</div>

<div align="right">97</div>

WILLIAM LINDSAY WINDUS

97 Too Late 1857–8
Inscribed 'WLW 1858' (initials in monogram)
Oil on canvas, $37\frac{1}{2} \times 30$ (95.3 × 76.2)
First exh: R.A. 1859 (900)
Tate Gallery

Exhibited in 1859 with a quotation in the catalogue from Tennyson's poem 'Come not, when I am dead':

—— If it were thine error or thy crime
I care no longer, being all unblest;
Wed whom thou wilt, but I am sick of time;
And I desire to rest.

Begun in 1857 with the figures following closely a small sketch of that year (formerly belonging to John Miller, Sotheby sale 15 March 1983, lot 48, repr.). Miller, who also acquired this picture, mentioned its progress in letters giving local news to Ford Madox Brown. On 15 March he wrote: 'Mr. Windus is going on slowly with his most charming picture and the head of the principal figure is full of that expression of agitated and inward thought at which he had aimed and tells the story of her ruined health and broken heart. He is painting it in sunlight but the sun seldom shines upon the picture and there is no chance of him completing it for many months' (FMBP). A Mr Borthwick sat for the lover and the background (according to Marillier 1904, p.248) was a view from a fellow artist's garden at Liscard, near Birkenhead, Wirral: the view is south-west towards Bidston Hill with the Welsh hills appearing on the far horizon. In June Miller again noted its slow progress: 'but he is more fastidious than ever, and on the hair of one head he has spent four weeks in time and three pounds in money for a sitter and it is not yet finished'. In another letter (Marillier 1904, p.245) he commented: 'but what he has done is beautiful in all eyes but his own, and it has been in and out, I should think, a hundred times'.

Miller lent the sketch to the Hogarth Club 1857–8 and Windus himself sent the picture to the 1859 R.A. but was characteristically doubtful of its merits, at one stage thought it 'unbelievably bad' and 'made up my mind to be slaughtered', as he wrote to Madox Brown (10, 24 April 1859, FMBP). It was hung but its pretensions were demolished by Ruskin in *Academy Notes*: 'Something wrong here: either this painter has been ill: or his picture has been sent in to the Academy in a hurry; or he has sickened his temper and dimmed his sight by

reading melancholy ballads. There is great grandeur in the work; but it cannot for a moment be compared with Burd Helen [No.73]. On the whole, young painters must remember this great fact, that painting, as a mere physical exertion, requires the utmost possible strength of constitution and of heart. A stout arm, a calm mind, a merry heart, and a bright eye are essential to a great painter. Without all these he can, in a great and immortal way, do nothing' (Ruskin, XIV, pp.233–4, 239).

The artist's immediate reaction to this is not recorded and he was certainly painting and planning new works later in 1859 and 1860 but such discouragement from such a source, followed on immediately by personal misfortune, confirmed the melancholy uncertainty of his temperament and he withdrew into obscurity. In the 1880s as the result of a renewed contact with Madox Brown (FMBP), the latter brought him and his picture forward sympathetically in an article on artists missing from the Manchester 1887 exhibition (*Magazine of Art*, 1888, p.122): he was 'a man who excited very much attention some twenty-five years ago. He was a figure painter, a painter of extreme enthusiasm and very great refinement. He always painted subjects of sentiment, and at that time created a great sensation by his "Burd Helen" – the Scottish "burd", or sweetheart of the ballad, who swam the Clyde rather than that her faithless lover should escape. There was also another subject of his that was exhibited in the Royal Academy, a picture that was intensely pathetic. It was called "Too Late". It represented a poor girl in the last stage of consumption, whose lover had gone away and returned at last, led by a little girl, when it was "too late". The expression of the dying face is quite sufficient – no other explanation is needed'.

<div align="right">M.B.</div>

<div align="right">[173]</div>

JOHN RODDAM SPENCER STANHOPE

98 Thoughts of the Past 1858–9
Inscribed 'JRS[?]' in monogram
Oil on canvas, 34 × 20 (86.3 × 50.8)
First exh: R.A. 1859 (890)
Tate Gallery

In a broken-down room overlooking the Thames at Blackfriars a prostitute stops short in her toilette, gripped with remorse as she thinks of the past. Various objects in the room underline her sorry condition: cracked window panes, torn curtains and broken furniture, pot plants struggling to the light, abandoned posies of violets and primroses, a man's glove and walking stick on the floor and his money, perhaps, on the table.

'Thoughts of the Past' was painted in the studio Stanhope occupied below Rossetti's at Chatham Place, Blackfriars. On 21 June 1858 G.P. Boyce called first on Rossetti and then 'Went into Stanhope's studio to see the picture he is engaged on of an "unfortunate" in two different crises of her life' (Surtees 1980, p.25). No.98 may have been part of this work, presumably a diptych of which the other part was not carried out. On 16 December the same year Boyce called again and found Stanhope 'painting on his picture of a gay woman in her room by side of Thames at her toilet. "Fanny" was sitting to him' (ibid., p.25). It was about this time that Fanny Cornforth also sat to Rossetti for the head of the fallen woman in 'Found' (see No.63). Her features are difficult to recognise in Stanhope's painting. Old Tate Gallery catalogues record 'Miss Jones' as the sitter but give no source for this information. The girl in No.98 does not resemble Augusta Jones (if she is the Miss Jones in question) as she appears in Burne-Jones's work.

A large pen drawing (Tate Gallery No.3232) for No.98 shows the girl turned more towards the window, with her eyes raised as if in supplication. If 'Thoughts of the Past' was originally intended as part of a diptych, it would presumably have formed the second, right-hand section, bearing in mind the direction of the figure in No.98. Some earlier 'crisis of her life', perhaps her seduction, may have been planned for the other canvas.

L.P.

JOHN BRETT

99 Val d'Aosta 1858
Inscribed 'John Brett 1858'
Oil on canvas, $34\frac{1}{2} \times 26\frac{3}{4}$ (87.6 × 68)
First exh: R.A. 1859 (908)
Sir Frank Cooper, Bt.

Towards the end of May 1858 Ruskin's *Academy Notes* were published. They included an enthusiastic review of Brett's 'The Stonebreaker' which ended with the words, 'If he can paint so lovely a distance from the Surrey downs and railway-traversed vales, what would he not make of the chestnut groves of the Val d'Aosta! I heartily wish him good-speed and long exile' (Ruskin, XIV, pp.171–2). Within a few days Brett had set off for the Continent and by 30 June he was in the Val d'Aosta. He took a room in the Chateau St Pierre at Villeneuve, some eight miles up the valley from the town of Aosta. The mediaeval castle was built on a hill on the lower slopes above the river Baltea, and this was to be Brett's base for the next five months.

The Val d'Aosta had been a source of inspiration for a number of English writers and artists (notably Turner, whom Brett had admired for many years), but Brett's approach to the subject was very different from that of his predecessors. Instead

98

of depicting the romantic grandeur of the valley and the surrounding mountain ranges, he confined his view to a narrow corridor looking due west towards Mount Paramont. He excluded from his picture the spectacular heights of Mont Blanc, and he concentrated on recording every detail within the area which he had selected. He made his task even more difficult by choosing to depict his subject under the hard, clear light of the midday sun.

The result was a tour-de-force of painting technique, as well as a monument to his application and patience. He was later to remark on the difficulties which he experienced in painting the picture and to note that 'it is as I plan at present my last land-scape' (Brett Diary, 25 December 1859, PC). Indeed, during the course of the next two years he turned his attention increasingly to seascapes which, by their very nature, offered some respite for an artist who had taken to heart Ruskin's famous dictum to go to Nature, 'rejecting nothing, selecting nothing and scorning nothing' (Ruskin, III, pp.623–4).

Perhaps more than any other Pre-Raphaelite landscape painting, 'The Val d'Aosta' bears Ruskin's mark. Brett's treatment of the foreground boulders and the distant mountain slopes faithfully reflect the views expressed in the fourth

99

volume of *Modern Painters*, subtitled 'Of Mountain Beauty'. Moreover, Ruskin not only suggested the subject matter but during the course of the summer that Brett was working on the picture, he summoned him over to Turin so that he might check on its progress and give the artist a 'hammering' to put him on the right lines (Ruskin, XIV, p.xxiii). When the picture was completed and shown at the Academy exhibition of 1859 he devoted his most eloquent prose to pointing out its merits. 'And here, accordingly, for the first time in history', he wrote in his *Academy Notes*, 'we have, by help of art, the power of visiting a place, reasoning about it, and knowing it, just as if we were there, except only that we cannot stir from our place nor look behind us. For the rest, standing before this picture is just as good as standing on that spot in Val d'Aosta, so far as gaining of knowledge is concerned; and perhaps in some degree pleasanter, for it would be very hot on that rock today, and there would be a disagreeable smell of juniper plants growing on the slopes above' (Ruskin, XIV, p.209).

The other critics were less impressed. One reviewer described the picture as 'Truly an epitaphical gravestone for Post-Ruskinism' (*Critic*, XVIII, 1859, p.544), and Millais commented that 'There is a wretched work like a photograph of some place in Switzerland, evidently painted under his [Ruskin's] guidance, for he seems to have lauded it up sky-high' (Ruskin, XIV, p.22n.). To Brett's dismay, the painting failed to find a buyer at the Academy or in the months following the exhibition. In the end Ruskin himself, learning that Brett was badly in need of money, bought the picture for £200. He hung it in the drawing room of his house at Herne Hill and there it remained until his death in 1900.

D.M.B.C.

JOHN EVERETT MILLAIS

100 The Vale of Rest 1858
Inscribed 'JM 1858' (initials in monogram)
Oil on canvas, $40\frac{1}{2} \times 68$ (102.9 × 172.7)
First exh: R.A. 1859 (15)
Ref: R.A. 1967 (57)
Tate Gallery

In later life Millais would speak of No.100 as his favourite among his own pictures, 'that by which, he said, he set most store' (Spielmann, p.74).

The theme of mortality hinted at in 'Spring' (No.96), to which the work was conceived as a pendant, is here made explicit. Most obviously, the nun on the left is digging a grave, which is positioned ominously to suggest the spectator might be in it with her. The other nun's rosary has a skull attached to it as well as a cross. It is sunset at autumn-time and a vaguely coffin-shaped cloud appears in the sky – a harbinger of death according to Scottish superstition (see Spielmann, p.74). The bell presumably sounds the angelus or vespers. Millais had treated a nun subject before in the drawing 'St Agnes' Eve' (No.200), an illustration to Tennyson's poem in which a nun longs for death and Christ, 'the Heavenly Bridegroom'. Here the same notion of death as the nun's spiritual marriage with Christ is ingeniously suggested by the visual allusion to wedding-rings in the yellow funerary wreaths. The ivy to the left of the picture is a common symbol of everlasting life.

The artist's wife Effie wrote the following description of the picture's origins and progress: 'It had long been Millais' intention to paint a picture with nuns in it, the idea first occurring to him on our wedding tour in 1855. On descending the hill by Loch Awe, from Inverary, he was extremely struck with its beauty, and the coachman told us that on one of the islands there were the ruins of a monastery. We imagined to ourselves the beauty of the picturesque features of the Roman Catholic religion, and transported ourselves, in idea, back to the times before the Reformation had torn down, with bigoted zeal, all that was beautiful from antiquity, or sacred from the piety or remorse of the founders of old ecclesiastical buildings in this country. The abbots boated and fished in the loch, the vesper bell pealed forth the 'Ave Maria' at sundown, and the organ notes of the Virgin's hymn were carried by the water and transformed into a sweeter melody, caught up on the hillside and dying away in the blue air. We pictured, too, white-robed nuns in boats, singing on the water in the quiet summer evenings, and chanting holy songs, inspired by the loveliness of the world around them . . .'.

'Millais said he was determined to paint nuns some day, and one night this autumn [1858], being greatly impressed with the beauty of the sunset (it was the end of October), he rushed for a large canvas, and began at once upon it, taking for background the wall of our garden at Bowerswell [Effie's family home in Perth], with the tall oaks and poplar trees behind it. The sunsets were lovely for two or three nights, and he dashed the work in, softening it afterwards in the house, making it, I thought, even less purple and gold than when he saw it in the sky. The effect lasted so short a time that he had to paint like lightning.'

'It was about the end of October, and he got on very rapidly with the trees and worked every afternoon, patiently and faithfully, at the poplar and oak trees of the background until November, when the leaves had nearly all fallen. He was seated very conveniently for his work just outside our front door, and, indeed, the principal part of the picture, excepting where the

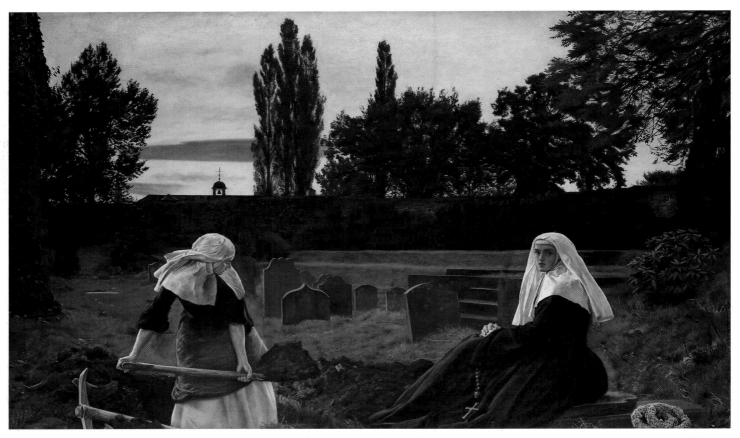

100

tombstones come, is taken from the terrace and shrubs at Bowerswell . . . The graveyard portion was painted some months later [from Kinnoull old churchyard in Perth], in the very cold weather, and the wind often threatened to knock the frame over. The sexton kept him company, made a grave for him, and then, for comfort's sake, kept a good fire in the dead-house. There Millais smoked his pipe, ate his lunch, and warmed himself' (J.G. Millais, I, pp.328–30).

On 10 December 1858 Millais wrote to Holman Hunt that he was 'painting *figures*, & all *entirely* in the open air – wh. adds much to the difficulty but the result is so much more satisfactory that I don't hesitate, although it is sometimes great pain from the intensity of the cold' (HL). The nun with the spade caused him particular trouble. J.G. Millais relates that after he had painted and repainted her 'every day for seven weeks', Effie and her mother hid the canvas away for a few days. When they returned it to him, 'he saw at a glance where his mistake lay, and in a few hours put everything right' (I, pp.331–2). On 16 December he wrote to Lowes Dickinson: 'I want to paint the Monk's rosary, or beads with the wooden cross wh. you sent me before. Will you kindly send them here at your *earliest* convenience, as I cannot finish some drapery without it' (Dickinson Collection, PUL). This suggests that he was at that time at work on the habit of the nun on the right. He had borrowed Dickinson's rosary before as a prop for 'The Escape of a Heretic, 1559' (exh. R.A. 1857, now Museo de Arte, Ponce).

The title of No.100 and the line 'Where the weary find repose' which accompanied it in the R.A. exhibition catalogue in 1859 are taken from the English version of the Mendelssohn part-song 'Ruhetal' from *Sechs Lieder*, Opus 59, No.5. Millais wrote to Effie on 7 April 1859: 'I heard William [his brother]

singing it and said it just went with the picture, whereupon he mentioned the name and words, which are equally suitable' (J.G. Millais, I, p.336).

The work was bought from the exhibition by the dealer D.T. White, on behalf of the well-known Pre-Raphaelite collector B.G. Windus (letter from the artist to his wife, 17 May 1859, Millais Papers, PML). In early April Millais had been asking £1000 for the work, but after the R.A. exhibition had been open for over a fortnight and it was still unsold, he became desperate for a sale and was more than willing to accept the £700 that White offered.

After the exhibition, Millais had his brother bring it back up to Perth for him to retouch the face of the nun on the right, making it 'a little prettier', using a Mrs Paton as his model (J.G. Millais, I, p.349). In 1862 he changed the same face again. J.G. Millais states that 'he had the picture in his studio for a week, and repainted the head from a Miss Lane' (I, p.333).

A photograph of No.100 in an unfinished state is reproduced in Bennett 1967, p.46, fig.26. There is a sketch in Birmingham City Art Gallery (650'06) and a watercolour version of 1863 at Manchester City Art Gallery (1917.31).

M.W.

FREDERICK SANDYS

101 **Mary Magdalene** *c.*1858–60
Oil on panel, 13¼ × 11 (33.6 × 27.9)
Ref: Brighton 1974 (46)
Delaware Art Museum (Samuel and Mary R. Bancroft Memorial)

In this early work Sandys depicts Mary Magdalene with the alabaster 'box' of ointment with which she annointed Christ's feet. As the Brighton catalogue points out, the design may owe something to Rossetti's watercolour 'Mary Magdalene Leaving the House of Feasting' of 1857 (Tate Gallery, Surtees No.88). In 1869 Rossetti actually accused Sandys of plagiarism, mentioning amongst other works one of this subject: 'as to the *Magdalene*, the moment taken by me was taken then for the first time in art, and constituted entirely the value of my design' (Doughty & Wahl, II, p.698). However, it seems unlikely that on this occasion Rossetti was complaining about No.101. Like Sandys' 'Queen Eleanor' of 1858 (National Museum of Wales) and 'King Pelles' Daughter' of 1861 (private collection), which also depict women holding vessels, 'Mary Magdalene' has almost no narrative content. Indeed, the subjects of these three works have been confused in the past. As well as the inscriptions 'F.Sandys' and 'Mary Magdalene by F.Sandys', the back of No.101 carries the legend 'Queen Ele[. . .] by Fr.Sandys'. Affinities with these other two paintings suggest a date of *c.*1858–60 for 'Mary Magdalene', which also has the same brocade background as Sandys' 1860 portrait of Philip Bedingfeld (Norwich Castle Museum, exh. Brighton 1974, No.83).

<div style="text-align:right">L.P.</div>

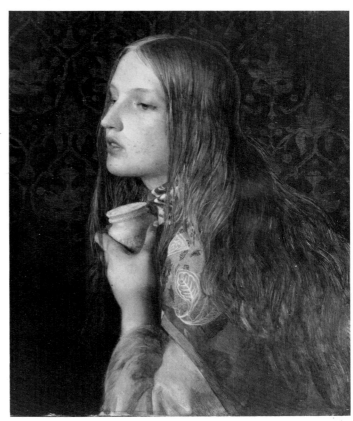

101

WILLIAM HOLMAN HUNT

102 **The School-girl's Hymn** 1858, 1859, 1860, ?1861
Inscribed '18 Whh 59' (initials in monogram)
Oil on panel, $13\frac{3}{4} \times 9\frac{7}{8}$ (35 × 25)
First exh: *Winter Exhibition*, Gambart, French Gallery 1859 (97)
Ref: Liverpool 1969 (36)
Visitors of the Ashmolean Museum, Oxford

102

Hunt went down to Fairlight in September 1858 to stay with the Martineaus: he there completed 'Fairlight Downs' (No.52) and began painting 'The School-girl's Hymn' (Hunt to Lear, 23 September 1858, JRL). Similarities between the landscapes of both pictures suggest that much of the background of the later work was painted during this visit. Hunt must have been satisfied with his progress, for he informed Lear on 4 October: 'I finished and came back on Saturday' (JRL).

According to a memorandum written by Thomas Combe and pasted on to the back of No.102, the figure was 'a portrait of Miriam Wilkinson a labourer's daughter – in the spring of 1859 she came up to Kensington that he might finish it' (AM). Hunt was, however, working hard on 'The Finding of the Saviour in the Temple' (No.85) that spring, and it seems unlikely that he would have found the time to advance No.102 at this point. He returned to Fairlight in mid-August 1859, and wrote to F.G. Stephens on 23 August: 'I am getting on with my potboiler nearly made it into a hundred pounder already – three more days will finish it I hope' (BL). A further letter to Stephens, of 7 September, revealed this hope to have been unfounded: he was still working on No.102, and 'having to endure the thousand vexatious interruptions of my little model' (BL). The artist stayed at Fairlight for another fortnight (W. Bell Scott to Lady Trevelyan, 22 September 1859, reported that he had arrived in Northumberland by this date; MS, Newcastle University Library), and probably put the finishing touches to 'The School-girl's Hymn' on his return to London in October.

No.102 was shown the following month at the *Winter*

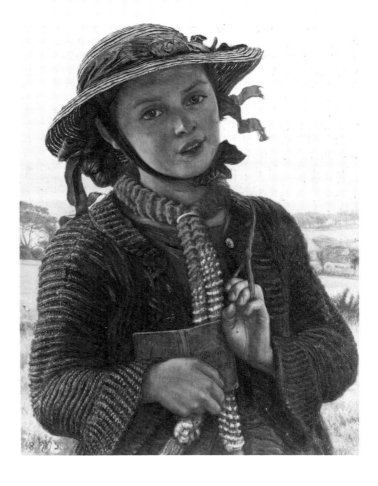

Exhibition of Cabinet Pictures by British Artists organised by Gambart. On 2 November Hunt wrote to the dealer: 'I left the little picture in Pall Mall yesterday evening – M^r Combe has taken it for himself' (HL). The letter contained an enclosure, concerning the '*Title and quotation to be printed in the catalogue*', which read as follows:

> The school-girl's Hymn –
> "A child o'ertook me on the heights,
> In ['cap' erased] hat and russet gown.

———————

> It was an alms taught sholar [sic] trim,
> Who – on her happy way,
> Sang to herself the morrow hymn
> For this was Saturday."

———————

> Vide Coventry Patmore's
> "Tamerton Church Tower"

Patmore's narrative poem, published in 1853, is about a man who, having been ecstatically happy in his marriage, gradually comes to terms with the tragic loss of his wife once his religious faith is awakened. The last section of the poem, from which Hunt's quotation is taken, suggests that the school-girl's hymn – which the narrator hears on his way home one evening – is an essential element in the healing process.

It would have been extremely difficult to convey the gist of Patmore's poem in visual terms, and Hunt's purpose was to paint a saleable genre picture rather than an illustration. The setting of No.102 is full daylight, and although the girl is clutching a volume of 'Psalms & Hymns' she is wearing a straw bonnet (hence the deleted 'cap' in Hunt's instructions to Gambart) and a deep turquoise jacket which virtually conceals her 'russet gown'.

No.102 received rather poor notices in the *Athenaeum* (19 November 1859, p.673), the *Critic* (26 November 1859, XIX, p.535) and *The Times* of 24 November 1859, although the latter noted: 'The redeeming point in Mr. Hunt's picture is the sky, and glimpse of down, with the sunlit sea beyond, streaked with pale green breadths of under-weed or cloud-shadow' (p.9). F.G. Stephens' long eulogy appeared in the *Dublin University Magazine* of April 1860, but even he conceded: 'At first sight the very force and truth of character of this wonderful little work disappoints us' (LV, p.481: this passage was not republished in Stephens 1860, pp.52–3). He went on however, to praise the characterisation of the face, 'the rendering of the curving lines of light that glitter through the interstices of [the girl's] straw hat', and the flesh painting.

Hunt himself came to feel that No.102 was unsatisfactory. He wrote to Combe on 12 May 1860, shortly after completing 'The Finding' (No.85): 'I shall ... perhaps go down to Hastings to finish Miriam. wh I will make *perfect* for you soon' (BL). There is no record of a visit to Sussex at this time, and in the light of a further letter to Combe of 19 October, which mentions going down to 'the sea-side for a day or two ... perhaps Brighton or its neighbourhood' (BL), 'Miriam' can be interpreted as Hunt's shorthand for 'the School-girl's Hymn' rather than a specific reference to its model. He did in fact go back to the Fairlight area, and wrote to F.J. Furnivall on 25 October 1860 from Hastings: 'I am obliged to remain working here for three or four days' (HL).

A letter to Combe of 4 July 1861 suggests that the reworking was fairly extensive, and may have continued after Hunt returned from the October 1860 visit: 'You are kind as usual in proposing an extra payment for the Miriam but – la bless you! I couldn't think of such a thing – the picture was sold at first with the idea in my head that it was as perfect as I could make it and it turned out to be not so – the fact was when I did it I was fagged to death, I had been for three years working with nothing in my pocket and I could only get on with my big picture [No.85] by leaving it off every month or two to do pot-boilers – ... the pot-boilers if very difficult suffered however and I have for my own satisfaction had to spend time upon them since. I question whether the Miriam would have sold – altho' I know several people who admired it very much – if you had not bought it' (BL).

No.102 is a figure picture with landscape background, rather than a figure in landscape, and in 1868–9 Hunt repeated the composition of a half-length figure of a little girl set against a sharply receding view in the 'Tuscan Girl Plaiting Straw' (Coll. Viscount Leverhulme, exh. Liverpool 1969, No.44; repr. Hunt 1905, II, facing p.144).

J.B.

FORD MADOX BROWN

103 **Walton-on-the-Naze** 1859–60
 Inscribed 'F.Madox Brown 1860'
 Oil on canvas, $12\frac{1}{2} \times 16\frac{1}{2}$ (31.7 × 42)
 First exh: L.A. 1860 (260)
 Ref: Liverpool 1964 (36)
 Birmingham Museum and Art Gallery

The artist was at this small resort on the east coast of Essex in late August and early September 1859, staying at Grosvenor Cottage with his wife Emma, and presumably their daughter Katty (UBC/LP). Described in Murray's Guide (1875) as 'this unpretending watering place washed on two sides by the sea', Walton-on-the-Naze had developed in the 1820s and 30s as a favoured resort of the county families and later in the century, as it expanded, of Londoners, who could reach it direct by steamer.

The view is from the west over wheat fields on the edge of the Backwaters (now a boating lake and caravan park), towards the sea, with the Martello Tower of 1810–12 at the right partially masking the small town and at the far distant left the Naze Tower beacon of 1720 just visible, red in the sun. In the far centre on the shore line is a block of buildings where the town was beginning to develop, forming East Terrace, The Bath House Hotel and, probably, the Terrace near Kent's Hotel (P.B. Boyden, *Walton 1800–1867*, 1981). A loaded cart moves along the dyke path at the left near workers in the fields; small boats sail in the waters by the windmill (demolished 1921; the Yacht Club stands on the site); a red barge and a three-masted man-of-war with white sails miraged in the clouds above, stand off on the horizon, and a steamer comes up to the pier beyond the houses at the far right.

Rain clouds clear off into the east, the moon rises in the wide expanse of sky illuminated by the arch of the rainbow. The time is late afternoon and everything in the low-lying expanse is minutely detailed in the raking light of the westering sun.

Madox Brown has introduced an undoubted self-portrait in the man in the foreground, whose wife and daughter (Emma and Katty) dry their hair after bathing and admire the effect down the radiating wheat-stocks as he 'descants learnedly on the beauty of the scene' (1865 catalogue). These figures are the

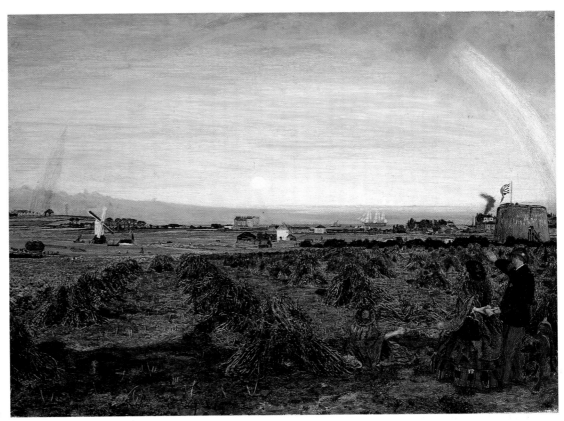

103

only gesture to the popular idea of a picture of the seaside, of happy recollections of summer holidays, popularised initially by Frith's 'Ramsgate Sands' of 1854, but even they turn away into the landscape to draw our attention with them. Madox Brown recorded the picture in his Account Book as 'painted on the spot / 59' and 'finished for Major Gillum For[tess] Ter[race] / 60' for £84.

It was the last of his small landscapes painted with the intense vision of his Pre-Raphaelite period, in each of which he attempted a different effect. The movement from foreground into distance is now thoroughly understood and the vast dome of sky given full prominence, while, in place of summer light in 'Carrying Corn' (No.61) or twilight in 'The Hayfield' (No.68), here the deliberate choice of raking afternoon light produces a concentrated sharpness of imagery over the whole landscape. As Staley remarks (p.43), this wide-eyed view in which everything is seen in the same clear focus, enhances its dream-like quality rather than its reality.

M.B.

DANTE GABRIEL ROSSETTI

104 Dantis Amor 1859–60
Inscribed, around Christ's halo, 'QUI EST PER OMNIA SÆCULA BENEDICTUS'
Oil on panel, 29½ × 32 (74.9 × 81.3)
Ref: Surtees No.117
Tate Gallery

This panel originally formed the centre door out of three on the upper part of a large settle belonging to William Morris. The side doors were painted with scenes in 1859, when the settle stood in Morris's London rooms but No.104 may have been painted after the summer of 1860 when the settle had been moved to Red House, Bexley Heath, where it still stands in the upstairs drawing room (Doughty & Wahl, I, p.379). By August 1863 the panels had been removed and the side ones framed as a diptych with a new version of 'Amor' on a thin section between them (Surtees No.116). These were sold, possibly to raise capital for the newly established firm of Morris, Marshall, Faulkner and Company but No.104 was kept apart. It is unfinished and probably only the heads are Rossetti's work. When compared with the finished design in Birmingham (Surtees No.117A) it can be seen that the details, especially the stars, entirely lack his vitality and highly developed sense of balance.

The subject of the panels is, on the left, 'The Salutation of Beatrice in Florence', and on the right, 'The Salutation in the Garden of Eden'. The central 'Amor' panel symbolises Beatrice's death between the two events. In the finished design the dial held by the 'Amor' indicates the day and hour of her death and an inscription along the diagonal divide reads, in translation: 'Love that moves the sun in heaven and all the stars' (*Divine Comedy*, last line). In the crescent moon cradling Beatrice's face is inscribed the beginning of the closing passage of the *Vita Nuova* which is completed around the edge of the sun haloeing Christ's head.

The composition not only symbolises the death of Beatrice and her transition from Earth to Heaven but also what Rossetti took to be the essential truth of both the *Vita Nuova* and the *Divina Commedia*, that Love is the generating force of the universe.

A.G.

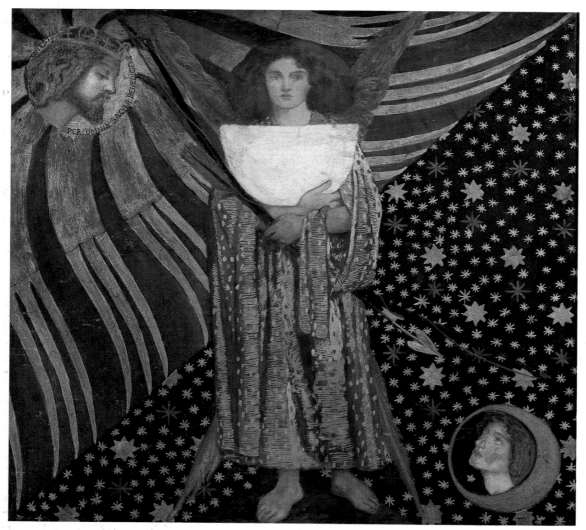

104

105

WILLIAM HOLMAN HUNT

105 Henry Wentworth Monk 1858
Inscribed 'Whh 1858' (initials in monogram)
Oil on canvas, 20 × 26 (50.8 × 66)
First exh: R.A. 1860 (510)
Ref: Liverpool 1969 (35)
National Gallery of Canada, Galerie nationale du Canada, Ottawa

In late November 1858 Hunt wrote to Combe: 'Only think of the Prophet turning up! I shall be very glad to see him because I believe him to be a thoroughly good fellow, and with talent that makes him able to make one think' (BL). Hunt told Combe that he was willing for Monk to stay at Tor Villa for only a few days, but according to Monk's biographer the visit lasted until 1862 (Richard Lambert, *For the Time is at Hand*, 1947, p.76). No.105 must have been painted shortly after Monk's arrival.

Hunt first met the Canadian Henry Wentworth Monk (1827–96) on 23 September 1854, when he breakfasted at the garden farm of Monk's employer, John Meshullam, at Ourtass, near Bethlehem (Hunt 1905, I, pp.432–3; Lambert, p.50 and Seddon, p.120). A friendship sprang up, and, on meeting Monk in Jerusalem at the home of Rev. W. Beamont, Hunt noted in his diary of 23 February 1855: 'we, host Monk and I talked of Monk's ideas. he is an interesting fellow' (JRL). At this time Monk expounded his views on the need to found a Jewish state in the Holy Land, which he felt divinely appointed to establish, as a prelude to the millenium, which he prophesied as imminent. The extent of his influence on Hunt may be gauged by the letter the artist wrote to Thomas Combe on 25 February 1855: 'Lately I have been reading the prophecies ... it is a study which unsettles me very much at times – yet I believe it a highly important and too much neglected pursuit' (BL).

According to Hunt's letter of 23 August 1855 to F.M. Brown, Monk was trained for the Church of England, but rejected conventional religious teaching when he fell desperately ill. During his delirium he went into a trance and experienced a revelatory vision of God. The letter continues: 'When he got better he became an infidel reading the Scriptures to find that they must have been written with the sort of supernatural revelation which he had had in his trance, and as all agreed he was mad he concluded that the Prophets and Apostles were mad. ... I don't know what brought him again to the Bible but when he took to it he made it a complete study alone without any attention to conventional commentaries to none in fact but lexicons. he speaks of having been assured that his conclusions were correct. as tho' by trances but he did not tell me. – however when he completed his work he professes to have had instructions to leave his worldly affairs and begin preaching' (HL). Monk's decision never to cut his hair or beard until the kingdom of Heaven was established on earth dates from this period; according to Hunt's letter of 8 January 1890 to John Clifford, it 'compelled him to declare himself as one under a vow to announce a new teaching' (Thomas B. Brumbaugh, 'Two William Holman Hunt Letters to John Clifford, chiefly concerning Henry Wentworth Monk', *The Pre-Raphaelite Review*, III, 1979, p.89).

Hunt, in the 1855 letter to Brown, did not subscribe wholeheartedly to Monk's 'notion ... that he is appointed for the planting of the everlasting Kingdom which is to succeed the European states', but he felt that 'he is certainly a man of intellect and with the clearest expositions of the Bible mysteries I have ever heard'. Hunt was all the more receptive to Monk's views because of his disillusionment with the corrupt Anglican mission in Jerusalem. Monk's retelling of the dramatic way in which his vocation had been revealed found an answering chord in the artist, who had undergone a similar, if less intense, experience leading to the painting of 'The Light of the World' (No.57). Moreover, Monk's personal interpretation of the Scriptures appealed to Hunt in his attempt to forge a new kind of religious art. It influenced the symbolism of 'The Scapegoat' (Walker Art Gallery, exh. Liverpool 1969, No.33, repr.), and of the bubbles in 'The Triumph of the Innocents' (Walker Art Gallery, ibid., No.52, repr.) which contain scenes prefiguring the millenium (see Hunt 1913, II, p.417).

Monk arrived in London in 1858 with his manuscript *A Simple Interpretation of the Revelation*. Hunt enlisted Ruskin's aid in getting the pamphlet published (Lambert, op.cit., pp.67–70), and in 1858 began No.105 as not only a tribute to his friend but also a broadside in the campaign.

'Revelation' provides the key to an understanding of No.105. The prophetical nature of the sitter is suggested in the trance-like, intense expression of the eyes and the uncut hair and beard, while the prominent role Monk is to take in the resettlement of the Jews in the Holy Land is symbolised by the brown and gold eastern robe, gold stars being emblems of heavenly brightness (Pugin, *Glossary of Ecclesiastical Ornament and Costume*, 1844, pp.137, 189). The copy of the Greek New Testament in his right hand, open at the Book of Revelation, and *The Times* prominently sealed in his left – symbolizing the seven seals of the apocalypse – relate to Monk's theories of millenarianism. They suggest that the time is now ripe for the seal to be broken, ushering in a period of warfare which is prefigured in the unsettled conditions reported in the newspapers of the day.

The green glass window behind the head of the sitter may be an allusion to St John's vision of the 'sea of glass' in heaven (Revelations 4. 6 and 15. 2). Monk's pamphlet on Revelation (pp.83–4) interpreted this sea of glass as enabling the chosen to see heavenly truths clearly. In this sense the window can be taken as a comment on Monk's vocation and the clarity of his vision. But the glass of the window is opaque, and thus recalls the passage which foretells the second coming and emphasises the blindness of the present day in the First Epistle of Paul the Apostle to the Corinthians: 'For we know in part, and we prophesy in part. But when that which is perfect is come, then that which is in part shall be done away. ... For now we see through a glass, darkly; but then face to face' (13. 9–10, 12). The globular nature of the glass may possibly look forward to the millenarian symbolism of the bubbles in 'The Triumph of the Innocents', while the link between window and sitter is established by the refracted green shadows on Monk's hands.

Perhaps it was just as well for Hunt that the esoteric nature of the symbolism of No.105 was not apparent to contemporary reviewers, who might have found it blasphemous. Though the portrait was badly hung at the 1860 Royal Academy, and in general badly received, the reviewer in the *Critic* of 2 June stated that 'Everything in this earnest and noble picture is physiognomic. Nothing is painted just to fill in' (xx, p.690).

In later years Hunt, though he could not go so far as to devote a tenth of his income to Monk's scheme for restoring the Jews to Palestine, did campaign in the press for a Jewish state, not merely as a solution to the problem of racial persecution, but also because he shared with Monk the belief that the Holy Land had the capacity to 'become a veritable garden of Eden' (Hunt to Ruskin, 6 November 1880, published in Marcia Allentuck, 'William Holman Hunt, Monk and Ruskin: An Unpublished Letter', *Apollo*, XCVII, 1973, p.156).

Without the establishment of a Jewish state in Palestine

Hunt felt certain that war would break out between the European powers (see his letter in the *Jewish Chronicle*, 21 February 1896, p.9), and he considered Monk's attempts to secure world peace to be the Canadian's most lasting achievement. When Sir Edmund Walker visited the artist on 20 July 1909 at Melbury Road and viewed No.105, Hunt played down the sitter's more eccentric beliefs and suggested 'that in a small way Monk had helped to create the Hague conference', which at that time kept the peace in Europe (Katharine A. Lochnan, 'The Walker Journals: Reminiscences of John Lavery and William Holman Hunt', *RACAR*, IX, 1983, p.62). In 1911 Walker bought No.105 on behalf of the National Gallery of Canada.

J.B.

WILLIAM DYCE

106 Pegwell Bay: A Recollection of October 5th, 1858
 ?1858–60
 Oil on canvas, 25 × 35 (63.5 × 88.9)
 First exh: R.A. 1860 (141)
 Ref: Marcia Pointon, *William Dyce 1806–1864*, 1979,
 pp.169–74, 193
 Tate Gallery

Pegwell Bay is on the Kent coast between Ramsgate and Sandwich. No.106 was probably begun when Dyce was there in the autumn of 1858, around the date contained in the title, although he had also visited the place a year before and made a watercolour of the same view (private collection). The man carrying artist's equipment in the middle distance on the right is presumably Dyce himself. In the foreground are, from right to left, his wife Jane, her sisters Grace and Isabella and one of his sons. The work is in a sense a family portrait, and Dyce sold it, for £400, to his wife's father James Brand. But it hardly expresses the idea of domestic togetherness normally associated with the 'conversation piece'. Impassive and isolated from each other, the figures seem engaged in some activity far more solemn and significant than what they are actually doing, which is collecting sea-shells. Their scale establishes them as fairly distant from the spectator, yet they are seen in crisp focus, which slightly detaches them from the setting and helps create an overall mood of unease. This is enhanced by the way Dyce's wife and son look enigmatically off to the left at something the spectator cannot see. Stranger still is what they are *not* looking at – for in the sky above them, apparently noticed only by the artist, is a comet.

Dyce was a keen amateur scientist and works such as Nos.106 and 109 clearly reflect a taste for the painstaking observation of natural phenomena. He was particularly interested in geology and must have been drawn to Pegwell Bay for its chalk cliffs rich in fossils. The comet bears witness to his

106

awareness of topical developments in astronomy. It is Donati's comet, first observed by G.B. Donati on 2 June 1858 and at its brightest on the date that No.106 'recollects'. Comets are traditionally bad omens, usually foretelling the death or over-throw of kings. But the meaning in this context has more to do with the general importance and implications of science in the Victorian period. The comet and the cliffs represent the vastness of space and time which were being opened up by astronomy and geology (the 'Terrible Muses' as Tennyson calls them) and causing so much anxiety and religious controversy. They are a background against which human life itself might seem no more than an afternoon's sea-shell gathering.

For a fuller discussion of No.106 as 'a painting about time, explored through an image of a particular moment', see Marcia Pointon, 'The Representation of Time in Painting: A Study of William Dyce's *Pegwell Bay: A Recollection of October 5th, 1858*', *Art History*, I, 1978, pp.99–103.

<div align="right">M.W.</div>

JOHN BRETT

107 The Hedger 1859–60
Inscribed 'John Brett 1860'
Oil on canvas, $35\frac{7}{16} \times 27\frac{9}{16}$ (90 × 70)
First exh: R.A. 1860 (360)
Private Collection

'Who knows what will be the fate of the Hedger', Brett wrote in July 1859. 'I hope it will be more felt that the Aosta: it is much more strongly painted, and is deeper in colour; not half so delicate and refined perhaps, but I cant think how I ever got the Aosta done. I have worked at the Hedger harder I think but there is nothing in it compared with the other nor anything like the difficulties' (Brett Diary, 31 July 1859, PC).

Brett had been deeply disappointed by the failure of his 'Val d'Aosta' (No.99) to sell at the Royal Academy exhibition of 1859, and, as the passage above suggests, he was also

107

conscious of the fact that several critics, including Ruskin, had remarked on its lack of feeling. Realising perhaps, that 'The Stonebreaker' (Walker Art Gallery, Liverpool) was a much more successful picture, he decided to return to the theme of the rural labourer in the English countryside.

He began work on 'The Hedger' in May 1859 and worked on it at his parent's home at Detling near Maidstone. Several of his preliminary studies for the painting have survived including sketches for groups of silver birch trees, the labourer himself, and two interesting studies for the whole composition. One of these shows that the painting was originally intended to be arched in shape with the single figure of the hedger in the centre of the picture. Inscriptions on this sketch clearly indicate the mood of the picture: 'a Kentish wood in spring – flowers everywhere|peeps of deep blue sky through the wood.|sunlight penetrating everywhere'. At a later stage Brett introduced the figure of the hedger's daughter stepping into the clearing with a younger child at her shoulder and the labourer's meal in a basket on her arm.

The painting was shown at the Academy exhibition of 1860 accompanied by a quotation from Coventry Patmore's poem 'The Angel in the House':

> In dim recesses hyacinths drooped,
> And breadths of primrose lit the air

Brett had first met Patmore in 1852, and was eternally grateful to him for having introduced him to Holman Hunt and Millais. The immediate inspiration for the subject matter of the picture was not Patmore's poem, however, but a passage written by Ruskin. In his first notice on the Royal Academy exhibition of 1858 Ruskin made a passing mention of Brett's 'The Stonebreaker' and then went on: 'How strange that among all this painting of delicate detail there is not a true one of English spring! – that no Pre-Raphaelite has painted a cherry-tree in blossom . . . nor a blackthorn hedge, nor a wild-rose hedge; nor a bank with crown-circlets of the white nettle; nor a wood-ground of hyacinths . . . nor even so much as the first springing leaves of any tree in their pale, dispersed delicate sharpness of shape' (Ruskin, XIV, p.154).

Ruskin's appeal was soon answered because, in addition to Brett's painting, a number of Pre-Raphaelite pictures with spring themes appeared during the course of the next few years. Ford Madox Brown completed his 'Pretty Baa-Lambs' (No.38) in 1859. Millais showed his 'Spring (Apple Blossoms)' (No.96) at the Academy in the same year, while Arthur Hughes, Frederick Smallfield and Inchbold also selected spring landscapes as the setting for certain pictures.

Unlike his earlier Academy exhibits, Brett's 'The Hedger' received unanimous approval from the critics. They all praised his depiction of the spring flowers in the foreground, while the reviewer of the *Examiner* (5 May 1860) considered that the picture 'is equal to *The Stonebreaker* of a former year in its minute truth, and has the advantage of a better subject'. The painting was bought for £300 by B.G. Windus who was a notable collector of Pre-Raphaelite pictures. The price compared very favourably with the £371 which Windus had spent the previous year on Ford Madox Brown's celebrated painting 'The Last of England' (No.62).

D.M.B.C.

JOHN EVERETT MILLAIS

108 The Black Brunswicker 1859–60
Inscribed 'M 1860'
Oil on canvas, 39 × 26 (99 × 66)
First exh: R.A. 1860 (29)
Ref: R.A. 1967 (59)
Merseyside County Council, Lady Lever Art Gallery, Port Sunlight

Designed as a pendant to 'A Huguenot' (No.41), 'The Black Brunswicker' is a reversion to the kind of narrative work on the theme of love in adversity that had made Millais popular in the early 1850s, but which he had moved away from with 'mood-pictures' such as 'Spring' (No.96) and 'The Vale of Rest' (No.100). His difficulties in selling those two paintings, which were his main works at the R.A. exhibition of 1859, may explain his decision not to go on in the same vein. He certainly did not lack encouragement to go back. 'Whatever I do, no matter how successful, it will always be the same story', he wrote to his wife Effie on 17 May 1859, '"Why don't you give us the Huguenot again?"' (J.G. Millais, I, p.348).

The artist explained his first idea for No.108 in a letter to Effie of 18 November 1859: 'Yesterday I dined with Leech, who had a small dinner party. Mrs Dickens was there, also Mr and Mrs Dallas, whom you remember, and Billy Russell (the *Times* correspondent) and his wife. Shirley Brooks and myself were the rest of the party. We had some very interesting stories and gossip from Billy Russell, which would delight you all. I will keep them for you, when we meet. Oddly enough, he touched upon the subject of *the picture I am going to paint*, and I asked him to clear up for me one or two things connected with it. He is a capital fellow, and is going to write me a long letter with correct information, which he can get. I told him my project (as it was absolutely necessary), but he promised to keep it secret, knowing how things are pirated. It was very fortunate, my meeting him, as he is the very best man for military information. My subject appears to me, too, most fortunate, and Russell thinks it first-rate. It is connected with the Brunswick Cavalry at Waterloo. "Brunswickers" they were called, and were composed of the best gentlemen in Germany. They wore a black uniform with death's head and cross-bones, and gave and received no quarter. They were nearly annihilated, but performed prodigies of valour. It is with respect to their having worn crape on their arms in token of mourning that I require some information; and as it will be a perfect *pendant* to "The Huguenot", I intend making the sweetheart of a young soldier sewing it round his arm, and vainly supplicating him to keep from the bugle-call to arms. *I have it all in my mind's eye, and feel confident that it will be a prodigious success.* The costume and incident are so powerful that I am astonished it has never been touched upon before. Russell was quite struck with it, and he is the best man for knowing the public taste. Nothing could be kinder than his interest, and he is to set about getting all the information that is required' (J.G. Millais, I, pp.350–3).

William Russell was the pioneer of war journalism, who had become famous for his uncompromisingly truthful news despatches from the Crimea.

Millais eventually abandoned the crape idea, which would perhaps have made the parallel with 'A Huguenot' a little too obvious, and the painting concentrates on the girl's vain gesture of holding back the door to delay her lover's departure. When it was shown at the 1860 R.A. exhibition, *The Times* reviewer inferred from the print of David's equestrian portrait of Napoleon in the upper left corner that the girl is meant to

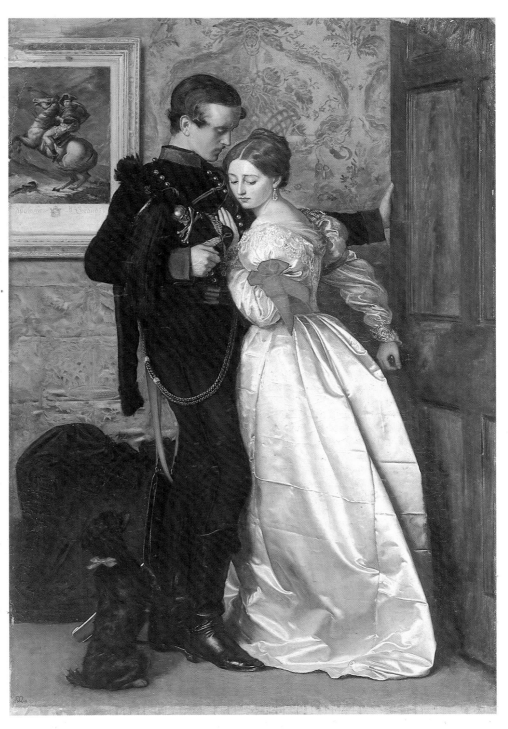

108

entertain 'a romantic admiration of this great conqueror, which lies mingled in her sentimental German soul with the love for her gallant *sabreur*' (5 May 1860, p. 5). Millais found the review 'flippant' and said that 'it reads the story wrong' – to which J.G. Millais adds that the scene is intended to be taking place 'on the eve of Waterloo or Quatre Bras, June, 1815, at which battle the leader of the Black Brunswickers, the Duke of Brunswick, was killed' and that in fact 'the young Prussian is supposed to be saying good-bye to an English girl' (I, p. 356). In other words, the print is to be interpreted symbolically not literally.

J.G. Millais identifies the models as Dickens' daughter Kate and a private in the First Life Guards: 'The poor fellow (I forget his name) died of consumption in the following year'. They posed separately, embracing lay-figures (I, pp. 353–4). At J.G. Millais' request, Kate wrote an account of the sittings: 'I made your father's acquaintance when I was quite a young girl. Very soon after our first meeting, he wrote to my father, asking him to allow me to sit to him for a head in one of the pictures he was then painting, "The Black Brunswicker". My father consenting, I used to go to your mother and father's house, somewhere in the North of London [Bryanston Square], accompanied by

an old lady, a friend of your family. I was very shy and quiet in those days, and during the "sittings" I was only too glad to leave the conversation to be carried on by your father and his old friend; but I soon grew to be interested in your father's extraordinary vivacity, and the keenness and delight he took in discussing books, plays and music, and sometimes painting – but he always spoke less of pictures than of anything else – and these sittings, to which I had looked forward with a certain amount of dread and dislike, became so pleasant to me that I was heartily sorry when they came to an end and my presence was no more required in his studio. As I stood upon my 'throne', listening attentively to everything that passed, I noticed one day that your father was much more silent than usual, that he was very restless, and a little sharp in his manner when he asked me to turn my head this way or that. Either my face or his brush seemed to be out of order, and he could not get on. At last, turning impatiently to his old friend, he exclaimed, "Come and tell me what's wrong here, I can't see any more, I've got blind over it." She laughingly excused herself, saying she was no judge, and wouldn't be of any use, upon which he turned to me. "Do *you* come down, my dear, and tell me", he said. As he was quite grave and very impatient, there was nothing for it but to descend from my throne and take my place beside him. As I did so I happened to notice a slight exaggeration in something I saw upon his canvas, and told him of it. Instantly, and greatly to my dismay, he took up a rag and wiped out the whole of the head, turning at the same time triumphantly to his old friend. "There! that's what I always say; a fresh eye can see everything in a moment, and an artist should ask a stranger to come in and look at his work, every day of his life. There! get back to your place, my dear, and we'll begin all over again!" ' (J.G. Millais, I, pp.354–5).

On 27 April 1860 Millais wrote to his wife that he was going the following day to touch up the picture at the R.A. exhibition, and on 2 May: 'All yesterday I was at the Royal Academy . . . I found the woman in "The Black Brunswicker" looking much better than I had hoped, and I very much improved her. The whole picture is by far the most satisfactory work I ever sent there. Everyone has expressed the same opinion; its success is certain' (ibid., I, pp.355–6).

He sold No.108 to the dealer Gambart for 1000 gns and he in turn sold it to Thomas Plint. An engraving, a mezzotint by T.L. Atkinson, was published by Graves and Moore, McQueen & Co. in 1864. This was made identical in size to the engraving of 'A Huguenot' so as to be a satisfactory pendant. Millais had probably been thinking of how No.108 would match that earlier work as an engraving, and not just as a painting, from the outset.

There are sketches for the work in the collections of Andrew McIntosh Patrick (exh. Arts Council 1979, No.76, verso), the Lady Lever Art Gallery, the Tate Gallery (ibid., Nos 63–5), Birmingham City Art Gallery (exh. R.A. 1967, No.365), the Ashmolean Museum, Oxford (paired with a sketch of 'A Huguenot' on the same sheet, exh. Arts Council 1979, No.62) and in a private collection. Watercolour versions are at the British Museum (ibid., No.66) and the Whitworth Art Gallery, Manchester (D.16.1937). The oil replica Millais painted in 1860 after the R.A. exhibition (see J.G. Millais, I, pp.355, 357, 362, II, p.470, and letters in the Millais Papers, PML) is untraced.

An early copy by Charles Compton, made as a pendant to his copy of 'A Huguenot', is in a private collection.

M.W.

109

WILLIAM DYCE

109 The Man of Sorrows 1860
Oil on board, $13\frac{3}{4} \times 19\frac{1}{16}$ (34.9 × 48.4)
First exh: R.A. 1860 (122)
Ref: Marcia Pointon, *William Dyce 1806–1864*, 1979, pp.161, 194
National Gallery of Scotland, Edinburgh

When this work was first exhibited at the R.A. in 1860, it was accompanied by the following lines by the artist's friend John Keble, printed in the catalogue and inscribed on the frame:

As, when upon His drooping head
His Father's light was pour'd from heaven,
What time, unsheltered and unfed,
Far in the wild His steps were driven,
High thoughts were with Him in that hour,
Untold, unspeakable on earth.

Images of Christ as the 'Man of Sorrows' generally show him displaying the wounds of the Crucifixion. In No.109 Dyce offers an alternative interpretation of the theme, with Christ shown in a meditative state, as the poem stresses, rather than as an object of meditation for the worshipper. Dyce was an extremely active and devout Christian who believed in a contemporary Christ and sought to portray him as a real, thinking human being with whom it was possible to identify oneself.

The minutely naturalistic setting enhances the sense of reality about the work, even though it is clearly some desolate part of Scotland (maybe near the artist's native Aberdeen) and not the Holy Land. Because Dyce was a Scot, the choice of location may have given the work special meaning for him. But its real importance is as an image of the stony hardness and inhospitality of the world towards Christ. As Keble's poem indicates, the biblical story behind No.109 is Christ's fast of forty days and forty nights in the wilderness, his temptation by the devil and perhaps in particular the incident described in Matthew 4.3–4: 'And when the tempter came to him, he said, If thou be the Son of God, command that these stones be made bread. But he answered and said, It is written, Man shall not live by bread alone, but by every word that proceedeth out of the mouth of God'. In the contemporary context, the survival of Christ in a rocky waste could be seen as a symbol of Christianity surviving an age in which geology seemed to be threatening the authority of the Bible.

No. 109 is one of several small studies of figures in rocky settings Dyce made in the later 1850s. Another is the 'David as a Youth' (National Gallery of Scotland, repr. Pointon, pl.68), which is almost identical in size and also in oil on board. It seems likely that the two pictures were painted as pendants. Since David was considered a kind of forerunner of Christ as well as literally an ancestor, and since the figure in 'David as a Youth' is positioned towards the right and looks in that direction, they relate satisfyingly together both thematically and compositionally.

M.W.

ARTHUR HUGHES

110 The Knight of the Sun 1860
Inscribed 'ARTHUR HUGHES'
Oil on canvas, 40 × 52⅛ (101.5 × 132.5)
W.N.M. Hogg, Seeburg Hotels, Lucerne, Switzerland

'The Knight of the Sun', wrote F.G. Stephens in 1873, 'illustrates a legend, an incident of which declared how an old Knight, whose badge was a sun, and who had led a Christian life throughout his career, was borne out of his castle to see, for the last time, the setting of the luminary he loved' (*Athenaeum*, 20 September 1873, quoted in Robin Gibson, 'Arthur Hughes: Arthurian and related subjects of the early 1860's', *Burlington Magazine*, CXII, 1970, pp.451–6: the chief source for this entry). The subject appears to be Hughes' own invention. A quotation inscribed on the frame is from George Macdonald's poem 'Better Things', published in his *Poems*, 1857:

> Better a death when work is done,
> Than earth's most favoured birth.

Although Hughes' intention to send the picture to the 1860 R.A. exhibition was announced in the *Athenaeum* (31 March 1860, p.448), he sold it directly to his patron Thomas Plint without first exhibiting it. In 1893 Alice Boyd (William Bell Scott's companion) asked Hughes to make a copy of the subject for her. Instead he appears to have worked up a small study he had kept, 'the study of the sky reflecting river seen thro' a wild cherry tree autumn turned, that gave me the idea first for the subject' (W.E. Fredeman, *A Pre-Raphaelite Gazette: The Penkill Letters of Arthur Hughes . . .*, 1967, p.50). This is now in a private collection (repr. Christopher Wood, *The Pre-Raphaelites*, 1981, p.55). A watercolour replica painted for the collector B.G. Windus and included in his sale in 1862 is now in the Ashmolean Museum.

In the article cited above, Robin Gibson observes that 'The Knight of the Sun' is one of the earliest Pre-Raphaelite paintings of an Arthurian subject. Hughes' interest in such themes was no doubt stimulated by his work in 1857 on the Oxford Union murals, to which he contributed 'The Passing of Arthur'. Allen Staley has suggested (p.87) that the sunset reflected in the water in No. 110 is inspired by the similar effect in Wallis' 'Stonebreaker' (No.92) but that behind both lie the sunset effects in Millais' 'Autumn Leaves' (No.74) and 'Sir Isumbras at the Ford' (Lady Lever Art Gallery, Port Sunlight).

L.P.

110

FORD MADOX BROWN

III **The English Boy** 1860
Inscribed 'F.MADOX BROWN / 60'
Oil on canvas, $15\frac{9}{16} \times 13\frac{1}{8}$ (39.6 × 33.3)
First exh: L.A. 1860 (728)
Ref: Liverpool 1964 (37)
City of Manchester Art Galleries

Portrait of the artist's eldest son Oliver at the age of five, holding a whip and top and wearing a pinafore over his plaid dress and a straw hat similar to that worn by Katty in 'Walton-on-the-Naze' (No.103). Behind him is a green striped wallpaper, probably in the Fortess Terrace house. Holbeinesque in treatment, it captures the immediacy of childhood and the individuality of the sitter without sentiment, using the same eye-level treatment as the earlier portrait of his half-sister Lucy (No.21).

Oliver was born on 20 January 1855 and Madox Brown started drawing portraits of him from three days' old. He was a precocious and promising child. He took up painting and worked, like his sisters, in his father's studio from the mid-1860s and exhibited from 1869. He also turned to writing and published his first romance, *Gabriel Denver*, in 1873. He died of blood poisoning on 5 November 1874 and this misfortune more or less coincided with the end of his father's short period of comparative prosperity.

This picture was painted with its companion 'The Irish Girl' (private collection) for T.E. Plint of Leeds, who had been asking for small pictures and more colour; they cost 100 gns for the two (FMBP). Its later appearance in a sale in 1876 was noted by the artist in a letter to his friend Charles Rowley: 'it was my poor Nolly five years of age with a whipping top' (UBC/AP); it was subsequently returned to him by the purchaser, Albert Wood of Conway, in an exchange arrangement and remained with him until his death.

<div align="right">M.B.</div>

III

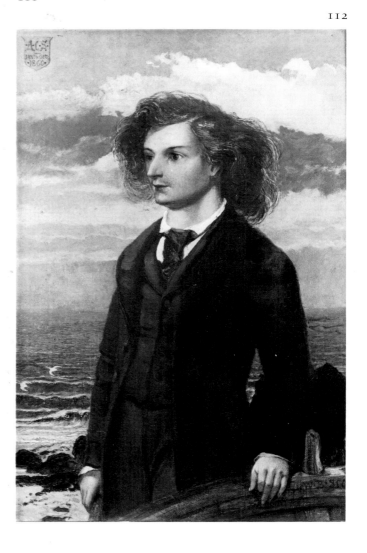

112

WILLIAM BELL SCOTT

112 **Algernon Charles Swinburne** 1860
Inscribed '·A·C·S·|JAN.ʸ·OCT:|·1860·' and
'W·B·SCOTT·'
Oil on canvas, $18\frac{1}{2} \times 12\frac{1}{2}$ (47 × 31.7)
Master and Fellows of Balliol College, Oxford

Scott's portrait of the twenty-two year old Swinburne was begun in January 1860 when the poet was staying with the Scotts in Newcastle, where Scott held the post of master of the School of Design. It was completed when Swinburne returned to Newcastle in October. In September of the previous year the two men had visited the Longstone lighthouse off the Northumbrian coast while staying with their mutual friends the Trevelyans at Wallington Hall, where Scott was painting murals of scenes from Northumbrian history (see Raleigh Trevelyan, *A Pre-Raphaelite Circle*, 1978, p.151). The expedition, planned so that he could get material for the painting of 'Grace Darling' in this series, may have been in Scott's mind when he painted his portrait of Swinburne. The imagery was in any case entirely appropriate. The sea, 'Mother and lover of men', is a central theme in Swinburne's poetry and it was between his two visits to Scott in 1860 that he composed the first of his many poems inspired by it, 'The Death of Sir John Franklin'.

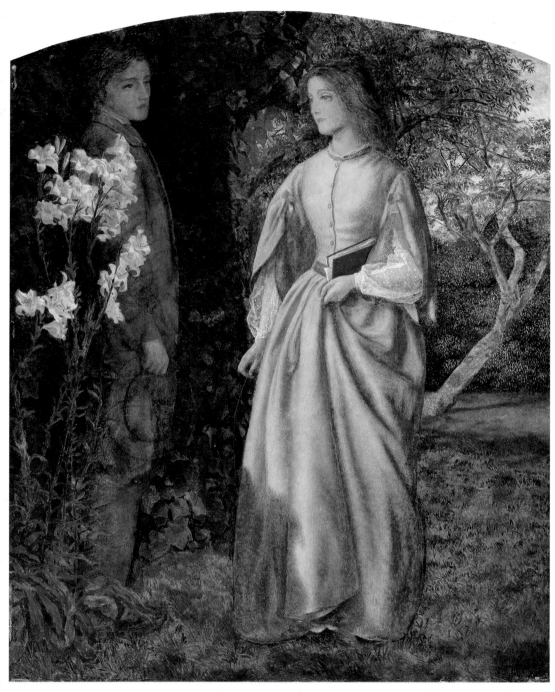

113

'This portrait used to arrest him long afterwards, when he visited me', Scott recalled in his *Autobiographical Notes*, 'as if it was new to him. He was delighted to find it had some resemblance to what he called his portrait in the National Gallery. This was the head of Galeazzo Malatesta in the picture of the Battle of Sant' Egidio by Uccello, which certainly was not merely the same type, but was at this time exceedingly like him' (Scott, II, p.18). Uccello's 'Niccolò Mauruzi da Tolentino at the Battle of San Romano' (as it is now known) had been acquired by the National Gallery in 1857.

After Scott's death and Swinburne's attacks on his posthumously published autobiography, Scott's companion Alice Boyd sold the portrait, which was later presented to Swinburne's old college (see W.E. Fredeman, *A Pre-Raphaelite Gazette: The Penkill Letters of Arthur Hughes . . .*, 1967, p.50). Despite his

reported fascination with the portrait, Swinburne himself never possessed it.

An etching by Scott of the portrait was published in his *Autobiographical Notes* (II, facing p.18). In this a small sailing boat takes the place of the birds seen in the painting.

L.P.

ARTHUR HUGHES

113 **Aurora Leigh's Dismissal of Romney ('The Tryst')** 1860
Inscribed 'A HUGHES'
Oil on panel, $15\frac{1}{4} \times 12$ (38.7 × 30.5)
Tate Gallery

The subject is from Mrs Browning's long narrative poem *Aurora Leigh*, published towards the end of 1856. Aurora, an orphan adopted by an unsympathetic aunt, aspires to be a poetess. On the morning of her twentieth birthday she rejects a proposal of marriage from her wealthy cousin Romney Leigh, who scorns her verses ('We want the Best in art now, or no art') and expects her to dedicate herself to his own philanthropic schemes. What you love, Aurora tells him,

> Is not a woman, Romney, but a cause:
> You want a helpmate, not a mistress, sir.
> A wife to help your ends, – in her no end!

'I too have my vocation', she says. In Hughes' painting Romney, having heard Aurora's refusal, is about to take his leave. Aurora holds a book of her verses which Romney has found in the garden and made fun of.

Never exhibited in Hughes' lifetime, 'Aurora Leigh' remained almost totally undocumented, and its true subject unknown, until 1964, when Rosalie Mander published correspondence relating to Ellen Heaton's commission of the painting ('"The Tryst" Unravelled', *Apollo*, LXXIX, pp.221–3). Virginia Surtees subsequently published this correspondence in full in her *Sublime and Instructive*, 1972. Ellen Heaton of Leeds, a patron of Rossetti and a friend of the Brownings, had been interested in Hughes' work since at least 1855. In February of that year she asked Ruskin to obtain the artist's address for a friend of hers. It was sent on to her by Rossetti, who took the opportunity of writing in glowing terms of Hughes' work (Surtees 1972, pp.157–8). In the summer of 1855 Miss Heaton consulted Ruskin about which of two, unspecified, pictures by Hughes she herself should buy (ibid., p.165). Later in the year Ruskin was recommending 'April Love' (No.72) to her, while pointing out that Hughes was 'quite safe – *every*-body will like what he does – in helping Rossetti you do more good. But you ought to have a Hughes too, someday – for his sense of beauty is quite exquisite' (ibid., p.175). Miss Heaton did not like 'April Love', however, and the matter seems to have rested until some time later when she decided to commission her own subject from Mrs Browning's 'Aurora Leigh'.

We do not know when No.113 was commenced but it was finished in 1860, not entirely to Ellen Heaton's satisfaction. A long letter, postmarked 14 December 1860 (Surtees 1972, p.228 n.2), from Hughes to his patron suggests that Miss Heaton had wanted a slightly earlier moment in the interview between Aurora and Romney than the one Hughes had painted, with Aurora depicted 'Half petulant, half playful' as she discusses Romney's proposal. 'The moment I chose to paint', Hughes explained, '– was the best – Romney turning away and should perhaps properly have included the Aunt, but that the incident concerned those two chiefly. If I had not chosen that moment the story as Romney's dismissal would I think have been confused, it would rather have seemed a quarrel of which we did not see the end nor know the cause'. The painter, he said, has 'only one moment for all this drama'. Miss Heaton had also wanted Aurora depicted in a white dress, as described in the poem, but Hughes thought this 'would not be agreeable' and chose a sea-green tint which would work better with the landscape.

Ruskin wrote to Ellen Heaton the same day, 14 December 1860, to support Hughes. The picture, he admitted, was 'not Aurora Leigh in the least' but 'a charming one of two people in love'. He admired it exceedingly and thought Miss Heaton fortunate in possessing it (Surtees 1972, pp.227–8). Miss

Heaton was evidently soon reconciled to the picture, since she set about commissioning another the same month: 'That Was a Piedmontese', completed in 1862 and now in the Tate Gallery. However, this also initially failed to satisfy and Ruskin had to intervene again to support Hughes' explanations.

In No.113 Hughes originally painted Romney holding a hat in his hand. He changed the position of the hat but eventually painted out both versions of it. The overpainting has subsequently become transparent, revealing the ghosts of the two hats.

L.P.

DANTE GABRIEL ROSSETTI

114 Regina Cordium 1860
Inscribed 'DGR' in monogram and 'Regina Cordium'
Oil on panel, 10 × 8 (25.4 × 20.3)
Ref: Surtees No.120
Johannesburg Art Gallery

This is an early example in the series of bust-length oil paintings of beautiful women which began in the summer of 1859 with 'Bocca Baciata' (fig.iv, Surtees No.114) and continued, growing larger and more luxurious, until *c.*1867. The change in style from the works of the previous decade is very marked and was developed with deliberation. Rossetti described his aims in a letter to Bell Scott written in November 1859 after he had completed 'Bocca Baciata': 'I have painted a half figure in oil, in doing which I have made an effort to avoid what I know to be a besetting sin of mine, and indeed rather common to P.R.

114

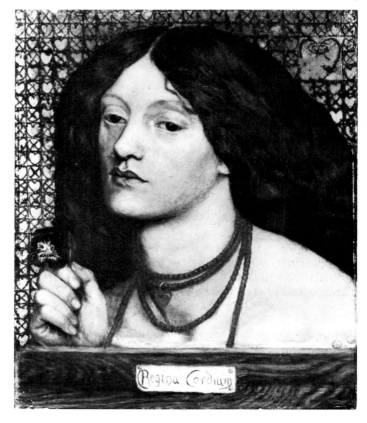

painting – that of stippling on the flesh. I have succeeded in quite keeping the niggling process at a distance this time, and am very desirous of painting, whenever I can find leisure and opportunity, various figures of this kind, chiefly as studies of rapid flesh painting. I am sure that among the many bother-ations of a picture where design, drawing, expression, and colour have to be thought of all at once . . . one can never do justice even to what faculty of mere painting may be in one. Even among the old good painters, their portraits and simpler pictures are almost always their masterpieces for colour and execution, and I fancy if one kept this in view one must have a better chance of learning to paint at last' (Doughty & Wahl, I, p.358).

Several prototypes 'among the old good painters' suggest themselves, for example Bellini's 'Doge Loredan' which entered the National Gallery in 1844 or his 'St. Dominic' which was purchased for the South Kensington Museum in 1856, or Van Eyck's 'Leal Souvenir' which entered the National Gallery in 1857. Like these paintings, 'Regina Cordium' is on panel but, unlike them, its subject, which remained of great importance, is the power of a beautiful woman over men's hearts.

Rossetti painted No.114 in the winter of 1860 from Elizabeth Siddal whom he had married the previous May. It is a study in shades of pink and red, deliberately naïve and with the decor-ative qualities of a playing-card. She holds a pansy, symbol of thought or memory, and wears a coral necklace with pendant heart. She is sandwiched in a constricted layer of space between the foreground parapet, bearing an inscribed cartouche, and the gold background, decorated with a red lattice of schematic hearts and 'kisses'. This lattice has been rubbed away in places. It is probable that the first owner was John Ruskin.

A.G.

WILLIAM DAVIS

115 A Field of Green Corn *c.*1860
 Inscribed 'W. Davis'
 Oil on panel, 12 × 15½ (30.5 × 38.2)
 First exh: ?L.A. 1860 (55)
 Private Collection

A characteristic example of Davis's numerous small-scale landscape studies which often have a high horizon, a closely studied foreground and a rather strange lack of depth in the perspective. The artist's interest in the humbler aspect of landscape is an echo of a similar interest shown by F.M. Brown in his landscapes, and both this and the unconventional handling of space are hallmarks of Pre-Raphaelite landscape.

In 1857 Ruskin had criticized Davis (though Rossetti with-held the criticism from Davis) for his failure to choose subjects of greater interest (Ruskin, XIV, pp.32–3). This attitude, but applied to the movement in general, was dealt with again by Ruskin in the final volume of *Modern Painters* where, in focussing on the artists' frequent lack 'of the power of feeling vastness', he discerned one of the ultimate weaknesses of the Pre-Raphaelite approach.

'A Field of Green Corn' may have been the painting exhibited under the title of 'Green Corn' at the L.A. in 1860; it was unpriced (as Davis's pictures often were, probably because they were already sold) and its first owner was James Leathart of Newcastle.

R.H.

115

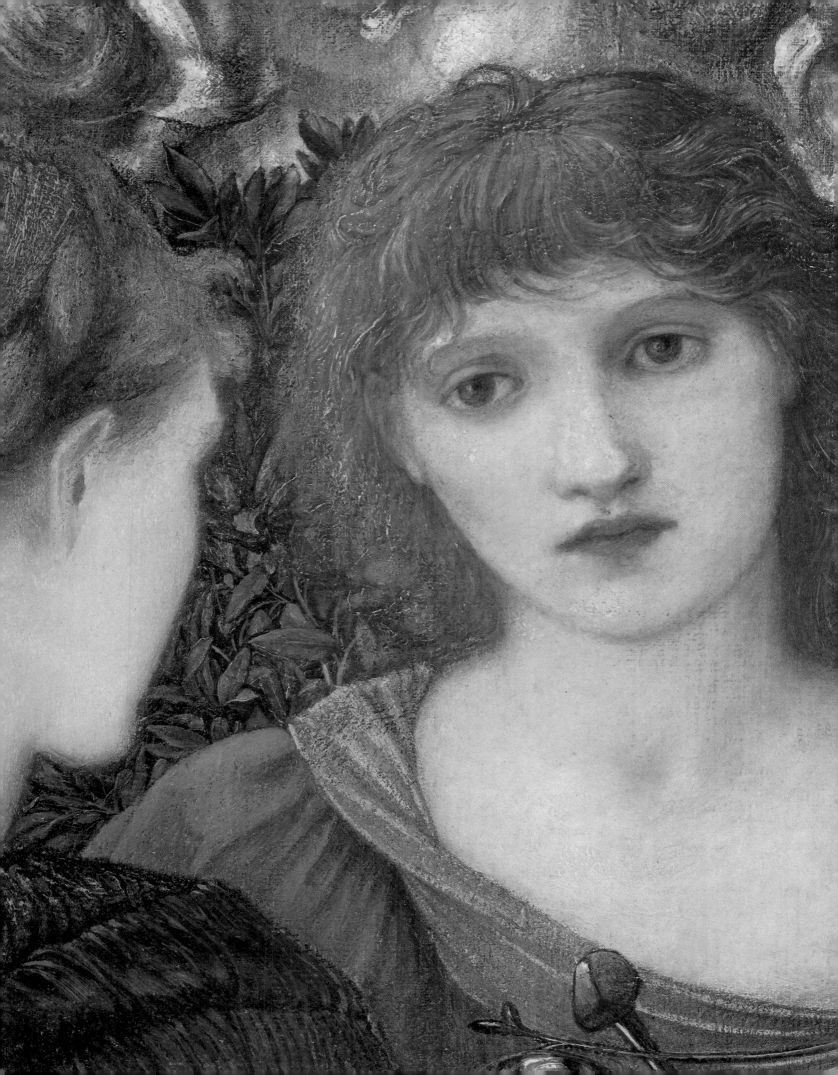

SECTION VI After 1860

This section surveys the later years of Pre-Raphaelitism, up to the death of Rossetti in 1882, but without attempting the detailed coverage given to the earlier periods.

Of the original Pre-Raphaelites, only Hunt tried to remain faithful to the Brotherhood's ideals. The highly-wrought style in which he continued to paint biblical and modern-life subjects set him increasingly apart from the general drift of English art, though he maintained a substantial public following. By the 1860s Millais, now emulating the free brushwork of Velasquez and Hals in sentimental subject pictures and society portraits, made no claim to be any sort of Pre-Raphaelite. A few of his later pictures are nevertheless included here, representing the more personally-felt work of which he was still sometimes capable.

Rossetti was undoubtedly the most influential figure of these later years. From about 1860 his painting, now largely in oils, grew more sensuous both in subject and manner, moving ever further from the original concerns of Pre-Raphaelitism and closer to those of Aestheticism. Bust-length pictures of beautiful women, richly textured and partly modelled on sixteenth-century Venetian painting, gave way in the late 1860s to more languorous and melancholy images that finally became little more than decorative ciphers of his own disillusionment.

The decorative elements in Rossetti's work found a more practical outlet through the firm of 'fine art workmen' founded by William Morris in 1861: Rossetti, Burne-Jones and Madox Brown were all active partners in this. Brown's own painting from this time on reflects his involvement with the firm's projects as well as the influence of Rossetti's later painting. After working for many years primarily in gouache (though often on a large scale), Burne-Jones came to the fore as an oil painter when he showed eight canvases in the opening exhibition of the Grosvenor Gallery in 1877. Pursuing his own cult of beauty through a variety of legendary and mythological sources, Burne-Jones effectively took over Rossetti's role as leader of the second phase of Pre-Raphaelitism, by this time quite unrecognisable in terms of the art of 1848 but closely aligned both to the Aesthetic Movement and to Symbolism.

opposite Edward Burne-Jones, 'Laus Veneris', 1873–8 (detail, No.150)

FREDERICK SANDYS

THOMAS WOOLNER

116 Autumn *c.*1860–2
 Oil on canvas, $31\frac{5}{16} \times 42\frac{13}{16}$ (79.6 × 108.7)
 Ref: Brighton 1974 (52)
 Norfolk Museums Service (Norwich Castle Museum)

An old soldier reclines beside the river Wensum near Norwich;
his medal ribbons point to him being a veteran of the Sikh wars
of 1845–9. A woman, possibly his daughter, sits beside him
with a child. The grim expressions on their faces suggest that
the soldier has been recounting his experiences of war but the
subject is not fully explained. The significance of the Chinese
jar, for example, is unclear. Bishop's Bridge and the unrestored
Norwich Castle appear in the background. Esther Wood, writ-
ing during Sandys' lifetime, described the picture rather oddly
as a 'sunny healthy pastoral' which depicted children who had
been birds-nesting and who had 'come to show their spoils to
the old soldier lying on the grass, regaling them in his turn with
stories of his youth' (*A Consideration of the Art of Frederick
Sandys*, 1896, p.39).

 Sandys appears to have contemplated a series of paintings of
the seasons, of which only 'Autumn' was executed. A drawing
for 'Spring' exists (Norwich Castle Museum, exh. Brighton
1974, No.47). Various drawings for 'Autumn', one dated
1860, and a smaller painted version are at Norwich and
Birmingham (ibid., Nos 48–51, 53). Sandys exhibited one of
the drawings at the R.A. in 1862.

 'Autumn' is indebted to Millais' 'Sir Isumbras at the Ford'
(Lady Lever Art Gallery, Port Sunlight; exh. R.A. 1967, No. 55)
of 1857, especially for the treatment of the landscape back-
ground. It was Sandys' print 'A Nightmare', a parody of Millais'
picture, that led to his friendship with Rossetti.

L.P.

117 Constance and Arthur 1857–62
 Also known as 'The Fairbairn Group', 'Deaf and Dumb'
 and 'Brother and Sister'
 Inscribed 'CONSTANCE 1862 ARTHVR'
 Marble, 38 × 28 × 22 (96.5 × 71.1 × 55.9)
 First exh: International Exhibition, 1862
 Sir Brooke Fairbairn, Bt.

Woolner was introduced to Thomas Fairbairn by Holman
Hunt, who was making some effort to persuade his patron to
commission a work of some substance from his sculptor friend.
Woolner visited Manchester early in August 1857 and met the
two elder Fairbairn children, Constance and Arthur, who were
both deaf and dumb. Woolner was at work on a sketch for the
group at the end of August, though not to his own satisfaction;
the sketch was finished however by mid-October 1857.
Woolner was at work on the full-scale model possibly by
January 1858, certainly by June that year. But again he ex-
perienced difficulties, partly from having to undertake at the
same time more humdrum work (busts, medallions) in order to
bring in some income, but also from the effort he was making to
produce something different – 'if one is not content to do work
in the old conventional manner, the difficulties he draws upon
himself are not light', he wrote to Mrs Tennyson on 7 June
1858 (Woolner, p.149). The model was nearing completion
towards the end of May 1859, but Woolner then experienced
great difficulty in obtaining marble – there seems to have been
a general hold-up in imported supplies for the best part of the
year 1860. By October 1861 he was progressing well with the
group, writing to Mrs Tennyson that 'the marble has turned
out most perfect and excites the admiration of all who see it, for
the tone and texture are most choice' (Woolner, p.205). At the

116

end of March 1862 he was working hard getting the group ready for sending in to the International Exhibition, and on 14 April he was visited by Lady Ashburton and Robert Browning who viewed the work with admiration. The group remained in the Fairbairn family's possession and at some point after the deaths of the sitters (Constance in 1904, Arthur in 1915) it was placed above their shared grave in Tunbridge Wells Borough Cemetery.

The work is strictly speaking a portrait group, that is, something high up the scale of portrait sculpture, much more substantial than a simple bust, more than a full-length portrait statue. Such works are not unknown in Victorian sculpture, but relatively rare; Alexander Munro was exceptional enough in producing a series of child portrait groups in the 1850s and 1860s to be rated a specialist. To this straightforward category, Woolner has added two distinct elements. In the first place the children are deaf and dumb (the work is sometimes called simply 'Deaf and Dumb'). The sculptor has made every effort to register this, in their pose replete with tactile emphases and in their lack of marked facial animation to be expected in a soundless world. They are clearly together, communicating with each other, in spite of their disability. This is quite clearly aimed to elicit from the spectator a sympathetic response, if not something stronger in the way of sentiment. Here Woolner is heightening an accepted and established category, that of the possibly sentimental child portrait which verges on genre. Other artists were to take up this mixed category particularly in the 1860s: Millais excelling at such in paintings from shortly afterwards ('My First Sermon' of 1863, etc.), while the sculptor Joseph Durham produced a number of such works – perhaps less evidently sentimental – each year from 1865 to 1867 ('On the Sea Shore', alias Sir Savile Crossley as a boy; 'Waiting His Innings', alias Basil Lawrence; 'The Picture Book', alias the Redhead children).

To both convey such a message and reinforce it, Woolner has maintained the vein of naturalism and realism already seen effectively in the Tennyson bust (No.89). The children's feeling for each other is confirmed by the total naturalism of their pose, which is thus given an extra boost for the viewer who knows their disability. On top of this, every detail (and it *is* every one if the group is inspected closely) is represented realistically, there is no glossing or conventionalising of anything in the group, whether fitment or overall design. This must explain Woolner's comment (quoted above) about not being content to do work in the old conventional manner and the difficulties that therefore arise. Certainly his message and the means he used to achieve it were recognised by contemporaries. Robert Browning, ten days after his visit to Woolner's studio, called back to leave a poem he had written on the group. Called 'Deaf and Dumb – A Group by Woolner', it registers love's capacity to express itself in spite of disability – 'so may a glory from defect arise'. J.B. Waring, in his *Masterpieces of Industrial Art and Sculpture at the International Exhibition, 1862*, clearly recognised Woolner's achievement: 'Nothing can be more life-like and true than the treatment of every portion of the composition, from the excellently studied figures of the children to the diapered cloth or fringed rug on which their feet rest. Nor can too great praise be awarded to the drapery, which is often slurred over by sculptors with anything but artistic feeling, and in a conventional style, which may suit ideal subjects, but is not endurable in works professing to embody and perpetuate Nature itself. We think this work of Mr Woolner's places him at the head of the Realistic school' (1, commentary to plate 54).

B.R.

117

ALEXANDER MUNRO

118 Benjamin Woodward *c.*1861
Inscribed 'AM' in monogram
Marble medallion, set in green serpentine,
$18\frac{1}{2} \times 18\frac{5}{16} \times 8\frac{1}{4}$ (47 × 46.5 × 21)
University Museum, Oxford

On the death of Benjamin Woodward in 1861 a Memorial Committee was set up to organise a range of commemorations. Of all these, only the portrait medallion by Munro seems to have come off in the end, and it was eventually installed at the Oxford Museum.

This was obviously appropriate, as Woodward was co-architect of the Museum with Sir Thomas Deane. But it was also fitting from Munro's point of view, as he was closely involved in the artistic embellishment of the Museum, providing individually by far the greatest number (six) of the portrait statues of famous scientists to be placed against the arcade of the Main Courtyard inside the building. Other sculptors in and around the Pre-Raphaelite circle such as Woolner and J.L. Tupper executed other figures for the Museum; some more purely decorative sculpture, foliate and animal, was executed by the O'Shea brothers with a relentlessness of truth to nature that must have pleased Ruskin, who actually designed the ornament for one of the Museum's windows. At one stage, painted decoration by Rossetti and others was envisaged for inside the building. This would have been analogous to that at the Oxford Union building, also by Deane and Woodward – this too had sculpture by Munro, a tympanum relief of King Arthur and the Knights of the Round Table, from a design by Rossetti.

This work is a good example of Munro's medallion portraiture. He developed a distinctive style in this. The alignment of the head varied from profile to full-face, with corresponding variation in the depth of relief. The scale was usually close to life-size so that a considerably greater impact was achieved than in, say, Woolner's medallions (see Nos 30, 76–77). Because the heads emerged from an emphatic solid background one can again detect a trace of architectural-sculpture thinking behind the basic arrangement, not separating the sculpture from a supporting structure, and this would accord both with Munro's background training, and with the ideas on sculpture held at the time by such as William Michael Rossetti and Francis Turner Palgrave of the Pre-Raphaelite ambience. Subjects of Munro's medallion portraits included Millais, both Sir Walter and Lady Pauline Trevelyan of Wallington, and William Bell Scott's painter brother David. These portraits certainly do not lack an element of verisimilitude, though they do retain the smoothness and stylistic heightening that are characteristic of Munro's work overall.

The full appositeness of this work is summed up in the 1893 edition of Acland and Ruskin's *The Oxford Museum* (p.112): 'Alexander Munro made a medallion worthy alike of the most accomplished sculptor who also died in his prime abroad, and of our common friend. It may be studied . . . at the Museum, both as a work of Art, and as the expressive record of a guileless contemplative nature'.

B.R.

118

DANTE GABRIEL ROSSETTI

119 Girl at a Lattice 1862

Inscribed 'DGR 1862' (initials in monogram)
Oil on canvas, $11\frac{1}{2} \times 10\frac{3}{8}$ (29.2 × 26.3)
Ref: Surtees No.152
Fitzwilliam Museum, Cambridge

Rossetti's intimate friend G.P. Boyce records buying this painting on 7 May 1862: 'To Rossetti. Liking a head of a girl at a lattice which he had painted at Madox Brown's, being the latter's maid servant, he tendered it to me for £30. I accepted' (Surtees 1980, p.34). It is a further example of the type of painting of women at bust length, started in 1859, in which Rossetti restricted the size and spatial recession so that he could concentrate on the arrangement of colour and the technique of rapid flesh painting in oil (see No.114). It is an important type which was taken up by Rossetti's friends, Sandys, Burne-Jones and Madox Brown c.1863. Here Rossetti picks up the ruddy, brown/red of the wall-flowers in the foreground, in the coral necklace and the girl's cheeks. The willow-pattern jug and dish probably belonged to Madox Brown who had collected this kind of cheap, artisan pottery since the early fifties. By the time No.119 was painted there was a vogue for it and the more expensive Far Eastern 'blue and white' china in Rossetti's circle, as a slightly later entry in Boyce's diary than the one quoted above shows: 'July 28 [1862] Spent the evening at Swinburne's, taking with me as a contribution to his housekeeping 2 old blue and white wedgwood dishes and a very fine Chinese plate or dish. Present: D.G. Rossetti, Whistler, Val Prinsep, Ned Jones and Sandys' (Surtees 1980, p.35). The frame of No.119 is original and was designed by Rossetti.

A.G.

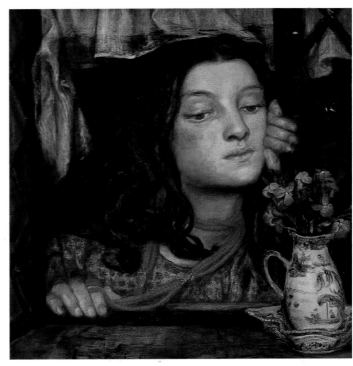

119

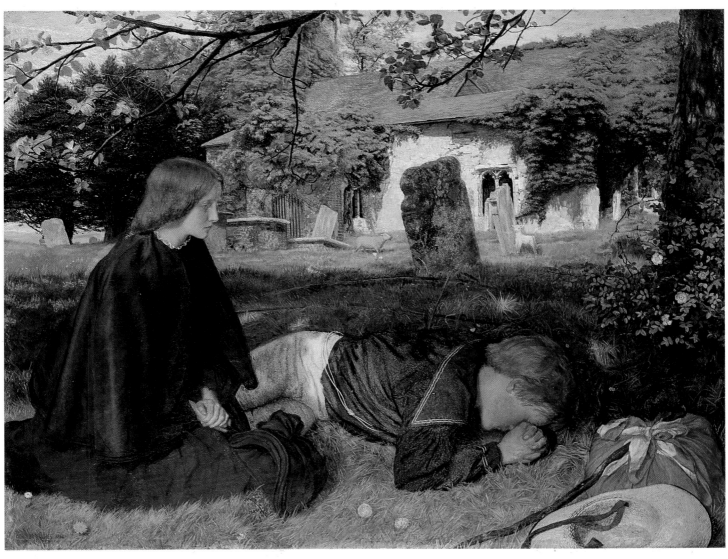

120

ARTHUR HUGHES

120 **Home from Sea** 1856–62
Inscribed 'ARTHUR HUGHES 1862'
Oil on panel, 20 × 25⅝ (50.8 × 65.1)
First exh: Russell Place 1857 (35) and, in revised form,
R.A. 1863 (530)
Visitors of the Ashmolean Museum, Oxford

Hughes described this painting (and made a quick sketch of it)
in a letter of 6 January 1901 to William Hale-White: 'Well,
about that Sailor boy picture – I called it though "Home from
Sea" and it represented a young sailor lad in his white shore
going suit, castdown on his face upon the newly turfed grave
where his mother had been put in his absence – his sister in
black kneeling beside him: his handkerchief bundle beside –
Sunshine dappling all with leafy shadows – old Church behind
with yew tree painted at Old Chingford Ch: Essex: it was bought
of me by John Trist of Brighton . . . At the time I painted it my
wife was young enough to sit for the sister: and I think it was

like' (Tate Gallery Archives). A manuscript catalogue at the
Ashmolean Museum compiled by Charles Bell in about 1905
adds the information, presumably received from the artist (as
other of his information was), that the landscape was painted
at Chingford in the summer of 1856 (Ironside & Gere, p.43).

Hughes appears to have exhibited the painting at the Pre-
Raphaelite Exhibition in Russell Place in 1857 under the title
'A Mother's Grave'. Ironside and Gere point out that con-
temporary accounts do not mention the figure of the sister and
that she is not included in a drawing of the subject, datable to
April 1857 at the earliest, in the Ashmolean Museum (repr.
Ironside & Gere, pl.70). It is generally thought, therefore, that
Hughes added the girl after the picture's first exhibition and
before he re-exhibited it as 'Home from Sea' at the R.A. in 1863.

Tim Hilton has pointed out the resemblance of the boy's pose
to that of the man in Hunt's etching 'Of my Lady In Death',
published in the first issue of *The Germ* in 1850 (*The Pre-
Raphaelites*, 1970, p.118).

L.P.

WILLIAM HOLMAN HUNT

121 The King of Hearts 1862–3
Inscribed '18 Whh 62' (initials in monogram)
Oil on panel, $15\frac{1}{4} \times 11\frac{7}{16}$ (38.8 × 29)
First exh: R.A. 1863 (146)
Private Collection

No. 121 is a portrait of Hunt's nephew and godson Teddy (later Dr Edward) Wilson (1857–96). According to the 1906 catalogue of Hunt's retrospective at the Leicester Galleries (p.31, No.19), 'The background was painted in the garden of Ockham Park', Ripley, Surrey, where Hunt stayed from late September to early November 1862 in order to paint the portrait of Judge Stephen Lushington (National Portrait Gallery, London; repr. Richard Ormond, *Early Victorian Portraits*, 1973, I, p.279). It seems likely that Hunt was working on both portraits in 1863, in the light of a letter to Combe of 15 February: 'Teddy has gone home for a day so tomorrow I shall again work at the portrait of the octogenarian' (JRL). The two portraits were exhibited at the 1863 Royal Academy and, according to Hunt's letter of 24 April 1863 to William Bell Scott, 'each of them took me an enormous time the first [No.121] principally because it was a sunlight picture –' (PUL).

The difficulties, in the case of 'The King of Hearts', were compounded by the fact that as figure and landscape were painted at different times of the year and in two different places harmonisation was much harder to attain. The result is that the figure appears somewhat two-dimensional, and Hunt's

121

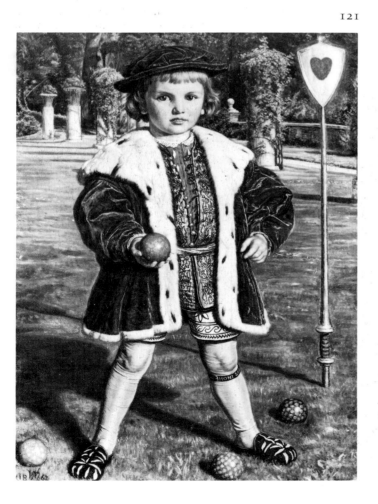

choice of title is perhaps a deliberate allusion to the flat image of the king on a pack of playing cards. The lance and shield, with its heart gules which gives rise to the title, was not, however, part of the original conception: thin strips have been added to the panel at the right-hand side and lower edge. The title 'The King of Hearts' may also allude to the sitter's winsome appearance and it has the ring of an old nursery rhyme, deepening the playful associations conjured up by the spectacle of a five year old dressed as Henry VIII.

The 1906 Leicester Galleries catalogue noted that the sitter's costume had been made for a fancy dress ball, and the 1951 catalogue of the Pre-Raphaelite exhibition at the Russell-Cotes Gallery stated that Hunt had designed it (p.11, No.44). It is possible that the design was partly based on Hunt's studies, annotated with colour notes (Coll. Mrs Burt), from two portraits of the Holbein circle: as Mary Bennett has pointed out, one is similar to, though not identical with, Guillim Stretes' full-length portraits of Edward VI, while the other (exh. Liverpool 1969, No.208) is after a Holbein half-length portrait of Henry VIII in three-quarters profile to the right, copied either from the original, then in the collection of Lord Spencer (now Thyssen-Bornemisza Collection, Lugano), or from a copy (National Portrait Gallery, London) which was with the dealer Henry Graves in 1862–3 (Roy Strong, *Tudor and Jacobean Portraits*, 1969, I, p.153). While the patterning of the child's tunic in No.121 may be indebted to this image, Hunt was also influenced by Holbein's full-length portraits of Henry VIII, legs astride, in his ermine-lined cloak, of which there are numerous versions and engravings.

Hunt's interest in old master painting had been awakened by his visit to the Manchester Art Treasures Exhibition. He wrote to Combe from Manchester in September 1857: 'Some of the portraits of all times are so lovely as to send me quite crazy – I am hopelessly in love with several ladies painted by different painters down to Gainsborough and Reynolds' (BL). Pre-Raphaelite contempt for Sir 'Sloshua' was, in Hunt's case, superseded by respect, and he could have seen many more Reynolds portraits at the British Institution from 1858–62. The strong visual parallels between 'Master Crewe as Henry VIII' (Coll. Lord O'Neill; then in the collection of the Marquess of Crewe, but widely known through engravings) and 'The King of Hearts' suggest that Hunt's portrait was executed as a homage to Reynolds as well as a pastiche of Holbein and his followers.

Reynolds' 'Master Crewe' was acknowledged as the source by Hunt's friend Palgrave, in his notice in the *Saturday Review* of 16 May 1863 (XV, p.628; reprinted in *Essays on Art*, 1866, p.7). Palgrave also mentioned 'the china ball' the child is about to throw, and this suggests inside knowledge of the fact that 'the bowls were an original set of Tudor ones (they were made of china then, not wood), which belonged to the artist' (catalogue of the 1951 Pre-Raphaelite exhibition, Russell-Cotes Gallery, p.11, No.44). The bowls, of course, further point up the parallels with Henry VIII, who had bowling alleys constructed at Whitehall Palace, but there may also be an underlying allusion to the then fashionable and popular game of croquet, which had only recently been introduced into England – the lance can be interpreted as a giant-sized croquet peg. Hunt and Teddy Wilson used to play croquet in the garden of the artist's Tor Villa home, as Lewis Carroll relates in his diary of 30 September 1863 (ed. Roger Lancelyn Green, 1953, I, p.202). On 1 October 1863 Carroll took some photographs of Teddy as 'the little Henry VIII in full dress' (ibid.) which, if they could be traced, would make an interesting comparison with No.121.

The circumstances of the sale of 'The King of Hearts' are unknown. The painting was in the collection of J.P. Carter by 18 June 1870, when it was offered for sale at Christie's, without the copyright (lot 132, bought in at 250 gns).

A chalk portrait of the head of Teddy Wilson in three-quarters profile, signed with Hunt's monogram and dated 1863, is in Worthing Art Gallery.

J.B.

JOHN EVERETT MILLAIS

122 The Eve of St Agnes 1862–3
Inscribed 'JM 1863' (initials in monogram)
Oil on canvas, 46½ × 61 (118.1 × 154.9)
First exh: R.A. 1863 (287)
Ref: R.A. 1967 (63)
Her Majesty Queen Elizabeth The Queen Mother

An illustration to Keats' poem, showing a scene earlier in the story than Holman Hunt's painting of the same title, No.9. Madeline undresses in the moonlight, watched secretly by her lover Porphyro from a closet:

Anon his heart revives; her vespers done,
Of all its wreathèd pearls her hair she frees;
Unclasps her warmèd jewels one by one;
Loosens her fragrant bodice; by degrees
Her rich attire creeps rustling to her knees:
Half hidden, like a mermaid in sea-weed,
Pensive awhile she dreams awake, and sees,
In fancy, fair St Agnes in her bed,
But dares not look behind, or all the charm is fled.

The work is close in composition to an oil sketch of the same scene painted in 1849 (private collection). Millais had perhaps

intended, though the idea was not realised, to follow 'Isabella' (No.18) with another major Keats subject at the R.A. exhibition of 1850. By 1862 the sketch belonged to Thomas Combe, who made a note on the back, dated 19 September that year, that Holman Hunt had just seen it and said 'it was one of his first things after taking up Pre-Raphael.ⁱˢᵐ'. Being reminded of the earlier work by Combe or Hunt, or indeed seeing it again himself, may well have been what prompted Millais to paint this later, larger version of the subject.

The setting is the King's Bedroom at Knole. According to J.G. Millais, the artist spent three cold nights in succession there in December 1862, working for a few hours after midnight in order to catch the moonlight falling correctly on the figure. His wife Effie posed at Knole but the figure was finished afterwards in the studio from a professional model, Miss Ford. 'Millais lit up his canvas with a bull's-eye lantern when painting this subject in London', J.G. Millais notes. 'He found that the light from even a full moon was not strong enough to throw, through a stained glass window, perceptible colour on any object, as Keats had supposed and described in his poem' (I, pp.372–3).

Effie Millais recalled: 'This picture was marvellously quickly executed. After three days and a half at Knole and two days more at home, the work was complete, and highly finished. The magnificent bed represented was that in which King James I slept. It cost £3000, and the coverlet was a mass of gold thread and silver appliqué gimp and lace; the sheets were white silk, and the mattresses of padded cotton wool. Millais' fingers got numb with the cold, but there was no time to be lost, as the private view day was drawing near. When we got back from Knole the figure of Madeline had to be altered; and when the work was exhibited the public thought the woman ugly, thin, and stiff. "I cannot bear that woman with the gridiron," said Frank Grant (Sir Francis Grant, P.R.A.), alluding to the vivid streams of moonlight on the floor; and Tom Taylor said,

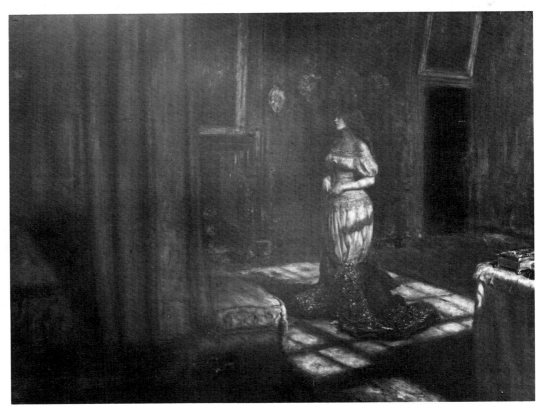

122

"where on earth did you get that scraggy model, Millais?"' (J.G. Millais, I, p.373).

A letter from Effie to her mother of 11 March 1863 describes Millais as still working frantically on it (Bowerswell Papers, PML) and G.P. Boyce refers to it in his diary for 22 March as merely 'a commencement of Madeleine' (Surtees 1980, p.37). It was presumably finished in time for sending in to the R.A. exhibition in early April.

It was bought from the artist for £800, possibly by the dealer Gambart. By 1865 it was in the collection of Charles Lucas.

There are pencil studies for the figure in Birmingham City Art Gallery (exh. R.A. 1967, No.365, verso) and a private collection, and a study in watercolour and oil on paper for the figure was sold Christie's 29 July 1977 (105). A watercolour version of 1863 is at the Victoria and Albert Museum (D.141-1906).

M.W.

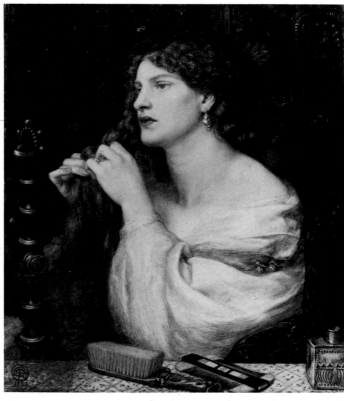

123

DANTE GABRIEL ROSSETTI

123 Fazio's Mistress 1863
Inscribed 'DGR 1863' (initials in monogram)
Oil on panel, 17 × 14½ (43.2 × 36.8)
First exh: L.A. 1864 (149a)
Ref: Surtees No.164
Tate Gallery

Rossetti was working on 'Fazio's Mistress' in October 1863 when he described it as 'chiefly a piece of colour'. Ten years later he retouched it, bringing out the colours by fresh glazes and perhaps altering the lips. It is one of a group of pictures of 'fleshly', narcissistic women, entrancedly absorbed in their own sensuous beauty, modelled by Fanny Cornforth, which begin with the illustration on the frontispiece of *Goblin Market* in 1862 and reach a climax in the painting 'Lilith' of 1864–8. White draperies are predominant, broken by small areas of blue and touches of red. There are similarities with Whistler's contemporary pictures, especially 'The Little White Girl No.2' of 1864. For Rossetti the main influence came from Venetian early sixteenth-century painting. He admired Titian especially and the Louvre's 'Alphonse Ferrare et Laura de Dianti' is an important prototype for his work of this period (cf. also 'Portrait of a Lady', Venetian School, National Gallery, London, No.595).

The title 'Fazio's Mistress' refers to a poem of Fazio degli Uberti describing his lady's beauty, a translation of which Rossetti included in his *Early Italian Poets* in 1861. The description of the lady's 'amorous beautiful mouth', 'white easy neck' and 'large arms, so lithe and round', could be applied to any of the women in Rossetti's paintings of the period, as could the suggestion of a bait being set to ensnare men:

> I look at the crisp golden-threaded hair,
> Whereof, to thrall my heart, Love twists a net:
> Using at times a string of pearls for bait,
> And sometimes with a single rose therein.
> I look into her eyes which unaware
> Through mine own eyes to my heart penetrate.

(W.M. Rossetti 1911, p.488. The poem is so Rossettian that he may have made it up.)

A.G.

WILLIAM HOLMAN HUNT

124 London Bridge on the Night of the Marriage of the Prince and Princess of Wales (The Sea-King's Peaceful Triumph on London Bridge, 10th of March, 1863) 1863–6, retouched 1868
Inscribed '1863.6 | Whh' (initials in monogram)
Oil on canvas, 25⅝ × 38⅝ (65 × 98)
First exh: New Gallery, 16 Hanover Street 1864
Ref: Liverpool 1969 (38)
Visitors of the Ashmolean Museum, Oxford

Hunt was one of the very many Londoners thronging London Bridge on the night of 10 March 1863 to celebrate the marriage of Edward, Prince of Wales to Princess Alexandra of Denmark (Hunt 1905, II, pp.242–3). Munby's diary of that date provides us with a contemporary account of the scene: 'The bridge itself, with its parapets topped with tripods of burning incense and statues with rings of light round the pedestals and tall pennons that waved dimly above, was very beautiful: a lane of brilliant fantastic colour, and full of eager struggling human beings; and on either side, far down, the dark water of the Thames, its ripples faintly gleaming here & there, but still and solemn every where' (ed. Derek Hudson, 1972, pp.152–3). Munby graphically described the immense crowd of people, and it seems amazing that Hunt managed that night to make any sketches of the scene (Hunt 1905, II, p.243). The only extant sketch (Coll. the late Stanley Pollitt) contains no people, and is a rapid pencil drawing of that part of the bridge depicted on the right of No.124.

124

It is possible that the painting was begun on 11 March 1863, as related in Hunt's memoirs (II, p.243), but pressure of other work would have prevented its being advanced at this period. The first reference to No.124 in Hunt's correspondence is on 29 November 1863, when the artist informed Combe of the completion of 'The Afterglow' (No.87) and added: 'London Bridge I am doing now' (BL). He was working on it during the new year, as Stephens' letter to Hunt of 4 January 1864 indicates: 'I have failed in trying to see "Woodthorpe" – as he styles himself, like a Peer – the Town Clerk of London, about the London Bridge decorations. On inquiry at the Architect's Office, Guildhall I learnt that if the Elephant [on the top of the standards in No.124] was introduced at all they thought it must have been not in a conspicuous manner. I found however that the London Stereoscopic Company took photographs of the bridge on the occasion in question, and have directed them to print, from the negatives they possess, copies and to send them to you' (UBC/Hunt Papers). Hunt replied three days later: 'The stereoscopic photographs will be of great value to me – what the clerk – Woodthorpe – says I cannot understand for I saw the Elephants in the most conspicuous places – and drew them in my sketch' (BL). He added that an 'illustration in the London News' also showed the animals. The wood engraving to which he referred is entitled 'The Royal Procession at Grand Arch, London Bridge' (Illustrated London News, XLII, 21 March 1863, pp.300–1), and its depiction of the burning tripod braziers and standards with shields at their base, gilt elephants on top, and Danish flags waving, was obviously one of the sources of No.124. No doubt Hunt also knew of the description of the decorations in the Illustrated London News of 7 March 1863: 'The parapets of the bridge will be ornamented from the south to the north with portraits of the Kings of Denmark from the earliest period to his present Majesty, Frederick VII., affixed on the Danish national standards, surmounted with ravens and elephants. Between the standards one hundred tripods will be placed, from which incense will arise. At the south and north approaches of the bridge will be erected pedestals, on which will be placed statues of fame, surmounted by Danish warriors holding the "Danebrog", the national flag of Denmark [visible in right background of No.124]' (ibid., p.239).

Lewis Carroll noted in his diary that Hunt was still working on the picture on 1 April 1864 (ed. Roger Lancelyn Green, I, p.211). In the event, the private view of the Hanover Street exhibition had to be postponed from 14 May to 16 May 1864 to enable Hunt to finish No.124 (Hunt to Stephens, 11 May and 12 May, BL). Although the artist would have been gratified by reviews such as the long notice in the Daily Telegraph of 18 May (p.5), or the mention in the Art Journal of 1 July – 'The London Bridge subject is certainly one of the most unmanageable themes that could be propounded to a painter, but Mr. Hunt seems to have multiplied the difficulties simply in order to show how he could overcome them' (p.221) – he must have come to feel that No.124 needed a certain amount of reworking, for the date on the support of the bridge reads '1863.6'. According to W.M. Rossetti's diary of 22 April 1868, the painting was also further retouched at this time (W.M. Rossetti 1903, p.305).

Hunt's account of the picture's genesis mentions 'the Hogarthian humour' of the crowd (1905, II, p.243), but the

numerous incidents of No.124 recall Frith's 'The Railway Station' (Royal Holloway College, University of London), which had been an immense financial and popular success in 1862, rather than Hogarth. Hunt was in touch with Frith in 1863 (Hunt to Millais, 5 June 1863, ASU), and may have envisaged No.124 as a contrasting pendant to Frith's 'The Marriage of the Prince of Wales' of 1863–5, commissioned by Queen Victoria. P.G. Hamerton reacted with dismay to reports of Hunt's depiction of the celebrations in the metropolis: 'There is much in this choice of subject which betrays the evil influence of the art-speculator. It is a subject precisely suited to a sensation picture . . . It appeals adroitly to the London crowd by giving it a picture of itself . . . for such a subject to be chosen by one of the chiefs of an intellectual school of painting is an exceedingly bad symptom' (*Fine Arts Quarterly Review*, II, May 1864, p.262n.)

Criticism of this sort may have led Hunt to exhibit No.124 with the title 'The Sea-King's Peaceful Triumph on London Bridge, 10th of March, 1863' (noted by F.G. Stephens in the *Athenaeum*, 21 May 1864, p.715). Hunt, in a letter of 12 May 1864 to Stephens, who was writing a description of No.124 for distribution at the exhibition, asked him to give further emphasis to the historical dimension by including 'some historical allusions to the Danish contests that took place on the spot' (BL; Stephens' description is republished in Hunt 1913, II, pp.406–8). The statue of the warriors embracing at the far left of the painting symbolises the reconciliation of the two powers, while the frame, designed by the artist, incorporates allusions to the former state of war between them (arrows and shields below) and the love between the British prince and Danish princess (hearts and rosettes above). The shields in the upper corners bear the coats of arms of the royal couple; those below, now missing, were heart-shaped and depicted a lion and a raven, symbols of England and Denmark (1917 description, AM, states that the bird was a chough, but in the light of the passage in the *Illustrated London News* of 7 March 1863, quoted above, a raven was probably intended).

Stephens' 1864 description listed the many 'humorous' incidents of No.124, ranging from the boy waving the cage of crinoline above his head (above the diagonal supports of the bridge) to the policeman about to intercept a thief who has clambered over the parapet of the bridge (a touch recalling the arrest of a criminal in Frith's 'The Railway Station'). The *Daily Telegraph* critic noted the presence, in the lower right-hand corner, of the writer Thomas Hughes holding up his daughter to enable her to view the celebrations (18 May 1864, p.5), and this figure was erroneously identified as Millais in the 1909 catalogue of the Combe Bequest to the Ashmolean Museum (p.13). Hunt was sent a copy of this (C.H. Bell to Mrs Holman-Hunt, 20 January 1909; MS, Kenneth Spencer Research Library, University of Kansas), and he then identified the balcony in the right foreground as that of the Fishmongers' Hall with Hughes and daughter and one of Millais' sons (additions and emendations annotated by Edith Holman-Hunt to her husband's dictation, MS, ibid.; copy in AM). The bearded figure on the balcony was identified, in the 1913 edition of *Pre-Raphaelitism*, as 'Henry Wentworth Monk, the prophetic dreamer' (II, p.408, n.3). Other additions to the 1909 catalogue noted the presence of Thomas Combe at the far left, 'arm in arm with the painter half of whose face only shows'; and his wife with Millais' father and brother and Robert Martineau (whose 'Last Day in the Old Home' was exhibited with Nos 87 and 124 at Hanover Street in 1864) on top of one of the vans (MS, Kenneth Spencer Research Library, University of Kansas; copy in AM). It is unlikely that all these friends actually witnessed the celebrations on 10 March 1863, but Mrs Combe obviously appreciated the tribute paid to her husband, for after his death she negotiated with Hunt to purchase No.124 (Mrs Combe to Hunt, n.d., November 1872, BL).

In one important respect, the way in which the picture is a study of the effects of artificial light and moonlight, 'London Bridge' is a characteristic Hunt work. His interest in different sources of light can be traced back to 'The Light of the World' (No.57), and was to be further explored in 'The Ship' of 1875 (Tate Gallery, exh. Liverpool 1969, No.51, repr.). The lights reflected in the river on the far side of the bridge recall Hunt's small 'The Thames at Chelsea, Evening' (Fitzwilliam Museum, exh. 1969, No.26, repr. Staley pl.27b), their calm contrasting with the lurid-coloured flames from the braziers on their tripods.

Hunt had written to William Bell Scott on 11 February 1860: 'I always try to paint every thing as unlike to the thing I last painted as possible people are not unfrequently taken by surprise when I show them my work' (PUL), and Stephens' 1864 description emphasised the contrast between 'London Bridge' and 'The Afterglow' (No.87), the other Hunt work on exhibition at Hanover Street (Hunt 1913, II, p.406). No doubt Hunt wished to show two such different paintings in order to prove the range of his repertoire, and the critics duly applauded his versatility (e.g. *Daily Telegraph*, 18 May 1864, p.5; F.T. Palgrave in the *Saturday Review*, XVII, 18 June 1864, p.751, republished in *Essays on Art*, 1866, p.163).

J.B.

THOMAS WOOLNER

125 Thomas Combe 1863
Inscribed 'THOMAS COMBE 1863' and 'T. WOOLNER . Sᶜ| LONDON'
Marble, 26″ high (66 cm high)
First exh: R.A. 1864 (1024)
Visitors of the Ashmolean Museum, Oxford

Woolner first met Thomas Combe through Holman Hunt; he went down with Hunt, for instance, to stay with the Combes in June 1860. The plaster model of the bust was cast by August 1863, the marble certainly complete by April 1864.

It was fitting that Combe, 'the Patriarch' and early patron of the Pre-Raphaelites (see Nos 25, 33, 34, 57) should eventually be portrayed in his patriarchal maturity by arguably the greatest of the Pre-Raphaelite portraitists. The *Art Journal* (1864, p.168) certainly thought 'T. Woolner's graphic head of Mr. Combe is of school Pre-Raphaelite'. Combe was also responsible for commissioning from Woolner his bust of John Henry Newman; this later passed from Mrs Combe to Keble College, Oxford.

B.R.

JOHN EVERETT MILLAIS

126 Leisure Hours 1864
Inscribed 'JM 1864' (initials in monogram)
Oil on canvas, 34 × 46 (86.3 × 116.8)
First exh: R.A. 1864 (289)
Ref: R.A. 1967 (66)
Detroit Institute of Arts (Founders Society Purchase, Robert H. Tannahill Foundation Fund)

125

126

A portrait of Marion (left) and Anne (right), daughters of Sir John Pender and his second wife Emma, née Denison. Pender was a businessman involved in textiles and telegraphy, and at the time No.126 was painted was Liberal M.P. for Totnes. He collected modern British art, already owned Millais' 'The Proscribed Royalist, 1651' (No.46) and later bought 'The Parable of the Tares' (now Birmingham City Art Gallery). Marion (1856–1955) married Sir George William Des Voeux in 1875. Anne (1852–1902) never married.

No.126 is contemporary with Millais' famous pair of paintings 'My First Sermon' and 'My Second Sermon' (Guildhall Art Gallery). It shows the same kind of subject and the same rich combination of reds and greens which characterises much of Millais' work of the early 1860s. But the mood could hardly be more different. Aimed at popular taste and specifically the print market, the 'Sermon' pictures are straightforwardly anecdotal. 'Leisure Hours' evokes a strange solemnity reminiscent of 'Autumn Leaves' (No.74) and 'Spring' (No.96), and the prominent goldfish bowl is surely a symbolic allusion to the artificial, circumscribed life led by Victorian upper middle-class girls such as these. The screen, perhaps not incidentally, recalls the blue-and-gold wall-hangings in 'Isabella' (No.18) and 'Mariana' (No.35).

M.W.

FORD MADOX BROWN

127 **Elijah and the Widow's Son** 1864
Inscribed 'FMB/64' (initials in monogram)
Oil on panel, $20\frac{3}{4} \times 13\frac{1}{2}$ (52.5 × 34.3)
First exh: Piccadilly 1865 (33)
Ref: Liverpool 1964 (under Nos 85–6)
Birmingham Museum and Art Gallery

Illustrating 1 Kings, 17. 23. Elijah in the midst of drought dwells in the house of a widow, and her son falls sick and seems

dead. The moment chosen is when the prophet brings down the child, restored to life, from the loft where he has prayed over him, to his mother, 'and Elijah said, See, thy son liveth'. A version of a design for Dalziels' illustrated Bible.

This oil was described by Madox Brown as a 'finished study for a picture' and he explained his concept in the catalogue of his 1865 exhibition: 'The child is represented as in his grave-clothes, which have a far-off resemblance to Egyptian funereal trappings; having been laid out with flowers in the palms of his hands, as is done by women in such cases. Without this, the subject (the coming to life) could not be expressed by the painter's art, and till this view of the subject presented itself to me I could not see my way to make a picture of it. The shadow on the wall projected by a bird out of the picture returning to its nest, (consisting of the bottle which in some countries is inserted in the walls to secure the presence of the swallow of good omen), typifies the return of the soul to the body. The Hebrew writing over the door consists of the verses of Deut. vi. 4–9, which the Jews were ordered so to use (possibly suggested to Moses by the Egyptian custom). Probably their dwelling in tents gave rise to the habit of writing the words on parchment placed in a case instead. As is habitual with very poor people, the widow is supposed to have resumed her household duties, little expecting the result of the Prophet's vigil with her dead child. She has therefore been kneading a cake for his dinner. The costume is such as can be devised from the study of Egyptian combined with Assyrian, and other nearly contemporary remains. The effect of vertical sunlight, [is] such as exists in southern latitudes'.

In November 1863 the artist had accepted a commission from the Brothers Dalziel, the engravers and art editors, for three illustrations for their projected illustrated Bible. This was to be a prestigious publication with wood-engravings after designs by several of the rising artists of the day, headed by Frederic Leighton and including Holman Hunt and Burne-Jones. Madox Brown had previously designed an illustration for them in 1856 of 'The Prisoner of Chillon'.

From their list he chose two subjects, the 'Elijah' and 'Jacob

and Joseph's Coat' (see No.129), and a little later offered his own choice for a third subject, 'Ehud and Eglon' (pen and ink drawings of the first and third in the Victoria and Albert Museum, and for 'Joseph' in the British Museum). Due to problems over the text a selection only of all the illustrations was published much later in 1881 as *Dalziels' Bible Gallery* long after paintings from them had become known. Madox Brown's approach to all three of his designs was essentially historical and factual, with emphasis on visual action.

He began the drawing for this subject in January 1864 and sent it off in March, when he made it clear to the Dalziels that he proposed, in his now usual fashion, to paint pictures from his designs and he asked for photographs of them to show to clients; these the Dalziels needed themselves in any case for the reproduction as they by this date no longer required drawings to be done on the wood block. The artist had already begun a watercolour sketch in February (MS Account Book, p.87) for a commission which came to nothing. In July, J.R. Trist, a wine merchant of Brighton, commissioned him through Arthur Hughes for a companion to the small painting of 'King Rene's Honeymoon' which he had just bought from him. Trist agreed to this subject but wanted an oil so this version was undertaken for 100 gns. Trist sent a present of wine and was delighted with the picture which was finished at the end of September (FMBP; Trist Papers). The small watercolour was afterwards finished

127

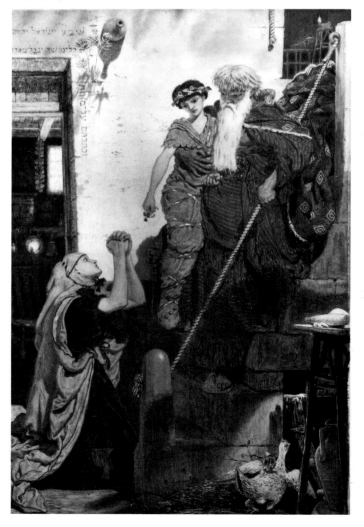

for the dealer Gambart and thence passed to F.R. Leyland (on the art market 1981). A much larger and highly finished watercolour was painted, rather reluctantly, in 1868 for Frederick Craven of Manchester, who bought only water-colours (now Victoria and Albert Museum).

In each of these versions the dramatic strength of the original fine pen drawing (which Madox Brown liked to call an 'etching'), with its emphatic diagonal composition centred on the rugged figure of Elijah, the textured detail and effect of southern light, has been translated into brilliant sunbaked colour.

M.B.

WILLIAM HOLMAN HUNT

128 **The Children's Holiday (Portrait of Mrs Thomas Fairbairn and her Children)** 1864–5
Inscribed 'Whh 1864' (initials in monogram)
Oil on canvas, $82\frac{3}{4} \times 57\frac{1}{2}$ (214 × 147)
First exh: New Gallery, 16 Hanover Street, May 1865
Torbay Borough Council, Torquay

On 20 July 1864 Hunt wrote to Richard Monckton Milnes: 'I am engaged to go down to my friend Mr Fairbairn in Sussex to paint in the first week of August' (MS, Trinity College Cambridge). By this date Thomas Fairbairn owned 'Valentine rescuing Sylvia from Proteus' (No.36) and 'The Awakening Conscience' (No.58), and had, through Hunt's influence, commissioned works from Woolner and Lear (see Bronkhurst, pp.591–2).

Fairbairn was intimately connected with the genesis of 'The Children's Holiday'. The format of No.128, nearly seven foot by five, suggests that it was commissioned to hang at the top of the impressive staircase at Burton Park, near Petworth, Fairbairn's country seat. It seems likely that the decision to pose the family in the grounds at Burton was prompted by Hunt's knowledge of James Archer's 'Summer-time, Gloucester-shire' (National Galleries of Scotland, Edinburgh, repr. Bronk-hurst, fig.12), which Fairbairn almost certainly purchased from the 1862 International Exhibition. Even the dependence of the composition of No.128 on Van Dyck's 'The Five Eldest Children of Charles I' (Coll. H.M. the Queen) may have been influenced by Fairbairn: the Van Dyck had been shown at the 1857 Manchester Art Treasures Exhibition, of which Fairbairn was Chairman, while Hunt was specifically commissioned to paint Mrs Fairbairn and the five younger children, presumably because Fairbairn felt that Woolner's statue of the two eldest children, Constance and Arthur (No.117), could not be bettered. Fairbairn's interest in the Caroline period dated from 1853, when he had purchased the oil sketch for Frederick Goodall's 'An Episode in the Happier Days of Charles I' (see Bronkhurst, p.588, repr. fig.7).

Hunt went down to Burton in mid-August 1864, and, despite his admiration for his patron, found that 'I have not the love of the country general among artists, not enough to make me quite happy in it after the first two weeks of rusticating' (Hunt to F.T. Palgrave, 27 September 1864; HL). He missed the company of his artist friends, and his loneliness was exacerbated when Thomas and Allison Fairbairn left Burton at the end of September on a two month tour of Europe. During their absence, Hunt worked on the portraits of the children, whom he found very trying as models, and, when the wind was too harsh for them to pose out-of-doors, painted the tea service (see Bronkhurst, pp.593–4). Fairbairn returned to Burton in late

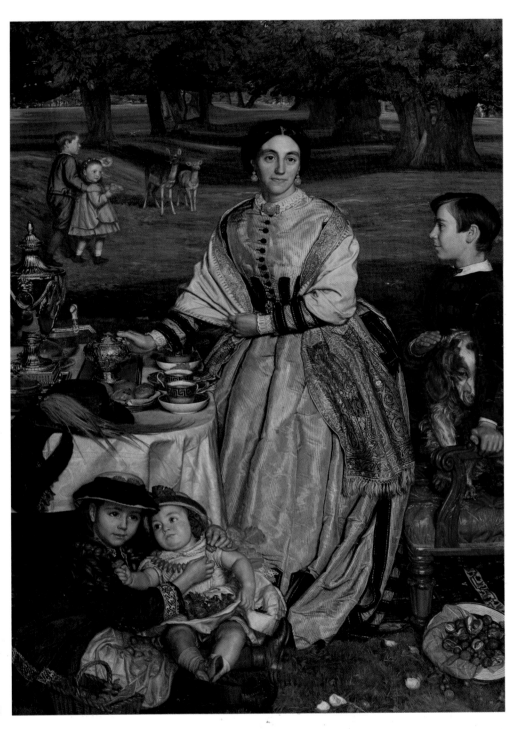

128

November, and although he was pleased with the work in progress Hunt was resentful that the portrait was taking him far longer than he had anticipated. Only then did the artist finally decide on the position in the composition of Mrs Fairbairn, as the annotation on a small pencil study of her seated at the tea urn – 'Fairbairns arrive 27th' – makes clear (Coll. the late Stanley Pollitt, repr. Bennett 1970, fig. 16). Hunt was still working at Burton at Christmas, and as late as 27 February 1865, in a letter to F.G. Stephens, expressed himself far from satisfied with his progress: 'My wretched fate still keeps me in the intolerable dreary, miserable country at this agonising task. I work like a madman but what with the interruptions from natural causes, endless darkness and little petty social considerations I lose half my time and see my work drivel on most demonaically . . . I am now desperate and will stay no longer whether the work be finished or not on Thursday or Friday I shall come to town and breathe again in my own house' (BL).

At this point the draperies were unfinished, and when Lewis Carroll visited the artist's studio on 8 April he found Hunt still working on No.128, 'for which', as he noted in his diary, 'I suggested the name "The Children's Holiday", which he ultimately adopted' (ed. Roger Lancelyn Green, 1953, I, p.229). By 29 April 1865 the work was installed in 16 Hanover Street,

where it formed the centrepiece of Hunt's exhibition.

One of the reasons for the length of time expended on No.128 was the difficulty in harmonising the portions painted at different times and in different lights. Lear wrote to Hunt on 1 May: 'The Portrait picture is more brought together than when I saw it, and looks wonderfully real and bright' (HL). The reviewer in the *Illustrated London News* of 27 May, however, found the work more convincing in its details than as an ensemble, and noted that 'the draperies and accessories . . . look far more real than the face' of Mrs Fairbairn (p.510). The still life portions of No.128, like the carefully depicted costume and valuable coral jewellery of Mrs Fairbairn, not only display the artist's virtuosity but underline the social status of the family in a way that fuses Pre-Raphaelite naturalism with a tribute to Thomas Fairbairn as the instigator of the work.

Although 'The Children's Holiday' was not mentioned in Sir Thomas Fairbairn's Will as a specific bequest, it remained in the family until 1932, when it was given to Torre Abbey.

J.B.

FORD MADOX BROWN

129 The Coat of Many Colours 1864–6
Inscribed 'F. MADOX BROWN / 66'
Oil on canvas, $42\frac{1}{2} \times 40\frac{5}{8}$ (108 × 103.2)
First exh: *Winter Exhibition*, Gambart, French Gallery, 1866–7
Ref: Liverpool 1964 (40)
Merseyside County Council, Walker Art Gallery, Liverpool

Illustrating Genesis 37. 32: 'And they sent the coat of many colours, and they brought it to their father, and said, This have we found: know now whether it be thy son's coat or no'. Like No.127, painted after one of his designs for Dalziel's illustrated Bible of 1863–4. The colour veers towards stone and hot earth tints which, while appropriate for the subject, indicate a growing tendency from this time along with a broadening and softening of the artist's style.

In his 1865 catalogue Madox Brown described the treatment of his illustrations, in which he had taken his costumes from Assyrian and Egyptian sources which 'alone, it seems to me, should guide us in Biblical subjects'. The subject, at this stage called 'Jacob and Joseph's Coat', was described at length: 'The brothers were at a distance from home, minding their herds and flocks, when Joseph was sold. Four of them are here represented as having come back with the coat. The cruel Simeon stands in the immediate foreground half out of the picture, he looks at his father guiltily and already prepared to bluster, though Jacob, all to his grief, sees no one and suspects no one. The leonine Judah just behind him, stands silently watching the effect of Levi's falsity and jeering levity on their father; Issachar the fool sucks the head of his shepherd's crook, and wonders at his father's despair. Benjamin sits next his father, and with darkling countenance examines the ensanguined and torn garment. A sheep dog without much concern, sniffs the blood which he recognizes as not belonging to man.

'A grand-child of Jacob nestles up to him, having an instinctive dislike for her uncles. Jacob sits on a sort of dais raised round a spreading fig-tree. The ladder, which is introduced in a naturalistic way, is by convention the sign of Jacob, who, in his dream, saw angels ascending and descending by it.

'The background is taken from a drawing made by a friend in Palestine . . .'.

Unlike either Thomas Seddon or Holman Hunt, he had not travelled in the Near East and his approach to these Biblical subjects was that of a history painter relying on source books and the British Museum collection. Perhaps here in emulation of Holman Hunt and himself unable to paint before the motif, he was concerned to provide verisimilitude through correct topography: the landscape background to which he refers, used in both illustration and painting, has been identified by Allen Staley (pp.43–4, pl.52a) as after a watercolour of 'The Well of Enrogel' by Seddon, painted in Palestine in 1854 (Preston Art Gallery). Madox Brown had helped and advised Seddon on his work after his return at that time and probably acquired the watercolour (which may have been the undescribed watercolour by Seddon in Madox Brown's executors' sale, 29/31 May 1894, lot 114).

The artist was quick to seize on the pictorial possibilities of the drawings commissioned by Dalziel and planned to carry out both 'Jacob' and 'Elijah' in oil and watercolour versions. Like the Elijah subject the 'Jacob' was also chosen from the list sent him by the Dalziels in November 1863 and is noted in his MS Account Book as designed that year (FMBP). This date has been questioned as a pencil sketch for the composition (Birmingham, 788'06), which is the size of the final illustration, is dated 1855. This date, however, is very probably a mistaken later addition by the artist (nor is it an isolated instance of this). Even bearing in mind Madox Brown's connection with Seddon in 1854–5, the first conception can reasonably be ascribed to 1863–4 in agreement with the Account Book and on grounds of style. Jane Hauggard has, however, recently suggested a possible connection, in the 1855 period, with Charles Wells' *Joseph and his Brethren*, a poetic drama which Rossetti, certainly, early admired and wished (around 1849) to see republished with his and his friends' illustrations. Rossetti's design of 'Joseph accused before Potiphar' of 1860 (Birmingham; Surtees No.122) was probably intended for a frontispiece for a yet later projected new edition which proved abortive (J.B. Hauggard, 'A Pre-Raphaelite Shibboleth: Joseph', *The Journal of Pre-Raphaelite Studies*, III, No.1, November 1982). While this connection in the 1850s, for Madox Brown, seems altogether too tenuous, nevertheless the Rossetti drawing itself, of 1860, seems a certain source of inspiration and emulation for Madox Brown's own design. While in distinction to Rossetti's, the latter's is an outdoor scene full of variegated sunlight, the composition is similarly a very tight format with the standing group at the right half out of the picture and equally elaborate costume and textural details adding up to a decorative whole. Madox Brown may have seen another outlet for his Dalziel illustration in tandem with Rossetti in the abortive publication.

The oil painting was chosen by George Rae from the list of subjects sent him at Christmas 1863, but commissioned only in March 1864, for 450 gns. A 'cartoon' (untraced), apparently full-scale, was being worked on during the year and a watercolour sketch (possibly the Tate version) was also being started (Brown to Rae, 9 March 1864, LAG/RP). The pen and ink drawing for the Dalziels was itself only done in September–October 1864 (that is, subsequent to that for Elijah), and the oil was commenced immediately afterwards. However, the painting appears really to have got going only in September of the following year, after the artist was free of his one-man exhibition and resumed his diary which cryptically details his work on it section by section.

He had started on the drapery of Judah, and on Jacob and Joseph, and had made a necklace for Levi when he wrote on 5 October 1865 to Rae, by whom he had already been paid in full,

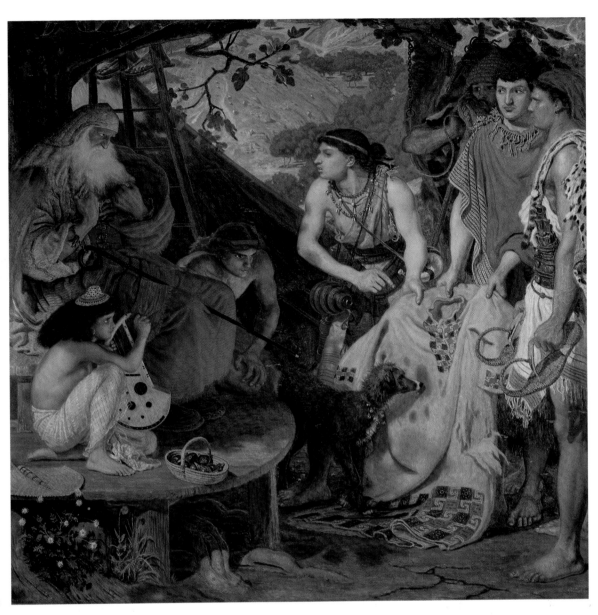

129

explaining his delay: 'As to myself & "Jacob" I have ordered his frame if that is any evidence of progress – This I have been unable to do till the other day because I could not make quite sure of the sight measure of the picture, as there was a margin of canvas to suit the requirements of the composition . . . Five of the figures, the camel & all the background are now in, all indeed that is intricate or difficult except the little girl. One reason why I do not get on quite so fast as I reckoned is that I find in a work of this size the elaborate small drawing I made [for Dalziels] is of next to no use, except as [a] previous study, I mean that though it has been of advantage to the work in helping to avoid errors, it is of no use to copy from. The flesh has all to be painted from nature & the draperies & accessories all to be placed again. The necklace for Levi I had to *manufacture* before I could paint it' (Hueffer, pp.207–8; LAG/RP).

On 28 September Holman Hunt called and then probably aired his superior knowledge of the Near East and carped at the introduction of the dog, the touch of which might be con-

sidered a defilement. He retracted his statement in a letter soon afterwards, citing other biblical sources and remembering that he had himself '*seen* the dogs allowed to exercise their natural instincts as watchdogs'. Madox Brown's reply was laconic (FMBP and HL). He continued to record each piece he worked at, the various men and their clothes and accessories, having models for Simeon and for Levi, and 'out to Zoological after Camel. Eveng general effect' (5 February 1866), until, with interruptions, he finished it in April and showed it in his studio on the 21 April and later at the French Gallery.

Rae was enthusiastic and hoped that he would concentrate on subjects from the Bible and Shakespeare for the future. Reviewers found it awkward (*Saturday Review*, 1867, pp.269–70) and eccentric and abnormal in style (*Art Journal*, 1866, pp.374–5) and the latter commented: 'We cannot deny genius to this work. Yet why it should be quite so peculiar and repellent we cannot pretend to say. The picture is just one of those performances about which artists and *dilettanti* are likely

to be intense one way or the other, either in the extreme of love or hate. As for the multitude we shall gratify the painter when we say that his picture is beyond them'.

Rae, who held on to his Rossettis, sold it privately in the 1870s. The watercolour of 1866–7 was bought by Frederick Leyland (now Tate Gallery), and an oil replica, commenced by the artist's children acting as studio assistants (letter to Shields, 29 January 1869, PUL, and to Lucy, 8 September 1869, UBC|AP) was finished in 1871 for William Brockbank of Manchester (now Museo de Arte, Ponce, Puerto Rico).

M.B.

DANTE GABRIEL ROSSETTI

130 **Venus Verticordia** 1864–8
Inscribed 'DGR' (in monogram)
Oil on canvas, $38\frac{5}{8} \times 27\frac{1}{2}$ (98 × 69.9)
Ref: Surtees No.173
Russell-Cotes Art Gallery and Museum, Bournemouth

Though commissioned in April 1864 it was only completed four years later. In June 1864 William Allingham saw Rossetti painting 'a very large young woman almost a giantess, as "Venus Verticordia"' (Allingham 1907, p.100). The figure appears slightly over life-size. The honeysuckle in the foreground was painted in August of this year and in the same month Rossetti wrote to Brown: 'What do you think of putting a nimbus behind my Venus's head? I believe the Greeks used to do it' (Doughty & Wahl, II, p.519). The painting was described, although 'not quite finished', in the *Athenaeum* of 21 October 1865 but in January 1868 Rossetti completely repainted the figure and head. In the same month he wrote a sonnet for it but it was only sent to the purchaser, J. Mitchell of Bradford, in September.

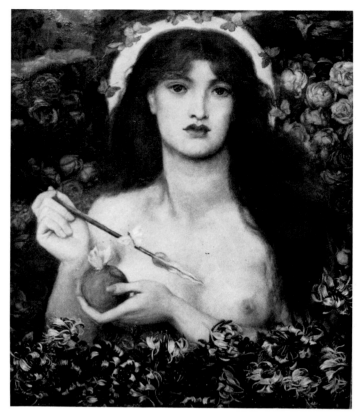

130

> She hath the apple in her hand for thee,
> Yet almost in her heart would hold it back;
> She muses, with her eyes upon the track
> Of that which in thy spirit they can see.
> Haply, 'Behold, he is at peace,' saith she;
> 'Alas! the apple for his lips, – the dart
> That follows its brief sweetness to his heart, –
> The wandering of his feet perpetually!'
>
> A little space her glance is still and coy;
> But if she give the fruit that works her spell,
> Those eyes shall flame as for her Phrygian boy.
> Then shall her bird's strained throat the woe fortell,
> And her far seas moan as a single shell,
> And through her dark grove strike the light of Troy
> (W.M. Rossetti 1911, p.210)

The Phrygian boy is Paris who awarded the golden apple to Aphrodite and was persuaded by her to woo Helen.

The composition of No.130 is of the same type as was established in works of *c*.1860 such as 'Regina Cordium' (No.114) and again there are fifteenth- and sixteenth-century prototypes, in this case possibly Van der Weyden's 'Antoine, Grand Batard de Bourgogne' which Rossetti may have seen on a visit to Brussels in September 1863. The red roses symbolise sensual love. Honeysuckle had sexual connotations for Rossetti because of its form and its attractiveness to bees (see his poems

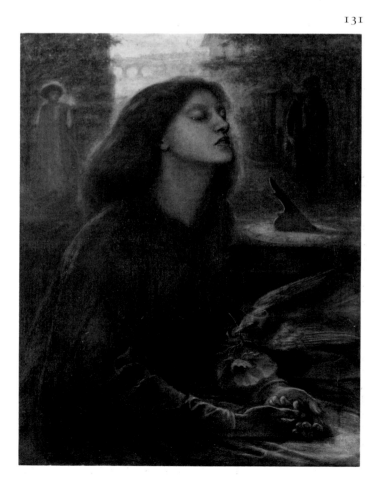

131

'The Honeysuckle' and 'Chimes' in W.M. Rossetti 1911, pp.199, 227). The blue bird, foretelling woe, is perhaps the blue bird which the ancients thought lived but a day. The butterflies drawn to the halo are souls, perhaps, of lovers already dead.

The subject was probably influenced by Swinburne with whom Rossetti was intimate during the first half of the sixties. The dominating *femme-fatale*, and contrasts, often shocking, between pagan, classical themes and Christianity occur frequently in Swinburne's contemporary poetry:

Wilt thou yet take all, Galilean? but these thou shalt
 not take,
The laurel, the palms and the paean, the breasts of the
 nymphs in the brake
('Hymn to Proserpine', lines 23, 24)

The description in the *Athenaeum*, ostensibly by F.G. Stephens, also closely resembles Swinburne's style and way of thought: 'She guards the apple with the threatening dart, while the Psyche, tremulous of wing, traverses its surface. Winner of hearts, she reeks not of the soul; fraught with peril, her ways are inscrutable; there is more of evil than of good in her; she is victorious and indomitable' (*Athenaeum*, No.1982, 21 October 1865, p.546). Ruskin was strongly disturbed by the picture (Ruskin, XXXVI, pp.490–1).

A.G.

DANTE GABRIEL ROSSETTI

131 Beata Beatrix *c.*1864–70
Inscribed 'DGR' in monogram
Oil on canvas, 34 × 26 (86.4 × 66)
Ref: Surtees No.168
Tate Gallery

Probably based on drawings of Elizabeth Siddal made before her death in February 1862; indeed the pose resembles that found in the earliest drawings of her made in 1851 for 'The Return of Tibullus to Delia'. In the winter of 1852–3 Rossetti was engaged on a picture in two parts: 'symbolizing in life-sized half-figures, Dante's resolve to write the *Divina Commedia* in memory of Beatrice' (Fredeman, p.98) This must have been abandoned but the beginnings were rediscovered by Rossetti in the winter of 1863 and were probably modified to form the basis of No.131. The picture was certainly well in progress in March 1866 (Surtees 1980, p.44) and was almost completed in the summer of that year, by which time it had been commissioned by the Hon. William Cowper-Temple (Doughty & Wahl, II, p.603). But for some reason it was not finally finished until the close of 1870. It was presented to the nation in 1889 by his widow, Lady Mount Temple, and was already by that date one of the artist's most celebrated works.

Rossetti himself described the subject in a letter of 11 March 1873: 'The picture must of course be viewed not as a representation of the incident of the death of Beatrice, but as an ideal of the subject, symbolized by a trance or sudden spiritual transfiguration. Beatrice is rapt visibly into Heaven, seeing as it were through her shut lids (as Dante says at the close of the Vita Nuova): "Him who is Blessed throughout all ages"; and in sign of the supreme change, the radiant bird, a messenger of death, drops the white poppy between her open hands. In the background is the City which, as Dante says: "sat solitary" in mourning for her death; and through whose street Dante himself is seen to pass gazing towards the figure of Love

opposite, in whose hand the waning life of his lady flickers as a flame. On the sundial at her side the shadow falls on the hour of nine, which number Dante connects mystically in many ways with her and with her death' (F. Horner, *Time Remembered*, 1933, p.25).

'Beata Beatrix' is markedly different from the 'fleshly' contemporary pictures modelled by Fanny Cornforth. Rossetti himself characterised it as 'a poetic work' (Doughty & Wahl, II, p.603) and there is no doubt that he thought of it as a memorial to his wife. He must have included a white poppy because she had died of an overdose of laudanum. F.G. Stephens, who published descriptions of Rossetti's works which were vetted by the artist, points out that the colours of the drapery, a green tunic over a dress of purple-grey, are 'the colours of hope and sorrow as well as of life and death' ('*Beata Beatrix* by Dante Gabriel Rossetti', *Portfolio*, XXII, 1891, p.46). The blurred effect of the background and radiation around the head may have been influenced by the idealised, 'soft focus' photographs of Julia Margaret Cameron, started in January 1864, which Rossetti greatly admired. Strangely, nobody has remarked on the phallic pointer of the sun-dial projecting towards the frozen ecstasy of Beatrice's face.

The subject of No.131 is made clearer by the inscriptions and decorations on its frame which was designed by the artist. At the bottom is the line from Lamentations 1.1, quoted by Dante in the *Vita Nuova* on the death of Beatrice: 'Quomodo sedet sola Civitas!'. At the top is the date of Beatrice's death, now partly erased: 'Jun: Die 9: Anno 1290'. And in the roundels are representations of the sun, the stars, the moon and the earth, referring to the last lines of the *Divina Commedia*: 'Love which moves the sun and the other stars'.

A.G.

DANTE GABRIEL ROSSETTI

132 The Blue Bower 1865
Inscribed 'DGR|1865' (initials in monogram)
Oil on canvas, $33\frac{1}{16} \times 27\frac{7}{8}$ (84 × 70.9)
Ref: Surtees No.178
Barber Institute of Fine Arts, University of Birmingham

On 18 April 1865 Rossetti wrote to Brown: 'I've begun an oil-picture all blue, for Gambart, to be called "The Blue Bower"' (Doughty & Wahl, II, p.552). The painting was finished by the start of October of that year. It is one of the culminating works in the series of bust-length pictures of beautiful women, set in a confined space, which began in 1859 with 'Bocca Baciata' (fig. iv, Surtees No.114). Fanny Cornforth was again the model. She wears a robe of green/blue opened at the front to reveal its lining of white fur. The blue, hexagonal tiles behind her are evidently of Arabic shape but are decorated with a Chinese prunus pattern. The vivid blue corn-flowers at the front are set off by the sharp yellow of the exotic musical instrument (a goto?). The restricted colour range perhaps shows the influence of Japanese prints such as Hokusai's 'Views of Fuji' which are also coloured in varying shades of blue. Like his friend Whistler, Rossetti is making a picture without a specific subject but which is a colour harmony. F.G. Stephens, writing in the *Athenaeum* of 21 October 1865 (pp.545–6), remarked that beyond the eastern tiles and passion flowers 'there is nothing to suggest subject, time or place. Where we thus leave off, the intellectual and purely

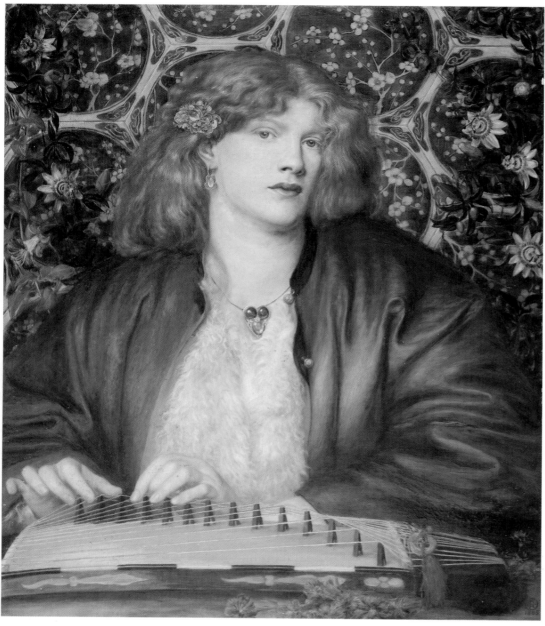

132

artistic splendour of the picture begins to develop itself. The music of the dulcimer passes out of the spectator's cognizance when the chromatic harmony takes its place in appealing to the eye'.

The dealer Gambart paid Rossetti £210 for No.132 and sold it a year later to Agnew for 500 gns.

A.G.

DANTE GABRIEL ROSSETTI

133 The Beloved 1865–6
Inscribed 'DGR | 1865 –6' (initials in monogram)
Oil on canvas, 32½ × 30 (82.6 × 76.2)
First exh: Arundel Club for one day, 21 February 1866
Ref: Surtees No.182
Tate Gallery

Although started in the early summer of 1863 as a 'Beatrice' subject it was changed in July to the Bride from The Song of

Solomon because Rossetti found the model's complexion too bright for his conception of Dante's Beatrice. At the bottom of the frame, which is decorated with wavy fronds and roundels and probably dates from 1873, is inscribed:

My Beloved is mine and I am his.
Let him kiss me with the kisses of his mouth:
for thy love is better than wine.
She shall be brought unto the King
in raiment of needlework: the virgins
that be her fellows shall bear her
company, and shall be brought unto thee.
(Song of Solomon 2. 16; Psalms 45. 14)

Burne-Jones had done eight cartoons from The Song of Solomon in 1862 but in fact Rossetti probably derived the idea for his subject from Dante, for Beatrice's appearance in the *Purgatory* is heralded by her attendants singing 'Veni sponsa de Libano'

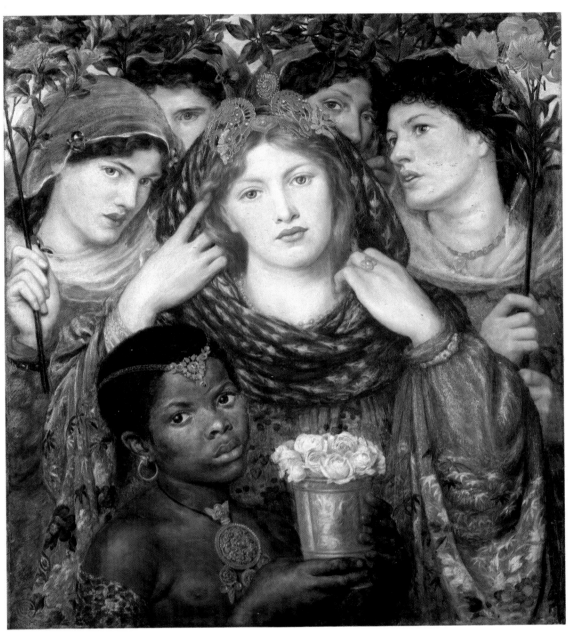

133

(*Purgatory*, Canto xxx, line 12).

No.133 was commissioned in 1863 by George Rae, for £300, but not finished until the winter of 1865–6. The model for the bride was Marie Ford. In March 1865 a 'green Japanese lady's dress' was painted on to her figure and at the same time a black boy replaced what had been a mulatto girl in the foreground (Surtees 1980, p.42). The picture was complete enough to be described in detail by F.G. Stephens in the *Athenaeum* on 21 October 1865 but some work went on into the winter. It was considerably altered by Rossetti in 1873 when the tone was changed and the heads of the bride and of the attendant on the right side and the bride's left hand were made more ideal (W.M. Rossetti 1889, p.55; a photograph of the picture in an early state is repr. in F.M. Hueffer, *Rossetti*, 1896, frontispiece).

As in 'The Blue Bower' (No.132) and 'Monna Vanna' (No.136) of the same period, Rossetti has taken care to 'embroider' a limited though bright range of colours through-out the picture. He uses rich, exotic details such as the Japanese costume and the bride's head-dress, which is evidently of Peruvian featherwork (Marillier 1899, p.132). The composition intentionally resembles the setting of a jewel or the furled petals of a rose. It was perhaps influenced by Titian's 'Allegory of Alfonso d'Avalos' in the Louvre, while the idea of including a black girl to set off the Caucasian features of the bride may have been suggested by 'Olympia' which Rossetti probably saw on a visit to Manet's studio in November 1864, the month before he painted the mulatto model.

F.G. Stephens' description in the *Athenaeum* emphasises that the subject is the power of women's beauty to move men: 'Coming near, she draws from before her face, with a graceful action of both hands, the bridal veil of blue and white . . . As she unveils, they [the attendants] look with different expressions for the effect of the disclosure on the coming man' (21 October 1865, p.546).

A.G.

WILLIAM HOLMAN HUNT

134 **The Festival of St Swithin** 1865–6, 1874–5
Inscribed 'Whh 66–75' (initials in monogram)
Oil on canvas, $28\frac{3}{4} \times 35\frac{7}{8}$ (73 × 91)
First exh: Colnaghi's 1866
Ref: Liverpool 1969 (39)
Visitors of the Ashmolean Museum, Oxford

134

Hunt wrote to Stephens from 1 Tor Villa, Campden Hill, Kensington (now Tor Gardens) on 12 May 1866: 'I am slaving away like a nigger to get that pigeon picture done which I think I shewed to you as my sisters work she – of course – gave the work up after I had spent about an hour per day upon it for the last eight or nine months – besides a good sum of money – as the design of the picture was my own and I was really interested in the subject I determined to save the picture from the fate which Emily's previous incomplete works enjoy of a place in my Mother's spare room so I adopted it – it is an aggravation to me in many ways to be thus delayed in my departure but at the best I have no little difficulty in arranging money matters for my journey and this picture had to be converted into cash either by her completion of it or my own – it is now I trust nearly done' (BL). Hunt needed funds not only to provide for his intended journey to the East and to keep his own family (he had married Fanny Waugh on 28 December 1865 and she was expecting a child), but also because the Consolidated Bank, in which he was 'a largish shareholder', failed at this time (Hunt to Stephens, 30 May 1866, BL). Moreover, ever since the death of his father in November 1856, Hunt had been financially responsible for his mother and unmarried sisters, of whom Emily (b.1836) was the youngest.

Hunt had moved into Tor Villa in the summer of 1857 with Emily (Hunt to Combe, 9 August 1857, BL). However, the house sharing was not continuous, as Hunt's letter of 5 June 1861 to Ford Madox Brown reveals: 'My sister is staying here now' (PC). Emily became Hunt's pupil, and on 11 May 1862 Hunt complained that his progress on 'The Afterglow' (No.87) was being held up by his having to advance her picture: 'when I get up from my own work to rest my eyes for a minute or two. I find my sisters work so backward that I have to labor at that' (BL).

Considering the difficulties Hunt encountered with the pigeons for 'The Afterglow' in 1862–3, it seems almost sadistic of him to have set Emily a similar task in 1865. Perhaps he felt that she needed the challenge, for he hoped that she might become a self-supporting artist (Hunt 1905, II, p.253). The pigeon house was in the garden of 1 Tor Villa so he could supervise her work without too much inconvenience; the high viewpoint of No.134 suggests that the work was painted from the studio. Emily may have abandoned the picture for reasons other than the sheer difficulty of the task: when Hunt returned from a short honeymoon in the new year of 1866 he was temporarily unable to move into Tor Villa with Fanny, 'because my sister is occupying the house and won't give it up' (Hunt to Stephens, 11 February 1866, BL). After such a fracas it seems unlikely that Emily would have continued working on No.134.

Her part in 'The Festival of St Swithin' was explicated in Hunt's letter of 19 June 1868, addressed, presumably, to John Heugh, the first private owner of the painting: 'My sister . . . was about two or three years since staying with me at Kensington – at that time I suggested to her this subject – one which in nature had frequently amused me – and I pointed out how while in my house she might conveniently undertake the subject under my daily direction. to combat her objections to

the task I designed the subject. I chose the canvas I bought the pigeon house – having it fitted up close to a convenient window – and I selected the pigeons to be introduced into the picture – and I then commenced the painting – not with mere sketching out but with the complete painting of particular birds . . . Having brought the picture to a very forward state in all parts then commenced I left my sister with it for a fortnight while I went into the country [presumably on his honeymoon] – on my return she was thoroughly disheartened by the difficulty of the task and she declared her determination to relinquish it – At that point I had to choose between throwing away all my labor – with what I then thought and still think a very good and very original subject – or making the picture my own. I determined to do the latter. my first step was to erase every bit of work not done by myself – and then to return to the parts done myself and carry them to a higher pitch than would have been at all necessary had the picture to have been exhibited in my sister's name. By the time it was completed I had in addition to the first time I had given to it spent three months of the best part of the year upon it, I had obliterated every touch not done by myself – and had finished [it] more highly than any picture I had ever painted – '(PML). Although No.134 is no doubt an original idea, the subject may have been partly inspired by another view from an artist's 'back window', Ford Madox Brown's 'An English Autumn Afternoon' (No.51), which Hunt and Emily would have seen at Brown's 1865 one-man show.

No.134 took Hunt longer to complete than he had anticipated. In true Pre-Raphaelite fashion, he was constrained to wait for the right meteorological conditions, as he informed William Bell Scott on 29 June 1866: 'I am in distress for want of rain to finish my pigeon picture floods come in the night and in the circle of neighbourhoods nigh in the day time but here altho appearances are so strong that I am induced to wet my picture all over not a drop comes for my purpose –'(PUL). The lease of 1 Tor Villa had reverted to James Clarke Hook on 25 June, but, Hunt continued, 'I am hanging on a few more days for the hope of finishing'. Rain came soon afterwards and Hunt's hope was gratified.

Although Hunt's letter to (?) John Heugh (PML) mentions that he then approached Lewis Pocock (the dealer and former owner of the oil sketches for 'Claudio and Isabella' and 'Valentine rescuing Sylvia') as a potential buyer, it seems that No.134 was actually purchased by Colnaghi's. It was exhibited at their premises by the end of July 1866, according to F.G. Stephens'

notice in the *Athenaeum* (28 July, p.121). Colnaghi's tried unsuccessfully to sell the picture at auction (Christie's, 16 March 1867, lot 989, bought in at 540 gns) before exhibiting it at the 1867 Royal Academy (No.364), where it was 'hung on the line in the middle room' (Millais to Hunt, 17 May 1867, HL) and received good notices (e.g. *Athenaeum*, 11 May 1867, p.628; *Art Journal*, 1 June 1867, p.143). On 25 April 1874, Hunt, dismayed by the poor prices his works had been fetching at auction (Hunt to J.L. Tupper, 2 June 1874, HL), purchased 'The Festival of St Swithin' from John Heugh's sale at Christie's (lot 151) for £367.10s.

In September to early November 1874 Hunt took advantage of his friend Alfred William Hunt's absence on a painting trip to borrow his old studio at 1 Tor Villa (Hunt to A.W. Hunt, 30 August 1874, and to Mrs A.W. Hunt, 7 November 1874; MSS, Cornell University Library). Although Holman Hunt was principally engaged in painting portraits of his son Cyril (possibly an untraced work rather than the portrait in the Fitzwilliam Museum, exh. Liverpool 1969, No.54) and his fiancée Edith Waugh (untraced) at this time, he may, while in his former studio, have repainted parts of No.134 (Hunt to J.L. Tupper,

4 November 1874, HL, mentions coming to the end of a third, unspecified, task). It is possible that the pigeon on the roof of the cote and the two pigeons on either side of its lower ledge were added at this period: none of them is mentioned in F.G. Stephens' detailed description of the birds in the *Athenaeum* of 28 July 1866 (p.121), and the fact that Hunt included '-75' on the upper ledge of the pigeon house after the original monogram and date suggests that the reworking was fairly significant. There is no specific reference to retouching No.134 in Hunt's correspondence of 1875, but letters to Tupper of 3 April and 4 June mention the difficulties he was encountering in trying to finish tasks other than Cyril's portrait (HL).

Mrs Combe probably purchased 'The Festival of St Swithin' from the artist before he left England on 5 November 1875. She wrote to him on 22 August 1876 that the picture 'delights me more and more, and I am not singular in appreciating it so very highly' (BL). Apart from the accomplished bird painting and rendering of the roof of the pigeon house, shimmering in the driving rain, No.134 provides an interesting record of mid-nineteenth century 'villa' architecture in northern Kensington.

J.B.

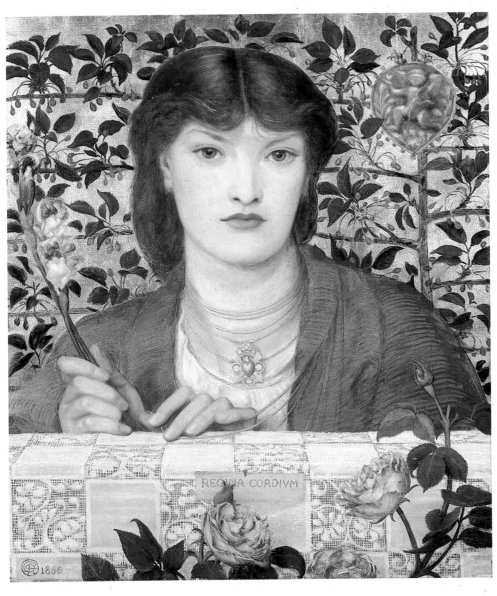

135

DANTE GABRIEL ROSSETTI

135 Regina Cordium 1866
Inscribed 'DGR 1866' (initials in monogram) and
'REGINA CORDIVM' on the cartouche
Oil on canvas, 23½ × 19½ (59.7 × 49.5)
Ref: Surtees No.190
Glasgow Art Gallery and Museum

One of the last and most highly developed of the series of
paintings of bust-length women in confined layers of space
which began in 1859 with 'Bocca Baciata' (fig.iv, Surtees
No.114). Rossetti plays off nature and artifice. The 'realistic',
red/pink roses in the foreground contrast with the flat, stylised
plants on the lace covering of the parapet. The espalier cherry
on the gold background carries a heart-shaped medallion of a
blindfolded cupid. The sitter was Alexa Wilding. The frame is
original except, probably, for the black fillet. The picture was
commissioned by J. Hamilton Trist for £170.

A.G.

DANTE GABRIEL ROSSETTI

136 Monna Vanna 1866
Inscribed 'DGR 1866' (initials in monogram)
Oil on canvas, 35 × 34 (88.9 × 86.4)
Ref: Surtees No.191
Tate Gallery

One of a group of sumptuous, decorative pictures, of which
'The Beloved' (No.133) is another example, painted in the mid-
sixties in celebration of women's beauty. The model is Alexa
Wilding whom Rossetti started to use in the spring of 1865.
No.136 was painted during the summer of the following year
and was retouched in 1873. The spiral pearl clasp and red coral
necklace are among the artist's most often used decorations
and here provide a *leit-motif* for the overall, circular com-
position. The white and gold drapery is also used in other
pictures of this date, for example 'Monna Rosa'. Here it is made
up into a great sleeve which recalls that in Raphael's portrait of
'Giovanna of Aragon' in the Louvre'. The title 'Monna Vanna'

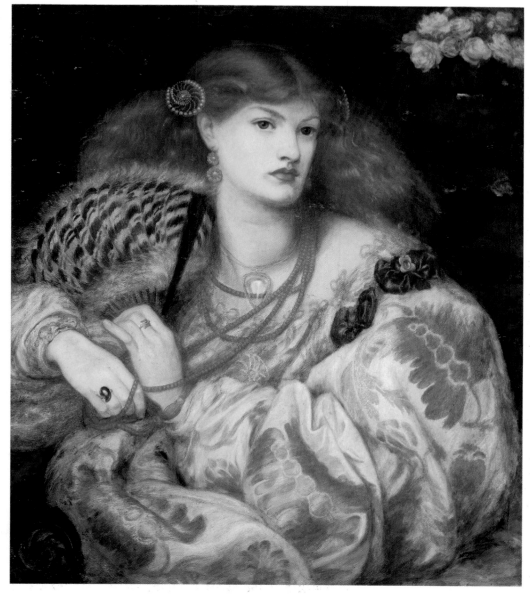

136

does not refer to a specific subject, though the name occurs in Dante and Boccaccio, but was chosen after the picture was finished because of its Italian connotations. Rossetti himself considered it had Venetian qualities and originally titled it 'Venus Veneta': 'I have a picture close on completion – one of my best I believe, and probably the most effective as a room decoration which I have ever painted. It is called 'Venus Veneta', and represents a Venetian lady in a rich dress of white and gold, – in short the Venetian ideal of female beauty' (27 September 1866, Doughty & Wahl, II, p.606).

The first owner was the Cheshire patron W. Blackmore, who also bought 'Fazio's Mistress' (No.123), but who soon passed them on to George Rae of Birkenhead, one of Rossetti's most important patrons and from whose collection came many of the Tate's Rossettis. The frame of No.136 is original and is in two parts, an outer box of reeded black barred with gold and an inner flat decorated with a wavy frond pattern.

A.G.

FORD MADOX BROWN

137 The Entombment 1866–8
Inscribed 'FMB 68' (initials in monogram)
Oil on canvas, 21¾ × 19 (55.3 × 48.2)
First exh: *Grand Loan Exhibition*, Walker Art Gallery, Liverpool, 1886 (1164)
Faringdon Collection

'The golden Aurioles or Nimbuses are not intended to represent facts but rather that traditional glory which for all good Christians attaches to certain of the greater personalities in the divine drama or legend . . . The Tomb itself is formed according to the most recently received archaeological views . . . St. John & Nicodemus (the latter but half seen) bear the body of Jesus to the Tomb. St. Mary Magdalen (with her long hair, with which she wiped the Saviour's feet) is depicted near his feet. St. Mary Virgin has her face concealed with his handkerchief; the third female is the one known in the holy story as St. Mary Altera literally *the other* Mary. St. Joseph of Arimathea, a rich man who partly supplied the expenses of the internment, is the remaining figure . . . A French Critic [source untraced] . . . remarked that the only half-closed eyes of Jesus (an unusual though truthful mode of representation) seemed like a foretoken of the resurrection. Such was not the artist's conception . . . yet it may unconsciously have guided him' (note by the artist for Charles Rowley, post 1883, Horsfall Papers, MAG).

Out of the artist's steady production of cartoons for church glass for the Morris Firm, to which he belonged as a founder member, 1861–75, came this theme for the most deeply emotional painting of his later years. His cartoons were distinctive for their dramatic energy and contained movement, gained through a fluent linearism appropriate to the two-dimensional needs of stained glass (see A.C. Sewter, *The Stained Glass of William Morris and his Circle*, 1974, I, pp.68–72). His later painting style took on much of their sensuous and decorative rhythmic qualities. Madox Brown viewed his cartoons as his raw material but paintings were dependent on commissions and although he had other religious subjects in mind ('Christ and Little Children', a 'Nativity', 'The Supper at Emmaus', which was carried out as a watercolour 1875–6, and 'The Baptism of St. Oswald', which was much later transposed into part of 'The Baptism of St. Edwin' in Manchester Town Hall), this subject was the outstanding outcome of the 1860s.

It was designed initially as a cartoon in 1865 for St Olave's, Gatcombe, Isle of Wight (Sewter, *Catalogue*, p.78 and pl.252). The subject combines an Italianate concept of composition with an all-enveloping sinuous linear pattern in the draperies. These both enfold the mourning figures and emphasise the movement into the tomb within a limited depth. The potential in terms of painting has been fully grasped and the colour is deliberately rich and sombre. Stylistically it heralds the Aesthetic movement.

The cartoon itself is lost (and does not appear in Hueffer's lists). A watercolour was begun in February 1866 for a commission afterwards retracted, with additional figures of watching children on the right and a view of the Cross, which provided additional depth; a pen and ink study from the cartoon was commissioned for an illustration to *Lyra Germanica* in July 1866; and this oil, similarly following the original design, was also perhaps begun that month. Both oil and watercolour awaited a client before being much proceeded with and were on offer to various patrons during the next few months. This oil was finally completed for one of the artist's small circle of new patrons, Frederick Leyland of Liverpool (introduced by Rossetti), in July 1868 for £210. The watercolour was finished in 1869 for James Leathart of Newcastle (Leathart family collection). A later watercolour of larger format and with the additional figures, which was to become the best known through exhibitions (now National Gallery of of Manchester and completed 1870–1. Craven and his wife did not like the nimbuses in their picture and the artist 'softened' them but did not wish to make any other alterations; he got it back in 1878 and sold it the same year to Charles Rowley of Manchester and it was apparently exhibited in Paris (correspondence with various clients, FMBP, LAG/RP).

All the versions were admired by the artist's friends for their

137

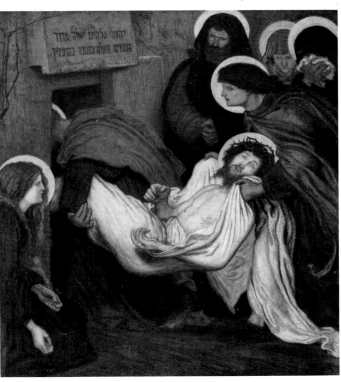

fine colour. Leathart considered his, for its colour, to be Madox Brown's best work and hung it beneath Rossetti's 'Paolo and Francesca', which he considered, he wrote in December 1869, 'the finest piece of colour in English art, and I am happy to say does not suffer from this ordeal' (UBC/LP). Frederic Shields, as artist friend of both Madox Brown and of Craven at Manchester, commented on the 'solemn beauty' of that version and admired especially 'the invention which has cast a warm glow of sunset over the torso of the dead body of Christ' (8 March 1871, FMBP); and the *Athenaeum* (14 December 1878, when it was on show in Bond Street) thought it a 'design of rare dignity, pathos and perfect originality . . . perhaps the artist's masterpiece and stands on a level with if not superior to "The Last of England" and "Elijah and the Widow's son"'. On this oil version Leyland made no comment at all in writing but was prompt in payment.

M.B.

WILLIAM HOLMAN HUNT

138 Isabella and the Pot of Basil 1866–8, retouched 1886
Inscribed 'Whh. FLORENCE. 1867.' (initials in monogram)
Oil on canvas, $73\frac{1}{2} \times 45\frac{1}{2}$ (187×116)
First exh: Gambart, King Street, St James's, 1868
Ref: Liverpool 1969 (41)
Laing Art Gallery, Newcastle upon Tyne (Tyne and Wear County Council Museums)

Hunt arrived in Florence with his pregnant wife Fanny in September 1866; owing to a cholera epidemic at Marseilles, they were unable to pursue their intention of travelling to the East (Hunt 1905, II, p.255). On 9 October Hunt wrote to Stephens that he was 'making arrangements about a Studio . . . At first I confess the necessity seemed to me to be a very hard one but by good luck I have bethought myself of a delicious subject and this gives me a hope of keeping the sieve from emptying itself . . . and I am thus reconciled to my lot' (BL). The 'delicious subject' of Isabella mourning her dead lover, whose head is buried in the pot she is cradling, was well suited to Hunt's residence in Florence, as this enabled him to illustrate Keats' poem with the correct setting and accessories and to use Italian models for the figure. The letter to Stephens suggests that No.138 was partly conceived as a viable financial proposition: Hunt's half-length, life-sized 'Il Dolce far Niente' (Forbes Magazine Collection, repr. Hunt 1913, II, p.156) had been sold to Thomas McLean soon after its completion in 1866, and the artist was well aware that a life-sized female figure on the scale of 'The Afterglow' (No.87) would prove extremely saleable.

Fanny Holman Hunt gave birth to a son on 26 October 1866. She was extremely ill but, as Hunt informed Stephens on 10 November, was expected to survive. He continued: 'Here I must do a serious and large picture to stand on its own merits' and mentioned that he had begun 'a lovely subject' which he hoped to finish in time for the 1867 Exposition Universelle (BL). Fanny's condition, however, deteriorated, and on 20 December she died of miliary fever. Thereafter No.138 became not only a celebration of the love Hunt had experienced during his year-long marriage, in the sensuality of the figure of Isabella, but also an expression of the anguish of his bereavement. He wrote

to W.M. Rossetti on 14 January 1867: 'I am now trying to get to work . . . If the daily painting will keep me from falling into drear melancholy I must trust to that for a time –'(UBC/AP). By 1 February Hunt had evolved a strict regime of leaving for his studio at 8 a.m. and working there until 5.30 p.m.: 'I bless God that I am not an idle man for then I don't know how I could bear the weight of my sorrow, now tho' all the day long my mind has a burden of grief singing thro' it I can direct it to work . . . and this with less difficulty because she for whom I suffer – sat at my side – while I planned the task I am doing, and she expressed her interest in it from the first almost to the last day of her illness. I will not forego my determination – made when I married – to rouse myself to work better than ever I have yet done –' (Hunt to Combe, JRL).

The artist returned to London with his baby son in September 1867, and No.138 arrived at the studio Hunt had rented at 13 Upper Phillimore Gardens on 6 November (Hunt to F.G. Stephens, BL). Hunt informed J.L. Tupper on 19 November that he was 'engaged in finishing with glazes and delicate touches' the picture, which had already been sold to Gambart (HL). The sum of £2500 mentioned in D.G. Rossetti's letter of 7 July 1868 to Alice Boyd (Doughty & Wahl, II, p.660) was the price of No.138 together with the sketch (Society of Fine Arts, Wilmington, Delaware), one third the size of the original, which had been begun in Florence by a copyist (Hunt to John Wharlton Bunney, January 1868, published in Bennett 1970, pp.40–1) and was worked on by Hunt in London concurrently with No.138. Gambart probably thought that the life-size picture was virtually finished when he purchased it, but Hunt decided that certain changes were needed, principally on the face, and also in the colour of the curtains, 'the restricted fulness of the blue bed-coverlet', and 'the amount of atmosphere of the inner room' (Hunt to Bunney, 25 November 1867, ibid., p.40). Once these alterations were begun, the repainting was delayed by bad light, and No.138 was only finally completed in late January or early February 1868.

The picture depicts Isabella worshipping at a shrine she has erected in her lover's memory, and this idea was probably inspired by George Scharf's illustration to 'Isabella, or the Pot of Basil', in Moxon's 1854 edition of Keats' poems, which also contains a *prie-dieu* and altar-cloth (p.209). The inlaid *prie-dieu* of No.138 had been purchased by Hunt just before Fanny's death (Diana Holman-Hunt, *My Grandfather, His Wives and Loves*, 1969, p.254), while the exquisite embroidery of the altar-cloth, with its roses and passion-flowers, Latin texts and prominently displayed 'Lorenzo', recalls the second stanza of Keats' poem: 'Her lute-string gave an echo of his name, | She spoilt her half-done broidery with the same'. The glass chandelier dimly burning above the 'altar' indicates that the scene is set in the early hours, in illustration of stanza 53:

> And she forgot the stars, the moon, and sun,
> And she forgot the blue above the trees,
> And she forgot the dells where waters run,
> And she forgot the chilly autumn breeze;
> She had no knowledge when the day was done,
> And the new morn she saw not: but in peace
> Hung over her sweet Basil evermore,
> And moisten'd it with tears unto the core.

Isabella's long dark tresses not only drape themselves round the pot of basil but actually intermingle with its soil, giving the lie to Marvell's 'The Grave's a fine and private place, | But none I think do there embrace'; while the grisly contents of the vase, which Hunt has transformed from Keats' 'garden-pot' into an

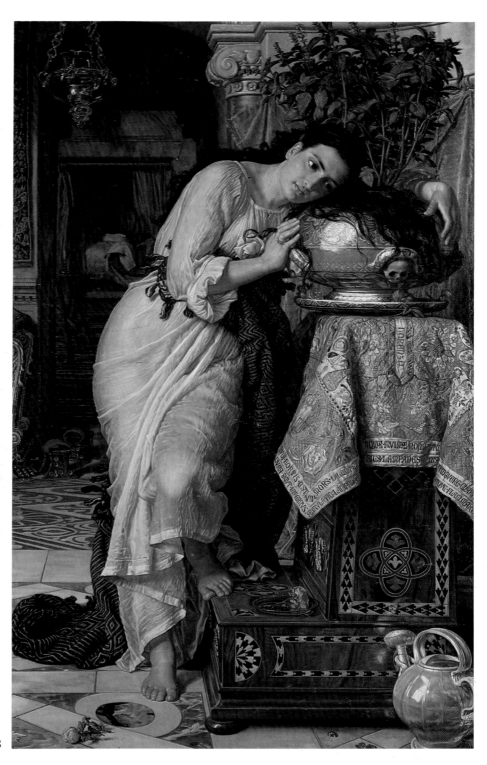

138

elaborate piece of maiolica, are indicated by the skulls' head handles. The vase was, according to Bernard Cracroft's article in the *Fortnightly Review* of 1 June 1868, designed by the artist, who 'had it cast, painted it himself, obtained a fragment of mayolica to study the glaze, and then painted from the model so created' (n.s., III, p.657).

The luxuriantly sprouting basil seems to indicate that Lorenzo's murder occurred some time before the scene depicted in No. 138. However, only a certain paleness of complexion suggests the effect on Isabella's health, and Hunt has here departed from his source, which states that she pined away and eventually died. Hunt probably decided to depict a blooming Isabella in order to point up the tragedy and also to suggest the passionate nature of her former relationship with Lorenzo.

The exhibition of 'Isabella and the Pot of Basil' opened in mid-April 1868 at Gambart's King Street premises, and the painting was generally well received, although the depiction of the figure did come in for a fair amount of criticism (e.g. F.G.

Stephens in the *Athenaeum*, 18 April 1868, p.566; *Illustrated London News*, LII, 25 April 1868, p.418). No.138 was sold by Gambart in April 1870 to James Hall of Newcastle for £1550 (Maas, p.219; Hall may have bargained with the dealer, for W. Bell Scott's letter of 21 March 1870 to James Leathart mentions the sum of £2000: UBC/LP). Hunt cleaned and varnished No.138 in March 1886, just before it was exhibited in his retrospective at the Fine Art Society (William Hayward, *James Hall, of Tynemouth. A Beneficient Life of a Busy Man of Business*, 1896, I, p.147; Hunt to ?Marcus Huish, 14 March 1886, MS, Fitzwilliam Museum Library). By this date the image had been so widely disseminated in the form of Blanchard's engraving (published in 1871) that *The Times* of 15 March 1886 could describe No.138 as 'a picture which has long since become the classic rendering in art of this last episode of Keats's poem' (p.12).

J.B.

DANTE GABRIEL ROSSETTI

139 Mariana 1868–70
Inscribed 'DGR 1870' (initials in monogram)
Oil on canvas, 43 × 35 (109.2 × 88.9)
Ref: Surtees No.213
Aberdeen Art Gallery and Museums

This was started in 1868 at the same time as a related 'Portrait of Mrs William Morris' (Surtees No.372). The startlingly rich blue dress is found in both works. No.139 was commissioned by William Graham for £500. The subject is from *Measure for Measure*, Act IV, Scene i, and shows Mariana listening to a boy's song which reminds her of her cold-hearted lover Angelo's neglected promise to marry her. Rossetti may also have had Tennyson's poems from the same source in mind. The subject, like that of the contemporary painting 'La Pia' (No.153), for which Jane Morris also sat, had a personal

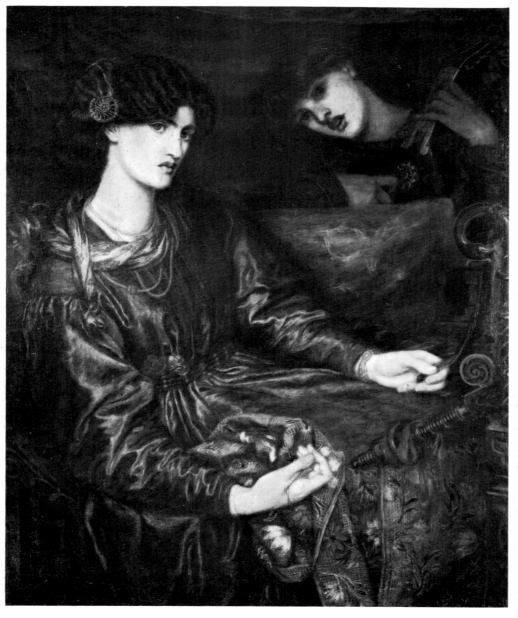

139

relevance for both artist and sitter. The lines from Shakespeare's song are inscribed on the contemporary frame:

Take, O take those lips away,
That so sweetly were forsworn;
And those eyes, the break of day,
Lights that do mislead the morn:
But my kisses bring again,
 Bring again;
Seals of love, but seal'd in vain
 Sealed in vain.

<div align="right">A.G.</div>

JOHN EVERETT MILLAIS

140 Chill October 1870
Inscribed 'JM 1870' (initials in monogram)
Oil on canvas, $55\frac{1}{2} \times 73\frac{1}{2}$ (141 × 186.7)
First exh: R.A. 1871 (76)
Ref: R.A. 1967 (76)
Private Collection

The first of the large-scale Scottish landscapes Millais painted periodically throughout his later career. Usually autumnal and often bleakly unpicturesque, they evoke a mood of melancholy and sense of transience that recalls his cycle-of-nature paintings of the later 1850s, especially 'Autumn Leaves' (No.74) and 'The Vale of Rest' (No.100), though with little or no symbolism or human activity to point up their meaning.

No.140 shows a view across a backwater along the north bank of the Tay at Kinfauns, just below Perth. The artist and his wife Effie had lived in Perth for a few years after their marriage and still regularly visited the place to stay with Effie's parents at their home, Bowerswell. According to Spielmann (p.118), Millais used to say that 'there is more significance and feeling in one day of a Scotch autumn than in a whole half-year of spring and summer in Italy'. J.G. Millais (II, p.29) quotes the artist's own note of 18 May 1882 pasted on the back: 'The scene,

simple as it is, had impressed me for years before I painted it. The traveller between Perth and Dundee passes the spot where I stood. Danger on either side – the tide, which once carried away my platform, and the trains, which threatened to blow my work into the river. I chose the subject for the sentiment it always conveyed to my mind, and I am happy to think that the transcript touched the public in a like manner, although many of my friends at the time were at a loss to understand what I saw to paint in such a scene. I made no sketch for it, but painted every touch from Nature, on the canvas itself, under irritating trials of wind and rain. The only studio work was in connection with the effect'.

It was bought on 23 February 1871 by the dealer Agnew, along with the figure subject 'Yes or No?' (Yale Center for British Art), for a total of £2000. Agnew's sold it on 10 May 1871 to the Manchester textile manufacturer Samuel Mendel and in 1882 published an etching of it by A. Brunet Debaines.

<div align="right">M.W.</div>

DANTE GABRIEL ROSSETTI

141 The Boat of Love 1871–2
Inscribed 'Guido vorrei che tu e Lapo ed io'
Oil (brown monochrome) on canvas,
49 × 37 (124.5 × 94)
Ref: Surtees No.239
Birmingham Museum and Art Gallery

This illustrates a sonnet addressed by Dante to Guido Cavalcanti describing an idyllic voyage to be made by Dante, Guido, another poet and their three ladies. The sonnet was translated by Rossetti and published in his *Early Italian Poets* in 1861. He was strongly attracted to the subject and made a drawing of it as early as *c*.1848 (Surtees No.239G) and began a large watercolour in 1855–6 (Surtees No.239C). This oil monochrome was probably executed by March 1872. He seems to have regarded it as a counterpart, a scene of happy wish

140

141

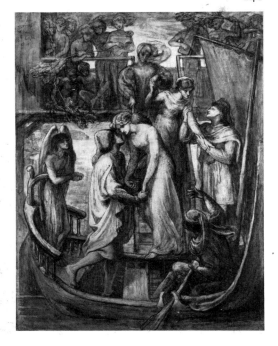

fulfilment, to the tragic scene of 'Dante's dream at the time of the death of Beatrice' which also occupied him in 1855–6 and again, in his largest oil, in 1870–71.

Rossetti described the subject to Frederick Leyland in a letter of 24 December 1871: 'Dante and his two friends are in the enchanted ship, while Love brings Beatrice and two other ladies down the steps of a pier to join them for their love-voyage. . . The pier, river, and city beyond, with the ship in the foreground, and a row of children along the pier at the top of the picture, bearing branches for love-pageant, make a delicious ensemble' (*Art Journal*, 1892, p.250). Rossetti's assistant, H.T. Dunn, built an elaborate model ship based on one in Lasinio's Campo Santo engravings. But, although Leyland commissioned a painting of the subject and then William Graham a reduced version, Rossetti gave up the idea because he thought a large work needed a 'central tragic interest' and this the subject lacked (ibid., p.251). He was worried that Burne-Jones's 'Golden Stairs' (No.154), designed in 1872, would destroy the originality of the composition (H.R. Angeli, *Dante Gabriel Rossetti: His Friends and Enemies*, 1949, pp.35, 36). Compared with the version of the subject begun in watercolour in 1855–6 this conveys a mood of sensual lethargy and dreamlike enervation. The drawings of Fuseli and Michelangelo, both admired by Rossetti now, were probably influential.

A.G.

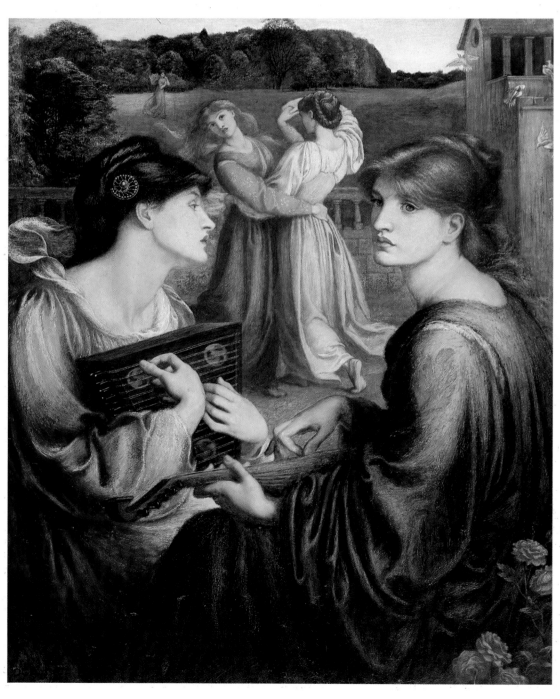

142

DANTE GABRIEL ROSSETTI

142 The Bower Meadow 1871–2
Inscribed 'D G Rossetti | 1872'
Oil on canvas, $33\frac{1}{2} \times 26\frac{1}{2}$ (85.1 × 67.3)
Ref: Surtees No.229
City of Manchester Art Galleries

This was in progress in December 1871 when its composition was different as it showed 'two ladies . . . playing music, while Love holds a song bird whose music chimes with theirs' (*Art Journal*, 1892, p.249). There is a pen drawing corresponding to this description in the Ashmolean (Surtees No.229B). The finished picture was sold on 2 June 1872 to Pilgeram and Lefevre for £735 who sold it soon afterwards to Walter Dunlop (W.M. Rossetti 1895, I, p.307). It was painted on part of a canvas, containing a fragment of landscape of distant trees, which Rossetti had started as a Dante subject at Sevenoaks in 1850. The composition resembles that of an early Italian painting of musical angels. There is a carefully ordered symmetry in the poses of the women and in the colouring of their dresses and their hair. It was possibly influenced by Burne-Jones's 'The Mill' of 1870 but it must be remembered that 'The Mill' reflects Burne-Jones's admiration for Rossetti's illustration 'The Maids of Elfen-Mere' and that Rossetti had written a sonnet on Mantegna's 'Parnassas' in the Louvre as early as 1849. No.142 was first offered to Frederick Leyland, a keen amateur musician, who bought the contemporary picture 'Veronica Veronese' which has a related subject. The sitters were Alexa Wilding and Marie Stillman.

A.G.

WILLIAM HOLMAN HUNT

143 The Shadow of Death 1870–3, retouched 1886
Inscribed '18 Whh 70–3 | JERUSALEM' (initials in monogram)
Tempera and oil on canvas,
$84\frac{5}{16} \times 66\frac{3}{16}$ (214.2 × 168.2)
First exh: Agnew's 1873
City of Manchester Art Galleries

Hunt arrived in Jerusalem on 31 August 1869 and informed Stephens that 'I have been working at some subjects in my head which I intend to undertake here' (BL). His reading of Renan's *Vie de Jésus* did not shake the artist's Christian beliefs (ibid.) but may have encouraged him to undertake a major work depicting Christ as a young adult working in a carpenter's shop. The originality of the conception was very important to Hunt: 'with my particular picture and old religious priest teaching I see nothing at all in common, and I should think that so far from any ecclesiological school being pleased with it that it is more fitted by itself for the Renan class of thinkers who have been studying the life of Christ as one particular branch of history – . . . my picture is strictly – as the Temple picture [No.85] was – *historic* with not a single fact of any kind in it of a supernatural nature, and in this I contend it is different for [*sic*] all previous work in religious art' (Hunt to unidentified correspondent, after 30 October 1872, fragment; BL). The final phrase underlines that Hunt certainly regarded No.143 as a work of religious art: the preparatory compositional drawings (private collection, Germany, and National Gallery of Victoria, Melbourne, both repr. Bennett 1970, p.53, fig.17) reveal that the Virgin's inspection of the gifts of the Magi,

recalling Christ's birth, and her apprehensive gaze at the shadow of the Cross projected on to the back wall of the hut, prefiguring his Crucifixion, were part of the original idea. The conception of Christ as a humble worker can be related both to Carlyle's strictures on 'The Light of the World' (No.57) for failing to embody his idea of the Saviour 'toiling along in the hot sun' (Hunt 1905, I, p.358) and to the sage's emphasis on the nobility of manual labour (in, e.g., *Past and Present*). Hunt felt that in No.143, Christ's life 'furnishes an example of the dignity of labour' (*Mr. Holman Hunt's picture, "The Shadow of Death"*, 1873, p.3: this pamphlet was almost certainly written by the artist), and he was especially gratified by the popularity of the picture among the working classes, both in Jerusalem (diary of 13 June 1872, JRL) and England (Hunt 1905, II, p.310).

Hunt began painting the subject in October 1869 in Bethlehem, but used a smaller canvas (Leeds City Art Galleries, exh. Liverpool 1969, No.45, repr.) than that of No.143, as this could be transported to 'carpenters shops and other places where the proper accessories could be found and it enabled me to try experiments with the effect and composition' (Hunt to J.L. Tupper, July 1870, HL). Hunt returned to Jerusalem and began No.143 in April, 'laying in the whole of the big picture' in tempera before painting it in oils (Hunt to Combe, 20 April 1870, BL). The artist worked on both versions concurrently, and although he used brushes a yard long for No.143 (Hunt to J.L. Tupper, July 1870, JL), and was at first sanguine of his chances of finishing the large picture in time for the 1871 exhibition season (e.g. Hunt to Lear, 21 September 1870, JRL), he came across tremendous difficulties. These were partly owing to his having 'so many fixed conditions imposed by the need of making the subject [i.e. symbolism] evident that at every pass something desirable is forbidden' (Hunt to J.L. Tupper, 30 June 1871, HL), but largely a result of his determination to capture faithfully the impression of the setting afternoon sun. Although Hunt could work indoors on the accessories when the weather was poor (e.g. Hunt to Combe, 9 February 1871, JRL), the models had to pose on the roof of his house in Jerusalem, where a movable wooden hut was constructed in an attempt to regulate the light (Hunt 1905, II, p.287). However, as Hunt's diary entry of 29 February 1872 suggests, the ideal of truth to nature on a canvas the size of No.143 was virtually unattainable: 'one cause of my difficulty in finishing this picture is that to get the light right from the Sun as it shifts from summer to winter and morng to evening I have to change my position with every day. and with every change there is an alteration of effect and form and every time nature looks so much better – and so exclusively indeed the only right thing that I can't resist changing my picture more or less –' (JRL).

The whole process of painting became a struggle 'with the powers of chaotic darkness' (Hunt to Combe, 4 September 1871, BL), with Hunt continually making changes on both versions and thinking that he was on the point of finishing, only to find that further corrections had to be made (see his diary of 1872, JRL). The artist's loneliness and lack of self-confidence, engendered by the problems he had encountered, pushed him to breaking point; he even contemplated destroying No.143, but realised that 'were it the best picture that ever was painted – after the long term of unhappiness it has caused me I should hate it to a degree that would prevent me from seeing any but defects in it' (Hunt to Combe, 25 March 1872, BL).

At least three different models, the chief of whom was Hunt's cook Miriam, posed in Jerusalem for the Virgin, and at least

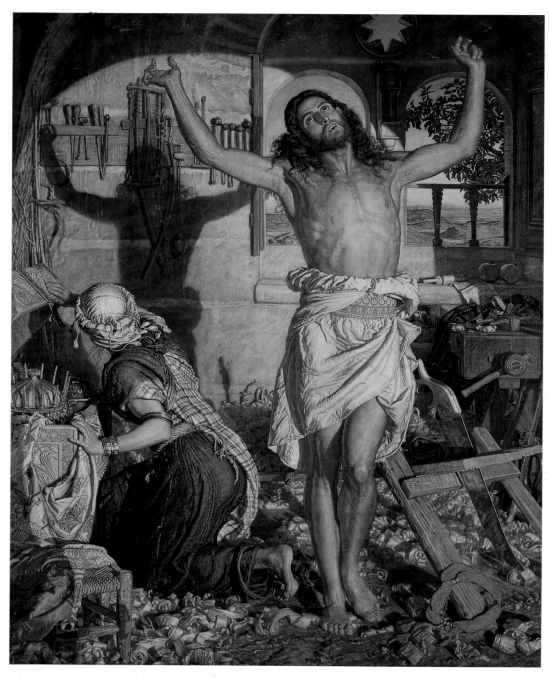

143

four for the figure of the Saviour (1872 diary, JRL); other sitters were engaged on Hunt's return to England (Hunt to J.L. Tupper, c. late August–September 1872, HL). The head of the Saviour presented particular problems, as Hunt explained to Combe on 10 May 1871: 'I must depend upon this to shew people the personage it represents for the originality of the treatment would lead people away from recognising it – yet I want to get in the head too much that is different from the conventional head which always seems too weak to me' (JRL).

On 11 June 1872 Hunt at last felt that he could leave off painting No.143, and confided to his diary: 'I bless God that He has thus far released me from this task which has been so heavy to me!' (JRL). He arrived in London in mid-July, thinking that only 'a few changes' needed to be made to the large picture (Hunt to J.L. Tupper, 22 July 1872, HL). Once he began

working, the changes proved far more extensive than he had anticipated, and on 9 September he informed J.L. Tupper: 'I have been entirely repainting some of the most important parts' (HL). It was not until 11 February 1873 that Hunt was able to write to Lear: 'the large picture . . . has now no more than about three hours work to be done to it –' (JRL); the smaller version was completed on 2 June 1873 (Hunt to J.L. Tupper, 2 June 1873, HL).

By this date both pictures had been sold to Agnew's. Hunt's terms were a down payment of 5500 gns to be followed by a similar sum representing a half-share of the net profits arising from exhibition fees, sales of the engraving and of both versions of 'The Shadow of Death' (Hunt to Agnew, draft, 21 March, JRL; Agnew's stock book of 31 December 1873 records that Hunt actually received £10,500: Maas, p.241). The engraver

needed a copy of No.143 to work from, and a half-size replica (private collection, exh. 1969, No.46) was commenced in April 1873, delaying the exhibition of the major work until late November. Its immense popularity encouraged Agnew's, in 1877, to issue the engraving by Frederick Stacpoole in an edition of over 4000, and profits from sales of the print made possible the donation of No.143 to the city of Manchester in 1883. Three years later Hunt retouched the picture before sending it to his retrospective at the Fine Art Society (Hunt to ?Marcus Huish, 14 March 1886; MS, Fitzwilliam Museum Library).

The pamphlet published by Agnew's in December 1873 to accompany the exhibition of 'The Shadow of Death' stressed the archaeological accuracy of the depiction, but, in typical Hunt fashion, did not elucidate the symbolism. Much of this deepens the associations aroused by the picture's title (which was itself only decided after 26 August 1872: Hunt to John H. Bradley, PUL). Christ's discarded red head-dress represents the crown of thorns (and recalls the red fillet on the head of the scapegoat, No.84); the reeds in the left background of the hut recall the reed thrust in Christ's hand as a mock sceptre just before the Crucifixion (Matthew 27. 29), while the pome-granates on the window-sill symbolise the Passion (George P. Landow, 'William Holman Hunt's "The Shadow of Death"', *Rylands Bulletin*, LV, 1972, p.235). The *Saturday Review* of 6 December 1873 pointed out that 'the circular window which looks out on the evening sky is so placed as to surround the head as with a nimbus, while a smaller star-shaped opening is supposed to refer to the star which was seen in the East' (XXVI, p.728). The critic was not alone in interpreting the portrayal of the Virgin, back turned to the spectator, as an anti-Romanist gesture (ibid., and see Hunt's diary of 13 June 1872, JRL); Hunt explained in his memoirs that only her 'direct glance at the shadow gave the tragedy of the idea' (1905, II, p.308).

Apart from a clay model of the head of the Saviour, which Hunt constructed in April 1870 (now destroyed; Hunt to J.L. Tupper, 26 April 1870 and July 1870, HL), four versions of 'The Plain of Esdraelon' (see No.148), the oil sketch of No.143 in Leeds, and the two compositional sketches mentioned above, numerous studies for 'The Shadow of Death' include a sketch of carpentry tools (Coll. Mrs Burt, exh. 1969, No.219) and of the interior of a carpenter's shop at Messina (Coll. the late Stanley Pollitt); studies of the fig tree in the right background (ibid. and National Gallery of Victoria, Melbourne, exh. 1969, No.221; repr. Hunt 1905, II, p.293); sketches for the window (Coll. of the late Stanley Pollitt; private collection; and Coll. T. Clark Esq.); a slight pen and ink sketch of Christ stretching (private collection, repr. Bennett 1970, p.53, fig.17), and a finished chalk study of the head of the Saviour (private collection, exh. 1969, No.220; repr. Hunt 1905, II, p.297). The oil replica of the head, commissioned by Queen Victoria in early April 1873, was completed in 1898 (Coll. H.M. the Queen, repr. Hunt 1905, I, facing p.236).

J.B.

DANTE GABRIEL ROSSETTI

144 La Ghirlandata 1873
Inscribed 'D.G. Rossetti | 1873'
Oil on canvas, 45½ × 34½ (115.6 × 87.6)
Ref: Surtees No.232
Guildhall Art Gallery, Corporation of London

Painted at Kelmscott Manor in the summer of 1873 with Alexa Wilding sitting for the woman and May Morris for the angel

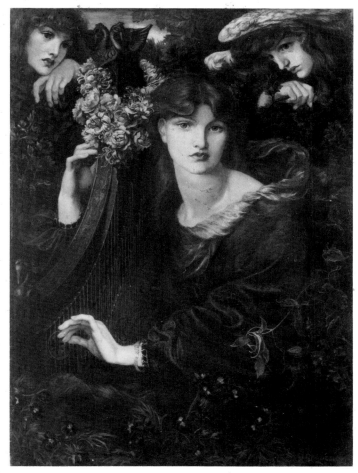

144

heads (Doughty & Wahl, III, pp.1185, 1206, 1207). It is one of a group of decorative paintings of women playing musical instruments, made between 1871 and 1874, which were offered to F.R. Leyland. Other examples are 'Veronica Veronese' (Surtees No.228), 'The Bower Meadow' (No.142) and 'The Roman Widow' (Surtees No.236). Although Leyland, in fact, only bought 'Veronica Veronese' and 'The Roman Widow' from this group, his taste was possibly a formative influence on them all. He was himself a keen amateur musician and he was much concerned with the decorative effect of pictures in his houses, carefully considering the shape, size and colour scheme of each work before he purchased them. But he preferred Rossetti's pictures containing single figures and 'La Ghirlandata' was bought instead by William Graham, who paid £840 for it.

Rossetti described it as 'The greenest picture in the world . . . the principal figure being draped in green and completely surrounded with glowing green foliage' (Rosalie Glynn Grylls, *Portrait of Rossetti*, 1964, p.157). It has no specific subject but, like all the artist's late works, combines a sense of still entrancement with one of burgeoning change, controlled by a beautiful woman. She plays a harp decorated with blue wings, symbolic of the flight of time. The garland, which gives the picture its name, hanging around the harp, is made up of roses and honeysuckle, flowers which suggested sexual attraction to Rossetti (see No.214). In its composition, colour and theme, the picture looks ahead to 'Astarte Syriaca' (No.147). The frame is original.

A.G.

145

JOHN EVERETT MILLAIS

145 Winter Fuel 1873
Inscribed 'JM 1873' (initials in monogram)
Oil on canvas, $76\frac{1}{2} \times 59$ (194.3 × 149.8)
First exh: R.A. 1874 (75)
Ref: R.A. 1967 (83)
City of Manchester Art Galleries

Another of the series of large Scottish landscapes Millais began with 'Chill October' (No.140). The view is looking southwards from near St Mary's Tower, Birnam, the house he rented from Lord John Manners and lived in with his family this autumn, towards Birnam Hill in the background.

In the catalogue to the R.A. exhibition of 1874 at which the work was first shown, the title was accompanied by the line 'Bare ruined choirs, where once the sweet birds sang' from Shakespeare's Sonnet 73. The image can be taken to refer both to the chopped wood in the foreground and the general state of the woods in autumn.

No.145 was bought from Millais by Agnew's on 19 January 1874, together with four other pictures for a total of £10,000. It was sold by them immediately to the well-known businessman and collector Albert Grant.

M.W.

EDWARD BURNE-JONES

146 Venus Discordia Begun 1872
Oil on canvas, 50 × 82 (127 × 208.5)
Ref: Hayward Gallery 1975–6 (123)
National Museum of Wales, Cardiff

In 1870 Burne-Jones conceived the idea of painting a large triptych illustrating the story of the Fall of Troy. An unfinished oil at Birmingham (repr. Hayward Gallery 1975–6, cat. p.49) shows the scheme as he envisaged it. The three main panels represent key incidents in the story – the Judgment of Paris, the Rape of Helen, and Helen taken captive in the burning streets of Troy. Below is a predella with supplementary scenes and appropriate allegorical figures, and the whole is set in an elaborate Renaissance-style frame. Drapery and foliage are festooned above in what T.M. Rooke, Burne-Jones's assistant, called 'the Crivelli manner'.

Not surprisingly this ambitious project was never realised in its complete form, but, as so often with Burne-Jones, designs for some of the separate panels were later taken up and developed as independent paintings. No.146 is a large unfinished version of the composition which was designed as part of the predella to be placed below the right-hand main panel, showing the capture of Helen. It represents Venus, the goddess who presides over the whole Troy story, watching a scene of carnage inspired by the four Vices – Anger, Envy, Suspicion and Strife – who stand huddled together on the right. In the complete scheme the composition was to be balanced by another panel, 'Venus Concordia', below the main panel on the left, 'The Rape of Helen'. In this Venus is seen in her beneficent aspect, seated in a sylvan landscape with Cupid asleep at her feet and accompanied by the three Graces, while happy lovers occupy the background. Delicate pencil drawings for both compositions, dating from 1871–2, are in the Whitworth Art Gallery, Manchester, and a large oil version of 'Venus Concordia', begun at the same time as No.146 and also unfinished, is in the Plymouth Art Gallery. After Burne-Jones's death in 1898, both pictures were among the works placed on public display in his Fulham studio, and they were included in his second studio sale, held at Christie's in June 1919. No.146 was bought by the first Lord Leverhulme, who collected his work extensively, many examples still remaining at the Lady Lever Art Gallery, Port Sunlight.

No.146 is one of Burne-Jones's most Italianate conceptions. The battle raging in the background seems to owe something to Marcantonio's famous engraving of 'The Massacre of the Innocents' after Raphael (and Burne-Jones certainly copied Marcantonio's engravings), while the proportions of the figures show the strong influence of Pollaiuolo, Signorelli and Michelangelo. These were the artists Burne-Jones had studied so carefully on his third visit to Italy in 1871, and over whom he had all but quarrelled with his old mentor, Ruskin, who attacked Michelangelo in one of his Slade lectures delivered at Oxford that summer.

However, the picture is more than an art-historical essay. It was Henry James, writing on the Grosvenor Gallery in 1877, who observed that Burne-Jones's imagination always rests on a firm grasp of reality, 'a vast deal of "looking" on the painter's part'. Walter Sickert made a similar comment about 'Venus Discordia'; he was referring to the Whitworth drawing although the point is equally applicable to the painting. 'The drawing by Burne-Jones of *Venus Discordia*', he wrote in the *Manchester Guardian* in 1926, 'makes one regret that the exigencies of the reign of Queen Victoria dictated drapery as a

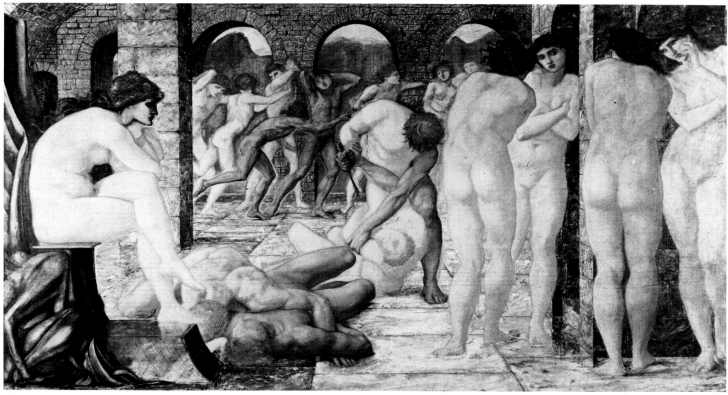

146

necessary veil for the figure. How odd is reputation! Nine-tenths of the people of England knew Burne-Jones through the distorting medium of *Punch*'s stupidities. Lank, cadaverous, etc. Were ever plumper little partridges from Fulham than the *saevitias, iracundias, invidias, crudelitases*, etc., that make up this delicate drawing?' In fact every figure in the composition would have been carefully studied from the model in a series of preparatory drawings in which the artist attempted to abstract the values he wished to convey. As Graham Robertson wrote many years later, 'I have often watched him drawing from the life, and so strong was his personal vision that, as I gazed, Antonelli the model began to look very like Burne-Jones's study, although the study never began to look like Antonelli' (*Time Was*, 1931, p.83).

<div align="right">J.C.</div>

DANTE GABRIEL ROSSETTI

147 Astarte Syriaca 1875–7
Inscribed 'D.G. Rossetti. 1877.'
Oil on canvas, 72 × 42 (182.9 × 106.7)
Ref: Surtees No.249
City of Manchester Art Galleries

The composition was established by the summer of 1875. As well as designs for the composition there survives from this year a fine chalk drawing of Mrs William Morris's head, frontally posed and monumental in appearance (Surtees No.249c). The picture was commissioned at this time by Clarence E. Fry for £2,100. After a false start in the winter of

1875–6, the picture was almost completed by mid-December 1876 when Rossetti was waiting for the frame 'which it needs to balance the tone of colour' (Doughty & Wahl, III, p.1467). By 22 February 1877 it was finished (ibid., IV, p.1478).

The Syrian Venus is shown in three-quarter length, frontally posed and flanked by her two winged attendants bearing torches. Above her head, between the yellow sun and white moon, her eight pointed star floats in a purple haze. As in other works of the last decade of his life, Rossetti has created a sinuous pattern with arms and hands. Here the Venus' pose is of the traditional 'Pudica' kind and her hands draw attention to her girdle, of alternate links of roses and pomegranates, which has the power to excite love. The drapery is also classical but the lethargically bent wrists suggest the influence of Michel-angelo, as does the width of Astarte's shoulders. The sym-metrically placed spirits with their flame-like draperies may have been inspired by the pairs of angels found in Blake's *Book of Job* which were specially praised by Rossetti in his contri-bution to Gilchrist's *Blake* (1863, I, p.288).

Rossetti was probably encouraged to paint the Syrian Venus by his friend Watts-Dunton, who was interested in Eastern mythology, and, more importantly, by Mrs Morris's Eastern rather than Grecian appearance (T. Watts-Dunton, 'The Truth about Rossetti', *The Nineteenth Century*, March 1883, p.413). The symbolism of the picture is certainly related to Rossetti's love for the sitter. She takes the place of the figure of Love, which in the 1859–60 panel 'Dantis Amor' (No.104) was placed between the sun and moon and had the power to move the stars. The predominant green, growing progressively lighter and more intense from the bottom to the top of the picture, is like that found in the later 'Daydream', for which she also posed, and symbolises regenerate love.

The frame, designed by the artist, bears the last six lines of his sonnet for the picture. It was quoted in full in the *Athenaeum* of 14 April 1877 (p.487):

Mystery: lo! betwixt the Sun and Moon
Astarte of the Syrians: Venus Queen
Ere Aphrodite was. In silver sheen
Her twofold girdle clasps the infinite boon
Of bliss whereof Heaven and Earth commune:
And from her neck's inclining flower-stem lean
Love-freighted lips and absolute eyes that wean
The pulse of hearts to the spheres' dominant tune.

Torch-bearing, her sweet ministers compel
All thrones of light beyond the sky and sea
The witnesses of Beauty's face to be:
That face, of Love's all-penetrative spell
Amulet, talisman, and oracle, –
Betwixt the Sun and Moon a mystery.

A.G.

147

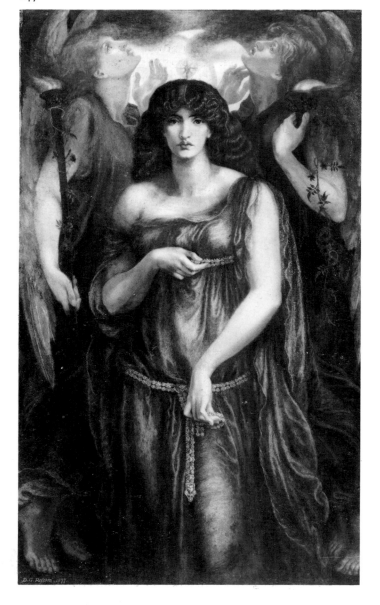

[226]

WILLIAM HOLMAN HUNT

148 The Plain of Esdraelon from the Heights above Nazareth 1870, 1877
Inscribed 'Whh' in monogram
Oil on canvas, $16\frac{1}{8} \times 29\frac{1}{2}$ (41 × 75)
First exh: Grosvenor Gallery 1877 (48)
Ref: Liverpool 1969 (47)
Visitors of the Ashmolean Museum, Oxford

Hunt wrote to J.L. Tupper on 15 July 1877 from Jerusalem: '"The Grosvenor" [Gallery exhibition] I shall not see as I desired to do. My plain of Esdraelon is what I did for, but which I did not use – for the view from the window of my last picture ['The Shadow of Death', No.143] I finished it this year. by painting the foreground' (HL).

Hunt had gone to Nazareth on 1 June 1870 to paint the view through the window in 'The Shadow of Death', and returned to Jerusalem on 21 June 1870 (Hunt to F.G. Stephens, 21 June 1870, BL). He 'encamped below the town, and ascended each morning to the eminence on which the ancient city had been built' (Hunt 1905, II, p.287). From there he painted 'the hills of Galilee, with Gebel-al-Covvies, the Hill of Precipitation, and, further off, the plain of Jezreel [Esdraelon], and, beyond this, the mountains of Gilboa; almost meeting on the right the range of Carmel, while in the far distance, on the left, are the remote mountains extending to Moab behind the Jordan' (*Mr. Holman Hunt's picture, "The Shadow of Death"*, 1873, p.7, and see also the description of the view in Hunt 1905, II, pp.287–8), a landscape full of sites mentioned in the Old Testament (e.g. I Samuel 31. 1; II Samuel 2. 9; I Kings 18. 19; and see Hunt 1905, II, p.288) in addition to being the land of Christ's upbringing. It might seem that the symbolic associations of the landscape, so important to 'The Shadow of Death', were played down when Hunt chose to exhibit No.148 at the Grosvenor Gallery in 1877 with the title 'On the Plains of Esdraelon above Nazareth'; the artist had, however, wanted the picture to be shown in an inscribed frame (Hunt to F.G. Stephens, 15 June 1877, BL), and it is almost certain that the passage he chose was the quotation from *Henry IV, Part I* which now appears on it: 'In these [sic] holy fields Over whose acres walked those blessed feet Which fourteen hundred years ago were nail'd For our advantage on the bitter cross' (Act 1, Scene i, 24–7; the passage may first have been brought to Hunt's attention by C.A. Collins in a letter of 7 September 1853, HL). King Henry's words are uttered in the context of a proposed crusade, and by this means Hunt wanted to remind the spectator not only of the associations with the Saviour but also of the fact that the Holy Land was still under Moslem jurisdiction (the Shakespearian quotation was printed in the 1880 Walker Art Gallery catalogue when No.148 was exhibited for the second time).

Hunt's 1877 letter to Tupper states that No.148 was not, in the event, used as the basis of the landscape in 'The Shadow of Death', and there are in fact four known versions of 'The Plain of Esdraelon'. A panoramic landscape without foreground details, buildings or figures (private collection, exh. Liverpool 1969, No.48, repr.) is almost certainly 'the sketch from [sic] my picture the view out of window', which Hunt informed Combe, in a letter of 25 June 1870, he had been working on in Nazareth (BL), as it is closest to the landscape in 'The Shadow of Death'. Although this letter did not mention that Hunt was working on more than one oil sketch during the Nazareth visit, he may have begun one or possibly two other landscape views of the same site from further up the hillside: either No.148 or the compositionally identical version in the collection of Pierre

148

Jeannerat (which is less highly finished than the Ashmolean canvas); and, though this is less probable on account of its size ($19\frac{1}{2} \times 48$; 49.5×122), a boldly painted, unfinished oil sketch in the collection of Mrs Suzanne Hamilton, Delaware. It seems likely that Hunt further worked on these sketches after his return from Nazareth: a letter of 21 September 1870 to Edward Lear states that 'for the last three months I have been devoting myself to studies necessary for background and accessories . . . which could not be done later –' (JRL).

Hunt returned to Jerusalem for a third visit in December 1875, and six months later informed F.G. Stephens that he had agreed to contribute to the inaugural exhibition of the Grosvenor Gallery (19 June 1876, BL). He was not particularly enthusiastic about the new venture, and there is no evidence that he contemplated leaving his work on 'The Triumph of the Innocents' (Walker Art Gallery, exh. 1969, No.52, repr.) to return to Nazareth to complete 'The Plain of Esdraelon'. The unsettled state of the country would probably have made such a trip impracticable. Letters to Stephens of 1 February and 7 February 1877 reveal that Hunt was hoping to complete his pictures for the forthcoming exhibition season, but feared that he would not obtain an export licence (BL). No.148 was sent off by post before 23 April 1877, when Hunt wrote to Stephens that he only completed it by painting 'literally from sunrise to sunset until I could scarcely stand –' (BL). Although he resented spending time on anything other than 'The Triumph of the Innocents', he hoped that the exhibition of No.148 might 'break thro' the very inconvenient spell which has prevented me from selling any work for so many years –' (ibid.).

Unfortunately No.148 did not reach London in time for the opening of the Grosvenor Gallery exhibition, and was represented by an empty frame inscribed 'The Plains of Esdraelon' (*Spectator*, 19 May 1877, p.632). Hunt, in a letter to Stephens of 7 June 1877, referred to this as a 'beggarly makeshift' and regretted that 'the Nazareth is to be exhibited in the flat' (BL). The artist, no doubt aware of the prevailing aestheticism of the Grosvenor Gallery, had gone to a great deal of trouble to send Stephens designs and descriptions for a carved frame and painted flat (1 March and 23 April 1877, BL), and feared that an ordinary frame would impede sales (Hunt to Stephens, 23 April 1877, BL). Hunt had written to Agnew's offering them

first refusal of No.148 (ibid.), which, when it finally appeared at the Grosvenor Gallery, was on sale for 1000 gns (*Architect*, XVIII, 28 July 1877, p.41). No prospective purchaser came forward, and the price had gone up to 1100 gns when the work was shown in 1880 at the Liverpool Autumn Exhibition. In March 1886 No.148 was shown at Hunt's retrospective with the title 'Over whose pastures walked those blessed feet', by which date it was in the collection of Mrs Combe.

The purchaser was no doubt fully aware of the religious associations of the landscape, but No.148 appealed to Burne-Jones on aesthetic grounds. He told T.M. Rooke on 13 April 1898 that works such as 'The Plain of Esdraelon' and 'Jerusalem by Moonlight' (No.204) 'once seen can never be got out of the mind again . . . They won't leave the memory they're so beautiful' (Lago, p.178).

J.B.

EDWARD BURNE-JONES

149 **Le Chant d'Amour** 1868–77
Inscribed 'E.B.J.'
Oil, with some gold paint, on canvas,
44 × 60 (112 × 152.5)
First exh: Grosvenor Gallery 1878 (108)
Metropolitan Museum of Art, New York (Alfred N. Punnett Endowment Fund 1947)

This picture marks the climax of the Giorgionesque element which runs so strongly through Burne-Jones's early work (see also No.236). The title is taken from the refrain of an old Breton song:

Hélas! je sais un chant d'amour,
Triste ou gai, tour à tour.

This may well have been one of the songs of this type that were collected and sung by Georgiana Burne-Jones, and certainly

the design was conceived as part of the decoration of a small upright piano that the Burne-Joneses were given as a wedding present in 1860 (Victoria and Albert Museum; see Michael I. Wilson, 'Burne-Jones and Piano Reform', *Apollo*, CII, 1975, p.344, fig.4). Painted on the inside of the lid, probably about 1863, the composition at this stage was in monochrome and included only the lady playing the organ and the figure of Love at the bellows. In 1865, however, Burne-Jones painted a watercolour of the subject, adding the listening knight on the left and a landscape background (Museum of Fine Arts, Boston). This was followed in 1866 by another watercolour, in which the knight was again omitted (Hayward Gallery 1975–6, No.86). No.149 is the final and definitive version. Begun in 1868, it was painted mainly in the early 1870s but only completed in 1877 – a good example of Burne-Jones's habit of working on his pictures over long periods of time. The composition is substantially the same as that of the 1865 watercolour, the main difference being that Love has a more elegant pose in the later painting.

The 1865 watercolour was one of the earliest works by Burne-Jones to be bought by William Graham, and he commissioned No.149. Graham was Burne-Jones's single most impor-tant patron, and his taste was not without influence on his work. Some fifteen years older than the artist, he was a Scot of strict evangelical faith. He had made a fortune as an India merchant, and belonged to the Liberal establishment of the day, entering Parliament as member for Glasgow in 1865. His religious convictions did not preclude a passionate love of beauty, and he built up an enormous collection, embracing a wide variety of old and modern masters. He was particularly attached, however, to the Italian schools and the work of Rossetti and Burne-Jones, with both of whom he was on close terms. Indeed to Burne-Jones he became a deeply valued friend. He loved to drop in on him as he painted, and Burne-Jones would dine regularly at his house in Grosvenor Place. He advised the artist over business matters, and in later years even acted as his agent. After Graham's death in 1885, his sale at Christie's, held the following April, included no less than thirty-three works by Burne-Jones, and their high prices did much to confirm his reputation. The large 'Chant d'Amour' fetched 3105 gns, the highest price of the entire sale.

Unlike Frederick Leyland, who sought expert advice over purchases and thought of pictures as part of a decorative ensemble (see No.244), Graham was a true connoisseur, as

149

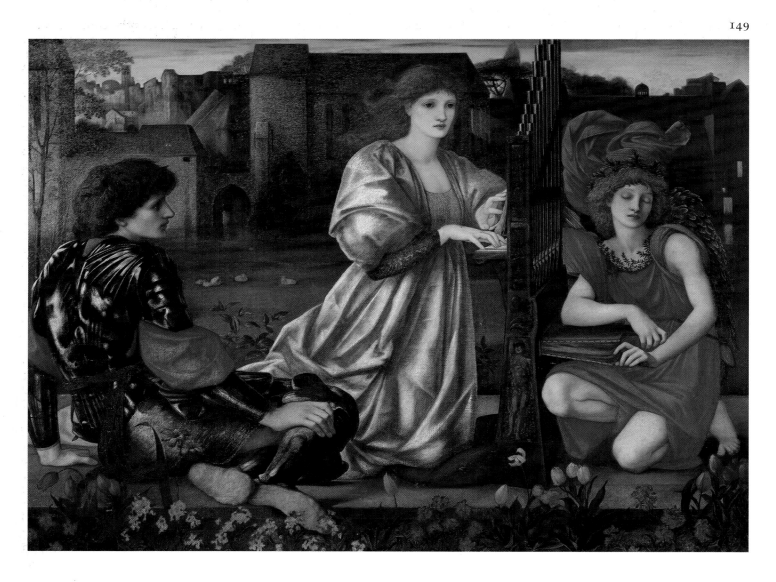

Gladstone recognised when he made him a Trustee of the National Gallery in 1884. He liked pictures for their own sake, allowing them to line his walls, sit about on chairs or tables, or stand in ranks on the floor. He looked above all for 'charm, either of colour or feeling, or choice of subject', and although he owned major paintings both by old masters and living artists, he was equally attracted to small or unpretentious works if he felt they had these qualities. He once made the romantic gesture of kissing a picture by Burne-Jones that particularly appealed to him, and he clearly had a special fondness for the Giorgionesque figure groups, rich in colour and atmosphere, that the artist was painting in the early 1860s. He not only owned the early version of 'Le Chant d'Amour' but that of 'Laus Veneris', another design in this style; and he commissioned large versions of both (see also No.150), as well as owning the later oil version of the very Giorgionesque 'Green Summer' (No.236). Thus it was largely due to Graham that Burne-Jones returned to this type of composition after his excursion into aesthetic classicism in the late 1860s (see No.240).

In fact the large 'Chant d'Amour' is one of Burne-Jones's most hauntingly poetic works; the musical theme, the emotional tension of the figures, the 'Arthurian' landscape and buildings, and the evening light, combine to create a mood of nostalgia and yearning which he often approaches but seldom captures in so intense a form. It is hardly surprising that he chose to use the composition in a very personal context, as a miniature in an illuminated manuscript held by Mary Zambaco in his portrait of her of 1870 (Clemens-Sels-Museum, Neuss; Hayward Gallery 1975–6, No.114). No.149 was among the chief works in progress at the time of their liaison, which reached a dramatic climax early in 1869 but continued for several years thereafter.

In 1878 No.149 was one of Burne-Jones's main contributions to the second exhibition of the Grosvenor Gallery, when he must have been particularly anxious not to disappoint after the sensation caused by his exhibits the previous year. As before, the works received great attention from the press, much of it harping on the artist's 'morbid' or 'unmanly' vision. Among those who noticed them was the young Henry James in a review in the American magazine the *Nation*. True to his principle of approaching the artist 'good-humouredly and liberally [since] he offers an entertainment which is for us to take or to leave', he described the 'Chant d'Amour' tongue-in-cheek as 'a group of three figures, seated, in rather an unexpected manner, upon the top of a garden wall'. He noted especially 'the beautiful, rapt dejection of the mysterious young warrior . . . we should hardly know where to look for a more delicate rendering of a lovesick swain'; and he considered the colour 'a brilliant success', 'like some mellow Giorgione or some richly-glowing Titian . . . full of depth and brownness, the shadows . . . warm, the splendour subdued'. True, the artist had faults. His figures 'are too flat . . . they exist too exclusively in surface. Extremely studied and finished in outline, they often strike one as vague in modelling – wanting in relief and in the power to detach themselves'. Nonetheless, his pictures, 'this year, as last, . . . are far away the most interesting and remarkable things in the exhibition'. 'No English painter of our day has a tithe of his "distinction"', and his compositions 'have the great and rare merit that they are *pictures*. They are conceptions, representations; they have a great *ensemble*'. Coming from James, who believed that 'all art is one' and that 'the most fundamental and general sign of the novel . . . is its being everywhere an effort at *representation*', this was the highest praise.

J.C.

EDWARD BURNE-JONES

150 Laus Veneris 1873–8
Inscribed 'E. BURNE-JONES 1873–5'
Oil, with gold paint, on canvas, 48 × 72 (122 × 183)
First exh: Grosvenor Gallery 1878 (106)
Ref: Hayward Gallery 1975–6 (135)
Laing Art Gallery, Newcastle upon Tyne (Tyne and Wear County Council Museums)

This famous picture, with its dramatic colour scheme, has often been seen as one of Burne-Jones's most successful works. Graham Robertson, for example, writing to a friend in 1933 (at the time of the Burne-Jones centenary exhibition at the Tate), asked, 'I wonder which you consider to be his best picture. I should vote for "Laus Veneris" . . . a lovely, glowing thing – as fresh and brilliant as ever after all the years' (Kerrison Preston (ed.), *Letters from Graham Robertson*, 1953, pp.284, 295). The conception is based on the German legend of the Tannhäuser, the wandering knight who comes to the Venusberg and abandons himself to a life of sensual pleasure. Overcome by remorse, he goes to Rome to seek absolution from the Pope, who tells him that this is as impossible as that his pastoral staff should blossom. In despair Tannhäuser returns to the arms of Venus, but in three days' time the Pope's staff miraculously puts forth flowers. Emissaries are sent far and wide to find the sinner, but he is never heard of again.

The story was re-cast by many nineteenth-century German writers, and, like Meinhold's *Sidonia* (see No.230), gained currency in England through the vogue for German Romance. The best-known version was that incorporated in Tieck's tale *The Trusty Eckart*, which was translated by Carlyle in his *German Romance*, 1827. William Morris, who treated the story as *The Hill of Venus* in his narrative cycle *The Earthly Paradise* (1868–70), is said to have derived it from Tieck, and no doubt Burne-Jones was also familiar with this version, probably from his Oxford days when he had read so much Carlyle and been fascinated by another author included in Carlyle's collection, Fouqué. There is also evidence to suggest that he was aware of two English treatments of the story which appeared in 1861: *Tannhäuser; or, The Battle of the Bards*, a long Tennysonian poem by Neville Temple and Edward Trevor (pseudonyms for Julian Fane and Edward Bulwer Lytton); and a translation from the old German ballad by Lady Duff Gordon (who also translated Meinhold), published in *Once a Week* in August with an illustration by Millais.

Certainly Burne-Jones himself first attempted the subject this year, in a watercolour (private collection) which is in fact an early version of No.150. It was owned by his great patron, William Graham, who had a special feeling for these romantic, rather 'Venetian' compositions of the early 1860s (see No.149), and he commissioned the larger picture. This was begun in 1873, worked on in 1874 and 1875, but only finished (despite the inscription) in 1878, when it was shown at the second exhibition at the Grosvenor Gallery. Not surprisingly, it attracted great attention. F.G. Stephens in the *Athenaeum* thought it 'the finest work he has achieved' and a source of 'unending pleasure'. Others, while admiring the brilliant colour, seized on the mood of oppressive languor as the embodiment of all that was most suspicious in the Aesthetic movement. Frederick Wedmore, writing on 'Some Tendencies in Recent Painting' in the July number of the magazine *Temple Bar*, described the figure of Venus as 'stricken with disease of the soul, . . . eaten up and gnawed away with disappointment and desire . . . The very body is unpleasant and uncomely, and

the soul behind it . . . ghastly'. Henry James made a similar point more wittily in his review in the *Nation*: 'She has the face and aspect of a person who has had what the French call an "intimate" acquaintance with life; her companions, on the other hand, though pale, sickly, and wan, in the manner of all Mr Burne-Jones's young people, have a more innocent and vacant expression, and seem to have derived their languor chiefly from contact and sympathy'.

The sensuous mood of the picture owes much to the close connection between the early version and Swinburne's well known poem of the same name. One of his finest expressions of his favourite theme, the destructive force of love, this was among the poems which caused such an outcry when it was published in *Poems and Ballads* in 1866. It comes very close to Burne-Jones's design in imagery and atmosphere. The languid Venus, her musician attendants, the figure of Cupid on the tapestry, the knights in a wintry landscape, all reappear. There is the same suggestion of claustrophobic space:

Inside the Horsel here the air is hot,

and the same colour emphasis:

Her little chambers drip with flower-like red,

a line echoed throughout the poem in the repeated use of such words as 'blood', 'flame' and 'fire'. Even the cat which appears in the 1861 watercolour finds a parallel in the panther, tiger and serpent which Swinburne uses as symbols of passion and languor.

Since the first stanzas of the poem were written on 14 June 1862, by which time the watercolour was apparently complete, it may seem that Swinburne was simply influenced by Burne-Jones. But Burne-Jones's choice of subject is so Swinburnian that poem and picture were clearly twin expressions of shared ideas; this was, after all, the moment when the two men were particularly close (see also Nos 230, 235), a fact reflected in the dedication of *Poems and Ballads* to Burne-Jones. Among these ideas was a great admiration for Edward Fitzgerald's *Omar Khayyám*, published anonymously in 1859 and 'discovered' by Rossetti and Swinburne about the beginning of 1861. Swinburne's *Laus Veneris*, according to George Meredith, who was present, was begun immediately after a reading of *Omar* and was 'a compliment' to the poem; and it was Swinburne who gave Burne-Jones a copy of Fitzgerald's work. Another topic in the air at the time was Swinburne's passionate admiration for Baudelaire's *Les Fleurs du Mal* (1857); this he expressed in a rapturous review in the *Spectator* in September 1862, in which he dwelt on precisely those values – 'the weariness of pain and the bitterness of pleasure . . . a heavy, heated temperature, with dangerous hot-house scents', etc. – which he exploits in *Laus Veneris*. Again, there was probably some knowledge of Wagner's *Tannhäuser*, which met such a hostile reception in Paris in March 1861. Both Swinburne and Burne-Jones were admirers of Wagner, and Baudelaire was to send Swinburne his pamphlet on *Richard Wagner et Tannhäuser à Paris* in 1863. If Wagner did help to inspire Burne-Jones's 1861 watercolour, then it makes an interesting parallel to Fantin-Latour's 'Scène du Tannhäuser' (Los Angeles), which was shown at the Salon in 1864. Nor

150

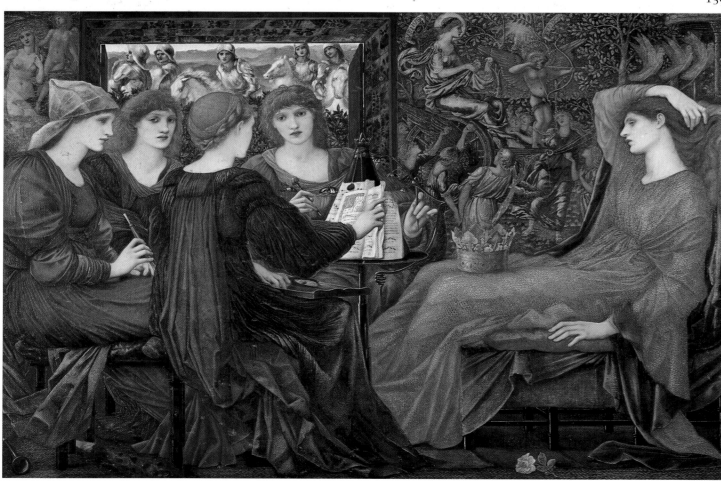

would this be fortuitous since by 1862 Fantin, Burne-Jones and Swinburne had a mutual friend in Whistler; indeed Swinburne himself was to see Fantin's 'Tannhäuser' when he visited the artist's studio in 1863.

The relationship between Burne-Jones's 'Laus Veneris' and the other literary treatment of the legend in his circle, Morris's 'Hill of Venus' in *The Earthly Paradise*, is not nearly so striking. Burne-Jones did, however, make a series of twenty designs to this poem in 1866, when a lavishly illustrated edition of Morris's book was projected.

No. 150 is the outstanding example in Burne-Jones's work of his tendency to reduce the sense of recession by arranging his compositions in parallel planes and emphasising surface pattern. The whole picture has a tapestry-like consistency of style. This he achieves partly by chromatic means, using many devices, including his fondness for 'shot' effects, to place his colours arbitrarily and so keep the balance going right across the canvas. Even more remarkable, however, are the rich textures, a particularly striking passage being the dress of Venus, which has evidently been stamped all over with a circular punch in the wet underpainting prior to glazing with colour. The concern for pattern even extends to the frame, which is decorated rather like some of Whistler's frames at this period, underlining once again the relationship between the two artists in the very year that Burne-Jones had to give evidence against Whistler on behalf of Ruskin at the famous libel trial. The problem of integrating the distant knights is solved by framing them in the window so that they appear like a picture on the wall, while the wall itself is covered with 'real' tapestries – tapestries, so to speak, within a tapestry, linked to the foreground figures not only in terms of colour and texture but thematically, since they represent subjects in which Venus appears. The composition on the right, showing her drawn in a chariot while Cupid shoots arrows at her votaries, was conceived in 1861 as a design for tiles (see Martin Harrison and Bill Waters, *Burne-Jones*, 1973, p.52, fig.59). It was later treated as an easel painting (repr. ibid., col. pl.26), and in 1898 adapted again for a tapestry made by the Morris firm. Two further decorative details should be noted: the tiles round the window, so reminiscent of those made by Burne-Jones's friend William de Morgan; and the seats, strikingly modern in design and surely marvellous examples of the famous Pre-Raphaelite disregard for comfort.

J.C.

151

DANTE GABRIEL ROSSETTI

151 Proserpine 1873–7
Inscribed, on the scroll bottom left, 'DANTE GABRIELE ROSSETTI RITRASSE NEL CAPODANNO DEL 1877' and, in the top right, with Rossetti's sonnet on the subject in Italian
Oil on canvas, 42 × 22 (119.5 × 57.8)
First exh: *Art Treasures Exhibition*, Royal Institution, Manchester, 1878.
Ref: Surtees No.233
L.S. Lowry Collection (on loan to Manchester City Art Gallery)

No.151 is one of no less than eight versions of 'Proserpine' which were started on canvas during the last decade of the artist's life although not all reached completion. This one began as a painting completed for Leyland in the winter of 1873 but then severely damaged. The face and hands were cut out and mounted on a fresh canvas in 1877 when, after retouching, it was sold to W.A. Turner. Rossetti explained the subject in a letter to Turner: 'The figure represents Proserpine as Empress of Hades. After she was conveyed by Pluto to his realm, and became his bride, her mother Ceres importuned Jupiter for her return to earth, and he was prevailed on to consent to this, provided only she had not partaken of any of the fruits of Hades. It was found, however, that she had eaten

one grain of a pomegranate, and this enchained her to her new empire and destiny. She is represented in a gloomy corridor of her palace, with the fatal fruit in her hand. As she passes, a gleam strikes on the wall behind her from some inlet suddenly opened, and admitting for a moment the light of the upper world; and she glances furtively towards it, immersed in thought. The incense-burner stands beside her as the attribute of a goddess. The ivy-branch in the background (a decorative appendage to the sonnet inscribed on the label) may be taken as a symbol of clinging memory' (W. Sharp, *D.G. Rossetti*, 1882, p.236). In an earlier letter to Leyland, Rossetti pointed out that the half-lit background suggested the division of Proserpine's time between Earth and Hades: 'The whole tone of the picture is a gradation of greys – from the watery blue-grey of the dress to the dim hue of the marble, all aiding the "Tartarean grey" which must be the sentiment of the subject' (*Art Journal*, 1892, pp.251–2).

The model was Mrs William Morris with whom Rossetti had established an intimate relationship by July 1869. A crayon drawing from her, dated 1871 and probably drawn at Kelmscott Manor, shows the composition already established but without the decorative and symbolic attributes (Surtees No.233A). The tall, narrow format and the position of the figure within it were possibly suggested by Botticelli's portrait of Smeralda Bandinelli, now in the Victoria and Albert Museum, which Rossetti had bought for his own collection in 1867. In its final form, he thought he had achieved 'a unity which is the right thing for a work of this kind' (W.M. Rossetti 1889, p.88). The bitten pomegranate echoes the shape and colour of the red lips and also contains the fatal seed; the ivy is a 'symbol of clinging memory' and also 'a decorative appendage'. In this, as in all Rossetti's paintings from Jane Morris, we are reminded of his close friend Watts-Dunton's statement that to him, the mouth represented the sensuous part of the face no less certainly than the eyes the spiritual (T. Watts-Dunton, 'The Truth about Rossetti', *The Nineteenth Century*, March 1883, p.412).

From 1964 to his death in 1976 L.S. Lowry owned this version of 'Proserpine' – 'I don't like his women at all, but they fascinate me, like a snake' (*A Pre-Raphaelite Passion*, Manchester, 1977, p.3).

The picture is in its original frame with wide gold bevelled boards decorated with roundels, resembling a section through a pomegranate, and bearing at the bottom the English version of the sonnet describing its subject:

Afar away the light that brings cold cheer
Unto this wall, – one instant and no more
Admitted at my distant palace-door.
Afar the flowers of Enna from this drear
Cold fruit, which, tasted once, must thrall me here.
Afar those skies from this Tartarean grey
That chills me: and afar, how far away,
The nights that shall be from the days that were.

Afar from mine own self I seem, and wing
Strange ways in thought, and listen for a sign:
And still some heart unto some soul doth pine,
(Whose sounds mine inner sense is fain to bring,
Continually together murmuring,)–
'Woe's me for thee, unhappy Proserpine'.

A.G.

FORD MADOX BROWN

152 The Finding of Don Juan by Haidee 1878
Inscribed 'FMB 78' (initials in monogram)
Oil on canvas, $45\frac{5}{8} \times 57\frac{1}{8}$ (116×145)
First exh: ?*Liverpool Autumn Exhibition*, Walker Art Gallery, 1878 (151)
Musée d'Orsay (Palais de Tokyo), Paris

Illustrating Byron's *Don Juan*, Canto II, verses 110–12. It is one of three versions, of which a watercolour dates from 1869–70 (Melbourne), a large oil was finished 1873–6 (Birmingham), and the present smaller oil was completed in 1878. The composition follows one of a set of illustrations the artist had designed for Byron's poems for a popular edition of the English poets edited by W.M. Rossetti and published by Moxon.

Madox Brown planned to carry out most of the designs as paintings and this subject was already on offer in April 1869 to James Leathart, before the illustrations had been sent to the publisher. It was one of three new subjects he had in mind: 'I have *in head* two or three admirable subjects I wish to paint . . . but each of them includes naked figures which would do you good, but you might object to – one Haydee & her maid finding the naked & all but lifeless body of Juan on the beach after the shipwreck . . .'. He begged that his subjects be kept secret, 'for they might be snapped up & painted otherwise before I can get time to think of them' (UBC/LP).

Byron's poems had been a chief delight since his youth. Besides the opportunity this subject gave him to paint the nude, he also took full advantage of the setting on the seashore to experiment with radiant opalescent colours. The composition is only slightly varied from the illustration in the pose of Zoe, the maid, and in its more elaborately worked out background (drawing, Whitworth Art Gallery).

Coming as his first important commission for nearly a year, Frederick Craven of Manchester ordered a watercolour in May 1869 for 200 gns, this time definitely as a companion to Rossetti's 'Tibullus' (Surtees No.62 R.I; see No.239). Madox Brown wrote to him the following November that he had got a 'young Neopolitan' for Don Juan and Miss Spartali, the beautiful daughter of the Greek Consul in London and a pupil of the artist, to sit for Haidee (FMBP). The watercolour was quickly finished in January 1870 and W.M. Rossetti noted that it was 'in some respects about his finest work' (1903, p.415). Craven, however, thought it weak, and the artist promised to look out for suitable rocks around Lynmouth during his 1871 holiday to paint into it; a drawing of the upturned boat is dated 1871 (Houghton Album, Ashmolean Museum), and was presumably also painted in as part of a retouching.

A large oil was in hand in 1870 and sold to Frederick Leyland in 1872, at 400 gns, finished in 1873 and retouched on and off until 1876. On the evidence of the unreliable Charles Howell, Leyland did not much like it, thought the water looked 'most rummy, and all the rocks look like the Pantomime scene at Astley's' (Doughty & Wahl, III, p.1144n). Further, to the artist's annoyance, F.G. Stephens in the *Athenaeum* also commented unfavourably: 'While admitting the rare merit and extraordinary value of many parts of this important picture, we cannot regard it as a fortunate illustration of the powers of the artist, except so far as regards the superb glow of colour and light' (11 November 1876, p.631; and W.M. Rossetti, MS diary, 12 November, UBC/AP). On the other hand, the *Art Journal* (January 1877, p.15) listed it as one of his masterpieces, admired the 'opalescent effects' and the artist's thorough

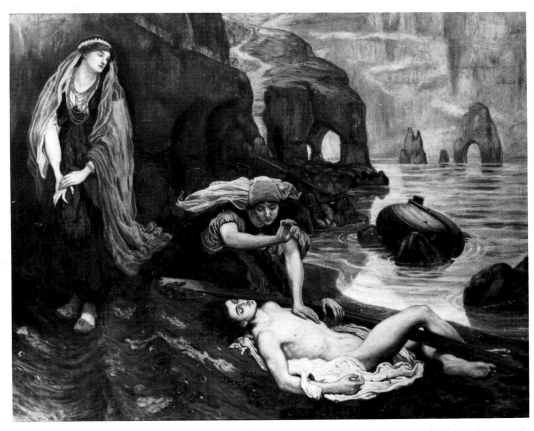

152

knowledge of emotion and the 'high intellectual and poetic value of his attainments'.

In spite of these diverging opinions this third picture was commissioned by the enthusiastic Craven in 1878 in preference to his watercolour, which he returned in exchange along with his 'Entombment'. It may also have had some beginnings earlier, in line with Madox Brown's usual practice; he informed his old patron George Rae in June that he planned to 'finish the work I give Craven in exchange . . . and then I shall begin my Manchester Town Hall cartoons I trust – I am oppressed with work, but it pays poorly' (LAG/RP).

The exchange probably led to the confusion between the versions in Hueffer's lists. The watercolour was, according to him, reworked in this year, 1878, but he may be confusing it with this oil. The watercolour belonged later to Henry Boddington of Manchester and passed to the National Gallery of Victoria, Melbourne in 1905. Leyland's oil, which he sold in 1880, was presented to Birmingham City Art Gallery in 1912. The present smaller oil passed after the sale of Craven's pictures in 1895, following his death, to Miss Mathilde Blind, poetess and close friend of the artist, who bequeathed it to the Louvre, 1897.

M.B.

DANTE GABRIEL ROSSETTI

153 La Pia de' Tolomei 1868–80
Inscribed 'D G Rossetti'
Oil on canvas, $41\frac{1}{2} \times 47\frac{1}{2}$ (105.4 × 120.6)
Ref: Surtees No.207
Spencer Museum of Art, University of Kansas

Pia de' Tolomei was confined to a fortress in Maremma, a malarial district near Siena, by her husband Nello della Pietra.

Here she died, either through fever or poison. The subject is from Dante's *Purgatory*, Canto V, lines 130–36. These lines are inscribed on the contemporary frame, with Rossetti's translation:

> Remember me who am La Pia; me
> Siena, me Maremma, made, unmade.
> This in his inmost heart well knoweth he
> With whose fair jewel I was ringed and wed.

Rossetti's attention may have been drawn to her story by a play by Charles Marenco, *Pia dei Tolomei*, which was performed in London in 1856 and 1857 with Adelaide Ristori in the title role. The subject is one of several concerning unhappy marriage which occupied Rossetti at this period and he chose them because they related to the personal life of his main model and inspiration, Jane Morris.

On 23 January 1868 his brother records that initial studies for the picture had been made and that Jane Morris had engaged to sit (W.M. Rossetti 1903, p.296). A surviving rough note-book sketch shows the figure at the left side, reclining behind a parapet, with a mirror behind reflecting the Maremma marshes (Surtees No.207E). She already fingers her wedding-ring and the mood of sadness and regret is already established. Rossetti wrote to Jane Morris on 6 March 1868 to tell her that all was ready for the picture and to assure her that the pose 'is a very easy one, so you shall be punished as little as possible for your kindness' (J. Bryson and J.C. Troxell (eds.), *Dante Gabriel Rossetti and Jane Morris*, 1976, p.1). She sat later that month. In the early drawings, from her and from Alexa Wilding (Surtees Nos.207D, 207B), the head is tilted back but this was soon altered to a forward position which helps to draw attention to the hands and wedding-ring. Swinburne described the

incomplete picture in the spring of 1868: 'her pallid splendid face hangs a little forward, wan and white against the mass of dark deep hair . . . In her eyes is a strange look of wonder and sorrow and fatigue' (Gosse and Wise (eds.), *The Complete Works*, 1927, XV, p.214). He also mentions an embroidery frame which has been removed but which links the picture with the contemporary 'Mariana' (No.139). Their subjects are similar.

Although Rossetti was thinking of painting the background in June 1869, by which time it had probably been commissioned by F.R. Leyland for the large sum of 800 gns, the picture was put aside and only completed at the end of 1880 (Doughty & Wahl, II, p.702). A letter of 1875 mentions the outer dress which probably derives from one in a Botticelli portrait bought by Rossetti in 1867 and now in the Victoria and Albert Museum (ibid., III, p.1384). In 1880 Fairfax Murray sent him drawings from Italy of Maremma for the background and in the late summer the foliage of the fig-tree and ivy was painted (W.M. Rossetti 1889, p.110; H.R. Angeli, *Dante Gabriel Rossetti: His Friends and Enemies*, 1949, p.246). By early December the picture was complete (Doughty & Wahl, IV, p.1820). It joined Leyland's important collection at 49 Princes Gate where it hung in the entrance hall.

The fig-tree, symbol of fruitfulness, is perhaps an ironic comment on La Pia's situation. The ivy is a symbol of life in death. The wheeling rooks recall verse five of Rossetti's poem 'Sunset Wings', written in 1871, which is about changed love never to be relived. The sundial, with the Blake-like angel and wheel of fortune, also refers to change, as do the old letters from her husband. The rosary and devotional book allude to the prisoner's name – The Pious. The mood of lassitude and weary introspection, the emphasis on change, are found in all the late works for which Jane Morris sat.

A.G.

153

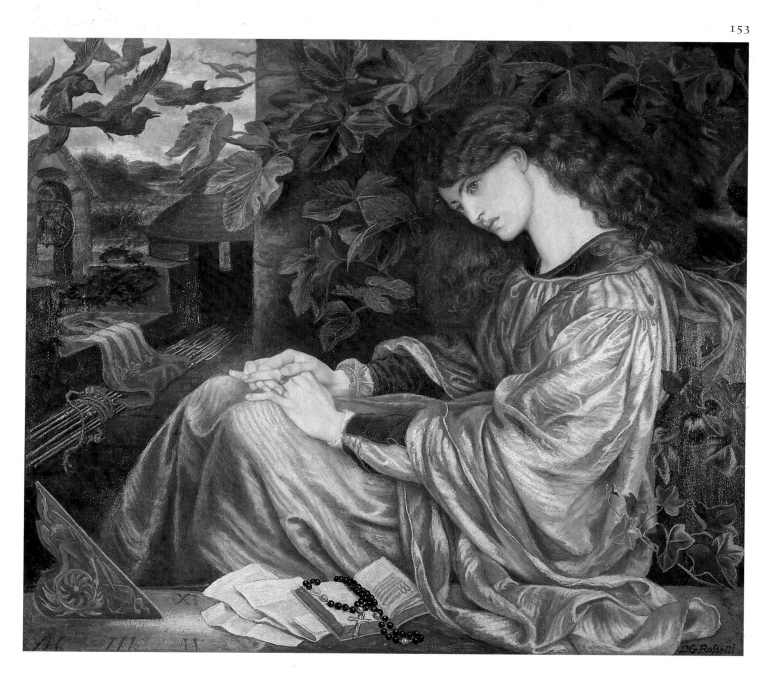

EDWARD BURNE-JONES

154 The Golden Stairs 1876–80
Inscribed 'EBJ 1880'
Oil on canvas, 109 × 46 (277 × 117)
First exh: Grosvenor Gallery 1880 (120)
Ref: Hayward Gallery 1975–6 (138)
Tate Gallery

The picture was designed in 1872, begun in 1876, and shown at the Grosvenor Gallery in 1880. It was Burne-Jones's sole contribution that year, and was completed under great pressure. On 22 April, only a few days before the opening, his wife recorded in her diary: 'The picture is finished, and so is the painter almost. He has never been so pushed for time in his life' (G. Burne-Jones, II, p.103). It shows, however, no signs of haste, each detail being treated with his usual care.

It is Burne-Jones's last and most ambitious attempt at a 'subjectless' composition (for earlier examples, see Nos.236, 240); significantly, two other titles – 'The King's Wedding' and 'Music on the Stairs' – were considered before the present one was chosen. F.G. Stephens, reviewing the Grosvenor exhibition in the *Athenaeum* on 8 May, commented aptly that the figures 'troop past like spirits in an enchanted dream, each moving gracefully, freely, and in unison with her neighbours . . . What is the place they have left, why they pass before us thus, whither they go, who they are, there is nothing to tell'. Contemporaries, imbued with the Victorian belief that 'every picture tells a story', were naturally puzzled, and according to Lady Burne-Jones, 'many were the letters [the artist] received from different parts of the world, asking for an "explanation"' (G. Burne-Jones I, p.297). It would be interesting to have his answers. To quote the *Memorials* again: 'When [a picture] was finished . . . he wanted everyone to see in it what they could for themselves. He was often amused by the anxiety people had to be told what they ought to think about his pictures as well as by their determination to find a deep meaning in every line he drew' (ibid.).

In fact 'subjectless' is not really the right word for a picture like 'The Golden Stairs'; Burne-Jones is not simply performing an exercise in formal values but rather deliberately keeping his subject vague in order to leave it open to varied interpretation. It is this above all that links him to the Symbolist movement, which exploited ambiguity and the enigmatic in many forms. The idea was to be expressed most vividly some ten years later in Mallarmé's famous dictum that 'to *name* an object is to suppress three-quarters of the enjoyment to be gained from a poem . . . *suggestion*, that is the dream'.

Closely linked to the principle of ambiguity was the tendency of many Aesthetic and Symbolist painters to draw some kind of analogy between their art and music: one has only to think of Fantin-Latour's Wagnerian subjects and Whistler's 'Symphonies' and 'Nocturnes'. The key text here – 'all art constantly aspires towards the condition of music' – had been vouchsafed by Pater in his *Renaissance* (1873), and this would have been known to Burne-Jones, who constantly relies on musical references to create mood and atmosphere. Again 'The Golden Stairs', in which most of the figures carry musical instruments, is an outstanding example, but see also Nos.240, 149, 150. As a pictorial approach to music, his may have lacked the sophistication of Whistler's, but it was based on a much greater love and appreciation of music than Whistler possessed. There are many accounts of Burne-Jones attending concerts and opera. Many of his friends were musical, and music was often heard at his house, his wife being a talented

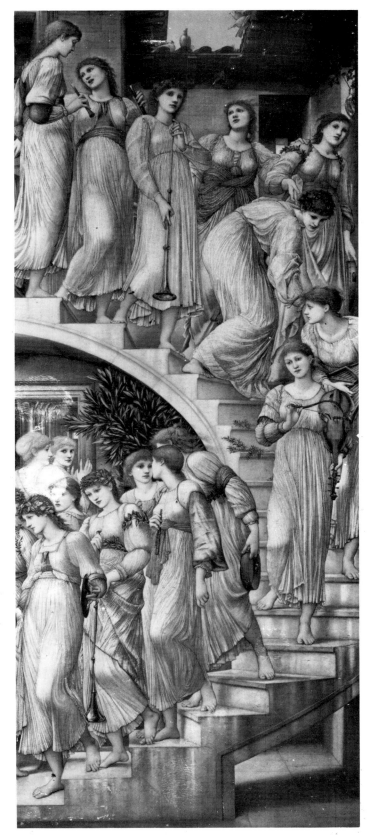

154

pianist and singer, with a special feeling for the then little-known field of pre-classical music. He even kept a small organ in his studio.

No.154 belongs to a group of works of this date which are pale or monochromatic in colour and severe and classical in form; other examples are the well-known 'Pygmalion' series (Birmingham) and 'The Annunciation' (Port Sunlight), both shown at the Grosvenor in 1879. They make a dramatic contrast to the two richly coloured 'Venetian' works, 'Le Chant d'Amour' and 'Laus Veneris' (Nos.149–50), which had been exhibited in 1878. In fact 'The Golden Stairs' seems to have been more specifically classical at an earlier stage of development. F.G. Stephens, who knew Burne-Jones and had evidently watched its progress, commented in his review: 'Since we first saw this picture it has lost much of that Greek quality we then admired . . . It has . . . been modified, and now resembles in many points the art of Piero della Francesca. The pale golden carnations, the broad foreheads, the deep-set, narrow eyes and their fixed look, even the general contours and the poising of the heads on the shoulders, plainly tell of the influence of that lovely painter and poetic designer'. Burne-Jones is known to have admired Piero, an original taste for this date, and Stephens' observations may well be based on his own remarks.

The same stylistic tendencies also characterise the preparatory drawings for the picture, of which there is an impressive series. A large group of studies for the draperies (sketchbook in an English private collection), and others for the hands and feet (Fitzwilliam Museum; Hayward Gallery 1975–6, Nos 140–1), are drawn in hard pencil in a cold academic style, while a number of studies for the nude (e.g., ibid., No.139) are in silverpoint and white bodycolour on grey prepared paper, a technique inspired by Florentine quattrocento drawings. Many photographs of these were in Burne-Jones's possession.

The figures in No.154 were partly studied from professional models, including Antonia Caiva, a handsome Italian girl who also sat to Leighton, Poynter, and others, and Mrs Keene, who was a favourite model of Rossetti's and posed for many of Burne-Jones's best known works. However, a number of the heads are portraits of Burne-Jones's family and circle. May Morris appears prominently, facing the spectator half-way down the stairs. His daughter Margaret stands at the top, and Frances Graham, the daughter of his patron William Graham and herself a close friend for many years, is seen holding cymbals at lower left. The fascinating Laura Tennant, later Mrs Alfred Lyttelton, and Mary Stuart Wortley, sister-in-law of his friend Norman Grosvenor, are also said to appear. These likenesses helped to give the picture contemporary relevance and make it a key image for popular, fashionable Aestheticism. Indeed it was reputedly a source of inspiration for W.S. Gilbert's famous satire on the craze, Patience, first produced in 1881. The picture's influence was further enhanced by a number of engravings, notably that of Felix Jasinski (1862–1901), published in an edition of 350 proofs in 1894.

'The Golden Stairs' was bought by Cyril Flower, later Lord Battersea, and his wife Constance, who was a Rothschild. They had married in 1877 and two years later took Surrey House, at the corner of Oxford Street and the Edgware Road, where they built up a collection and entertained political and artistic society. Like so many of Burne-Jones's patrons, Flower, who was noted for his glamorous good looks and is said to have been the model for Dean Farrar's Eric, or Little by Little, belonged to the Liberal establishment, entering Parliament as member for Brecon in 1880 and serving Gladstone as Whip until he was raised to the peerage in 1892. In her Reminiscences (1922), Lady Battersea gives an amusing description of a meeting she

had in 1911 with two Frenchwomen, both ardent devotees of Burne-Jones: '"Ah, how beautiful is his picture called 'The Golden Stairs'!" said the older lady . . . "I am so glad," I replied, "for I have it." "Indeed!" said the lady, "and what may be the size of the engraving?" "Oh," I answered, "there are many sizes . . . (but) I have the picture itself". "You have the original?" screamed the lady – "the very original? . . . O je vous en félicite!" She jumped up and shook my hand. "Yes", I said, much amused, "Burne-Jones painted it expressly for us". "Then you knew him – you knew the master?" "Yes, of course; he was a very great friend of ours"'. It is a measure of the subsequent eclipse of Burne-Jones's reputation that only five years after this incident was recorded the Bloomsbury critic Clive Bell reproduced 'The Golden Stairs' in his book Landmarks in Nineteenth-Century Painting (1927) as an example of all he disliked in Pre-Raphaelitism, a movement of 'utter insignificance in the history of European culture'.

Rossetti complained that the composition of No.154 was 'stolen' from his picture 'The Boat of Love' (No.141), designed in the mid-1850s, taken up as a large oil in 1874, and abandoned in 1881. Both pictures show figures descending a staircase in a similar direction, but there the resemblance ends.

J.C.

EDWARD BURNE-JONES

155 The Wheel of Fortune 1875–83
Inscribed 'EB·J MDCCC|LXXXIII'
Oil on canvas, 78⅜ × 39⅜ (199 × 100)
First exh: Grosvenor Gallery 1883 (67)
Musée d'Orsay (Palais de Tokyo), Paris

The picture shows Fortune turning her wheel to which three mortals are bound – at the top a slave, in the centre a king, and below a poet. It is the largest and by far the most important of a number of versions of a design which Burne-Jones conceived in 1870 as part of the Troy Triptych (see No.146). Four allegorical figures – Fortune, Fame, Oblivion and Love, representing all together the theme of 'Amor vincit omnia' – were designed to frame and separate the predella panels, Fortune appearing on the far left. The triptych was never completed as a whole, but certain compositions within it were subsequently treated as independent pictures. Of these 'Fortune' came to have a significance for Burne-Jones out of proportion to all the rest, partly no doubt because he liked the composition, which expresses more powerfully than any other work his allegiance to Michelangelo, but also because it encapsulated much of his personal philosophy. 'My Fortune's Wheel is a true image', he wrote many years later, 'and we take our turn at it, and are broken upon it' (letter to Helen Mary Gaskell, quoted in P. Fitzgerald, Edward Burne-Jones, 1975, p.245). There are at least five other versions, including two largish oils (Melbourne and Cardiff; for the latter, see Martin Harrison and Bill Waters, Burne-Jones, 1973, p.133, fig.190) and a highly-finished watercolour (Fulham; Hayward Gallery 1975–6, No.124). The present picture, however, outstrips them all in its monumental conception. It is said to have been Burne-Jones's own favourite among his finished oil paintings.

It was begun in 1875 and worked on fairly consistently during the next few years. Numerous studies exist showing how carefully he considered every detail, the nudes, the drapery, and especially the head of Fortune, for which there are not only pencil drawings but several large monochrome sketches in oil on canvas. According to Mrs Comyns Carr, whose husband was one of the directors of the Grosvenor

Gallery, and who was responsible for many of the dresses worn on stage by Ellen Terry, Fortune's head-dress was modelled from 'a quaint little bonnet' of her design. Eventually, despite illness ('how hard I have worked on her in the middle of pain, or more correctly with pain in the middle of me', G. Burne-Jones, II, p.128), the picture was finished in time for the Grosvenor Gallery exhibition of 1883. There it dominated the west gallery and its sombre, metallic colour scheme made a striking contrast to the bright hues of his other major contribution that year, 'The Hours' (Sheffield). It was bought by Arthur Balfour, the wealthy young Conservative politician and leading member of that section of society soon to be known as 'The Souls'. Balfour had been brought to Burne-Jones's studio by Lady Airlie in the spring of 1875, not long after the death of May Lyttelton, to whom he was all but engaged. Though opposed in their political views, they were strongly attracted personally and intellectually, Balfour 'instantly becoming', as he put it, 'a victim of [the artist's] mind and art', and Burne-Jones claiming that he loved 'both [Balfour] and his company' (G. Burne-Jones, II, p.235). Balfour commissioned Burne-Jones to paint a series of canvases illustrating the story of Perseus to decorate the music room of his London house, 4 Carlton Gardens – a task which remained unfinished at Burne-Jones's death twenty-three years later (the incomplete oil set is at Stuttgart, the gouache cartoons at Southampton). The circumstances of the purchase of 'Fortune' are not known, but it was clearly a suitable subject for a patron whose first work of philosophy, *A Defence of Philosophic Doubt*, had been published in 1879. Nowhere perhaps is there a better illustration of Henry James's comment that Burne-Jones's is an 'art of culture, of reflection, of intellectual luxury'.

'Fortune' was warmly received at the Grosvenor. *The Times*, so often hostile to Burne-Jones in the past, observed: 'The artist is not one who varies his types . . . But never has the type been more splendidly realised than here; nor has any painting of this unquestioned but unequal genius ever been more completely successful'. It went on to note 'the wonderful technical skill . . . , the beauty of the grays, yellows, and flesh tints . . . [and] the admirable drawing of the figures, which shows that the artist has quite got rid of the faults of draughtsmanship which were noticeable in his work only a few years ago'. At last Burne-Jones was becoming accepted; it was a prelude to the great triumph he was to score a year later with 'King Cophetua' (Tate Gallery).

'Fortune' also plays a part in the story of Burne-Jones's European reputation. He had begun to exhibit in Paris in 1878, but his popularity there really dates from the appearance of 'Cophetua' at the Exposition Universelle of 1889. He continued to show in Paris until 1896, having a considerable influence in advanced Symbolist circles, and it seems that in 1891 Puvis de Chavannes tried to borrow 'Fortune' for exhibition at the independent Société Nationale des Beaux-Arts, of which he was President. Indeed Lady Burne-Jones in her *Memorials* (II, p.225) states that the picture appeared at the exhibition, but it is not listed in the catalogue, nor do any critical notices refer to it. However, the picture was certainly known in France, being discussed, for instance, by Robert de la Sizeranne in his important book *La Peinture Anglaise Contemporaine*, 1894, and it is perhaps significant that when Burne-Jones gave a group of drawings to the Luxembourg in 1893, two were head studies for Fortune. The picture itself has now been in France for fifty years. Balfour kept it until his death in 1930, but in 1932 it was sold to the Vicomte de Noailles and in 1980 was bought from his daughter by the Louvre for display at the new Musée d'Orsay.

The idea of Fortune and her wheel has been popular in Western art and iconography since the Middle Ages, and Burne-Jones was undoubtedly familiar with many examples – the famous engraving by Dürer, the intaglio design on the pavement of Siena Cathedral, and so on. Whatever bearing these had on his own design, however, the formal language he employs is that of Michelangelo. The slave and the king have the massive torsos of his male figures, their contorted poses recalling especially the 'Dying Slave' in the Louvre and the 'Captives' in the Accademia in Florence, while Fortune herself, in spirit as well as in the forms of her dress, looks back to the Sibyls of the Sistine Chapel ceiling. Michelangelo was one of the crucial influences on Burne-Jones's later work, his passion for him dating from his third visit to Italy in 1871, when he had sketched the Accademia 'Captives' and studied the Sistine ceiling closely, lying on the floor and gazing up through opera glasses. So important did the artist become for him that the same year he all but quarrelled with his old friend and mentor, Ruskin, over Ruskin's intemperate attack on Michelangelo in a Slade Lecture at Oxford. Michelangelo, Burne-Jones claimed, was 'immeasurable', his work expressing a 'mystery' that was 'intellectually grander' than the 'burden' of any other artist (G. Burne-Jones, II, pp.262–3). Small plaster casts of two of his most famous sculptures, the 'Dawn' and 'Evening' in the Medici Chapel at S. Lorenzo, stood prominently over the fireplace in the drawing-room at The Grange.

J.C.

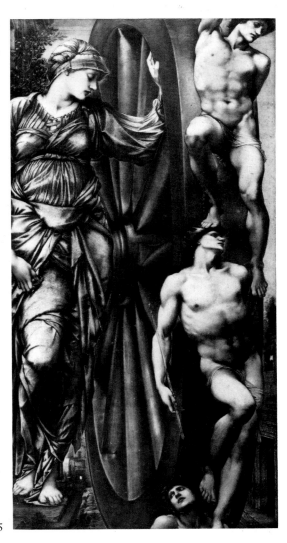

155

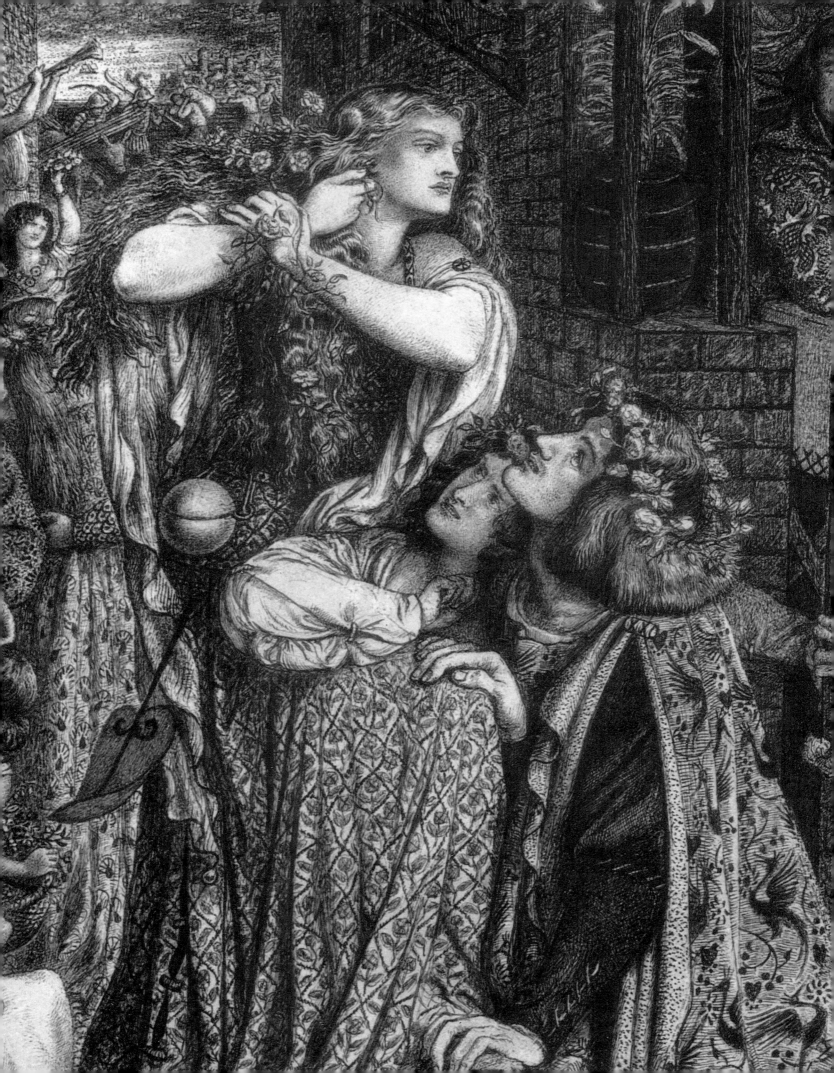

Drawings and Watercolours

SECTION VII

This selection of drawings and watercolours covers the same period as the sequence of oil paintings in Sections I–VI and is also arranged in approximate chronological order. For reasons of space, working drawings and preparatory studies have generally been excluded.

opposite Dante Gabriel Rossetti, 'Mary Magdalene at the Door of Simon the Pharisee', 1853–9 (detail, No.223)

FORD MADOX BROWN

156 Oure Ladye of Good Children 1847, 1854, 1861
Inscribed 'F.MADOX BROWN 1847–61'
Pastel and watercolour, with gold paint, arched top,
$30\frac{5}{8} \times 23\frac{1}{4}$ (77.8 × 59)
First exh: ? Free Exhibition 1847
Tate Gallery

Designed as a cartoon in black chalk after the artist's return
from Italy in 1847 and then called 'Oure Ladye of Saturday
Night'. He wrote of it in 1865 that it 'was little more than the
pouring out of the emotions and remembrances still vibrating
within me of Italian Art. To look at it too seriously would be a
mistake. It was neither Romish nor Tractarian, nor Christian
Art . . . in intention; about all these I knew and cared little, it
was merely *fanciful* . . . if imitative of Italian Art in certain
respects, it is original in others. The defined effect of light
intended for just after sunset, is not Italian. In idea the children
are modern English, they are washed, powdered, combed, and

156

bedgowned, and taught to say prayers like English Protestant babes'.

It was conceived as a contemporary interpretation of the Italian Madonna and Child type in a style quite distinctive from the clear-cut archaisms of, for example, William Dyce and with a title designed to reflect the simplicity and normality of the current weekly practice of bathing. Its informal conception of a gentle domesticity raised onto a religious plane is set in an iconographically acceptable, centralised framework whose formality is partially concealed by the off-centre placing of the Madonna's canopy and by the widespreading tree and continuing landscape across the background. In the far left is a group perhaps suggesting the Flight into Egypt and a pair of (?)doves alighting beneath the arch. To the right men drive cattle home in the evening. A sheet of water stretches across the whole background. The intensive use of decorative patterns must reflect the artist's initial delight in Italian prototypes and is only intensified by the later addition of colour.

Though it was rejected by the Royal Academy in 1847 (perhaps both because then only a drawing and for its informality), it was one of the works admired by Rossetti when he was seeking a teacher (Doughty & Wahl, I, p.36).

No.156 remained as a drawing for some years. In 1854 Madox Brown spent some time on it to meet his dealer White's wishes. He acknowledged in his diary his inclination to touch and improve a work about to go out of his hands: 'Anyone might be surprised to read how I work whole days at an old drawing done many years since and which I have twice worked on since it was rejected from the Royal acady in /47 . . . but I cannot help it . . . If I give one touch to a head I give myself 3 days work & spoil it half a dozen times over, this is invariable – is it so with everyone?'. White returned it in April 1855 as unsaleable.

It was damaged (the artist called it 'destroyed') during the 1857–8 American exhibition of Pre-Raphaelite and British painting organised by Madox Brown, W.M. Rossetti and others, when the title was altered to the present one. It was taken up again in January 1861 for T.E. Plint, who commented 'I shall be glad to have *colour* in. I think *cabinet* works much more thus'. The Account Book records its restoration from 8 January, and completion on 29 June and sale to Plint without copyright for £189 – by then Madox Brown was concerned to preserve his rights of reproduction and exhibition. He had it back again when it belonged to James Leathart sometime between November 1863 and May 1864, ostensibly to touch it. 'I have worked over the angel's face again and deepened the tone of it', he wrote in July 1864, but his real intention was to make a smaller replica. The subject was one of several offered to George Rae in December 1863. Leathart was not happy about a replica and perhaps to alleviate his misgivings Madox Brown had a new frame made for it (?by Green) and on 12 July 1864 wrote: 'It only came back Saturday and then there was the gold to be toned down, which with these oak frames I have to get done at home by my assistant – also the lettering which I had to do – and 22 circles to be filled in with outlines of angels. I have designed it (the angels) and it is now drawn in – but I find it may take my pupil 2 or 3 days yet'. Albert Goodwin, who is mentioned in the artist's correspondence at this period, was probably the pupil referred to. The later title is lettered on the frame (FMBP, UBC/LP, LAG/RP).

The replica, with slight variations in the details, is dated 1866 (New York private collection). There are various pencil studies at Birmingham.

M.B.

DANTE GABRIEL ROSSETTI

157 Gretchen and Mephistopheles in Church 1848
Inscribed 'GCDR JULY 1848' (initials in monogram)
and, around the sword, 'DIES IRÆ'
Pen and ink, upper corners rounded,
$10\frac{3}{4} \times 8\frac{1}{4}$ (27.3 × 21)
Ref: Surtees No.34
Private Collection

The subject is from Part I of Goethe's *Faust*, 'the cathedral nave', and was a popular one with illustrators. Rossetti had drawn it earlier, *c.*1846, but this version of July 1848 is more finished, probably because it was submitted to the drawing society called the Cyclographic to which all the painter members of the future P.R.B. belonged. Millais' and Hunt's criticisms of it survive – they admired it, though Millais pointed out faults in the perspective (Fredeman, facing p.110). Rossetti himself explained the subject and gave the relevant text from *Faust* at the head of the Cyclographic Society's criticism sheet: 'Margaret, having abandoned virtue and caused the deaths of her mother and brother, is tormented by the Evil Spirit at Mass, during the chaunt of the "Dies Irae"'.

This drawing, in common with most of Rossetti's other early designs, belonged to his friend the sculptor Alexander Munro.

A.G.

157

JOHN EVERETT MILLAIS

158 Lovers by a Rosebush 1848
Inscribed 'PRB [in monogram] JEMillais 1848' and in
the margin: 'John E. Millais to his PRB [in monogram]
brother Dante Gabriel Rossetti'
Pen and ink, within a drawn border,
10 × 6½ (25.4 × 16.5)
Ref: Arts Council 1979 (12)
Birmingham Museum and Art Gallery

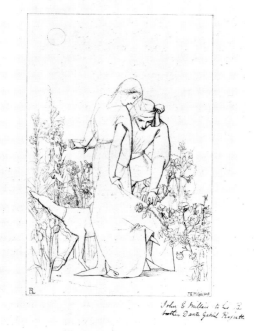

158

159

The general idea of this drawing, the combination of lovers,
rosebush and greyhound, is borrowed from an earlier design
Millais made to represent 'Youth' in the Four Ages of Man. This
was for a series of decorative lunettes for Little Woodhouse in
Leeds, the home of the solicitor John Atkinson. The original
sketch for 'Youth', probably made in 1847, is now in the
collection of E.G. Millais and the lunette that was painted from
it is in Leeds City Art Gallery. There are cupids hiding amongst
the roses in the lunette design and none here, but the more
important differences are stylistic. 'Youth' is a sweet, cur-
vaceous composition. No.158 shows the spiky, angular lines
and deliberate awkwardness of pose that characterise early
Pre-Raphaelite drawing. It is related in its mediaeval costumes
and chivalrous subject-matter to Millais' first major Pre-
Raphaelite painting, 'Isabella' (No.18). The heroine of that
work also has a pet greyhound and it is possible that No.158
illustrates the same Keats poem, showing Isabella with her
lover Lorenzo, although no scene exactly like this is described.
The work seems to have inspired some lines in Thomas
Woolner's poem 'My Beautiful Lady', which was written the
following year and published in the first number of *The Germ*:

> We thread a copse where frequent bramble spray
> With loose obtrusion from the side roots stray,
> (Forcing sweet pauses on our walk):
> I'll lift one with my foot and talk
> About its leaves and stalk
>
> Or may be that the prickles of some stem
> Will hold a prisoner her long garment's hem;
> To disentangle it I kneel,
> Oft wounding more than I can heal;
> It makes her laugh, my zeal.

No.158 may be identifiable with the drawing shown at the
large Millais exhibition at the Grosvenor Gallery in 1886 under
the title (presumably approved by the artist) of 'The Path of
True Love Never Did Run Smooth'. The catalogue compares
the work stylistically with 'The Disentombment of Queen
Matilda' (No.165) and mentions that the background was
'carefully studied from nature', but gives the date as 1849 not
1848.
 A small pencil study for the figure of the girl is in the
collection of E.G. Millais.

M.W.

WILLIAM HOLMAN HUNT

159 One Step to the Death-bed 1848
Inscribed 'W Holman Hunt to his PRB | Dante G Rossetti'
and, in another hand, 'WILLIAM HOLMAN HUNT | PRB.
1848'
Pen and ink, 7 × 11 (17.8 × 28)
Ref: Liverpool 1969 (100)
Richard L. Purdy

The handwriting of the inscription in the lower right-hand
corner of No.159 suggests that the drawing was presented to
D.G. Rossetti shortly after the foundation of the Pre-Raphaelite
Brotherhood. It was Rossetti who, on a separate piece of paper
formerly attached to the drawing, identified it as '"One step to
the deathbed" (Shelley)'. The phrase is taken from the second
verse of 'The Dirge' at the end of 'Ginevra':

> She is still, she is cold
> On the bridal couch,
> One step to the white death-bed,
> And one to the bier,
> And one to the charnel – and one, Oh where?
> The dark arrow fled
> In the noon.

Shelley's poem, written in 1821, relates the marriage and
subsequent death of Ginevra, forced against her will to marry
the rich Gherardi instead of her lover Antonio. The latter
secretly confronts Ginevra immediately after the ceremony,

and she gives him her wedding ring, saying:

'. . .Accept this token of my faith,
The pledge of vows to be absolved by death;
And I am dead or shall be soon – my knell
Will mix its music with that merry bell;
Does it not sound as if they sweetly said,
"We toll a corpse out of the marriage bed?"
The flowers upon my bridal chamber strewn
Will serve unfaded for my bier – so soon
That even the dying violet will not die
Before Ginevra . . .'

The wedding guests then lead the bride to the palace and leave her to rest while the festivities commence, but, true to her vow to Antonio, Ginevra's bed becomes her bier.

No.159 is the last in a series of illustrations Hunt made to the poem. His first drawing is postdated 1846 but probably belongs to 1847 as it includes sketches for the figure of Madeline in No.9: it depicts the finding of Ginevra's body and its being examined for signs of life (Coll. Mrs Burt, exh. Liverpool 1969, No.99). Hunt worked this up into an unfinished outline drawing in pen and ink (now known only through a Hollyer photograph in the collection of Mrs Burt), which, on stylistic grounds, seems to date from 1848 although it is postdated 1846 – 7. An outline pencil sketch, bearing the date 1847, was exhibited at the Tate Gallery in 1923 as 'The Pilgrim's Return: To the Newly Dead he had come instead of the Bridal Bed' (Coll. Professor George P. Landow, repr. Hunt 1913, I, p.71); this suggests that the source is 'Ginevra', and the facial features of the dead woman are close to those of the half-fainting protagonist of No.159.

The other three figures in 'One Step to the Death-bed' are largely a reworking of those in Hunt's pen and ink outline illustration to Leigh Hunt's 'Peace', a drawing made for the Cyclographic Society in the summer of 1848 (Cecil Higgins Gallery, Bedford, exh. 1969, No.96, repr.). The hooded old woman behind Ginevra may be derived from the figure of the witch in plate 9, 'Nur Frisch Hinunter!', of Retzsch's illustrations to *Faust*, 1816 (repr. Vaughan, p.129), despite the fact that on 27 July 1848 Hunt had denounced these illustrations to Goethe as 'artificial' (Fredeman, p.110). The odd little child recalls the infants in Lasinio's engravings after Bennozo Gozzoli frescoes in the Campo Santo, Pisa (e.g. plates XX, XXVII, XXVIII and XXXIV). An underlying reference to Florentine fifteenth-century art was apposite, as the poem 'Ginevra' was, according to Mrs Shelley's note in the 1847 edition, based on a story in *L'Osservatore Fiorentino*.

When Hunt and Rossetti drew up their List of Immortals in August 1848, Shelley was given the accolade of two stars (Doughty & Wahl, I, p.42, and Hunt 1905, I, p.159). Hunt wrote to Ruskin on 6 November 1880 that, before he read *Modern Painters*, 'Shelley and Lord Byron. with Keats were my best modern heroes – all read by the light of materialism – or sensualism –' (Cornell University Library). No.159 was executed some time after Hunt's discovery of Ruskin, and the artist's interest in Shelley's treatment of the tragic consequences of the thwarting of romantic love reveals his intensely idealistic nature. Although Ginevra's condition is caused by her passion for Antonio, there is no trace of sensuality in the severe outline style and the angular figures of No.159. The illustration's morbidity made it a fitting gift for Rossetti, whose early works (e.g. No.160) display a similar preoccupation, and 'One Step to the Death-bed' remained in Rossetti's possession until his death in 1882.

J.B.

160

DANTE GABRIEL ROSSETTI

160 **The Raven** *c.*1848
Pen and black ink and brown ink wash on light-brown paper, $9 \times 8\frac{1}{2}$ (22.9 × 21.6)
Ref: Surtees No.19B
Victoria and Albert Museum, London

This is a literal illustration of verses 12–14 of Poe's poem 'The Raven', first published in 1845. The raven perches on a bust of Pallas above the door. Seraphim are perfuming the air with unseen censers. The narrator has just 'wheeled a cushioned seat in front of bird, and bust and door' (line 68). A portrait of the lost Lenore hangs on the far wall. In June 1846 Rossetti drew an illustration to a slightly later incident in the same poem. He must have been one of Poe's earliest illustrators and his enthusiasm was perhaps encouraged by a youthful friendship with an American student named Charley Ware who, like Rossetti, enjoyed the supernatural (W.M. Rossetti 1895, I, p.89; Rossetti's annotated copy of Poe's *The Raven and other Poems*, 1846, is in the Troxell Collection at Princeton University). Hunt has testified to Rossetti's continued enthusiasm in 1848 and Poe is one of the Immortals listed by them in August of that year (Hunt 1905, I, pp.146, 154, 159). The subject of lovers separated by death interested Rossetti all his life. No.160 shows the influence of the illustrator John Leech in its technique. It is one of Rossetti's rare, and most convincing, portrayals of the dress and furnishings of his own time. He gave it to his friend the poet William Allingham.

A.G.

DANTE GABRIEL ROSSETTI

161 Ulalume 1848–9
Pen and black and brown ink over pencil on green
paper, $8\frac{1}{8} \times 7\frac{3}{4}$ (20.6 × 19.7)
Ref: Surtees No. 30
Birmingham Museum and Art Gallery

This illustrates Poe's poem 'Ulalume' (See No. 160). It shows
two variants of the narrator and his Soul walking in the 'ghoul-
haunted woodland of Weir' on the anniversary night of the
death of the narrator's lady, Ulalume:

> In terror she spoke, letting sink her
> Wings until they trailed in the dust –
> (lines 56–7)

Once again, the subject chosen by Rossetti, which he returns to
again and again, is about lovers separated by death and
remembrance of the past occasioned by the anniversary of the
death. The winged Psyche resembles an Angel from a fifteenth-
century Flemish painting but it is not known whether Rossetti
drew this illustration before or after his visit to Flanders in
October 1849.

<div align="right">A.G.</div>

<div align="right">161</div>

DANTE GABRIEL ROSSETTI

**162 Dante Drawing an Angel on the First Anniversary of
the Death of Beatrice** 1848–9
Inscribed 'Dante G. Rossetti | P-R.B. 1849' and, at the
top, 'Florence, 9th June, 1291: The first anniversary of
the death of Beatrice.'. In the top right, 'Dante G.
Rossetti | to his P R Brother | John E. Millais'. In the
window embrasure, 'Beata Anima bella, chi ti vede |
9 Giugno 1290'. At the bottom, Rossetti's translation of
the relevant passage from the *Vita Nuova*.
Pen and black ink, the inscriptions outside the drawn
frame in brown ink, $15\frac{3}{4} \times 12\frac{7}{8}$ (39.4 × 32.6)
Ref: Surtees No. 42
Birmingham Museum and Art Gallery

Dante is interrupted by friends while drawing an Angel on the
anniversary of Beatrice's death. Rossetti finished his trans-
lation of the *Vita Nuova* in October 1848 and intended to
illustrate it with his own designs. An almost complete drawing
of this subject, dated September 1848 (Surtees No. 42B), was
abandoned and this second version was finished in May 1849.
It was presented to Millais. The shading in this version is
harsher than in the first, it has an engraved quality, and the
details are elaborated. The statuette on the left is of St Reparata,
the patron saint of Florence. *Vanitas* symbols stand on the floor
below. The Alighieri coat of arms appears on Dante's chair and
in the window. Dante himself is modelled on the supposed
portrait by Giotto discovered in the Palazzo del Podestà in
Florence in 1840 (see Grieve 1978, p.14). His chief visitor,
perhaps intended as Guido Cavalcanti, wears a costume
adapted from a reproduction of a figure in the fourteenth-
century Spanish Chapel in Florence reproduced in Camille
Bonnard's *Costumes Historiques* (see Grieve 1973, p.15). As
well as Bonnard, influences on the style of drawing probably
came from Lasinio's engravings of the Campo Santo frescoes,
from the outline illustrations of the German artist Retzsch and
from earlier drawings by Millais such as his 'Isabella' design. In
May 1849 Millais was working on his drawing of the 'Dis-
entombment of Queen Matilda' (No. 165) and Hunt on his

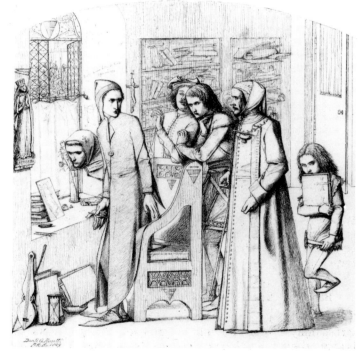

<div align="right">162</div>

'Lorenzo at his Desk in the Warehouse' (No. 163). All three are
initialled 'P.R.B.' and together they make the most convincing
demonstration of a shared style among the Brothers.

The inscription beneath Rossetti's drawing reads: 'On that
day on which a whole year was completed since my lady had
been born into the life eternal, – remembering me of her as I sat
alone, I betook myself to draw the resemblance of an Angel
upon certain tablets. And while I did thus, chancing to turn my
head, I perceived that some were standing beside me to whom I
should have given courteous welcome, and that they were
observing what I did: also I learned afterwards that they had
been there a while before I perceived them. Perceiving whom, I
arose for salutation, and said: "Another was with me". See
Dante's "Autobiography of his early life".'

<div align="right">A.G.</div>

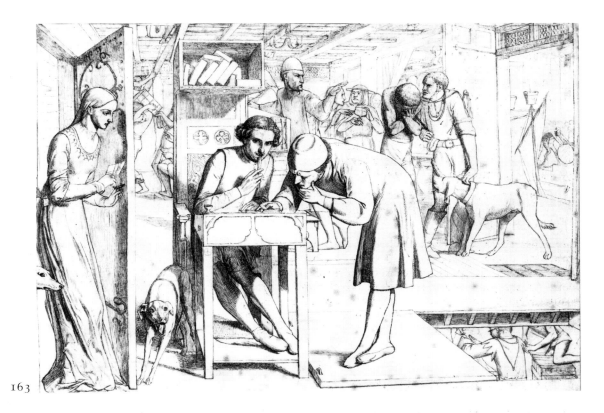

163

WILLIAM HOLMAN HUNT

163 Lorenzo at his Desk in the Warehouse 1848–50
Inscribed 'w.h.h. 1849 PRB'
Brush and ink and traces of pencil,
8¾ × 12½ (22.9 × 33.5)
First exh: *Collective Exhibition of the Art of W. Holman Hunt*, Walker Art Gallery, Liverpool 1907 (97)
Musée du Louvre, Cabinet des Dessins, Paris

When No.163 was exhibited at Hunt's Glasgow retrospective in 1907 (No.32), the catalogue contained the following couplet from the third stanza of Keats' 'Isabella, or The Pot of Basil':

He knew whose gentle hand was at the latch
Before the door had given her to his eyes.

The theme of young love thwarted by the opposition of the girl's family, depicted by Hunt in 'The Eve of St. Agnes' (No.9), is again the subject of 'Lorenzo at his Desk in the Warehouse'. Both can be seen as commenting on Victorian attitudes to courtship and marriage despite their source in Keats and their mediaeval setting. In addition No.163, begun in 1848, the year of revolutions and of the Chartist meeting, deals with the issue of class antagonism. Isabella's haughty brothers are shown as harsh taskmasters, not only in the imperious gesture and scowling countenance of the brother in the centre background, which reduces one employee to tears, but also in the glimpses of the exploited workforce crowded into the right-hand corners and behind the door in the left background of the drawing. Hunt took his cue here from stanza fourteen of Keats' poem:

With her two brothers this fair lady dwelt,
Enriched from ancestral merchandise,
And for them many a weary hand did swelt
In torchèd mines and noisy factories . . .

The decision to set No.163 in a warehouse was based on Keats' sneering reference to the brothers as 'ledger-men' (stanza eighteen), and was prompted by Hunt's own experiences of life in the city as a young clerk (Hunt 1905, I, p.142).

No.163 makes no attempt to encapsulate the story of Keats' 'Isabella' (for which see No.18), for it was conceived as part of a joint project of illustrations to the poem, and as a pendant to Millais' 1848 drawing of the same size and medium (Fitzwilliam Museum, exh. R.A. 1967, No.230, repr.), illustrating the first stanza. The two drawings display similarities in the presence of two greyhounds, the faces of Lorenzo and Isabella's brothers, as well as in the brothers' headgear.

There is conflicting evidence as to exactly when the Hunt and Millais drawings were begun: in 1886 Hunt placed this immediately after the formation of the Pre-Raphaelite Brotherhood (p.482), i.e. in September 1848. Millais' drawing was probably finished before then, as it does not bear the initials 'PRB'. In 1905 Hunt pushed back the starting date to June or July 1848 (II, p.451), but in both accounts minimised the part played by D.G. Rossetti, who, according to Esther Wood's 1894 *Dante Rossetti and the Pre-Raphaelite Movement*, had suggested eight subjects from 'Isabella' to be drawn by members of the Cyclographic Society (p.60). It is possible that Millais' and Hunt's drawings illustrate numbers one and two on her list: 'The Lovers' and 'The Brothers'. According to Hunt's autobiography, however, they were conceived 'in slightly shaded outline' as 'preparations for copperplate etchings' to the poem (Hunt 1905, I, pp.103–4). Such a potentially commercial idea, probably inspired by the engravings of Retzsch (Vaughan, p.154), was unlikely to have been mooted without the impetus of Monckton Milnes' biography of Keats, which was published in the first week of August 1848. The scheme was never brought to fruition because, as Hunt informed Rossetti on 29 May 1850: 'Moxon has the copyright of Keats's [illustrations] and is very jealous of the slightest infringement' (Troxell, p.35).

By this date Hunt still had not finished his design, which had

been abandoned in 1848 owing to pressure of work (Hunt 1905, I, p.104). According to W.M. Rossetti, Hunt had resumed work on 'Lorenzo in the Warehouse' by 23 May 1849 (Fredeman, p.5), and he called at Charlotte Street the following day 'to see Gabriel's tracings of costume' (ibid., p.6). Rossetti's recently completed 'The First Anniversary of the Death of Beatrice' (No.162) and Millais' 'Isabella' (No.18) had both drawn on Mercuri's engravings to Camille Bonnard's *Costumes Historiques* (Smith, pp.29, 32), and it seems likely that Hunt also used these as a source for his Lorenzo drawing. The influence of plate 15 of volume two, 'Jeune Française', can be detected in the sleeves of Isabella's dress, the way in which one knee is slightly bent and a shoe peeps out from beneath the flowing robe, and even, perhaps, in the simple profile, although this is a development of the face and hair of the girl at the foot of Ginevra's bed in the second drawing of that subject (now known only from the Hollyer photograph in the collection of Mrs Burt). The decoration on the neckline of Isabella's dress is taken from plate 45 of volume one, after Simon Memmi's portrait of Petrarch's Laura, while the costume of the 'Noble Florentin' (plate 16 of the same volume) is more elaborate but not dissimilar to the short tunics of the brothers in No.163. Florentine sources were, of course, apposite to the setting of Keats' poem, and the text to plate 16 mentions analogous costumes in Bennozo Gozzoli's frescoes in the Campo Santo, Pisa. Lasinio's engravings from these were a source for Millais' drawing of 'Isabella', and Hunt could certainly have drawn on the costumes of the young men in Gozzoli's 'The Meeting of Joseph and his Brothers' or 'The Childhood and First Miracles of Moses' (plates XXXIII and XXXIV). Lasinio's engraving after fragments of the frescoes by Bruno di Giovanni and Spinello Aretino may have influenced Hunt's utilisation of different levels of space in No.163.

The drawing was still in the artist's possession in the summer of 1910, when it was shown at the Liverpool Academy (No.402). It was purchased by Edmund Davis for presentation to the Luxembourg Museum *c*.1912–13.

<div align="right">J.B.</div>

WILLIAM HOLMAN HUNT

164 Compositional Study for 'A Converted British Family Sheltering a Christian Priest from the Persecution of the Druids' 1849

Pen and ink, $9 \times 11\frac{3}{4}$ (22.8 × 29.8)
First exh: *Collective Exhibition of the Art of W. Holman Hunt*, Walker Art Gallery, Liverpool 1907 (110)
Ref: Liverpool 1969 (109)
Johannesburg Art Gallery

According to the P.R.B. Journal, Hunt had commenced No.164 by 19 May 1849 and completed it by the evening of 23 May (Fredeman pp.4, 5). It reveals that certain elements in the symbolism of the exhibited picture (No.25) were part of the original conception, such as the vine trailing down from the roof of the hut, the corn and cabbages in the right middleground, and the cross and lamp at the back of the hut forming an altar. But here the cross assumes more prominence than in the painting, as it is carefully placed on a brick column rather than daubed on a stone, demonstrating that the monoliths which identify the persecutors as Druids were not part of the original conception. Like the wattle that was to supersede the

<div align="right">164</div>

brick structure of the hut, they help to establish the early Christian nature of the exhibited work.

The drawing is far more audacious than the painting in its religious imagery. In front of the makeshift altar Eucharist is being celebrated, for the nun-like figure sponging the lips of the tonsured priest looks as though she is offering him the Communion wafer. This may be a pun on the two meanings of 'minister', but such a reference would not have been intended for public consumption. In the painting Hunt was able to suggest that the Eucharist was about to be celebrated by changing the two figures at the far left. The impish child glancing sidelong at the missionary in the drawing gives no hint of the important role he was to assume in the finished work.

The group of three women ministering to the missionary recalls the imagery of the Deposition, and the priest himself is depicted placing his hand on his side, as if staunching a stigmatum. Thus the correspondence between the priest and Saviour is closer than in the exhibited picture, in which the missionary is winded after his escape from the Druids, rather than wounded.

The boy in the right foreground was, according to the P.R.B. Journal of 10 December 1849, originally transferred to the canvas in the awkward pose he assumes in this drawing (Fredeman, p.30); unaltered, it would hardly have endeared the work to the R.A. hanging committee. It creates a static effect by leading the eye upwards toward the central group, creating, with the bowl of baptismal water in the left foreground, a pyramidal composition offset by the perpendicular elements of the standing male figures and the rectangle of the hut. This contrasts greatly with the less schematic, and far more dramatic, composition of the painting, but is attuned to the mannered, elongated forms of the hard-edged Pre-Raphaelite style, which reached its apogee in the exactly contemporaneous 'The Disentombment of Queen Matilda' (No.165).

The device of water being cut off by the lower edge of the design may have been suggested to Hunt by plate XII of Lasinio's engravings after the Campo Santo frescoes, the fourteenth-century Pietro Lorenzetti's 'The Anchorites of Thebaid'. This anchorite community had formed around St Anthony, victim of religious persecution in the first century A.D., and the source was therefore apposite in terms of theme also.

<div align="right">J.B.</div>

165

JOHN EVERETT MILLAIS

165 The Disentombment of Queen Matilda 1849
Inscribed 'JEMillais 1849 PRB' (both sets of initials in monogram)
Pen and ink, $9 \times 16\frac{7}{8}$ (22.8 × 42.9)
First exh: *Third Autumn Exhibition*, Corporation Art Gallery, Manchester 1885 (727)
Ref: Arts Council 1979 (13)
Tate Gallery

The subject of this drawing is taken from Agnes Strickland's *Lives of the Queens of England*. The first biography in the book is that of Matilda of Flanders, Queen of William the Conqueror, in which Strickland describes how the Calvinists under Chastillon took Caen in 1562 and opened up the tomb of William the Conqueror. She continues: 'The fanatic spoilers also entered the church of the Holy Trinity, threatening the same violence to the remains of Matilda. The entreaties and tears of the abbess and her nuns had no effect on the men, who considered the destruction of church ornaments and monumental sculpture a service to God quite sufficient to atone for the sacrilegious violence of defacing a temple consecrated to his worship and rifling the sepulchres of the dead. They threw down the monument, and broke the effigies of the queen which lay thereon. On opening the grave in which the royal corpse was deposited, one of the party observing that there was a gold ring set with a fine sapphire on one of the queen's fingers, took it off, and, with more gallantry than might have been expected from such a person, presented it to the abbess, Madam Anna de Montmorenci, who afterwards gave it to her father, the constable of France, when he attended Charles IX to Caen, in the year 1563' (I, 1840, pp.119–20).

The P.R.B. Journal records on 15 May 1849 that 'Millais has done some figures of the populace in his design of the Abbey at Caen since last night'; on 17 May that he 'has put in some fat men, finding his general tendency to be towards thin ones'; and on 23 May that he has made 'considerable progress with the "Caen Nunnery", having put in the greater part of the populace' (Fredeman, pp.3, 5).

In their sufferings, Millais likens the nuns to Christ and the Christian saints and martyrs, represented in the background wall decorations, and the Calvinists to their torturers. The decorations show, from left to right, a saint with the marks of the stigmata, probably St Catherine of Siena; the Crucifixion; a female saint with a gridiron, the attribute of St Laurence; ? St Laurence himself, praying beside the fire over which he is about to be roasted; St Bartholomew with his attribute, a knife; and St Bartholomew suffering martyrdom by being flayed. In the lower right corner the coffin lid bears the inscription 'Matilda the Goode Wife of William Conqueror'. Next to it is an illuminated manuscript with a head of Christ inscribed 'Salvator Mundi' and an image of the Madonna and Child.

M.W.

WALTER HOWELL DEVERELL

166 Study for 'Twelfth Night' *c.*1849
Pen and ink and pencil, $8\frac{9}{16} \times 11\frac{5}{16}$ (21.8 × 28.8)
Tate Gallery

A squared-up study for 'Twelfth Night' (No.23), exhibited by Deverell at the National Institution in May 1850 but begun the previous year. In the painting Deverell revised the perspective and made numerous alterations to the design, solving at least some of the problems he encountered in the drawing – for example, the figure of the musician at the extreme right, shown here striking a bell he cannot possibly reach.

L.P.

166

WILLIAM HOLMAN HUNT

167 Study for 'Claudio and Isabella' 1850
Inscribed '18 Whh 50' (initials in monogram)
Pencil, pen, Indian ink and wash,
$12\frac{1}{2} \times 7\frac{1}{8}$ (31.7 × 18.4)
First exh: R.W.S. 1903–4 (174)
Ref: Liverpool 1969 (112)
Fitzwilliam Museum, Cambridge

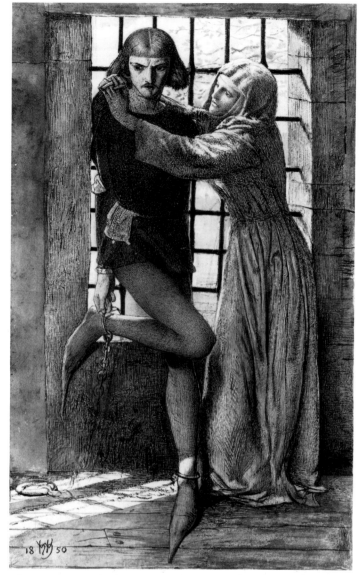

167

Identified by Hunt as the original drawing for No.45, this was one of three works submitted for inspection to a potential purchaser, as Hunt's letter of 29 May 1850 to D.G. Rossetti relates: 'Upon calling on Creswick with some designs this morning, and commencing business by reminding him of his commission, he politely told me that he did not remember anything whatever of it, and that he *thought* I must be mistaken' (Troxell, p.34). Rossetti professed himself 'utterly disgusted at Creswick's shabbiness' (letter to Hunt, 31 May 1850, ASU), while Millais, writing from Botley a few days later, expressed astonishment and asked, 'What does Egg say about it' (6 June 1850, HL).

According to Hunt's article on Egg in the *Reader* of 31 October 1863, the commission dated from 1849, when Thomas Creswick (here unnamed) congratulated Hunt on 'Rienzi' (No.17) and suggested 'that, if I painted some picture of a single figure, or two figures only, they would command a ready sale, and that he should be glad to see anything of the kind I might undertake, with a view to deciding upon one for himself... Accordingly, I selected three subjects [Nos.167, 168 and untraced], and made drawings of them; one of these was the prison-scene, "Claudio and Isabella", from "Measure for Measure". I sat up night after night to complete these' (p.517). Creswick not only failed to recollect the commission, but said 'that in any case he should not have been disposed to take either [sic] of the designs which I had brought' (ibid.). Crestfallen, Hunt called on Egg, who remembered that Creswick had spoken of the commission. Before showing him the designs, Hunt forestalled criticism by stating: '"I have done them in too great a hurry, probably, and, in the satisfaction of having conquered certain difficulties, did not consider that my ultimate purpose was not fully done justice to in these working drawings; perhaps, too, they are not up to the mark even in idea"' (ibid.). Although Egg 'objected to the quaintness of some of the forms', he 'accounted for this by the fact of the works having been done without models, and, to my great satisfaction, assured me that, generally, he found them to be full of merit. Upon the design of "Claudio and Isabella" he looked with especial favour' (ibid.), and encouraged Hunt to begin a painting from it.

Egg found features such as Claudio's immensely elongated footwear and lanky twisted limbs quaint, but to Creswick they must have appeared as confirmation of the critics' opinion on Hunt's and Millais' contributions to the 1850 Royal Academy (Nos 25 and 26). By 29 May these had been attacked as intolerably pedantic, affected, crude and perverse.

Such an extreme style, even without Creswick's strictures, was not intended for transfer to the medium of oil. In the exhibited work (No.45), the figures have been softened, partly by the addition of Claudio's fur-trimmed jerkin and the scapular worn over Isabella's *vestis* or gown, and their relationship has altered. In the drawing, Isabella holds her brother in a vice-like grip, suggesting that she is as frightened of yielding up her virginity to the hypocritical Angelo as her brother is of impending death, the penalty for her failing to do so. The protagonists thus seem equally matched and the emphasis on chastity as a positive virtue, so apparent in the painting, has not yet been developed. The sunlight streaming through the cell bars in No.167 symbolises the happy outcome of a seemingly insoluble dilemma, and thereby lessens the dramatic nature of the confrontation illustrated.

The drawing remained in Hunt's possession until 1906, when it was sold at Hunt's Leicester Galleries exhibition to Charles Ricketts for £100 (Ernest Brown & Phillips to E.R. Dibdin, 3 January 1907, WAG, and Hunt to Sydney Cockerell, 10 August 1909, Fitzwilliam Museum).

Further studies for the exhibited work are in a private collection (exh. Liverpool 1969, No.114) and the National Gallery of Victoria, Melbourne (ibid., No.113). The small oil sketch (The Makins Collection, ibid., No.18) differs from the final version in the colour of Claudio's tights and shoes and the positioning of the lovers' names which he has carved on the wall of the cell.

J.B.

WILLIAM HOLMAN HUNT

168 The Lady of Shalott 1850
Black chalk, pen and ink, $9\frac{1}{4} \times 5\frac{5}{8}$ (23.5 × 14.2)
Ref: Liverpool 1969 (119)
National Gallery of Victoria, Melbourne

According to William Michael Rossetti, No.168 was designed after the opening of the 1850 Royal Academy exhibition (Fredeman, p.73). It was finished by 29 May 1850, when it was inspected by Thomas Creswick (see No.167 and Hunt 1905, I, p.211).

Tennyson was one of the Pre-Raphaelites' favourite poets, and was considered by Hunt to be the natural heir to Coleridge, Keats and Wordsworth (ibid., I, p.326). In December 1849 the poet had begun sitting to Woolner for a portrait medallion (Fredeman, pp.30, 33; see No.30), but No.168 and Millais' contemporaneous design for 'Mariana' (Victoria and Albert Museum, exh. R.A. 1967, No.263; Fredeman, p.72) were the earliest Pre-Raphaelite illustrations to Tennyson's poetry. Unlike Millais, Hunt was unable to work up 'The Lady of Shalott' into a painting at this time, but the subject was to be of the utmost importance throughout his career, reaching its culmination in the large oil painting of 1886–1905 (Wadsworth Athenaeum, Hartford, Conn.; a small version is in Manchester City Art Gallery, exh. Liverpool 1969, No.58, repr.).

All of Hunt's versions of 'The Lady of Shalott' illustrate the lines:

> Out flew the web and floated wide;
> The mirror crack'd from side to side;
> 'The curse is come upon me', cried
> The Lady of Shalott.

The curse has befallen the lady for leaving her work and looking out of the window rather than into the mirror reflecting the world outside; and all of Hunt's representations of the theme depict Sir Lancelot, the agent of her fall, in the cracked circular mirror on the rear wall. In all of them, too, the lady is imprisoned within the frame of the magic tapestry she has been weaving and entangled by its threads. This does not follow Tennyson, who wrote: 'She left the web, she left the loom'. The lady could not therefore have been entangled in the threads of the tapestry, and the poet was to take exception to this feature of the design when it appeared in the illustration to the 1857 Moxon edition (Hunt 1905, II, pp.124–5; repr. 1969 exh.cat., pl.66).

Hunt's defence was ' "that I had only half a page on which to convey the impression of weird fate, whereas you use about fifteen pages to give expression to the complete idea" ' (1905, II, p.125). In the 1850 design he attempted to encapsulate 'the complete idea' through a series of eight roundels encircling the central mirror. The source for this was the mirror in Jan van Eyck's 'Arnolfini Marriage' (National Gallery), a feature that was to reappear in works by Brown (No.82), Rossetti (Surtees No.124) and Burne-Jones (No.235). The central mirror, which is higher in No.168 than in subsequent versions and reflects the back of the lady, represents the present: it depicts not only Sir Lancelot, but the view over the river, past the fields with the reapers and sheaves of barley, towards the walled city of Camelot, as described in Part I of Tennyson's poem. The smaller roundels are designed to be read clockwise from the top: the first sets the scene with a close-up view of one of the towers of Camelot. The lady is then revealed conscientiously working on her loom, while the third roundel shows her looking out of the window. The fourth depicts what has caught her attention: the resplendent Sir Lancelot, with his burning

168

helmet and helmet-feather and his horse's 'gemmy bridle' (Part III of the poem). A thread from the loom appears to bisect Lancelot's chest, connecting the knight with the fulfilment of the curse.

The fifth roundel is obscured by the lady, whose costume and long straight hair can be stylistically related to the figure of Isabella in 'Lorenzo at his Desk in the Warehouse' (No.163). The shawl knotted round her hips adds a touch of sensuality to an otherwise chastely mediaeval ensemble, and emphasises that part of her nature vulnerable to the dazzling sight of Sir Lancelot. It, together with the lady's reflection in the mirror, looks forward to 'The Awakening Conscience' (No.58), a work also concerned with the dereliction of duty, for this is how Hunt seems consistently to have interpreted his Tennysonian source (Hunt 1913, II, pp.401–3).

The remaining roundels illustrate Part IV of the poem; all are cracked, for they relate to future events, after the curse has been fulfilled. The sixth roundel portrays the lady writing her name on the prow of the boat, while in the seventh she is seen floating down the river 'Like some bold seer in a trance'. By the

time the boat reaches Camelot the lady is dead, and the last roundel depicts the people of Camelot who have come to look on her corpse:

> Out upon the wharfs they came,
> Knight and burgher, lord and dame,
> And round the prow they read her name,
> *The Lady of Shalott.*

According to Hunt's reminiscence of a conversation of *c.*1856 with D.G. Rossetti, No.168 '"was only put aside when the paper was so worn that it would not bear a single new correction"' (1905, II, pp.100–1). At this time Hunt was keen to work up his 1850 design into an illustration for the 1857 Moxon edition, and this may have led him to exaggerate his dissatisfaction with the drawing, which he castigated as 'immature' (ibid., II, p.102). He had by this date outgrown the hard-edged Pre-Raphaelite drawing style, of which No.168 is a superb example. By 1856 it had been given to the wife of a friend of the artist, who had expressed 'a violent liking for it' (ibid., II, p.101). This was Emily Patmore, and for many years the Patmore family respected Hunt's wish that the drawing 'should not be shown publicly' (ibid.). It was withdrawn before the sale of the collection of the late Coventry Patmore at Christie's on 6 April 1898 (lot 7), and only resurfaced in the autumn of 1920, when it was purchased by Frank Rinder on behalf of the National Gallery of Victoria.

J.B.

JAMES COLLINSON

169 The Renunciation of the Queen of Hungary 1850
Inscribed 'JC 1850' (initials in monogram incorporating anchor and cross motifs)
Pen and ink over traces of pencil,
$11\frac{7}{8} \times 17\frac{3}{4}$ (30.4 × 45.2)
Birmingham Museum and Art Gallery

A detailed composition study for the painting now in the Johannesburg Art Gallery, exhibited first at the Portland Gallery in 1851 as 'An Incident in the life of St. Elizabeth, of Hungary', and in 1852 at the Liverpool Academy as 'The Humility of St. Elizabeth' (repr. in colour in Christopher Wood, *The Pre-Raphaelites*, 1981, p.20). This was probably Collinson's most Pre-Raphaelite painting, although it was exhibited and presumably begun after he resigned from the Brotherhood in May 1850.

The story of St Elizabeth, Queen of Hungary in the thirteenth

century, is told in Charles Kingsley's play *The Saint's Tragedy*, published in 1848; the episode shown in Collinson's painting occurs at the beginning of Act I, Scene iii. Grieve has pointed out that the combination of history and comment on contemporary issues in Kingsley's play appealed to the Pre-Raphaelites, and inspired subjects for drawings by Millais and Rossetti as well as for Collinson (Alastair Grieve, 'A notice on illustrations to Charles Kingsley's "The Saint's Tragedy" by three Pre-Raphaelite artists', *Burlington Magazine*, CXI, 1969, p.293). Collinson appended a long extract from Montalembert's *Life of St. Elizabeth of Hungary* to his title in the Portland Gallery exhibition catalogue. In the episode quoted, the Landgravine of Thuringia has taken the Princesses Agnes and Elizabeth to Mass, where Elizabeth removes her crown and prostrates herself at the foot of the great crucifix to the disapproval of her companions.

The composition of the drawing is very similar to that of the painting, but there are important differences in the details of the architecture and the figures. The most notable change is the greater concealment of certain of the figures' anatomy with drapery – particularly the covering of the soles of the feet of the kneeling figure in the left foreground – perhaps following the adverse criticism of Millais' 'Christ in the House of His Parents' in 1850. The angularity of the drawing is considerably softened in the painting, particularly in the faces and the drapery folds, and the exaggeratedly pointed footwear worn by the courtiers on the right is curtailed.

Wood draws attention to the fact that many of the architectural details are nineteenth-century Gothic Revival in style, especially the encaustic tiling of the floor. Grieve notes that the date of this drawing coincides with Christina Rossetti's termination of her engagement to Collinson and his resignation from the Brotherhood, and that 'he must have felt the play's portrayal of the renunciation of human love and self-control through suffering as strongly applicable to his own problems'.

R.P.

FORD MADOX BROWN

170 Self-Portrait 1850, 1853
Inscribed 'Ford Madox Brown aetat 29 – Sep.t 1850 | retouched oct.r / 53'
Crayon, 10 × 9 (25.5 × 22.8)
Ref: Liverpool 1964 (62)
Private Collection

One of the two early self-portraits, the other in oil, which have always remained with the artist's descendants. In 1850 he was at work completing the great 'Chaucer' in his studio in Newman Street, and in 1853 when he was retouching this portrait he had a studio at Hampstead and was finishing 'An English Autumn Afternoon' from his landlady's window.

William Michael Rossetti described his appearance at the time of his first meeting with his brother Dante Gabriel: 'He was a vigorous-looking young man, with a face full of insight and purpose; thick straight brown hair, fair skin, well-coloured visage, blueish eyes, broad brow, square and rather high shoulders, slow and distinct articulation. His face was good-looking as well as fine; but less decidedly handsome, I think, than it became towards the age of forty. As an old man . . . he had a grand patriarchal aspect' (W.M. Rossetti 1895, I, p.118). His colouring and bearing are also borne out by the self-portrait in 'The Last of England' (No.62).

M.B.

169

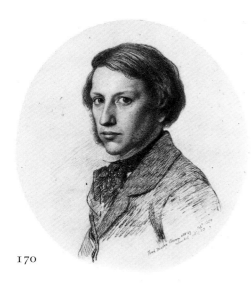

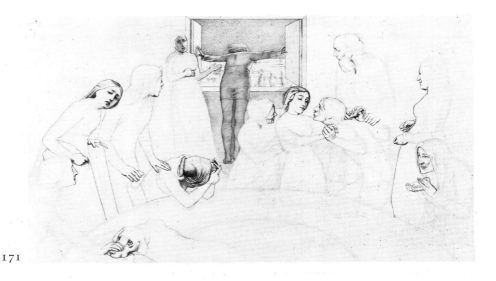

170

171

JOHN EVERETT MILLAIS

171 The Eve of the Deluge ?1850
Pen and ink, with grey wash, over pencil, divided into
¾-inch (approx.) squares, 9¼ × 16¼ (23.5 × 41.2)
Ref: Arts Council 1979 (47)
Trustees of the British Museum

A wedding feast in progress, with ominously mounting flood waters visible through the window. The subject is from St Matthew 24. 38–9: 'For as in the days that were before the flood they were eating and drinking, marrying and giving in marriage, until the day that Noe entered into the Ark, And knew not until the flood came, and took them all away; so shall also the coming of the Son of man be'. As a biblical scene with a number of figures around a table, No.171 resembles 'Christ in the Carpenter's Shop' (No.26) and was probably made as a sketch for a painting on the same scale to be a follow-up to that work at the R.A. exhibition of 1851, although no such painting was ever executed.

On 2 December 1850, the artist wrote to Mrs Thomas Combe: 'I have entirely settled my composition of "The Flood", and shall commence it this week' (J.G. Millais, I, p.91). On 10 December he showed a sketch, probably No.171, to D.G. Rossetti (P.R.B. Journal, Fredeman, p.86); and on 15 January 1851 he wrote again to Mrs Combe: 'I have not yet commenced "The Flood", but shall do so this week for certain' (J.G. Millais, I, p.94). By 28 January, however, he had given up the idea, at least as a possibility for that year's exhibition (ibid., I, p.97). Two pictures he did paint in 1851, 'The Return of the Dove to the Ark' (No.34) and 'The Bridesmaid' (No.37), may have come out of his concern with the themes of the Flood and marriage, although neither is anything like as ambitious as 'The Eve of the Deluge' would have been if realised.

Later that year, he sent Mrs Combe a description of what he had in mind for the composition: 'I shall endeavour in the picture I have in contemplation – "For as in the Days that were Before the Flood," etc., etc. – to affect those who may look on it with the awful uncertainty of life and the necessity of always being prepared for death, My intention is to lay the scene at the marriage feast. The bride, elated by her happiness, will be playfully showing her wedding-ring to a young girl, who will be in the act of plighting her troth to a man wholly engrossed in his love, the parents of each uniting in congratulation at the consummation of their own and their children's happiness. A drunkard will be railing boisterously at another, less intoxicated, for his cowardice in being somewhat appalled at the view the open window presents – flats of glistening water, revealing but the summits of mountains and crests of poplars. The rain will be beating in the face of the terrified attendant who is holding out the shutter, wall-stained and running down with the wet, but slightly as yet inundating the floor. There will also be the glutton quietly indulging in his weakness, unheeding the sagacity of his grateful dog, who, thrusting his head under his hands to attract attention, instinctively feels the coming ruin. Then a woman (typical of worldly vanity) apparelled in sumptuous attire, withholding her robes from the contamination of his dripping hide. In short, all deaf to the prophecy of the Deluge, which is swelling before their eyes – all but one figure in their midst, who, upright with closed eyes, prays for mercy for those around her, a patient example of belief standing with, but far from, them placidly awaiting God's will. I hope, by this great contrast, to excite a reflection on the probable way in which sinners would meet the coming death – all on shore hurrying from height to height as the sea increases; the wretched self-congratulations of the bachelor who, having but himself to save, believes in the prospect of escape; the awful feelings of the husband who sees his wife and children looking in his face for support, and presently disappearing one by one in the pitiless flood as he miserably thinks of his folly in not having taught them to look to God for help in times of trouble; the rich man who, with his boat laden with wealth and provisions, sinks in sight of his fellow-creatures with their last curse on his head for his selfishness; the strong man's strength failing gradually as he clings to some fragment floating away on the waste of water; and other great sufferers miserably perishing in their sins. I have enlarged on this subject and the feelings that I hope will arise from the picture, as I know you will be interested in it. One great encouragement to me is the certainty of its having this one advantage over a sermon, that it will be all at once put before the spectator without that trouble of realisation often lost in the effort of reading or listening' (J.G. Millais, I, pp.103–5). The drunkards and the praying woman were evidently ideas that had come to Millais since drawing No.171. Unfortunately there is no extant drawing for the composition that includes them.

The artist renewed his intention of painting 'The Eve of the Deluge' in 1852. In March that year he wrote to Thomas Combe: 'The subject I intend doing will not require much out-

of-door painting – nothing but a sheet of water and a few trees – a bit of flooded country such as I have seen near you at Whitham', but by October the work had again been put off until the following year (J.G. Millais, I, pp.162, 172). In 1853 he spoke of the subject to Ruskin, who reported to his father on 7 October that 'the moment he gets home [from Scotland] he means to begin his great picture', and on 11 November that 'He is going to set to work at present on another picture – his great one: which is to take him three or four years' (Lutyens 1967, pp.93, 110). What appears to be the last reference to the project is in a letter to Holman Hunt of 7 February 1854: 'I shall *certainly* join you next Autumn [in the Holy Land]. I shall there begin the Flood, which I shall be able to paint anywhere, and take about with me. It will be necessary to paint all kinds of heads in that, therefore it will be an advantage' (PML).

There are two studies for the pair of lovers, and two just for the young man, on the verso of a sketch for 'Ferdinand Lured by Ariel' (No.24) at the Victoria and Albert Museum (exh. R.A. 1967, No.250).

M.W.

JOHN EVERETT MILLAIS

172 Picnic Scene ?1851
Pen and sepia ink over pencil, $7\frac{1}{4} \times 11\frac{1}{4}$ (18.4 × 28.6)
Ref: R.A. 1967 (267)
Visitors of the Ashmolean Museum, Oxford

This drawing is not dated but may well have been executed during the summer of 1851 while Millais was at work on the background to 'Ophelia' (No.40). It was catalogued at the sale of D.S. MacColl at Christie's on 9 June 1944 (102) as a 'study at Ewell', which is near the site of 'Ophelia', and the willows in the background do suggest the river bank on which that picture was painted. Millais used the same kind of subject, and specifically the reclining figure on the left with a piece of grass in her mouth, though seen from a different viewpoint, in 'Spring' (No.96). The figure as it appears in 'Spring' was in turn used for an etching of 1861 called 'Summer Indolence'.

M.W.

DANTE GABRIEL ROSSETTI

173 The Salutation of Beatrice in Eden 1850–4
Inscribed 'DGR'
Watercolour, $11\frac{1}{2} \times 9\frac{7}{8}$ (29.2 × 25.1)
Ref: Surtees No.116D; Grieve 1978, p.12
Fitzwilliam Museum, Cambridge

This shows Dante's longed-for reunion with Beatrice after her death, as described in his *Purgatory*:

> . . . then with act
> Full royal, still insulting o'er her thrall,
> Added, as one who, speaking, keepeth back
> The bitterest saying, to conclude the speech:
> 'Observe me well. I am, in sooth, I am
> Beatrice. What! and has thou deign'd at last
> Approach the mountain? knewest not, O man!
> Thy happiness is here?'

(trans. H.F. Cary, *The Vision . . . of Dante Alighieri*, 1845: *Purgatory*, XXX, lines 67–74).

Rossetti first designed the subject in 1850 as one compartment of a diptych which also showed, in the other compartment, Beatrice's salutation in Florence (Surtees No.116A). He planned to paint a large oil of it and in the autumn of 1850 started the background of the 'Salutation in Eden' from nature (see No.142). This was abandoned. The subject was evidently redesigned in May 1851 (Fredeman, p.97) but it was only three years later, in the spring of 1854, that this watercolour was finished for G.P. Boyce (Surtees 1980, p.12). The composition is developed from the design of 1850 with Beatrice's attendants now moved to either side of her rather than following in procession. The repetition of their intense, blue draperies and of their psalteries, provides a refrain to the meeting of the principal characters. Beatrice wears the colours described in the *Commedia*, a green mantle over a red dress. Dante's face is modelled on a supposed death mask of the poet which was in Rossetti's possession.

The frame is similar to that on No.174 and is one of the earliest surviving designed by the artist. It is inscribed with the relevant text and carved with suns and stars. In 1885 Boyce gave the watercolour to Philip Webb who in turn gave it to Sydney Cockerell who presented it to the Fitzwilliam Museum.

A.G.

172

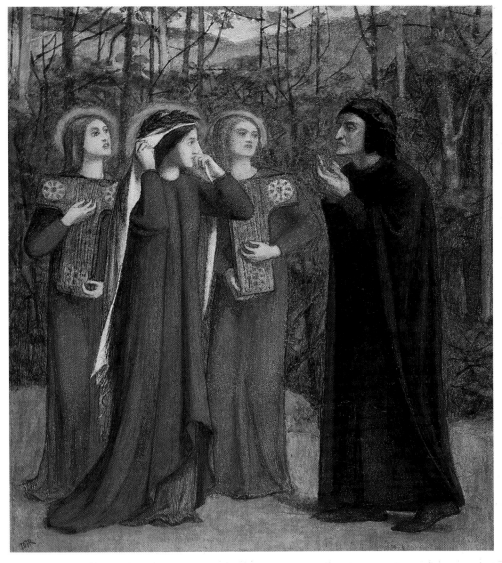

173

174

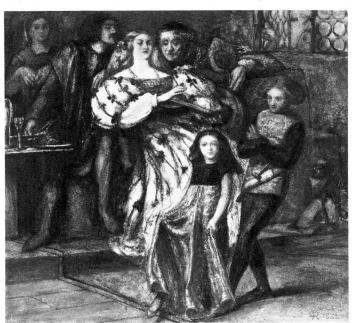

DANTE GABRIEL ROSSETTI

174 Borgia 1851–9
Inscribed 'DGR 1851' (initials in monogram, added
1860)
Watercolour, $9\frac{1}{8} \times 9\frac{3}{4}$ (23.2 × 24.8)
First exh: Hogarth Club, January 1859
Ref: Surtees No.48
Carlisle Museum and Art Gallery

This composition was first designed in 1850 in a small, highly
finished, pen drawing described, at first, simply as 'Music, with
a Dance of Children' (Surtees No.47). The watercolour,
No.174, probably resembled this pen drawing more closely
than it does today for its first owner, G.P. Boyce, records that it
was drastically converted into a 'Borgia' subject between 27
December 1858 and 3 January 1859 (Surtees 1980, p.26).
The old man on the right is Lucrezia Borgia's father, Pope
Alexander VI. Her brother, Cesare, smells a rose in her hair and
beats time to her music on a wine-glass. Lucrezia wears a
sumptuous dress which Rossetti adapted from a reproduction
of a late fifteenth-century Italian dress in Bonnard's *Costumes
Historiques* (see Grieve 1978, p.53). She plays music for a

dancing boy and girl who wear gold and black costumes.

The subject of music being played occurs frequently in Rossetti's painting and poetry. In fact he was unmusical and probably used it to concentrate attention on the passage of time which was a major preoccupation. The idea of converting this to a 'Borgia' subject possibly came from his new friend Swinburne, who venerated Lucrezia.

The frame is probably original and appears to be one of the earliest designed by the artist.

A.G.

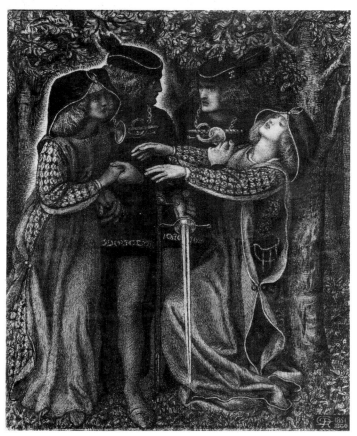

175

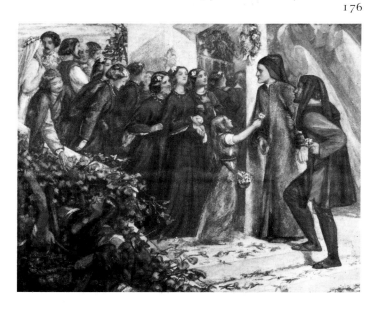

176

DANTE GABRIEL ROSSETTI

175 How They Met Themselves 1851–60
Inscribed 'DGR 1851 | 1860' (initials in monogram)
Pen and brush, 10½ × 8¼ (26.9 × 21.2)
Ref: Surtees No.118; Grieve 1978, p.61
Fitzwilliam Museum, Cambridge

Two mediaeval lovers walking in a dense wood are shocked at meeting their doubles who glow supernaturally and appear to assert a stronger right to existence. There seems to be no specific source for the subject, Rossetti himself simply referred to No.175 as 'the Bogie pen and ink' but *Doppelgänger* imagery occurs in poems he admired such as Elizabeth Barrett's 'The Romaunt of Margaret' and Poe's 'Silence' and also frequently in his own more autobiographical poems such as 'The Portrait', 'Sudden Light', 'Even So' and 'Willowwood':

> And I was made aware of a dumb throng
> That stood aloof, one form by every tree,
> All mournful forms, for each was I or she,
> The shades of those our days that had no tongue.
> ('Willowwood', sonnet 2, lines 5–8)

The elaborate finish emulates Dürer prints and is found in other drawings of this decade such as 'Hesterna Rosa' and 'Hamlet and Ophelia' which were also only completed several years after they were conceived. The figure grouping in No.175 resembles that in the illustration 'La Belle Dame sans Merci' of 1848 (Surtees No.32) but we know Rossetti was working on it in October 1860 and it bears the double date 1851/60 (Surtees 1980, p.30). The hat of the female figures recurs in several other works of *c.*1857–*c.*1860 and is adapted from a plate in Shaw's *Decorations and Dresses of the Middle Ages* (see J.G. Christian, 'Early German Sources for Pre-Raphaelite Designs', *Art Quarterly*, XXXVI, Nos.1/2, 1973, p.79, note 3).

No.175 was owned by G.P. Boyce by at least the New Year of 1861. Two watercolour replicas were made (Surtees No.118, R.1, R.2).

A.G.

DANTE GABRIEL ROSSETTI

176 Beatrice, Meeting Dante at a Marriage Feast, Denies him her Salutation 1852
Watercolour, 13¾ × 16¾ (34.9 × 42.5)
First exh: *Winter Exhibition*, Gambart, French Gallery 1852 (196)
Ref: Surtees No.50; Grieve 1978, pp.17–18
Private Collection

The subject of No.176 is one of thirteen which Rossetti lists in November 1848 as intended illustrations for his recently completed translation of Dante's *Vita Nuova* (Doughty & Wahl, I, p.49). It was painted while he was staying at Highgate in the early summer of 1852 (ibid., p.122) and exhibited that winter with another watercolour of a Dante subject, 'Giotto painting Dante's Portrait', which is untraced. Both were described as sketches for pictures but neither were in fact carried further. No.176 shows Dante 'overpowered by the great lordship that Love obtained, finding himself so near unto that most gracious being' (W.M. Rossetti 1911, p.320). The catalogue of the 1852 exhibition carried an abbreviated passage from the *Vita Nuova*:

Therefore I feigned to lean my person unto a painting which ran round the walls of that mansion; and fearing lest others should discern my confusion, I lifted my eyes, and looking on those Ladies perceived among them the most gracious Beatrice; whereupon many of the Ladies, noticing the change that was come upon me, began to marvel and to whisper, mocking me with my Lady.

The remarkably intense and harmoniously balanced colours of this watercolour drew Ruskin's admiration to Rossetti for the first time: 'I am very much delighted with a sketch of Rossetti's in the Winter Exhibition Beatrice and Dante – a *most glorious* piece of *colour*. The breadth of blue-green – and fragmentary gold is a perfect feast' (9 January 1853, to Holman Hunt; Grieve 1978, p.18). W.M. Rossetti remarked on the combination of blue and green: 'This was one of the first paintings, or perhaps the first, in which Rossetti tried a combination of colour of which he was extremely fond . . . bright light green bordering upon bright light blue' (*Art Journal*, 1884, p.151). It is the repetition of these two colours which holds the drawn-out composition together. Dante wears red, the colour of love. He is placed against a wall frescoed with light blue angels and is offered flowers by a little girl dressed in gold, the colour of charity. Beatrice is painted from Elizabeth Siddal. She is flanked by two dark-haired bridesmaids who watch the effect she has on Dante – a subject taken up with a related composition over ten years later in 'The Beloved' (No.133). The strain of this meeting is contrasted with the cheerful mood of the girl in the bottom left holding a basket of grapes – symbol of fertility.

The work was sold to H.T. Wells in 1852 for about £10. A second version was painted in 1855 and bought by Ruskin (Surtees No.50 R.1).

<div style="text-align: right">A.G.</div>

177

FORD MADOX BROWN

177 Study of F.G. Stephens for 'Jesus Washing Peter's Feet' 1852
Inscribed 'FMB-52.' (initials in monogram)
and with title
Pencil, $11\frac{1}{2} \times 13\frac{1}{4}$ (29.2 × 33.5)
Tate Gallery

Full-scale study for No.42, and the only portrait study recorded for the picture, where the hair was altered and a beard added.

Stephens, one of the Pre-Raphaelite Brothers, sat also for Millais' 'Isabella' and 'Ferdinand Lured by Ariel' and for Holman Hunt's 'Converted British Family' (Nos 18, 24, 25). In later life as art critic for the *Athenaeum* he frequently noticed Madox Brown's works, often closely following material supplied by the artist himself.

<div style="text-align: right">M.B.</div>

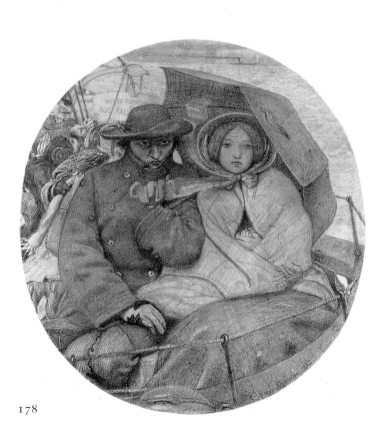

178

FORD MADOX BROWN

178 Cartoon for 'The Last of England' 1852, 1855
Inscribed 'F MADOX BROWN 1852'
Pencil, oval, $16\frac{5}{8} \times 14\frac{7}{8}$ (42.2 × 37.8)
First exh: 33 Percy Street, September 1855
Ref: Liverpool 1964 (71)
Birmingham Museum and Art Gallery

Cartoon for No.62, showing the slightly narrower oval of the first idea, enclosing the principal figures more tightly; and having less figures in the background, where the boat also is in a slightly different position and is inscribed 'WHITE HORSE LIN[E]|of|AUSTRALI[A]'. There are no cabbages, the woman's shawl has a wide check which was changed in the picture after September 1854, and there is no string to the man's hat, which was added in the painting to please the dealer White who bought it. The tautness of the drawing, in contrast to the painting posed from the life, seems to intensify the desperate pathos of the subject, and is a characteristic feature common also to Millais and Holman Hunt.

This cartoon was designed, with the coloured sketch (lost),

just before Christmas 1852. It was being got ready with other sketches to 'sell to dealers or others' when Madox Brown took up the picture again in September 1854. It was, however, worked at again on several evenings during March 1855 possibly in harness with figures in the background of the painting itself. Such details as the horizon and sea, which were altered in the picture (*Diary*, 3 June, 26 August 1855), appear the same here; and he noted on 2 September 1855, when the picture was almost finished: 'drew in the mothers hand holding the babys in the drawing which has never been done yet'. D.T. White bought it for £7 and it went to B.G. Windus, like the picture itself.

This cartoon of a quarter the area of the painting (half-scale measurements) is rare in the artist's production at this date. Following his great cartoons for the Westminster Hall Competitions, after 1845 he more usually produced for his major paintings a small outline drawing, an oil or watercolour sketch for the colour and a variable number of life and portrait drawings. The watercolour (?) sketch for this subject is lost and he appears to have confined himself to one portrait study only, the full scale one of Emma (No.179). Other details appear to have been worked out on the picture itself. In the 1860s, as was to become his general practice, he produced an oil and a watercolour replica of this subject (Fitzwilliam Museum and Tate Gallery); and thereafter he generally designed cartoons (possibly following an initial book illustration) which were taken up only when he had a commission.

M.B.

179

FORD MADOX BROWN

179 Study of Emma for 'The Last of England' 1852, ?1855
Inscribed 'FMB Decr/52' (initials in monogram)
Black chalk, 6½ × 7 (16.5 × 17.8)
Ref: Liverpool 1964 (72)
Birmingham Museum and Art Gallery

Emma Hill, later the artist's wife, appears first to be mentioned in his diary during 1848, though not by name, and his first study of her is dated Christmas 1848 (Birmingham 789'06: used for 'King Lear'). They were married in 1853. A girl of little formal education, she appears to have had a sweet and gentle temperament, which is apparent in this study, certainly his finest of her. It is characteristic, in its close-up head-on view, of most of the artist's portraits, particularly of his family, who all appear as models in his pictures.

When this study for No.62 was made at Hampstead in December 1852, Emma was living on the other side of the Heath and early in the New Year she sat again for the picture itself, 'coming to sit to me in the most inhuman weather from Highgate' (Surtees 1981, p.80). The head in the picture almost exactly matches this study in size and detail, and the artist took infinite pains with its painting, as indeed he did with the whole picture: 'The madder ribbons of the bonnet took me 4 weeks to paint' was one despairing comment. He called it 'a complete portrait' when taking up the picture again in September 1854 at their new home at Grove Villas, Church End, Finchley, and he touched it at intervals, with and without Emma sitting, between September 1854 and August 1855. More than once he scraped it out with a penknife: 'to begin getting thereby the ground partly seen through, for the repainting this head is with zink white on zink white ground. I keep it faithfully like Emma' (*Diary*, 22 March 1855). In the evening of 11 April, after cleaning his palette, he 'worked at Emma's head, the drawing I made at Hampstead when I began the picture. Emma would not sit so I worked from feeling'. He was still despondent over the picture and found when he first tried it in its frame that 'the head of Emma struck me as very bad & made me miserable all night. This morning I scraped at it with my penknife & so widened the cheeks some, & improved it, the color is good but the chin & jowls too heavey' (*Diary*, 20 April 1855). Just before completing the picture in August he recorded his final satisfaction with it.

Her gentle expression and youthful bearing contrast with the dour misery of her husband in the picture and her face was considered 'the chief charm of the picture' by the *Saturday Review* critic (4 July 1857).

M.B.

FORD MADOX BROWN

180 St. Ives, An.Dom. 1636 1853, 1856, 1874
Inscribed 'F.Madox Brown 1853-56-74'
Gouache, pen and ink, coloured pastel, over pencil, and slight surface scratching, arched top,
13½ × 9¾ (34.3 × 24.7)
First exh: L.A. 1857 (505)
Ref: Liverpool 1964 (75)
Whitworth Art Gallery, University of Manchester

The design dates initially from the same period as the Hampstead pictures and like 'Work' (No.88) the subject stems from Carlyle, in this case *Cromwell's Letters and Speeches* (1845;

a 3rd edition was published in 1849). Hueffer (p.94) suggests that Madox Brown saw a parallel to his own situation in that of Cromwell at the time of his retirement from the political scene to his country estate in the early 1630s, before the outbreak of the Civil War. Carlyle described Cromwell's life at St Ives in 1636: 'A studious imagination may sufficiently construct the figure of his equable life in those years. Diligent grass-farming; mowing, milking, cattle-marketing; add "hypochondria," fits of the blackness of darkness, with glances of the brightness of heaven; prayer, religious reading and meditation ... we have a solid substantial inoffensive Farmer of St. Ives'. The composition is woven round Carlyle's descriptions of the area, while, like 'Work', this also is a morality and infused with symbolism, here arising from Psalm 89, from which the artist took verse 45 for his text on first exhibiting the drawing.

Cromwell has come to a standstill on his old pale horse in a country lane near his house, the church of Huntingdon in the distance over the river Ouse. He clutches an oak sapling, symbol of moral or physical strength. One hand in his pocket, with the other he keeps the place in his Book of Common Prayer from which he has just read the passage in the psalm: 'Lord, how long wilt thou hide thyself – for ever? And shall thy wrath burn like fire?'. Deep in meditation he gazes into the wreathed smoke and flames of the bonfire made by the labourers clearing and mending the hedgerow, perhaps contemplating the future still obscured in mist while the deadwood of the past is destroyed. He is quite unconscious of the noise and chaos around him caused by the escaping pigs and the yokel with squawking duck shouting to him over the hedge that the cattle are out of control. His browsing old horse (close in composition to Delacroix's 'The Capture of Constantinople by the Crusaders', Louvre, in reverse), and the lamb eating at its head, are heedless likewise.

This drawing was taken up again in 1856 when the artist intended the subject to be one of two projects for the next year or so. He spent much time and enthusiasm on developing the design, but noted on 26 April, 'bought 10 penny cakes of water color & have been all day & this evening coloring the pencil designe of Cromwell. It does *not* look well in its Present state. We shall see'. He had trouble with Cromwell's figure but continued at the drawing until June. Early that month he followed in the footsteps of Carlyle to Huntingdon and St. Ives, where he found some differences in the true locations and little concrete material to help him, and persisted in his mistake of confusing Huntingdon church for that of St Ives mentioned by Carlyle. Then on 19 June he recorded: 'out to Old Whites [his dealer], who had sent for the sketch to see it & show it to [B.G.] Windus. The result was that instead of buying it he strongly recommended me not to paint it, nothing that I do pleases him now'. This was the end of his project for the time and in the autumn came the commission from Plint for 'Work'. He gave this drawing to J.P. Seddon, the architect, in part exchange for 'King Lear' (No.16).

He was still ambitious to paint a large oil from it and James Leathart toyed with the idea in 1859 and again early in 1865 but then Madox Brown frightened him off with talk of a life size version at £1050 as he was anxious at that time to sell off his 'Chaucer' instead (UBC/LP). The drawing was in his 1865 exhibition still awaiting a commission and with a minimum of explanation: '... the farmer is intended to foreshadow the king, and everything is significant or emblematic'. Finally in 1873 it was commissioned by William Brockbank of Manchester on a more acceptable scale for £400 (Lady Lever Art Gallery). Some details were altered, in particular the high quaker hat which Rossetti recommended him to change, 'and to give the subject

a less quaint and more dignified aspect' (Doughty & Wahl, III, p.1159). Madox Brown was quick to complete it, painting many details direct from nature, and in writing to his friend Frederic Shields in 1874 considered that it had become perhaps his finest work (UBC/AP). In preparing for it he had this drawing back on loan. However, his style had now changed to a more subdued and earthy range of colours and he was taken aback by it: 'It does look crude – you would not believe how much', he wrote to his daughter Lucy in June 1873 (UBC/AP). He retouched it before sending it back, commenting to Seddon that he had 'taken some of the louder colour out of it which I found offensive for my present taste ... & I have added a date to it – that of the present year – 74' (letter pasted on the back).

M.B.

180

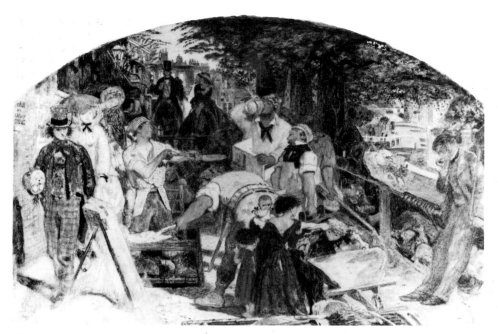

181

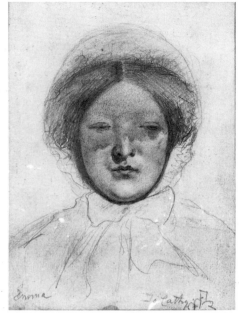

182

FORD MADOX BROWN

181 Sketch for 'Work' ?1852, 1864
Inscribed 'FMB' in monogram
Watercolour and pencil, arched top,
$7\frac{3}{4} \times 11$ (19.7 × 28)
First exh: Piccadilly 1865 (47)
Ref: Liverpool 1964 (70)
City of Manchester Art Galleries

The artist wrote to his patron George Rae on 31 July 1864: 'I have been *grinding* chiefly at watercolours, among others I have finished up in colour the first sketch of "Work" the design before the picture was painted. This has turned out rather satisfactory' (LAG/RP). This seems to agree with other not wholly clear references (MS Account Book; 1865 catalogue), but a letter of 12 June 1890, at Manchester, states that it was painted from the original pen and ink sketch of 1852 and seems to suggest that it dates wholly from 1864 (the pen and ink drawing was itself 'finished' for T.E. Plint only in 1860, and is now lost). Either way it was turned into a potboiler and its chief interest is the light it throws on the first idea for the figures. These seem to follow those in the slight pencil sketch, now also at Manchester, and show some variations from the final scheme.

At the left is a young man in what appears to be a travesty of fashionable dress, with a tall hat; he smokes a clay pipe and holds a lap-dog, perhaps that of the lady behind (is he a 'poodle-faker'?). In the oil picture (No.88) he becomes a ragged wild-flower seller wearing a torn 'wide-awake' hat bought and painted in March 1857 after Plint's commission: his trade was perhaps suggested by that of the groundsel or chickweed seller in Mayhew's *London Labour and the London Poor*, 1851. The lady's dog, changed to a tiny greyhound, crouches in the foreground of the oil picture confronted by two other dogs. Her bonnet in the watercolour is of the wide, early 1850s form and seems more up to date in the oil picture. A donkey cart careers down the hill: in the picture a coach is just emerging round the

bend. Most important, at the right here, is a solitary contemplative man in grey who must be the 'artist' who Madox Brown was redesigning on 1 January 1855. This figure seems to suggest that Madox Brown originally intended to underline the factual and objective vision of the artist as a contrast to the source of his ideas in the works of Carlyle, the philosopher. In replacing this figure by Carlyle himself and F.D. Maurice as representative of the philosophical and spiritual thinkers, to conform with Plint's wishes (see No.88), he may have reflected that he himself as the artist was the executant and presenter in any case.

M.B.

FORD MADOX BROWN

182 Study of Emma for 'Work'
Inscribed 'Emma' and 'to Cathy FMB' (initials in monogram)
Pencil, 7 × 5 (17.8 × 12.7)
Ref: Liverpool 1964 (68)
Private Collection

Full-scale study for the lady at the left in No.88, 'whose only business in life as yet is to dress and look beautiful for our benefit' (1865 catalogue). Her face is half in shade thrown by the scalloped edge of the parasol which appears in the picture. The close and slightly pointed style of the bonnet and Emma's rather older expression point to a date in the later 1850s, certainly after the commission by Plint in 1856.

In the smaller replica painted for James Leathart (Birmingham), Mrs Leathart was painted in her place.

M.B.

WILLIAM HOLMAN HUNT

183 John Everett Millais 1853
Inscribed 'W. holman hunt to|his PR Brother
Tom Woolner April 12ᵗʰ 1853'
Pastel and coloured chalks, 12⅞ × 9¾ (32.7 × 24.8)
First exh: *Collective Exhibition of the Art of W. Holman
Hunt*, Walker Art Gallery, Liverpool 1907 (86)
Ref: Liverpool 1969 (127)
National Portrait Gallery, London

On 7 May 1853 Dante Gabriel Rossetti wrote to William Bell
Scott: 'On the 12th of April, the PRB all made portraits of each
other, which have been forwarded to Woolner. Millais did
Stephens [National Portrait Gallery; exh. R.A. 1967, No.288,
repr.] – Hunt did Millais and myself [No.184] – Stephens did
Millais – I did Hunt and William [Rossetti – untraced] – and
William did the whole lot of us in his own striking style
[untraced]' (PUL). This suggests that two portraits of Millais
were executed, and does not necessarily conflict with Stephens'
letter of 21 April 1853 to Woolner: 'I made an attempt at his
most splendid head, but the failure was utter and in spite of all
the tauntings he could pronounce, with proddings from Hunt, I
viciously refused to proceed . . . However, Hunt, with his
indefatigable affection for me leaned over my shoulder and
altered it' (Woolner, p.58). The matter was further elucidated
in 1899, when Stephens was quoted in J.G. Millais' biography
of his father: 'I was utterly unable to continue the sketch I
began. I gave it up, and Mr. Holman Hunt, who had had D.G.
Rossetti for his *vis-à-vis* and sitter, took my place and drew
Millais' head' (I, p.82). Stephens' portrait of Millais is untraced,

183

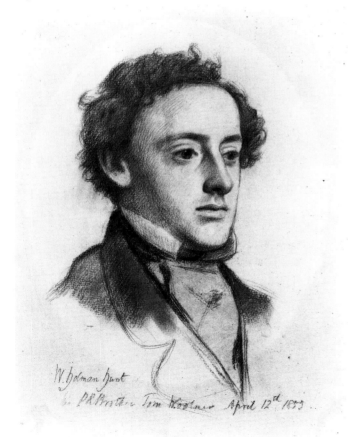

but the contemporary accounts contradict Hunt's assertion
that 'Stephens abstained from any attempt' (1905, I, p.341).

In his memoirs Hunt complained that Rossetti took so long
over his portrait (Surtees No.341) that dusk fell before he could
complete No.183 (1905, I, p.341). He again referred to it as
unfinished in a letter of 19 November 1882 to W.M. Rossetti
(UBC/AP) and ten years later, in a letter to the then owner,
Harry Quilter, stressed that the drawing 'was undoubtedly done
by me' (Harry Quilter, *Preferences in Art, Life and Literature*,
1892, p.69), presumably in answer to a query as to Stephens'
part in it.

A further, pencil, drawing of Millais, also in three-quarters
profile to the right, was executed in December 1853 (private
collection; exh. 1969, No.128, repr.). The success with which
Hunt, on both occasions, captured the likeness is apparent
from a comparison with the 1854 photographs of the sitter,
reproduced in the 1899 biography (J.G. Millais, II, pp.218–9).
 J.B.

WILLIAM HOLMAN HUNT

184 Dante Gabriel Rossetti 1853
Inscribed 'W. Holman Hunt|to his PR Brother|
T Woolner|April 12' and, under mount, 'Unfinished'
Pastel and coloured chalks, oval,
11¼ × 10³⁄₁₆ (28.6 × 25.9)
First exh: *Loan Exhibition of Pictures*, Leighton House
1902 (2)
City of Manchester Art Galleries

The group of drawings sent to Woolner in Australia, to which
this and No.183 belong, was undertaken at D.G. Rossetti's
instigation and was not originally conceived as an exclusively
Pre-Raphaelite project. Rossetti wrote to Woolner on 8
January 1853: 'Last night at my party, it was agreed that all
your intimates here should meet at a certain day and hour, the
equivalent of which was to be found by you Australians . . . for
some act of communication, the nature of which was left for me
to decide. I therefore fix that on the 12th of April (which will
keep us clear of the Exhibition burners) at 12 o'clock in the day,
we shall each of us, wheresoever we be, make a sketch of some
kind (mutual portraits preferable) – or for any who do not draw
some verses or a letter – and immediately exchange them by
post, between London and Melbourne' (Woolner, p.48).
Rossetti wrote to Hunt the following Tuesday informing him of
the project, 'which you know was left to my decision', and
stressing that 'each of Woolner's friends here who like to join'
would be welcome (ASU). As it turned out, F.M. Brown declined
to contribute (Doughty & Wahl, I, p.130), and the occasion
turned into a thoroughly Pre-Raphaelite affair, with the
possible exception of Millais' pencil drawing of Alexander
Munro (William Morris Gallery, Walthamstow; exh. R.A.
1967, No.289; repr. Richard Ormond, 'Portraits to Australia: a
group of Pre-Raphaelite drawings', *Apollo*, LXXXV, 1967, p.26,
fig.4), dated 12 April, which may have been sent to Woolner
with the other portrait drawings.

The account Hunt presents in his autobiography of the
genesis of the scheme was coloured by his estrangement from
Woolner. The drawings were conceived purely in the spirit of
friendship, for in January 1853 Woolner was still trying his
hand at gold-digging (Doughty & Wahl, I, p.122) and could not
have solicited the portraits in an attempt to gain commissions
(1905, I, pp.340–1).

On the morning of Friday 12 April 1853 five Pre-Raphaelites

(with the exception of Collinson, who had already resigned from the Brotherhood) assembled in Millais' Gower Street studio, and Hunt and D.G. Rossetti set about drawing each other's likenesses (Rossetti's drawing, Surtees No.341, is in Birmingham City Art Gallery). The intense expression in Rossetti's downturned blue eyes can be attributed to the fact of his looking at the drawing on which he was engaged while posing for its sitter.

Rossetti, in a letter of 16 April to Woolner, accompanying all the drawings, singled out Nos.183 and 184 for especial praise: 'Are not Hunt's sketches wonderful? They are made with "Swiss chalks", not Creta Levis. The "Swiss" are softer than the Creta, but I think much more beautiful in colour' (Woolner, pp.50–1). Woolner very much appreciated Hunt's portrait of D.G. Rossetti, writing to William Michael on 21 July 1882: 'I have a drawing of your brother by Hunt, which I think one of the best things he ever did, and as I feel sure it will now have more interest to you than any other could have for it I shall be pleased if you will let me send it to you' (UBC/AP).

W.M. Rossetti accepted Woolner's gift, and on 19 November 1882 Hunt wrote to him with a request to have the drawing copied: 'It occurs to me . . . that to reproduce the portrait of Gabriel by me as a representation of what he was when still youth and its hunger of inspiration was glowing in his face ought to be . . . interesting' (UBC/AP). At this time Hunt was contemplating an etching rather than the replica in oils which he in fact executed (Birmingham City Art Gallery; exh. Liverpool 1969, No.56). Although Hunt, in his memoirs, states that this was painted because the chalk portrait was badly rubbed (1905, I, p.341 n.1), there is no mention of the drawing being in a poor state of conservation in Hunt's letter to W.M. Rossetti of 3 December 1882, written after the artist had had 'the opportunity of reexamining it' (UBC/AP). The more likely explanation is contained in Edith Holman-Hunt's letter of 24 November 1922 to Lawrence Haward, the Curator of Manchester City Art Gallery: 'The original being painted in pastel my Husband feared it wᵈ in time perish, & as he valued it he asked Mʳ William Rossetti to lend it to him for the purpose of reproduction' (MAG). The chalk drawing had been purchased by Manchester in October 1922 from G.A. Rossetti, William Michael's son.

J.B.

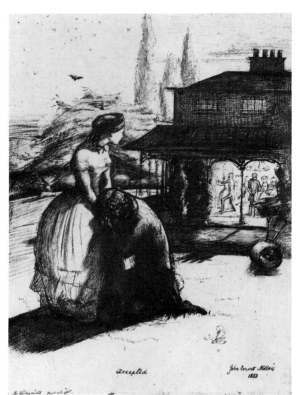

185

JOHN EVERETT MILLAIS

185 Accepted 1853
Inscribed 'To be painted moonlight | Accepted | John Everett Millais | 1853'
Pen and sepia ink, $9\frac{7}{8} \times 6\frac{7}{8}$ (25.1 × 17.5)
Ref: R.A. 1967 (328)
Yale Center for British Art (Paul Mellon Collection)

One of a number of drawings from modern life made by Millais in 1853–4 (see also Nos 186–94). They recall scenes from contemporary novels, though apparently not illustrating any in particular, and also the 'modern moral subjects' of Hogarth, in both respects following the lead taken by Holman Hunt in 'The Awakening Conscience' (No.58). Here a young man is overjoyed at the acceptance of his marriage proposal and kisses his beloved's hands. She looks back into the ballroom at the party they have left to be alone.

Though much more dramatic, No.185 is related to the many sketches of party scenes Millais drew in 1850–1. If it was intended as a sketch for a picture, as the inscription 'To be painted' suggests, the background could only, given Millais' normal practice, have been executed outdoors during the summer months. This points to a likely date for the drawing in spring or early summer, probably before the end of May 1853, by which time he had decided to spend the summer away in Scotland with the Ruskins. The study for 'The Order of Release, 1746' (No.49) on the verso would have been made earlier, probably in December 1852. Millais apparently never began a painting based on No.185 and only embarked upon his first modern-life picture, 'The Blind Girl' (No.69), in 1854.

There is a copy of No.185 by Effie Ruskin, the artist's future wife, in the collection of Raoul Millais.

M.W.

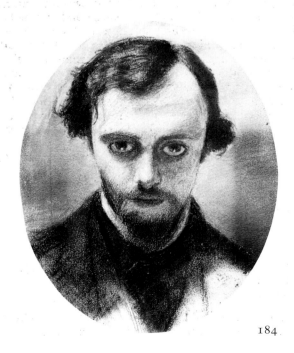

184

JOHN EVERETT MILLAIS

186 Goodbye, I Shall See You Tomorrow 1853
 Inscribed with title and 'JMillais | 1853' (initials in
 monogram)
 Pen and sepia ink, $9\frac{13}{16} \times 7$ (24.9 × 17.8)
 Ref: R.A. 1967 (329)
 Yale Center for British Art (Paul Mellon Collection)

This drawing is normally paired with No.185 and given the
title 'Rejected'. The two works are in the same technique and
size, and they show comparable scenes that may be intended as
complementary. But the title 'Rejected' is questionable. It is not
inscribed on the drawing like the title of No.185, or recorded
anywhere until 1899, three years after the artist's death, and
may well have been invented by J.G. Millais or some other
member of the family. The inscription the work does bear, here
given as its title, is sufficiently ambiguous not to reveal what is
happening in the scene at all, leaving its interpretation to the
spectator's imagination.

There is a copy by Effie Ruskin, the artist's future wife, in the
collection of Raoul Millais.

M.W.

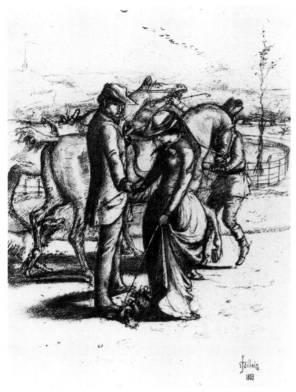

186

JOHN EVERETT MILLAIS

187 Married for Rank 1853
 Inscribed 'JEM 1853' (initials in monogram)
 Pen and black and sepia inks, $9\frac{3}{4} \times 7$ (24.7 × 17.8)
 Ref: Arts Council 1979 (20)
 Mr & Mrs Harold Wernick

A beautiful woman on the arm of her husband, an unpre-
possessing old man wearing the Order of the Garter. On the
right a wounded young officer, her former lover, looks aghast
at her wedding ring.

No.187 is usually grouped together with Nos 188–9 to
form a kind of triptych on the theme of marriage. This may
have been the artist's intention, although the 'Married for . . .'
titles are not recorded before 1898, two years after his death,
and may be someone else's idea. No.187 was once inscribed
'Married for Money' but that was erased and is now barely
visible. This would be a reasonable title but 'Married for Rank'
seems better since the contrast between the old man and the
young officer is expressed more through signs of rank than
wealth, and 'Married for Money' is more appropriate for
No.188. It may be that 'Married for Money' was Millais'
original title for No.187 but that it was reassigned to No.188
when he, or perhaps another member of his family, or a
collector, decided that the three marriage drawings should
have matching titles.

M.W.

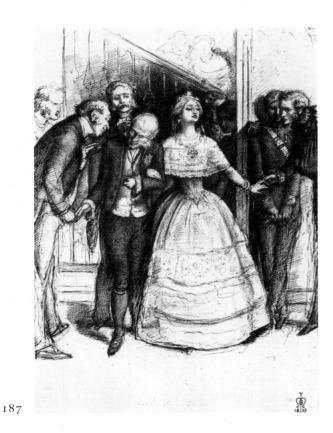

187

JOHN EVERETT MILLAIS

188 Married for Money 1853
 Inscribed 'John Everett Millais'
 Pen and black and sepia inks, $9 \times 6\frac{3}{4}$ (22.9 × 17.2)
 Ref: Arts Council 1979 (21)
 Private Collection

A young woman in the gallery of a church, watching the
marriage of her former lover. No.188 has been known as

188

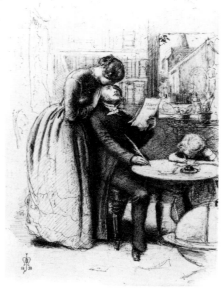

189

'Married for Rank' but incorrectly, since however much the man might gain financially from his marriage, his 'rank' would remain the same – and the drabness of the disappointed young woman's clothes suggests she may be from a poorer family than the bride's, but not necessarily one of lower social standing.

There is a copy of No.188 by Effie Ruskin, the artist's future wife, in the collection of Raoul Millais. It is dated 1854 which, since Millais did not see Effie during that year, shows that the original was in her possession or Ruskin's at the time.

It was engraved by T.O. Barlow as an illustration to the poem 'When I first Met Thee', a woman's upbraiding a lover who has deceived her, in the edition of Thomas Moore's *Irish Melodies* published by Longman in 1856 (facing p.84).

M.W.

JOHN EVERETT MILLAIS

189 **Married for Love** 1853
Inscribed 'JEM 1853' (initials in monogram)
Pen and black and sepia inks, 9¾ × 7 (24.7 × 17.8)
Ref: Arts Council 1979 (19)
Trustees of the British Museum

A curate with his wife and child, writing a sermon inscribed 'Trinity Sunday'. In 1853 this was on 22 May, which may be a clue to the date of the work, although the allusion may merely be to the 'trinity' of husband, wife and child. There is a copy of No.189 by the artist's future wife, Effie Ruskin, in the collection of Raoul Millais.

M.W.

JOHN EVERETT MILLAIS

190 **The Race Meeting** 1853
Inscribed 'JEM | 1853' (initials in monogram)
Pen and black ink, with touches of sepia,
10 × 7 (25.4 × 17.8)
Ref: R.A. 1967 (330)
Visitors of the Ashmolean Museum, Oxford

190

No.190 was probably inspired by a visit to Epsom for the Derby on 25 May 1853, which Millais describes in a letter to Charles Collins: 'Such tragic scenes I saw on the course . . . in another carriage I saw a woman crying bitterly, evidently a paramour of the man who was languidly lolling back on the cushions flushed with drink and trying to look unconcerned at the woman's grief. This was probably caused by a notice that his losses that day obliged him to do without her society for the future' (Ironside & Gere, p.41). It is influenced by the many horseracing scenes John Leech drew as illustrations for *Punch*. The best-known Victorian image of the races, W.P. Frith's 'The Derby Day' (Tate Gallery), was exhibited at the R.A. in 1858.

M.W.

191

JOHN EVERETT MILLAIS

191 The Blind Man 1853
Inscribed 'JEM 1853' (initials in monogram)
Pen and sepia ink, within a drawn border,
8 × 11 (20.3 × 28)
Yale Center for British Art (Paul Mellon Fund)

A busy street scene with a blind beggar being led through the traffic by a charitable young woman. The crossing-sweeper represents another, less abject kind of beggary, the horses with their blinkers a kind of partial blindness. The stationer's shop in the background reminds us that the blind man is denied the uses of reading and writing.

Millais treated a similar subject, including the same 'Pity the Blind' sign, in 'The Blind Girl' (No.69), which he began the following year.

There is a sheet of pencil studies for No.191 in the collection of R.A. Cecil, Esq.

M.W.

192

JOHN EVERETT MILLAIS

192 The Dying Man 1853–4
Pen and sepia ink with wash, $7\frac{3}{4} \times 9\frac{5}{8}$ (19.7 × 24.4)
Ref: R.A. 1967 (336)
Yale Center for British Art (Paul Mellon Fund)

Probably the drawing Millais refers to in a letter to his wife of 13 April 1859: 'Yesterday I met in the Burlington Arcade an old friend from India, the brother of our old friend Grant who died (I drew him in pen-and-ink, dying, surrounded by his family.) The brother has grown into an enormous man, with moustaches nearly half a yard broad – a very handsome fellow' (J.G. Millais, I, p.340). 'Our old friend Grant' is unfortunately not identifiable.

A study for the young woman reading a book, probably the dying man's sister, is in the collection of E.G. Millais.

M.W.

193

JOHN EVERETT MILLAIS

193 A Ghost Appearing at a Wedding Ceremony 1853–4
Inscribed 'I don't, I don't'
Pencil, pen and black and sepia inks,
$12\frac{1}{4} \times 10\frac{1}{4}$ (31.1 × 26)
Ref: Arts Council 1979 (29)
Victoria and Albert Museum, London

Though undated, No.193 is clearly one of the group of modern-life subjects Millais drew in 1853–4. It shows a bride haunted by the ghost, which only she can see, of a former lover. At his appearance she suddenly refuses to make her vows. The germ of the subject may have come via Ruskin from the Edinburgh doctor James Simpson, who told a story about a patient who saw a spectral vision of her old sweetheart at a dinner party. Ruskin noted the story in his diary on 26 November 1853 (J. Evans and J.H. Whitehouse (eds.), *The Diaries of John Ruskin*, 1958, II, p.483) and may have related it to Millais during sittings for his portrait (No.56) in London in January–April 1854.

M.W.

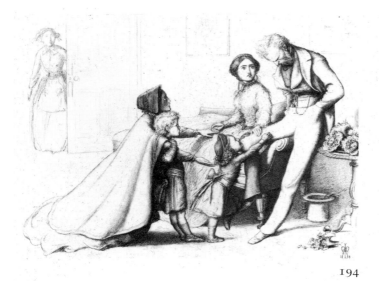

194

JOHN EVERETT MILLAIS

194 Retribution 1854
Inscribed 'JEM 1854' (initials in monogram)
Pen and sepia ink, 8 × 10¼ (20.3 × 26)
Ref: R.A. 1967 (334)
Trustees of the British Museum

A mother with her two children surprise her husband with a pretty young woman, who was evidently unaware till now that he was married. J.G. Millais calls the work 'The Man with Two Wives' (II, p.490) and 'Retribution' (I, p.227). Both titles are probably his own invention rather than the artist's. The first seems inappropriate because there is no indication that the man is married to the woman on the couch. The second is preferable, largely because it is vaguer and respects what seems to be a deliberate ambiguity about the drawing itself. Guessing the story that has led up to the encounter depicted is very much left to the spectator's ingenuity and the potential 'clues' one notices, especially the bouquets and the picture of a ballet dancer on the wall, seem to resist definite interpretation.

M.W.

JOHN RUSKIN

195 Study of Gneiss Rock, Glenfinlas 1853
Pen, wash and bodycolour, 18¾ × 17⅞ (97.6 × 31.5)
Visitors of the Ashmolean Museum, Oxford

One of at least three drawings dating from about July 1853 when Millais was painting Ruskin's portrait at Glenfinlas, Perthshire (No.56). The other drawings are in the Ruskin Galleries at Bembridge, Nos 1465 and ADD/G/26, the latter (pencil and watercolour, 7⅝ × 12¾; 19.4 × 32.4) being a preliminary study for the area of rock just above the surface of the stream shown in No.195.

It is to the Ashmolean drawing that Ruskin is probably referring in a letter of 6 September to Lady Trevelyan: '... we all go out to the place where he [Millais] is painting – a beautiful piece of Torrent bed overhung by honeysuckle and mountain ash – and he sets to work on one jutting piece of rock – and I go on with mine, a study for modern painters vol.III, on another just above him' (Virginia Surtees, *Reflections of a Friendship,*

1979, p.57). At this time, Ruskin seems to have spent about 3–4 hours a day on the drawing though by the time the party left Glenfinlas at the end of October it was still not finished; it was not finally completed until 8 February 1854.

There is no precedent in Ruskin's work for the meticulousness of this study, clearly inspired by Pre-Raphaelite example, particularly Millais'. The drawing did not, in the end, appear in volume III of *Modern Painters* though it was presumably intended to accompany the various discussions of the nature of rocks which appear in that book.

R.H.

DANTE GABRIEL ROSSETTI

196 Found 1853
Inscribed 'DGR 1853' (initials in monogram) and, at the foot, 'I remember thee: the kindness of thy youth, the love of thy betrothal.' [Jeremiah 2. 2]
Pen and brown ink and some Indian ink and grey wash, 8¼ × 7½ (21 × 18.4)
First exh: Hogarth Club 1859
Ref: Surtees No.64B; Grieve 1976, pp.2–5
Trustees of the British Museum

This drawing gives us the most complete representation of the subject of 'Found' as both oil versions (see No.63 and fig.iii)

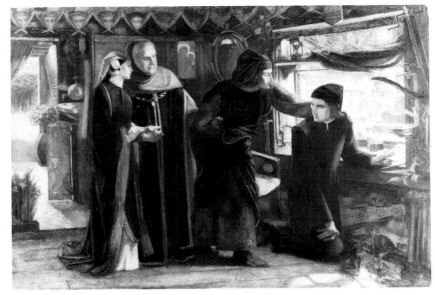

196

197

remained unfinished at Rossetti's death. Rossetti himself sent a description of the subject to Hunt on 30 January 1855, just after he had started to paint it: 'The picture represents a London street at dawn, with the lamps still lighted along a bridge which forms the distant background. A drover has left his cart standing in the middle of the road (in which, i.e. the cart, stands baa-ing a calf tied on its way to market), and has run a little way after a girl who has passed him, wandering in the streets. He had just come up with her and she, recognising him, has sunk under her shame upon her knees, against the wall of a raised churchyard in the foreground, while he stands holding her hands as he seized them, half in bewilderment and half guarding her from doing herself a hurt. These are the chief things in the picture which is to be called "Found" and for which my sister Maria has found me a most lovely motto from Jeremiah: "I remember Thee, the kindness of thy youth, the love of thine espousals." . . . The calf, a white one, will be a beautiful and suggestive part of the thing' (see Surtees No.64).

Further details are included in the drawing which add to the pathos of the subject. Two nesting birds gather straw fallen from the cart, there is a cat on the far pavement and a vagrant sleeping in a embrasure on the bridge with another figure standing nearby who is perhaps a 'Peeler'. A tombstone in the top left bears a fragmentary inscription from either The Parable of the Lost Sheep or The Parable of the Lost Coin (Luke 15. 7, 10) hinting at repentance and forgiveness.

The subject can be linked with that of Hunt's 'Awakening Conscience' (No.58) shown at the R.A. in 1854 and of Millais' stylistically similar Virtue and Vice drawings of 1853-4 (Nos 185-94). There is no reason to doubt the correctness of the date inscribed on Rossetti's drawing, '1853', as references to the subject in his letters start in May of that year and show that the detailed symbolism was developed by September. But it is likely that alterations to the calf, which is drawn in black ink rather than brown like the rest of the drawing, were carried out after the painted version done in November 1854 (No.63).

Parallels with the subject occur in the writings of authors such as Blake, Mayhew, Mrs Gaskell, Mary Howitt, W.B. Scott and Dickens. The dramatic meeting of David Copperfield and Mr Peggotty with the prostitute Martha, described by Dickens in

David Copperfield, seems especially appropriate as it occurred on the site of the Tate Gallery: 'she still repeated the same words, continually exclaiming, "Oh, the river!" over and over again. "I know it's like me!" she exclaimed. "I know that I belong to it. I know that it's the natural company of such as I am! It comes from country places, where there was once no harm in it – and it creeps through the dismal streets, defiled and miserable – and it goes away, like my life, to a great sea, that is always troubled – and I feel that I must go with it!"' (*David Copperfield*, 1850, Chap. XLVII, para.x. Alan Bowness has drawn attention to a later passage describing the finding of Emily: 'for she was found. I had only to think as she was found. . .', Chap.LI, para.x).

No.196 was bought from the artist in 1860 by Colonel William Gillum, a member of the Hogarth Club and one of Philip Webb's most important early patrons.

A.G.

DANTE GABRIEL ROSSETTI

197 **The First Anniversary of the Death of Beatrice** 1853-4
Inscribed 'DGR|1853' (initials in monogram)
Watercolour 16½ × 24 (42 × 61)
First exh: Russell Place 1857 (55)
Ref: Surtees No.58; Grieve 1978, pp.19-20
Visitors of the Ashmolean Museum, Oxford

This shows Dante interrupted by friends while drawing an Angel on the anniversary of Beatrice's death. The subject, from the *Vita Nuova*, is the same as that of No.162, finished in May 1849, but the composition is quite different. It was probably started in the early summer of 1853 and by 1 July had been commissioned by Francis McCracken but was only sent to him in late March or early April of the following year (Doughty & Wahl, I, pp.147, 153, 176, 185). It was Rossetti's largest watercolour to date and much more than a 'sketch'. Living models were used who were the artist's close acquaintances. W.M. Rossetti probably posed for Dante, a family servant called Williams for the elderly male visitor, Elizabeth Siddal for the female visitor. The fact that one of the visitors is a woman is a

major difference between this work and the earlier composition. Rossetti wrote about her in a letter to McCracken of 14 May 1854: 'I had an idea of an intention of the possibility of a suggestion that the lady in my drawing should be Gemma Donati whom Dante married afterwards and for that reason meant to have put the Donati arms on the dresses of the three visitors, but could not find a suitable way of doing so . . . But I had an idea also of connecting the pitying lady with another part of the *V.N.* and in part the sketch is full of notions of my own in this way, which would only be cared about by one to whom Dante was a chief study' (Doughty & Wahl, I, pp. 197, 198).

A cross-bow, symbol of Dante's active life, hangs on an easel at the right of the picture beside a quill pen and ink bowl. On the left of the window is a lily, symbol of Florence, and on the right, a pomegranate. Below the sill are *vanitas* symbols, a lute, a skull, an ivy tendril, and a book of Virgil.

This is Rossetti's most successful creation of a mediaeval interior to date but his models derive from Northern Europe rather than Italy and from a later period than Dante's. The view onto the Arno recalls details in Flemish fifteenth-century paintings and miniatures. The mirror is like one in Memlinc's 'Virgin and Child' in the Academy at Bruges which Rossetti saw on 25 October 1849. The towel, urn, and basin at the left are borrowed from a Dürer woodcut of 'The Birth Chamber' in the series 'The Life of the Virgin'. But Dante himself, as in all the subject from the *Vita Nuova* in which he appears, wears a headpiece modelled on that in his so-called portrait by Giotto in the Bargello, a copy of which Rossetti owned (see Grieve 1978, p. 14).

McCracken sent the work to John Ruskin as soon as he received it and on 10 April 1854 Ruskin wrote direct to Rossetti: 'I think it a thoroughly glorious work – the most perfect piece of Italy, in the accessory parts, I have ever seen in my life – nor of Italy only – but of marvellous landscape painting' (Troxell, p. 26). Three days later he called on Rossetti and his patronage rapidly became of great importance (Doughty & Wahl, I, p. 185). In May, McCracken gave £50 instead of the commissioned sum of 35 gns. for the watercolour. At McCracken's sale, in the following year, the work was purchased for Thomas Combe of Oxford and was seen in his collection by Edward Burne-Jones and William Morris whose perception of the middle-ages it helped to form.

A.G.

ELIZABETH ELEANOR SIDDAL

198 The Lady of Shalott 1853
Inscribed 'E.E. Siddal Dec 15./53'
Pen, black ink, sepia ink, and pencil,
$6\frac{1}{2} \times 8\frac{3}{4}$ (16.5 × 22.3)
First exh: ? Russell Place 1857
Jeremy Maas

One of the first recorded works by Elizabeth Siddal, this is a drawing for Tennyson's 'The Lady of Shalott' (published in *Poems*, 1842). The Lady of Shalott is held by a mysterious curse to weave 'a magic web of colours gay' depicting scenes reflected in the mirror. When Sir Launcelot 'flash'd into the crystal mirror' the Lady turns her attention from her task to look down on Camelot.

> Out flew the web and floated wide;
> The mirror crack'd from side to side;
> 'The curse is come upon me,' cried
> The Lady of Shalott.

In the closing section of the poem the Lady, dying, floats by boat down the river to King Arthur's court at Camelot.

The drawing shows the Lady looking over her left shoulder towards the window, the web bursting, the mirror fracturing, Launcelot appearing. The bird perched on top of the tapestry frame, the furniture and the crucifix are not found in the poem, nor are certain details in the poem included in the drawing. To account for these differences we need to dispense with the notion that the poem is the exclusive source for the drawing, the origin of its meaning. Nor should we propose artistic licence or imaginative interpretation. The poem and the drawing are separate texts with a specific inter-textual relation: to read the poem alongside the drawing is to produce this relation. Intrinsic meaning is not hermetically sealed in the poem or drawing, transferable from one to the other. Both poem and drawing are sites of inter- and intra-textual relations, calling up echoes of other texts. This process of textual citation is not a personal activity, occurring outside history and society. It is an ideological practice, in and by which specific knowledges are produced, circulated and secured.

The drawing of 'The Lady of Shalott' is actively productive in the construction of gender difference, and it is strategically placed within historically specific discourses on woman constituted in and by the representation of the mediaeval past. Across and within a range of texts on the mediaeval past produced in the 1840s and 1850s, and including catalogue Nos 217, 221, 224, 225, mid-nineteenth-century constructions of masculinity and femininity inform the distinctions made between knights and their ladies. In this drawing gender difference is marked in several ways. The Lady, attired in a long robe, her head uncovered, her hair worn loose, is seated at her loom in an interior. In contrast the knight, clad in armour, wearing a plumed helmet and carrying a shield, rides through the countryside and is reflected in the mirror. Indoors and outdoors are seen in opposition to each other. The drawing produces and reproduces the ideology of the separate spheres of men and women, and in its representation of an historical past it works over contemporary distinctions between the private indoor world of women and the public outdoor world of men.

The drawing does not put the poem into pictorial form. It does not illustrate a content which exists outside of itself or in the poem. Its narrative comes into being in the telling, creating another story to that told in the poem or in those drawings by Hunt, Millais, and Rossetti which claim the poem as their subject. The small mirrors in Hunt's drawing of 'The Lady of Shalott' (No. 168) are deployed to present a cycle of past and future. As in Millais' drawing (National Gallery of South Australia) in which the Lady floats down river, we know her end. In Rossetti's drawing for the Moxon illustrated edition of Tennyson's *Poems* of 1857 Launcelot gazes at the dead woman, scrutinising her face. Woman is constituted as helpless, cursed, dying, dead. Rich textures, the sensuous curves of the constructed feminine body, the fairness of the feminine face are presented for the pleasure of the masculine gaze. Siddal's drawing refuses the narrative drive of the poem, resists the ending in death. We are offered an interior which is cool, airy and spacious: a work-room with evidence of past labours in the tapestry hanging on the far wall, a sanctuary with a crucifix for devotional use. In Siddal's drawing the Lady is constructed as pure, chaste, calm, and up to this moment apart from the chivalric practices of the Arthurian court. The Lady is represented at the moment of *her* look. She is not offered as a victim or a spectacle for the masculine gaze, nor does she attain visibility within its relays of power.

D.C.

198

199

JOHN EVERETT MILLAIS

199 William Holman Hunt 1854
Inscribed 'JEM 1854' (initials in monogram)
Pencil and watercolour, 8 × 7 (20.3 × 17.8)
Ref: R.A. 1967 (339)
Visitors of the Ashmolean Museum, Oxford

Millais made this portrait of his friend for Thomas Combe just before Hunt's departure for the Holy Land. He was so pleased with the first likeness he made for Combe that he could not resist keeping it for himself (it is now in the collection of Mrs Elizabeth Burt). He wrote telling Combe as much and promising him a copy on 26 December 1853 (J.G. Millais, I, p.221). He reported back again, this time saying he had made a drawing that Combe could have, on 12 January 1854: 'I have made a drawing of Hunt which I think you will find very like. It is not a copy of the one I have got but another I drew Sunday evening [8 January]. I will get it framed for you (as it would rub sent as it is), and forward it to you as soon as it is out of the frame-maker's hands' (J.G. Millais, I, p.226). Hunt left London the following day and was away for two years.

M.W.

200

JOHN EVERETT MILLAIS

200 St Agnes' Eve 1854
Inscribed 'JEM 1854' (initials in monogram)
Pen and sepia ink, with green wash,
9¾ × 8¼ (24.8 × 21)
Ref: Arts Council 1979 (30)
Private Collection

An illustration to Tennyson's poem of the same title, which begins:

Deep on the convent-roof the snows
 Are sparkling to the moon:
My breath to heaven like vapour goes:
 May my soul follow soon!

The shadows of the convent-towers
 Slant down the snowy sward,
Still creeping with the creeping hours
 That lead me to my Lord:
Make Thou my spirit pure and clear
 As are the frosty skies,
Or this first snowdrop of the year
 That in my bosom lies.

The nun likens her white robes, 'soil'd and dark' in comparison with the pristine snow, to her soul in comparison with Christ and her present state in comparison with what she hopes and longs for, which is the consummation of her spiritual marriage with Christ in death. The open gate in the drawing, surmounted by a triangle symbolising the Trinity, refers to the lines:

 . . . the gates
 Roll back, and far within
For me the Heavenly Bridegroom waits,
 To make me pure of sin.

There are snowdrops, the birthday flower for St Agnes' Eve, both at the nun's breast and in the leading of the window on the right, a variation on the use of a snowdrop motif in the stained-glass in 'Mariana' (No.35), which also includes the same silver caster as shown here on the nun's little altar.

No.200 is an image of the artist's own yearning, which was at the time apparently hopeless, for his future wife Effie Ruskin – and equally hers for him. The composition is based on the sketch he had made the previous year for a proposed portrait of Effie standing by a window in Doune Castle, now at Birmingham City Art Gallery (602'06). The portrait was to be a pendant to that of her husband (No.56) but was never realised. Millais gave No.200 to Effie early in 1854 through Ruskin, who was giving sittings for his portrait. According to Effie, Ruskin used it as a pretext for veiled accusations concerning the obvious attraction that existed between her and the artist. 'John has been trying again to get me by taunts to write to Millais', she told her mother in a letter of 25–27 February. 'He accepted that St Agnes drawing, etc, it now hangs before me, and then he said, didn't I still write to him and where was the harm if he gave me drawings?' (Lutyens 1967, p.144). On 2 March she again wrote of Ruskin's using the drawing 'in a most decided manner to get me into a scrape' and noted how like a self-portrait the face of the nun was, clearly realising the significance of this feature: 'The Saint's face looking out on the

snow with the mouth opened and dying-looking is exactly like Millais' – which however, fortunately, has not struck John who said the only part of the picture he didn't like was the face which was ugly but that Millais had touched it and it was better, but it strikes me very much' (ibid., pp.147–8). Effie brought the work with her when her marriage to Ruskin was annulled and she married Millais.

Millais illustrated the same poem, though with a different design, in the Moxon edition of Tennyson's poems (1857).

A wood-engraving of No.200 by A. Hyer was used as the frontispiece to Henry Leslie's *Songs for Little Folks*, 1865.

 M.W.

WILLIAM HOLMAN HUNT

201 Cairo: Sunset on the Gebel Mokattum 1854
Inscribed "Whh Cairo 1854' (initials in monogram)
Watercolour with surface scratching,
$6\frac{1}{2} \times 14$ (16.5 × 35.6)
First exh: Russell Place 1857 (41)
Ref: Liverpool 1969 (131)
Whitworth Art Gallery, University of Manchester

No.201 was first exhibited in June 1857, in the Pre-Raphaelite exhibition at 4 Russell Place, as 'Sketch from a house in New Ca. looking towards the Gebel Mokattam', the range of hills to the east of the city. Its meticulous detail and use of high-keyed colour made the work a fitting contribution to the show.

Hunt's visit to the East was first mooted during his stay in Oxford in the summer of 1852 (Millais to Hunt, and Collins to Hunt, both n.d., *c*.July 1852, HL), and on 1 October 1852 he wrote to Miss Rosaline Orme from Fairlight asking her whether she had yet read *The Crescent and the Cross* (Flora Masson, 'Holman Hunt and the Story of a Butterfly', *Cornhill Magazine*, n.s., XXIX, 1910, p.646). Eliot Warburton's celebrated two volumes, published in 1845 and subtitled *Romance and Realities of Eastern Travel*, were an important source for Hunt's expectations of life in Egypt, as his casual reference to 'Warburton' in a letter of 12–13 March 1854 to D.G. Rossetti underlines (Lutyens 1974, p.57). Warburton's lyrical description of his first view of Cairo may have influenced the choice of subject of No.201, which was executed shortly after Hunt arrived in the city in February 1854: 'The bold range of the Mokattam mountains is purpled by the rising sun, its craggy summits are cut clearly out against the glowing sky, it runs like a pro-

201

montory into a sea of the richest verdure, here wavy with a breezy plantation of olives, there darkened with acacia groves. Just where the mountain sinks upon the plain, the citadel stands upon its last eminence, and widely spread beneath it lies the city, a forest of minarets with palm trees intermingled, and the domes of innumerable mosques rising, like enormous bubbles, over the sea of houses' (I, p.63).

Hunt's watercolour conveys his initial enchantment with Cairo, before he became disillusioned over the difficulties of obtaining sitters – the high viewpoint of No.201 suggests that the two girls in the left foreground were sketched surreptitiously. The elder is engaged in the typically Egyptian task of winnowing corn, seated cross-legged on the roof of the house, from the parapet of which is hung a richly patterned oriental carpet.

Hunt's main preoccupation in No.201 was with studying the effects of light on the landscape: the purples, browns, blues and pinks of the parapet wall give way to the gold and white of the middleground buildings, and thence to the bright purples and pinks of the Gebel Mokattum. The blue and purple shadows are closely observed, and the watercolour is thinly worked, the white surfaces being conveyed by leaving the paper bare rather than by the use of bodycolour.

In late April 1861, 'Claudio and Isabella' (No.45) and five of Hunt's middle eastern watercolours, including No.201, were shown in an adjoining room to the exhibition of 'The Finding of the Saviour in the Temple' (No.85) at the German Gallery, 168 New Bond Street (Critic, XXII, 27 April 1861, p.543). The group of watercolours encompassed the gamut of light effects from early morning, in 'The Dead Sea from Siloam' (Birmingham City Art Gallery, exh. Liverpool 1969, No.163; repr. Staley, pl.30b; Hunt to Combe, 7 September 1855, JRL); full daylight in 'Nazareth' (No.205); evening in 'The Plain of Rephaim from Mount Zion' (Whitworth Art Gallery, exh. 1969, No.160; Staley, pp.73–4, repr. pl.32a); through 'Cairo – Sunset on the Gibel Mokattum', as it was now called, to 'Jerusalem by moonlight' (No.204). The reviewer in the Critic of 27 April 1861 commented enthusiastically: 'For earnest and conscientious treatment, and deep intensity of colour, they are among the most remarkable drawings ever executed'. All five watercolours were purchased by T.E. Plint for 700 gns(?) according to Gambart's agent Hobart Moore, who handled the transaction (W. Bell Scott to James Leathart, n.d., June 1861, UBC/LP; cf. W.M. Rossetti 1899, p.275, where the price is reported to have been £1,250).

The frames of all five watercolours were designed by the artist. The intricate patterning of the roundels on the gilt flat of No.201 was considered particularly suitable for an Egyptian scene, and the design was again used for the frame of 'Gazelles in the Desert' (private collection, repr. Hunt 1913, I, p.286).

J.B.

WILLIAM HOLMAN HUNT

202 The Sphinx, Gizeh, Looking towards the Pyramids of Sakhara 1854
Inscribed '18 Whh 54 | Egypt' (initials in monogram)
Watercolour, $10 \times 13\frac{15}{16}$ (25.4×35.5)
First exh: R.A. 1856 (1002)
Ref: Liverpool 1969 (133)
Harris Museum and Art Gallery, Preston

On 21 February 1854 Hunt informed Combe that he was about to go to the desert for a week (BL); according to Seddon, the visit was motivated by a compassionate desire to be near a dying Englishman, Nicholson, who was camping in a tomb at the Pyramids (p.49). Hunt returned to Cairo in the second week of March, and wrote to Millais that he had been 'driven back by the wind which disturbed the sand so much as to make sketching in colors a task of too much time for the result' (16 March 1854, ASU). According to Seddon, Hunt went back to Gizeh on 20 April 'to finish a sketch he had begun of the Sphinx' (p.71), and shortly afterwards Hunt wrote to Combe: 'today I have been sitting out of doors from 9 to 7 sketching' (BL). By the time he left the desert on 6 May (Hunt to Millais, 8 May 1854, JRL), Hunt had braved dangerous conditions to execute a large number of sketches (e.g. Liverpool 1969, Nos.134–5, 139–42), begun No.87, and worked up this rear view of the Sphinx which, unlike Seddon's contemporaneous watercolour (No.203), betrays no hint of the many people at the site engaged in Mariette's excavations (Seddon, pp.64–5).

Hunt's unconventional viewpoint, which enabled him to concentrate on the striations of the Sphinx as if it were a geological phenomenon rather than a monumental sculpture, may have been influenced by Louis Haghe's lithographs after David Roberts, e.g. volume 5 of *Egypt and Nubia*, 1849, showing the back view of 'Statues of Memnon at Thebes, during the Inundation', as Kenneth Bendiner has suggested ('The Portrayal of the Middle East in British Painting', Univ. of Columbia PhD thesis, 1979, p.105). It is quite possible, however, that Hunt arrived at his composition independently, for although he found the desert beautiful (Hunt to Millais, 16 March 1854, ASU) he was most anxious to avoid being branded as a topographical watercolourist. His marked lack of enthusiasm for the Pyramids (ibid.) led him to relegate these monuments to the upper left-hand corner of No.202.

Hunt's main concern, as in 'Cairo: Sunset on the Gebel Mokattum' (No.201), was with the effects of light on the landscape, and this was understood by the critic in the *Saturday Review* of 4 July 1857: 'The "Great Sphynx" represents the back of the colossal head, and seems somewhat wilful in the point of view taken, until we discern that the desert is the true subject, over which we are desired to look with the sphynx, who has been regarding the same for thirty centuries' (IV, p.12). Hunt conveys the sunlit areas of the drawing by leaving the paper bare, and has made copious use of indigo and purple in the shadows. The most vibrant colour is reserved for the enormous snake in the foreground. Its presence may be a comment on the *ménage* at Gizeh: Seddon's servant, Hippo, was a noted snake-charmer whose exploits fascinated his master, and Hunt's letter to Millais of 16 March 1854 contains a sketch of him entwined by a huge serpent (ASU). More importantly, however, it relates to Hunt's own encounter during an evening walk 'round the great Pyramid' on 27 April 1854: 'there, within two paces was an enormous serpent writhing about and rearing itself up most fearfully. there was no time and no necessity for consideration . . . so I retired some twenty feet lowered my gun, and fired and fortunately hit the beast in the throat and breast; he twirled about considerably but was too much hurt to be dangerous so I brought him home on the barrell of my gun: he is between six and seven feet long, of the most deadly kind . . . I find the feat has increased my reputation considerably with the Arabs' (Hunt to Combe, 26–27 April 1854, ASU). By this date Hunt's knowledge of Egyptian attacks on Christians in Cairo and the surrounding areas had given him an attack of xenophobia – 'Speaking generally I regard these people as the most detestable in existence' (ASU) – and it is tempting to view the serpent as an image of Hunt's belief in the superiority of the English set against the Arab race.

202

The snake in No.202 has been stoned, and this may refer also to Genesis 3. 15, which contains the prophecy that the seed of Eve will bruise the serpent's head. It thus becomes a symbol of the triumph of good over evil. Hunt was avidly reading the Bible at this period, and it is possible that his decision to adopt a position facing east, like the Sphinx, may have been partly motivated by religious considerations, if we can believe that the interpretation of the monument given in his memoirs had been conceived in 1854. According to his record of a conversation with Charles Dickens in 1860, Hunt at that time viewed the Sphinx as some sort of precursor of Christianity: '"the whole idea connected with this 'Watchful One' may be that it is lifting up its head to look always towards the rising sun for that Great Day in which the reign of absolute righteousness and happiness shall come"' (Hunt 1905, II, p.217). The Sphinx is facing east towards the Holy Land, Hunt's next port of call.

J.B.

THOMAS SEDDON

203 The Great Sphinx at the Pyramids of Gizeh 1854
Inscribed 'T.S.|1854' (initials in monogram)
Watercolour and bodycolour, 9¾ × 13¾ (24.7 × 35.3)
First exh: the artist's room, 14 Berners Street, London,
17 March–3 June 1855; L.A. 1855 (436)
Visitors of the Ashmolean Museum, Oxford

Painted sometime between February and May 1853 when Seddon was camping in the desert with Holman Hunt, who also produced a view of the Sphinx, though showing the back of it (No.202). An inscription 'Sky repainted' on the back of Seddon's work suggests that, as with a number of his other eastern subjects, the artist continued to work on the picture after he returned to London in 1855: the skies in both the oil paintings, 'The Valley of Jehoshaphat' (No.83) and the 'Pyramids at Sunset' (exh. *Eastern Encounters*, Fine Art Society 1978, No.59, repr.), produced on the same trip were improved with the assistance of F.M. Brown.

Compared with Hunt's unconventional rendering of the Sphinx, Seddon's watercolour, which shows the excavations being carried out by the French archaeologist Auguste Mariette, betrays the essentially topographical and limited nature of Seddon's landscape art; Ruskin later described this, in Seddon's case, as 'matter of fact representation' and it led him to describe the artist as one of the 'prosaic pre-Raphaelites' (Ruskin, XIV, pp.468–9).

'The Sphinx' was one of a group of at least nine eastern watercolours which Seddon showed, along with 'The Valley of Jehoshaphat', in his own studio in 1855; although, like the rest, it was favourably noticed, it remained unsold and was sent to the Liverpool Academy where it was priced at 30 gns. Again unsold, it was eventually bought by a fellow artist, G.P. Boyce, for the same price in February 1856 (Staley, p.99). It was exhibited, once more, in Seddon's rooms in Conduit Street in June the same year when a critic in the *Literary Gazette* drew a comparison between it and Hunt's 'Sphinx' then being shown in the Royal Academy (12 July 1856, p.476).

R.H.

203

WILLIAM HOLMAN HUNT

204 Jerusalem by Moonlight – Looking over the Site of the Temple to the Mount of Olives (The Mosque As Sakrah, Jerusalem, during Ramazan) 1854, ?1860–1
Watercolour heightened with bodycolour,
$8\frac{3}{4} \times 14$ (22.3 × 35.6)
First exh: R.A. 1856 (885)
Ref: Liverpool 1969 (151)
Whitworth Art Gallery, University of Manchester

Hunt and Seddon arrived in Jerusalem on 3 June 1854, and soon afterwards Hunt described to Mrs Combe his reaction to their first glimpse of the city: 'I saw there had risen up some distant minarets above that hard line in the pearly sky – "A city that is built on a hill cannot be hid" and I galloped forward to the brow of the hill – they were minarets on "the mount of olives" and under this somewhat to the right was the city of our King. It was truly on a hill, but it was lying close to the earth like one in sleep. whence men had reached up and heard the secrets of Heaven, and where God had come down and taught all the wisdom of life . . . You can never conceive the extreme beauty of this place . . . it is so perplexing to know what to do . . . there are certain scenes which one delights in at once, but then there were thousands of effects of light to choose from –' (n.d., June 1854, BL).

By 25 June 1854 Hunt was established in a house he had rented from a missionary (Seddon, p.96). He wrote to Millais: 'I have the most lovely prospect from my window to the right I look over the mosque of Homar [sic], which occupies the site of the Temple, towards the Mount of Olives which rises above every thing in the town' (June 1854, ASU). This is the view depicted in No.204, and Hunt recalls in his memoirs how impressive it looked by night from the roof of the house: 'It was a poetic and absorbing scene, and watching it from hour to hour for the most suitable light and shade, the moonlight effect enchanted me, and I proceeded to make a drawing' (1905, I, p.409). He goes on to recount that his Muslim neighbour accused the artist of spying on his wives while sketching – an allegation hotly denied (ibid.) – and this suggests that the drawing referred to is No.204, which includes part of the parapet wall of the house below, rather than the less highly finished watercolour 'The Holy City: The Mosque As Sakrah by moonlight' (Oldham Art Gallery).

The published account encourages one to view No.204 as basically topographical, whilst continuing the exploration of the effects of moonlight begun in 'The Light of the World' (No.57). It does not, however, do justice to the religious symbolism in the watercolour, which reflects Hunt's reading of biblical commentaries at this period. He found that studying these on the spot had a profound effect on his religious beliefs, as a letter of 24 July 1854 to John Lucas Tupper reveals: 'the course of the events seem so much more comprehensible – the journeys of the Saviour, in the last days of his ministration, from Bethany to Jerusalem to the Temple around the Mount of Olives and his rejection of the city from this road seem so real as to appear like an event of the day' (HL). The allusion to Christ's rejection of the city can be related to the first chapter of the Lamentations of Jeremiah, which describes how Jerusalem 'hath grievously sinned' (1.8) and was 'afflicted . . . for the multitude of her transgressions' (1.5), and this chapter has a strong bearing on the subject of No.204, which was exhibited at the 1856 Royal Academy with the title 'Jerusalem by moonlight – looking over the site of the Temple to the Mount of Olives'. The Mosque dominating the view of No.204 is not even mentioned, and the spectator is left to conclude that the rule of Islam is the penalty for the city's transgressions: the single star above the Mount of Olives may be near the horizon not only as a symbol of Christ's last days on earth but also as a comment on the low ebb to which Christianity has sunk in the Jerusalem of Hunt's day. The unveiled woman in the left foreground of the watercolour certainly does not belong to the artist's Muslim neighbour, and the beginning of the first chapter of Lamentations suggests that she may be a personification of Jerusalem itself: 'How doth the city sit solitary, that was full of people! how is she become a widow! she that was great among the nations, and princess among the provinces, how is she become tributary!' The city in No.204 might appear deserted at first glance but the woman is depicted peering over the parapet wall at a torchlit procession of Muslims on their way to or from the Mosque during the Ramazan celebrations. A further verse from Lamentations reads: 'The adversary hath spread out his hand upon all pleasant things: for she hath seen that the heathen entered into her sanctuary, whom thou didst command that they should not enter into thy congregation' (1.10).

The situation was reversed by the time of Hunt's residence in Jerusalem, and when he visited the Haram Es Shereef (to give the complex of mosques its correct title) on 7 April 1855, it was as a member of the first party of Christians to be given access to the site since the Muslim capture of Jerusalem at the time of the crusades (Hunt diary of that date, JRL). Hunt certainly regarded the area as sacred: not only was it the site of the

204

Temple, as the original title of No.204 emphasises, but the Mosque of Omar, the dome of which is prominently displayed in the centre of the watercolour, was also known as the Dome of the Rock, alluding to its having been built over the rock on which Abraham offered Isaac for sacrifice. According to the theory propounded by James Fergusson in his *Essay on the Ancient Topography of Jerusalem*, 1847, the Mosque of Omar was originally the Church of the Holy Sepulchre (p.179), and therefore the site of Christ's tomb as well as of God's first covenant with the Jews. Hunt came independently to the conclusion that it was originally a church (Hunt 1905, II, p.9), but the fact that F.G. Stephens mentioned 'Mr. Fergusson's theory of the true situation of the holy sites' in his review of No.204 in the *Athenaeum* of 4 May 1861 (p.603) suggests that Hunt endorsed Fergusson's thesis at this time.

The watercolour was on view that spring at the German Gallery, 168 New Bond Street, with the title 'The Mosque Es Sakkerah, Jerusalem, during Ramazan', which shifts the emphasis from that of a work intended to evoke religious meditations to a more topographical record of a Muslim festival. The change of title may suggest that the torchlit procession in the middleground was added after No.204 was shown at the Royal Academy. This feature of the drawing was not mentioned in *The Times* review of 12 May 1856, in which No.204 was described as 'a very rapid sketch' (p.12), and on 11 February 1860 Hunt informed Bell Scott that 'when I have finished this Temple picture [No.85] I shall have to do the same sort of service for two other Eastern pikturs [Nos 86–87] and several sketches' (PUL).

J.B.

WILLIAM HOLMAN HUNT

205 Nazareth 1855, ?1860–1
Watercolour, heightened with bodycolour,
$13\frac{7}{8} \times 19\frac{5}{8}$ (35.3 × 49.8)
First exh: German Gallery 1861
Ref: Liverpool 1969 (170)
Whitworth Art Gallery, University of Manchester

In September 1855 Hunt wrote to Mrs Combe from Jerusalem of his intention to travel through 'the northern part of the country that I may obtain some few sketches of the interesting localities on the way' (JRL). He left the city on 17 October and reached Nazareth at nightfall six days later, recording enthusiastically in his diary: 'Sweet Nazareth of Galilee – never did I imagine thee so lovely in all the many times that I have tried to picture the abode of our Lord' (JRL).

Hunt's diary of 24–27 October 1855 (JRL) presents a detailed account of his progress on No.205, which he began on the morning of Wednesday 24 October as 'a lovely view of the town from the Northern hill above the town'. On this first day he worked 'assiduously in outlining it till noon', broke off for lunch and a visit to the Latin church, and resumed sketching until dusk, despite overcast skies. The bleached quality of the light in No.205 is a result of Hunt working on it virtually continuously for the next three days. The diary entry for Thursday 25 October reads: 'Rise at 5 and go out to sketch before the Sun has risen. and continue working till noon when I descend for a meal rest an hour and ascend the hill again to continue my sketch which I do not leave till after sunset. If I can only advance it enough it will be a great pleasure to me all my days in England'. The subsequent two days followed a similar

205

pattern, but Hunt was not satisfied with the result: he recorded in his diary of 27 October that he left off 'at night very sorry that I cannot carry my sketch of Nazareth to a higher state of completion'.

Hunt had, however, faithfully recorded a vast amount of detail by this time, and his high viewpoint enabled him to depict not only the townscape but also a panoramic view of the surrounding landscape with the mountains of Carmel in the background. Hunt's other eastern landscapes were less ambitious in scope, and tended to concentrate on either one (e.g. No.204) or the other, as in the case of the watercolour on which he was engaged immediately before leaving Jerusalem, 'The Plain of Rephaim from Mount Zion' (Whitworth Art Gallery, University of Manchester, exh. Liverpool 1969, No.160).

No.205 was probably completed in 1860–1 (see letter to Bell Scott, quoted under No.204), and a photograph of the site, taken by James Graham on 27 October 1855 (Coll. Palestine Exploration Fund), may well have been used as an aide-memoire. The figures are almost certainly later additions. The boy's costume is similar to that of Jesus in 'The Finding of the Saviour in the Temple' (No.85), and the allusion to the childhood of Christ is underlined by the presence of a large snake, which the boy is frightening away. As in 'The Sphinx, Gizeh' (No.202), this incident recalls the passage in Genesis 3.15, but whereas in the earlier drawing Hunt had concentrated on the first part of God's prophecy to the serpent, symbolising the triumph of good over evil, both parts are applicable here: 'it shall bruise thy head, and thou shalt bruise his heel'. According to biblical exegesis, the verse foretells that Christ will conquer evil but will in turn be crucified. By including the snake in No.205, Hunt alerts the spectator to an awareness of the future life, and death, of Christ, whilst meditating on the associations aroused by a view of the town in which he lived.

No.205 was first shown at the German Gallery in April 1861, in a frame designed by the artist and used for other watercolours of the Holy Land in that exhibition (e.g. No.204). F.G. Stephens, in his review in the *Athenaeum* of 4 May 1861, described 'Nazareth' as 'lying deep in the bosom of the hill-country of Galilee' (p.603), a somewhat mystical phrase that could well have been suggested by the artist. Hunt was to return to the site in 1870 to make oil sketches for the view from the window in 'The Shadow of Death' (see Nos 143 and 148).

J.B.

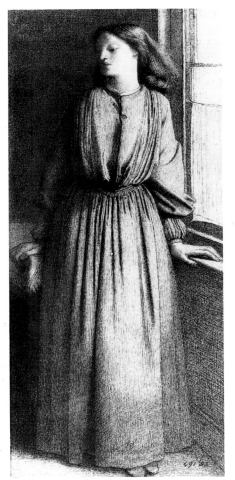

206

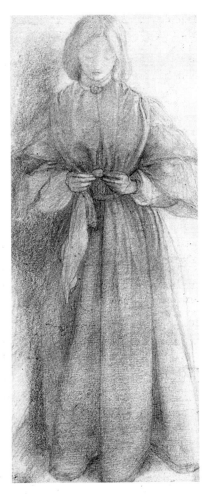

207

DANTE GABRIEL ROSSETTI

206 Elizabeth Siddal 1854
Inscribed 'Hastings May 1854'
Pen and black ink, $8\frac{3}{4} \times 3\frac{7}{8}$ (22.2 × 9.7)
Ref: Surtees No.464; Grieve 1978, p.80
Victoria and Albert Museum, London

Elizabeth Siddal was born on 25 July 1829. Her father was an ironmonger living, by 1851, off the Old Kent Road, Southwark. She was introduced to the Pre-Raphaelite circle, probably in late 1849, by Walter Deverell who found her working in a milliner's shop in Cranbourne Alley, Leicester Square. Rossetti probably met her when she posed for Deverell's 'Twelfth Night' (No.23), exhibited at the National Institution in April 1850. By the winter of 1851–2 she ceased to model except for Rossetti and his brother thinks that they became engaged at this time (W.M. Rossetti, 'Dante Gabriel Rossetti and Elizabeth Siddal', *Burlington Magazine*, I, 1903, p.277). Certainly their relationship was close and affectionate by the summer of 1852 but she was only introduced to Rossetti's mother in April 1855 and Rossetti did not visit her family home until September of that year.

From early on their relationship was overshadowed by her ill-health. Rossetti first mentions it in a letter of 25 August 1853 (Doughty & Wahl, I, p.153). During the following years she spent long periods at spas, often accompanied by Rossetti. In the spring of 1854 she was at Hastings and Rossetti joined her there on 3 May, staying until late June. He made some of his finest drawings of her on this visit (as well as No.206, see Surtees Nos 465, 466, 495). Sometimes, as in No.206, she stands but more often she is seated in a chair. Light is more important in these drawings than in any other of Rossetti's works. Its source is restricted. It is used carefully to reveal her form, the texture of her loose dress, her hair and skin, the furniture which supports her.

Rossetti retained this work, like most of the drawings he made of her. On 6 August 1855 he showed a drawer full of them to Madox Brown who remarked: 'it is like a monomania with him' (W.M. Rossetti 1899, p.40).

A.G.

DANTE GABRIEL ROSSETTI

207 Elizabeth Siddal *c.*1854
Pencil, $10\frac{1}{4} \times 4$ (26 × 10.2)
Ref: Surtees No.490; Grieve 1978, p.80
Private Collection

This drawing resembles those made at Hastings in May and June 1854 (see No.206). It was bought at the sale on 12 May 1883, following Rossetti's death, by Professor Daniel Oliver, a family friend, for £6.16s.6d. It is one of the finest Rossetti drew of Elizabeth Siddal.

A.G.

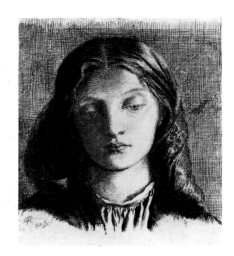

208

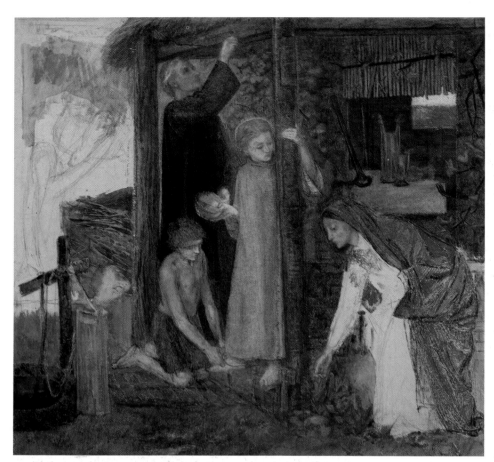

209

DANTE GABRIEL ROSSETTI

208 Elizabeth Siddal 1855
Inscribed 'DGR|Feb. 6|1855' (initials in monogram)
Pen and brown and black ink with some wash,
$5\frac{3}{32} \times 4\frac{7}{16}$ (12.9 × 11.2)
Ref: Surtees No.472; Grieve 1978, p.90
Visitors of the Ashmolean Museum, Oxford

One of the most highly finished drawings of Elizabeth Siddal
and a rare, full-face view. The lights on the hair suggest its
copper colour. On 20 September 1855 Rossetti drew a self-
portrait in a similar style and size (Surtees No.436).

A.G.

DANTE GABRIEL ROSSETTI

**209 The Preparation for the Passover in the Holy
Family** 1854–5
Watercolour, 16 × 17 (40.6 × 43.2)
Ref: Surtees No.78; Grieve 1978, pp.34–6
Tate Gallery

Ruskin commissioned this watercolour c.1854, preferring it to
a related subject of 'The Eating of the Passover in the Holy
Family' possibly because of its out-of-doors setting. Rossetti
may have already been working on it in September of this year
but seems to have spent most time on it during the summer of
1855 (W.M. Rossetti 1899, p.18; Doughty & Wahl, I, p.260).
He used Elizabeth Siddal for the Virgin, a local school-boy for
Christ (see Sotheby's, 27 October 1982, lot 101 for a fine study
of the boy's head) and Williams, an old family servant who had
posed in a similar position for Joachim in 'The Girlhood . . .'
(No.15), for Zachariah. That autumn Ruskin suggested that
he should take it to Wales to finish from nature but instead
Rossetti rapidly painted 'Paolo and Francesca da Rimini'
(No.215) and joined Elizabeth Siddal in Paris (Ruskin, XXXVI,
p.225). On 8 November 1855 Ruskin complained that it was
still incomplete, that bits had been added and taken away, a
patch inserted at Christ's head and His robe changed from
white to red (Surtees 1972, p.168). He then removed it from
Rossetti's studio and it remains today in the state described
above, thus providing a remarkable insight into the artist's
working methods. The patch at Christ's head is clearly visible,
so are the strips added at either side. Parts are only lightly
sketched in – Mary's dress and the area at the top left which
shows Elizabeth lighting a pyre and Joseph with the corpse of a
lamb. Mary's blue robe is dryly scumbled in and hatched with
the wrong end of the brush so that the white of the paper shows
through. Other parts are finished and strongly convey the
qualities of different materials – brick, thatch, wattle, foliage,
flesh.

The subject closely follows the description in Exodus (12.
1–13) of the Jewish rites for the feast of the Passover. Rossetti
shows the rites being performed by the Holy Family and he
conceived it as one out of several incidents in the life of the
Virgin which he drew and painted between 1848 and 1858.

The related subject of 'The Eating of the Passover . . .' was planned as the central compartment of a triptych with flanking scenes of the Virgin as a girl and as an old woman. The almost square shape of No.209 suggests that it too may have been conceived as the central section of a triptych. Rossetti later explained the subject in a sonnet and short prose description: 'The scene is in the house-porch, where Christ holds a bowl of blood from which Zacharias is sprinkling the posts and lintel. Joseph has brought the lamb and Elizabeth lights the pyre. The shoes which John fastens and the bitter herbs which Mary is gathering form part of the ritual' (W.M. Rossetti 1911, p.210). He stressed that, unlike earlier pictures of Christ's childhood by artists such as J.R. Herbert and Millais, his showed not a trivial, made-up incident but an important feast in the Jewish calendar which 'must have actually occurred during every year of the life led by the Holy Family' (Doughty & Wahl, I, p.276). His emphasis on historical fact accords, not surprisingly, with Ruskin's views. In the third volume of *Modern Painters*, published in January 1856, Ruskin remarked that most religious art had been dishonest and had been quite rightly condemned by Calvin, Knox and Luther: 'Of true religious ideal, representing events historically recorded, with solemn effort at a sincere and unartificial conception, there exist, as yet, hardly any examples' (Ruskin, V, p.72). He believed that No.209, though unfinished, was such an example.

A.G.

DANTE GABRIEL ROSSETTI

210 The Ballad of Fair Annie *c.*1854–6
Pen, sepia and a little Indian ink, pencil and black chalk, $5\frac{3}{4} \times 6\frac{1}{2}$ (14.6 × 16.5)
Ref: Surtees No.68; Grieve 1978, pp.65–7
Basil Gray

The ballad of *Fair Annie* is about two sisters, one of whom has a large dowry and is about to marry Lord Thomas, while the other is his mistress and has born him seven children (see W. Scott, *Minstrelsy of the Scottish Border*, 1802, II, p.102). The sisters meet just before the wedding, after long separation, and the situation is happily resolved, the wealthy sister giving her dowry to the mistress whom Lord Thomas marries instead. No.210 shows the meeting of the sisters. In an earlier sketch (Surtees No.68c) Rossetti showed the mistress holding her youngest child and looking secretly at the preparations for the wedding but he settled on the subject of their meeting, the moment when their fortunes are most poignantly contrasted. The selected episode is one of several 'salutations' planned at this time of which 'Found' (see Nos 63, 196) is the best known example.

Rossetti had read Percy's *Reliques* and Scott's *Minstrelsy of the Scottish Border* as a child and he retained a deep interest in Border Ballads all his life. In 1854–5 he and Elizabeth Siddal planned to produce illustrations for a projected Book of Ballads to be collected by William Allingham. In a letter of 2 May 1854 to Allingham, Rossetti mentions a sketch he had made from the ballad of *Lord Thomas and Fair Annie* (Doughty & Wahl, I, p.189). But, on stylistic grounds, No.210 would seem to date from a year or two later. The careful balance of rectangular openings, the bunk bed and locker, relate the composition to 'Dante's Dream' of 1856 (No.218) and to 'The Tune of Seven Towers' of 1857 (No.220).

A.G.

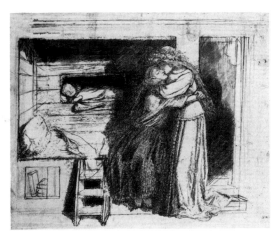

210

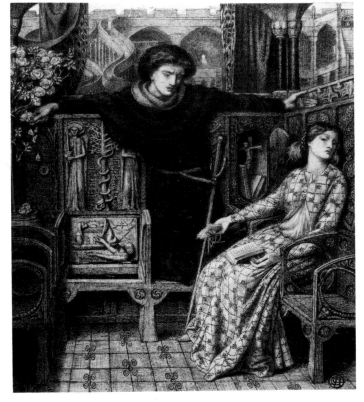

211

DANTE GABRIEL ROSSETTI

211 Hamlet and Ophelia *c.*1854–9
Inscribed 'DGR' in monogram
Pen and black ink, $12 \times 10\frac{1}{2}$ (30.5 × 26.7)
Ref: Surtees No.108; Grieve 1978, pp.67–9
Trustees of the British Museum

The first sketch for this composition (Surtees No.108A) evidently once formed part of a larger sheet of paper which also contained an early study for 'Mary Magdalene at the Door of Simon' (Surtees No.109D). Both subjects concern the dramatic confrontation of a man and woman and both took several years to reach completion. There is a drawing in the British Museum with an entirely different composition which probably dates from *c.*1853–4 and there are references in letters

from Rossetti to Allingham, in the summer of 1854, to work on an important drawing of the subject which may relate to the beginnings of No.211. He wrote then that he wanted 'to embody and symbolize the play without obtrusiveness or interference with the subject *as a subject*' (Doughty & Wahl, I, p.223). But the drawing was probably only finished shortly before mid-February 1859 when it was sold for forty gns to Thomas Plint who was soon to purchase also the finished drawing of 'Mary Magdalene at the Door of Simon' (No.223). Both drawings are remarkable for their all-over detail which is reminiscent of Dürer prints and Flemish paintings. On the stalls are carvings symbolic of Hamlet's self-destruction – the Tree of Knowledge with the inscription 'ERITIS SICUT DEUS SCIENTES BONUM ET MALUM' and, on the misericord below, 'UZZAUS', the man who touched the Ark of the Covenant and died. On the seat arms are carvings of self-devouring snakes. Quotations inscribed on the contemporary mount of the drawing, taken from the play and the Bible, emphasise Hamlet's wanton self-destruction and the change in his love for Ophelia.

The subject is taken from Act III, Scene i of the play, in which Hamlet delivers his famous soliloquy, Ophelia tries to return his gifts and he scornfully tells her to enter a nunnery. The intricately involved architecture in the background relates to Hamlet's state of mind. He is racked by doubt and mistrust and his pose echoes that of Christ on the crucifix in the locker beside him. The model for Ophelia was Elizabeth Siddal. Possibly by the date the drawing was completed its subject had a personal relevance for the artist. Contemporary poems by him such as 'Even So', 'A Little While' and 'A New Year's Burden' all describe the impossibility of reviving love which has died.

A.G.

DANTE GABRIEL ROSSETTI

212 The Annunciation 1855
Watercolour, 14 × 9½ (35.6 × 24.1)
Ref: Surtees No.69; Grieve 1978, pp.37, 38
Private Collection

This is one of a series of scenes from the Virgin's life which began with 'The Girlhood of Mary Virgin' (No.15) in 1848 and continued through the 'fifties. All show her engaged on everyday activities, in this case washing in a stream. It was probably completed at the end of March 1855, though retouched in 1858–9 (see Christie's sale catalogue, 11 July 1972, lot 46). Rossetti's close friend G.P. Boyce purchased it but it was strongly coveted by Ruskin and the unconventional treatment of the subject corresponds with that commended in the third volume of his *Modern Painters* published in January 1856. Here Ruskin criticises artists who, in their pictures of the Virgin: 'instead of calling up the vision of a simple Jewish girl, bearing the calamities of poverty, and the dishonours of inferior station, summoned instantly the idea of a graceful princess, crowned with gems, and surrounded by obsequious ministry of kings and saints' (Ruskin, V, p.75). A drawing of Elizabeth Siddal, made in 1854 (Surtees No.463), was used for the Virgin. Like the other watercolours of the period, this is intensely green. The frame has been changed but the fictile-wood mount is original and bears Biblical inscriptions which justify the prolific flowers: 'My Beloved is mine and I am his: he feedeth among the lilies.'; 'hail, thou art highly favoured: blessed art thou among women'.

A.G.

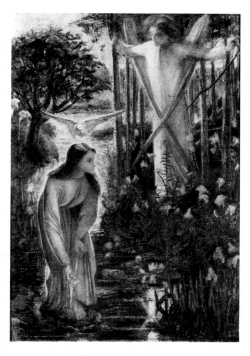

212

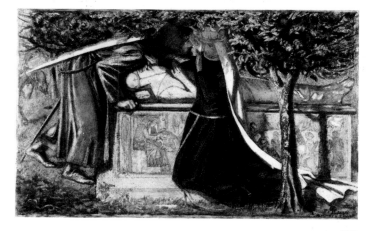

213

DANTE GABRIEL ROSSETTI

213 Arthur's Tomb 1855
Inscribed 'DGR 1854 | Arthur's Tomb' (initials in monogram)
Watercolour with gum arabic and some pencil and pen, 9¼ × 14⅞ (23.5 × 37.8)
Ref: Surtees No.73
Trustees of the British Museum

Although dated '1854' all documentary evidence indicates that this watercolour was painted in the late summer of 1855 (Doughty & Wahl, I, pp.269, 283; W.M. Rossetti 1900, p.46). Ruskin bought it then for £20. It is Rossetti's first Arthurian subject and is taken from Malory's *Morte d'Arthur*, Book XXI:

And whan quene Gwenyver undirstood that kynge
Arthure was dede . . . she wente to Amysbyry. And there
she lete make herselff a nunne, and wered whyght
clothys and blak . . . Than sir Launcelot was brought
before her; than the quene seyde to all tho ladyes,
'Thorow thys same man and me hath all thys warre be

wrought . . . thorow oure love that we have loved togydir ys my moste noble lorde slayne . . . therefore, sir Launcelot, I requyre the and beseche the hartily . . . that thou never se me no more in the visayge' . . . [Launcelot]: 'madame, I praye you kysse me, and never no more'. 'Nay', sayd the quene, 'that shal I never do, but absteyne you from suche werkes.' And they departed . . . (E. Vinaver, *The Works of Sir Thomas Malory*, 1962, pp.873, 876, 877.)

Rossetti has used some license for the scene takes place at Almesbury while Arthur was buried at Glastonbury.

'Arthur's Tomb' provides a further example of the dramatic confrontation of man with woman which is such a dominant feature of the Dante and Beatrice subjects of the same period. Its subject can also be connected with that of the triptych 'Paolo and Francesca' (No.215) which was painted a few weeks later, also for Ruskin, while the theme of repentance and renunciation unites it with Holman Hunt's 'Awakening Conscience' (No.58) finished in January 1854. Symbolic details enhance the meaning. In the lower left corner there is a snake and an apple and the attempted kiss takes place in the shadow of an apple-tree. On the tomb is a scene of the Holy Grail appearing to the knights of the Round Table and, at the left, King Arthur and Queen Guenevere knighting and rewarding the kneeling Lancelot. He wears red, the colour of passionate love. The tomb echoes the shape of the picture as a whole, perhaps following the composition of Titian's 'Sacred and Profane Love', while the abrupt changes in scale and the form of the trees are more mediaeval in inspiration. The armour and heraldic trappings are hall-marks of Rossetti's 'Arthurian' period of 1855-8. It was his enthusiasm for such subjects and mediaeval accessories that was to draw him, in the New Year of 1856, into the company of William Morris and Edward Burne-Jones. They had discovered Southey's edition of Malory for themselves in late August or September 1855 but they evidently did not mention it to Rossetti until they heard him speak of it and the Bible as the two greatest books in the world (Mackail, I, p.81).

A watercolour replica of No.213 was made in 1860 (Surtees No.73 R.I).

A.G.

DANTE GABRIEL ROSSETTI

214 Dante's Vision of Rachel and Leah 1855
Watercolour, 14 × 12½ (35.6 × 31.1)
Ref: Surtees No.74; Grieve 1978, pp.22-3
Tate Gallery

This illustrates the following passage from Dante's *Purgatory*, Canto XXVII, lines 97-109:

A lady young and beautiful, I dream'd,
Was passing o'er a lea; and, as she came,
Methought I saw her ever and anon
Bending to cull the flowers; and thus she sang:
'Know ye, whoever of my name would ask,
That I am Leah: for my brow to weave
A garland, these fair hands unwearied ply.
To please me at the crystal mirror, here
I deck me. But my sister Rachel, she
Before her glass abides the livelong day,
Her radiant eyes beholding, charm'd no less,

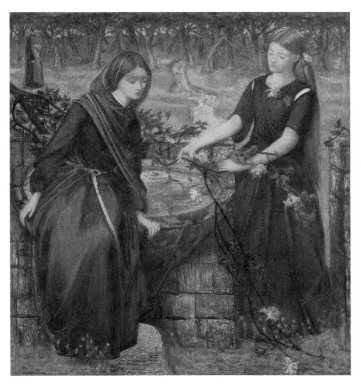

214

Than I with this delightful task. Her joy
In contemplation, as in labour mine.'
(H.F. Cary's translation.)

The passage was one of seven from the *Purgatory* proposed to the artist by Ruskin in April 1855. Out of these seven Rossetti painted only two, No.214 and 'Dante's Vision of Matilda gathering flowers' (Surtees No.72), which is lost. Both are outdoor subjects with girls picking flowers and would understandably have appealed to Ruskin. But Rossetti confessed that the subject of No.214 never interested him and he was slow to start it. On 15 August 1855 Madox Brown noted: 'Rossetti here still painting at his drawing of Rachel & Lea. I suggested his putting in Danté in the distance & sundry great improvements & now he is in spirits with it & will ask 5£ more for it' (Surtees 1981, p.149). On 13 September Rossetti wrote to Brown that Ruskin had given him £30 instead of the 20 gns asked (Doughty & Wahl, I, p.269).

No doubt to please Ruskin, Rossetti has paid particular attention to the plants and water in the foreground of the picture. Ruskin was attracted to them and to the remarkable colour: 'The colour of the purple robe – and the stonework & honeysuckle *flower* – COLOUR – renders the picture unique as far as I know in some points of colour – so strangely delicate & scented. I think very lovely' (Surtees 1972, pp.174-5).

The two girls symbolise the active and contemplative life. Leah, the active one, works with tendrils of honeysuckle and carries a red rose in her long, loose hair. Both flowers had connotations of sexual attraction to Rossetti. She wears a green dress, the colour of life. Rachel is dressed in purple, the colour Rossetti often associates with inactivity and sometimes even death. Possibly there is a personal meaning here as the model for Rachel was Elizabeth Siddal who was ill and who left on 23 September 1855 for a cure in the South of France, partly financed by money from the sale of this watercolour. Her state of health possibly dictated her pose for in a preliminary sketch,

done without models (Surtees No.698), both figures are shown standing.

In November 1855 Ruskin passed No.214 on to Ellen Heaton. He explained to her that the figure of the active Leah could also be taken as Dante's Matilda and stood for 'the very Ruling Spirit of the Work of the Middle ages, as I defined it . . . "The expression of man's delight in God's work."' (Surtees 1972, p.181). Ruskin had it framed in a silver and black frame but this has been altered for a conventional moulded gilt one which makes the work difficult to judge. An irregular strip of paper, about half an inch wide, has been added by Rossetti at the left side, making it closer to a square in shape.

A.G.

DANTE GABRIEL ROSSETTI

215 Paolo and Francesca da Rimini 1855
Inscribed, at the foot of the left compartment: 'quanti dolci pensier quanto disio'; at the foot of the right compartment: 'menò costoro al doloroso passo'; at the top of the central compartment: 'o lasso!' (*Hell*, Canto V, lines 110–11)
Watercolour, $9\frac{3}{4} \times 17\frac{1}{2}$ (24.8 × 44.5)
Ref: Surtees No.75; Grieve 1978, pp.5–8
Tate Gallery

The subject is from Dante's *Hell*, Canto V, lines 123–133, where Francesca da Rimini tells Dante of her adultery with Paolo, her brother-in-law, and their punishment:

. . . One day
For our delight we read of Lancelot,
How him love thrall'd. Alone we were, and no
Suspicion near us. Oft-times by that reading
Our eyes were drawn together, and the hue
Fled from our alter'd cheek. But at one point
Alone we fell. When of that smile we read,
The wishèd smile so rapturously kiss'd
By one so deep in love, then he, who ne'er
From me shall separate, at once my lips
All trembling kiss'd. (H.F. Cary's translation)

Rossetti had drawn the lovers reading, possibly inspired by Leigh Hunt's poem *The Story of Rimini* rather than Dante, as early as *c*.1846–7 (Surtees No.75E). W.M. Rossetti records

that a triptych was planned in November 1849 with the same scenes as in the watercolour but differently ordered: 'In the middle, Paolo and Francesca kissing; on the left, Dante and Virgil in the second circle; on the right, the spirits blowing to and fro' (W.M. Rossetti 1900, p.232). Drawings of the lovers kissing survive which probably date from this time (Surtees No.75D) but it was only in the autumn of 1855 that Rossetti took the subject up again and completed it as this watercolour. It was painted rapidly to obtain money for Elizabeth Siddal who had run out of funds on her way to the South of France, as Madox Brown records: 'Gabriel, who saw that none of the drawings on the easel could be completed before long, began a fresh one, "Francesca di Rimini", in *three compartments*; worked day and night, finished it in a week, got 35 gns. for it from Ruskin, and started off to relieve them' (W.M. Rossetti 1899, pp.46–7). A finished pencil drawing which establishes the composition of the lovers kissing in front of a halo-shaped window must have been made slightly earlier (Surtees No.75A).

Paolo is in red and it can be seen that the picture in the book he is reading, which closes the circle and leads to the fateful kiss, shows Lancelot also dressed in red. A plucked red rose lies at the lovers' feet. Ruskin, who offered the watercolour to his protégé Ellen Heaton, who had herself commissioned an unspecified subject from the artist, was worried that the boldness of the scene might make it 'not quite a young lady's drawing': 'The common-pretty-timid-mistletoe bough kind of kiss was *not* what Dante meant. Rossetti has thoroughly understood the passage throughout' (Surtees 1972, pp.169, 173).

A.G.

DANTE GABRIEL ROSSETTI

216 Robert Browning 1855
Inscribed 'October 1855'
Watercolour, pencil and coloured chalks,
$4\frac{3}{4} \times 4\frac{1}{4}$ (12.1 × 10.8)
Ref: Surtees No.275
Fitzwilliam Museum, Cambridge

Rossetti's enthusiasm for Browning's poetry dates from *c*.1847 when he wrote to the poet expressing his admiration for *Pauline*

215

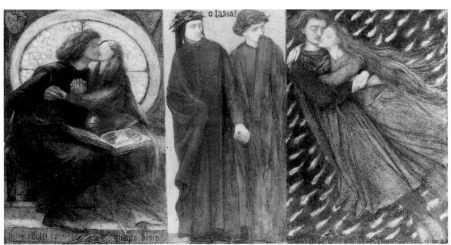

216

which he had discovered in the British Museum (Doughty & Wahl, I, pp.32–3). They met in August 1851 but only became close during the autumn of 1855. During September, October and November of this year they were frequently in each other's company. On 27 September, at Browning's London lodgings, Rossetti drew his well known sketch of Tennyson reading *Maud* (Surtees No.526). No.216 was started shortly after this, in October, and possibly finished in early November in Paris where Rossetti spent ten days and was often, again, in Browning's company (Doughty & Wahl, I, pp.273, 278). At least by early January 1856 the portrait was finished and hanging over Rossetti's mantelpiece at 14 Chatham Place (ibid., p.282).

Browning's deep knowledge of mediaeval art was a close bond between him and Rossetti. In Paris they toured the Louvre together where Rossetti found 'his knowledge of early Italian Art beyond that of anyone I ever met' (ibid., p.280). Rossetti particularly admired Browning's poems on Italian artists, such as 'Andrea del Sarto', which had just appeared in *Men and Women*.

The intense green/blue ground of No.216 was perhaps inspired by the portraits of Clouet or Bronzino. Rossetti thought of it as a preliminary to a more ambitious portrait in oils of Browning and Elizabeth Barrett which was not carried out (ibid., p.283).

For a medallion of Browning by Woolner, see No.77.

A.G.

ELIZABETH SIDDAL AND
DANTE GABRIEL ROSSETTI

217 The Quest of the Holy Grail or **Sir Galahad at the Shrine of the Holy Grail** *c.*1855–7
Inscribed 'EES inv. EES & DGR del.'
Watercolour, $11 \times 9\frac{3}{8}$ (28×23.8)
Ref: R.A. 1973 (145)
Private Collection

According to the inscription, the composition was invented by Elizabeth Siddal and it was executed jointly by her and Rossetti. It belonged to Ruskin who, in the spring of 1855, had started to give her money in exchange for all she produced. Like many of her works this is weird, macabre, peopled by stiff, drawn-out figures moving through an insubstantial architectural setting.

The source for the subject is probably Tennyson's poem 'Sir Galahad', though lines 45–9 from his 'Morte d'Arthur' are also applicable. The design may have been made initially in connection with a plan to involve Elizabeth Siddal in the illustrated edition of Tennyson's poems published by Moxon in 1857 (Doughty & Wahl, I, p.245).

> Sometimes on lonely mountain-meres
> I find a magic bark;
> I leap on board: no helmsman steers:
> I float till all is dark.
> A gentle sound, an awful light!
> Three angels bear the holy Grail:
> With folded feet, in stoles of white,
> On sleeping wings they sail.
> Ah, blessed vision! blood of God!
> My spirit beats her mortal bars,
> As down dark tides the glory slides,
> And star-like mingles with the stars.
> 'Sir Galahad', verse iv

A.G.

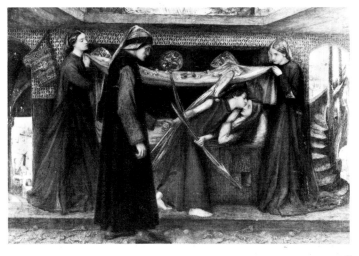

217

218

DANTE GABRIEL ROSSETTI

218 Dante's Dream at the Time of the Death of Beatrice 1856
Watercolour, $18\frac{1}{2} \times 25\frac{3}{4}$ (47×65.4)
First exh: Russell Place 1857 (54)
Ref: Surtees No.81; Grieve 1978, pp.25–7
Tate Gallery

The subject is taken from a passage in the *Vita Nuova* where Dante describes a very clear dream, of the death of Beatrice, he has had on the ninth day of a feverish illness:

> Then lifting up mine eyes, as the tears came,
> I saw the Angels, like a rain of manna,
> In a long flight flying back Heavenward;
> Having a little cloud in front of them,
> After the which they went and said, 'Hosanna';
> And if they had said more, you should have heard.
> Then Love said, 'Now shall all things be made clear:
> Come and behold our lady where she lies.'

These 'wildering phantasies
Then carried me to see my lady dead.
Even as I there was led,
Her ladies with a veil were covering her;
And with her was such very humbleness
That she appeared to say, 'I am at peace.'
(Rossetti's translation; W.M. Rossetti 1911, p.330, lines 57–70)

The subject was of great importance to Rossetti. It expresses most poignantly his favourite theme of earthly love broken by the death of one of the lovers. No.218 is his largest watercolour and the largest oil he painted (Surtees No.81 R.1) is of the same subject. He intended designing it already in 1848 when he finished his translation of the *Vita Nuova* but No.218 was only completed in April 1856. It was painted for Ruskin's protégé Ellen Heaton who, although she had expressly forbidden a melancholy subject, had no choice but to accept it (Surtees 1972, p.174).

The setting itself is dreamlike, theatrical and floating above the real world. Dante walks on a lower level than the figures he sees in his dream and he walks on a floor strewn with red poppies, symbolic of dreams. He is linked to the dreamworld by the hand of Love who bends to kiss Beatrice. Love wears the pilgrim's scallop shell and has red wings. Beatrice's attendants are in green, the colour of life. They hold a pall full of May blossom with which they are about to cover Beatrice. She lies in a recessed bunk which echoes the shape of the whole picture. The composition was probably influenced by Blake's title-page to *Songs of Experience* which shows a recessed bier, placed parallel to the surface plane, with mourning figures bending over it. The ceiling is open to allow the cloud of angels to ascend and arched entrances on either side give Eyckian views onto Florence.

Before being delivered to Miss Heaton, the picture was lent to Dr Acland in Oxford and then to the Brownings in London (Surtees 1972, p.186 note 1, p.189 note 3). Either on its travels or in Rossetti's studio in April it was seen by his friend Vernon Lushington who described its appearance at that time in a valuable article published in William Morris's *Oxford and Cambridge Magazine* in August 1856 (p.484). He compared the colours, now faded, to the 'plumage of tropical birds' and remarked that the frame, which has since been changed, had a silver flat inscribed with relevant texts. Both Morris and Burne-Jones must have seen Rossetti working on this watercolour and the vision of the mediaeval world it depicts was shared by all three men.

A.G.

DANTE GABRIEL ROSSETTI

219 · **The Blue Closet** 1856–7
Inscribed 'DGR 1857' (initials in monogram)
Watercolour, $13\frac{1}{2} \times 9\frac{3}{4}$ (34.3 × 24.8)
First exh: Russell Place 1857 (59)
Ref: Surtees No.90
Tate Gallery

Though dated '1857' this watercolour must have been at least almost complete by the end of the previous year when William Morris wrote a poem inspired by it (Doughty & Wahl, I, p.312). Its subject is enigmatic and Rossetti himself simply described it as 'some people playing music' (ibid., I, p.376). It may be related to the death of Arthur for Rossetti completed his illustration of 'King Arthur and the Weeping Queens' for the Moxon Tennyson at the end of 1856 and Morris's poem hints at an Arthur subject. Morris's poem also contains references to another possible source – Villon's mournful *Ballad of Dead Ladies* which Rossetti translated.

Four women in mediaeval costume stand in a room lined with blue tiles. The two inner women play a strange musical instrument, the outer women sing from sheets of music. The symmetrical grouping and echoed poses recall the composition of mediaeval scenes of the flagellation of Christ or of angels making music (e.g. Orcagna's panel of 'Musical Angels' in Christ Church, Oxford). The sprigs of holly which lie along the top of the instrument perhaps refer to the time of year in which the picture was painted. The device of the sun and moon, also on the instrument, is one frequently used by Rossetti to suggest the passage of time. Morris's poem connects the red-orange lily in the foreground with death.

This work was bought by Morris, which is not surprising as it relates closely to his own contemporary interests. He belonged to a plain-song society, wrote 'mediaeval' carols, made 'mediaeval' costumes and furniture. Indeed, his activities probably encouraged Rossetti's own taste for mediaevalism at this period. The frame is original.

A.G.

219 ·

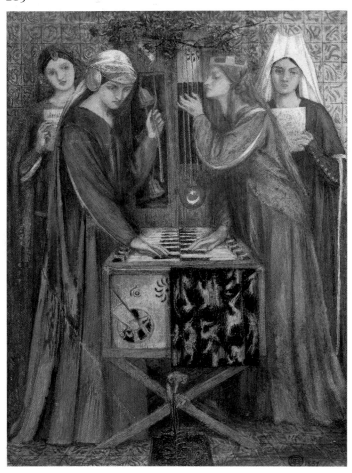

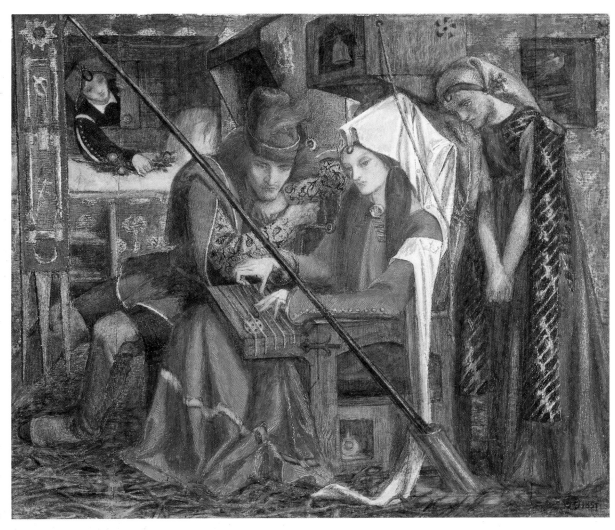

220

DANTE GABRIEL ROSSETTI

220 The Tune of Seven Towers 1857
Inscribed 'DGR 1857' (initials in monogram)
Watercolour, 12⅜ × 14⅜ (31.4 × 36.5)
Ref: Surtees No.92
Tate Gallery

Probably begun in the spring of 1857 but not quite finished in time for the private exhibition of Pre-Raphaelite pictures at Russell Place in July (Doughty & Wahl, I, p.325). It is one of a group of watercolours with mediaeval subjects made when Rossetti was particularly close to William Morris, who bought this work and others of the group. In them we find heraldic pattern, elaborate mediaeval dress, 'built-in' furniture.

The composition of No.220 derives from a drawing of 1853 titled 'Michael Scott's Wooing' (Surtees No.56) but the mediaeval setting and enigmatic detail are more developed. The subject is mysterious and possibly partly autobiographical. During this period Rossetti considered marrying Elizabeth Siddal but was depressed by her illness which was thought to be fatal. She posed for the woman dressed in red playing the stringed instrument and she wears a scallop shell at her neck – a symbol of pilgrimage and a possible reference to her travels in search of health. At the left side, a maid appears through a hatch to place a branch of an orange-tree, symbol of marriage, on a bed. In an aperture at the right, a dove, used as a hiero-glyph for Siddal by Rossetti, flutters in a spiral staircase. The pennant hanging on the left side of the picture bears the device of a lily and a rose, the moon and the sun, symbols of purity and passion, female and male, night and day. Around them is a schematic castle with seven towers. A golden emblem of a seven-towered castle also appears on the top of the man's chair. The source may possibly lie in one of the collections of mediaeval songs issued at this time or in a mediaeval tale such as *Aucassin and Nicolete* which was a favourite with Morris. The extraordinary furniture may also reflect the artist's friendship with Morris for we know he was impressed by the 'intensely mediaeval furniture . . . like incubi and succubi' which Morris had made for his London rooms in the winter of 1856 (Doughty & Wahl, I, p.312). And Lady Burne-Jones records a Christmas party in the following year to celebrate the arrival of a large 'mediaeval' chair: 'with a box overhead in which Gabriel suggested owls might be kept with advantage' (G. Burne-Jones, I, p.177).

In its early stages No.220 must have been almost square but Rossetti added strips of paper at either side which make it wider than it is high. The frame is original.

A.G.

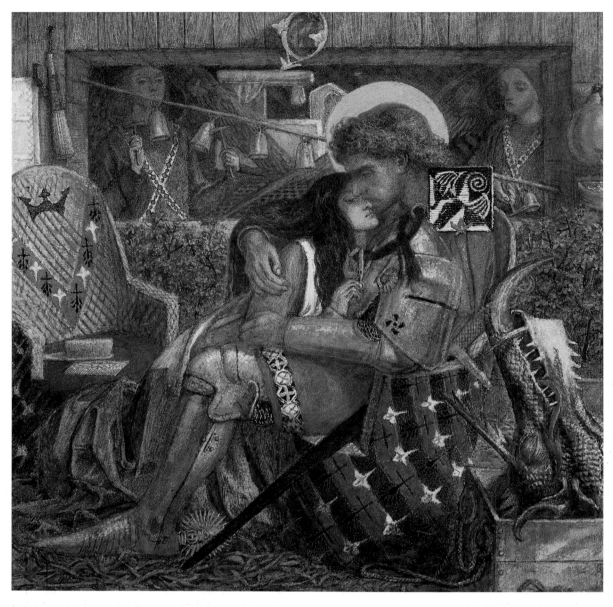

221

DANTE GABRIEL ROSSETTI

221 The Wedding of St George and Princess Sabra 1857
Inscribed 'DGR | 1857' (initials in monogram)
Watercolour, $13\frac{1}{2} \times 13\frac{1}{2}$ (34.3 × 34.3)
First exh: L.A. 1858 (297)
Ref: Surtees No.97
Tate Gallery

Rossetti was working on this in October 1857 at Oxford where he lived in close companionship with Morris, Burne-Jones and other members of the 'Birmingham' set (Mackail, I, p.126). He may have been drawn to the subject by them, for St George is traditionally connected with Coventry and Morris and Burne-Jones frequently depict this scene. Burne-Jones in fact made a stained-glass cartoon of the subject at about the same time (Victoria and Albert Museum). Marriage was in the minds of all three artists at this date. The subject's source is possibly a ballad in Bishop Percy's *Reliques* (see T. Percy, *Reliques of Ancient English Poetry*, III, 1889, p.232). The dragon has been killed. Princess Sabra has been dressing her hair and is tying a lock of it at St George's neck. Angels play bells behind a rose hedge. There is a bed in the background.

Perhaps here, more than in any other of the watercolours of this period, Rossetti has indulged his love for decorative shapes and inter-related heraldic patterns. A drawing (Surtees No.97A) for the embracing couple shows them relaxed and rather formless, while in the watercolour, St George is cramped into a series of right-angles, his face and the ailette on his shoulder placed in profile, parallel to the picture plane. Morris's enthusiasm for mediaeval brasses, for armour and illuminated manuscripts may be reflected in the composition though the work was not bought by him but by Thomas Plint of Leeds, best known for his commission to Madox Brown for 'Work'. The frame is original.

A.G.

ELIZABETH ELEANOR SIDDAL

222 Lady Clare ?1854–7
Inscribed 'ES / 57' (initials in monogram)
Watercolour, 15¼ × 10 (33.8 × 25.4)
Private Collection

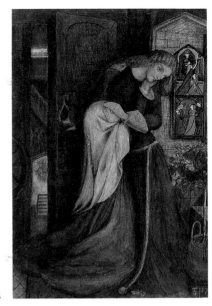

222

In 1853 the artist was preparing to work on a picture from Tennyson for exhibition at the Royal Academy (Doughty & Wahl, I, p.53). According to W.M. Rossetti a watercolour of 'Lady Clare' was among Siddal's early works, dating from *c.*1854 ('Dante Rossetti and Elizabeth Siddal,' *Burlington Magazine*, I, 1903, p.277).

Tennyson's 'Lady Clare' (*Poems*, 1842) tells of the impending marriage of Lady Clare and Lord Ronald. Lady Clare states in the third stanza,

'He does not love me for my birth,
 Nor for my lands so broad and fair,
He loves me for my own true worth,
 And that is well,' . . .

Alice, her maid, reveals to Lady Clare that she is not of noble birth, but that she is Alice's own daughter, and that her lands rightfully belong to Lord Ronald. Alice beseeches her child to keep her birth secret, but Lady Clare resolves to tell her betrothed, and to discover 'if there be any faith in man'. Lord Ronald dismisses her humble origins and undertakes to keep his promise to marry her so that she will retain her aristocratic status.

Nineteenth-century beliefs about love, sexuality and class structured the representations of the mediaeval past. As perceived in art and literature in the 1850s this historical period did not have a single, fixed meaning, but rather was the site for the construction of multiple and contradictory meanings, produced by and for the contradictory practices of the present. Heterosexual romantic love – with courtship leading to monogamous, companionate marriage – is historically specific; it emerged with the development of the middle classes, *c.*1780–1850. Its construction of the individual as freely choosing a partner for personal qualities and affective reasons rather than birth, status, or wealth masked the class and gender determinants on the formation of the individual and the choice of his or her partner. In the nineteenth century femininity was constructed in terms of difference and in subordination to masculinity; and female sexuality was organised around the central polarity of virgin/whore, Madonna/Magdalen. This construction was managed in and by visual representations of the mediaeval past, and it was responsible for the differences between Siddal's 'Lady Clare' and works such as Rossetti's 'Arthur's Tomb' (No.213). The purity and romantic marriage of Lady Clare are set in tension to and attain meaning against the impurity and 'illicit' love of Guinevere and Launcelot. In both through heterosexual romantic love women are constructed for men and bound in affective relation to them.

The watercolour represents two women. They are constructed in difference to each other through the production of daughter/mother, lady/servant, youth/age as poles of contrast. Lady Clare stands, attired in a rich blue robe worn with a golden girdle, a coronet on her cuff, all signifying her aristocratic status. Her hair is worn loose and long signifying her virginity in contrast to the older woman whose head is covered by a full veil. Alice kneels, her arms upraised to her daughter's face. It is a moment of recognition and of rejection. Lady Clare's loyalty lies with Lord Ronald – her beloved, her feudal lord, and the member of that class which she has until now considered to

be her own. The relationship of these two women, which has the potential to disrupt heterosexual romantic love and which has diverted dynastic succession, is here presented as one of conflict, difference, and divided interests.

The drawing of the figures and the organisation of the architectural space oppose Renaissance notions of anatomy and perspective which were enshrined in academic traditions. The figure drawing and perspective should not be attributed to the alleged technical ineptitude of the artist, but understood as calculated strategies in the production of 'mediaevalness'. In the 1840s and 1850s the mediaeval past was constructed in diametric contrast to the modern age. In 'Lady Clare' the difference of the mediaeval is produced through the representation of the figures with their 'awkwardness', the fourteenth-century dress, the 'archaic' story, the enclosed interior. The stained glass panels depicting the Judgment of Solomon have a special inter-textual relation to the principal figures. In the Biblical story the immanent death of the child prompts the natural mother to reveal herself as mother. In 'Lady Clare' it is the forthcoming loss of her daughter by marriage which initiates Alice's declaration.

The drawing produces a division between the interior and the exterior, viewed through the open door. As in Siddal's 'The Lady of Shalott' (No.198) this polarity works with the ideology of the separate spheres to construct woman as the guardian of the private sphere. In Rossetti's 'Dante Drawing an Angel' (No.162) the private domain of artistic activity is distinguished from the world outside glimpsed through the apertures. The inner/outer contrast signifies in the ideological construction of the artist and artistic activity as inspiration drawn from memory as against the outside world. At first sight these two watercolours appear to be alike. Both are produced within the pictorial language of Pre-Raphaelitism. If we attend only to the surface likeness of form and style we fail to address their specific historical insertion, their particular and different construction of class and gender. All too often Siddal's drawings are viewed as pale echoes of Rossetti's and said to be dependent on his for inspiration. Such analysis should be resisted. It produces and reproduces patriarchal ideology, constructing the woman artist and her work as negative, and sustaining the male artist and his art in a position of dominance and privilege.

D.C.

[283]

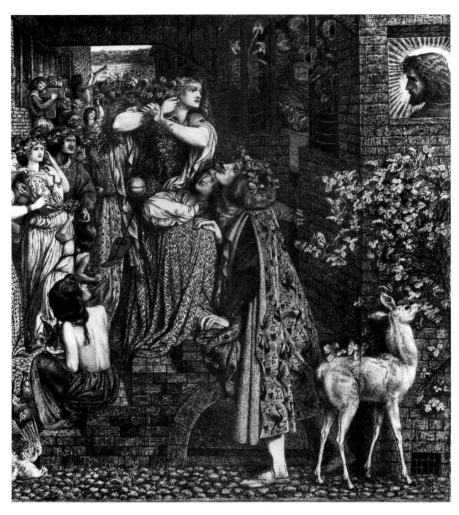

223

DANTE GABRIEL ROSSETTI

223 Mary Magdalene at the Door of Simon the Pharisee 1853–9
Inscribed 'DGR│1858' (initials in monogram)
Pen and black ink, $20\frac{3}{4} \times 18$ (52.7 × 45.7)
Ref: Surtees No.109; Grieve 1978, pp.43–5
Fitzwilliam Museum, Cambridge

Rossetti first considered this subject in the summer of 1853 and the earliest drawings for it probably date from then (Doughty & Wahl, I, p.147; Surtees No.109c). It was conceived at the same time as 'Hamlet and Ophelia' (No.211) and 'Found' (see No.196) and like them it shows a dramatic confrontation between a man and a woman of clashing temperaments. Indeed, Rossetti seems to have thought of its subject as a counterpart to 'Found'. Further studies were probably made in the mid fifties (Surtees Nos 109A, 109B) but No.223 was no doubt mostly drawn in 1858 when it was seen in Rossetti's studio by Boyce (Surtees 1980, pp.24–5). The fawn was drawn from life in March of the following year (ibid., p.27). Mary Magdalene was drawn from the actress Ruth Herbert and Christ from Burne-Jones. Strips were added at the right side and at the foot during its production.

Rossetti described the subject: 'The scene represents two houses opposite each other, one of which is that of Simon the Pharisee, where Christ and Simon, with other guests, are

seated at table. In the opposite house a great banquet is held, and feasters are trooping to it . . . Mary Magdalene . . . has suddenly turned aside at the sight of Christ, and is pressing forward up the steps of Simon's house, and casting the roses from her hair. Her lover and a woman have followed her out of the procession and are laughingly trying to turn her back' (Marillier 1899, p.97). Symbolic details help to bring home the meaning. The fawn, for example, is a reference to the first verse of Psalm 42: 'As the hart panteth after the waterbrooks, So panteth my soul after thee, O God'. The sunflower flanking the door is also a symbol of aspiration as it always turns its head to follow the sun. This is one of the earliest uses of the flower in Rossetti's circle although Morris had included it already in his Union Mural. The elaboration of detail is Düreresque and the composition resembles that of Dürer's 'Nativity' in the 'Small Passion'. The bird pattern on the lover's cloak is taken from a plate showing a fourteenth-century North Italian costume in Bonnard's *Costumes Historiques* (1830, II, No.54). A similar elaboration of detail is found in Burne-Jones's contemporary drawings such as 'Going to the Battle' (No.225) and 'Sir Galahad'.

No.223 was first owned by Thomas Plint but was discovered towards the end of the century by Charles Ricketts in a shop in the Brompton Road. It was influential on Ricketts' own style of drawing and was reproduced by him as a frontispiece to *The Pageant* (1896).

A.G.

EDWARD BURNE-JONES

224 The Knight's Farewell 1858
Inscribed 'EBJ 1858' (initials in monogram)
Pen and ink and grey wash on vellum,
$6\frac{1}{4} \times 7\frac{1}{2}$ (15.9×19.1)
Ref: Hayward Gallery 1975–6 (12)
Visitors of the Ashmolean Museum, Oxford

The drawing shows a knight and his lady parting before battle, while a youth seated on the right reads aloud from a book entitled 'Roman du Queste du Sangrail' and a troop of knights ride past beyond the enclosure wall. Still immature in drawing (note particularly the hands), it is one of the designs in pen and ink, elaborately finished and usually on vellum, which were Burne-Jones's main output for about four years following his crucial meeting with Rossetti in January 1856.

There were probably several reasons why he adopted the pen and ink medium at this time. It suited his delicate health. He was already familiar with it, having used it for the illustrations for Archibald Maclaren's *Fairy Family* which he had begun in 1854 while still at Oxford. It was much employed by Rossetti in the 1850s. And Ruskin, whom he also met in 1856, advocated it for beginners in his *Elements of Drawing* (1857). Burne-Jones's use of the pen is much dryer and more finicky than Rossetti's, but very similar to the method recommended by Ruskin, in which the tones are built up with minute touches and dots and the penknife used to soften forms and erase unwanted lines. Ruskin also urges his readers to study Dürer's engravings, and Burne-Jones's pen drawings, both technically and in their use of certain motifs, often suggest that he had such models in mind. Significantly, Rossetti described them to Bell Scott in February 1857 as 'marvels of finish and imaginative detail, unequalled by anything unless perhaps Albert Dürer's finest works' (Doughty & Wahl, I, p.319). Burne-Jones's main source for Dürer prints was probably Ruskin himself; Ruskin had a large collection which he used specifically for teaching purposes, notably at the Working Men's College.

The interest in Dürer was part of the craze for everything mediaeval that prevailed in Rossetti's circle in the late 1850s, reaching a climax in the famous episode of 1857 when he and a group of followers, including Burne-Jones, painted murals illustrating Malory's *Morte d'Arthur* in the Oxford Union. 'The Knight's Farewell' is one of several mediaeval subjects which Burne-Jones drew after his return to London in February 1858, probably mainly during the summer months which he spent recovering from nervous exhaustion under the wing of Mrs Thoby Prinsep at Little Holland House in Kensington. These drawings are closely comparable to Rossetti's contemporary watercolours, which were described by the artist himself as 'chivalric Froissartian' in theme, and reveal an almost perverse delight in quaint detail and flat decorative pattern. A further parallel is provided by William Morris's early poems, published as *The Defence of Guenevere* in March 1858. Morris in fact owned 'The Knight's Farewell', presumably purchasing it at the time of its execution, just as he purchased many of Rossetti's 'Froissartian' watercolours. He later sold the Rossettis, but he retained 'The Knight's Farewell', which descended to his daughter, May Morris, and was included in the sale of the contents of Kelmscott Manor after her death in 1938.

The drawing is particularly comparable to two watercolours painted by Rossetti for Morris in 1857, both now in the Tate Gallery. A very similar group of lovers parting occurs in 'The Chapel before the Lists', while the sloped pennon re-appears as

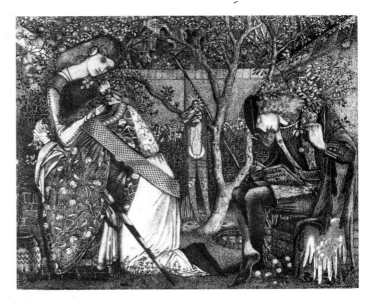

224

a prominent feature in 'The Tune of Seven Towers' (No.220), a picture which inspired an early poem by Morris of the same name. In Morris's poetry itself the closest parallel is found in 'Sir Galahad, A Christmas Mystery', where the parting lovers are again encountered, together with the motif of knights riding past and a reference to the Holy Grail:

> Before the trees by autumn were well bared,
> I saw a damozel with gentle play,
>
> Within that very walk say last farewell
> To her dear knight, just riding out to find
> (Why should I choke to say it?) the Sangreal . . .
>
> . . . long time they stood there, fann'd
>
> By gentle gusts of quiet frosty wind,
> Till Mador de la porte a-going by,
> And my own horsehoofs roused them; they untwined,
> And parted like a dream . . .

The setting, however, is more like that of the tragic 'Golden Wings':

> Midways of a walled garden,
> In the happy poplar land,
> Did an ancient castle stand,
> With an old knight for a warden.
>
> Many scarlet bricks there were
> In its walls, and old grey stone;
> Over which red apples shone
> At the right time of the year.

It is possible that Burne-Jones originally intended his drawing to show the parting of Paris and Helen, one of the 'Scenes from the Fall of Troy' which Morris was planning to treat as a cycle of narrative poems, conceived in a mediaeval spirit, in 1857. A year or two later Burne-Jones certainly intended to paint these subjects for Morris on the staircase at Red House.

At this early period Burne-Jones was still thinking in conventional Pre-Raphaelite terms and struggling to work from nature. The trees were almost certainly drawn from life, possibly from examples at Little Holland House, where Morris is recorded drawing a tree about this date, or perhaps at Summertown in North Oxford, in the garden of Archibald

Maclaren and his wife, with whom Burne-Jones stayed in June 1858, half-way through his sojourn at Little Holland House. This holiday, during which he is known to have worked on another pen drawing, 'Sir Galahad' (Fogg Art Museum, Harvard), is perhaps reflected in a further motif in 'The Knight's Farewell', the troubadourish figure on the right, for Lady Burne-Jones, describing the Oxford visit in her *Memorials*, recalled that 'Edward read aloud to us a great deal from the Morte d'Arthur' (G. Burne-Jones, I, p.181).

Typically, however, any autobiographical references the drawing may contain are muted; there is nothing approaching the running commentary on his emotional life that Rossetti offers the spectator in his paintings. Nor does Burne-Jones seek the dramatic intensity that Rossetti would have found in the parting lovers; even the knights riding heedlessly past beyond the wall fail to make the poignant contrast that they would in the hands of Rossetti. Instead Burne-Jones was already more concerned with a mood of pensive yearning and formal questions of linear rhythm and surface texture and pattern, all outstanding features of his developed style.

J.C.

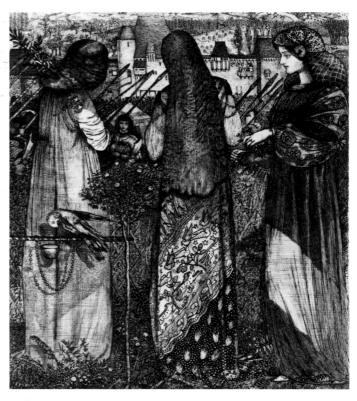

225

EDWARD BURNE-JONES

225 Going to the Battle 1858
Pen and ink and grey wash on vellum,
$8\frac{7}{8} \times 7\frac{11}{16}$ (22.5 × 19.5)
Ref: Hayward Gallery 1975–6 (13)
Fitzwilliam Museum, Cambridge

This drawing of ladies watching their knights go off to battle belongs to the same group of mediaeval subjects as No.224. Though not inscribed, it is dated 1858 in a work-list made by Burne-Jones in a contemporary sketchbook (Victoria & Albert Museum, E.1-1955). It was probably exhibited at the semi-private Hogarth Club in the winter of 1858–9, and by 1861 it belonged to Richard Mills, who also bought two other works of this date by Burne-Jones. Later well-known as a collector of oriental porcelain, Mills was one of Burne-Jones's earliest patrons outside his immediate circle of friends.

The title and theme of the drawing may owe something to Tennyson's 'Ballad of Oriana', which Burne-Jones had admired since his Oxford days. This tells of a knight who accidentally kills his lady with an arrow as she stands on the battlements watching him fight, and includes the line 'We heard the steeds to battle going'. Burne-Jones in fact met Tennyson at Little Holland House in July 1858, probably about the time that the drawing was in progress.

However, 'Going to the Battle', like No.224, also illustrates the close relationship which existed between Burne-Jones, Rossetti and Morris in the late 1850s. The three standing female figures are perhaps a reminiscence of Rossetti's famous illustration to 'The Maids of Elfenmere' in William Allingham's *Day and Night Songs*, which had made such an overwhelming impression on Burne-Jones when he saw it in 1855. More recently, Rossetti himself had treated the subject of ladies

seeing their knights off to war in the watercolour 'Before the Battle' (Surtees No.106). Begun in the autumn of 1857 when he was staying with Miss Siddal at Matlock, this was first seen by his circle when he returned to London the following spring. The painter G.P. Boyce noted it when he called on Rossetti on 10 May 1858, and it was probably about this time that Burne-Jones began his version. Besides the similarity of theme, the bird, fish and star patterns on his central figure's dress are very like those on the banner which the lady is tying to a knight's pennon in Rossetti's watercolour.

Morris, too, provides a striking parallel in his poem 'The Sailing of the Sword', published in *The Defence of Guenevere* in March 1858, but no doubt known to Burne-Jones considerably earlier:

> Across the empty garden-beds,
> *When the Sword went out to sea,*
> I scarcely saw my sisters' heads
> Bowed each beside a tree.
> I could not see the castle leads,
> *When the Sword went out to sea . . .*
>
> O, russet brown and scarlet bright,
> *When the Sword went out to sea,*
> My sisters wore; I wore but white:
> Red, brown, and white, are three;
> Three damozels; each had a knight,
> *When the Sword went out to sea.*

In coming close to Morris, Burne-Jones also absorbed something of the spirit of Froissart, who had such a profound impact on Morris's early poetry. Most of Burne-Jones's pen drawings of 1858 owe more to Malory, the other great literary influence on this mediaeval phase; indeed even in the present drawing he characteristically shuns the strong element of cruelty in

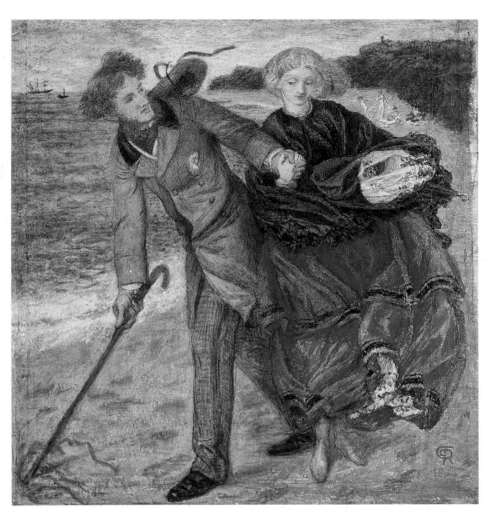

226

Froissart which Morris uses to such dramatic effect. However, the drawing's background seems to be the 'happy poplar land' of France, so often the setting of Morris's poems. Burne-Jones had seen this at first hand when he and Morris toured north France in the Long Vacation of 1855, noting (in Morris's words) how 'gloriously the trees are grouped . . . especially the graceful poplars and aspens', and how 'the hedgeless fields of grain . . . [sweep] up to the brows of the long low hills till they [reach] the sky' (ed. P. Henderson, *The Letters of William Morris*, 1950, p.13) – the very effects suggested in 'Going to the Battle'. Morris was in the region again in August 1858, and possibly his letters home revived Burne-Jones's memory of these sights of three years before. The architecture in the drawing's middle distance also looks French, although the immediate source was perhaps Dürer's engravings. The towers topped with gabled roofs are of a type that Ruskin discusses in one of his Edinburgh Lectures, so enthusiastically greeted by Morris and Burne-Jones as undergraduates in 1854; and Ruskin comments that while 'The finest example I know . . . is that on the north-west angle of Rouen Cathedral . . . the backgrounds of Albert Dürer are full of them' (Ruskin, XII, p.43). One further passage in the drawing seems to owe something to Morris: the parrot on its perch supported by a little tree in the left foreground. These motifs, more formally treated, occur as a repeating pattern with this motto 'If I can' on a woollen hanging which he designed and embroidered in 1857, now at Kelmscott Manor.

J.C.

DANTE GABRIEL ROSSETTI

226 Writing on the Sand 1858–9
Inscribed 'DGR|1859' (initials in monogram)
Watercolour, 10½ × 9½ (26.7 × 24.1)
Ref: Surtees No.111
Trustees of the British Museum

Though dated '1859' this watercolour was in progress in June of the previous year when Rossetti borrowed two sketches by G.P. Boyce to help in the background (Surtees 1980, p.24). He painted it for Ruth Herbert, the beautiful actress whom he had met shortly before and who strongly attracted him. Her face is possibly used in this picture. Though Rossetti made many slight drawings of figures in contemporary dress throughout his career this is the only example where they have been worked up in watercolour. A pen drawing survives of the same subject with Elizabeth Siddal as the model for the woman (Surtees No.111A). The provocative combination of crinolines, a windy day and sea-bathing was used by contemporary caricaturists in suggestive cartoons. No.226 is similar to such a cartoon published in 1858 in the scatological journal *Paul Pry* (see C. Pearl, *The Girl with the Swansdown Seat*, 1955, facing p.217). While in progress the watercolour was enlarged by being stuck on to a bigger sheet of paper. The colours of the sea and sky recall those in William Blake's illustrations which Rossetti saw as forerunners of his own work.

A.G.

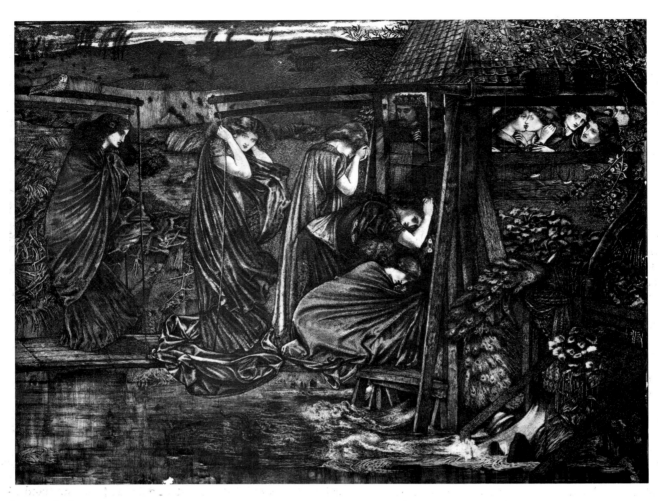

227

EDWARD BURNE-JONES

227 The Wise and Foolish Virgins 1859
Pen and ink and grey wash, scraped in places with
the knife, $17\frac{7}{8} \times 23\frac{3}{8}$ (45.5 × 60.5)
First exh: New Gallery 1892–3 (155)
Ref: Hayward Gallery 1975–6 (16)
Private Collection

This illustration to the parable of the Ten Virgins (Matthew
25), a subject which has inspired artists since the Middle Ages,
is another of Burne-Jones's early pen and ink drawings; it
dates, however, from a year later than Nos.224–5, and, as
well as treating a different type of subject, religious rather than
mediaeval, is both larger in scale and more proficient in
drawing. According to the record of his work which he began
to make in 1872 in a notebook now in the Fitzwilliam
Museum, the design was to have been carried out subsequently
in oils. This painting, however, was never undertaken,
although three figure studies for the Foolish Virgins, in the
Victoria and Albert Museum (E.2842, 2846 and 2849-1927),
may be connected with it. There also exist three preliminary
composition sketches (one exh. Hayward Gallery 1975–6,
No.17). The finished picture was bought from Burne-Jones by
the Leeds stockbroker T.E. Plint, who, until his early death in
1862, was the artist's chief patron. Later in the nineteenth
century the drawing was in another important Pre-Raphaelite

collection, that of the Liverpool banker, George Rae, but it was
then missing for many years, only reappearing in 1974.

Just as Nos 224–5 may be seen as variations on con-
temporary watercolours by Rossetti, so 'The Wise and Foolish
Virgins' is related to his elaborate pen and ink drawing of 'Mary
Magdalene at the Door of Simon the Pharisee' (No.223),
planned in 1853, dated 1858, but still in progress in 1859.
Both subjects deal with the longing of the soul for God, and the
compositions have much in common. The connection is seen
most clearly in the preliminary drawings, which in both cases
differ considerably from the solutions finally adopted. It is still,
however, apparent in the finished pictures, notably in two
details common to both: the head of Christ, brightly haloed and
framed in a small window, and an animal eating placidly in the
lower right corner, Burne-Jones substituting a peacock for
Rossetti's fawn. In Rossetti's drawing, these details, which
occur on a separate strip of paper added at the right-hand edge,
seem to have been left to the last, and he was certainly still
making studies for them in 1859, the date of 'The Wise and
Foolish Virgins'. In fact Burne-Jones was the model for the head
of Christ in Rossetti's drawing.

However, Burne-Jones was not only thinking of one particu-
lar Rossetti. By raising some of his figures on a platform and
framing the heads of others in windows, he was borrowing part
of the older artist's stock in trade. Both these motifs, together
with two other elements of his design, the lock or boat-house

and the rushing river, had been anticipated in one of his very early illustrations to *The Fairy Family* (Pierpont Morgan Library, New York), a collection of fairy stories in verse by Archibald Maclaren, his fencing master at Oxford. He had begun these drawings in 1854 and abandoned them in despair two years later after coming into contact with Rossetti. The design in question, illustrating a poem called 'The Rusalki' and featuring a mill over a river, belongs to the period – the end of 1855 or the beginning of 1856 – when he was making his first attempt to assimilate Rossetti's style.

The motif of the lock or mill clearly held some special appeal for Burne-Jones, finding its fullest expression many years later in his painting 'The Mill' (Victoria and Albert Museum), exhibited in 1882. It was probably first suggested by a scene on the river in or around Oxford, such as the lock at Godstowe, the burial place of Fair Rosamund, to which he had made 'terminal pilgrimages' as an undergraduate. Perhaps significantly, he is recorded revisiting Godstowe, together with Charles Faulkner and the painters G.P. Boyce and Eyre Crowe, in March 1859, probably about the time that he was planning 'The Wise and Foolish Virgins'. He was also in Oxford later this year, first for Morris's wedding in April, and subsequently for an appointment with Dean Liddell at Christ Church, where he was designing the window devoted to the life of St Frideswide in the Cathedral. Several of the scenes here are similar in composition and spirit to 'The Wise and Foolish Virgins'.

There are many hints in this drawing of Ruskin's hopes and ambitions for Burne-Jones at the time. Ruskin was distressed by the excessive mediaevalism of Rossetti's circle in the late 1850s, seeing it as a frivolous departure from the lofty ideals of the Pre-Raphaelite movement he had championed in the early part of the decade. Typically, he tried to engineer a reaction, pinning his hopes not so much on Rossetti, whom he found increasingly difficult to handle, but on the younger and apparently more pliable Burne-Jones. He found an ally in G.F. Watts, who was equally concerned about Rossetti's influence on his pupil Val Prinsep, and much of Burne-Jones's early development may be seen in terms of the efforts of these two mentors to guide his steps in what they conceived to be the path of artistic virtue. In 'The Wise and Foolish Virgins' the most striking indication of Ruskin's influence is the subject itself. Ruskin believed that the greatest themes an artist could choose were religious, and that Holman Hunt and Rossetti in their religious works of the early 1850s (including Rossetti's 'Mary Magdalene at the Door of Simon the Pharisee', conceived in 1853) had given to this area of subject matter an altogether new dimension, 'forming [as he put it in *Modern Painters*, III] the first foundation that has been ever laid for true sacred art'. Ruskin would also have approved of the drawing's carefully studied naturalism, since one of his main arguments against the mediaeval style was that it was too cerebral and mannered; while Burne-Jones's improved draughtsmanship seems to relate to his later admission that 'it was Watts who compelled me to try and draw better' – advice surely first given during the summer of 1858 when he was living in daily contact with Watts at Little Holland House. Finally, the new weight and grace of the figures, their frieze-like arrangement and repetitive drapery forms, may be seen as evidence, borne out in his contemporary sketchbooks, that Burne-Jones was beginning to look at Greek sculpture, particularly the Elgin Marbles. This again reflects the views of Ruskin and Watts, who both regarded classical Greek sculpture as the source of abiding values in Western art, and the natural antidote to the mediaeval style.

J.C.

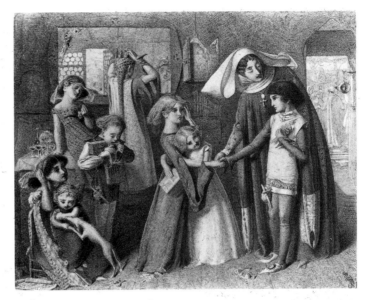

228

SIMEON SOLOMON

228 Dante's First Meeting with Beatrice 1859–63
Inscribed 'ss|12/9|59–|63' (initials in monogram)
Pen and ink, 7⅝ × 9 (19 × 33)
Tate Gallery

This is one of Solomon's finest early drawings in pen and ink, a medium he shared with Rossetti and Burne-Jones but handled with more finesse than either of them. The subject is taken from the beginning of Dante's *Vita Nuova*, where the poet describes how 'first the glorious Lady of my mind was made manifest to my eyes'. According to Boccaccio, the meeting took place at a May Feast given in 1274 by Beatrice's father, Folco Portinari, one of the principal citizens of Florence, Dante having gone to the banquet with his father, Alighiero Alighieri. 'She appeared to me', he continues in his own account, 'at the beginning of her ninth year almost, and I saw her almost at the end of my ninth year. Her dress, on that day, was of a most noble colour, a subdued and goodly crimson, girdled and adorned in such sort as best suited with her very tender age'.

The translation is Rossetti's, from his *Early Italian Poets* (1861), and no doubt Solomon's choice of theme owes something to the older artist, for whom Dante was of such importance. However, Rossetti by no means provides the only parallel. Indeed Solomon must have been consciously competing with a treatment of the same subject by his close friend Henry Holiday, which was rejected by the Academy in 1860 but shown there the following year (No.649). Another friend, Edward Poynter, also exhibited a Dantesque subject in 1862, and all three artists were working within a genre of scenes from Italian literature which was represented time and again on the Academy's walls in the middle years of the century. Another notable exponent on the fringe of the Pre-Raphaelite circle was Frederic Leighton, who exhibited a 'Paolo and Francesca' in 1861 (Leonée and Richard Ormond, *Lord Leighton*, 1975, No.65), and a deeply impressive 'Dante in Exile' in 1864 (ibid., No.100; currently on loan from the British Rail Pension Fund to Leighton House).

J.C.

DANTE GABRIEL ROSSETTI

229 Annie Miller 1860
Inscribed 'Annie Miller | aetat XXI | 1860 | DGR' (initials in monogram)
Pen and ink, $9\frac{1}{2} \times 9$ (25.5 × 24.2)
Ref: Surtees No. 354
L.S. Lowry Collection (on loan to Manchester City Art Gallery)

In 1858 Rossetti started to make highly finished pen drawings of beautiful women other than Elizabeth Siddal. Fine drawings were made of Jane Morris, Ruth Herbert and Fanny Cornforth at this time. This drawing of Annie Miller relates to them in style. All were made to record and praise the sitters' beauty. Emphasis is given to length of neck, firmly modelled profile, cupid's-bow mouth, hooded eyes and richly waving hair. Annie Miller had sat occasionally to Rossetti from *c*.1854 although Holman Hunt regarded her as his exclusive model and planned to marry her. Boyce records that their engagement was broken off in December 1859 and that she was again available to model for other artists: 'December 28. Annie Miller came and sat to me. Rossetti came in and made a pencil study of her. She looked more beautiful than ever' (Surtees 1980, p.28).

This drawing was owned by L.S. Lowry from 1966 and was one of his favourite works.

A.G.

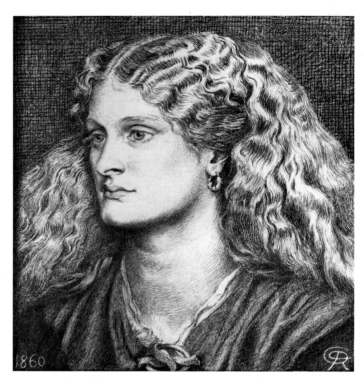

229

EDWARD BURNE-JONES

230 Sidonia von Bork 1860
Inscribed '1860 E. Burne Jones.fecit.' lower right, and 'Sidonia von Bork 1560' on the original oak mount
Watercolour with bodycolour, $13 \times 6\frac{3}{4}$ (33 × 17)
First exh: New Gallery 1892–3 (8)
Ref: Hayward Gallery 1975–6 (24)
Tate Gallery

In the early 1860s Burne-Jones turned to watercolour as his primary medium, using it with a large amount of bodycolour to produce highly original effects, often more akin to oil. The results are among his most attractive works, marked by a freshness of vision and a poetic intensity that would later be lost in the search for other values.

This well-known picture and its companion (No.231) are early examples. They were painted during the summer of 1860, being completed before the artist and his young wife Georgiana, married that June, went to stay with the Morrises at the newly-built Red House in August. In October the frames were being made by Burne-Jones's father, who ran a small carving and gilding business in Birmingham, and the pictures were then sold to James Leathart, the Newcastle industrialist who formed one of the most important Pre-Raphaelite collections of the day. After Leathart's death in 1895 they were acquired by W. Graham Robertson, the young aesthete and Blake enthusiast who later wrote so perceptively of Burne-Jones in his reminiscences, *Time Was* (1931). A second version of No.230 (private collection) was painted in 1860 and sold to T.E. Plint of Leeds.

The paintings were inspired by Wilhelm Meinhold's romance *Sidonia von Bork, die Klosterhexe*, first published in 1847, and in an English translation by Lady Wilde (as *Sidonia the Sorceress*) in 1849. Written in the form of a contemporary chronicle, the story traces the career of a girl of noble Pomer-

anian family who in 1620, at the age of eighty, was burnt as a witch at Stettin. Of such beauty that all who see her fall in love with her, Sidonia is also incurably vicious. In alliance with her lover, the leader of a gang of outlaws, and latterly at the convent of Marienfliess (hence the original title), she pursues a life of crime, eventually bewitching the entire ruling house of Pomerania to death or sterility. In No.230 she is seen as a girl of twenty (according to the date on the mount) meditating some outrage at the decorous court of the dowager Duchess of Wolgast, the scene of her early crimes; the Duchess herself advances in the distance.

Meinhold's work gained currency in England as part of the vogue for German Romantic literature. He was best known for a slightly earlier story, *Mary Schweidler, The Amber Witch*. Set in Coserow, the village of which he was pastor on the Prussian shore of the Baltic, this appeared in two English translations in 1844, and was adapted as an opera by W.V. Wallace, produced at Her Majesty's Theatre in February 1861. Although both books were admired in Rossetti's circle, *Sidonia* was undoubtedly the favourite, Rossetti himself conceiving 'a positive passion' for it, and declaring that no work of fiction had impressed him so much until he read *Wuthering Heights* in 1854. Like the *Morte d'Arthur* and the poetry of Browning, which they embraced with equal fervour, it was a convenient stick with which to beat the philistine, while its combined themes of beauty, evil and magic, together with a wealth of descriptive detail, proved irresistible to a collective imagination centred on the cult of the 'stunner' and profoundly influenced by notions of the supernatural. By adding a dimension of menace to the worship of female beauty, *Sidonia* became an important source for the concept of the *femme fatale*, so vital an element in later Pre-Raphaelite and Symbolist imagery. Morris reprinted Lady Wilde's translation at the Kelmscott Press in 1893.

The tight, finicky handling of Nos 230–1 looks back to the earlier pen drawings (see Nos 224–5, 227) with their de-

pendence on Dürer prints, a link reinforced by the Germanic theme. Indeed the figure of Sidonia is partly based on a portrait of the witch 'of the school of Louis Kranach' (*sic*) that Meinhold claimed to have seen 'at Stargord, near Regenwalde, in the castle of the Count von Bork'. Like the 'Cranach', Burne-Jones's picture shows Sidonia 'in the prime of mature beauty', with 'a gold net drawn over her almost golden yellow hair, and carrying 'a pompadour of brown leather', while her dress seems to owe something to a terrifying figure of the sitter 'added, after a lapse of many years, to the youthful portrait . . . The Sorceress is arrayed in her death garments – white with black stripes'.

Both Burne-Jones's pictures, moreover, reflect the High Victorian decorative style – heavy, sombre and ultra-gothic – with which he was closely involved at the time. There are hints in the backgrounds of stained-glass windows such as he was designing for Powells and was soon to design for Morris, and massive pieces of furniture of the type being designed by Philip Webb and decorated by himself. The colour harmonies – reddish-browns and blacks set off against passages of dull white, acid yellow, blue and green – are precisely those of the decorative schemes by Butterfield, Burges, Seddon, Bodley and Morris to which he was contributing during these years.

At the same time the pictures are examples of the new taste for Venetian art and sixteenth-century themes that was now coming to the fore in Rossetti's circle, superseding, or at any rate modifying, the mediaeval ideal. There was a sudden pre-occupation with Renaissance crimes, the main impetus apparently coming from Swinburne, devoted as he was to the Elizabethan dramatists and fascinated by the connection between eroticism and pain. Burne-Jones's von Bork designs were painted at a moment when his relationship with Swinburne was particularly close. They must often have discussed Swinburne's verse play, *The Queen Mother*, about Catherine de' Medici and the Massacre of St Bartholomew, which was published the same year, and his plans for another drama, *Chastelard* (published 1865), about a young courtier in love with Mary Queen of Scots who is discovered in her bedroom and executed; or again, the prose and verse that he was soon to write about 'my blessedest pet . . . Lucretia Estense Borgia', in whose 'holy family' he had taken 'the deepest and most rever-ential interest' since childhood. Needless to say, Swinburne was one of the most ardent devotees of Meinhold, and evidently admired Burne-Jones's 'Sidonia'. In his important article, 'Notes on Designs of the Old Masters at Florence', published in the *Fortnightly Review* in July 1868, he calls it a 'nobler' drawing of a witch than another by an artist he already rates highly, Filippino Lippi.

Rossetti himself never illustrated Meinhold but he did paint Borgia subjects, and his watercolour 'Lucretia Borgia' (Surtees No. 124) is particularly relevant here. Painted in 1860–61, it is closely related to Burne-Jones's 'Sidonia', both thematically (Lucretia is shown washing her hands after administering poison to her husband) and in terms of composition, although the formal similarity was more apparent before Rossetti re-worked the 'Lucretia' some years later (see Marillier 1899, p. 105 for an early photograph). Rossetti's interest in the Borgia story even overcame his antipathy to music and he conceived a great admiration for Donizetti's opera, *Lucretia Borgia*, which was often performed at Covent Garden during these years, with Mario and Grisi in the principal roles. It is known that he urged his friends to see it, and Burne-Jones, who had a natural taste for opera, may well have done so.

Closely linked to the interest in Renaissance subject matter was a growing awareness of Venetian sixteenth-century

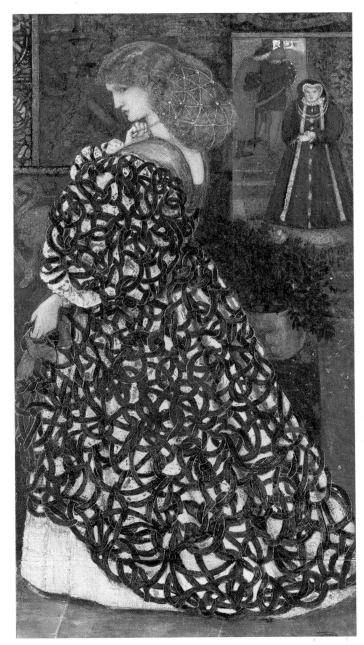

230

painting as a stylistic ideal. This found its most vital expression in Rossetti's 'Bocca Baciata' (fig.iv), completed in October 1859; a voluptuous female half-length 'in late 16th century costume', painted in oil in a new, 'rapid', style, it was rightly described by Rossetti as having 'a rather Venetian aspect'. The sources of this Venetian phase are complex, but it was cer-tainly associated with the advent of Rossetti's mistress, Fanny Cornforth, whose coarse good looks and golden hair made her its muse, just as Miss Siddal had inspired his Dantesque and mediaeval periods. She was the model for 'Bocca Baciata', and it is noticeable that the currently popular heroines conform to her type. The set were well aware of the lock of Lucretia Borgia's golden hair preserved, with her letters to Bembo, in the Ambrosiana; and Sidonia, as already noted, had 'golden yellow hair' in the 'Cranach' portrait so vividly described by

Meinhold. In fact Fanny may well have been the model for Burne-Jones's 'Sidonia'. She is recorded sitting to him in January 1858, and her features may be traced in several of his early paintings and drawings.

There is also a more formal development. Visiting the Pitti in September 1859, Burne-Jones had made a sketch of Titian's 'La Bella', and he now had a comparable source in mind. According to Edward Clifford, his friend and faithful copyist, and once the owner of the second version of 'Sidonia', the witch's dress with its fantastic serpentine pattern was 'suggested by a picture at Hampton Court' (*Broadlands as It Was*, 1890, p.55). This was clearly the well-known portrait of 'Isabella d'Este', now attributed to Giulio Romano, which must in fact have 'suggested' not only the pattern of the dress but the motif of figures entering and leaving the room in the upper right corner. No doubt Burne-Jones was drawn to the picture by its curiously sinister mood, while its surroundings further intensified its effect. Hampton Court was a favourite haunt of his circle at this period; a number of visits are recorded, including one by Rossetti and Boyce in 1865 when the painters had 'a 2 hours' spell at the pictures' (Surtees 1980, p.43). While the pictures were important, however (and it is significant that they include a high proportion of Venetian works), they were clearly not the whole attraction. Equally alluring was the palace itself with its small dark Tudor apartments, the perfect *mis-en-scène* for Renaissance crimes.

J.C.

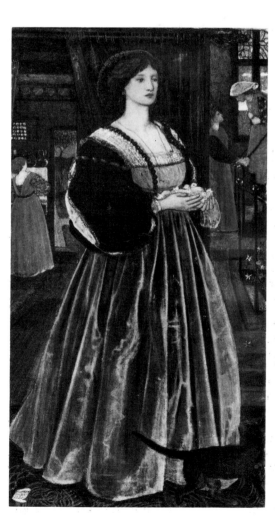

231

EDWARD BURNE-JONES

231 Clara von Bork 1860
Inscribed 'E. JONES | PINXIT | 1860' lower left, and 'Clara von Bork 1560' on the original oak mount
Watercolour with bodycolour, 13¼ × 7 (34 × 18)
First exh: New Gallery 1892–3 (11)
Ref: Hayward Gallery 1975–6 (25)
Tate Gallery

A pair to No.230. The subject is the gentle Clara von Dewitz who serves as a foil to Sidonia in Meinhold's romance. Married to Sidonia's virtuous cousin, Marcus Bork, she protects the witch when she gets into trouble, only to be repayed with a hideous fate, Sidonia giving her a filtre to induce the appearance of death so that she is entombed alive. Their relationship is symbolised by the nest of fledgling doves she holds and the black cat, Sidonia's familiar, that looks at them with longing. If the wordly Fanny Cornforth seems to be the model for Sidonia, Clara would appear to be a likeness of the high-minded Georgiana Macdonald, whom Burne-Jones married in June 1860, about the time the pictures were painted.

It is interesting that while No.230 is signed 'E. Burne Jones', No.231 is signed simply 'E. Jones'. Burne-Jones was beginning to use the double-barrelled name but it was not yet invariable practice and the hyphen was still lacking.

J.C.

WILLIAM HOLMAN HUNT

232 Asparagus Island 1860
Watercolour with traces of pencil, 7¾ × 10¼ (19.5 × 26)
First exh: *The Pictures of Mr. Holman Hunt*, Fine Art Society 1886 (30)
Private Collection

In September 1860 Hunt and Val Prinsep joined Palgrave, Woolner and Tennyson on a walking tour of the west country. Hunt wrote to Combe from Exeter on 2 October 1860: 'Tennyson & Palgrave left us Prinsep and myself at the Lizard since which we have been walking and sketching alternately industriously – excepting for three days at Falmouth' (BL). On the same day Palgrave, now back in London, wrote to Emily Tennyson: 'We were sorry not to have more of Hunt's company, but as he preferred his Art to our honourable society, what could be done?' (MS, Tennyson Research Centre, Lincoln).

According to Hunt's memoirs, 'Prinsep and I each began a drawing of Asparagus Island' while Tennyson and Palgrave were with them at Kynance Cove (Hunt 1905, II, p.211). The artists 'placed ourselves upon a tongue of cliff which divided a large bight into two smaller bays; thence we could, to right and left, see down to the emerald waves breaking with foam white on to the porphyry rocks' (ibid.). After Palgrave and Tennyson left, Hunt and Prinsep remained working on the cliffs for two or three days (ibid., II, p.214) and followed their friends to Falmouth on 22 September (Hunt to Palgrave, 30 September 1860, HL, and to Combe, 20 October 1860, BL). No.232 was almost lost, as Hunt relates: 'My drawing was on a block, of which the sun had gradually drawn up one corner; this warped surface did not seriously interfere with my progress until one day a sudden gust of wind compelled me to put my hand on brushes in danger of going to perdition, when, turning round on my saddle seat, I saw my nearly completed picture circling

232

about among the gulls in the abyss below. Luckily, a fresh gust of wind bore it aloft, until the paper was caught by a tuft of grass at the brink of the precipice. It proved to be within reach of my umbrella, which fixed it to the spot until with the help of my friend, I was able to rescue the flighty thing for completion' (ibid., II, pp.214–5). The precarious nature of Hunt's position on the cliff-top is indicated by the rock in the lower right-hand corner of No.232. While the interest in sunlight on the water continues the theme of 'Fairlight Downs' (No.52), the use of bare paper to suggest the eddies round the small rocks in the central middleground is reminiscent of the technique of 'The Sphinx, Gizeh' (No.202).

Hunt regarded the trip to Devon and Cornwall as a holiday, for although it was prolific in terms of his watercolour output, the sketches were executed for the artist's own enjoyment rather than in the hopes of an immediate sale. The other major watercolour views of the Cornish coast dating from September 1860 are a less finished study of The Lizard in the collection of Mrs Burt (exh. Liverpool 1969, No.197), and the untraced 'The Land's End, Cornwall' (repr. Hunt 1913, II, p.157) and 'Cornish Coast' (repr. *Old Water-Colour Society's Club*, XIII, 1935–6, pl.VIII).

On 17 March 1862 Hunt informed Combe that he had 'sold the Cornwall drawing for 60 Guineas – I think' (BL). It is quite likely that No.232 was sold at this time to Henry Virtue Tebbs, who had acted as Gambart's lawyer in 1860 when the dealer purchased 'The Finding of the Saviour in the Temple' (No.85) from Hunt (Maas, p.118).

J.B.

SIMEON SOLOMON

233 The Painter's Pleasaunce 1861

Inscribed 'ss.|2/12/61'
Watercolour with bodycolour, $10\frac{1}{8} \times 13$ (25.6 × 33.1)
Whitworth Art Gallery, University of Manchester

This attractive picture shows Solomon working in the Venetian style of the early 1860s. The name of the painter represented is not revealed, but he could well be intended for Giorgione. Certainly the picture belongs to the genre of incidents from artists' lives which enjoyed such a vogue in the nineteenth century. It was particularly popular in France where, as Francis Haskell has shown (see *Art Quarterly*, Spring 1971, pp.55–85), as many as thirty examples might appear at the Salon in the 1840s, '50s and '60s. There were never so many at the Royal Academy but most exhibitions during the same period contained a few; notable instances were Leighton's 'Cimabue's Madonna' (1855) and 'Titian's First Essay in Colour' by Dyce (1857), both of which were exhibited while Solomon was a student at the Academy schools.

The taste was also reflected in literature, and within the Pre-Raphaelite circle many of the most important examples were of this type. Browning's poems about Italian Renaissance painters were greeted with rapture by Rossetti and his followers when they appeared in *Men and Women* in 1855, and Ruskin included a lyrical account of the boyhood of Giorgione in the last volume of *Modern Painters* (1860). In painting, Bell Scott treated an incident from the life of Dürer (c.1853; Edinburgh),

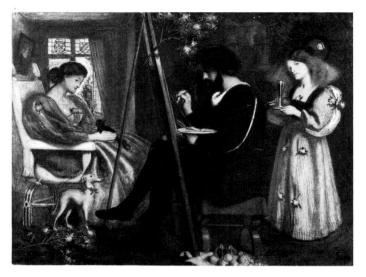

233

while Rossetti attempted a number of these subjects, including 'Giotto Painting the Portrait of Dante' (Surtees No.54), Fra Angelico and Giorgione painting (ibid., Nos 694–5), and a scene in which a model poses to an artist for a figure of St Catherine (No.90). This type of theme also proved popular as decoration for Pre-Raphaelite furniture, since it often had a particular relevance to the pieces in question. In 1861 Rossetti, Madox Brown, Burne-Jones and others contributed panels representing the artistic endeavours of King René of Anjou (a theme derived from Scott's *Anne of Gierstein*) to a cabinet designed by J.P. Seddon to hold his architectural drawings (Victoria and Albert Museum). Similarly, in 1859 William Burges designed a fantastic bookcase to hold his books on art, and had it decorated with an elaborate scheme representing Pagan and Christian art in terms of famous incidents symbolising poetry, architecture, sculpture, painting and music (Ashmolean Museum). Solomon was among a galaxy of artists involved, painting in all three subjects including that of Pygmalion and Galatea.

Technically No.233 is very characteristic of the watercolour method practised in Rossetti's circle at this date, coming particularly close to the contemporary work of Burne-Jones. The paint would be applied rather dry, generally over a monochrome underpainting. Bodycolour would be used extensively, and the surface scraped with a knife to take out highlights and soften forms. Finally a varnish seems to have been applied, often causing the paint to crack and flake in the course of time.

<div align="right">J.C.</div>

EDWARD BURNE-JONES

234 The Merciful Knight 1863
Inscribed 'EDWARD BURNE JONES 1863'
Watercolour with bodycolour,
$39\frac{1}{2} \times 27\frac{1}{4}$ (100.3 × 69.2)
First exh: O.W.C.S. 1864 (215)
Ref: Hayward Gallery 1975–6 (45)
Birmingham Museum and Art Gallery

The subject is the well-known incident which is said to have inspired the Florentine knight, St John Gualberto, to found the Valombrosan Order in 1039. After sparing the life of a kinsman's murderer who had begged for mercy 'for Jesus' sake'

on a Good Friday, he was miraculously embraced by a wooden figure of Christ while praying at the convent of S. Miniato. The composition underwent major revisions before the present solution was reached. A group of preparatory drawings in the Tate Gallery (No.4346) shows that at one stage Burne-Jones intended to represent the knight standing with an altar placed between him and the figure of Christ. He was making studies for the woodland background when he stayed with Spencer Stanhope at Cobham in Surrey in June 1863, and Lady Burne-Jones recalled that he found the marigolds in Russell Square, not far from the rooms in Great Russell Street, opposite the British Museum, where they were then living. Until 1895 the picture was in the collection of the Newcastle industrialist, James Leathart, who also owned Nos 230–1.

'The Merciful Knight', like the following two works (Nos 235–6), was painted during the period between Burne-Jones's return from his second visit to Italy, in the summer of 1862, and the autumn of 1864 when a series of circumstances changed the tempo of his life, with profound repercussions for his style. The picture is therefore one of the last of the early watercolours, as well as the largest. To Lady Burne-Jones it seemed 'to sum up and seal the ten years that had passed since Edward first went to Oxford' (I, p.262), and it does in fact mark a watershed in his career, giving final expression to a world of ideas he was soon to leave behind. It is said to have been his favourite among his early works, and in 1894 he tried to borrow it back from Leathart to make a copy in oils.

The mystical subject is one he must have encountered as an ardent young follower of the Tractarians at Oxford since it appears in Sir Kenelm Digby's *Broadstone of Honour* (1st ed. 1822). This curious work, a manual of conduct for the Christian gentleman based on a highly romantic view of the age of chivalry, impressed him deeply at the time, and indeed remained on his bedside bookshelf all his life. Robert Southey, another writer of some importance for him during his Anglo-Catholic phase, had also treated the story in one of his *Ballads*. And there is a passage in Newman's novel *Loss and Gain* (1848), where the hero prays at a wayside cross, which is strangely reminiscent of the subject as Burne-Jones conceives it.

Formally, too, the picture looks back. A drawing of a knight kneeling before a cross in a wood appears among the very early illustrations to Maclaren's *Fairy Family* (Pierpont Morgan Library), which Burne-Jones had begun as an undergraduate in 1854. The simple wooden architecture and the raised platform echo Rossetti's work in the 1850s, and both theme and composition are anticipated in his illustration of 'Sir Galahad at the Ruined Chapel' in the Moxon Tennyson (1857). The conception may also owe something to Ruskin. During his revelatory visit to Italy in 1845 he had visited S. Miniato and found the church 'deserted, but not ruinous, with a narrow lawn of scented herbage before it, and sweet wild weeds about its steps, all shut in by a hedge of roses' (Ruskin, XXXV, p.359).

'The Merciful Knight' was one of four works which Burne-Jones showed on his first appearance at the Old Water-Colour Society in 1864. Encouraged by Ruskin, he had sought election in an attempt to gain a wider audience now that the short-lived Hogarth Club was defunct. It was a courageous move since the Society, founded in 1805, was intensely conservative; its ethos was still determined by the old English watercolour school, and its ideas about the treatment of historical subjects had advanced little further than the art of George Cattermole, who was still alive. No Pre-Raphaelite had yet entered its ranks, let alone one of the second, 'Rossettian' generation. It was therefore hardly surprising that Burne-

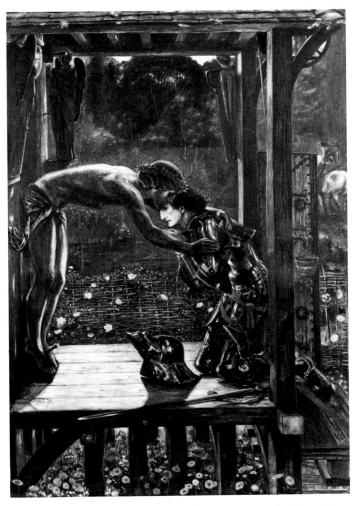

234

Jones's contributions, startlingly new in treatment and un-orthodox in technique, met a bitterly hostile reception. On his first application for membership, in 1863, he was turned down, and after his election the following year (together with G.P. Boyce and Fred Walker) two members of the committee, including the veteran marine and landscape painter Edward Duncan, refused to shake his hand. Special disfavour was shown towards 'The Merciful Knight', the largest and most uncompromising of his exhibits. Many years later he described to T.M. Rooke, his studio assistant, how 'it was stuck right up on top . . . so that no one could see it. Some of them were furious with me for sending it, and let me see that they were. They would be talking together when I turned up and let drop remarks about it of a hostile nature for me to overhear' (Lago, p.107). The press too was fiercely critical. *The Times*, though admitting that the pictures had 'exquisite qualities of colour', complained that 'Mr Jones dwells and works in the 14th and 15th centuries . . . His figures are queerly drawn, stand in contorted attitudes, [and] show neither bone, muscle nor curvature of flesh under their robes, while the accessories display utter contempt for keeping or probability'. The *Spectator* spoke of 'affectation of ungainliness . . . and grimace', and the need for 'a more catholic taste for beauty than is implied in studying every head from one model with protruded chin'; and the *Art Journal* wondered 'what spectacles [Mr Jones] can have put on to have gained a vision so astounding . . . Fervour [his pictures] may possibly have for minds mortified to all natural sense of beauty, but to those who believe what

indeed the noblest Italian Art teaches, that truth is beauty, and beauty is truth, forms such as these are absolutely abhorrent'.

Nonetheless, Burne-Jones immediately began to attract adherents, both patrons and followers. Walter Crane in his *An Artist's Reminiscences* (1907) recalled the impact that these early contributions to the Old Water-Colour Society made on him and his contemporaries. 'The curtain had been lifted, and we had had a glimpse into a magic world of romance and pictured poetry . . . a twilight world of dark mysterious wood-lands, haunted streams, meads of deep green starred with burning flowers, veiled in a dim and mystic light' (p.84). The words suggest that he was thinking especially of 'The Merciful Knight', which is indeed among the most intensely poetic of all Burne-Jones's works.

J.C.

EDWARD BURNE-JONES

235 Fair Rosamond 1863
Inscribed 'EDWARDUS JONES PINXIT AD MDCCCLXIII'
Watercolour with bodycolour and some gold paint,
$32\frac{3}{4} \times 16\frac{1}{4}$ (83.2 × 41.3)
First exh: O.W.C.S. 1864 (109)
Ref: Hayward Gallery 1975–6 (39)
Private Collection

Rosamond, the daughter of Walter, Lord Clifford, was the mis-tress of Henry II. According to tradition, the king built her a 'bower' at Woodstock, this being apparently a house in the centre of a maze of which he and she alone knew the secret. However, in the words of Stowe, the historian, Queen Eleanor, Henry's wife, 'came to her by a clue of thridde . . . and so dealt with her, that she lived not long after'.

The story is the subject of one of the early ballads that enjoyed such a vogue in the Romantic period, when they were collected and popularised by Percy, Scott, Motherwell and others. Burne-Jones is said to have had a 'passionate sympathy' with them, but they were an important source of inspiration for many of the Pre-Raphaelites. In 1854 Rossetti and Miss Siddal began making illustrations for a collection that Allingham was to edit for Routledge, and Miss Siddal subsequently developed some of her designs as watercolours. In 1856 the Liverpool Pre-Raphaelite W.L. Windus exhibited his well-known 'Burd Helen' (No.73) at the Royal Academy. Burne-Jones, who had just settled in London, was to have copied the picture for engraving, although the proposal did not materialise. In the literary field, Rossetti, Bell Scott, Morris and Swinburne all wrote poems in ballad form. Swinburne had a special feeling for the genre, being attracted both by the recurring themes of love and violence and, as a Northumbrian, by the border origins of so many examples. He was an acknowledged authority, and his own productions were so authentic that many thought them genuine. Ballads were also popular at Pre-Raphaelite entertainments. Burne-Jones and his wife would visit the Tottenham home of Peter Marshall, one of the partners of the Morris firm, to hear him sing 'Sir Patrick Spens' or the tragic 'Clerk Saunders', which inspired a watercolour by Burne-Jones of 1861 (Tate Gallery). Marshall allowed Georgiana Burne-Jones to take down the traditional tunes, and she too was a talented performer. Her rendering of 'The Three Ravens' was much admired by Rossetti, and at the Bell Scotts' in the summer of 1860 she is recorded singing 'the ballad of "Green Sleeves"' and others in loud wild tones, quite novel and charming'.

No ballad theme was more popular with the circle than that of Fair Rosamond. Between 1853 and 1863 it was treated not only by Burne-Jones but also, either in painting or poetry, by Bell Scott, Arthur Hughes, Rossetti, Swinburne and Frederick Sandys. Burne-Jones himself attempted the subject on no less than five occasions. The first four of these designs, a lost pen and ink drawing of 1861 and three watercolours, two dated 1861 and 1862 and one unfinished (exh. Hayward Gallery, 1975–6, Nos 28–30), showed the dramatic moment when Rosamond is confronted by the angry Queen, bent on her destruction. No.235 is the last of the series, and is unique in showing her standing alone in her bower.

Burne-Jones's interest in the story was probably aroused as an undergraduate at Oxford in the early 1850s by the 'terminal pilgrimages' he made to Godstowe, where Fair Rosamond is reputedly buried in the ruined nunnery. He was at Godstowe again in March 1859, this time with the landscape painter G.P. Boyce, who may already have been planning a watercolour of 'Godstow Nunnery, where Fair Rosamond died' (exh. o.w.c.s. 1864, No.152). Another locality which probably helped to bring the story alive for him was Hampton Court. This was a favourite haunt of his circle at this time (see No.230) and in

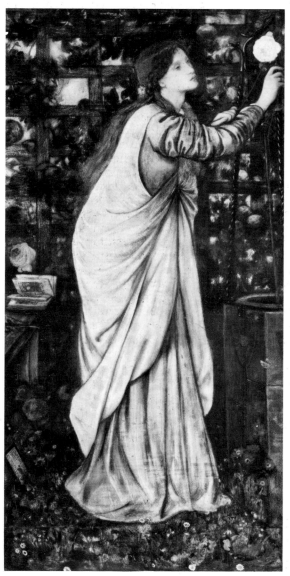

235

October 1860 he and Rossetti had 'lost' themselves in the maze. Both painters seem to have found the experience curiously stimulating. Rossetti bought a 6d. plan which he used when drawing a labyrinth in a design a few years later, and Burne-Jones attempted the subject of figures in a maze not only in his Fair Rosamond designs but in a watercolour of 'Theseus and Ariadne' of 1862 (private collection; exh. Hayward Gallery 1975–6, No.36).

Of the other Pre-Raphaelite treatments of the Fair Rosamond story, the most interesting here is Swinburne's *Rosamond*, one of two verse dramas published as his first book in 1860. He and Burne-Jones were very close at this period; they must often have discussed the subject, and indeed Swinburne's image of Rosamond,

> binding the wet tendrils there
> Last night blew over,

or complaining

> I have flowers only
> And foolish ways to get me through the day,

is very similar to Burne-Jones's in No.235.

At a more fundamental level the picture betrays the strong influence of Ruskin, whose attempts to wean Burne-Jones from the mediaeval style, already traceable in No.227, had now reached a climax. In the summer of 1862 he had taken the painter and his wife to North Italy and made him copy those artists – Giotto, Titian and Tintoretto – whom he saw as the great exponents of the classical tradition and the qualities of 'grace', 'tranquility' and 'repose' which he rated so highly. 'Fair Rosamond' is one of a group of single female figures painted by Burne-Jones on his return in which he was clearly seeking to express these Ruskinian values. Indeed it is a particularly significant example since it actually shows him breaking with the more dramatic treatments of the story he had attempted previously. During the 1860s Ruskin's pre-occupation with the relationship between art and society led him to insist on the need for 'constant' as against 'dramatic' art, that is to say art which uplifted the beholder by inviting him to contemplate a serene and beautiful image, rather than satisfying his craving for sensation by depicting some exciting or morbid event. In painting Rosamond calmly tending her flowers instead of trembling on the verge of death, Burne-Jones was fulfilling Ruskin's programme to the letter. It is no accident that in one of Ruskin's most considered statements on the subject, his lecture 'On the Present State of Modern Art' delivered at the Royal Institution in June 1867, he took Burne-Jones as an example of his ideal. No living British artist, he declared, had 'purer sympathy for the repose of the Constant schools . . . in their purity and seeking for good and virtue as the life of all things and creatures, his designs stand, I think, unrivalled and alone' (Ruskin, XIX, pp.206–7). He was describing a phenomenon he had done much to create himself.

In fact by this time 'Fair Rosamond' belonged to Ruskin since it had been bought by his father, without his knowledge, in 1863. An inveterate snob, John James Ruskin had disapproved of his son's friendship with the little-known and impoverished artist, and on 12 August 1862 Ruskin had written to him about this, telling him frankly that 'in nothing is [your] pride more hurtful than in the way it has destroyed through life your power of judging of noble character'. After some strong words about his parents' delight 'when I associated with men like Lords March & Ward – men who had their drawers filled with pictures of naked bawds . . . who swore – who diced – who drank – who knew *nothing* except the names of racehorses', and a glowing account of Burne-Jones, 'whose life is as pure as

an archangel's – whose genius is as strange & high as that of Albert Durer or Hans Memling – who loves me with a love as of a brother . . . [and] whose knowledge of history and of poetry is as rich and varied, . . . and incomparably more *scholarly*, than Walter Scott's was at his age', Ruskin urged his father to invite the painter to a 'quiet dinner – ask him about me – ask him anything you want to about mediaeval history – and try to forget that he is poor' (Surtees 1972, p.240). The letter had its effect and Mr Ruskin was soon receiving the Burne-Joneses at Denmark Hill, confiding to them his fears about his son's plan to settle abroad, and buying 'Fair Rosamond'. The picture gave him intense pleasure. '[It] came home last evening', he wrote to Georgiana, '[and] I was charmed – excited – exalted by it . . . I spent part of the morning at Mr Bicknell's, whose pictures you will see on 25th and 29th April will bring many Thousands,. and after my eye had dwelt on the canvases and paper of the first names of the Century I am happy to say my evening Contemplation of Rosamond yields me the greater satisfaction' (G. Burne-Jones, I, p.261).

In the summer of 1864 the picture was one of four that Burne-Jones showed on his first appearance at the Old Water-Colour Society. It met with less hostility than 'The Merciful Knight' (No.234). 'There is a great deal of bad drawing in Mr Jones's *Fair Rosamond*', wrote F.G. Stephens in the *Athenaeum*, 'but the romantic feeling, luxury of colour and poetic realisation of a youthful dream, redeem worse faults than those of imperfect training'. Shortly before the exhibition opened, in March 1864, John James Ruskin had died, and the picture thus descended to his son, who kept it all his life. It hung in the drawing-room at Brantwood, expressing some of his most cherished aesthetic and moral beliefs and perhaps, in view of the roses Rosamond is tending in obvious allusion to her name, becoming associated for him with Rose La Touche.

J.C.

EDWARD BURNE-JONES

236 Green Summer 1864
Inscribed 'EBJ | 1864'
Watercolour with bodycolour, $11\frac{3}{8} \times 19$ (29 × 48.3)
First exh: O.W.C.S. 1865 (105)
Ref: Hayward Gallery 1975–6 (49)
Private Collection

This charming picture, which was painted at Red House in May 1864 and exhibited at the Old Water-Colour Society the following year, has no subject in the conventional Victorian sense, being simply an arrangement of figures expressive of a poetic mood and allowing the artist to create harmonies of line and colour. The theme of a group of reclining figures, listening to music or a story read aloud from a book, had been in Burne-Jones's mind for some time. It clearly owed much to Giorgione, a source in accordance with the Venetian taste of his circle at this period, and probably something to Boccaccio. Indeed when 'Green Summer' was exhibited, the *Art Journal* referred to it as a 'Boccaccio composition'. Many parallels could be cited here, perhaps the most interesting being a comparable figure group specifically based on the *Decameron*, which was drawn by Edward Poynter in 1859 (Birmingham). Poynter was a close friend of Burne-Jones by this time and was to become his brother-in-law in 1866.

'Green Summer' was also Burne-Jones's most complete realisation so far of the idea of basing a picture on a restricted colour harmony. In 1861 he had painted a female half-length, 'Viridis of Milan' (private collection), as a 'harmony in blue',

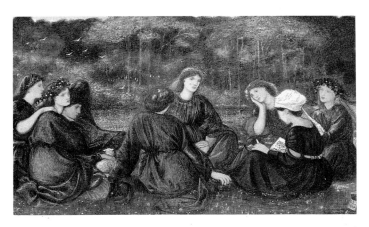

236

and this had inspired the Dalziel brothers, the famous wood-engravers, to commission a 'harmony in red'. The result was an 'Annunciation' painted in 1863 (exh. Hayward Gallery 1975–6, No.43). 'Green Summer' could well be described as a 'harmony in green', as the *Art Journal*'s critic implied when he complained that Burne-Jones had 'woven the robes of the picnic party out of the green grass whereon they sit, thus bidding defiance to known laws of chromatic art, which are now established with the certainty of scientific axioms'.

This comment was unusual: in general, even the severest critics of Burne-Jones's early paintings admitted that he had a remarkable sense of colour. No doubt Rossetti had encouraged his experiments in this field. His famous 'Annunciation' of 1850 (No.22) had been virtually a 'harmony in white', although he had yet to paint Fanny Cornforth in 'an oil-picture all blue . . . to be called The Blue Bower' (No.132), let alone 'Veronica Veronese' (1872; Surtees No.228) as 'a study of varied greens'. Burne-Jones's interest in colour harmonies also seems to be associated with Ruskin, whose current theories about Venetian painting, revealed in the last volume of *Modern Painters* (1860), had so much to do with the prevailing Venetian taste. He is said to have commissioned Burne-Jones's 'Viridis of Milan', the 'harmony in blue', and this may well be connected with his study of Titian's female portraits in Germany in 1859, when he paid great attention to their colour effects. The link perhaps lies in a copy Burne-Jones made of Titian's 'La Bella' in the Pitti, again in 1859. As he carefully noted on his sketch (Fitzwilliam Museum), the sitter wears a rich blue velvet dress. Ruskin even provides some interesting parallels to the idea of calling a picture a 'harmony'. There are a number of passages in his writings from the late 1850s on where he seeks to convey pictorial values in musical terms.

It may seem surprising that Ruskin, who was later to clash so violently with Whistler, should apparently have encouraged Burne-Jones to adopt an 'aesthetic' approach. But the cross-currents in this area of Victorian painting were bewilderingly complex in the early 1860s, and it is typical of the period that 'Green Summer', for all its roots in Pre-Raphaelitism and the views of Ruskin, should also represent a position analogous to that currently reached by Whistler and the artist with whom he was soon to be so closely associated, Albert Moore. Indeed in some respects Burne-Jones was more advanced. Moore's first truly 'subjectless' picture was 'The Marble Seat', exhibited at the Royal Academy in 1865, and Whistler, although he had long been interested in colour harmonies and pictures which lacked narrative content but were strong in mood, was not to adopt a musical title until he painted his 'Symphony in White No.3' (Barber Institute, Birmingham), a particularly Moore-

like work exhibited in 1867. Nonetheless the relationship was a real one and had both an intellectual and a social basis. Moore's early work shows strong Pre-Raphaelite influence, and he was now evolving his 'aesthetic' style out of a close study of the Elgin marbles, to which Burne-Jones was also turning his attention (see No.240). There is no record of their meeting, but they must have encountered one another. Both had painted panels for a bookcase by William Burges about 1860, and Moore had designed stained glass for the Morris firm. They were neighbours in fashionably bohemian Bloomsbury, and had friends, including Henry Holiday and Simeon Solomon, in common. As for Whistler, he had felt the impact of Rossetti in the early 1860s, was well aware of the feeling for Venetian art, and was soon, under Moore's influence, to look hard at Greek sculpture. It is true that Oriental art, which played so vital a role in his development at this time, hardly touched Burne-Jones; yet there is a Burne-Jones watercolour of 1863 – the 'Cinderella' at Boston – which has a striking colour harmony created with the aid of a background of blue and white plates like those Whistler was collecting. The two artists seem to have met for the first time in July 1862, and they continued to meet, especially when Whistler settled early the following year in Lindsey Row, Chelsea, very close to where Rossetti was living in Cheyne Walk. Whistler's personal relations with Burne-Jones were never so close as they were with Rossetti and Swinburne, but Burne-Jones's general sympathy with Whistler and his work is reflected in the intense embarrassment which he felt at having to give evidence against him on Ruskin's behalf at the famous libel trial of 1878.

There is a particularly fine group of red-chalk studies for the figures in 'Green Summer', divided between the Birmingham City Art Gallery (191-193′04) and the Ashmolean Museum, Oxford. A larger oil version was painted in 1868 and acquired by Burne-Jones's important patron, William Graham, who had a special liking for these Giorgionesque compositions. It was sold at Christie's on 25 May 1979, lot 196, fetching what was then a record price for his work, and is now in an American private collection.

J.C.

DANTE GABRIEL ROSSETTI

237 Morning Music 1864
Inscribed 'MORNING MUSIC' and 'DGR 18|64' (initials in monogram)
Watercolour, $11\frac{5}{8} \times 10\frac{1}{2}$ (29.5 × 26.7)
Ref: Surtees No.170
Fitzwilliam Museum, Cambridge

The subject of a beautiful woman having her hair dressed while music is being played goes back to 'A Christmas Carol' of 1857–8 (Surtees No.98). Earlier works such as '"Hist!" – said Kate the Queen' (No.31) and 'Borgia' (No.174) are also related. But in 'Morning Music' the subject is more blatantly sensual, as it is in the contemporary 'toilette' pictures of 'Fazio's Mistress' (No.123) and 'Lilith'. Like them the predominant colour here is white broken by touches of brilliant red, blue and gold. And, as with them, the model Rossetti is following is Venetian art such as Giorgione's 'Fête Champêtre' and Titian's 'Young Woman at her Toilette' in the Louvre. Another possible prototype is Etty's picture 'The Duett' which was shown at the 1862 International Exhibition.

Rossetti shared with his close friend Swinburne at this period a fervent belief in 'art for art's sake'. They thought that art

should serve to gratify the senses. Together they read such books as Fitzgerald's *Rubáiyát of Omar Khayyám*, Baudelaire's *Les Fleurs du Mal*, de Sade's *Justine* and Gautier's *Mademoiselle de Maupin*. The ideas behind Rossetti's 'toilette' paintings of c.1864 are the same as those expressed by Gautier in his preface to the last book: 'la jouissance me parait le but de la vie, et la seule chose utile au monde. Dieu l'a voulu ainsi, lui qui a fait les femmes, les parfums, la lumière, les belles fleurs, les bons vins, les chevaux fringants . . .' ('enjoyment seems to me to be the end of life, and the only useful thing in the world. God has willed it so, He who created women, perfumes and light, lovely flowers, good wines, lively horses . . .'; trans. J. Richardson, *Mademoiselle de Maupin*, 1981, p.40).

A.G.

GEORGE PRICE BOYCE

238 Windmill Hills, Gateshead-on-Tyne 1864–5
Inscribed 'G.P. Boyce. 1864.5.'
Watercolour, $11 \times 15\frac{3}{4}$ (28 × 40)
First exh: O.W.C.S. 1865 (293)
Laing Art Gallery, Newcastle upon Tyne (Tyne and Wear County Council Museums)

This is an example of Boyce's work in watercolour from the last years in which he can be regarded as a Pre-Raphaelite. From the middle 1860s his work was often looser in handling and on occasion close to Whistler. In No.238 Boyce uses one of his favourite devices, placing a screen of trees between the spectator and the main part of the landscape, the upper foliage of the trees forming a tracery against the sky.

L.P.

238

FORD MADOX BROWN

239 Cordelia's Portion 1865–6, 1872
Inscribed: 'FMB 66 – 72' (initials in monogram)
Watercolour, gouache, and pastel,
$29\frac{1}{2} \times 42\frac{1}{4}$ (75 × 107.3)
First exh: Dudley Gallery, 1867
Ref: Liverpool 1964 (under No.41)
Merseyside County Council, Lady Lever Art Gallery, Port Sunlight

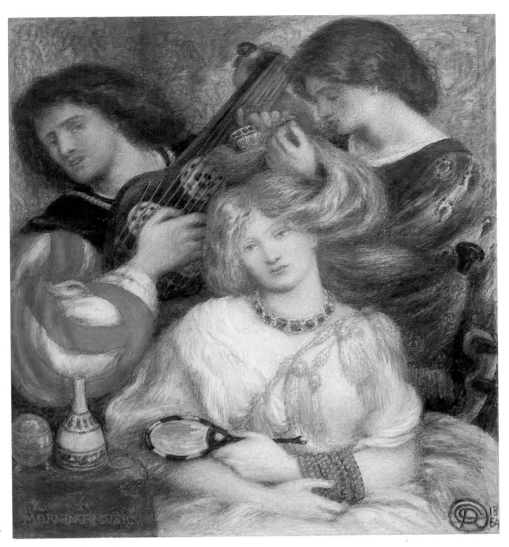

237

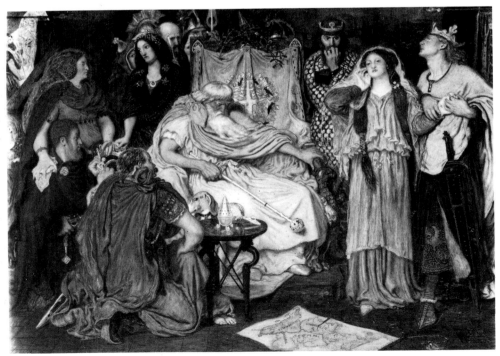

239

The last of the artist's three paintings interpreting the doomed conflict of Shakespeare's *King Lear* (see also No.16) and arising out of his robust pen and ink sketches made at Paris in 1843–4 (this subject is from elements of two of them, Nos 1288–9, Whitworth Art Gallery, Manchester). While similarly composed as a stage set viewed frontally, the barbaric line of the drawing is transposed into the sinuous decorative linearism of his later 'sensuous' style, with Lear, smouldering with passion, as the central pivot in a swaying circle of opposed good and evil. It illustrates Act I, Scene i, the moment when the King of France takes the disinherited Cordelia for his wife, following Lear's speech: 'Let it be so; thy truth then be thy dower . . . Cornwall and Albany, with my two daughters' dowers digest the third'.

The broadening of Madox Brown's patronage in the 1860s afforded an opportunity to take up these early designs again and this subject was included in the list of proposals to George Rae in 1863. He was then thinking on an expansive scale with figures three feet high (LAG/RP). The drawings were in his 1865 exhibition, evidently with the eye to a commission, and in the following November Frederick Craven of Manchester was persuaded to commission this watercolour at 500 gns. Initially he had wanted a companion to Rossetti's 'Tibullus' (Surtees No.62 R.I) of a two-figure subject from a Shakespeare play, but probably because Rossetti would not commit himself to size, he finally agreed to this format and subject (FMBP).

In the few remaining diary notes, work on it is recorded from 17 December 1865, after a move of house to the more central Fitzroy Square where began the artist's short, more prosperous period. The composition must have been worked on in the concurrent full-scale cartoon as no other preliminary sketches are known (the cartoon was later finished up, 1869, for engraving by the Autotype Company, and is now in Manchester City Art Gallery). The watercolour took second place until the completion of 'Jacob and Joseph's Coat' in April 1866, and then became the chief work mentioned until his diary peters out in July. It was finished and on display in his studio on 19 November 1866. Craven was happy with the result.

The *Reader* (1 December 1866) gave it a sympathetic and descriptive review, commenting particularly on Lear himself: 'This figure, indeed, is a noble creation, and would make or clench the fame of any man'; at the same time, like many of the artist's critics, the reviewer thought there was too much detail. However, when on show at the Dudley Gallery early in 1867 it was virulently demolished in the *Saturday Review* (2 March) in a notice in imitation of Hippolyte Taine (whose *Philosophie de l'Art* had been published in English in 1866): 'When foreigners interested in the fine arts do us the honour to visit our exhibitions, they find in them a class of productions elsewhere unknown, and which excite sensations of unlimited astonishment. Mr. Ford Madox Brown is exactly the sort of painter to astonish a Frenchman. M. Taine would regard his ''Cordelia's Portion,'' in the Dudley Gallery, with mingled perplexity and abhorrence. The colour is splendid, but glaring in the extreme; the arrangement eccentric and ungraceful, the drawing positively bad. Some details – as, for example, the throne of Lear – are painted with great power; and though the violent colours everywhere fatigue the sense, there are passages of much delicacy and truth, and evidences of poetical invention. That Mr. Madox Brown is an artist of real genius every good judge must be ready to admit, but his energy is not accompanied by moderation and good taste. M. Taine's feelings in the presence of such works as this are a matter of perfect indifference to us, and we by no means wish to imply that Mr. Brown ought to abandon his way of painting in order to please philosophers; but it sometimes happens, as it certainly does in this instance, that considerable gifts are neutralized for the want of restraint; and though an artist need not defer to the opinions of others, he ought to be able to criticize himself'.

It was slightly retouched several times for Craven and an oil version was painted for another patron, Albert Wood, in 1875 (Southampton Art Gallery).

M.B.

EDWARD BURNE-JONES

240 **The Lament** 1866
Inscribed 'E·B·J | 1866'
Watercolour with bodycolour, $18\frac{3}{4} \times 31\frac{1}{4}$ (47.5 × 79.5)
First exh: O.W.C.S. 1869 (43)
Ref: Hayward Gallery 1975–6 (93)
William Morris Gallery, Walthamstow (London Borough of Waltham Forest)

This picture represents a development from 'Green Summer' (No.236), painted little more than a year before. It is again essentially subjectless, but the inspiration now comes not from Giorgione but from classical Greek sculpture, especially the Elgin frieze. Burne-Jones's sketchbooks, of which there is a large group in the Victoria and Albert Museum, begin to reveal an intense interest in the antique about 1863. He made numerous copies both from books of engravings and from the sculpture in the British Museum, which lay conveniently close to the rooms he occupied at 62 Great Russell Street from 1861 to the end of 1864. Many reflections of this study can be traced in his paintings of the later 1860s, but in none more than 'The Lament', with its frieze-like composition, pale colours creating a sense of low relief, and figures expressing a mood of restrained sadness, like those on a Greek tombstone. In fact, as so often with Burne-Jones, the process from source to finished picture can be traced with revealing clarity. One of his sketchbook copies (V&A, E.3-1955, p.16) is taken from the seated figure of Ares on the Parthenon frieze (slab IV, figure 27). He is facing to the left with his hands clasped on his knees, and clearly inspired an early study for the girl on the right in the painting (Birmingham, 207'04), in which she is seen seated in an upright position. In further studies and the painting itself she is bent forward in a pose more expressive of grief, still retaining however the clasped hands of the Greek original, as well as being more classical in dress and coiffure than her dulcimer-playing companion.

Burne-Jones's reasons for turning to classical sources in the 1860s were complex. It was partly the culmination of the process begun long before when Ruskin had tried to deflect him from the mediaeval style of the late 1850s in the direction of that quality of 'repose', or 'classical grace and tranquility', which he saw as a crucial ingredient of all great art. Yet it was also a response to the prevailing classicism of the 1860s, as revealed most clearly in the work of Leighton, Poynter, Armstrong, Albert Moore and, for a time, Whistler. It is important to remember that Burne-Jones was closer in age to these artists than to his Pre-Raphaelite masters, Rossetti and Madox Brown. They were all among his friends, and he was associated with them professionally on numerous decorative projects and in the current revival of good book illustration. This professional collaboration was particularly influential, for many of his new associates had received a thorough training abroad in the French classical tradition, and were, as academic

draughtsmen, far superior to Burne-Jones. Of this he was painfully aware, for not only had G.F. Watts long been urging him to 'draw better', but the most common criticism of the pictures he showed at the Old Water-Colour Society in the 1860s was that they were badly drawn. The obvious remedy was to study the antique, and indeed by doing so Burne-Jones soon produced the desired effect. As Ruskin said of him in 1867, 'his pictures were at first full of very visible faults, which he is gradually conquering' (Ruskin, XIX, p.207). The truth of this is apparent if one compares 'Green Summer' (No.236) with No.240 and notes the dramatic advance in drawing and technique made in little more than a year.

Burne-Jones was not interested in the anecdotal classicism of Poynter or Alma Tadema, who settled in London in 1870. He was, however, strongly attracted to the 'aesthetic' approach of Albert Moore and Whistler, who met each other in 1865 and worked along similar lines for several years. In fact the comparison with these artists, still latent in 'Green Summer', has become strikingly apparent in 'The Lament'. There is a close resemblance to Moore's lost painting, 'The Marble Seat' (repr. A.L. Baldry, *Albert Moore*, 1894, facing p.28), his first fully aesthetic work, exhibited at the Royal Academy in 1865; and a general relationship with such pictures by Whistler as his 'Symphony in White No.3' (Barber Institute, Birmingham), begun in 1865 and shown at the Academy two years later. All three pictures are contemporary: all show ideal figure groups inspired, at one remove or another, by the Elgin frieze. The Burne-Jones and the Whistler are both carefully balanced colour harmonies in a light key; so undoubtedly was the Moore, although this is now known only from an early black and white photograph. One of the most interesting points of comparison is the way in which Burne-Jones and Whistler introduce sprays of foliage and blossom on the right of their pictures to help create their chromatic effects. This device was to be used time and again by Whistler and Moore and, in their case at least, betrays a debt to Japanese prints.

The first owner of No.240 was the Brighton wine merchant,

John Hamilton Trist. He had a large collection which also included another 'aesthetic' work of this period by Moore, his 'Pomegranates' of 1866 (Guildhall Art Gallery), as well as examples of Rossetti, Madox Brown, Arthur Hughes, Leighton and Alma Tadema. His pictures were sold at Christie's in April 1892, and 'The Lament' subsequently belonged to the artist Frank Brangwyn, who had started his career working for William Morris. There is a later version of No.240, smaller and in oils, with a landscape background (sold Christie's, 4 July 1967, lot 57).

J.C.

FREDERICK SANDYS

241 **Finished Design for 'If'** 1866
Pen and ink, $6\frac{1}{4} \times 4\frac{5}{8}$ (15.9 × 11.7)
Ref: Brighton 1974 (276)
Birmingham Museum and Art Gallery

This is Sandys' final design for the wood-engraving by Swain published in the *Argosy*, March 1866, to accompany the first publication of Christina Rossetti's poem 'If', later retitled 'Hoping against Hope'. The poem begins:

If he would come to-day, to-day,
 to-day,
Oh what a day to-day would be!

In his notes to the 1904 collected edition of Christina Rossetti's *Poetical Works*, William Michael Rossetti observed of Sandys' design that it was very able 'but (to my thinking) not in character with the poem'.

The landscape background was based on a drawing made at Weybourne Cliff, near Sheringham, on 1 November 1858 (Victoria and Albert Museum, exh. Brighton 1974, No.278; repr. *Art Journal*, 1909, p.150).

L.P.

240

241

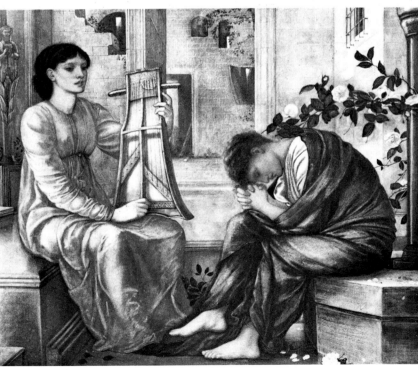

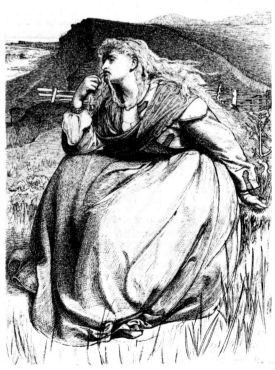

WILLIAM HOLMAN HUNT

242 The Golden Prime of Haroun Alraschid (Recollections of the Arabian Nights) 1866, ?1891
Inscribed 'Whh' in monogram
Watercolour on vellum, $4 \times 5\frac{1}{4}$ (10.2 × 13.3)
First exh: R.W.S. 1889 (249)
Ref: Liverpool 1969 (200)
National Museum of Wales, Cardiff

No.242 is a watercolour version of Hunt's illustration to Tennyson's 'Recollections of the Arabian Nights', which was published as the headpiece to the poem in the Moxon edition of 1857; it is inscribed on the flat with the following quotation from the first stanza:

> And many a sheeny-summer morn,
> Adown the Tigris I was borne,
> By Bagdat's shrines of fretted gold,
> High-walled gardens green and old.

William Michael Rossetti had posed for the figure in the illustration (W.M. Rossetti to Herbert M. Thompson, 2 December 1898; MS, National Museum of Wales, Turner House Autograph Book) and on 5 September 1858 William Bell Scott wrote to him: 'Please forward the enclosed letter to Hunt. A friend here wants a little drawing of the Arab in the boat in Tennyson and I write to ask him about it' (MS, Durham University Library). Six days later, Hunt wrote to Bell Scott: 'At present I must ask you to excuse me to the gentleman who wishes to have a water color drawing of the youth in the boat, because I have got so many drawings and paintings on hand and I have determined to begin no others until I have completed some of my tasks . . . If he will allow me I shall be glad to answer his question about doing it when I have got free – his interest in the design gratifies me I had some times thought it a suitable one for working out in color' (PUL).

Scott reminded Hunt of the commission in a letter of 24 December 1859 and this identifies the potential patron as a Mr Crawhall of Newcastle (UBC/Holman Hunt Papers). Hunt was preoccupied with his work on 'The Finding of the Saviour in the Temple' (No.85), and had not had time to begin No.242, as his letter to Scott of 11 February 1860 reveals: 'The little subject which Mr Crowhall [sic] takes an interest in will scarcely require me to fight the fates in the East so I think I may promise to have some drawing of it done and forwarded or kept here for his refusal' (PUL; the transcript in Scott, II, p.50 is inaccurate).

Hunt kept the patron in mind and wrote to Bell Scott again on 4 June 1866: 'The little drawing of the Arab poet in the boat will shortly be ready ` to whom shall I write about it – if the friend you last spoke of desire it I will send it for him to see – the price I cannot yet fix upon –' (PUL). Scott thought that it was highly unlikely that Crawhall would be interested after such a long period of time, and he wrote to Leathart on 7 June 1866, enclosing Hunt's letter, to ask his advice about placing the watercolour (UBC/LP). He also approached T.E. Crawhall and Thomas Burnett, once Hunt informed him of the price of the work (Scott to Hunt, 11 June 1866, UBC/Holman Hunt Papers), but Crawhall was no longer interested, and as Scott did not receive an immediate reply from Burnett he advised Hunt to look elsewhere for a purchaser (22 June 1866, ibid.). On 29 June 1866 Hunt informed Scott that he intended sending No.242 to Agnew's (PUL), but it seems that the watercolour was in fact sold privately, as Hunt's letter of 19 November 1891 to James Pyke Thompson, which states that the artist was handling 'Haroun Alraschid' on behalf of the son

of 'the gentleman who bought it from me', reveals (MS, National Museum of Wales, Turner House Autograph Book).

Thompson had seen No.242 at the 1891 Art Society of Cardiff exhibition, and he negotiated with Hunt to buy it for the modest sum of £75 (Hunt to James Pyke Thompson, 29 October 1891; MS, ibid.). The artist stressed that he regarded the watercolour 'with great pride, and I can say so the more confidently now because after your brother left I determined to examine frankly the accuracy of a certain query about the reflections of the boat in the water, and I took the vellum on its little stretcher out of its frame, and in touching on it I was able to estimate the work more carefully –' (Hunt to Thompson, 19 November 1891; MS, ibid.). This seems to suggest that No.242 was slightly retouched at this date.

J.B.

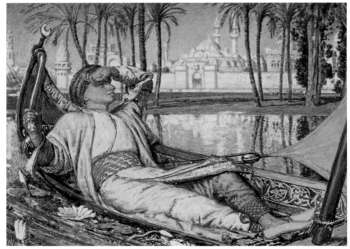

242

WILLIAM HOLMAN HUNT

243 Sunset in the Val d'Arno, from Fiesole 1868, ?1869
Inscribed 'Whh 68' (initials in monogram)
Watercolour and bodycolour, $14 \times 19\frac{3}{4}$ (35.5 × 50)
First exh: Walker Art Gallery, Liverpool 1892 (564)
Ref: Liverpool 1969 (214)
Johannesburg Art Gallery

Hunt returned to Florence in late June 1868, to superintend the completion of the marble monument he had designed for his wife's grave in the English Cemetery. He went up to Fiesole shortly after his arrival, because of poor health, and wrote to J.L. Tupper on 12 July: 'I am just now for the sake of the open air working at water color-landscapes' (HL). John Wharlton Bunney's diary entry of 14 July 1868 seems to suggest that one watercolour, which 'will come very nice when done', was commenced at the beginning of the month, and a second

during the week of 6–12 July (Bennett 1970, p.41). The view over the valley of the Arno is similar in both works, but whereas in No.243 Hunt depicted a panorama of the plain viewed from the precipitous road leading to Fiesole from Florence, he positioned himself further up the hillside, just outside the gates to the estate of his friend, William Blundell Spence, in order to paint 'Festa at Fiesole' (Coll. Mrs Burt, exh. Liverpool 1969, No.212, repr.).

Although Hunt had 'not quite finished his Fiesole bit' on 14 July, he left Florence that evening for a trip to Naples, as Bunney relates in his diary (Bennett 1970, p.41). He was in the south for some weeks (Hunt to F.G. Stephens, Florence, 14 September 1868, BL), and 'for the sake of the effect and sentiment of the light' (ibid.), executed the watercolours 'Interior of Salerno Cathedral' (private collection), 'Moonlight at Salerno' (untraced), and 'Sunset at Chimalditi' (private collection, exh. 1969, No.213; repr. Staley, pl.35a). The exploration of light effects was, of course, central to the Fiesole watercolours also, and on 25 September Hunt wrote to Stephens from Florence: 'In about another ten days I think I shall send home my batch that is *if* the perpetual storms of rain will allow me to get up to Fiesole to which place I must go to finish one of the most important – I think they are far the best drawings I have ever done –' (BL). Hunt presumably worked on No.243 at Fiesole that autumn, but it did not form part of the consignment of watercolours sent off to England in November (Hunt to J.W. Bunney, November 1868: Bennett 1970, p.42; Hunt to A.W. Hunt, 9 February 1869, states that he will instruct Gambart to send his four recently completed watercolours to the Old Water-Colour Society: MS, Coll. Kenneth Lohf).

No.243 may have been worked on further in the summer of 1869: according to Walburga, Lady Paget, Hunt stayed with Spence at the Villa Medici in June of that year, and used the stables as his studio (*The Linings of Life*, 1928, I, p.141). She mentions his painting 'the sunlit cornfields on the slopes below' which could describe No.243 rather than the picture she erroneously identifies as relating to the background of 'The Shadow of Death' (No.143).

It was to be many years before 'Sunset in the Val d'Arno, from Fiesole' was exhibited, at the Walker Art Gallery in the autumn of 1892. It remained in the Holman Hunt family until the 1940s, and has been in South Africa since 1959.

J.B.

243

EDWARD BURNE-JONES

244 The Wine of Circe 1863–9
Inscribed 'E. BURNE JONES'
Watercolour with bodycolour, 27½ × 40 (70 × 101.5)
First exh: O.W.C.S. 1869 (197)
Ref: Hayward Gallery 1975–6 (105)
Private Collection

The daughter of Helios, the sun god, by Perse, an ocean nymph, Circe was a sorceress who inhabited the island of Aeaea and transformed human beings into animals. Homer describes how Odysseus encountered her on his return from the Trojan War. She turned his crew into swine, but he himself, having received from Hermes a magic herb which rendered him immune to enchantment, was able to force her to restore his companions to their proper form. Burne-Jones shows her preparing her wine for the heroes, whose ships approach in the distance.

This important and beautiful picture was exhibited at the Old Water-Colour Society in 1869 and did much to establish Burne-Jones's reputation. As the critic of *The Times* wrote, it was 'the most complete work . . . which this painter of rare and real imagination . . . [had] yet produced'. Even the consistently hostile *Art Journal* felt that he had 'never given more decisive proof of distinguished, though abnormal and perverted, talent'. It found 'the lines of the composition . . . studiously offensive', disliking, for example, 'the way in which the awkwardly protruded back of Circe is carried out on either side by the long flat sea horizon'; and it moaned once again that such pictures had 'not the breath of life, the health of nature, or the simplicity of truth'. It admitted, however, that the colour would 'be accepted by all, not only as intense, but as peculiarly responsive to deep emotion, and altogether harmonious and lovely'. F.G. Stephens in the *Athenaeum* also praised the picture's colour and commended the artist for improving his drawing. For him the weakest part was the head of Circe herself – 'expressionless, if beautiful . . . her features mean nothing'.

The picture had been started as long ago as 1863 and radical changes had taken place during its six years' gestation. Early composition sketches (Tate Gallery and Birmingham) still look back to the mediaeval style of the late 1850s. Circe is seen in a dark interior with massive pieces of gothic furniture. The sails of Odysseus' ships fill the window, thus adding to the sense of claustrophobia and the feeling of tension between the enchantress and her victims. In the finished picture, however, the room is flooded with light and the design is conceived less in terms of mood and chiaroscuro than as a series of carefully balanced linear rhythms and chromatic harmonies. The ships have been pushed back to allow a breezy view of the sea. The original heavy wooden throne has been replaced by a bronze one of elegant classical design, and the snuffling pigs that occur in the early drawings have become a pair of sinuous panthers. Only the low ceiling betrays something of the first conception.

As in 'Green Summer' and 'The Lament' (Nos.236, 240) – both painted while 'Circe' was in progress – behind these changes lies a fascinating combination of Ruskinian principle and pictorial and decorative fashion. If Ruskin did not actually commission the picture it was certainly based on a design made for him. On 18 November 1863 he told Ellen Heaton that Burne-Jones was 'making me a drawing of [Circe] poisoning the meat and going all round the table like a cat – it will be lovely' (Surtees 1972, p.251). During his visit to Italy with Burne-Jones in the summer of 1862 he had started a series of controversial papers on political economy for *Fraser's Magazine*, subsequently published as *Munera Pulveris*. Bitterly

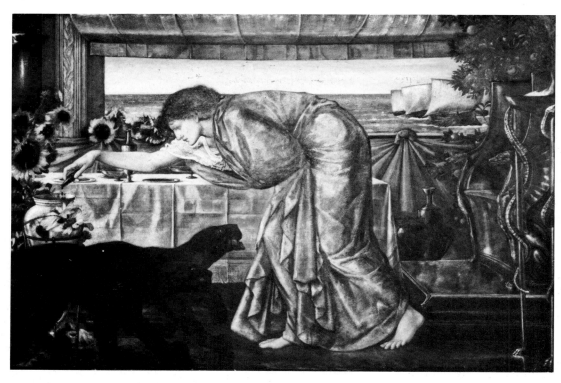

244

critical of current conceptions of wealth, they were written at a time when he was making a minute study of Greek myths and are full of abstruse mythological and allegorical allusions. On his return to England in 1863 he asked Burne-Jones to make him a series of designs for the book version. 'I want a Ceres for it', he wrote excitedly, 'and a Proserpine, and a Plutus, and a Pluto, and a Circe... and ever so many people more' (G. Burne-Jones, I, pp.271–2).

In giving him this commission, Ruskin was asking him to fulfil his own conception of the artist's role in its highest form – that of the prophet or seer who would create what he called 'ideal grotesques', allegorical designs which, by their beauty of form and noble subject, would instruct and uplift the spectator to the ultimate benefit of society at large. For Ruskin Circe symbolised a profound moral and political truth. As he explained in *Munera Pulveris*, whereas the Sirens, whom Odysseus also encounters, are symbols of avarice who 'promise pleasure, but never give it... [and] slay by slow death', Circe – 'daughter of the strong elements, Sun and Sea' – represents 'pure Animal life'. 'Her power is that of frank, and full vital pleasure, which, if governed and watched, nourishes men; ... She is ... indeed an Enchantress ... but always wonderful ... even the wild beasts rejoice and are softened around her cave; the transforming poisons she gives to men are mixed with no rich feast, but with pure and right nourishment, – Pramnian wine, cheese, and flour; that is, wine, milk, and corn, the three great sustainers of life – it is their own fault if these make swine of them' (Ruskin, XVII, p.213).

There is abundant evidence that Burne-Jones was anxious to accommodate himself to Ruskin's views in the 1860s, and indeed Ruskin claimed that the painter came near to realising his ideal in a lecture he gave 'On the Present State of Modern Art' in June 1867. It seems, therefore, the 'Circe' should be seen in relation to Ruskin's programme and not, like 'Sidonia von Bork' (No.230), as an essay in the sinisterly occult subject matter so popular in Rossetti's circle a few years before. This

might appear a quibble, but Ruskin was not only concerned with thematic interpretation. He was equally insistent on the moral significance of those stylistic qualities revealed in the finished 'Circe'. As he would have put it, beauty of form and clear tonality were signs of the 'gladdening' power of Aglaia, the goddess of Grace whose laws, 'binding on Art practice and judgment', he discusses in another extravagantly allusive work of this period, *The Cestus of Aglaia* (1865). Ruskin's sense of colour symbolism is particularly interesting here. Dark, murky colours, he believed, either symbolised greed or were associated with 'foul' subjects which were themselves socially harmful, while 'it is the aim of the best painters to paint the noblest things they can see by sunlight', light being the symbol of divine, life-giving love (Ruskin, XIX, p.109). The great expression of this idea is his analysis of two of Turner's mythological paintings, 'The Garden of the Hesperides' and 'Apollo Killing the Python', at the very end of *Modern Painters*, but he seems to have urged Burne-Jones to follow a similar course and discard the sombre colours of his 'Venetian' phase for a brighter palette. 'Put the black out of [your] box', he told him with characteristic fussiness in 1864, 'and the browns, and the indigo blue – or perhaps it might be shorter to shake everything out of the box and then put back in it the vermilion and the violet carmine, and the cobalt and smalt, and chinese white, and perhaps a little emerald green or so, and try what you can do with these, on gold ground, so as not to have any nasty black and brown things to make me look at when I come to ask what you've been about' (Ruskin, XXXVI, p.468). The results of these orders seem traceable not only in 'Circe' but in 'The Lament' (No.240) and other works of the period.

However, there was more to the development of 'Circe' than compliance with Ruskin's recondite philosophical ideas. Burne-Jones was also showing himself responsive to the classical and 'aesthetic' trend of the time. The figure of Circe herself probably owes something to the well-known relief of a charioteer from the Mausoleum (British Museum, No.1037)

which he copied in the mid-1860s, and there are copies from classical sources made in connection with the throne, the wine jars and other details (V&A sketchbook, E.6-1955, exh. Hayward Gallery 1975–6, No.343). Studies for Circe's drapery exist in white chalk on coloured paper, the technique which is so characteristic of drawings by Leighton and Albert Moore (ibid., No.107); and the finished picture was clearly intended to be a 'harmony in yellow', comparable to colour schemes found in contemporary works by Moore and Whistler.

These developments must have been encouraged by the fact that at some stage (ironically in view of the connection with Ruskin's political ideas) the commission was taken over by the wealthy Liverpool shipowner, Frederick Leyland. In fact 'Circe' was the first of eleven pictures which Burne-Jones would paint for this important patron, all of them major works. A self-made man of humble origin, Leyland had started his collecting career buying works by popular artists of the day, but in the 1860s he turned his attention to the Pre-Raphaelites and the Italian Old Masters. He was advised not only by Rossetti, for whom he had a deep regard, but by two dealers and connoisseurs who did much to direct the course of the Aesthetic movement, Murray Marks and the notorious Charles Augustus Howell. These men, who worked for a time in partnership, were both friends and agents of Burne-Jones, and no doubt they watched over the progress of 'Circe' with interest, perhaps even suggesting ideas that would help it fit into a decorative ensemble for which Moore and Whistler were also currently working. It is known that Marks 'specially selected' pictures for Leyland, while Howell, who was particularly intimate with Burne-Jones until they suddenly quarrelled in 1871, placed great emphasis on overall colour effects, decorating rooms in his own house in blue, gold or white to show to potential customers, who would commission him to recreate the same effects for them and perhaps purchase the works of art the rooms cunningly displayed. In 1869 Leyland took 23 Queen's Gate as his London home, but in 1874 he moved to 49 Prince's Gate and there, with the help of Marks, Whistler and Norman Shaw, created one of the great 'aesthetic' houses of the day, Whistler's Peacock Room being its most famous feature. 'Circe' hung on the magnificent staircase imported from Northumberland House, together with pictures by Rossetti, Legros and others. The walls were painted a delicate willow green, while the dado below was enriched with panels decorated by Whistler in imitation of aventurine lacquer with floral patterns in pink and white in the Japanese taste.

'Circe' seems to show signs of her revisions in the thick bodycolour that covers much of the surface (it is interesting that Leyland, in paying Burne-Jones, voluntarily added £100 to the price in recognition of 'all the work' he had given to it). However, as Charles Fairfax Murray, who became Burne-Jones's studio assistant in 1866, observed, it was the painter's usual practice to handle watercolour almost exactly as he did oil, building up the forms by glazing over a firmly modelled under-painting and even using hog-hair brushes. The only difference was that with watercolour 'the colour on the surface could be mixed with the ground by slightly moistening it. This trick, so dangerous to the uninitiated, I have known him constantly practice with unvarying success [and] perfectly magical results. Sometimes the colour was moistened very slightly and sometimes it was worked up almost as far as the paper, often spoiling the brush by breaking and spreading the hairs' (MS notes in Birmingham City Art Gallery).

'Circe' was the subject of a sonnet by Rossetti published in his *Poems* of 1870.

J.C.

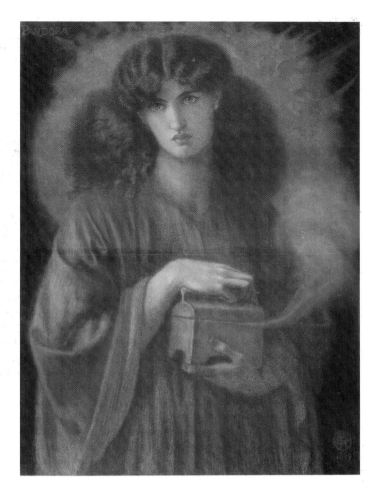

245

DANTE GABRIEL ROSSETTI

245 Pandora 1869
Inscribed 'PANDORA | DGR | 1869' (initials in monogram)
Coloured chalks on two sheets of paper,
$39\frac{5}{8} \times 28\frac{5}{8}$ (100.7 × 72.7)
Ref: Surtees No.224A
Faringdon Collection

There are several versions of the Pandora myth, one of which is found in Heywood's *History of Women*, a copy of which was owned by Rossetti: 'she was by Jupiter sent to Prometheus with all the mischiefes that are, included in a boxe; which he denying gave it to Epimetheus; who taking off the cover or lid, and perceiving all these evils and disasters to rush out at once, he scarce had time to shut it againe, and keep in Hope, which was the lowest and in the bottome' (T. Heywoode, *Tunaiken – or Nine Books of Various History Concerning Women*, London, 1624, p.32). In Rossetti's version, Pandora herself is opening the box to let a cloud of winged 'mischiefes' escape.

In December 1868 he was working on 'some crayon heads of Mrs. Morris as *Pandora* etc.' (W.M. Rossetti 1903, p.337). There are further references in the spring of 1869 which are probably to this and another (Surtees No.224B) half-length version of the subject in chalks (ibid., pp.384, 391). In July of this year a three-quarter length oil (Surtees No.224) was started which was only completed in February 1871 (ibid., p.403; Doughty & Wahl, III, p.929). The pose was possibly

suggested by one of the photographs which Rossetti had taken of Mrs Morris in 1865 (see Rosalie Glynn Grylls, *Portrait of Rossetti*, 1964, facing p.160). The photograph shows the length and expressiveness of her hands, which play an important part in all the pictures he made from her. Here, her right hand, which is lifting the lid, resembles the left hand of Michelangelo's 'Dawn' in the Medici Chapel. An influence from Michelangelo is found in many other works after 1868. Unlike the drapery in earlier pictures such as 'Monna Vanna', that in 'Pandora' is unpatterned and falls in near vertical folds. And whereas the figures in earlier works were bust or half-length, Pandora is shown almost three-quarter length. Rossetti much wished to paint a full-length version of the subject from Mrs Morris in the summer of 1869.

The artist turned increasingly to the medium of chalks from 1868. He used it on sheets of paper tinted green/blue, measuring about $28\frac{1}{2} \times 20$ inches. Here the colour of the chalks is predominantly red, symbolising warning. No doubt the subject, with Mrs Morris as the sitter, had a personal meaning to Rossetti as he appears to have fallen in love with her at the time this drawing was made, in 1868–9. By mid-March 1869 he had written a sonnet for the subject:

> What of the end, Pandora? Was it thine,
> The deed that set these fiery pinions free?
> Ah! wherefore did the Olympian consistory
> In its own likeness make thee half divine?
> Was it that Juno's brow might stand a sign
> For ever? and the mien of Pallas be
> A deadly thing? and that all men might see
> In Venus' eyes the gaze of Proserpine?
>
> What of the end? These beat their wings at will,
> The ill-born things, the good things turned to ill, –
> Powers of the impassioned hours prohibited.
> Aye, hug the casket now! Whither they go
> Thou mayst not dare to think: nor canst thou know
> If Hope still pent there be alive or dead.

A.G.

246

DANTE GABRIEL ROSSETTI

246 La Donna della Fiamma 1870
Inscribed 'La Donna della Fiamma' and 'DGR 1870'
Coloured chalks on two sheets of paper, $40\frac{1}{16} \times 30$ (101.8 × 76.2)
Ref: Surtees No.216
City of Manchester Art Galleries

A beautiful woman, modelled by Jane Morris, holds in her hand a flame containing the winged figure of Love. The symbolism derives from Dante whose *Vita Nuova* Rossetti had translated in 1848. Here Dante describes Beatrice's power to engender love:

> Whatever her sweet eyes are turned upon,
> Spirits of love do issue thence in flame,
> (W.M. Rossetti 1911, p.324)

Rossetti used the image of fiery Love not only in this drawing but in several contemporary poems and the relationship between his art and his poetry is very close at this time. He writes, for example, in 'The Stream's Secret' (verse 19):

> Pity and love shall burn
> In her pressed cheek and cherishing hands;

and in 'Love Lily' (verse 1):

> Between the hands, between the brows,
> Between the lips of Love-Lily,
> A spirit is born whose birth endows
> My blood with fire to burn through me;

The main inspiration of all his work, artistic and poetic, from 1868 was his love for Jane Morris. In that year she posed for several major oils, 'La Pia' (No.153) and 'Mariana' (No.139) among them, and for a group of head studies in chalk, some of which were later worked up into larger drawings with subjects. Rossetti realised that subject pictures were more saleable than head studies and 'La Donna della Fiamma' is one of several drawings of 1870 in which Jane Morris is given attributes and turned into a subject. Other examples are 'Silence', 'The Roseleaf', and 'La Donna della Finestra'. It is possible that No.246 was started in 1868 as the pose is similar to that found in 'La Pia'. All the works of this period for which Jane Morris posed are prefigured in a remarkable series of photographs of her which were taken under Rossetti's direction in 1865. Her poor health dictated 'easy' poses and there is a sense of lassitude and introspection in the works for which she modelled. She is clothed in unpatterned draperies which are given a flowing, flamelike movement in contrast to the lack of energy in her limbs. In this drawing the figure of Love suggests the influence of Blake.

Rossetti used chalks a great deal from 1868, partly because he suffered eye trouble and he found this medium the least painful with which to work. His friend Frederic Shields had encouraged him to use a 'compressed charcoal' and he also

employed red conté chalk and pipe-clay on paper tinted greenish-grey (see the entry on No.245 and F. Shields, 'A note upon Rossetti's method of drawing in crayons', *Century Guild Hobby Horse*, v, 1890, pp.70–3).

A.G.

EDWARD BURNE-JONES

247 The Evening Star 1872–3
Inscribed 'EBJ'
Watercolour with bodycolour and some gold paint,
$31\frac{1}{8} \times 22$ (79 × 56)
Ref: Hayward Gallery 1975–6 (102)
Private Collection

The picture is a second version of a design exhibited at the Old Water-Colour Society in 1870 and bought by Burne-Jones's friend and patron George Howard, later Earl of Carlisle (Hayward Gallery 1975–6, No.100). The two versions are identical in size and similar in colour and design, although in the later picture the figure's head, formerly shown turned away, is in profile, and the drawing of the body is better. These changes are probably due to the criticism provoked by the early version when it was exhibited in 1870. The *Spectator* thought it a 'far-fetched experiment' that had 'missed the mark'. The *Art Journal* felt the artist had 'fashioned . . . a nondescript being, neither fowl nor fish, and yet scarcely human'. And F.G. Stephens in the *Athenaeum* described the picture as 'grand poetry expressed in bad grammar', complaining, not unjustly,

of the 'disproportions of the figure, of the head to the body, and of the limbs to each other'.

No.247 was painted for Frederick Craven of Manchester, who had a fine collection of paintings and watercolours and acquired several works by Burne-Jones in the 1870s, including the well-known 'Pygmalion' series (Birmingham), exhibited in 1879. He was also a patron of Madox Brown and Rossetti, who described him as 'a very good paymaster, and not a haggler at all – a grave and (let us say in a whisper) rather stupid enthusiast of the inarticulate business type, with a mystic reverence for the English watercolour school'.

No. 247 has a companion, 'Night', dated 1870 (Hayward Gallery 1975–6, No.103), and a third design of the same type, 'Luna', was begun in oils in 1872 and completed for Alexander Ionides in 1875 (present whereabouts unknown). All three pictures seem to have been the outcome of a series of drawings of flying female figures which Burne-Jones made in the late 1860s in white chalk on brown paper, a technique he used extensively at this time (see Hayward Gallery 1975–6, No.104). The paintings, with their strong blue tones, are a little reminiscent of certain allegorical works of G.F. Watts, 'Luna' being particularly close to his famous figure of 'Hope', painted in its definitive form (Tate Gallery) in 1886, but probably conceived many years before. Burne-Jones's friendship with Watts was established during his prolonged stay at Little Holland House in 1858 and continued throughout his life. He was in the habit of going to the older artist for advice when in difficulties with his work, and Watts painted his well-known portrait of him (Birmingham) in 1870.

J.C.

247

DANTE GABRIEL ROSSETTI

248 The Question 1875
Inscribed 'The Question | DGR | 1875' (initials in monogram)
Pencil, $18\frac{3}{4} \times 16$ (47.6 × 40.6)
Ref: Surtees No.241
Birmingham Museum and Art Gallery

This is Rossetti's version, disagreeable in this writer's opinion, of a subject made famous by Ingres and Moreau. He drew it in the spring and summer of 1875 (Doughty & Wahl, III, p.1330; Surtees 1980, p.62). His own explanation of it was sent to F.G. Stephens for an article on his most recent works which was published in the *Athenaeum* on 14 August of that year (pp.220–1): 'In this design the subject represents three Greek pilgrims . . . In the distance, between sharp rocks on either side . . . is seen the ship which has brought them . . . the sphinx is enthroned in motionless mystery, her bosom jutting out between the gaunt limbs of a rifted laurel-tree . . . The youth, about to put his question, falls in sudden swoon from the toils of the journey & the over-mastering emotion; the man leans forward over his falling body and peers into the eyes of the sphinx to read her answer; but those eyes are turned upward and fixed without response on the unseen sky . . . Meanwhile the old man is seen still labouring upwards . . . eager to the last for that secret which is never to be known. In the symbolism of the picture (which is clear and gives its title founded on Shakespeare's great line To be or not to be, that is the question) the swoon of the youth may be taken to shadow forth the mystery of early death, one of the hardest of all impenetrable dooms'.

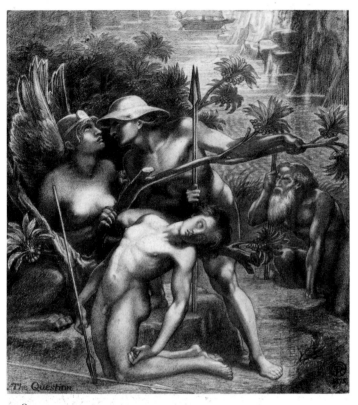

248

The dominant place given to the dying youth was probably in response to the death of Madox Brown's son Oliver, at the age of nineteen, in November 1874. The youth's pose is derived from a statue of 'Menelaus with the body of Patroclus' of the third century B.C. of which casts were widely distributed. The pairs of spears carried by each pilgrim are a traditional motif found on Greek vases. The background glimpse of sea, coast and moonlight, was possibly influenced by a frontispiece by Tissot to Tom Taylor's *Ballads and Songs of Brittany* which Rossetti had greatly admired on its publication in 1865 (L.M. Packer, *The Rossetti-Macmillan Letters*, 1963, p.40).

A large strip of paper was added at the right side of the drawing while it was made.

A.G.

DANTE GABRIEL ROSSETTI

249 The Death of Lady Macbeth *c.*1876
Inscribed 'The Death of Lady Macbeth|DGR|1876
[? partially erased]' (initials in monogram)
Pencil, $18\frac{3}{4} \times 24\frac{1}{2}$ (47.6 × 62.2)
Ref: Surtees No.242
Carlisle Museum and Art Gallery

Though the date of this drawing is uncertain, on stylistic grounds it must have been drawn after *c.*1875. It is filled with a sense of frenzy and nightmarish flux and is similar to other late works such as the predellas for 'Dante's Dream' (third version, Surtees No.81 R.2) and the second version of 'Pandora' of 1878 (No.250). Influences can be seen from Fuseli and his follower Theodore von Holst, who did a painting of this subject, both artists admired by Rossetti in his youth and again now, in the years shortly before his death.

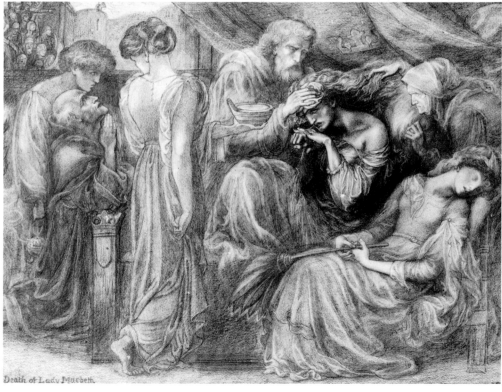

249 Death of Lady Macbeth

The subject is taken from *Macbeth*, Act v, Scene i, and shows a room in Dunsinane castle. Lady Macbeth, delirious and shortly to die, is watched by her physician and attendants as she cries: 'Out, damned spot! out, I say! . . . Here's the smell of the blood still: all the perfumes of Arabia will not sweeten this little hand. Oh, oh, oh!'.

The mount and frame are original. This is the most finished version of several studies for the composition, which Rossetti hoped to paint. It was bequeathed to Carlisle by the poet and playwright Gordon Bottomley.

<div align="right">A.G.</div>

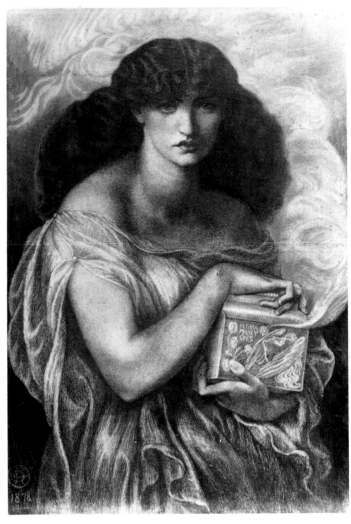

250

DANTE GABRIEL ROSSETTI

250 Pandora *c.*1874–8
Inscribed 'DGR | 1878' (initials in monogram)
Chalks, 38½ × 25½ (97.8 × 64.8)
Ref: Surtees No.224 R.I.A.
Merseyside County Council, Lady Lever Art Gallery,
Port Sunlight

This version of 'Pandora' is very different to the one established in 1869 (No.245). The figure has bared shoulders similar to, but even more massive than, those of 'Astarte Syriaca' (No.147) and recalls the Cumaen Sibyl of the Sistine ceiling. The box now bears the inscription 'VLTIMA | MANET | SPES' and a winged head of Hope with sunflowers. The drapery and cloud of 'ill-born things' twist and writhe with a life of their own. Menace and frenzied movement have replaced the lethargic gloom of the earlier version.

Rossetti was making studies for a 'monumental' version of 'Pandora' in December 1874 (Doughty & Wahl, III, pp.1324–5). In a letter of 19 December 1877 to Jane Morris, who provided at least the initial inspiration, he wrote that he had finished the drapery on a drawing of 'Pandora' and on 18 March 1878 he wrote again: 'I have taken up the Pandora drawing again with a fresh system of bogies round the head, and have now made it very complete indeed' (ed. J. Bryson and J.C. Troxell, *Dante Gabriel Rossetti and Jane Morris*, 1976, pp.45, 59).

<div align="right">A.G.</div>

LIST OF LENDERS

Her Majesty Queen Elizabeth the Queen Mother 122

Aberdeen Art Gallery and Museums 139
Art Gallery of South Australia 5
Ashmolean Museum 6, 25, 33, 34, 66, 102, 120, 124, 125, 134, 148, 172, 190, 195, 197, 199, 203, 208, 224

Balliol College, Oxford 112
Barber Institute of Fine Arts 132
Birmingham Museum and Art Gallery 36, 38, 44, 51, 59, 62, 69, 85, 86, 92, 95, 103, 127, 141, 158, 161, 162, 169, 178, 179, 234, 241, 248
Bradford Art Galleries and Museums 8
British Museum 171, 189, 194, 196, 211, 213, 226

Carlisle Museum and Art Gallery 63, 174, 249
Sir Frank Cooper Bt. 99
Miss Sylvia Crawshay 20

Delaware Art Museum 55, 101
Detroit Institute of Arts 126

Mrs Jane Elliot 11
Eton College 31

Sir Brooke Fairbairn Bt. 117
Faringdon Collection 137, 245
Fitzwilliam Museum 37, 119, 167, 173, 175, 216, 223, 225, 237
FORBES Magazine Collection 23

Glasgow Art Gallery and Museum 135
Basil Gray 210
Guildhall Art Gallery 9, 32, 71, 144

Harris Museum and Art Gallery 202
W.N.M. Hogg 110

Jesus College, Oxford 47
Johannesburg Art Gallery 53, 114, 164, 243

Keble College, Oxford 57

Laing Art Gallery 138, 150, 238
Viscount Leverhulme 10, 96
Lincolnshire Museums 30
Musée du Louvre 163

Jeremy Maas 198
Makins Collection 12, 24, 35, 41
Manchester City Art Galleries 27, 39, 50, 74, 80, 84, 88, 111, 142, 143, 145, 147, 181, 184, 246
Mr and Mrs L.S. Melunsky 78
Merseyside County Council 13, 18, 73, 108, 129, 239, 250
Metropolitan Museum of Art 149
William Morris Gallery 240

National Gallery of Canada 105
National Gallery of Scotland 109
National Gallery of Victoria 67, 168
National Museum of Wales 146, 242
National Portrait Gallery 183
National Trust 76, 77, 81
Norfolk Museums Service 116

Musée d'Orsay 152, 155
Owens Art Gallery 14
Oxford University Museum 118

Private Collections 4, 17, 21, 28, 29, 46, 52, 56, 93, 107, 115, 121, 140, 151, 157, 170, 176, 182, 188, 200, 207, 212, 217, 222, 227, 229, 232, 235, 236, 244, 247
Richard Purdy 159

Russell-Cotes Art Gallery 130

Southampton Art Gallery 87
Spencer Museum of Art 153

Tate Gallery 3, 7, 15, 16, 19, 22, 26, 40, 42, 43, 45, 48, 49, 54, 58, 60, 61, 64, 65, 68, 72, 75, 79, 82, 83, 90, 91, 94, 97, 98, 100, 104, 106, 113, 123, 131, 133, 136, 154, 156, 165, 166, 177, 209, 214, 215, 218–221, 228, 230, 231
Torbay Borough Council 128
Trinity College, Cambridge 89

Victoria and Albert Museum 1, 160, 193, 206

Mr and Mrs Harold Wernick 187
Whitworth Art Gallery 180, 201, 204, 205, 233
Major General C.G. Woolner 2

Yale Center for British Art 70, 185, 186, 191, 192

CORRECTIONS AND ADDITIONS

Unless otherwise indicated, references are to catalogue numbers

General: works by Hunt referred to as being in Mrs Burt's collection were sold at Sotheby's on 10 October 1985.

p.32 Biographical note on Hunt: dates of 'The Triumph of the Innocents' should read 1876–8, 1879–83, 1885, 1887, 1890; for 'Cyril Benone' read 'Cyril Benoni'.

2　Presented to the Tate Gallery by the Patrons of British Art through the Friends of the Tate Gallery 1991 (T 05857). Size should read 19⅝ × 14 × 11⅙ (49.8 × 35.5 × 28).

3　Hunt entered the RA Schools as a Probationer in July 1844 and as a Student in December.

4　There should be a line break after 'RECTOR' in the inscription.

9　Retouched 1858 (see Christie's sale cat., 26 March 1859, p.8). Liverpool 1969 no.91 now Walker Art Gallery, no.92 now Guildhall Art Gallery. Liverpool 1969 no.11 is in fact a replica of c.1857.

12　Liverpool 1969 no.108: now Makins Collection.

15　Metric size should read 83.2 × 65.4.

17　For 'first picture' in first line, read 'only picture'. An oil study for this work was sold at Christie's, 22 June 1984 (256, repr. in col.) and is now in the FORBES Magazine Collection, New York.

18　For the relationship of this work to the wings of Lorenzo Monaco's 'Coronation of the Virgin' (National Gallery), see Malcolm Warner, 'The Pre-Raphaelites and the National Gallery' in The Pre-Raphaelites in Context, 1992, pp.1–11.

19　For 'McCracken' read 'M'Cracken'. A letter from John Miller to F.M. Brown, 17 May 1857, indicates that Miller gave the picture to Mrs Wilson as a present.

20　Now National Museum of Wales, Cardiff. For 'boy' in penultimate line, read 'girl'.

22　For 'Feast of the Immaculate Conception' near end of entry, read 'Feast of the Annunciation to the Virgin'.

23　This was no.143 in the 1850 exhibition.

26　On Dickens's review see also J.B. Bullen, 'John Everett Millais and Charles Dickens: New Light on Old Lamps', English Literature in Transition 1880–1920 (University of North Carolina at Greensboro), Special Series, no.4, 1990, pp.125–44.

29　Purchased by the Tate Gallery 1984 (T 03958). Size should read 13⅞ × 18 (35.3 × 45.7).

36　Liverpool 1969 no.115: now Makins Collection.

39　See also: Kay Dian Kriz, 'An English Arcadia Revisited and Reassessed: Holman Hunt's The Hireling Shepherd and the Rural Tradition', Art History, vol.10, no.4, 1987, pp.475–91. Liverpool 1969 no.122: now Cleveland Museum of Art, Cleveland, Ohio.

40　The watercolour mentioned in the last two lines was sold at Sotheby's, 23 June 1987 (53).

41　The oil version sold at Sotheby's on 19 March 1979 was sold again there on 19 June 1990 (24).

45　Hunt received £25 or gns (not 50) for the picture (Hunt 1886, p.822; 1905, I, p.342). The pamphlet mentioned at the end of the entry was issued in 1865 (not 1864) and was written by F.G. Stephens.

49　The watercolour version mentioned at the end of this entry was sold at Sotheby's, 26 April 1988 (109, repr. in col.).

58　See also: Caroline Arscott, 'Employer, Husband, Spectator: Thomas Fairbairn's Commission of The Awakening Conscience' in Janet Wolff and John Seed (eds.), The Culture of Capital: Art, Power and the Nineteenth-Century Middle Class, 1988, pp.159–90, and Kate Flint, 'Reading The Awakening Conscience Rightly' in Marcia Pointon (ed.), Pre-Raphaelites Re-Viewed, 1989, pp.45–65.

63　The height of the work is approximately 19 in.

67　See also Robyn Cooper, 'Millais's The Rescue: A Painting of a "dreadful interruption of domestic peace"', Art History, vol.9, no.4, 1986, pp.471–85. The date of Dickens's letter should read 30, not 13, January 1855.

85　Liverpool 1969 nos.154, 156: now Birmingham Museum and Art Gallery. Both Cyril Flower and Arthur Prinsep sat for the figure of Christ. The Sudley House version mentioned at the end of the entry is quarter-size (not half) and is a replica, probably begun in 1861.

87　Pencil study for the etching: now National Gallery of Canada, Ottawa. Liverpool 1969 no.204: now Fitzwilliam Museum, Cambridge.

94　The title was changed to 'La Belle Iseult' following publication of new evidence by Jan Marsh ('William Morris's Painting and Drawing', Burlington Magazine, vol.128, Aug. 1986).

96　Now Lady Lever Art Gallery, Port Sunlight (National Museums and Galleries on Merseyside).

99　Sold Sotheby's 20 June 1989 (24, repr. in col.).

102　For 'a hundred pounder' in the letter to Stephens, read 'a hundred pounds'.

105　Inscription should read 'Whh | 1858'.

110　Sold Christie's 22 June 1984 (302, repr. in col.).

121　The study similar to Stretes's portrait is now in Birmingham Museum and Art Gallery. Both studies were made from portraits included in a South Kensington Museum exhibition in June 1862.

122　Last paragraph: another pencil study was sold at Christie's on 13 Nov. 1992 (95) and there are two more, not one, in private collections. The study sold on 29 July 1977 was bought for Her Majesty Queen Elizabeth The Queen Mother.

124　Date should read '1863–4, retouched 1866 and 1868'.

132　For 'goto' read 'koto'.

133　Line break after 'King' in the verses should in fact come after 'raiment of'.

137　A line is missing in the penultimate paragraph on p.215. Line 18 should read: 'Victoria, Melbourne), was commissioned by Frederick Craven'.

138　Blanchard's print was published in 1869, not 1871.

139　Penultimate line of verse should read 'Seals of love, but sealed in vain,'.

140　Sold Sotheby's 19 June 1991 (235, repr. in col.).

141　Inscription should read 'Guido | vorrei | che tu | e Lapo | ed io'.

143　The replica is quarter-size (not half) and the print was issued in 1878, not 1877. For 'four versions of "The Plain of Esdraelon"', read 'two'.

146　Date should read 'Begun 1873'.

148　The sketch in Mrs Hamilton's collection is of the Philistine Plain and was made in 1876, not 1870.

149 Line 12 on p.228 should read 'in which the figure of Love was omitted...'.

151 Sold Christie's 27 Nov. 1987 (140, repr. in col.). The full point should precede the quotation mark after 'Proserpine' at end of entry.

153 First line of verse should end 'La Pia, – me' and the second should read 'From Siena sprung and by Maremma dead.' New final line should read 'Dante Purgatory Canto V.'

159 Now Yale Center for British Art, New Haven. It was W.M., not D.G., Rossetti who identified the subject as from Shelley.

163 Imperial size should read 9 × 13⅜.

167 Ricketts paid 100 gns, not £100, for this.

168 See also: Alison Inglis and Cecilia O'Brien, '"The Breaking of the Web": William Holman Hunt's Two Early Versions of *The Lady of Shalott*', *Art Bulletin of Victoria*, no.32, 1991, pp.32–50.

170 Now Walker Art Gallery, Liverpool (National Museums and Galleries on Merseyside). Size should read 9⅞ × 9⅛ (25 × 23).

182 As for no.170. The size should read 6⅞ × 4⅞ (17.5 × 12.5).

183 1853 portrait of W.M. Rossetti: now National Portrait Gallery.

196 Part of the quotation in the first paragraph should read: 'I remember Thee: the Kindness of thy youth, The love...'.

197 Paragraph two: omit 'on an easel'.

204 First exh: German Gallery, April 1861. The 1856 RA exhibit was the Oldham work.

207 Sold Sotheby's 26 Nov. 1985 (52).

209 Paragraph one: omit 'so are the strips added at either side'.

210 Now private collection.

211 Last sentence of first paragraph should begin 'Quotations which were inscribed...'.

212 In penultimate line read 'favored' for 'favoured'.

243 Sold Sotheby's 20 June 1988 (41).

248 Medium should read 'Pencil ?and black chalk'.

249 As for 248.

Recent literature includes:

GENERAL: Mary Bennett, *Artists of the Pre-Raphaelite Circle: The First Generation: Catalogue of Works in the Walker Art Gallery, Lady Lever Gallery and Sudley Art Gallery*, 1988; Roger W. Peattie (ed.), *Selected Letters of William Michael Rossetti*, 1990; Benedict Read and Joanna Barnes (eds.), *Pre-Raphaelite Sculpture: Nature and Imagination in British Sculpture 1848–1914*, 1991; Lynn Roberts, 'Nineteenth Century English Picture Frames, I: The Pre-Raphaelites', *International Journal of Museum Management and Curatorship*, vol.4, no.2, June 1985, pp.155–72; Jane Vickers (ed.), *Pre-Raphaelites: Painters and Patrons in the North East*, exh. cat., Laing Art Gallery, Newcastle upon Tyne 1989

BOYCE: Christopher Newall and Judy Egerton, *George Price Boyce*, exh. cat., Tate Gallery 1987.

BROWN: Teresa Newman and Ray Watkinson, *Ford Madox Brown and the Pre-Raphaelite Circle*, 1991.

BURNE-JONES: Maria Teresa Benedetti and Gianna Piantoni, *Burne-Jones: dal preraffaellismo al simbolismo*, exh. cat., Galleria Nazionale d'Arte Moderna, Rome 1986.

HUNT: Judith Bronkhurst, 'William Holman Hunt: A Catalogue Raisonné of Paintings and Drawings Executed up to his Departure for the Near East on 13 January 1854', PhD thesis, Courtauld Institute of Art, London University 1987; Jeremy Maas, *Holman Hunt and The Light of the World*, 1984.

INCHBOLD: Christopher Newall, *John William Inchbold: Pre-Raphaelite Landscape Artist*, exh. cat., Leeds City Art Gallery 1993.

MILLAIS: Malcolm Warner, 'The Professional Career of John Everett Millais to 1863, with a Catalogue of Works to the Same Date', PhD thesis, Courtauld Institute of Art, London University 1985.

MORRIS: Joanna Banham and Jennifer Harris (eds.), *William Morris and the Middle Ages*, exh. cat., Whitworth Art Gallery, University of Manchester 1984.

ROSSETTI: Maria Teresa Benedetti, *Dante Gabriel Rossetti*, 1984; Alicia Faxon, *Dante Gabriel Rossetti*, 1989; W.E. Fredeman (ed.), *A Rossetti Cabinet: A Portfolio of Drawings by Dante Gabriel Rossetti*, special number of *The Journal of Pre-Raphaelite and Aesthetic Studies*, 1991; Virginia Surtees, *Rossetti's Portraits of Elizabeth Siddal*, 1991.

SIDDAL: Jan Marsh, *The Legend of Elizabeth Siddal*, 1989; Jan Marsh, *Elizabeth Siddal 1829–1862: Pre-Raphaelite Artist*, exh. cat., Ruskin Gallery, Sheffield 1991.

SOLOMON: Simon Reynolds, *The Vision of Simeon Solomon*, 1984.